MONOGRAPH 44

Ceramic Production and Circulation in the Greater Southwest

Source Determination by INAA and Complementary Mineralogical Investigations

Edited by Donna M. Glowacki and Hector Neff

The Cotsen Institute of Archaeology
University of California, Los Angeles
2002

The Cotsen Institute of Archaeology at UCLA
Charles Stanish, Director
Marilyn Beaudry-Corbett, Director of Publications

Edited by ZoAnna Carrol, Rita Demsetz, Marilyn Gatto, Brenda Johnson-Grau, and Kathy Talley-Jones
Designed by Brenda Johnson-Grau
Production by Erin Carter, Merlin Ramsey, Karla Saenz, and Alice Wang

Library of Congress Cataloging-in-Publication Data

Ceramic production and circulation in the greater southwest: source determination by INAA and complementary mineralogical investigations / edited by Donna M. Glowacki and Hector Neff.
p. cm.
Includes bibliographical references.
ISBN 0-917956-98-2
1. Indian pottery--Southwest, New--Analysis. 2. Indians of North America--Commerce--Southwest, New. 3. Archaeological chemistry. 4. Indians of North America--Southwest, New--Antiquities. 5. Southwest, New--Antiquities. I. Glowacki, Donna M. II. Neff, Hector.
E78.S7 .C337 2002
979'.01--dc21

2002000650

Cover illustration: Thirteenth- and fourteenth-century White Mountain Red Ware types.
Illustration prepared by Daniela Triadan

Contents

Preface v

1 Ceramic Source Determination by Instrumental Neutron Activation Analysis
in the American Southwest
Hector Neff and Donna M. Glowacki 1

2 Quantitative Techniques for Analyzing Ceramic Compositional Data
Hector Neff 15

3 Black Mountain Phase Ceramics and Implications for Manufacture
and Exchange Patterns
Darrell Creel, Matthew Williams, Hector Neff, and Michael D. Glascock 37

4 Chaco and the Production and Exchange of Dogoszhi-Style Pottery
Jill E. Neitzel, Hector Neff, Michael D. Glascock, and Ronald L. Bishop 47

5 Resource Use, Red-Ware Production, and Vessel Distribution
in the Northern San Juan Region
Donna M. Glowacki, Hector Neff, Michelle Hegmon, James W. Kendrick, and W. James Judge 67

6 Artifact Design, Composition, and Context: Updating the Analysis of
Ceramic Circulation at Point of Pines, Arizona
M. Nieves Zedeño 74

7 From Compositional to Anthropological: Fourteenth-Century Red-Ware Circulation
and Its Implications for Pueblo Reorganization
Daniela Triadan, Barbara J. Mills, and Andrew I. Duff 85

8 Ceramic Production and Distribution in Two Classic Period Hohokam Communities
 Karen G. Harry, Paul R. Fish, and Suzanne K. Fish 99

9 Protohistoric Ceramics from the Texas Southern Plains:
 Documenting Plains–Pueblo Interactions
 Douglas K. Boyd, Kathryn Reese-Taylor, Hector Neff, and Michael D. Glascock 111

10 Patayan Ceramic Variability: Using Trace Elements and Petrographic Analysis
 to Study Brown and Buff Wares in Southern California
 John A. Hildebrand, G. Timothy Gross, Jerry Schaefer, and Hector Neff 121

11 Typologies and Classification of Great Basin Pottery:
 A New Look at Death Valley Brown Wares
 Jelmer W. Eerkens, Hector Neff, and Michael D. Glascock 140

12 A Petrographic Approach to Sand-Tempered Pottery Provenance Studies:
 Examples from Two Hohokam Local Systems
 James M. Heidke, Elizabeth J. Miksa, and Henry D. Wallace 152

13 Using INAA in the Greater Southwest
 Donna M. Glowacki and Hector Neff 179

Glossary *prepared by Michael D. Glascock* 186
Bibliography 193
List of Contributors 217

Preface

THE USE OF INSTRUMENTAL NEUTRON ACTIVATION ANALYSIS (INAA) in ceramic research in the American Southwest has become widespread over the last ten years. This volume presents case studies of Southwestern ceramic production and distribution in which INAA is used as the primary analytical technique. Most of the studies were first presented in a symposium at the 1997 Society for American Archaeology meetings in Nashville, Tennessee. Reduced to barest essentials, all the papers address the question of ceramic provenance, using provenance determination to explore such issues as migration, social identity, and economic organization. Our goal in bringing these papers together is to convey a sense of the cumulative contribution to knowledge of Southwest prehistory that INAA-based ceramic characterization is making as of the late 1990s.

Were it not for one discouraging recent development, we would expect INAA to continue to play an important role in Southwestern research during the coming years. Unfortunately, during the past year, the secretary of the Smithsonian Institution has proposed eliminating the Smithsonian Center for Materials Research and Education (SCMRE), which has been responsible for approximately 40% of archaeometric INAA in the US during the past twenty years. Fortunately, the US Congress intervened during budgetary negotiations and disallowed any closings of scientific units, including SCMRE, pending a full review of all science at the Smithsonian. We hope that an informed review leads to SCMRE's survival. Archaeometric INAA programs at the Missouri University Research Reactor Center (MURR), Texas A&M, and other university research reactor centers might be able to take on some of the work that previously would have gone to SCMRE, but, clearly, archaeological provenance research in the US would suffer a major blow if the SCRME-NIST program were to close.

With the capability to undertake INAA in the US in some jeopardy, we encourage provenance researchers to explore the potential of alternative characterization techniques that are now becoming available, especially inductively coupled plasma-mass spectroscopy (ICP-MS) (Kennett et al. 2001). At the same time, we hope that the contributions of INAA-based research are not overlooked in a rush to hit old nails with new hammers. Much has been learned through INAA studies, both about provenance methods and about patterns of material circulation in many regions of the world. Most concretely, INAA-based provenance research has generated and continues to generate a huge database of artifact chemical analyses that, with careful attention to data compatibility issues, can continue to be built upon in the future. Some of these data are currently available electronically. For instance, all the data employed in this volume can be obtained at a web site maintained by the MURR Archaeometry Lab (http://web.missouri.edu/~reahn/archdata.htm). We decided to publish the data electronically rather than as appendices in order to leave more space for the authors to discuss and expand interpretations and because of the convenience of web access. For data produced by the petrographic study by James M. Heidke, Elizabeth J. Miksa, and Henry D. Wallace, the authors should be contacted at Desert Archaeology, Inc., 3975 N. Tucson Blvd., Tucson, AZ 85716.

The editors would like to thank MURR, Crow Canyon Archaeological Center and the Anthropology Department at Arizona State University for their institutional support to produce this volume. We would also like to thank the contributors for their good-natured cooperation and perseverance. Special thanks to Jim Cogswell, Marilyn Beaudry-Corbett, Andrew Duff, Michael Glascock, Michelle Hegmon, Keith Kintigh, Daniela Tridan, and M. Nieves Zedeño, who were especially helpful and supportive through the course of this endeavor. Above all, we thank Ronald L. Bishop and M. James Blackman of SCMRE, whose efforts over the past twenty-five years have transformed INAA-based artifact provenance research from an arcane, vaguely understood pursuit of "archaeometrists" into a standard, accepted part of archaeological research.

– DONNA M. GLOWACKI
– HECTOR NEFF

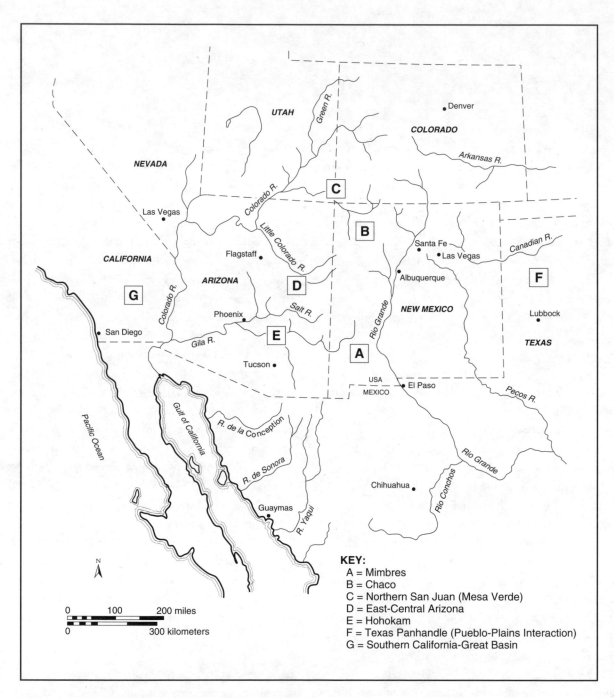

1.1 Map of the Southwest with case studies indicated.
Illustration prepared by Shearon Vaughn

Ceramic Source Determination by Instrumental Neutron Activation Analysis in the American Southwest

Hector Neff and Donna M. Glowacki

THE GOAL OF THIS VOLUME is to provide an overview of chemistry-based ceramic provenance studies in the US Southwest. Most of the chapters are case studies involving the application of instrumental neutron activation analysis (INAA) in different Southwest regions (figure 1.1). Chapters 1, 2, and 13 are more synthetic in nature.

In this introduction, our goal is to provide background information that will enhance the reader's understanding of the volume's substantive chapters. Most of the ceramic source determinations reported here and many other recent studies in the Southwest are based on chemical characterization via INAA, and so we begin by considering briefly thee merits of chemical approaches compared to other approaches to ceramic source determination and why INAA has become the most popular of several available chemical characterization techniques that can be used in ceramic provenance research. We move next to a discussion of the basics of INAA and some of the specifics of how it is applied in this volume's studies. Then we consider the basic methodology of chemistry-based ceramic source determination. Finally, to provide a context for evaluation of the research presented in this volume, we summarize results of some of the previous provenance research in the Southwest. Chapter 2 covers quantitative techniques that are useful for implementing the approach to ceramic provenance determination outlined in the present chapter. By taking care of these methodological and technical issues at the outset, we hope to leave more room for discussion of interesting substantive findings in the remaining chapters.

WHY CHEMICAL ANALYSIS?

Although they rest on the same underlying methodological principles, chemical and mineralogical characterization may not be equally well suited for all sourcing purposes. Mineralogical analysis had its strongest adherent in Anna Shepard, who once stated, "The great advantages of mineralogical analysis [over chemical analysis] are that it defines the potters' materials, affords a direct guide for locations of centers of production, and can be used effectively for samples of sufficient size for statistical analysis" (Shepard 1965:xi). From the point of view of practitioners of chemistry-based sourcing, the notion of "defining potters' materials" seems ambiguous, while the second two points seem highly debatable. Whether mineralogical or chemical analysis affords a "more direct" indication of source is an empirical issue, not an invariant feature of the natural world. And with modern instrumentation, samples of sufficient size for statistical analysis are actually easier to acquire using chemical analysis than using the most common mineralogical approach, optical petrography, which requires long hours laboriously identifying and counting mineral grains. One might also argue that whereas optical petrography requires extensive training and experience (for example, Stoltman 1989:147), instrumental chemical techniques such as neutron activation analysis are relatively free from dependence on the expertise and training of a single individual.

This is not to argue that chemical analysis is a better sourcing tool than optical petrography or x-ray diffraction but rather to point out that there are several points of view on the matter. As a counterpoint to the overwhelming emphasis on chemical approaches in this volume, we solicited a paper (chapter 12) that exemplifies one alternative approach to ceramic source determination in the Southwest. In our view, which is shared by many practitioners of mineralogical analysis (for example, Schubert 1986; Stoltman 1989) as well

as chemical analysis (for example, Bishop, Rands, and Holley 1982; Rice 1987), secure source determination often requires two or more complementary analyses. We—and most of the other contributors to this volume—rely on bulk chemical characterization by INAA, but we recognize that mineralogical or microchemical analysis is often necessary to achieve a clear understanding of patterning in the bulk chemical data. Some of the studies in this volume, especially Harry, Fish, and Fish (chapter 8) and Hildebrand et al. (chapter 10), show how mineralogical information can supplement bulk chemical characterization in ceramic provenance research.

WHY INSTRUMENTAL NEUTRON ACTIVATION ANALYSIS?

The predominance of INAA in the studies reported here should not be read as an endorsement of INAA over other, equally precise analytical techniques, but rather as an accident of history, through which INAA has become one of the most widely used techniques for chemically characterizing ceramics and other inorganic archaeological artifacts (Hughes, Cowell, and Hook 1991:ix; Pollard and Heron 1996:54–55). INAA achieved its current status as the characterization technique of choice despite severe limitations on the availability of analytical resources. Since the basic requirement for INAA is a source of neutrons, usually a nuclear reactor, archaeological applications of the technique had to be developed at a small number of reactor-based laboratories. In North America, the most prominent early work was done at Lawrence Berkeley Laboratory (LBL; see Perlman and Asaro 1969) and Brookhaven National Laboratory (BNL; see Sayre and Dodson 1957). Fewer than twenty labs have *ever* conducted any significant archaeometric INAA in the US (Neff and Glascock 1995a:Table 1), and recent research reactor decommissioning has further diminished the potential for carrying out INAA in the service of archaeology (for example, Hughes, Cowell, and Hook 1991:x). Today, the most active INAA programs in the US are the Archaeometry Laboratory at the Research Reactor Center of the University of Missouri (MURR) and the collaborative program between the Smithsonian Center for Materials Research and Education and the National Institute of Standards and Technology (SCMRE–NIST). Both programs are descended directly from the BNL program of the 1970s.

Ironically, limitations on the availability of INAA may have contributed toward its development into the preeminent technique for archaeological provenance investigations. The physicists and chemists who began applying INAA to archaeology during the 1960s and 1970s worked in a "big science" milieu, in which it seemed natural to invite archaeologists to join the laboratory research teams. The resulting close collaborations produced a number of influential articles (for example, Abascal, Harbottle, and Sayre 1974; Bieber et al. 1976; Brooks et al. 1974) and Ph.D. dissertations (for example, Bishop 1975; Branstetter-Hardesty 1978; Deutchman 1979). The strengths of INAA, such as analytical precision, sensitivity, and multi-element determination, became well known in archaeology through these publications and through subsequent work by some of the laboratory-trained archaeologists. The fact that INAA could be undertaken at only those few labs with reactors also tended to promote communication and cooperation within this small group of researchers (Neff and Glascock 1995a). This led, in turn, to a sense of community and historical continuity among the archaeologists, chemists, geochemists, and physicists involved in INAA–based archaeological provenance research. In such a milieu, it was natural for these researchers to begin working toward long-term maintenance of intercalibrated databases (for example, Harbottle 1982; Hughes, Cowell, and Hook 1991; Yellin et al. 1978). As a result, analytical data generated two decades ago at BNL and LBL can be combined today with new data to enhance the return on new analytical investment (for example, Neff et al. 1994; Slane et al. 1994).

Although the fact that archaeometric INAA in the US and elsewhere has been carried out mainly by a few large programs has had some beneficial effects, this circumstance has also tended to promote the perception among some archaeologists that INAA is an exclusive technique. Rice (1996:166–167), for instance, detects "a high degree of inbreeding" and "intellectual quasi-incest" in a volume edited by Neff (1992) on ceramic provenance research. True, the INAA data reported in the volume were generated at just a few labs (BNL, SCMRE–NIST, and MURR), but the fact that the volume's fourteen chapters were written by thirty individuals with twenty-one different institutional affiliations would seem to belie Rice's contention: That is, despite the paucity of facilities for INAA, archaeologists with diverse interests and backgrounds from a number of different institutions are involved in INAA-based ceramic provenance research.

The perceived limited availability of INAA has also led to suggestions about how to broaden the availability and

reduce the cost of chemistry-based provenance determination. There are other chemical characterization techniques that afford precision and sensitivity which may approximate or surpass those of INAA under the right conditions. These include x-ray fluorescence (García-Heras, Fernandez-Ruiz, and Tornero 1997; Schneider 1996), inductively coupled plasma optical emission spectroscopy (ICP–OES [Hart et al. 1987]), and ICP mass spectroscopy (ICP–MS [Bryan, Holmes, and Hoffman 1996]; see Parry [1991: Tables 1.1 and 1.2], Pollard and Heron [1996: Figure 2.5], and Schneider [1996] for comparisons of analytical precision among several techniques). Perhaps the most promising new techniques are ICP–OES and ICP–MS. Unfortunately, digesting silicate material (for example, ceramic) for analysis by ICP techniques is labor intensive and/or requires use of hazardous and toxic chemicals. The desirability of reducing the sample-preparation burden has led one research team (Burton and Simon 1993) to suggest a shortcut technique for use with ICP–OES. The shortcut, which involves soaking a powdered ceramic sample in a weak hydrochloric acid solution, can be shown nearly to quadruple the natural chemical variation in a ceramic reference group and thereby to obscure all but the grossest of interregional ceramic compositional differences (Neff et al. 1996). We agree entirely with Burton and Simon's (1993) motivations for seeking a fast, cheap, clean approach to chemistry-based ceramic source determination, but we believe that any scientific measuring instrument should be questioned when its data are shown to be so noisy that the signal of interest is hopelessly lost.

INSTRUMENTAL NEUTRON ACTIVATION ANALYSIS AT MURR AND TEXAS A&M

In keeping with historical tradition in INAA-based ceramic provenance investigations, the studies in this volume are based on analytical data generated in only a few laboratories. Although SCMRE–NIST and BNL data figure peripherally in several articles, the vast majority of analyses discussed here come from just two laboratories, MURR and the Texas A&M Center for Chemical Characterization and Analysis (Glascock [1992] has described INAA procedures used at MURR; for those at Texas A&M see James, Brewington, and Shafer [1995] as well as Carlson and James [1995]). The MURR and Texas A&M labs use comparable irradiation and counting procedures and the same multi-element standards.

The basic requirement for INAA is a source of neutrons, such as a nuclear reactor, for irradiation of samples. When a

reactor is running, fission of uranium-235 atoms in fuel elements in the reactor core produces neutrons, which may interact in various ways with samples placed in or near the core. Thermal (slow) neutrons tend to combine with nuclei of the various elements in the sample to form radioactive nuclei (radioactive isotopes). The radioactive nuclei decay with characteristic half-lives, giving off gamma rays in the process. Different radioactive nuclei emit gamma rays of differing energies when they decay, so the number of radioactive nuclei of a given type in a sample can be determined from the number of decay events counted at a given energy. Because the number of radioactive nuclei of some element formed by irradiation of a sample is proportional to the number of atoms of that element in the sample, the concentrations of various elements can be determined by counting decay events at different gamma-ray energies.

The measurements made in INAA are obtained by using a high-purity germanium detector to collect from each irradiated sample a spectrum of gamma-ray emissions in the energy range of about 100 to 3200 keV. Because radioisotopes of interest decay with widely varying half-lives, different peaks will be visible above the spectrum background depending on how long the sample is allowed to decay following irradiation. Therefore, at most INAA labs, several gamma spectra are collected in order to maximize the number of detected elements and to enhance the precision of measurement (Gilmore 1991; Glascock 1992; Hughes, Cowell, and Hook 1991:31; Landsberger 1994; Pollard and Heron 1996). Very short half-life isotopes can be determined only by an analysis involving a separate, short irradiation together with a very short decay time. Spectral interferences and other complexities involved in the measurement of gamma rays in neutron activation analysis are discussed by Gilmore (1991), Glascock (1994), Landsberger (1994), and Williams and Wall (1991), among others.

For geological and archaeological applications, a major advantage of INAA over other characterization techniques is that bulk characterization of solid samples is possible with minimal sample preparation. Because the main constituents of most geological materials (silicon, aluminum, and oxygen) have extremely low neutron capture cross sections, neutrons penetrate such matrices with minimal attenuation of flux. In addition, most geological materials are ineffective at stopping the high-energy gamma rays given off by radioactive decay, so decay events throughout the sample have about the same chance of reaching the gamma-ray detector.[1]

Despite the relative ease of preparing solid samples for

Table 1.1 Comparison of analytical conditions and procedures, MURR vs. Texas A&M

	MURR	Texas A&M
Short irradiation time	5 seconds	30 seconds
Short irradiation flux	8×10^{13} n/cm²/s	2×10^{13} n/cm²/s
Decay time before first count	25 minutes	20 minutes
Count time, first count	720 seconds	500 seconds
Standards for pottery, first count	SRM-1633a (coal fly ash); SRM-688 (basalt rock for Ca); Ohio Red Clay (quality control)	SRM-1633a (coal fly ash); SRM-688 (basalt rock for Ca); Ohio Red Clay (quality control)
Elements determined from short irradiation	Al, Ba, Ca, Dy, K, Mn, Na, Ti, V	Al, Ca, Dy, Mn, Ti, V
Long irradiation time	24 hours	14 hours
Long irradiation flux	5×10^{13} n/cm²/s	2×10^{13} n/cm²/s
Decay time before second count	1 week	1 week
Count time, second count	2000 seconds	2000 seconds
Standards for pottery, second count	SRM-1633a (coal fly ash); Ohio Red Clay (quality control); SRM-278 (quality control)	SRM-1633a (coal fly ash); Ohio Red Clay (quality control); SRM-688 (quality control)
Elements determined from second count	As, La, Lu, Nd, Sm, U, Yb	Na, As, La
Decay time before third count	3–4 weeks after second count	3–4 weeks after second count
Count time, third count	2.78 hours (10,000 seconds)	3 hours
Elements determined from third count	Ce, Co, Cr, Cs, Eu, Fe, Hf, Ni, Rb, Sb, Sc, Sr, Ta, Tb, Th, Zn, Zr	Ba, Lu, Nd, Sm, U, Yb, Ce, Co, Cs, Eu, Fe, Hf, Ni, Rb, Sb, Cr, Sc, Sr, Ta, Tb, Th, Zn, Zr

INAA, care must still be taken (Gilmore 1991). With ceramics, the main concerns in sample preparation are (1) to take sufficient care to minimize the chances for contamination and (2) to sample a large enough volume of material to ensure that it represents the bulk composition of the ceramic fabric. At both MURR and Texas A&M, sample preparation involves breaking off a piece weighing about 1 to 2 g from each sherd, then burring the piece with a silicon carbide burr to remove painted or slipped surfaces and adhering soil. The burred pieces are washed with de-ionized water and allowed to dry in air. These are then crushed in a laboratory mortar to yield a fine, homogeneous powder. At MURR, a second piece of each sherd is retained, unpowdered, for the MURR archive of analyzed ceramic fabrics. The powder samples are oven-dried for twenty-four hours. At MURR, portions of approximately 150 mg are weighed and placed in small polyethelene vials used for short irradiations, while 200 mg of each sample are weighed into high-purity quartz vials used for long irradiations. At Texas A&M, a single sample of 100 mg encapsulated in a polyethylene vial is used for both the short and long irradiation. Along with the unknown samples, reference standards of SRM-1633a (coal fly ash) and SRM-688 (basalt) are similarly prepared, as are quality control samples (that is, standards treated as unknowns) of SRM-278 (obsidian, not used at Texas A&M) and Ohio red clay.

At both MURR and Texas A&M, two irradiations and a total of three gamma counts (Carlson and James 1995; Glascock

1992; James, Brewington, and Shafer 1995) are used to determine a total of thirty-two (Texas A&M) or thirty-three (MURR) elements in most archaeological ceramic samples (see table 1.1 for the irradiation and counting configurations used at MURR and Texas A&M, along with the elements determined by each gamma count at the two labs). At both laboratories, short irradiations are carried out through a pneumatic tube system, whereas the long irradiations are done in cans placed in irradiation positions next to the reactor. At Texas A&M, every eighth sample is duplicated in order to provide an additional check on reproducibility (James, Brewington, and Shafer 1995).

Differences between INAA at MURR and Texas A&M include (1) the use of different radioactive isotopes of barium with different half-lives for the determination of barium concentrations; (2) failure to detect potassium following the short irradiation at Texas A&M; (3) determination of sodium at Texas A&M from the second count rather than the first; and (4) preference at Texas A&M for third-count data on several elements determined on the second count at MURR. Despite these differences, data on Ohio red clay replicates reported by James, Brewington, and Shafer (1995) suggest that the agreement between the two laboratories on most elements is fairly good. Such compatibility is to be expected considering the use of similar irradiation, counting, and standardization (table 1.1).

The Basic Premise of Sourcing

Provenance Postulate*

| Analytical units (ppm, weight %, etc.) | Archaeological concept, "source" (geographic coordinates) |

* "that there exist differences in chemical composition between different natural sources that exceed, in some recognizable way, the differences observed within a given source."

(Weigand, Harbottle, and Sayre 1977:24)

1.2 The provenance postulate depicted as a means for constructing a bridge between units measured in two distinct domains, one being the analytical domain, which is directly accessible in the laboratory, and the other being the domain of geographic coordinates, which is the domain of interest to the archaeologist carrying out the provenance study. *Illustration prepared by Hector Neff*

METHODOLOGY OF CHEMISTRY–BASED CERAMIC PROVENANCE INVESTIGATIONS

The basic purpose of characterizing archaeological pottery by INAA or some other technique is to identify sources or source zones where raw materials were procured and ceramics were produced. The implicit underlying model is extremely simple: It holds that artifacts made from raw materials procured from the same source or within the same source zone will be compositionally similar. Sources or source zones are geographic locations described in terms of geographic coordinates (for example, longitude and latitude) or ranges of geographic coordinates. Although raw materials are invariably moved some distance from procurement location to manufacturing location, least-cost considerations dictate that the distances involved will not be very great (Arnold 1985). As a result, raw material source location can usually be considered a guide to location of manufacturing and vice versa.

Specifying a clearly defined, measurable concept ("source" in this case) is a crucial first step in any methodology. With the focal concept thus defined, the next methodological tasks are to specify how it is to be measured and to understand effects and conditions that might compromise the reliability and validity of measurements. For instance, effects during and after manufacture can intervene and complicate the task of matching ceramics to raw materials. Fortunately, investigators involved in chemistry-based provenance determination have, from the beginning, given considerable thought to methodological concerns (for example, Sayre and Dodson 1957).

The provenance postulate

The most fundamental proposition of provenance research has been called the "provenance postulate" (Weigand, Harbottle, and Sayre 1977:24).[2] This postulate (figure 1.2) states simply that sourcing is possible as long as between-source variation exceeds within-source variation. Although Weigand, Harbottle, and Sayre (1977) intended the provenance postulate to apply to quantitative variation encountered in chemistry-based sourcing, this is an unnecessarily narrow formulation. Mineralogy-based sourcing rests on the same basic principle, and the postulate applies to qualitative as well as quantitative differences. Thus, a more general statement of the fundamental principle underlying provenance research is roughly as follows: Sourcing is possible as long as there exists some qualitative or quantitative, chemical or mineralogical difference between natural sources that exceeds the qualitative or quantitative variation within each source.

The provenance postulate can be thought of as a bridge between units measured in two distinct domains (figure 1.2; Neff 1998). One domain is that of the individual, analyzed specimen, in which the units are imposed by the analytical technique, for example, parts per million (ppm) of the various measured elements or oxides, presence/absence of

1.3 Contrast between methods of provenance determination for materials such as obsidian, which occur in restricted flows, and materials like ceramics, source materials for which are extremely widespread in natural occurrence. *Illustration prepared by Hector Neff*

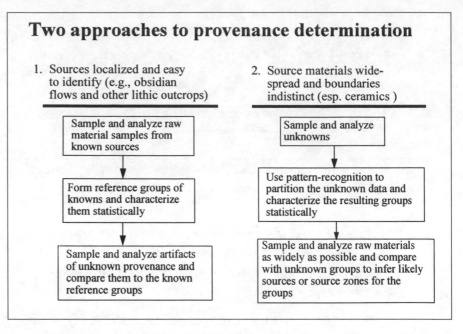

some unusual mineral, proportion of common minerals in the total nonplastic assemblage, and so on. The other domain is geographic space, in terms of which "source" may be described. The units in this second domain are conventional geographic coordinates (for example, latitude and longitude). The fundamental methodological challenge in ceramic provenance research is to specify reliable and valid means by which to construct the bridge from the analytical units measured by INAA or some other laboratory technique to the geographical coordinates used to specify source locations (Neff 1998).

Logically, constructing the bridge between the analytical and the geographic domain may follow two separate tracks (figure 1.3). If sources are localized and relatively easy to identify, as in the case of obsidian flows, the known sources can be characterized and artifacts of unknown provenance can then be compared to the range of variation of the known groups. If sources are widespread, as is true especially in the case of ceramic raw materials, sampling and characterizing most or all of the possible sources is impractical. As a result, ceramic provenance research generally involves an alternative approach, in which reference groups are created from the unknowns rather than knowns. In this more common approach to sourcing pottery, elemental concentration units are mapped onto geographic coordinates by comparing individual, known samples (raw materials) to the unknown ceramic reference groups. (Quantitative techniques for identifying and evaluating reference groups in ceramic provenance investigations are discussed in chapter 2.)

The criterion of abundance

In practice, ceramic compositional investigations are very often undertaken without any sampling of raw materials. This precludes establishing direct linkages between ceramic reference groups and geographic locations. In order to circumvent this limitation, ceramic provenance researchers often adopt the "criterion of abundance" (Bishop, Rands, and Holley 1982), which extends to compositional research the commonsense assumption that things are most frequent closest to where they originate. Thus, a homogeneous compositional group of unknown derivation is assumed to come from the site or region where it is most heavily represented archaeologically.

The problem is that one can imagine numerous conditions under which the criterion of abundance would be a poor guide to the origin of ceramics fitting a particular composition. Peculiarities of past consumption patterns may cause a particular kind of pottery to peak in frequency at some distance from its production center. Or, because of the vagaries of archaeological sampling, relative frequencies in excavated assemblages may not accurately represent variation in the frequency of occurrence of pottery derived from some source. Similarly, vagaries of sampling the assemblages for analysis may distort the relative frequencies of various compositional groups. All in all, too much faith in provenance assignments based on the criterion of abundance would seem to be ill-advised.

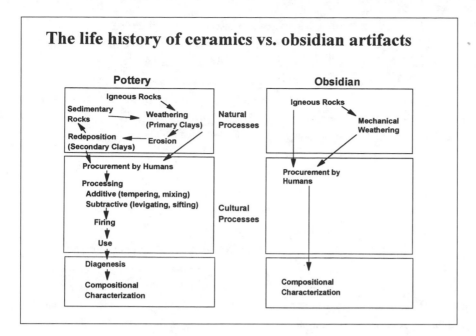

1.4 Contrast between the life history of pottery and obsidian, showing the greater complexity and greater potential for attenuation of reliability and validity of provenance determination in the case of pottery. *Illustration prepared by Hector Neff*

Considerations of regional geology

Arguments about source locations, whether on the basis of sampling of raw materials or the criterion of abundance, can often be strengthened by considering features of regional geology. This stands to reason since all ceramics start out as natural geological materials, most often, in the case of prehistoric ceramics, as sediments or soils containing variable quantities of clay minerals, nonplastic sand- and silt-sized mineral grains and rock fragments, and organic matter. Geological maps and highly detailed descriptions of both bedrock geology and soils, often including summary information on mineralogy, are available for many regions and constitute a valuable resource for ceramic provenance researchers.

Geological conditions have to be considered at a spatial scale appropriate for the goals of a particular provenance project. Steponaitis, Blackman, and Neff (1996), for instance, have shown that groups of Mississippian pottery pertaining to broad regions of the southeastern and midwestern US differ chemically in precisely the ways expected on the basis of differences in clay mineralogy among the different drainage basins. At a smaller geographical scale, in the northern Valley of Guatemala, a localized outcrop of granodiorite helps explain the peculiar chromium-cobalt profile of modern pottery from the area and helps eliminate it as a source of certain regionally distributed prehistoric ceramics (Neff et al. 1994). At a scale intermediate between these two extremes, ongoing research in Cyprus (Gomez et al. 1995, 1996; Rautman et al. 1993) is incorporating extensive raw-material sampling coupled with consideration of Cypriot bedrock geology and weathering history to infer source zones for a number of compositionally distinct ceramic groups.

In the Southwest, a precedent appears to have been set for the explicit incorporation of regional geological information into INAA-based ceramic provenance studies. Examples include Deutchman (1979), who incorporated a detailed discussion of the geology of Black Mesa into her discussion of Sosi and Dogozhi Black on White production and exchange patterns; Stewart et al. (1990), whose study of ceramics from a Lincoln phase site in southeastern New Mexico incorporates detailed consideration of regional igneous geology, petrography, and geochemistry; Neff, Larson, and Glascock (1997), who describe regional geology and identify likely clay-bearing formations in their study of ceramics from a Pueblo III site in south-central Utah; and Triadan (1997:18–20), who discusses the geology of the Grasshopper region as a prelude to a consideration of chemical patterning in the region's ceramic compositional data. We believe these studies have set good precedents, and we hope that such applications continue to distinguish INAA-based ceramic provenance studies in the Southwest. Toward this end, we have asked the authors of the chapters in this volume to provide descriptions of geological conditions at a scale appropriate to their goals and to evaluate any inferences of source zone in light of the geological conditions described.

Ceramic life history and its effects on the reliability and validity of provenance determination

Some of the complexities involved in chemistry-based ceramic source determination can be illustrated by considering

the "life history" of ceramic artifacts (figure 1.4). Like lithics, ceramic life histories encompass (1) residence in the geological environment prior to use as implements by humans; (2) procurement, modification, and use by humans; (3) residence in the burial environment after discard; and (4) recovery and analysis. A key difference between the life histories of ceramics and lithic artifacts, such as those made of obsidian, is that ceramics may undergo considerable chemical alteration during manufacture, use, and burial (figure 1.4). The special problems that paste preparation and diagenesis might create for chemistry-based sourcing have been appreciated for some time (Sayre and Dodson 1957).[3]

Because both natural and cultural processes can affect the raw material (figure 1.4), the compositional profile derived from the chemical analysis of a ceramic sample may not match any single "source." Even the addition of a relatively pure material, such as quartz, as temper will reduce elemental concentrations in a ceramic paste by a constant proportion (Olin and Sayre 1971). On the other hand, addition of other kinds of nonplastic temper or clay will result in a complex relationship of dilution and enrichment (Arnold, Neff, and Bishop 1991; Bishop 1980; Bishop, Rands, and Holley 1982; Neff, Bishop, and Sayre 1988, 1989). Firing has been shown not to be an important contributor to chemical variation, except through removal of water and carbon dioxide and the consequent proportional enrichment of measured elemental concentrations (Cogswell, Neff, and Glascock 1996a; Kilikoglou, Maniatis, and Grimanis 1988). Use, however, is postulated as a cause of increased zinc concentrations in at least one case (Cogswell et al. 1996), and post-depositional addition of barium is well documented in several others (Cogswell et al. 1996; Picon 1985, 1987). Other diagenetic modifications of the bulk ceramic fabric, either through leaching (Myers, Olin, and Blackman 1992) or addition (for example, García-Heras 1993; Lemoine and Picon 1982; Walter and Besnus 1989), are documented as well.

Effects during each of the ceramic life history stages (figure 1.4) may attenuate both the reliability and the validity of chemical analysis as a monitor of geographic source (Neff 1998). Reliability concerns the noise, slop, or uncertainty in the source determinations; validity concerns the extent to which groups within the chemical data truly represent sources rather than chemical similarity caused by other life-history processes. If tempering and diagenesis increase the chemical variation of ceramics derived from a single source, in effect they introduce additional noise that compromises the reliability of chemistry-based sourcing.

Ceramic life history influences may compromise the validity of source determination because of the possibility that non-source-related patterning arises from chemical changes during manufacture, use, or diagenesis. In general, there are three viable alternatives to the hypothesis that subgroups in bulk chemical data represent distinct raw clay sources: (1) the groups may represent some paste-preparation effect, such as tempering; (2) the groups may have been created by some use-related or diagenetic change; or (3) the groups may represent some combination of the effects of source differences, paste preparation, and use-related or diagenetic change. Alternatives to the hypothesis that chemical groups are source-related become less plausible if compositional variation in the ceramics can be shown to parallel compositional variation in sampled raw materials or to be expected because of regional geology. Supplementary analyses, such as low-power microscopic examination, optical petrography, scanning electron mircroscopy (SEM), x-ray diffraction, and, especially, microchemical analysis also may provide crucial information bearing on the plausibility of one or more of the alternatives (Neff 1998).

Effects of analysis on reliability and validity of provenance determination

At the end of the ceramic life history, choice of analytical procedures is crucial. Using a very imprecise (unreliable) analytical technique may introduce so much noise into the analytical data that chemically distinct sources cannot be discriminated, and the provenance determinations derived from the chemical data therefore become completely unreliable as well. For instance, as mentioned previously, Neff et al. (1996) have shown that the weak-acid approach to chemical characterization magnifies the natural variation of chemical groups derived from a single source zone by up to four times. In an example used for illustration, several groups of Tanque Verde Red-on-brown pottery that are exceptionally well discriminated by many elements determined by INAA are completely impossible to discriminate with weak-acid ICP data. The practical implication of this comparison is that unmistakable and somewhat surprising evidence for long-distance circulation of Tanque Verde Red-on-brown pottery would not have come to light if the study had been based on the weak-acid extraction approach.

Choices made at the analysis stage may also affect validity of source determination. For instance, Triadan, Neff, and Glascock (1997) identified spurious (non-source-related)

compositional patterning in ceramic chemical data generated by the weak-acid extraction approach. The "groups" in the weak-acid data may reflect preferential leaching of various paste constituents in the acid bath, the exact composition of the leachate depending on firing temperature, post-depositional processes, or other effects unrelated to raw material source location. Not only does the noise added by weak acid sample preparation compromise the reliability of chemical analysis as an indicator of source, it also compromises the validity of this approach to provenance determination.

A BRIEF SUMMARY OF INAA–BASED PROVENANCE RESEARCH IN THE SOUTHWEST

Linda Cordell (1991) has pointed out the profound influence that provenance investigations can have on archaeological frames of reference. Earlier in this century, archaeologists as-sumed implicitly that prehistoric pueblos in the southwestern US conformed to an ideal of community self-sufficiency, much like contemporary pueblos. Doubts about this proposi-tion were first raised by Anna O. Shepard's (1942; 1965) pet-rographic study of Rio Grande Glaze Paint ware at Pecos Pueblo, New Mexico. In a direct refutation of community self-sufficiency, Shepard demonstrated that substantial pro-portions of the pottery consumed at Pecos could not have been made locally. Cordell notes that Shepard's study initially received a lukewarm reception among Southwestern archae-ologists, who were reluctant to give up what was almost a central tenet of Southwestern prehistory. Gradually the evi-dence piled up, however, and by the late 1970s, many investi-gators were comfortable with the view that ceramics were frequently moved across the southwestern landscape (for ex-ample, S. Plog 1980, 1994; Toll, Windes, and McKenna 1980).

With the growing awareness of the importance of ceramic circulation, it is perhaps not surprising that INAA-based provenance investigations of Southwestern ceramics began to appear regularly after about 1980. Most of these investigations have been reported as journal articles, chapters in edited volumes, or technical appendices to project reports. Recently, however, two Southwestern ceramic provenance investigations have appeared as full-length monographs (Triadan 1997; Zedeño 1994), an indication that such studies have become central to understanding of the region's prehistory. On the whole, as the following summary demonstrates, the ceramic provenance determinations produced by INAA studies leave little doubt that prehistoric southwestern communities were strongly interdependent and

that movement of ceramic vessels was a frequent activity of the region's prehistoric inhabitants.

Although the INAA evidence is generally unambiguous that ceramics were moved frequently across the southwestern landscape, there is considerable variation among studies in the relative emphasis placed on local production and consumption versus ceramic circulation. At one extreme, the distances between sampled sites may be so large that ceramic circulation did not, in fact, take place, and each site's assemblage thus appears "local." At the other extreme, geological conditions may be such that a definitive distinction cannot be made between ceramic compositional diversity resulting from circulation of ceramics and compositional diversity resulting from exploitation of diverse local ceramic resources. In general, careful attention to sampling designs for both ceramics and raw materials can help minimize these problems.

INAA-based ceramic provenance investigations in the Southwest got off the ground in the late 1970s, when two dissertations incorporating INAA of southwestern ceramics were undertaken (Deutchman 1979; Gould 1982). Gould's dissertation reported INAA data for a small sample of about sixty Pueblo II and Pueblo III ceramics from the Mustoe site in southwestern Colorado. He concluded that the various Black-on-white, Red, and Corrugated types were all produced locally and that two sherds from nearby sites were compositionally similar as well.

Haree Deutchman's dissertation project (also see Deutchman 1980) was more ambitious than Gould's. Focusing on regional exchange in northern Arizona, she analyzed (at BNL) Sosi and Dogozhi Black-on-white pottery from five sites on Black Mesa, three in the Klethla Valley, one on the Kaibito Plateau, and one to the north of Black Mesa, just south of Navajo Mountain. The dissertation incorporates a detailed account of regional geology, technical aspects of INAA, and multivariate approaches to analysis of compositional data, as well as the relevant archaeological information. Deutchman found that both Sosi and Dogozhi were produced in multiple locations and that any given site's assemblage also contained ceramics pertaining to different compositional groups. Initially, Deutchman's study seems not to have received much attention. Recently, however, Kojo (1996) undertook a "low-tech" source analysis of Pueblo II ceramics from the Black Mesa area and reached conclusions strikingly similar to Deutchman's. Although the magnitude of vessel movement inferred by Deutchman (about 35 to 50% of ceramics on a site are nonlocal according to Deutchman

[1980:126]) may be somewhat inflated, Kojo, like Deutchman, found a surprisingly clear signal that ceramics were moved frequently among Pueblo II sites in the Black Mesa region.

INAA-based ceramic provenance research during the 1980s and early 1990s continued to evaluate the evidence for movement of ceramics on various geographic scales. At a relatively large scale, Neitzel and Bishop (1990) looked at Black-on-white cylindrical vessels from Chaco Canyon and Allentown, a Chacoan outlier, both in New Mexico, and compared them to Dogozhi compositions in Deutchman's Black Mesa data set. The main conclusion reached in this study was that cylindrical vessels from Chaco Canyon overlapped compositionally with Black-on-white bowls from Chaco, a finding that refuted the hypothesis that cylindrical vessel production represented some kind of localized, specialized craft activity (Neitzel and Bishop 1990:79). In addition, compositional differences observed among the three locations (Chaco, Allentown, and Black Mesa) implied local production and provided no indication of exchange or other forms of vessel movement. As Neitzel and Bishop (1990:80) recognized, the geographic scale involved in this study was so large that evidence for movement of vessels would be quite surprising, especially with the small sizes of the samples from Chaco and Allentown. The contribution by Neitzel, Neff, Glascock, and Bishop in the current volume (chapter 4) is a more geographically focused study of Chaco ceramics.

Another project conceived on a large geographic scale is the study of Gila Polychrome carried out by Crown and Bishop (1991, 1994). Gila is the temporally intermediate expression of the Salado Polychrome tradition studied by Crown (1994). The total analyzed Gila Polychrome sample (Bishop and Crown 1994: Figure 3.1, Table 3.1) included 215 analyses from sites spread across 130,000 km² of Arizona, New Mexico, and Chihuahua (Mexico). The main question addressed by this study was whether the wide distribution of Gila Polychrome reflected exchange from a central production center or widespread local production (Bishop and Crown 1994:21–22). Identification of thirteen distinct compositional reference groups within the analyzed sample demonstrated unequivocally that Gila Polychrome was not made in a single production center. Moreover, because the various compositional groups tended to be restricted to a few sites within specific regions, production loci apparently were widespread (Bishop and Crown 1994:31). At the same time, most of the identified compositional groups included analyses from several sites, and several sites included representatives of more than one compositional group. Overall, the distributions of Gila Polychrome compositional groups suggest to Crown and Bishop that "even though most sites apparently had a single nearby primary source for Gila Polychrome bowls, vessels from distant sources were exchanged into the sites" (1991:55).

A number of INAA-based provenance studies since 1980 have sought evidence of vessel movement on geographic scales smaller than the broad scale represented by the Chaco and Gila Polychrome studies. A major focus of several studies has been Pueblo III and IV periods of the eastern Arizona mountains. A study by Tuggle, Kintigh, and Reid (1982) focused on white wares from the Chevelon and Q-Ranch regions of eastern Arizona but also included a few corrugated sherds and a few sherds from the Tonto-Roosevelt and Grasshopper regions. Despite the small sample size (*n*=45), the study indicated that the members of two white ware compositional groups were present among the analyses from several regions. Corrugated sherds from Q-Ranch formed a distinct compositional group inferred to be local; white wares from Q-Ranch, in contrast, grouped with white wares from other regions, and were inferred to be nonlocal. In sum, this project provided an initial indication that white ware ceramics were moved extensively around the eastern Arizona mountains.

The southern Colorado Plateau and eastern Arizona mountains have continued to be a focus of INAA-based ceramic provenance excavations, with recent monographs by Zedeño (1994) and Triadan (1997) adding considerable detail to the tantalizing yet fuzzy picture of ceramic circulation offered by Tuggle, Kintigh, and Reid (1982). Zedeño reported analyses of Cibola White Ware and Roosevelt Red Ware together with corrugated and plain pottery from Chodistaas, a small pueblo in the Grasshopper region. Cibola White Ware specimens were found to come from three or more analytical sources, all probably located north of the Mogollon Rim; interestingly, specific Black-on-white design styles were all represented in more than one compositional group. Roosevelt Red Ware and corrugated sherds from Chodistaas also appeared to fall into multiple compositional groups, and Zedeño (1994:101) concludes that at least one-third of the ceramics consumed at Chodistaas were obtained from neighbors near and far. In chapter 6 of this volume, Zedeño considers another site, Point of Pines, where much of the ceramic assemblage appears to have derived from sources to the north.

In Zedeño's (1994) study, White Mountain Red Ware was assumed to have been imported to the Grasshopper region from north of the Mogollon Rim, but no analyses

were undertaken. Triadan (1997) filled in this picture by analyzing White Mountain Red Ware from Pueblo IV contexts in the Grasshopper region. Triadan, like Zedeño, found that a large proportion of the vessels were nonlocal to the Grasshopper region and were probably imported from sources north of the Mogollon Rim. Grasshopper residents, however, also began producing their own local version of White Mountain Red Ware along with a local decorated ware known as Grasshopper Polychrome. Initiation of local production implies that producers of White Mountain Red Ware had migrated into the Grasshopper region. In the present volume, Triadan, Mills, and Duff (chapter 7) update the study of White Mountain Red Ware with many new analyses from sites both north and south of the Mogollon Rim.

The Hohokam region also saw the initiation of INAA-based ceramic provenance research in the late 1980s. In one study, several types of analyses, including INAA, were performed on fifty Tucson Basin pottery and raw material samples from the San Xavier Bridge site on the Santa Cruz River in southern Arizona. The analyses were done by a commercial analytical laboratory, and the resulting data were examined by Bishop (1987; also see Whittlesey 1987). Since the analyzed sample pertained to a single site, the goal of the study was to provide some initial estimate of a local compositional profile for the region (Bishop 1987:395). This goal was achieved: A presumed local Tanque Verde-Rincon compositional group was identified, and test tiles made of local materials were found to be "closely similar yet statistically separated" from the presumed local reference group (Bishop 1987:407). Specimens of several types, including Gila and Pinto-Gila Polychrome and Tucson Polychrome, were consistently distinct from the local reference group, so the study also suggested that some pottery had been imported.

P.R. Fish, S.K. Fish, Whittlesey, and colleagues. (1992) later analyzed a much larger sample of Classic period (AD 1150 to 1350) Tanque Verde Red-on-Brown pottery from the Tucson Basin and neighboring regions of southern Arizona. The primary goal was to test the hypothesis that Tanque Verde Red-on-brown vessels were made in localized areas in the western Tucson Basin and along the Santa Cruz River. Among the identified subgroups were four that, based on comparison with raw materials and relative abundance, are certainly local to the Tucson Basin. Tentative provenances within the Tucson Basin were suggested for these four groups based on abundance of group members in various sampled

zones. Occurrence of several compositional groups sampled from individual sites within the northern basin provided evidence that vessels moved within the northern basin, and examples of northern Basin groups in the Phoenix area and downstream along the Gila River demonstrated movement of vessels out of the Basin. In addition, one well-defined non-Tucson-Basin group was found to be extremely widely distributed across southern Arizona. Thus, while this study refuted the hypothesis that Tanque Verde Red-on-brown production was restricted to just a few places in the northern Tucson Basin (Whittlesey 1987), it also demonstrated that these vessels were regularly moved substantial distances across the southern Arizona desert. Karen Harry and her colleagues have recently analyzed an even larger sample of Tanque Verde Red-on-brown from two distinct Classic period communities in the northern Tucson Basin (this research is summarized in chapter 8).

The northern Southwest has seen several INAA-based ceramic provenance investigations since Deutchman's (1979, 1980) pioneering work on Black Mesa. One example (Bishop et al. 1988) is a study of late prehistoric Hopi yellow-firing pottery that combined INAA with technological and decorative analyses. Although the ceramic analytical groups identified in this study "are not homologous to the Hopi potters who produced and exchanged their wares between A.C. 1300 and 1600," the analysis did demonstrate that "pottery production was village specific" (Bishop et al. 1988:332). Villages on Antelope Mesa evidently either exploited similar clays or interacted in such a way that ceramics were moved between them, but the study produced only ambiguous evidence that ceramics moved between the Antelope and First Mesa (Bishop et al. 1988:330). It did, however, show that vessels produced on Antelope Mesa, in north-central Arizona, were moved south to sites on the Little Colorado River and east to Pottery Mound, on the Rio Puerco in New Mexico (Bishop et al. 1988: 330, 333).

In the Four Corners region, Hegmon and her colleagues (Hegmon, Hurst, and Allison 1995; Hegmon et al. 1997) have reported INAA-based provenance data on Pueblo I period red and white wares. Two reference groups of San Juan Red Ware were attributed to southeastern Utah production zones, with distribution beyond this region likely being the result of exchange (Hegmon et al. 1997:459–460). The contemporaneous white wares, in contrast to San Juan Red Ware, appear to have been produced widely (Hegmon, Hurst, and Allison 1995:45). Glowacki and her colleagues (Glowacki 1995; Glowacki, Neff, and Glascock 1995, 1998) have

reported sources for Pueblo III Black-on-white types from the vicinity of Mesa Verde in southwestern Colorado. A large sample of Pueblo III Black-on-white pottery from Lowry Ruin together with additional raw materials were recently added to the Four Corners database. As reported by Glowacki and colleagues (chapter 5), addition of the new analyses provided a convenient occasion to synthesize the analytical data from several projects in order to take a more global view of compositional variation in the region.

The greater Mogollon region of southern New Mexico has also seen some exploratory INAA-based ceramic provenance research during the past decade. In one study, Stewart and colleagues (1990) analyzed Chupadero Black-on-white and other ceramics from Robinson Pueblo, south-central New Mexico and compared them to local clays. Despite their focus on a single site, the incorporation of regional geological data permitted the inference of substantial circulation of ceramics among the twelfth- to fifteenth-century communities of the region. In a study of Classic Mimbres pottery from the Mimbres heartland, Gilman, Canouts, and Bishop (1994) found that several compositional groups were present among the analyzed ceramics from several sites, implying regional circulation of ceramics in this case as well. The database of analyses from the Mimbres, Jornada, and El Paso areas has grown considerably over the past several years as a result of work undertaken at both Texas A&M and MURR; aspects of patterning in this data set are discussed in the present volume by Creel and colleagues (chapter 3).

All studies cited above focus on interaction among groups living within the confines of the Southwest culture area. One wonders, however, to what extent interaction networks may have extended across the boundaries recognized by archaeologists and to what extent the signal of interaction on the Southwestern periphery may be detectable in ceramic provenance data. Three studies in this volume address Southwest peripheral areas: Hildebrand et al. (chapter 10) examine movement of ceramics by mobile groups of western Patayan living in the desert, mountains, and coastal plain of southern California; Eerkens Neff, and Glascock (chapter 11) consider the evidence for ceramic circulation in eastern California, with a focus on Death Valley; and Boyd et al. (chapter 9) examine the ceramic evidence of interaction between Puebloan and southern Plains groups. These studies extend chemistry-based provenance investigation into regions bordering the Southwest that have not been studied previously; we expect these to provide valuable comparisons with the better known cases.

The single clearest conclusion that emerges from a consideration of INAA-based provenance investigation undertaken over the past two decades in the Southwest is that ceramics were moved across the landscape in substantial quantities. In part, this pattern may be related to sampling bias: Provenance researchers in many cases have focused on decorated vessels that might be expected to have been circulated more frequently. On the other hand, several recent INAA studies (Duff 1999; Glowacki 1995:83; Neff, Larson, and Glascock 1997; Zedeño 1994) suggest that corrugated and/or plain wares were no more spatially inert than decorated wares. Even if sampling bias has inflated the apparent frequency of vessel movement, the pattern is pervasive and impossible to deny. The frequency of decorated and undecorated vessel movement suggested by the INAA studies is reinforced by numerous other kinds of provenance investigations (for example, Abbott 2000; Blinman and Wilson 1992; Kojo 1996; Shepard 1942; Toll, Windes, and McKenna 1980; Wilson and Blinman 1995). Such a pattern deserves explanation.

At some level, most of the investigators whose work is cited above have sought to explain the patterns of vessel movement revealed by the chemical data. In most cases, the theory that underpins the explanation is implicit and/or resides at the level of common sense: Mechanisms such as "exchange" or "migration" are simply assumed to underlie the observed archaeological distributions. Implicitly, the theoretical rationale for such an assumption is that mechanisms such as these can be observed to result in the movement of goods in ethnographic contexts. In their recent monographs, Triadan (1997) and, especially, Zedeño (1994) take a more explicit approach to the inference of behavior from the information on ceramic provenance produced by INAA studies. In both cases, the theoretical basis for inference appears to derive from behavioral archaeology (Reid, Schiffer, and Rathje 1975; Schiffer 1995; Schiffer and Skibo 1997; Skibo and Schiffer 1995). The goal is to use the information on ceramic provenance together with other kinds of observations that can be made about ceramics (archaeological context, design style, form, and so on) plus ethnoarchaeological and/or experimental observations to reconstruct behavior of the makers and consumers of the pots, so that the people who left the archaeological record can be studied in anthropological terms (Triadan 1997:1; Zedeño 1994:14–21, 100; also see Crown 1994). Zedeño devotes a full chapter to archaeological correlates of ceramic

circulation, wherein she observes that "the isolation of archaeological correlates for these mechanisms is seriously limited because they often produce similar material outcomes and distributional patterns" (Zedeño 1994:18). Similar reservations concerning behavioral reconstructions based on ceramic provenance data are expressed by others (for example, Bishop et al. 1988; Neitzel and Bishop 1990:80; Triadan 1997:107). Nonetheless, behavioral reconstruction clearly remains the dominant theoretical framework for making sense out of ceramic provenance data in the Southwest, where a range of behaviors, from migration (Triadan 1997) to specialized production for exchange (Hegmon, Hurst, and Allison 1995) are inferred from the results of provenance determination. In the present volume, Zedeño (chapter 6) provides an up-to-date discussion of the material correlates of various behaviors involved in circulation of ceramics.

Once prehistoric behavior has been reconstructed (whether through an implicit or explicit behavioral correlates approach), issues judged to be of true anthropological import may be investigated. One such issue is whether late prehistoric movement of ceramic vessels was related to development of managerial elites and regional political alliances, as proposed by Upham (1982). Crown (1994:195–198), for instance, finds the lack of evidence for high-volume, long-distance exchange of Salado polychromes sufficient reason to reject the notion that their wide distribution indicates widespread participation in a Salado alliance. Bishop and his colleagues (1988) focus on Upham's model in their study of Hopi Yellow ware and, because there is no evidence for central control of ceramic resources by villages on the Hopi Mesas, they appear to reject the political alliance model for Hopi. Gilman, Canouts, and Bishop (1994) also reject the political control model for the circulation of Classic Mimbres vessels. Zedeño (1994:101–102) observes that the abundance of nonlocal pots at a small, briefly occupied pueblo (Chodistaas) tends to sever the presumed connection between social complexity and ceramic exchange. Triadan (1997:106) concurs, noting that local production of White Mountain Red Ware indicates migration rather than exchange, and, further, that high frequencies of imported and locally made White Mountain Red Ware in household contexts and at small sites in the Grasshopper region are inconsistent with the hypothesis that the ware was associated with elites. In sum, then, INAA-based provenance investigations appear to refute the idea that the late prehistoric Southwest was integrated by supra-community

political alliances.

Specialization is another anthropological issue addressed in some of the Southwest ceramic provenance investigations. Hegmon, Hurst, and Allison (1995), for instance, compare compositional data on Pueblo I white and red wares from the Four Corners region and conclude that Bluff Black on Red pottery was produced in specialized communities, while two white ware types reflect less specialization. Later, Hegmon et al. (1997) provided additional evidence in support of the view that Bluff Black on Red and other variants of San Juan Red Ware were produced in a few specialized communities in southeastern Utah. "Specialization" in this context refers to the extent to which ceramic production itself or production of specific kinds of ceramics may have been restricted to specific communities within a region. If formally distinct ceramics are also chemically distinct, then different pottery-producing communities must have "specialized" in the production of vessels with particular formal properties. Conversely, if formal properties are not preferentially associated with certain compositional groups, then the compositional evidence contradicts the hypothesis of local specialization.

The potential of provenance investigation to address ceramic production and circulation patterns simultaneously has been exploited in a series of recent papers focused on the Pueblo III Ancestral Puebloan occupation of southern Utah (Larson et al. 1996; Neff and Larson 1997; Neff, Larson, and Glascock 1997). An evolutionary design argument relating production and circulation patterns to the relative predictability of subsistence is used to derive expectations for assemblage compositional diversity in predictable and unpredictable environments. An assemblage from the arid environment of southern Utah conforms well to expectations for an unpredictable environment.

It must be acknowledged that evolutionary theory has yet to win many converts in Southwest archaeology (but see Leonard 1989; Leonard and Reed 1993; Maxwell 1995). It is also true, however, that the challenge being faced directly by proponents of evolutionary archaeology—to derive testable expectations from an explicit, overarching theoretical framework—is not being taken seriously by adherents of any other theoretical framework. The only alternative at present is to reconstruct behavior through either an implicit or explicit behavioral correlates approach (for example chapter 6) and then to explain the behavior in commonsense or ethnographic terms. One of us (Neff) views this interpretive procedure with skepticism; the other (Glowacki) regards it

more favorably. (For a more detailed critique of behavioral reconstruction, see Dunnell [1982]; Schiffer [1996] provides a behavioral archaeologist's appraisal of evolutionary archaeology; and O'Brien, Lyman, and Leonard [1998] have recently responded to Schiffer's critique.)

CONCLUSION

Space limitations preclude a complete review of analytical techniques other than INAA and their contributions to southwest ceramic provenance investigations. We reiterate that our focus on INAA should not be read as an endorsement of INAA over other analytical techniques. INAA has, however, been used frequently enough in the Southwest to permit something approaching a synthetic overview of ceramic circulation patterns, and that is its main advantage in the present context. We suspect that a full consideration of provenance results obtained by petrography or other reliable chemical techniques would paint substantially the same picture as that sketched above: In broadest terms, the analytical data leave little room for doubt that southwest ceramics were moved across the landscape in considerable quantities during all southwest prehistoric periods. Among other things, chapters 3 through 12 in this volume provide a wealth of detail to back up this assertion. Variation in the frequency of vessel movement, the kinds of vessels that were moved, and the cir-

cumstances surrounding their movement are only beginning to be appreciated, and so we hope the chapters in this volume also contribute toward a better understanding of variation in the ceramic circulation patterns that are so clearly attested by the INAA data.

Notes

1. Landsberger (1994:132–133) points out, however, that high concentrations of elements with high neutron capture cross sections (for example, boron, cadmium, gold, and silver) can give rise to neutron self-shielding that inhibits the penetration of neutrons into a sample. Similarly, the presence of high-atomic-number elements (for example in ore concentrates) can severely limit the detection of lower energy gamma rays, which are absorbed by such matrices (Landsberger 1994:132). For most ceramic matrices, however, neutron self-shielding and gamma-ray absorption within the sample do not pose significant analytical problems.

2. Weigand, Harbottle, and Sayre (1977) call this the "provenience postulate." We use the term "provenance" in order to eliminate confusion that may arise from using the same word to refer to the two distinct concepts, source and archaeological context.

3. Firing variation, which might be suspected to engender chemical variation in ceramics, has been found to be unimportant for a wide range of elements determined by INAA (Cogswell, Neff, Glascock 1996; Kilikoglou, Maniatis, and Grimanis 1988), and therefore it will not be considered here.

Quantitative Techniques for Analyzing Ceramic Compositional Data

Hector Neff

THE BASIC APPROACH to ceramic provenance determination outlined in the introductory chapter is extremely simple: Reference groups are defined among the unknowns, and sources for the various unknown groups are then determined by sampling knowns and comparing them to the unknown groups, by invoking the "criterion of abundance," and/or by invoking arguments about regional geological variation. Although the basic approach is simple, complexity is introduced by the nature of the characterized materials and the specific historical circumstances in which artifacts were made, used, and discarded. A further difficulty, which lies at the heart of this discussion, is that mathematical pattern recognition techniques used to recognize groups among the unknown ceramic samples not only reveal structure but may also impose structure. Thus, the choices among data analytical approaches must be made with reference to the nature of materials analyzed and the requirements and assumptions of the various multivariate techniques. In light of this observation, proposals to develop "uniform methodology" involving multivariate analysis of compositional data (Vitali and Franklin 1986) would seem to offer little promise for complex materials such as ceramics.

A data matrix produced by instrumental neutron activation analysis commonly contains twenty-five or more metric variables (elemental concentrations) determined for an even greater number of observations (artifacts). Each observation is also described by a number of descriptive variables, which may be metric or nonmetric and may pertain to both the artifact's archaeological context and to its inherent properties. The basic goal of quantitative analysis in a provenance investigation is to extract structure from this data matrix in such a way that as many as possible of the individual artifacts can be assigned a specific (source) location in geographic space.

One approach sometimes used to search for structure in a ceramic compositional data matrix may be characterized as the "analysis of variance" approach. This approach focuses on interrelationships among variables in the data rather than similarities among the observations. As a simple example, analyses of artifacts from two archaeological contexts may be viewed as two samples about which the question is asked, "Do these samples represent the same or different underlying populations? In the simplest (univariate) approach, t-tests may be used to compare elemental concentration means and standard deviations from the two contexts, with an inference of variation in source utilization drawn if the t-tests suggest statistically significant differences. More elaborate examples of this approach employ multivariate analysis of variance and examine interactions among descriptive categorical variables such as location, type, and time period in determining the structure of chemical variation (for example, Vitali et al. 1987). A variant of this approach is to calculate linear discriminant functions for groups defined purely on the basis of descriptive categories (for example, Culbert and Schwalbe 1987). In a related study, Schwalbe and Culbert (1988) explore the statistical properties of several measures of intragroup homogeneity and intergroup separation calculated on preexisting descriptive categories.

In effect, the analysis of variance approach sidesteps the issue of identifying source-related groups. Variation in elemental concentrations among the categories implies source-utilization variation, but no inferences about the number or geographical extent of sources are ever drawn, nor are any explicit attributions of specimens to sources ever suggested. Although important methodological contributions

have been made by studies undertaken in this manner (for example, Schwalbe and Culbert 1988), the approach suffers from a fundamental flaw: The compositional structure of archaeological assemblages is the result of differential source utilization, and sources must be addressed explicitly in order to make the compositional studies relevant to archaeology. To clarify the problems inherent in the analysis of variance approach, consider two assemblages, of which ten artifacts have been analyzed in each. Analyzed artifacts in assemblage 1 all come from source 1, while assemblage 2 analyses include seven artifacts from source 1 and three from source 2. The analysis of variance approach finds different elemental means and standard deviations when the two assemblages are compared, implying a source utilization difference. However, because no attempt is made to determine the true, two-source structure of the analytical data, the nature of variation in past source-utilization patterns remains obscure.

The noncompositional descriptive information contained in a data matrix produced by chemical analysis is far from irrelevant to the goal of assigning artifacts to source locations. One possibility is to view the descriptive information as a basis for the formulation and testing of working hypotheses regarding the number, membership, and nature of subgroups in the compositional data. One might, for instance, hypothesize that specimens of a particular "ware" found in some region come from a single production center. Assuming that the conditions specified by the provenance postulate apply, this hypothesis implies that analytical data for specimens of that ware will be found to cluster around a centroid, or center of mass, in the elemental concentration space and that the cloud of data points surrounding the centroid will be distinguishable from other such clouds of points. If quantitative analysis shows that the analytical data for the ware do not conform to these expectations, then the hypothesis must be rejected, either for the group as a whole or for specific hypothesized group members.

Thus, quantitative approaches are useful in the analysis of ceramic compositional data to the extent that they permit the recognition and evaluation of source-related subgroups of artifacts in the data. While eschewing a "cookbook" approach, I recognize that a typical data analysis will often proceed along similar lines, starting with (1) initial transformations of variables, proceeding to (2) a search for possible subgroups within the multivariate concentration space, and finally to (3) an evaluation of the multivariate coherence of the suggested subgroups (Bishop and Neff 1989). Steps 2 and 3 may be repeated many times in the course of the analysis. Throughout the analysis it must be borne in mind that natural and cultural processes can account for much of the observed compositional variation (see chapter 1, especially figure 1.4).

DATA TRANSFORMATIONS

Transformations can be applied to the data so that they will more closely follow a normal distribution or to eliminate the effect of greatly differing magnitudes of the elemental concentrations. In addition, it may be desirable in some cases to scale the data to compensate for certain well-understood effects of paste preparation.

Log transformations are justified in part by the argument that the distributions of many elements are so skewed that transformation to log concentrations produces more nearly normal distributions, which are assumed by many statistical procedures (Ahrens 1965; Baxter 1994a; Bieber et al. 1976; Harbottle 1976; Luedtke 1976; Pollard 1986; Sayre 1975). Ahrens (1965), suggests that log-normal distributions are most common, and this seems to be supported for pottery by data presented by Pollard (1986). Judging, however, from the results of Kaplan (1980) together with experience with many different artifact types, it is difficult to identify elements that consistently exhibit normal or log-normal behavior (for example, Bishop , Harbottle , and Sayre1982). In some cases, skewness (and apparent log-normality) may be an artifact of detection limits of particular techniques, which may cut off the lower range of an element's observed concentration range. Skewed distributions could also result from human practices of material preparation (for example, tempering clay); alternatively, initially skewed distributions might be artificially normalized by material preparation practices. While there are elements whose distributions are approximately normal without log transformation, the author has found few or no cases in which distributions become more skewed following log-transformation. Consequently, without unambiguous data on which elements are normally distributed and which are log-normally distributed, the safest procedure would seem to be to convert all raw data to log concentrations. In principle, one could use log-concentrations for elements that are log-normally distributed and raw concentrations (or concentrations scaled by some other means) for elements that are normally distributed (Baxter 1994a; Pollard 1986), though this is rarely done in practice.

Baxter (1994a:46–47) points out that normality is not an essential requirement of most multivariate methods used in compositional data analysis, and, further, that multimodal distributions of elemental concentrations due to the presence of multiple compositional groups would make it difficult to

judge the appropriateness of taking logarithms. There is, however, another, perhaps more important, reason for converting data to log concentrations. For data analysis in which major, minor, and trace-elemental concentrations are employed, some form of scaling is necessary to keep the variables with the larger concentration from having excessive weight in pattern recognition and statistical analysis. Baxter (personal communication, 1998) suggests that this is the main reason to transform to log concentrations. Using transformations that equalize the magnitude of the measurements and the amount of variation is in keeping with one of the premises of numerical taxonomy, that is, no individual variable should assume more weight than another in an analysis involving the calculation of resemblance (Harbottle 1976; Sneath and Sokal 1973).

Log transformation may still leave some variables with much higher variances than others. The way to ensure equivalence of variances is to standardize by expressing the data as deviations from the mean concentration (that is, the mean is subtracted from each individual value and the result is then divided by the standard deviation of the distribution). In the author's own experience, data analysis undertaken on log-transformed and standardized data do not seem to yield very different results, so the question of which transformation is superior may be moot. Baxter (personal communication, 1998) suggests, however, that log transformation may sometimes create outliers and/or artificial groups, especially when the raw data are very close to zero. There may be instances in which two transformations of the data are of interest, for example, transforming the data to logs and then ensuring equal weight through standardization (for example, Pollard 1986:69). One practical problem with relying on standardization is that it can be quite cumbersome in ongoing projects for which new data are continually being produced, since all standardized values must be recalculated whenever the membership of the data set changes.

Another possible approach to the transformation of raw data is to take ratios or logarithms of ratios. For compositional data that sum close to 100%, Aitchison (1986) has suggested a transformation that circumvents problems arising from the fact that correlations in such compositional systems are negatively biased. Aitchison's transformation is:

$$z_{i,j} = \ln[x_{ij}/g(x_i)] \qquad (2.1)$$

where $g(x_i)$ is the geometric mean (mean of natural logs) calculated across the various elements measured for a particular specimen. Leese, Hughes, and Stopford (1989) have pointed

out that even for data sets that are not "fully compositional," the transformation of equation 1 has the desirable effect of removing dilution, which often occurs with ceramics (for example, through use of an inert tempering agent, such as quartz sand, the composition of which is not determined by INAA), through a symmetric treatment of the variables (also see Baxter 1994a). Tangri and Wright (1993), however, indicate that the transformation may introduce spurious structure into some data sets. Baxter (1989, 1991, 1992b, 1993, 1994a) provides extensive consideration of how this transformation performs in the analysis of archaeometric compositional data.

Baxter (1991, 1992b, 1994a) adopts a sensible overall approach to data transformation. Based mainly on experiments involving the effect of data transformations on principal components analysis (PCA), he suggests that it is often useful to look at the results of analysis based on several transformations and to apply similar analyses to different subsets of the variables, possibly using different scales in the several analyses.

Certain data-scaling operations are based on an understanding of the unique properties of the data at hand. For instance, the diluting effect of large amounts of shell temper may be compensated by a transformation that assumes that elemental calcium is present exclusively as calcium carbonate (Steponaitis and Blackman 1981; Steponaitis, Blackman, and Neff 1996), and this mathematical correction can be shown to perform far better than chemical approaches to the removal of the shell temper (Cogswell, Neff, and Glascock 1998). Shell temper is a special case since it can be assumed to be nearly pure $CaCO_3$ (Cogswell, Neff, and Glascock 1998). Similarly, for nearly pure quartz sand, a pure dilution effect may be assumed, so that, if the proportion of temper is known, the original clay composition can be determined by scaling the ceramic concentrations up by an appropriate factor.

If there are grounds for suspecting that a ceramic's composition has been modified by dilution, but the magnitude of the dilution (for example, the proportion of added quartz sand) is unknown, a "best relative fit" can be calculated between the diluted data and some assumed undiluted composition. Sayre (1975) calculates the best relative fit with geometric mean, but the equivalent transformation can be carried out with the arithmetic mean (also see Mommsen, Kreuser, and Weber 1988):

$$f_{a,b} = \frac{1}{m} \sum_{i=1}^{m} \frac{a_i}{b_i} \qquad (2.2)$$

where f is the factor by which to multiply the elemental concentrations to be adjusted, b_i are the measured concentrations

in the sample, and a_i are the concentrations to which the sample is to be fit. Note that a_i can be a single elemental concentration in a single sample, several concentrations in a single sample, an average concentration for some group, or several averages for the group. Selection of the elements is crucial; for instance, one would not want to include elements likely to have been enriched by the addition of temper when calculating the average dilution. A common approach is to adjust all specimens within a group to the mean concentrations of elements that were potentially diluted, a transformation that preserves the mean values of the adjusted group (Sayre 1975). Mommsen, Kreuser, and Weber (1988) point out a useful property of the average dilution factor calculated between pairs of samples, namely that the variance of this measure can serve as a distance measure analogous to Euclidean distance (see below under Distance measures).

In most cases, mixing materials together to create a composite fabric (such as ceramic paste) cannot be assumed to entail simple dilution of one component by the other. In general, the composition of a mixture expresses all mixed components with each component weighted by its proportional contribution in the mixture. Thus, mixing a clay and temper to make pottery produces a sherd compositional profile as follows:

$$S_i = (1 - P)\, C_i + PT_i \qquad (2.3)$$

where C_i represents the clay concentrations, S_i represents the sherd concentrations, T_i represents the known concentrations in the temper, and P represents the proportion of temper in the paste. One approach to investigating the relationships of analyzed pottery to characterized clays and tempers is to compare a series of clay-temper mixtures to the range of compositional variation of ceramic groups (Arnold, Neff, and Bishop 1991; Neff, Bishop and Arnold 1988; Bishop and Neff 1989). If the sherd and temper concentrations together with the temper proportion are known, the clay concentrations can be obtained by:

$$C_i = \frac{S_i + PT_i}{1 - P} \qquad (2.4)$$

An operation related to the calculation of multicomponent mixtures is the regression-based calculation of mixing proportions from measured elemental concentrations in an artifact along with measured concentrations in two or more components assumed to have been mixed in the manufacture of that artifact. In the common application to tempered pottery, for instance, S_i in equation 2.3 would be the dependent variable and C_i and T_i would be the two independent variables. The mixing parameter, P, is then estimated by the regression. Sayre wrote a computer program, COMPO, to carry out such an analysis as part of the investigation of pottery from Nile Valley alluvial clays (Kaplan, Harbottle, and Sayre 1982). More recently, Neff and Bove (1999) have incorporated linear unmixing into the comparison of ceramics with sampled clays and tempers from coastal Guatemala. Another interesting archaeological application of this basic strategy is to determine the proportional representation of different chronological periods in mixed surface assemblages of pottery (Kohler and Blinman 1987).

PATTERN RECOGNITION

Identifying potential source-related subgroups in the compositional data matrix is arguably the most crucial step in ceramic provenance investigation. One approach, mentioned previously, is to use noncompositional information, such as archaeological provenience or ceramic type designations as a basis for hypothesizing which ceramics in a collection might be grouped together. A nonexclusive alternative to this practice is to use numerical pattern-recognition techniques to identify analyzed specimens that are compositionally similar to one another.

Two basic categories of approach to pattern recognition can be defined: ordination and partitioning (Bishop and Neff 1989). The former include simple bivariate plots and numerous methods based on eigenvector extraction, the most common of which is principal components analysis (PCA). Partitioning approaches include various forms of cluster analysis. The literature on both eigenvector extraction-based approaches and cluster analysis is voluminous, and a thorough review is beyond the scope of this discussion. Readers interested in such a review should consult Baxter's (1994a) recent book, *Exploratory Multivariate Analysis in Archaeology*, which is a detailed and accessible guide to pattern-recognition techniques that makes explicit and extensive reference to the analysis of archaeometric compositional data. Doran and Hodson's (1975) classic book, *Mathematics and Computers in Archaeology*, and J.C. Davis's (1986) *Statistics and Data Analysis in Geology* are other useful references for pattern-recognition and other quantitative techniques useful in the analysis of ceramic compositional data.

A crucial point that must be kept in mind is that pattern recognition is the beginning, not the end, of the analysis. The hypothetical compositional groups recognized on some

bivariate plot or on some dendrogram must be evaluated carefully in terms of their internal coherence and external isolation.

Data display

Any data-display technique is also a pattern-recognition technique. Positions on a single axis can be plotted, but there seems little reason not to add a second axis of the several present in a multivariate data set. The resulting bivariate scatterplots provide two-dimensional "windows" through which the positions of data points relative to the two axes may be observed. Computer programs that make it possible to inspect several bivariate plots in rapid succession, to label the data points, and to zoom in on parts of the display can provide a very powerful means of recognizing sets of points that consistently group together in the compositional space. In the best-case scenario of obsidian, extreme within-source homogeneity along with large between-source differences often makes it possible to recognize all source-related patterning on one or a few such plots. With most other materials and in the case of related obsidian sources, visual recognition of groups on two-dimensional scatterplots is more difficult.

Techniques for representing more than two dimensions at a time may sometimes be useful. One approach is to use perspective to represent three-dimensional data on a flat surface. Extending lines to the base of the perspective drawing sometimes enhances its ability to convey information about structure in the data. Three-dimensional visualization can also be enhanced by continuous rotation of the data points around three axes on a computer screen. Another data-display technique common in geology and sometimes used in archaeological compositional studies (for example, Stewart et al. 1990) is to normalize three components (for example, three element concentrations or three sums of element concentrations) to 100% and then to plot the data points in a triangular (or ternary) diagram. The three apices of the diagram represent idealized "endmembers" of pure composition. Stewart and colleagues (1990), for instance, use sums of elements representing relatively immobile elements, mafic rocks, and felsic rocks as endmembers for displaying their data on pottery from the Chupadero region of New Mexico. In the end, both perspective drawings and triangular plots remain tied to the two-dimensional surface on which they are represented, and, as a result, it is debatable whether they actually enhance human ability to detect discontinuities in data by visual inspection.

Principal components analysis

If, as in most compositional investigations, the compositional data matrix includes data for more than three elements, it is impossible to represent the total structure of the data visually. Therefore, a number of numerical techniques have been used to represent the information within a data matrix in spaces of reduced dimensionality. In archaeology, the most commonly used of these techniques is principal components analysis (PCA) (Bishop and Neff 1989; Neff, Bishop, and Arnold 1988).

PCA is based on the extraction of eigenvalues and eigenvectors (also called characteristic roots and characteristic vectors) from a minor product matrix, $X'X$ (in R-mode analysis), or major product matrix, XX' (in Q-mode analysis), of a data matrix, X (Baxter 1994a; J.C. Davis 1986). R-mode analysis is thought of as focusing on variables, whereas Q-mode analysis is thought of as focusing on objects. In R-mode analysis, scores of the observations on successive principal components are found by $S=XU$, where X is the data matrix and U is the square matrix of eigenvectors of $X'X$. In other words, the elements of each eigenvector are coefficients of a linear equation that define a transformation of measured elemental concentrations (possibly logged or standardized, as discussed previously) into a score on that eigenvector. (Note that any observation can be projected into the principal component space with these coefficients, whether or not the observation was included in the original extraction of eigenvalues and eigenvectors.) Typically, the eigenvectors are scaled by the singular value matrix, E, to yield $A^R=UE$, the factor loading matrix, before calculating $S^*=XA^R$ (E has square roots of the eigenvalues of $X'X$ on the diagonal and zeros elsewhere). The Eckart-Young Theorem establishes a close relation between R-mode and Q-mode analysis (J.C. Davis 1986:519–524): Q-mode loadings (the proportion of variance of a variable that is accounted for by a particular data point) are proportional to R-mode scores and vice-versa, and the non-zero eigenvalues of the major product and minor product matrices are identical.

Rearrangement of the terms in the Eckart-Young theorem yields the singular value decomposition of the data matrix, X, which implies several approaches to the simultaneous display of objects and variables (Baxter 1992a, 1994a; J.C. Davis 1986; Neff 1994). The singular value decomposition (see Gower 1984; Jolliffe 1986) can be written as $X=VEU'$, where E and U are the singular value and eigenvector matrices, respectively, as described above; and V is a $n \times p$ matrix (in which p is the rank of X) that must, given E and U, con-

tain the standardized principal component scores (Jolliffe 1986:38). The singular values (on the diagonal of E) are the standard deviations of scores on each principal component, so it follows that VE contains R-mode principal component scores from which standardization has been removed, that is, $VE=S=XU$. As Baxter (1992a) points out (following Gabriel 1971; Gower 1984; Jolliffe 1986) the singular value decomposition gives rise to three alternative types of biplots, that is, simultaneous (RQ-mode) representations of the variables and observations: (1) object coordinates from VE, variable coordinates from U; (2) object coordinates from V, variable coordinates from UE; and (3) object coordinates from VE, variable coordinates from UE.

Baxter (1994a) considers only types 1 and 2 to be true biplots in the sense that they both specify combinations of variable and object coordinates whose inner product reproduces the original data matrix exactly. Geometrically, a particular object's score on one of the original variables is represented by the projection of its biplot coordinates onto the vector connecting the origin with the coordinates for the variable of interest (Jolliffe 1986:79–80). However, both types 1 and 2 biplots have disadvantages: The principal component coefficients (that is, the eigenvectors of $X'X$) used to represent variables on a type 1 plot do not represent the variance-covariance structure of the data as faithfully as does UE, the scaled loading matrix used to represent variables in type 2 plots (Baxter 1992a; Baxter and Heyworth 1991; Corsten and Gabriel 1976; Gabriel 1971; Gower 1984; Jolliffe 1986); and VV', the distances between objects on a type 2 biplot, do not preserve Euclidean relationships (Baxter 1992a; Gower 1984; Jolliffe 1986; Zhou, Chang, and Davis 1983). These observations lead Gower (1984) to prefer type 3 plots, which preserve both Euclidean relationships and variance-covariance structure. Furthermore, despite loss of the exact relationship between the biplot and the original data that is preserved by types 1 and 2 (Jolliffe 1986; also see Baxter 1992a), this relationship remains straightforward, since weighting the inner product of the object and variable coordinate matrices by the singular value matrix reproduces the original data, that is, $X=[VE]E^{-1}[UE]'$.

As Neff (1994) has pointed out, the simultaneous RQ-mode PCA proposed by Zhou, Chang, and Davis (1983) for geological applications is an example of Baxter's (1992a) type 3 biplot. Without any initial scaling of the data, non-zero eigenvalues and eigenvectors of $X'X$ and XX' are the same, and R-mode and Q-mode factor loadings are defined for the same factor loading space (J.C. Davis 1986:595); the R-mode

loadings are the coordinates of the variables, $UE=A^R$, and the Q-mode loadings are the coordinates of the data points, $VE=A^Q$ (these are also the nonstandardized R-mode principal component scores, S, as pointed out above).

In practice, raw data are almost always scaled prior to analysis so that eigenvalues and eigenvectors are extracted from a matrix of meaningful measures of similarities among variables or objects. In R-mode analysis, centering the data by columns produces a variance-covariance matrix as the minor product matrix, $X'X$; if the data matrix is first not only centered but also standardized, the minor product matrix is a correlation matrix; this is the most common starting point for a PCA.[1] In Q-mode analysis the data matrix is scaled so that the major product matrix, XX', contains meaningful measures of similarity between observations; two widely used measures are Euclidean distance in principal coordinates analysis (Gower 1966; Joreskog, Klovan, and Reyment 1976) and the cosine-theta measure of proportional similarity in Q-mode factor analysis (Joreskog, Klovan, and Reyment 1976). Simultaneous RQ-mode PCA could be based on any of the foregoing scaling procedures. However, for RQ-mode analysis to be congruent with R-mode and Q-mode analyses and in order to ensure a meaningful dual solution, the most desirable procedure would yield meaningful measures of *both* intervariable similarity in $X'X$ and interobject similarity in XX' (Zhou, Chang, and Davis 1983:586).

In light of the above considerations, Zhou, Chang, and Davis (1983; J.C. Davis 1986) have proposed the following scaling of X as a basis for RQ-mode PCA:

$$w_{ij} = \frac{x_{ij} - \overline{x}_j}{\sqrt{n}} \qquad (2.5)$$

where w_{ij} are the transformed data and x_{ij} are the original data, \overline{x}_j being the means of each variable over all objects. Using this transformation, WW', the major product matrix, is a principal coordinates matrix, which incorporates Euclidean distances, and $W'W$, the minor product matrix, is a variance-covariance matrix (Zhou, Chang, and Davis 1983:588). Including the standard deviation of the jth variable in the denominator yields a correlation matrix as the minor product matrix (as would a simple standardization of the original data) and a matrix incorporating Euclidean distances between standardized data for the major product matrix. R-mode factor loadings are computed from the minor product matrix, and Q-mode loadings are given by the product of the scaled data matrix and R-mode eigenvectors, that is, $A^Q=WU$ (Zhou, Chang, and Davis 1983). Note that the Q-

mode loadings are simply nonstandardized R-mode scores for the scaled data. From an R-mode perspective, this is a straightforward PCA (see J.C. Davis 1986), while from a Q-mode perspective, it is a principal coordinates analysis (see Gower 1966; Joreskog, Klovan, and Reyment 1976).

The principal component axes obtained by eigenvector extraction are arranged in order of decreasing amount of variance subsumed. Also, because greater interpoint distances may be expected for members of different groups, it is expected that distinct source-related subgroups will appear as separate point clouds on the object plots of the first few principal components. This is the basic rationale behind using PCA as a pattern-recognition technique in provenance investigations. When used in the RQ mode, display of objects along with element coordinates on PCA plots also indicates which elements contribute most strongly to separation between the (hypothesized) subgroups in the data. Conversely, elements that contribute mostly to elongating groups along parallel axes and do not contribute to group separation may also be identified.

The view of the data derived from principal components analysis depends crucially on the subset of observations chosen as the basis for the analysis. For instance, common practice at BNL was to calculate principal components (characteristic vectors) based on some presumed source-related reference group (for example, Harbottle 1976; Sayre 1975). The fact that this approach requires at least one reference group to be defined beforehand would seem to preclude its use in a pure pattern-recognition mode. Another problem is that there is no necessary reason to expect that the axes along which a *group* is most elongated should be the same axes that best separate it from other groups. Put another way, although two groups may be well separated on the first two principal components of the combined data set, the first two components of either group alone might not show any separation at all. In recognition of this problem, Harbottle and Bishop (1992:29) remark that when PCA is run on a single group, it may even be the dimensions of *smallest* variance that are most useful for differentiating that group from others. This observation suggests that the group-based approach does not reduce the number of dimensions that have to be inspected, and therefore it would seem to be of little use in the search for structure in compositional data.

Although the usefulness of PCA in ceramic provenance investigation derives from its ability to reveal subgroup structure on the first several components, it is also true that the first component itself may sometimes be relatively uninterest-ing from the point of view of identifying source-related patterning. This is because the first component, along which the data set as a whole is most elongated, is often interpretable as a "size" component, that is, one that is determined by correlated increase in magnitude of a majority of the determined elements (Baxter 1994a: 71–72; Bishop and Neff 1989). On a PCA biplot, a size component will have most or all variables plotting to one side of the diagram. Pure enrichment-dilution based on variable quantities of quartz sand is one effect that can introduce a size component into a compositional data set. As another example, Neff and colleagues (1996: Fig. 4) have shown that the first component of acid-extraction ICP data from pottery primarily reflects the "size" of the extractable portion of each sample. Whether or not the first component can be interpreted in this way, the pattern-recognition potential of PCA is seldom if ever exhausted by inspection of just the first two principal components.

Cluster analysis

In a variable space such as that defined by elemental concentrations or log concentrations, groups will be identifiable as regions of relatively high point density that are separated from other groups by regions of lower point density (Everitt 1993). The data display and dimensionality reduction techniques discussed above are basically means for exploring the variable space in search of such clusters. There also exist numerical techniques designed specifically for extracting subgroups from data sets of metric variables. These techniques, collectively referred to as "cluster analysis," are probably the most commonly employed techniques of data analysis in compositional investigations. Their application to compositional data derives largely from the biological field of numerical taxonomy (Harbottle 1976), the definitive reference for which is Sneath and Sokal (1973). A more recent guide to using cluster analysis is by Kaufman and Rousseeuw (1990). References on the use of cluster analysis in archaeology include Doran and Hodson (1975) and Shennan (1997). Baxter (1994a) also discusses cluster analysis.

All cluster analyses seek to partition a data set into smaller groups that contain samples that are more similar to co-members of the group than to other samples in the data set (Aldenderfer and Blashfield 1984). The two main varieties of cluster analysis, hierarchical and iterative partitioning, together encompass a large part of the range of grouping procedures used in compositional data analysis (Bishop , Harbottle, and Sayre 1982; Bishop and Neff 1989). Hierarchical procedures involve amalgamating or subdividing a data set to pro-

duce a treelike structure (dendrogram) on which similarities among individuals are represented by the distance that must be traveled from one specimen through the tree to reach the other. Nonhierarchical procedures operate by shifting specimens among a predetermined number of groups during successive passes through the data in order to find the optimal partitioning of the data into the specified number of groups.

Distance measures. The concept of distance or similarity, already introduced in the discussion of PCA above, is central to both hierarchical and nonhierarchical clustering. In order for most cluster analyses to be performed on a compositional data matrix, it is necessary to choose a means for measuring the similarity (or dissimilarity) between a particular analysis and any other point in the elemental concentration space. "Other points" in the concentration space may include other analyses or the centroids of groups. Both the initial scaling of the data (standardization, logarithms, and so on) and the manner in which point-to-point resemblance is defined help determine the outcome of a cluster analysis, and dramatically variant cluster analyses of the same data can always be generated simply by varying the scaling and similarity measure. This is not necessarily a disadvantage, for differing views of the same data may yield additional insight into the overall data structure; the goal is to avoid choosing a combination of scaling, similarity measure, and clustering method that imposes an inappropriate structure on the data (Everitt 1993).

Before calculating a similarity measure, the variables (elemental concentrations) to be used as the basis for the similarity calculation must be chosen. Because one does not know beforehand which elements will prove most effective in discriminating compositional groups, one reasonable approach is to adopt Sneath and Sokal's (1973:5) first principle of numerical taxonomy, which recommends retention of as many elements as possible (Harbottle 1976:45). During subsequent phases of group refinement, similarity may be calculated from different subsets of variables in order to explore different aspects of the data; this parallels Baxter's (1991) suggestion regarding the need to explore different PCA solutions derived from different sets of variables. Statistical evaluation of compositional groups (see below) along with continued exploration of PCA or bivariate elemental concentration plots may suggest subsets of variables to use during subsequent cluster analyses.

Points in the multivariate space defined by elemental concentrations selected for inclusion in the cluster analysis may be "similar" to one another in a variety of ways. Many measures for both metric and nonmetric data are discussed by Sneath and Sokal (1973; also see Anderberg 1973; Bezdek 1981; Everitt 1993; Romesburg 1984). Here attention is confined to similarity and distance measures calculated on metric data. Previous discussions of the use of similarity measures in clustering of compositional data have been presented by Beiber et al. (1976), Bishop and Neff (1989), Glascock (1992), Harbottle (1976), and Sayre (1975).

Metric distance functions used in compositional investigations include Euclidean distance and city-block distance. Euclidean distance is a straightforward measure of interpoint distance that is a generalization of the Pythagorean theorem to spaces of more than two dimensions. Geometrically, any specimen for which m elemental concentrations have been measured represents a point in m-dimensional concentration space. The determined elemental concentrations (or log-concentrations) are the coordinates of the point. For two points, the straight-line or Euclidean distance between them is:

$$ED_{a,b} = \sqrt{\sum_{i=1}^{m}(a_i - b_i)^2} \qquad (2.6)$$

where a_i and b_i are the m coordinates of the two points (elemental concentrations). Using the square of 2.6 (the squared Euclidean distance) gives greater weight to high-variance variables. If any coordinates are missing for either of the two data points, this sum of all differences will not be comparable to a Euclidean distance calculated for other pairs of points for which complete data are available. Consequently, it is common practice in compositional investigations to divide through by m, the number of elements measured, in order to calculate the mean Euclidean distance (MED) or squared mean Euclidean distance (SMED) (Bieber et al. 1976; Glascock 1992; Harbottle 1976; Sayre 1975).

A measure closely related to the Euclidean distance is the mean character difference or "city-block" distance:

$$MCD_{a,b} = \sum_{i=1}^{m} |a_i - b_i| \qquad (2.7)$$

where the symbols are as defined above. Again, the result is scaled by the actual number of variables over which the measure is calculated. Harbottle (1976) and Bieber et al. (1976) point out that this distance measure closely approximates the practice of "profile matching," in which data points are compared by overlaying plots of log-concentrations for the two points made on the same scale.

Angular measures constitute another class of similarity measures sometimes used in compositional investigations

(Harbottle 1976; Mommsen, Kreuser, and Weber 1988; Sayre 1975). The rationale for using such measures in a compositional analysis is that they are not sensitive to differences in magnitude, such as proportional shifts in elemental concentrations that might be engendered by addition of quartz sand to a clay during preparation of ceramic pastes. The cosine-theta coefficient is one common measure of angular similarity sometimes used in compositional investigations (Harbottle 1976). For two analyses, *a* and *b*, cosine-theta is:

$$\cos\theta_{a,b} = \frac{\Sigma(a_i)(b_i)}{\sqrt{\Sigma a_i^2 \Sigma b_i^2}} \qquad (2.8)$$

where a_i are the concentrations or log concentrations in specimen *a* and b_i are the corresponding concentrations in specimen *b*. The measure gives the cosine of the angle from an arbitrary origin to two data points in elemental concentration space, and is therefore not affected by proportional differences in magnitude in all concentrations. Maximum similarity (1.0) occurs when the vectors corresponding to two points coincide, and maximum dissimilarity (0.0) occurs when two vectors are at 90°.

The most popular measure of angular similarity is probably the Pearson product-moment correlation coefficient calculated between cases rather than between variables (Aldenderfer and Blashfield 1984:22):

$$r_{jk} = \frac{\Sigma(a_i - \overline{a})(b_i - \overline{b})}{\sqrt{\Sigma(a_i - \overline{a})^2(b_i - \overline{b})^2}} \qquad (2.9)$$

where the notation is the same as used in equation 2.6. Note that this measure is identical to the cosine-theta (equation 2.8) except that each case is standardized across the suite of elemental concentrations. The correlation coefficient ranges from -1 to +1, and, like cosine-theta, it measures similarity in terms of "shape" in the sense that the relative proportions of concentrations in an analysis rather than their overall magnitudes determine the strength of similarity.

Mommsen and his colleagues (Mommsen, Kreuser, and Weber 1988:48) point out that one problem with using the cosine-theta measure to counteract dilution effects is that the angle formed between vectors from the origin to two points in *m*-dimensional composition space will vary depending on the position of the origin. They devise another measure, called "dilution factor spread," which accounts for dilution and avoids the problem of dependence on the position of the origin. Calculating the dilution factor (best relative fit) between any two points using equation 2.2 above involves find-

ing the mean dilution factor calculated from each of several elemental concentrations. This mean value has an associated spread, which will be quite small if, in fact, two data points differ by only a constant ratio but will be much larger in magnitude if more than simple proportionality differentiates the points. To compare the spread between pairs of data points with different dilution factors, a normalized measure referred to as "relative dilution factor spread" can be calculated as follows:

$$RDFS_{a,b} = \frac{\sqrt{\frac{1}{m-1}\sum_{i=1}^{m}(\overline{f} - f_i)^2}}{\overline{f}} \qquad (2.10)$$

where f_i are the dilution factors between data points *a* and *b* calculated over *m* elemental concentration. Mommsen and colleagues (Mommsen, Kreuser, and Weber 1988; also see Beier and Mommsen 1994) show how the measure can be weighted to reflect errors in the original determination of elemental concentrations and define a reduced chi-square measure of "goodness of fit," which can also be used as a similarity measure. Although the idea of using analytical precision to weight the calculation of similarity is intuitively attractive, Mommsen, Kreuser, and Weber (1988:51) found that because of the extreme precision of some elements measured by neutron activation analysis, cluster analysis of INAA data using the weighted measure produced artificial clusters determined by the most precise measurements; thus, they arbitrarily increase the error terms on some elements prior to calculation of the relative dilution factor spread. One advantage of the dilution factor spread measure is that no initial scaling of the original data is necessary. Also, as in the case of the other distance measures discussed above, missing data are accommodated by dividing the spread between two points by the number of variates actually used. Examples of the use of this measure are given by Mommsen and his colleagues in several publications (Beier and Mommsen 1994; Mommsen, Kreuser, and Weber 1988; Mommsen et al. 1991; Mommsen et al. 1992) and by Bellido Bernedo (1989).

The possibility of combining chemical data with other descriptive information on a set of samples has led several investigators to explore the use of similarity measures that can incorporate mixed level data (nominal and ordinal as well as ratio). The most widely known such measure is Gower's coefficient:

$$G_{a,b} = \frac{\sum_{i=1}^{m} S_i}{\sum_{i=1}^{m} W_i} \qquad (2.11)$$

where S_i is the similarity score for the variable and W_i is a weight, 1 or 0, indicating whether the comparison is valid (Aldenderfer and Blashfield 1984). For presence-absence data, W_i is 1 if either one or both of the cases possesses the feature in question, and S_i is 1 if both possess the feature; for multi-state or ordinal data, S_i is 1 if the states in the two cases are identical and 0 otherwise. Similarities across all metric variables are calculated as follows:

$$S_{a,b} = \frac{\sum_{i=1}^{m} 1 - \frac{|a_i - b_i|}{R_i}}{m} \qquad (2.12)$$

where R_i are the ranges of the m metric variables. Note that similarities for nominal and multistate variables can also be calculated with 2.12; m provides the weighting factor since it is the total number of variables over which the comparisons are valid; this excludes nominal attributes that are absent for both cases being compared. Rice and Saffer (1982) have explored the use of Gower's coefficient with mixed-level data that include compositional analyses. Romesburg (1984) has suggested a more general method for measuring similarity in mixed-level data sets that has been applied to compositional data by Neff, Bishop, and Rands (1988).

Another distance measure to be discussed later on is the Mahalanobis distance, or generalized distance. The distinguishing feature of Mahalanobis distance is that it incorporates information about correlation among the variables in a group and therefore requires enough points to estimate multiple correlation effects (Aldenderfer and Blashfield 1984; Bellido Bernedo 1989; Bishop and Neff 1989; Harbottle 1976). With no correlation, Mahalanobis distance is identical to squared Euclidean distance.

One way to use the distance measures discussed above is simply to find other analyses that lie "close" to a specimen of interest, that is, to form groups around that specimen. Beier and Mommsen (1994:293-295) describe such an approach, which begins with a search for "close" specimens using a variant of Euclidean distance (equation 2.6) that incorporates analytical error for both the focal specimen and each comparison specimen. Later on in the process of group formation, as group size enlarges, comparison is based on the Mahalanobis distance. As Beier and Mommsen (1994:295-298) point out, a similar approach can be built around formula 2.10, the relative dilution factor spread proposed by Mommsen, Kreuser, and Weber (1988).

Many computer statistics and cluster analysis packages calculate some or all of the similarity and dissimilarity measures described above. One example is the program NADIST (Bieber et al. 1976; Harbottle 1976; Sayre 1975) and its successor, CONDIST, which have been used with compositional data since 1974 at BNL, SCMRE-NIST, MURR, and other laboratories for calculating distance matrices for input to the hierarchical agglomerative clustering program AGCLUS. Modern commercial software packages, such as S-Plus (Venables and Ripley 1997), may, however, be a better choice for most users because of the flexibility offered by built-in programming facilities, their wide availability, and their capability to deal with data in a variety of formats (Baxter, personal communication 1998).

Hierarchical clustering techniques. As discussed above, ordination techniques can be used as grouping procedures; by the same token, although hierarchical cluster analysis is normally viewed as a means for forming groups, it is more accurately conceived as a means to represent ungrouped variation along multiple dimensions in a space of only two dimensions, in this case a dendrogram. If the similarity or dissimilarity measures discussed above are applied to all pairs of n analyses in a data set, the result is a n x n matrix of similarities or dissimilarities. The goal of hierarchical cluster analysis is to use the information contained in such a matrix to link data points into groups that resemble each other but differ from data points assigned to other groups. The results are commonly displayed as a dendrogram, which depicts a hierarchy of groups from individual data points on up to the entire data set. The similarity between any two data points can be assessed visually by tracing the length of the route that must be traversed through the dendrogram from one data point to the other. Although hierarchical divisive techniques of clustering are available, they have seen little use in compositional investigations and therefore will not be discussed here.

Hierarchical agglomerative clustering is probably the most widely used technique in compositional investigations (Baxter 1994b; Bieber et al. 1976; Bishop, Harbottle, and Sayre 1982; Bishop and Neff 1989; Harbottle 1976). Aldenderfer and Blashfield (1984) provide a useful overview discussion of hierarchical agglomerative techniques. Lance and Williams (1967) show that all hierarchical agglomerative methods can be derived from a single, four-parameter equation. The first step in any agglomerative clustering is to link the two most similar specimens in an undifferentiated data set. In the simplest of the agglomerative techniques, single-linkage, subsequent steps also involve finding the next-closest pair of points in the data set; if one of the points is already part of a cluster,

then the new point joins the cluster; if both points are already members of clusters, then the two clusters are joined. In the end, after $n − 1$ steps, all points in the data set are joined into a single large cluster.

A major drawback of single linkage cluster analysis in compositional studies as in other fields is the tendency of the technique to form long chains that make it difficult to distinguish important bifurcations on dendrograms. Other hierarchical agglomerative techniques that are less affected by the chaining tendency include complete linkage, average linkage, and Ward's Method (Aldenderfer and Blashfield 1984).

Complete linkage or "farthest neighbor" clustering joins individuals to clusters or clusters to one another if the similarity between the most distant points in the clusters is a minimum (Aldenderfer and Blashfield 1984; Harbottle 1976). This procedure yields dendrograms on which discrete clusters are readily apparent; inspection of bivariate scatterplots or PCA plots shows that these clusters are usually tight and circular, suggesting hypersphericity in the full elemental concentration space.

Average linkage clustering joins individuals to clusters or clusters to one another based on the average distance between the two (Aldenderfer and Blashfield 1984; Harbottle 1976). One method, unweighted pair-group method with arithmetic averages (UPGMA) averages every possible pair of points. Another method, centroid clustering, makes joins based on minimum distance from a point to cluster centroids or the minimum distance between two centroids. Average linkage cluster analysis is probably the most widely used clustering procedure in compositional data analysis.

Ward's Method clustering seeks to join individuals to clusters or to join clusters together in such a way as to minimize the increase in error sum of squares within clusters (Aldenderfer and Blashfield 1984; Ward 1963), that is, minimize

$$ESS = \frac{1}{m} \sum_{k=1}^{n} \sum_{i=1}^{m} \left(x_{ki} - \overline{x}_{.i} \right)^2 \qquad (2.13)$$

x_{ki} here is the ith elemental concentration for the kth analysis, n is the current size of the cluster, and m is the number of determined elemental concentrations. If squared mean Euclidean distances have been calculated initially, the error sum of squares can be calculated from the distances between points in the cluster (Bieber et al. 1976; Harbottle 1976). A related clustering technique minimizes the difference between the size of the new cluster and the sum of the sizes of the two joined clusters (Bieber et al. 1976; Harbottle 1976), where "size" is the error sum of squares defined in 2.13. Schwalbe

and Culbert (1988) define a Euclidean distance-based measure that resembles the within-cluster sum of squares, the average intragroup point separation, and use bootstrap techniques to establish uncertainty limits for x-ray fluorescence (XRF) data on pottery from the Maya site of Tikal.

A number of issues complicate the application of hierarchical cluster analysis. First is the problem of choosing an appropriate combination of data scaling, resemblance measure, and clustering algorithm. The large number of combinations guarantees that multiple, mutually contradictory dendrograms can be produced from the same data. Second, the reduction of the mutivariate similarity matrix to a two-dimensional dendrogram can introduce considerable distortion, one measure of which is the cophentic correlation (Sokal and Rohlf 1962); while the resemblance relationships of the lower linkages of the dendrogram are usually well represented, the relationships among higher linkages are not. Related to this issue, hierarchical clustering requires no assumptions about the number of "groups" present in the data set, but neither does it provide any unambiguous answer to how many groups might exist. Although inspection of the dendrogram does not inform directly on the "best" levels of linkage for group arrangement, a method for testing the distinctness of clusters has been proposed by Sneath (1977). It has been demonstrated that a "large" change in cluster level of a dendrogram may be a necessary condition for cluster break but it is not itself a sufficient condition (Everitt 1979). Obviously, the notion of "best" relates not only to a large break in a dendrogram, but as well to the research objectives. Still other problems arise from the fact that once two samples are linked, that link can not be broken. Given all these difficulties, there seems little reason to expect that a hierarchical cluster analysis alone will yield a definitive partition of a data set into source-related compositional groups except, perhaps, in cases of extreme intrasource homogeneity combined with extreme intersource difference (as in the case of obsidian).

Since 1974, the program AGCLUS (Olivier 1973) has proved useful in chemistry-based provenance investigations in several laboratories, including BNL, SCMRE-NIST, and MURR (Bieber et al. 1976; Glascock 1992; Harbottle 1976). CLUSTAN (Wishart 1987) is a package devoted to cluster analysis that incorporates most or all of the features available in AGCLUS. Most widely used statistical packages, such as SAS, SPSS, SYSTAT, and S-Plus include some variety of hierarchical agglomerative cluster analysis as well.

Iterative clustering techniques. The hierarchical clustering procedures discussed above are inflexible in that once a

specimen is joined to a particular cluster, it cannot be shifted to another. Iterative procedures incorporate the possibility of shifting from cluster to cluster. These procedures also differ from hierarchical techniques in that they produce unnested clusters. Useful references on the various procedures includ Aldenderfer and Blashfield (1984), Anderberg (1973), Doran and Hodson (1975), and Everitt (1993). Although not as widely used in sourcing as hierarchical clustering, both methodological statements (Baxter 1994a; Bishop, Harbottle, and Sayre 1982; Bishop and Neff 1989; Harbottle 1976; Rapp 1985) and applications (Bishop 1975; Bishop and Rands 1982; Deutchman 1979) have appeared.

Iterative clustering involves the use of some criterion that simultaneously maximizes intragroup homogeneity and intergroup separation. Unfortunately, as pointed out with respect to compositional investigations by Schwalbe and Culbert (1988), there exists no unique measure of either property. Measures that have been proposed as a basis for iterative clustering are all based on the fundamental partition equation (Wilks 1962; Bishop, Harbottle, and Sayre et al. 1982):

$$T = B + W \qquad (2.14)$$

where T is the matrix of sums of products in the data set as a whole, being comprised of B, the between-group sums of products matrix and W, the within-groups sums of products matrix. Of particular interest here are B and W, which indicate variation between and within groups, respectively. Cooley and Lohnes (1971) and J.C. Davis (1986) discuss the elements of each of these matrices, which find their primary use in multivariate analysis of variance. Some clustering criteria implied by these relationships include (1) minimize trace-W; (2) minimize determinant-W; (3) maximize trace-BW^{-1}; or (4) maximize largest eigenvalue of BW^{-1}.

Like the resemblance measures used in hierarchical clustering, these criteria seek different kinds of relationships in the data and therefore create different kinds of clusters from the same data. For example, the use of trace-W, which ignores off-diagonal elements of W, is the same as Ward's Method, and will lead to formation of hyperspherical clusters. Minimizing the determinant-W, meanwhile, tends to find groups of roughly the same size and shape (Aldenderfer and Blashfield 1984; Baxter 1994a; MacRae 1971; Marriott 1971; Scott and Symons 1971). Unfortunately, the source-related groups of interest in provenance investigation seldom conform to either of these assumptions, and so the usefulness of

techniques based on these criteria is very debatable. Baxter (1994a:178) gives an example in which both criteria 2 and 3 yield a solution that is "worse than useless" when compared to PCA and several hierarchical agglomerative techniques.

K-means cluster analysis, one of the most widely used iterative techniques (J.C. Davis 1986), tends to minimize trace-W, although the criterion is not explicitly incorporated into the procedure (Aldenderfer and Blashfield 1984). The procedure begins with specification of an initial partition of the data, either based on specification of initial number and location of cluster centroids or on initial cluster membership (from which initial centroids can be calculated). Initial partitions or centroids can be chosen randomly (for example, Bishop, Harbottle, and Sayre 1982) or on the basis of some initial assumptions about the structure in the data; one approach that has yielded good recovery of known structure is to use the groups defined by hierarchical cluster analysis as the starting groups (Milligan 1980). The next step is to allocate data points to the nearest cluster centroid and then to recalculate the centroids. Data points are moved in an iterative fashion until there are no further changes in cluster membership. In use, the k-means programs usually examine a range of possible solutions, stepping from an initial guess as to the minimum number of groups to some specified maximum number.

In contrast to k-means algorithms, hill-climbing iterative procedures explicitly seek to optimize one of the clustering criteria mentioned above (Aldenderfer and Blashfield 1984; MacRae 1971). Reassignments at each step are made based on their effect on the criterion selected for optimization.

There are several problems that are of particular concern with respect to iterative clustering. First, it is impossible to examine all possible partitions. Because all possible cluster solutions cannot possibly be examined, even in small data sets, there always exists the possibility of finding a local rather than a global optimum solution (Aldenderfer and Blashfield 1984). Another difficulty of particular interest in the application of iterative procedures to source determination is that no estimate of the likely number of sources (groups) in the data is usually available. And, just as the notion of "best partition" does not relate simply to a large break in a dendrogram, neither does it relate to some specific value of the criterion being optimized. However, informal measures may be used to gain some insight into possible number of "natural groups" in the data. Bishop and Rands (1982) use the flattening of the curve relating an optimization criterion value to the number of groups as an indicator of the number of "natural" groups.

In the author's own experience in compositional investigations, iterative procedures have proven to be very sensitive to outlying analyses, which often end up in separate, single-member clusters, and this tendency makes it difficult to achieve a reasonable solution even when there exists some means for estimating the likely number of groups.

Additional remarks on clustering. The principle that the cluster analysis procedures discussed here are exploratory techniques cannot be overemphasized. Cluster analysis invariably discards useful information regarding the compositional characteristics of sources, no matter on what level "source" is conceived. Of particular consequence in compositional studies is the information residing in the correlations among elements (Bellido Bernedo 1989; Bishop and Neff 1989; Glascock 1992; Harbottle 1976; Sayre 1975). Euclidean distances, being pair-wise, straight-line distances, are incapable of incorporating information about inter-element correlation. Thus, cluster analysis of a matrix of Euclidean distances tends to force data into hyperspherical groups, a demonstrably inappropriate structure into which to force compositional data. Likewise, k-means clustering, as mentioned above, will impose a hyperspherical structure on the data because it ignores off-diagonal elements of the within-groups sums of products matrix. In both cases, elongated groups (characterized by strong interelement correlations) may go unrecognized.

The potential for cluster analysis to impose inappropriate structure on a data set can be illustrated easily by reference to the example of the four groups plotted relative to iron and scandium in figure 2.1. The groups are elongated due to interelement correlation, and they are fully separable at a 90% confidence level (calculation of multivariate probabilities of group membership are discussed in the following section). Without any prior knowledge of the structure in this data set, one might begin a search for structure with an average-linkage hierarchical agglomerative cluster analysis of Euclidean distances between points. Cluster analysis of the two variables in this case erroneously partitions data points from the Tucson and Marana-A groups, as indicated by the dotted and dashed lines in figure 2.1, top. The problem is that Euclidean distance is inappropriate for use with correlated variables because it is based only on pairwise comparisons without regard to the elongation of data point swarms along particular axes. In effect, Euclidean distance imposes a spherical constraint on the data set because of its treatment of the variables as independent (Everitt 1993). When the reference axes are re-oriented by means of a PCA of the two-variable data set (figure 2.1, bottom), Euclidean distance and average linkage cluster analysis accurately returns the four groups. Observations such as this have motivated some investigators to use cluster analysis on principal component scores rather than raw or logged elemental concentration data in order to gain an initial indication of what groups may exist in the data (for example, Bellido Bernido 1989).

Baxter (1994a:169) points out that cluster analysis based on principal component scores performs better in examples such as figure 2.1 because the whole data set is elongated along approximately the same axis as the individual groups, so that the variance-covariance matrix of the whole is a reasonable approximation of the variance-covariance-matrices of the individual groups. In effect, using principal component scores in such cases is roughly equivalent to expressing sample-to-sample relationships in Mahalanobis distance units (see below), which, in the example given here, places greater weight on measurements along an axis running perpendicular to the main axis of correlation in the data. In the two-variable case illustrated here (figure 2.1, top), both cluster analysis and PCA are highly superfluous because the true structure in the data is readily apparent by inspection. This observation underscores the importance of using a variety of data-display techniques together with common sense during the pattern-recognition phase of the analysis.

Incidentally, figure 2.1, top, also demonstrates the fallacy inherent in the common practice of eliminating "redundant" (that is, highly correlated) variables from an analysis. Eliminating either one of the variables and displaying the data as a histogram would completely obscure the separateness of the Tucson and Marana-A groups.

Only those clustering techniques that have seen some use in compositional investigations have been discussed. The voluminous literature on cluster analysis, only a small fraction of which is cited here, describes many kinds of analyses that I have omitted. In addition, many subtleties about the performance of the various clustering algorithms have not been mentioned. Perhaps the very best approaches to clustering compositional data have even been omitted entirely. However, as a practical matter, one can argue that it is a waste of time to sort through all the different possible approaches to find the one best suited to a particular sourcing application. This is because cluster analysis is best viewed as an exploratory technique only. What provides the closest approximation to true source-related groups in one data set may perform extremely poorly in other cases. Therefore, it is permissible, even desirable, to examine multiple cluster solutions derived

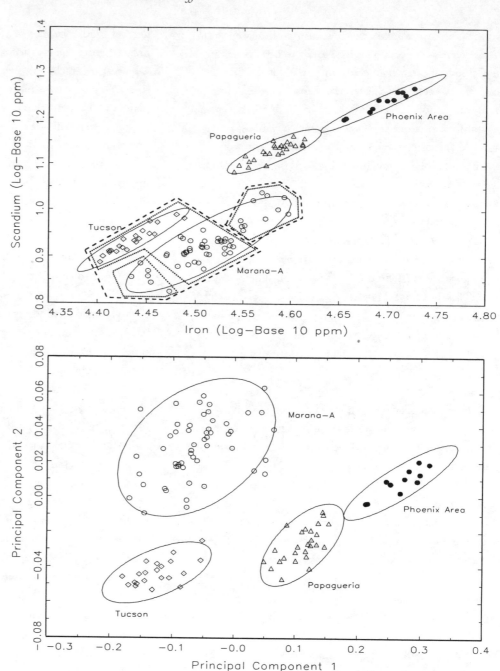

2.1 *Top,* Iron and scandium concentrations in four compositional groups of Tanque Verde Red-on-brown pottery. Ellipses indicate 90% probability of group membership. Dotted lines indicate one level of clustering indicated on a dendrogram produced by average linkage cluster analysis of Euclidean distances based just on these two elements. Dashed lines indicate a slightly higher level of clustering indicated on the same dendrogram. *Bottom,* Same data as top figure but with axes reoriented via a PCA of the correlation matrix for iron and scandium. Average linkage cluster analysis in this case recovers the groups indicated by the four ellipses. *Illustration prepared by Hector Neff*

from different sets of elements, different data scaling procedures, different similarity measures, and different clustering algorithms. The different solutions provide hypotheses to be examined both with the ordination techniques discussed previously and with the statistical group evaluation procedures discussed below. Under no circumstances should the search for structure in a compositional data set end with the application of some preferred cluster solution.

GROUP EVALUATION

The conception of a compositional group as a center of mass in the *m*-dimensional space defined by (logged) elemental concentrations (Harbottle 1976) has been largely implicit in foregoing sections of this chapter. Evaluation of whether a potential group identified through ordination and pattern recognition may represent a localized source, workshop, or source zone requires that the criteria for judging group coherence be stated more formally and explicitly. Two basic characteristics define the discreteness or coherence of groups in multivariate elemental concentration space: location (centroid) and shape (variance-covariance structure). For instance, the four Tanque Verde Red-on-brown groups plotted in fig-

ure 2.1 clearly have distinct centroids (locations), but they also differ in terms of how compact they are and how they are oriented, whether one examines the original logged data (figure 2.1, top) or the PCA plot (figure 2.1, bottom). Paste preparation and diagenesis may shift the locations and shapes of pottery groups relative to the sources from which they are derived (Arnold, Neff, and Bishop 1991; chapter 1); for instance, in figure 2.1, top, addition of a pure quartz sand to the Phoenix group would tend to move the iron and scandium concentrations of its members down along the group correlation line, into the range of variation of the Papagueria group. The two characteristics of location and shape are equally important in investigations of the chemical composition of ancient glass (for example, Henderson 1989) and lead isotopic composition of ancient metals (Leese 1992; Sayre, Yener, and Joel 1992; Sayre et al. 1992).

Recognizing that natural compositional groups are defined by shape as well as location invalidates the univariate approach to group evaluation advocated originally by Perlman and Asaro (1969) and more recently by Gunneweg and his colleagues (Gunneweg, Perlman, and Yellin 1983). In this approach, each element is considered an independent observation bearing on whether a particular specimen belongs to a particular group. For elements within one standard deviation, a probability of 1 is arbitrarily assigned, while for elements farther than one standard deviation from the mean, the probability associated with the standardized distance is used. The product of the individual element probabilities gives an "index of disagreement" that is used to judge whether or not a specimen belongs to a group. While this procedure is both arbitrary and subjective, its main problem lies in the completely invalid assumption of independence among the determined elemental concentrations; theoretical considerations lead one to expect strong correlation between elements in the materials used for ceramic pastes (for example, Pollard and Heron 1996: Chapter 4), and innumerable empirical studies clearly document the validity of this expectation. Far from being hypershperical (as assumed by this approach), source-related groups are characterized by unique patterns of interelement correlation that impart unique shapes, and shape cannot be ignored in evaluating whether an individual specimen might belong to a particular group. A specific example of the failure of the univariate approach has been demonstrated by Slane et al. (1994).

Other group evaluation procedures that do not explicitly consider variation in group shape may be rejected on similar grounds. These would include two measures of intergroup

separation suggested by Schwalbe and Culbert (1988). One measure, the average intergroup point separation, is just the average Euclidean distance between all possible pairs of points in two groups. Being derived from pairs of points, neither this measure nor its normalized counterpart incorporates information about correlation. Schwalbe and Culbert (1988) also propose to evaluate the separation between two groups by means of Hotelling's T^2, a statistic based on Mahalanobis D^2 distance or generalized distance between the groups (see J.C. Davis 1986):

$$D^2 = (\overline{X} - \overline{Y})' S^{-1} (\overline{X} - \overline{Y}) \qquad (2.15)$$

where X is the mean vector for one group, Y is the mean vector for the other group, and S^{-1} is the inverse of the pooled covariance matrix. As Schwalbe and Culbert (1988:676) clearly recognize, assuming homogeneity of the covariance matrices of the two groups (that is, assuming identical group shapes) is completely unjustified, as their own data demonstrate. Although statistical tests for homogeneity of variance-covariance matrices are available (J.C. Davis 1986) and more elaborate multivariate analysis of variance could be undertaken (for example, Vitali et al. 1987), no satisfactory measure of the distinctiveness of two groups that incorporates differing variance-covariance structures has yet been discovered. Schwalbe and Culbert (1988:676) test a Hotelling's T^2 statistic based on a weighted vector of differences between arbitrary pairs of points in the two groups but find too much instability in the resulting statistic.

As noted previously, the design of the Schwalbe-Culbert study sidesteps the issue of source-related groups in compositional data, carrying out the statistical tests on groups defined by typological and chronological criteria. In effect, the question being asked is whether the distribution of sources represented in the typo-chronological groups is the same or different. From this perspective, the magnitude of difference between two typo-chronological groups is inherently interesting because it bears on the magnitude of variation in past resource exploitation practices. The alternative approach advocated in chapter 1 involves identifying the source-related groups themselves, and in this case the question asked in evaluating groups has to do with the likelihood of membership of individual analyses in several alternative groups for which distributions of elemental concentrations have been estimated. Using this approach, the potential groups defined by ordination and grouping procedures such as those discussed in the previous section are almost certain to be statisti-

cally different, no matter what measure is used to assess difference. The application of statistical tests to intergroup separation is inadmissible because the whole strategy rests on *finding* discontinuities in the compositional data. The magnitude of differences between sources depends on geological variation, and its inherent value is that it affects the ease with which discontinuities can be recognized in a data set and individual analyses assigned to groups. Assessing variation in past resource exploitation depends on cross-tabulating identified sources with typo-chronological categories.

This is not to suggest that information on type, form, chronological position, and so on, should be ignored in sourcing studies. On the contrary, potential compositional groups are often formed by reference to the noncompositional data, with group evaluation procedures (such as those discussed below) then used to include or exclude specimens based on composition. However, in forming and refining such a group, there is an implicit hypothesis that the group represents a compositionally distinct source, source zone, workshop, or some similar geographic entity.

Single group evaluation

When applied to the question of group membership of individual samples, Mahalanobis distance provides a clear means for incorporating information on group shape. As explained in several previous publications dealing with compositional data analysis (Beier and Mommsen 1994; Bieber et al. 1976; Bishop, Harbottle, and Sayre 1982; Bishop and Neff 1989; Glascock 1992; Harbottle 1976), Mahalanobis distance is a multivariate generalization of standardized univariate distance (z-score), whether the distance is between the means or centroids of two groups (as in equation 2.15 above), between two points, or between a point and a group centroid. Of greatest interest here is the Mahalanobis distance between a point and a group centroid:

$$D^2 = (X_i - \overline{X})' \, S^{-1} \, (X_i - \overline{X}) \qquad (2.16)$$

where X_i is a vector of elemental concentrations determined for a specimen i being considered as a possible member of group X and S^{-1} is the inverse of the variance-covariance matrix for the group. Just as calculating a z-score indicates a point's distance in standard deviation units from the mean, so including the variance-covariance matrix in the calculation of Mahalanobis distance scales the measure so that it indicates multivariate distance from a centroid in units scaled to reflect the rate of fall-off in point density between the centroid and

the point of interest. Hotelling's T^2 is a test statistic that is nearly equivalent to Mahalanobis distance for individual points, and probabilities associated with a particular value of the test statistic can be readily obtained following a transformation of the T^2 statistic that follows an F distribution (J.C. Davis 1986). The latter probability is the probability that the group would include a point situated at the calculated Mahalanobis distance from the centroid. These probabilities may be referred to as probabilities of group membership, although "p-value" is perhaps a more statistically defensible designation (Roaf and Galbraith 1994).[2]

Parenthetically, one may note that substituting a vector of coordinates for a second point for the mean vector in equation 2.16 gives the Mahalanobis distance between two points. Such a measure can be used as the basis for a hierarchical cluster analysis (Aldenderfer and Blashfield 1984; Harbottle 1976). Harbottle (1976) presents an example of how cluster analysis based on Mahalanobis distance more successfully recovers known structure in a data set than does clustering of Euclidean distances. However, it is crucial to recognize that a single variance-covariance structure must be assumed by such a procedure (either the pooled variance-covariance matrix or the variance-covariance matrix for a specific subset), and such an assumption is invalid for compositional groups derived from geological materials. Imposing a single nonhyperspherical structure during cluster analysis would seem to have no better justification than imposing a hyperspherical structure, as one does in a hierarchical cluster analysis based on Euclidean distances.

One property of Mahalanobis distance that limits its application in compositional studies is the need to have a fairly high specimen-to-variate ratio in order for single specimens not to have undue influence on the group shape, thus artificially inflating their own probabilities of group membership. Harbottle (1976) refers to this as "stretchability," in recognition of the propensity of individual divergent members of small groups to stretch the probability envelope of the group so as to include themselves. The number of variates, m, imposes an absolute lower limit on the number of specimens, since the variance-covariance matrix is singular and not invertible with fewer than $m + 1$ observations; the analogous situation in the univariate case would be attempting to calculate a standard deviation from a single data point. If there are only a few more specimens than variables, obviously the estimated central tendency (mean or centroid) and dispersion (standard deviation or variance-covariance matrix) will be greatly affected by inclusion or exclusion of single points.

Unfortunately, limitations on budgets and analytical resources often curtail the number of analyses that can be run, and this means that source-related groups will not often be represented by a sufficient number of specimens to provide stable estimates of the centroid and variance-covariance matrix of each group. Beier and Mommsen (1994:289-290) therefore propose an alternative to Mahalanobis distance that ignores interelement correlation (that is, off-diagonal elements of the variance-covariance matrix) but also avoids problems associated with the uncertainty involved in estimating correlations with small group sizes. Another way to deal with the stretchability problem is by a "jackknife" procedure, in which each specimen assumed initially to be a member of a particular group is removed from the group before calculating its own probability of membership (Baxter 1994b; Benfer and Benfer 1981; Leese 1992; Leese and Main 1994). Table 2.1, which presents probabilities calculated using the jackknife and resubstitution (nonjackknife) method for a moderate size group (thirty-two elements, fifty-three specimens) conveys a sense of how severely the uncertainty involved in estimating group variance-covariance structure from small groups can affect the corresponding probability estimates. When the ratio of specimens to variates is much larger (as in the case of the principal component probabilities shown on the right side of table 2.1), the difference between the jackknife and resubstitution methods are much less marked (the calculation of group membership probabilities based on principal component scores is discussed further below).

Reducing the number of variates may also be used to deal with the stretchability problem, but there is generally no a priori means of identifying elements that will be unimportant in group definition. The common practice of eliminating "redundant" (that is, strongly correlated) variables is clearly unacceptable since, as illustrated by figure 2.1, eliminating either one of a pair of correlated elements may completely obscure clear distinctions between groups. Exclusion of certain elements may be justified in some cases by theoretical arguments and/or a consideration of technology, geological environment, and diagenetic conditions; for instance, calcium probably would not be a good discriminator of sources if variable amounts of shell temper were added to ceramic pastes (for example, Cogswell, Neff, and Glascock 1998; Steponaitis, Blackman, and Neff 1996). A strategy of evaluating groups based on multiple subsets of elements also would seem to hold some promise (for example, Baxter 1992b).

Perhaps the most non-arbitrary way to reduce the number of variates on which to base the calculation of group mem-

Table 2.1 Probabilities of membership in the Marana-A compositional group of Tanque Verde Red-on-brown pottery calculated several different ways

	Elements		PC1–PC6	
Anid	Jackknife	Resubst.	Jackknife	Resubst.
PF022	42.59	99.02	1.23	6.24
PF032	15.94	98.01	19.07	29.73
PF033	11.98	97.73	13.64	24.01
PF043	60.21	99.40	26.30	36.78
PF045	24.86	98.45	69.04	73.74
PF053	39.87	98.95	35.26	44.98
PF077	88.58	99.84	56.84	63.56
PF080	77.91	99.69	72.53	76.64
PF084	34.19	98.79	15.88	26.43
PF091	25.21	98.47	19.15	29.81
PF092	12.41	97.76	82.57	85.02
PF094	80.15	99.72	90.30	91.54
PF096	99.55	99.99	99.16	99.23
PF099	8.92	97.44	47.72	55.84
PF100	50.99	99.21	73.76	77.67
PF105	72.93	99.61	83.13	85.49
PFI06	60.36	99.40	38.83	48.14
PFI07	56.05	99.32	92.61	93.51
PFI08	44.27	99.06	64.89	70.29
PFI09	78.06	99.69	6.62	15.51
PFII5	42.11	99.01	44.26	52.87
PF121	53.59	99.27	16.90	27.50
PF122	53.73	99.27	14.96	25.44
PFI41	13.78	97.86	80.92	83.64
PF143	90.96	99.87	49.21	57.11
PF165	64.74	99.48	90.31	91.54
PF173	83.94	99.77	8.82	18.38
PF177	55.13	99.30	79.12	82.13
PF178	74.29	99.63	14.02	24.43
PFI80	53.85	99.27	10.44	20.34
PF186	13.43	97.84	6.98	16.00
PF189	59.30	99.38	94.53	95.17
PFI91	91.50	99.88	57.50	64.11
PF192	80.26	99.72	42.03	50.94
PF194	79.96	99.72	98.95	99.05
PF195	78.87	99.70	89.35	90.73
PF196	73.82	99.62	57.86	64.41
PF200	57.64	99.35	79.76	82.67
PF201	12.36	97.76	48.54	56.53
PF209	11.61	97.70	76.95	80.33
PF216	4.40	96.80	45.60	54.02
PF274	8.34	97.38	14.94	25.42
PF275	81.67	99.74	57.75	64.32
PF279	2.53	96.33	14.45	24.89
PF280	22.54	98.35	52.34	59.77
PF283	63.22	99.45	29.95	40.17
PF284	99.93	100.00	88.01	89.60
PF289	3.01	96.47	1.46	6.81
PF335	14.96	97.94	69.45	74.08
PF336	83.21	99.76	83.39	85.71
PF349	15.26	97.96	75.91	79.46
PF3S0	12.02	97.73	46.56	54.84
PF354	85.97	99.80	23.87	34.46

bership probability is to run a PCA of the data set of interest and then to eliminate from consideration the scores of the data points on the dimensions considered "noise." Any desired reduction to p dimensions can be achieved by eliminating all but the largest p principal components. As an example, scores on the first six components derived from a PCA of a subset of Tanque Verde Red-on-brown specimens analyzed by Fish and colleagues (P.R. Fish, S.K. Fish, Whittlesey, et al. 1992) were used to calculate probabilities of membership in one of the Tucson Basin reference groups. The six retained components account for more than 90% of variance in the total data set. Comparison of the jackknifed probabilities (second and fourth columns of table 2.1) indicates that if a 1% probability cutoff is adopted, group membership would not change whether the full suite of elements or the first six principal components are used for the probability calculation. This similarity reflects the fact that the major features of group shape and location within the compositional space defined by the total data set are largely subsumed by the six components on which probabilities were calculated.

An important clarification of the above approach is required here. As pointed out by Harbottle, Bishop, and Sayre in various contexts (Harbottle 1976; Harbottle and Bishop 1992; Sayre 1975), groups are as likely well separated along smaller dimensions of variance in a reference group as they are along the largest. This is entirely consistent with the view that major dimensions of variance in the data set *as a whole* will illustrate the major group separations in the data. The whole group is not just a larger version of its subgroups but a different entity with a different shape in multivariate compositional space, and there is no reason to expect the largest dimensions of variance of a single source-related group to coincide with the dimensions that best separate that group from others. On the contrary, elongation of a group in a particular dimension (making it a large dimension of variance) would tend to blur distinctions with other groups along that dimension. Conversely, very small dimensions of variance that are reasonably considered "noise" within a subgroup may be extremely meaningful on a more inclusive level because they effectively discriminate among several subgroups. Thus, it would be totally erroneous to run a PCA on a single reference group, and then use only a few of the largest components to calculate group membership probabilities for several groups with Mahalanobis distance; all dimensions would have to be considered potentially relevant to the issue of group separation, but using all dimensions would yield Mahalanobis distances identical to those calculated from the original data

(or, in the case of PCA based on a reference group correlation matrix, to distances based on data that had been standardized relative to that group).

A crucial philosophical issue that must be faced in single-group evaluation is whether the available sample accurately represents the true size, orientation, and shape of the group in multivariate space. The extent to which a group's natural distribution approximates normality and even whether a group is elongated linearly (rather than, say, banana shaped) may be questioned (for example, Reedy and Reedy 1992). Further, even assuming that multivariate normality or log-normality is a reasonable model of elemental distributions in most sources, using an arbitrary exclusion level, say 5% probability, arbitrarily biases the estimated group characteristics; at the very least, a confidence ellipse for any given probability level will be smaller than an ellipse calculated from a group for which a similarly arbitrary but smaller p-value (say, 1%) is chosen. Excluding low-probability specimens may be considered erroneous if one is characterizing sources based on raw material samples (for example, in the case of obsidian), but it perhaps cannot be avoided when one is searching for discontinuities among a set of characterized unknowns (for example, in the case of ceramics). In the author's experience, much ambiguity surrounding borderline specimens is dispelled by the jackknife or cross-validation procedure discussed above. Beyond this, practical experience indicates that examining the data from a number of different perspectives, both literally (by examining numerous bivariate plots of the original data and derived principal components) and figuratively (by calculating group membership probabilities under varying assumptions and using various probability cutoffs and comparing the results with what makes archaeological sense), are useful for identifying the most defensible groups in a data set of unknowns (see Leese [1992] and Sayre, Yener, and Joel [1992]; Sayre et al. [1992] for related discussions).

Another key use of Mahalanobis distance is in the calculation of replacement values for missing data. While a number of criteria might seem logical for replacing elemental concentrations that, for one reason or another are not determined for a particular specimen (for example, mean value for the group, detection limit, 0.5x the detection limit, and so on), a statistically preferable option is to minimize the Mahalanobis distance to the centroid of the group to which the specimen is thought to belong (Sayre 1975). The main practical issue to be resolved in applying this criterion is determining a priori to which group a particular specimen belongs. If the group is small, some subset of elements must be selected

as the basis for calculating the (reduced dimension) variance-covariance matrix for the group to which Mahalanobis distance is being minimized.

Beier and Mommsen (1994) provide the most detailed and mathematically rigorous discussion available of how Mahalanobis distance along with a number of additions and refinements can be used in the formation and evaluation of compositional groups. These authors circumvent the small group problem by leaving out the covariances, which yields the squared Euclidean distance of a specimen from a centroid expressed in standard deviation units. Beier and Mommsen (1994:302) appropriately term the latter a "multiple univariate" approach. Missing data are accommodated by dividing the Mahalanobis distance (or the analogous multiple-univariate measure) through by the number of variates, a procedure that is analogous to the calculation of mean Euclidean distance. Analytical measurement error for individual samples being compared to a group is considered by adding it to the group variances on the diagonal of the group variance-covariance matrix. These "filters" can be used for both group formation and group refinement, in a procedure that involves iteratively scanning a databank to find matching samples and recalculating group parameters as new group members are added. And, finally, these authors incorporate dilution effects (also see Mommsen, Kreuser, and Weber 1988), which, they argue (Beier and Mommsen 1994:300-303), removes correlation to such an extent that the arguments for using Mahalanobis distance (which incorporates correlation effects) rather than the alternative, multiple univariate measures are weakened.[3]

Single-group evaluative procedures are not implemented in most widely available statistical packages (SAS, SPSS, BMDP, and so on). Beier and Mommsen (1994) have written a series of in-house programs to carry out the Mahalanobis distance filtering procedures just described. ADCORR, a program developed at Brookhaven National Laboratory (Sayre 1975), performs single group multivariate evaluation based on Mahalanobis distance and the related Hotelling's T^2 statistic; a related program, ADSEARCH, searches a database for specimens matching a reference group at some specified multivariate probability level. One major drawback with AD-CORR is that it does not incorporate cross-validation (jack-knifing); this problem does not arise with ADSEARCH because specimens in the database being searched are assumed not to belong to the reference group. A series of programs written by the author in GAUSS (Aptech Systems 1994) permits jackknifing and provides multivariate probabil-

ities for several groups simultaneously. All these programs incorporate routines for replacing missing values with the minimum Mahalanobis distance criterion. These features could also be implemented in statistical packages that incorporate programmability, such as S-Plus (Venables and Ripley 1997).

Evaluation of multiple groups simultaneously

In effect, the single-group evaluative approach discussed above circumvents the question of whether all potential sources are being considered. The approach can be extended to multiple groups simply by calculating individual Mahalanobis distances for the members of each of several groups to all the groups being considered. As before, probabilities can be calculated from the original data or from reduced dimensionality data generated by PCA. If the initial groups are valid, the posterior probability that a particular specimen belongs to each of the reference groups will be highest (Mahalanobis distance will be lowest) for the group to which it was assigned initially. Misassigned specimens will be readily identifiable. For small or medium size groups (up to about 3x the number of variates), results will vary considerably depending on whether the focal specimen is assumed to be a member of the group or not; jackknifing (Baxter 1994b; Leese 1992) will provide a pessimistic assessment of whether the focal specimen belongs to its assigned group, while leaving it in its assigned group will provide an optimistic assessment (see table 2.1). There seems little reason not to take the more conservative jackknifing approach with all but very large groups: although the computational requirements are significantly higher (a new centroid and variance-covariance matrix must be calculated for each specimen), the extra time required on modern microcomputers is hardly noticeable (see Leese and Main [1994] for a computational shortcut).

The approach just described may leave a number of specimens unassigned (that is, those that fall below the probability cutoffs for all defined groups). Although vaguely dissatisfying, such a result is entirely expectable considering that a sample of unknowns represents an unknown number of natural sources, and, since some sources may be very sparsely represented in the sample, it is unreasonable to imagine that the pattern-recognition techniques described previously will permit all sources to be recognized. In fact, there are several potential interpretations of the specimens left unassigned: They may be derived from sources not represented among the defined groups; they may be statistical outliers from one of the identified groups; or they may represent anomalous paste preparation or diagenetic effects, which create a distinctive

fingerprint that is represented by only a few of the analyzed specimens.

There are several means to alleviate the dissatisfaction associated with a substantial catalogue of unassigned specimens. Sometimes tentative group assignments can be made if, say, the identified groups are well separated and certain unassigned specimens are obviously closest to one of the groups. Alternatively, assignment at a general level may be possible if several chemically similar groups from a single region can be combined and shown to subsume some of the unassigned specimens. Unassigned specimens that are very remote in compositional space from the bulk of analyses may be derived from distant sources that are represented very sparsely in the analyzed assemblages and in the analyzed sample; ultimately, as samples from an area (such as the Southwest) grow, additional examples of the highly anomalous compositions may be found, and possible source zones then may become evident.

In the approach just outlined, each group is allowed not only to have its own unique location in the multivariate compositional space but also to have its own unique shape (variance-covariance structure). In light of the importance of shape as a key component of group distinctiveness, such an approach would seem to be imperative when dealing with compositional data. However, permitting each group to have a distinct variance-covariance structure means that the groups will vary in how large an area of multivariate space is enveloped by a given probability contour (for example, Leese 1992). Because of this, probability estimates will be inflated for groups characterized by comparatively greater dispersion of data points around the centroid.

Linear discriminant analysis circumvents the problem of inflated probabilities for more dispersed groups but at the cost of forcing all groups to have the same variance-covariance structure. A typical linear discriminant calculation involves Mahalanobis distance calculated as:

$$D^2 = (X - C_j)' \, S_p^{-1} \, (X - C_j) \qquad (2.17)$$

where X is a vector of elemental concentrations determined for a specimen, C_j is the centroid vector for the jth group to which it is being compared, and S_p^{-1} is the inverse of the variance-covariance matrix pooled over all groups being considered (for example, Leese 1992). With the variance-covariance structure assumed to be the same for all groups, the best group assignment is the one for which the calculated value of D^2 is minimized. There are two problems here for provenance investigations: first, the assumption of homogeneous variance-covariance matrices is almost certainly erroneous; and second, forcing all specimens into the group to which they are closest in Mahalanobis distance terms denies the possibility that some of the specimens may belong to groups that are not defined due to their sparse representation in the analyzed sample.

What is referred to as quadratic discriminant analysis (Leese 1992) utilizes group-specific variance-covariance matrices but incorporates an adjustment for the relative dispersions of the groups:

$$D^2 = (X - C_j)' \, S_j^{-1} \, (X - C_j) + \ln |S_j| \qquad (2.18)$$

where X is a vector of elemental concentrations determined for a specimen, C_j is the centroid vector for the jth group to which it is being compared, and S_j^{-1} is the inverse of the variance-covariance matrix for the jth group. The natural log of the determinant of S_j, the group variance-covariance matrix, adjusts for the spread in group j. While the adjustment for dispersion is a potential advantage of this approach, like linear discriminant analysis, quadratic discriminant analysis provides no direct indication of how well a point approximates the characteristics of the group to which it is assigned (Leese 1992:320). Also, as Leese notes, quadratic discriminant analysis, like the individual group Mahalanobis distance approach described above, suffers from estimating S_j from small groups whose data may be non-normally distributed despite the correction for group dispersion. The best approach here again would seem to be to maintain flexibility, assessing group membership from a variety of perspectives and paying particular attention to how known group members (that is, raw material source samples if they are available) are grouped by the various procedures (Leese 1992).

The rubric "discriminant analysis" also refers to canonical discriminant analysis, an eigenvector-based technique for extracting linear combinations of variables that maximally separate predefined groups in the data (J.C. Davis 1986). Maximal separation is achieved when the ratio of between-group variation to within group variation is maximized, that is, maximize $W^{-1}B$, where B is the between-groups sums of products matrix and W is the within-group sums of products matrix (J.C. Davis 1986; Klecka 1980). With some matrix manipulation, it turns out that the matrix of eigenvectors corresponding to the positive eigenvalues of the asymmetric matrix $W^{-1}B$ contains coefficients of the original variables that maximize this ratio. Both the original grouped observations and

any other set of observations for which the same measurements are available can be projected into the resulting discriminant space by $A'Y$, where A is the matrix of discriminant coefficients and Y is the matrix of data for the points to be projected. The resulting reduced-dimensionality space can provide a means for assessing group membership both for the original observations included in the groups discriminated and for additional ungrouped observations projected into the discriminant space; such an assessment can be made on the basis of Mahalanobis distances in the reduced dimensionality space, using either the assumption of homogenous or heterogeneous variance-covariance structure within the discriminant function space.

Baxter (1994b) has recently highlighted the distinction between allocatory procedures, such as the Mahalanobis distance-based approach described previously, and separatory procedures, such as canonical discriminant analysis. In provenance investigations, the basic goal of assigning specimens to source-related chemical groups.is allocatory. However, the stepwise procedures often used in computer packages to choose a subset of "most useful" variables to be retained can only maximize separatory performance of the discriminant analysis; and separatory performance often does not translate into allocatory success. As Baxter (1994b:664) points out, stepwise procedures are even more questionable if certain specimens may belong to groups that are as-yet unrecognized, since variables eliminated by the stepwise procedure may be key discriminators of the new groups. The implication of Baxter's argument is that canonical discriminant analysis in general and stepwise procedures in particular are most useful in provenance investigations for identifying axes that afford the best graphical illustration of chemical distinctions between groups. The allocatory goals of provenance investigation are best served by other means, such as the calculation of Mahalanobis distances based on the original elemental concentrations or (if necessary) on some subset of principal components.

Additional caution is required in the use of canonical discriminant analysis with relatively small groups. The technique is sometimes applied to analyzed specimens in groups corresponding to several different sites in order to confirm a hypothesis of multilocus production. In this mode, canonical discriminant analysis is analogous to the "analysis of variance approach" mentioned previously, and some of the same criticisms apply. Canonical discriminant analysis is designed to calculate the best means of separating whatever groups are "fed in" in the first place. When each group is relatively small

in comparison to the number of variates, there is almost certain to be some linear function of the original variates (or some subset if a stepwise procedure is used) that produces what looks on a bivariate plot like reasonably good separation between the groups. Here again, evaluating subgrouping tendencies in the data from multiple perspectives (bivariate plots, PCA, and Mahalanobis distance calculations if the groups are large enough) is the best general guideline to avoid being misled by a powerful, packaged technique.

Linear discriminant and canonical discriminant analysis routines are available in most common statistical analysis software packages, and they have been programmed by the author in Gauss (Aptech Systems 1994). As mentioned previously, the individual-specimen Mahalanobis distance approach for multiple groups has been programmed in Gauss as well. Implementing the latter approach should be relatively straightforward in any package with matrix manipulation functions.

CONCLUSION

In this chapter, I have described some quantitative tools that have proven useful in chemistry-based ceramic provenance research. Once the data are in hand, the general course of investigation proceeds from data transformation to pattern recognition to group evaluation. In practice, however, there is feedback between these stages. Furthermore, each part of the analysis needs to be tailored to the specific conditions of the geological environment and ceramic technology under investigation; quantitative techniques of data analysis cannot be considered apart from problem definition, research design, and sampling. The studies reported in the rest of this volume show how the techniques described above can be combined in various ways to address questions about ceramic provenance in the Southwest

Acknowledgments. I must single out Ron Bishop and Mike Baxter for special thanks. Bishop has consistently encouraged my interest in the quantitative complexities of ceramic provenance determination, especially during 1987 to 1988, when he supervised my postdoctoral fellowship in Materials Analysis at the Smithsonian Institution. Mike Baxter provided extremely useful critique and suggestions on an earlier draft of this chapter.

Notes

1. The popularity of standardized, centered eigenvector analyses (that is, PCA of the correlation matrix) has more to do with the availability of software than with the appropriateness of the

assumptions (Bishop and Neff 1989). As a technique for ordination, eigenvector analysis requires neither centering nor standardization, and each may be undertaken without the other. J.C. Davis (1986:536) argues that in most geological applications the relative magnitudes of the variables are important, and it is therefore preferable to work with a variance-covariance matrix rather than a correlation matrix. He notes (J.C. Davis 1986:536) that using the correlation matrix tends to magnify the importance of elements that vary little across the dataset. Along similar lines, Baxter (1994a:64) points out that using the correlation matrix (that is, standardization) when the variables are measured on the same units is equivalent to imposing an arbitrary weighting scheme. On the other hand, Baxter (1989, 1991, 1994a) has also given examples in which the results obtained using standardized data are more readily interpretable. In the author's experience, while the structure recognizable on the first two components may often differ, inspection of the first several components usually will reveal similar structure, whether the PCA is based on the correlation matrix or the variance-covariance matrix. Neither approach is universally superior with respect to the depiction on the first two components of structure that holds up under further scrutiny.

2. Beier and Mommsen (1994:291) advocate use of chi-square rather than Hotelling's T^2 to obtain p-values and give a two-dimensional example in which use of Hotelling's T^2 erroneously suggests that distinct groups cannot be separated statistically. However, because of the extremely small size of one of the groups (four specimens) this example is somewhat contrived: In a real study, the four members of this group would best be considered unassigned until additional analyses enlarged the group and made it clearly recognizable.

3. In the author's experience, it is very unusual to find that removing dilution through a "best relative fit" (BRF) so drastically diminishes correlation in the data. This is because it is rare for tempering or refinement to introduce "pure dilution" except in cases involving the addition or removal of something that is not measured by INAA, SiO_2 (quartz) being the most obvious example. Usually, proportional adjustment of all elements reduces many correlations without entirely eliminating them, but there remain a number of elements for which the fit is inappropriate. As an obvious example, calcium, strontium and barium in calcite-tempered pottery will not be adjusted appropriately by a BRF calculated over all elements because it is precisely the addition of these elements (in the calcite) that dilutes the majority of elemental concentrations. In this case, therefore, to get a result approximating Beier and Mommsen's (1994) case, in which dilution nearly removes all correlation, one would have to omit calcium, strontium, barium, and perhaps a few other elements from the analysis. With more complex temper-related dilution-enrichment relationships, it is hard to imagine how, without knowing the composition of the temper, one could decide which elements to omit in utilizing the dilution-corrected multiple univariate filter. In general then, group-refinement approaches based on Mahalanobis distance rather than its multiple univariate analogue should be preferred.

Black Mountain Phase Ceramics and Implications for Manufacture and Exchange Patterns

Darrell Creel, Matthew Williams, Hector Neff, and Michael D. Glascock

IT HAS LONG BEEN WIDELY BELIEVED THAT the Mimbres area of southwestern New Mexico was largely, if not completely, abandoned around AD 1130 to 1150 with the so-called collapse of the Classic Mimbres system. It is also generally accepted that the area was subsequently reoccupied during what is known as the Black Mountain phase by a population related in some way to that at Casas Grandes in Chihuahua. In work at the Old Town site on the lower Mimbres River, however, ceramic attributes and occurrences were regularly found that seemed inconsistent with this prevailing interpretation of Mimbres area culture history. As part of the study of Black Mountain phase remains at Old Town and their relation to the earlier Mimbres Classic remains, a modest program of instrumental neutron activation analysis (INAA) was initiated with the hope that it might answer questions about changes in ceramic production and exchange and how these relate to other notable changes in material culture and regional interaction in the mid-1100s. This effort was initially undertaken in collaboration with researchers at Texas A&M University and the University of Missouri Research Reactor and has, more recently, included archeologists at Arizona State University; the University of Oklahoma; Fort Bliss, (in El Paso); and the Texas Historical Commission.

GEOLOGICAL SETTING

As part of the basin and range province, southwestern New Mexico has a complex geologic history, and a wide range of formations are currently exposed at the surface. The locations of the archeological sites represented in this analysis reflect the range of geological variability in the area; in the Mimbres Valley, however, there is comparatively little difference in surface geology from one site to another. Fortunately, this vari-

ability is to some extent imparted to clays and temper available to prehistoric potters, readily permitting recognition of chemical compositional groups among the ceramics. The exposed rocks represent a wide range of types: Precambrian granites and gneiss; a number of metamorphic rocks; volcanic rocks, such as tuff, rhyolite, and basalt; and more recent sedimentary deposits in stream valleys, pediments, and basins (Clemons, Christiansen, and James 1980; Elston 1957; G. Mack 1997). Because of the extensive geologic faulting and consequent limited exposure of many of these formations, it is likely that the distribution of particular minerals is also limited, although to a lesser extent, due to transport of weathered material. The occurrence of individual elements and suites of elements is related to the occurrence of the parent formations and transported materials weathered from them, as exemplified by the chemical distinctiveness of the clay samples from the different regions within the overall sample area (for example, see the clay samples from locations in the Lower Mimbres regions in table 3.1).

Petrographic studies have shown that mineralogical differences are expressed in prehistoric ceramics from the Mimbres River drainage (Rugge 1977), but such studies have also revealed that some of the differences appear to reflect deliberate selection of specific tempering materials according to the intended function of a pottery vessel (for example, Stoltman 1996). It is thus apparent that the mineralogical and chemical composition of Mimbres area ceramic pastes may often reflect the addition of exogenous material to a locally obtained clay.

Previous INAA research has indicated chemical similarity in a substantial portion of the Mimbres Black-on-white Style III pottery from much of the Mimbres Valley (Gilman,

Table 3.1 Compositional group assignment of samples by site and ceramic type

COMPOSITIONAL GROUP (columns: Main Playas Red, Playas Red Sub 1, Playas Red Sub 2, Tularosa/Cibola)

Region	Site	Type/ware	Chupadero	El Paso	Main Playas Red	Playas Red Sub 1	Playas Red Sub 2	Tularosa/Cibola	Unassigned	TOTAL
Arenas	LA 18342/18343	Chupadero B/W	3							3
		El Paso		3						3
		Playas			1	1			4	6
		Tularosa Sm. Corrugated		1				1		2
	Powe Site	Playas							2	2
Chihuahua	Casas Grandes	Playas			1				5	6
El Paso	Gobernadora	Chupadero B/W	4							4
		El Paso		30					1	31
	Hot Well	Chupadero B/W	3							3
		Playas			3		2			5
	Ojasen	Chupadero B/W							2	2
		El Paso		16			1		4	21
Gila	WS Ranch	Tularosa Sm. Corrugated		2				1		3
		Playas							3	3
Mimbres (Lower)	Old Town	Chupadero B/W	11						2	13
		El Paso		17	4					21
		Playas			5	16	1		2	24
		Tularosa Sm. Corrugated					2		2	4
		Plain Smudged				1				1
		Untyped Textured Rim			1					1
		Potter's Clay							1	1
		Clay: upland pedogenic			1					1
		Clay: alluvial			1					1
		Hearth and roof adobe							2	2
	Walsh Ranch	Clay: alluvial			1					1
	Taylor Mtn.	Kaolin							6	6
Mimbres (Middle)	Acequia Seca	Chupadero B/W							2	2
		El Paso		4	1				1	6
		Playas			3	1	2		1	7
		Smudged Corrugated							2	2
	Agape Acres	Chupadero B/W	4							4
		El Paso		2					1	3
		Playas			12		4		3	19
	NAN Ranch	El Paso		11					1	12
		Clay: alluvial			5		1		3	9
	Perrault	Chupadero B/W	1							1
		El Paso		3						3
		Playas			7					7
Palomas	LA 37726/37727	Chupadero B/W	1						3	4
		Untyped Cibola B/W						1		1
		El Paso		2						2
		Playas					1			1
		Tularosa B/W						1		1
		Untyped B/W			1			1	1	3
	LA 37728	Untyped Cibola B/W						1		1
		El Paso		1						1
		Playas			1					1
		Tularosa B/W						1		1
	Animas/Seco	Clay							1	1
	Ash Canyon #2	Clay							1	1
	Palomas drainage	Clay							1	1
	Seco drainage	Clay							1	1
Rincon	Dam Site	El Paso		2						2
		Playas				1	2			3
	Franzoy	El Paso		1					1	2

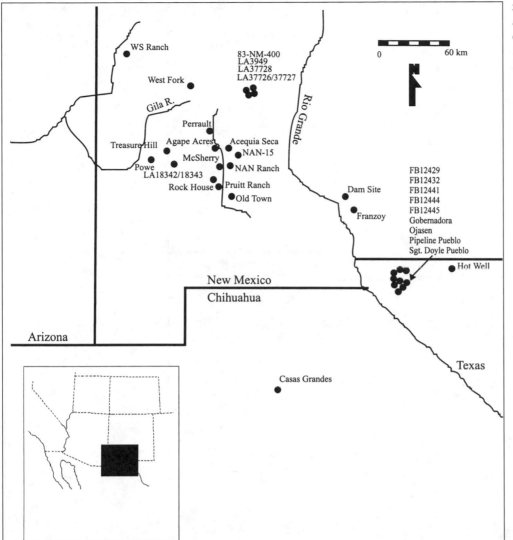

3.1 Map showing locations of archaeological sites contributing INAA samples. *Illustration prepared by Robin Barnes*

Canouts, and Bishop 1994; James, Brewington, and Shafer 1995). Our research has shown that there is considerable chemical homogeneity in Mimbres Valley alluvial clays from the NAN Ranch area and continuing downriver some fifteen miles to the Old Town area (figure 3.1). Not surprisingly, upland pedogenic clay from Old Town also has a chemical composition quite similar to that of the Mimbres River alluvium analyzed so far from this same locality. These facts indicate that INAA alone may not be able to discriminate manufacturing locales on a site-specific basis in the Mimbres Valley. The situation in the other regions, such as El Paso, may or may not be similar.

In all these studies, there are compositional groups without clay members whose membership is almost exclusively from single Mimbres Valley sites; the Playas Red Subgroup 1, for example, is almost all from the Old Town site (see also

Gilman, Canouts, and Bishop 1994). Since much of the surface rock in the area is volcanic and primary clays formed from the weathering of such rocks are often unsuitable for pottery manufacture, one can postulate prehistoric use of other, more localized alluvial clay sources not yet sampled for INAA. In fact, the soil surveys note the occasional occurrence of discontinuous clay strata in Mimbres Valley alluvium (Neher and Buchanan 1980; Parham, Paetzold, and Souders 1983); early test excavations at Old Town encountered such a clay deposit, but no samples were collected.

In addition to the alluvial and pedogenic clays in the area, there are other types of clay deposits including a large upland deposit of pure kaolinite—which is being commercially mined today—about a mile north of Old Town. This particular deposit has been sampled, and two of the samples show marginal similarity to the Chupadero Black-on-white com-

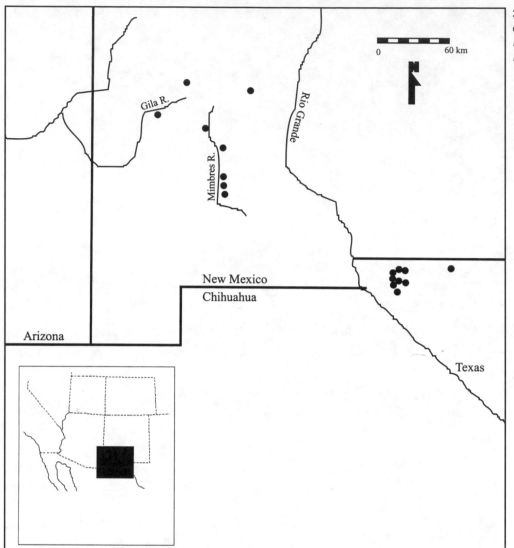

3.2 Map showing locations of clay samples used in study. *Illustration prepared by Robin Barnes*

positional group discussed below (all are listed under Taylor Mountain, unassigned in table 3.1). In general, though, this clay deposit seems not to have been used prehistorically, at least not for the bodies of vessels.

In general, the rather limited exposure of certain geologic formations in southwestern New Mexico and adjacent Texas makes it likely that efforts to define the general source area of ceramics by chemical composition techniques such as INAA will be successful. Extensive transport and mixing of weathered materials from different formations will, however, tend to dilute the precision with which source areas can be discriminated. Moreover, the selection of specific tempering material may further reduce the precision of sourcing using INAA alone.

SAMPLE COMPOSITION

So far, analyses have been focused primarily on three pottery types or wares: Chupadero Black-on-white, early El Paso Polychrome (predating AD 1250 to 1300), and Playas Red, all of which are fairly common at Black Mountain phase sites in the Mimbres area. Far less attention has been given to Tularosa and Cibola types. A total of 574 samples comprise the overall data set, but only the approximately 250 Black Mountain phase samples are discussed here. The remainder are mainly Mimbres wares, used here only for comparative purposes. These Black Mountain phase samples come from eighteen archeological sites and eleven clay sampling localities in eight separate regions (figures 3.1 and 3.2; table 3.1). Since this composite data set represents what are, in some cases, unrelated research efforts and uneven sample sizes from the different sites, any interpretation must be tempered accordingly.

ANALYSIS

INAA was carried out at MURR and Texas A&M using analytical protocols discussed in chapter 1. A total of thirty-one different elemental concentrations were represented by the data, twenty-three of which were common to all samples. The data used in this study presented many analytical challenges, especially in dealing with the large sample size and equally large variability. The data were first analyzed by Neff and Glascock who noted a series of compositional groups that make sense in terms of ceramic typology and that can be verified statistically. The data, along with a modest number of additional samples from the El Paso area (Fort Bliss samples—not specifically discussed here), were subsequently analyzed by Williams using different statistical methods to address somewhat different questions. More specifically, Williams sought to determine whether sorting the data into a larger number of compositional groups would yield results that make sense both typologically and archaeologically. Using k-means analysis, sorts were first made into an arbitrarily chosen number of groups, in this case, thirty-two, and, subsequently, into one hundred groups. Because of the differences in methods, the later groupings cannot be statistically compared to the originally identified compositional groups (see chapter 2, for a discussion of some of the problems associated with recognizing subgroups in a large body of ceramic data).

Both the original analysis by Neff and Glascock and the later analysis by Williams revealed the same fundamental results and are, in a sense, complementary. The more numerous compositional groups in the second analysis build upon the firm foundation provided by the first analysis and serve, if nothing else, to point out potentially important new research questions. The statistical methods used in all phases of this study are not elaborated here (see chapter 2).

RESULTS

The analysis of Black Mountain phase ceramics showed a general correspondence between composition and pottery type. As a result, the compositional groups recognized in the first analysis have been designated by the names of the types or wares comprising all or most of the members. These groups are Chupadero Black-on-white, El Paso Polychrome, Main Playas, Playas Subgroup 1, Playas Subgroup 2, and Tularosa/Cibola (table 3.1). The Chupadero Black-on-white and El Paso Polychrome groups show the greatest decorative uniformity, with no specimen of another type in either compositional group. No specimen of either type occurs in any other group with the exception of five El Paso Polychrome

sherds that fall within the Main Playas group. The compositional differences among these groups are illustrated by a biplot of principal components 2 and 4 (figure 3.3); the indicated enrichment of iron in the El Paso Polychrome group and of scandium in the Chupadero Black-on-white group is confirmed by a bivariate plot of the two elements.

Playas specimens pertain to a ceramic resource base distinct from that associated with either the El Paso or Chupadero groups. The largest group of Playas specimens, the Main Playas group, includes several decorative varieties of Playas Red, the previously mentioned El Paso Polychrome sherds, Tularosa Smudged Corrugated, and Mimbres Classic Corrugated. It diverges most obviously from the Chupadero group on principal components 2 and 4 (figure 3.3) and from the El Paso group on components 1 and 4 (see chapter 2). Iron and scandium are crucial contributors to the Chupadero/Main Playas separation, while europium and tantalum effect a clear separation between the El Paso and Main Playas groups (figure 3.4). Most important, cross-validated probabilities of group membership demonstrate that posterior allocation to the respective groups is completely unambiguous.

Compositional diversity is greater within the Playas type than within either Chupadero Black-on-white or El Paso Polychrome. Thus, besides Playas specimens in the Main Playas compositional group, there are the two previously noted smaller groups that contain little other than Playas type members (table 3.1). These two subgroups are separated from the El Paso and Chupadero groups on principal components 4 and 5 in part as a result of higher rubidium in Playas Subgroup 1 and lower thorium in Playas Subgroup 2. They are separated from the Main Playas group on principal components 1 and 2, largely as a result of higher rare earths (for example, samarium) in both subgroups and higher tantalum in Subgroup 2 (figure 3.5).

The Tularosa/Cibola group contains Tularosa and Cibola White Ware and is, thus, much like the other groups in the close correspondence between type and chemical composition (table 3.1). This group is compositionally unusual in that there are some elements such as iron and scandium on which the members fall completely outside the range of variation of the rest of the sample.

Playas Red

Determining the place of manufacture of Playas wares from Mimbres sites has proven to be an interesting, if not somewhat surprising, effort. Our Playas sample consists of eighty-three sherds from twelve sites in seven different areas (table

Top, 3.3 Plot of Chupadero B/W, El Paso Polychrome, and Main Playas groups on principal components 2 and 4. *Illustration prepared by Hector Neff.*

Middle, 3.4 Plot of El Paso Polychrome and Main Playas groups relative to concentration of tantalum and europium. *Illustration prepared by Hector Neff.*

Bottom, 3.5 Plot of Main Playas and Playas subgroups 1 and 2 relative to concentration of samarium and tantalum. *Illustration prepared by Hector Neff.*

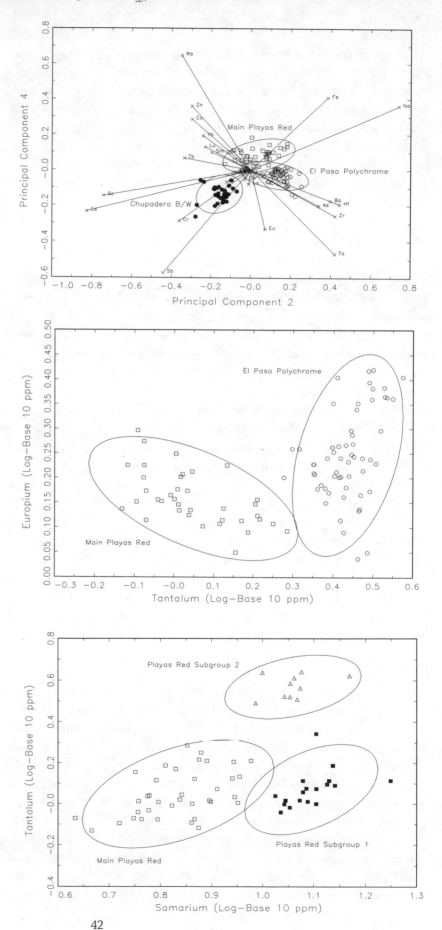

3.1; figure 3.1). More than half of the sample comes from two sites, both in the Mimbres Valley. The sample, thus, is biased but has nevertheless been revealing.

As previously noted, the Playas sherds are for the most part compositionally distinct from both El Paso Polychrome and Chupadero Black-on-white. Interestingly, though, several of the Playas sherds in our sample tend to group with Mimbres Classic Corrugated and smudged vessels. At Old Town and LA 18342/18343, for example, the latter is indicated by the membership of the Main Playas group (table 3.1). In our first analysis, the Main Playas compositional group had these types and also included Mimbres Black-on-white Style III and clays from the middle and lower Mimbres Valley. Playas Subgroup 2, containing Playas, Mimbres Classic Corrugated, and a few other types, from both Mimbres Valley and El Paso area sites, shows marginal similarity to Mimbres Valley clays and, therefore, may also derive from that area. Thus, there is good evidence for manufacture of Playas in the Mimbres Valley, but the INAA data alone do not permit us to identify more specific manufacturing locales, at least at the present time.

In finer scale analyses, a few of the compositional groups containing only Playas are strongly site specific, but for the most part these groups are so small that little can be said about them with certainty. In contrast, the largest exclusively Playas group (Playas Red Subgroup 1 in table 3.1; n=19) is dominated by sherds from the Old Town site in the Mimbres Valley (n=17, or about 80% of the Old Town Playas sample) but also has one sherd each from two other sites in the Mimbres drainage (Acequia Seca, a Black Mountain phase pueblo adjacent to NAN Ranch, and LA 18342, a Classic/Black Mountain phase site in the Rio Arenas drainage near Treasure Hill). The membership of this group has remained consistent through all levels of analysis, so we are confident of its reality. The strongly site-specific character of this group suggests manufacture in or perhaps near the Old Town site, but, at present, this group cannot be linked via clay samples to any particular manufacturing locale.

Each of the three Playas compositional groups in our original analysis is represented at most sites from which there is more than one Playas sample. We infer that this multigroup representation reflects fairly widespread manufacture and movement of Playas vessels, at least within the Mimbres area. In the present sample, the only known exception is Old Town where, as noted previously, most of the Playas is in the distinctive Playas Subgroup 1. Above and beyond this, the chemical distinctiveness of Playas sherds from sites such as

WS Ranch suggests additional manufacturing locales (table 3.1). We note, though, that the Main Playas compositional group convincingly linked to the Mimbres Valley contains Playas sherds from the Hot Well site, Casas Grandes, and two sites in the Rincon and Palomas areas. From this, we suggest that Playas vessels made in the Mimbres Valley were moved widely in the southern Southwest.

It is interesting in this regard to consider the small group of six Playas sherds analyzed from Casas Grandes. One is part of a group that contains mostly Mimbres Valley Classic period pottery type members (from numerous sites) and that is closely related to other groups also containing predominantly Mimbres Valley members, including clay samples. The source (or sources) of the other five is at present unknown. In sum, there is reasonable evidence for the manufacture of much Playas in the Mimbres Valley, and it was likely also made in Chihuahua, as has long been thought. In addition, our data suggest that Playas was made at still other localities that have yet to be identified (for example, the WS Ranch Playas).

El Paso Polychrome

The El Paso brown wares, primarily the early (before AD 1300) polychrome and bichrome types, comprise the largest pottery type sample in our analysis, with 120 sherds. For convenience, they are all referred to as El Paso Polychrome, since the polychrome type comprises the majority of the series. These come from six sites in the Mimbres Valley, eight sites in the El Paso area, two in the Hatch, New Mexico vicinity, and two sites on the east side of the Black Range (table 3.1; figure 3.1). The Mimbres Valley and El Paso sites contribute 80% of the sample, most of them from two sites in each area. The sample, thus, is decidedly biased but still sorts out into interesting yet largely predictable compositional groupings.

For the most part, the El Paso Polychrome is chemically distinct from all other material in our sample. That is, in the first analysis, virtually all the El Paso Polychrome fell into one group, with no members of other ceramic types. In the second analysis, nearly all the El Paso Polychrome fell into a larger number of groups, most still with no members of any other type. In the 32-level analysis, four compositional groups contained 104 of the 120 El Paso Polychrome sherds; two of these groups had El Paso area clay samples as members. In the other two groups, nearly all the members were from El Paso area sites. On this basis, it is possible to state with confidence that most of the El Paso Polychrome in our sample was indeed manufactured in the El Paso area. It should be noted, however, that our El Paso area samples are all from sites along

Table 3.2: Chupadero compositional groups in finer scale analysis

Site	Sample type	Group 1	Group 2	Total
LA 18342/18343	Chupadero B/W	2	1	3
Perrault	Chupadero B/W	-	1	1
Acequia Seca	Chupadero B/W	-	1	1
Agape Acres	Chupadero B/W	4	1	5
NAN Ranch	Smudged	1	-	1
Old Town	Chupadero B/W	6	5	11
Gobernadora	Chupadero B/W	4	-	4
Hot Well	Chupadero B/W	1	1	2
TOTAL		18	10	28

the east flank of the Franklin Mountains and doubtless represent only a portion of the chemical variability of El Paso brown ware manufactured in the El Paso area. It is possible that the El Paso Polychrome groups in the 32- and 100-group analyses with only Mimbres Valley members derive from manufacturing localities not represented by our sherds from El Paso sites.

There is also good reason to believe that a small number of the El Paso Polychrome sherds, four of them from the Old Town site, were actually made in the Mimbres Valley. These five sherds are members of the Main Playas group identified during the initial analysis, a group with several Mimbres Valley clay samples as members. In all the analyses, these sherds are chemically distinct from the other El Paso Polychrome in the sample. They may reflect a modest level of El Paso Polychrome manufacture in the Mimbres Valley. If so, their occurrence primarily at Old Town suggests that they may have been made in or near that community, a possibility that warrants further research. While this may in part reflect different sample sizes, the fact that none of the twelve El Paso brown ware samples from NAN Ranch are members of the Main Playas group suggests that this distinction is real. Moreover all five of these El Paso Polychrome sherds are from the part of Old Town with the latest occupation. At present, however, we cannot adequately evaluate the temporal significance of these chemically distinct sherds.

There are other intersite and intrasite differences in compositional group membership that are not currently understood. Some of these present additional puzzling hints of what may be temporal differences or perhaps exchange relationships between specific sites in the Mimbres and El Paso areas. For example, most of the El Paso Polychrome from the Acequia Seca site falls into a different group than do most of the specimens from the NAN and Old Town sites (the two Mimbres Valley sites with the largest El Paso brown ware samples). This difference is all the more curious because Acequia Seca and NAN are immediately adjacent to one an-

other. Given the apparent temporal difference in occupation of the two, the differences in compositional group membership may reflect changing intersite relationships.

In general, the traditional belief that El Paso Polychrome was made primarily in the El Paso/Jornada area is supported by this study. Clearly, much of it was distributed to the Mimbres Valley, and it is reasonable to assume that it was moved from the El Paso area in other directions as well. El Paso Polychrome is, after all, widely occurring in the western third of Texas, Chihuahua, and southern New Mexico. Continuing instrumental neutron activation analysis of the El Paso brown wares will no doubt clarify our understanding of their production and distribution over time.

Chupadero Black-on-white

Thirty-six sherds of Chupadero Black-on-white from eleven sites have been analyzed in this study. Of these, twenty-two are from sites in the Mimbres Valley, four are from a site in the Rio Grande drainage (Palomas region in table 3.1), and the other ten are from El Paso area sites (table 3.1; figure 3.1). Like most of the El Paso Polychrome, the majority of Chupadero samples appear to be distinct compositionally from any other sherds considered in this analysis. For example, in the initial analysis, the majority of these fell into one compositional group with no members of other types and into two groups in the later analysis; no group can as yet be confidently attributed to a particular manufacturing locale. Significantly, neither of the two Chupadero groups identified in the later analysis has more than one member of any other pottery type; neither of these specimens has more than a marginal probability of membership. Therefore, it is possible that most of the Chupadero was made outside the area represented by our samples and certainly outside the Mimbres Valley. Evidence from other analyses indicates that Chupadero was made in different localities east of the Rio Grande in the area east and north of the Tularosa Basin (for example, Stewart et al. 1990; Warren 1981a). More recent petrographic analyses of

a small number of Chupadero sherds from Mimbres area sites suggests that some may have been made in the eastern Mimbres area (our Palomas region; see Ennes 1996:8), but the INAA data on these same samples seem to contradict this inference to some extent.

Because of the small sample size, it is difficult to say much about the results of the finer level analysis, but most of the Chupadero Black-on-white consistently falls into two groups that crosscut the sample on an intersite basis (table 3.2). The compositional differences between these two groups are based largely on cesium and antimony. In light of all our analyses, these groups are presumed to reflect distinct but chemically similar clay sources; alternatively, they could reflect the addition of chemically different tempering materials to otherwise similar clays, perhaps indicating separate but nearby production locales. An effort is currently underway to address this issue.

Reserve, Tularosa, and Cibola Wares

Tularosa Smudged Corrugated bowls occur consistently in Black Mountain phase sites in the Mimbres area and, on stylistic grounds, have generally been presumed to have been imported. Only a few sherds of Tularosa Smudged Corrugated have been analyzed so far, all from sites in the Mimbres Valley or in the San Francisco River drainage (table 3.1). Given the small sample size, we hesitate to say too much about the chemical composition of this type. However, Tularosa Smudged Corrugated sherds from Mimbres Valley sites all fall into compositional groups that contain predominantly Mimbres ceramic types, and one of these groups contains Mimbres Valley clay samples as well (table 3.1). In contrast, two of the three Tularosa Smudged Corrugated sherds from the WS Ranch site on the San Francisco River are chemically distinct from any other sherds in the sample. On this meager basis, it is tentatively suggested that the Tularosa Smudged Corrugated in our sample was manufactured in both the Mimbres Valley and the upper Gila-San Francisco River area of southwest New Mexico.

Similarly, the sample of Tularosa Black-on-white and Cibola White Ware sherds from AD1100 to 1200 contexts is quite small and derives from two nearby sites in the Palomas drainage on the east side of the Black Range (table 3.1). All are compositionally unusual in that there are some elements (for example, iron and scandium) on which they fall completely outside the range of variation of the rest of the data set. These sherds have a chemical profile very similar to some sherds in a much larger and chemically diverse sample of Cibola White

wares from the Point of Pines site in Arizona,.[1] which suggests that some of the sources of Point of Pines Cibola White Ware are also represented in the Tularosa/Cibola group defined in our data set. There is no evidence that any of it was made in the Mimbres area, and we infer that our Cibola sherds are from imported vessels.

SUMMARY

In general, the results of our neutron activation analyses lead us to believe that the mid-1100s saw major changes in ceramic manufacture and exchange in the Mimbres area. For most of the Classic period, the Mimbres people appear to have produced essentially all the pottery needed in their villages (Gilman, Canouts, and Bishop 1994; James, Brewington, and Shafer 1995), and pottery vessels were apparently exchanged within the Mimbres area on a frequent basis. The Mimbres folks even produced a fair amount that found its way to more distant places, such as the Jornada region (Brewington, Shafer, and James 1997), but little pottery produced elsewhere appears to have been imported into the Mimbres area until the end of the Classic period.

In the subsequent Black Mountain phase, however, there is a major change. Suddenly, pottery vessels made in many different surrounding areas, such as the Jornada Mogollon and Cibola regions, began to appear in Mimbres villages. Common types include El Paso Polychrome and Chupadero Black-on-white. Occurring less frequently are White Mountain Red wares, such as St. Johns Black-on-red and Polychrome, Wingate Black-on-red, and Tularosa Black-on-white which, because of their low frequency, are assumed to have been imported (see chapter 7). For Tularosa Black-on-white, however, there is meager INAA evidence supporting our belief that it was imported. Somewhat surprising has been the indication that Tularosa Smudged Corrugated may have been made in small quantities in the Mimbres Valley. This would be consistent with the inferences made by Hegmon, Nelson, and Ennes (2000) that Cibola area residents immigrated to parts of the Mimbres area after about AD 1150.

Equally surprising is the evidence that Playas was made in the Mimbres Valley. Prior to beginning this research, the authors subscribed to the prevailing notion that Playas was basically a Chihuahuan product that reflected the influence of Casas Grandes. Now, however, there is reasonable evidence that Playas was made in different parts of, and moved over a large area in, the southern Southwest, including the Mimbres Valley. From a Mimbres Valley perspective, this is also consistent with continuity from Mimbres Classic Corrugated to

the pottery identified as a corrugated variety of Playas. Thus, at the end of the Mimbres Classic phase, the local production of the well-known Mimbres Black-on-white and polychrome pottery effectively ceased (LeBlanc 1983:158–166; Shafer 1996); more and more painted pottery was imported, but utility ware, be it Playas corrugated, incised, or cord-marked, was still made locally in substantial quantities. Some Playas does appear to have been imported into the Mimbres Valley just as some appears to have been exported.

In sum, our instrumental neutron activation analyses have supported some long-held notions regarding the production areas of certain pottery types but have modified other long-held notions. The evidence for major changes in ceramic production and exchange fits well with evidence for equally major changes in other aspects of material culture at about the same time with what has long been referred to as the collapse of the Classic Mimbres system. The mid-1100s, for example, saw a significant change in architecture from the masonry pueblos of the Mimbres Classic to coursed adobe Black Mountain phase pueblos. Settlement pattern also shifted, and there is some much debated evidence for population decline. Explanations for this transition from the Mimbres Classic to the Black Mountain phase are varied but often include the adverse impact of a serious drought in the 1130s, virtually complete abandonment, and the rising influence of Casas Grandes. It is emphasized here that the ceramic evidence indicates substantial reorganization of exchange relationships, probably varying somewhat from one part of the Mimbres area to another. Clearly, with our existing database and collaborative attitude, continuing instrumental neutron activation analysis of ceramics in the southern Mogollon area will surely bring increasingly meaningful results as well as new surprises.

Acknowledgments. A number of individuals and agencies have been involved in the research effort presented here. The basic research effort at the Old Town site has been sponsored in part by the Bureau of Land Management, New Mexico State Office and the Las Cruces District. Former and current BLM district archaeologists Mike Mallouf and Thomas Holcomb, as well as Steve Fosberg in the state office have provided assistance throughout the Old Town Project and have enthusiastically supported the research presented in this chapter. Many of the samples were analyzed at the University of Missouri Research Reactor under a grant from the National Science Foundation (DBS-9102016); Hector Neff and Michael Glascock were instrumental in all aspects of the analysis at MURR. Partial funding came from the Friends of the Texas Archeological Research Laboratory. Similarly, a large number of the samples used in our research were run at the Texas A&M University reactor as part of the NAN Ranch Project, courtesy of Dennis James, Harry Shafer, and Robbie Brewington. These individuals are part of a group of researchers collaborating in Mimbres area INAA studies; others include Michelle Hegmon, Margaret Nelson, Patricia Gilman, Myles Miller, and Valli Powell. Important series of samples were provided by LaVerne Herrington, Tom O'Laughlin, James Neely, and Clint and Dee Johnson. Specimens from the reference materials of Casas Grandes ceramics at the Texas Archeological Research Laboratory were made available by Thomas R. Hester. Data from Fort Bliss were provided by James Bowman and Myles Miller; Mark Bentley provided a few sherds from Fort Bliss for analysis. Useful comments on this chapter were provided by volume editors Donna Glowacki and Hector Neff.

Notes

1. Maria Nieves Zedeño generously allowed us to compare our Cibola analysis with her as-yet-unpublished data from Point of Pines, Arizona.

4

Chaco and the Production and Exchange of Dogoszhi-Style Pottery

Jill E. Neitzel, Hector Neff, Michael D. Glascock, and Ronald L. Bishop

Of the half dozen design styles used to decorate ceramics in the northern US Southwest, the Dogoszhi style is notable for two reasons. First, its appearance is quite distinctive, consisting solely of hatched curvilinear and rectilinear designs (Hantman et al. 1982). Second, it is the style most strongly associated with the dense concentration of multistory great houses in Chaco Canyon, New Mexico. Between AD 900 and 1150, this canyon in the middle of the San Juan Basin was the center of the most complex society ever to develop in the northern Southwest. The extent of this society is currently being debated by archaeologists, with proposed limits ranging from a "halo" immediately surrounding the canyon to the entire San Juan Basin (Neitzel 1994; Wilcox 1999). However these boundaries are ultimately defined, Chacoan influence extended beyond them, encompassing much of the northern Southwest (Lekson 1991).

Because of its high concentration at great houses in Chaco Canyon, the Dogoszhi style has been associated with the ceremonial, political, economic, and social power of Chacoan society. Several lines of evidence support the style's ceremonial significance. Inside the canyon, the highest frequencies of Dogoszhi-style pottery have been found at Pueblo Bonito (Neitzel 1995), the preeminent great house that was the focus of important ceremonial gatherings (Stein and Lekson 1992). In addition, cylinder vessels, a ritual artifact found almost exclusively Pueblo Bonito, were decorated most frequently in the Dogoszhi style (Neitzel and Bishop 1990). The ceremonial significance of the Dogoszhi style is also supported by data from outside the maximum proposed limits of Chacoan society. On Black Mesa in northeastern Arizona, Dogoszhi-style pottery occurs in significantly higher frequencies at sites with kivas than at sites lacking this ceremonial structure (S. Plog 1990, 1995a).

Probably not unrelated to its ceremonial significance, the Dogoszhi style may have also served as a symbol of political and social power within Chacoan society. Distributional analyses have supported the hypothesis that the Dogoszhi style was an elite style (Neitzel 1995). These analyses have revealed discrete drops in the relative occurrence of Dogoszhi-style pottery within each successively lower level of the four-tier Chacoan settlement hierarchy. Given the apparent association between the Dogoszhi style and Chacoan power, answers to questions about where Dogoszhi-style pottery was produced and how widely it was traded can contribute to our understanding of the internal organization and extent of Chacoan society as well as the nature of its broader influence. This study uses instrumental neutron activation analysis (INAA) to investigate questions about the production and exchange of Dogoszhi-style pottery both within and outside the Chacoan regional system.

We have framed our research with reference to the Chacoan regional system instead of Chacoan society because of the lack of consensus about what the limits of that society were. The term *regional system* is more ambiguous, referring to a zone of intense interaction that can encompass more than a single society (Neitzel 2000). For purposes of this research, the Chacoan regional system is defined as the San Juan Basin (figure 4.1). This regional system included the powerful society centered on Chaco Canyon as well as any remaining portions of the San Juan Basin. These other areas were strongly influenced by Chacoan society, but were not necessarily part of it. While areas outside the San Juan Basin were also influenced by Chacoan society, this influence was less intense; and we consider this zone to be outside the Chacoan regional system.

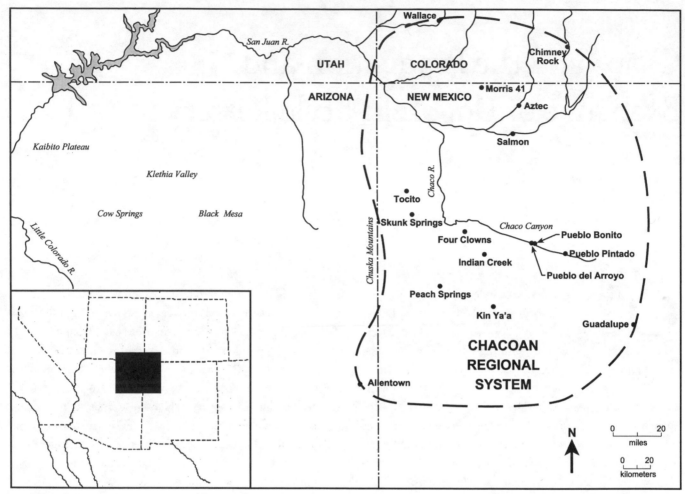

4.1 Map of site locations

This discussion of the production and exchange of Dogoszhi-style ceramics within and outside the Chacoan regional system is organized into four parts. First, relevant background information from previous studies of Chacoan ceramics is presented. Second, the data and analytical techniques applied in the current research are described. Next, the compositional patterns uncovered in the San Juan Basin are used to draw conclusions about the production and exchange of Dogoszhi-style pottery within the Chacoan regional system. Finally, the spatial scale is broadened to consider what the compositional patterns found outside the San Juan Basin indicate about the production and exchange of Dogoszhi-style ceramics throughout the northern Southwest.

PREVIOUS INSTRUMENTAL NEUTRON ACTIVATION ANALYSES

Three sets of background information are relevant to questions about the production and exchange of Dogoszhi-style ceramics. The first is what is known about the production

and exchange of Chacoan pottery in general. The second is data on the compositional variability of clays within the San Juan Basin. The extent of this variability would determine whether or not INAA is a suitable technique for addressing questions about ceramic production and exchange within the Chacoan regional system. Finally, there are the results of previous neutron activation analyses of Dogoszhi-style ceramics.

Production and exchange of Chacoan Ceramics

As with anything Chacoan, the focal point of Chacoan ceramic studies has been Chaco Canyon. During the course of the National Park Service's decade-long Chaco Project, tens of thousands of ceramics from sites within the canyon and its immediate vicinity were analyzed (McKenna and Toll 1984; Toll 1984, 1985, 1991, 1997; Toll and McKenna 1987, 1992). These analyses included not only traditional typological studies, but also temper identifications done with the aid of a binocular microscope. Several nonlocal tempers were identified in the canyon's ceramics. Since no evidence was found

Table 4.1 Relative frequencies of ceramics from three major production areas at all Chaco project sites*

Period	Red Mesa Valley	Chuska Mountains	San Juan River	Total Imports
Pre-AD 800	1.4	3.6	4.6	16.6
AD 800-920	13.2	9.7	4.3	28.1
AD 920-1040	7.9	12.3	2.9	25.2
AD 1040-1100	3.5	30.7	2.4	39.8
AD 1100-1200	1.2	31.3	3.0	50.4
AD 1200-1300	3.4	21.6	16.4	45.7

* Ceramics from three source areas identified based on presence of chalcedonic cement sandstone temper, trachyte temper, and igneous rock temper, respectively; figures for total imports derived from typological identifications, after Toll 1985:126-128.

indicating temper trade, ceramics with nonlocal tempers were presumably produced in the areas where the tempers were naturally available.

Temper analyses have revealed that a surprisingly high proportion of the canyon's ceramics were imported (see Toll 1985, 1991, 1997). The peak of this trade was between AD 1100 and 1200 when one-half of all vessels found in the canyon were produced somewhere else (table 4.1). Three areas, each with its own distinctive temper, produced most of the canyon's imports. The earliest important source area is located approximately 60 km south of the canyon in the vicinity of the Red Mesa Valley (table 4.1; see Toll 1985, 1991, 1997). Produced with a chalcedonic cement sandstone temper, ceramics from this area were brought to the canyon in their greatest relative frequencies between AD 800 and 920. During this interval, approximately 13% of the canyon's ceramics came from the Red Mesa area.

During this same time period, a second source area located approximately 75 km west of the canyon in the Chuska Mountains began to gain in importance (table 4.1; see Toll 1985, 1991, 1997). Ceramics were made here with a distinctive trachyte (aka sanidine basalt) temper (Warren 1967; Windes 1977). The importance of this source area reached its peak between AD 1040 and 1200 when almost one-third of the canyon's ceramics came from the Chuska Mountains.

The Chuska area continued to be the canyon's primary source of imported ceramics after AD 1200, although its importance diminished somewhat. This decline was matched by the increasing importance of another source area, the northern and eastern tributaries of the San Juan River located more than 100 km north of the canyon (table 4.1; see Toll 1985, 1991, 1997). Made with igneous rock temper, ceramics from this northern production zone comprised approximately 16% of the canyon's ceramics between AD 1200 and 1300.

Temper analyses have convincingly documented the huge volume of ceramics that were transported over great distances to Chaco Canyon. They have also revealed the changing im-

portance of the three major source areas in producing plain versus decorated pottery (see Toll 1985, 1991, 1997). In addition, other minor source areas have been identified based on temper and surface finish (for example, paint type and design characteristics used to define ceramic types). Together, the results of these various studies point to two directions for future research. One is to obtain a more fine-grained picture of pottery production within the canyon's primary source areas. The other is to broaden the focus beyond the canyon to obtain a picture of ceramic trade throughout the Chacoan region.

Clay variability and INAA

In order to investigate the nature of ceramic manufacture within production areas defined on the basis of distinctive temper types, the degree of compositional variability in ceramic clays must be assessed. If clays are compositionally variable on a spatial scale smaller than the sizes of proposed production areas, then compositional differences in pottery can be used to identify production centers within these areas. INAA is the analytical technique most sensitive to detecting compositional differences in ceramic clays (along with the tempers added to them) (see chapter 1).

The key question for determining the applicability of INAA is whether or not the clays available to prehispanic potters were compositionally variable. If they were not, then applying the technique would simply confirm their homogeneity. If the clays were variable, then INAA would reveal which of the available clays potters chose to use. By indicating reliance on different clay sources through the identification of groups of compositionally similar vessels, the existence of different production loci would be indicated.

There are two sets of evidence suggesting that prehispanic potters in the northern Southwest had access to a range of compositionally variable clays. The first evidence is geological. The entire northern Southwest, including the San Juan Basin, has had a complex geological history (Cooley et al.

1969; Dane and Bachman 1965; Molenaar 1977; Scott, O'Sullivan, and Weide 1984). As a result, many different kinds of clays can be found in the region's varied rock formations. For example, major geological formations containing sedimentary Cretaceous clays in Chaco Canyon include the Menefee formation, Cliff House formation, and Lewis Shale (Toll 1997). In addition, clays derived from Tertiary and Cretaceous deposits can be found in some of the canyon's alluvial settings.

Studies done outside Chaco Canyon in other parts of the San Juan Basin (Windes 1977) and on Black Mesa in northeastern Arizona (Deutchman 1979) have also documented the variety of clay sources that would have been available to potters. If these potters did in fact rely on locally available clays, as ethnographic studies have shown to be the usual practice (Arnold 1985), then INAA should be able to delineate vessels from the same source and thus reveal the number of local production centers present within an area.

This conclusion is reinforced by the results of oxidation experiments on clays from Chaco Canyon (Toll 1997; see also Bubemyre and Mills 1993; Garrett and Franklin 1983; Mills, Carpenter, and Grimm 1997 for experimental results from outside Chaco Canyon). Toll (1997) has documented considerable variability in the oxidation colors of clays from the same geological formation. Since oxidation color reflects the clay's chemical composition, this would suggest that compositional variation may exist at a scale smaller than the extent of a particular geological formation. Again, INAA is the technique that can detect such compositional variation.

Results of previous INAA

INAA has in fact proven its efficacy in two previous studies of Dogoszhi-style pottery. The first was done on ceramics recovered from outside the Chacoan regional system. Deutchman (1979, 1980) analyzed 109 Dogoszhi-style sherds from ten habitation sites in the Black Mesa region of northeastern Arizona (figure 4.1). The results indicated the presence of several homogeneous compositional groups that appeared to covary with such archaeological variables as vessel shape and design. Deutchman (1979:177) suggested that the Dogoszhi sherds found on Black Mesa could have been imported.

The second previous INAA of Dogoszhi-style pottery focused on three Chacoan great houses, two located in Chaco Canyon (Pueblo Bonito, Pueblo del Arroyo) and one located at the southwestern boundary of the Chacoan regional system (Allentown) (figure 4.1). Neitzel and Bishop's (1990) INAA of sixty Dogoszhi-style vessels from these sites re-

vealed a high degree of compositional homogeneity among cylinder vessels and bowls from the two canyon great houses, suggesting that they were made in the same place and/or with the same materials. However, bowls from the outlying great house were compositionally different, suggesting that they were manufactured at a different location. Comparisons of these distributional patterns with Deutchman's (1979) results from Black Mesa, Arizona revealed that the Black Mesa sherds were also compositionally different from those found in Chaco Canyon.

The primary conclusion drawn from Neitzel and Bishop's (1990) study was that Dogoszhi-style ceramics found throughout the northern Southwest were not all being made in the same place. The great houses in Chaco Canyon certainly exerted considerable influence on the surrounding region and probably on more distant areas as well. However, this influence did not include the widespread export of Dogoszhi-style ceramics from the canyon. Instead, potters in outlying areas apparently applied the style that predominated in the canyon to their own vessels.

While providing some new insights into the production and exchange of Dogoszhi-style ceramics, Neitzel and Bishop's (1990) study also raised additional questions: Where were the Dogoszhi-style ceramics at the canyon great houses of Pueblo Bonito and Pueblo del Arroyo being manufactured? Was production occurring inside the canyon, in the Chuska area, or somewhere else? What was the relative importance of various manufacturing centers in terms of ceramic exchange? These questions can be answered only through additional INAA of Dogoszhi-style ceramics from a larger sample of sites.

CURRENT RESEARCH

The purpose of the research reported here is to build on Neitzel and Bishop's (1990) earlier study by expanding the number of sites for which INAA of Dogoszhi-style ceramics have been done.

The database

Dogoszhi-style ceramics from thirteen Chacoan great houses were analyzed for this study (table 4.2). All these sites are located outside Chaco Canyon in other parts of the San Juan Basin (figure 4.1). In relation to the canyon, the thirteen outlying great houses extend in all directions and range in distances from nearby to far away. The sites represent all levels in the Chacoan settlement hierarchy (table 4.2). They include the largest outlying great houses of Aztec Ruin (405 rooms),

two other large outliers (135 to 175 rooms), five medium out-liers (44 to 75 rooms), and five small outliers (fourteen to thirty rooms).

A total of 188 Dogoszhi-style sherds were obtained from the thirteen sites (table 4.2). Because the purpose of this re-search was to obtain a fine-grained picture of the production and exchange of Dogoszhi-style pottery, the sherds were not classified by ceramic type. Such types are generally defined using various combinations of temper, paste, paint, and design attributes. The polythetic character of these definitions not only creates classification problems, but also severely limits the utility of types for fine-grained analyses of ceramic pro-duction and exchange. Because of these difficulties, type identification was not a relevant task for our research.

The 188 Dogoszhi-style sherds were subjected to INAA at the Missouri University Research Reactor Center (MURR). Statistical analyses were then carried out on the new data to-gether with data obtained previously by Neitzel and Bishop (1990) and Deutchman (1979). The latter included the results of analyses of six raw clay samples from Black Mesa. The pro-cedures by which the samples collected for this study were prepared, irradiated, and analyzed at MURR are described by Glascock (1992) and Neff and Glowacki (chapter 1). Neit-zel and Bishop (1990) and Deutchman (1979) describe the procedures by which the samples collected for their studies were prepared, irradiated, and analyzed at the SCMRE-NIST and Brookhaven National Laboratory (BNL), respectively.

Statistical analyses

The quantification techniques used in this analysis are de-scribed in detail by Neff and Glascock (1993). To summarize, source-related subgroups in the combined MURR, SC-MRE-NIST, and BNL data were identified through inspec-tion of principal components plots and group refinement with multivariate statistics (see chapter 2). Appendix 4.A indi-cates the final group affiliation and shows group membership probabilities for the two largest groups, which we have la-beled the Chaco and Black Mesa reference groups. These ref-erence groups should not be interpreted as containing all specimens produced in the vicinity of Chaco Canyon and at Black Mesa. Rather, they subsume compositional profiles for which there is little question as to correct assignment. Speci-mens were left unassigned if they did not appear to fit into any of the reference groups or if they appeared to match more than one reference group.

Particular caution is warranted with respect to the Black Mesa reference group. The Black Mesa analyses represent a

Table 4.2 Chacoan sites for which Dogoszhi-style sherds were analyzed for this study

Site	# Rooms	# Sherds	Sherd source
Aztec West	405	15	Museum of New Mexico
Chimney Rock	55	15	Frank Eddy
Four Clowns	14	15	San Juan County Museum
Guadalupe	25	15	BLM
Indian Creek	21	15	Museum of New Mexico
Kin Ya'a	44	8	Museum of New Mexico
Peach Springs	30	15	Museum of New Mexico
Morris 41	75	15	U of Colorado Museum
Pueblo Pintado	135	15	Museum of New Mexico
Salmon	175	15	San Juan County Museum
Skunk Springs	45	15	Museum of New Mexico
Tocito	20	15	Museum of New Mexico
Wallace	73	15	Bruce Bradley

number of proveniences both on and off Black Mesa. In ad-dition, they appear to subsume a continuum of compositions with no clear compositional subdivisions (Neitzel and Bishop 1990). In order to define a relatively homogeneous Black Mesa reference group that would not be so broad as to in-clude many nonlocal specimens, relatively conservative crite-ria for group membership were adopted in the present study. Specimens from sites on or near Black Mesa were excluded from the reference group if they showed less than 10% proba-bility of membership. Also, specimens from sites outside the Black Mesa region were not included in order to avoid using possible nonlocal specimens with spurious resemblance to Black Mesa to define reference group characteristics.[1] Use of these conservative statistical criteria to define the Black Mesa group reduces the chances of erroneously assigning non–Black Mesa products to Black Mesa and thus enhances the usefulness of the Black Mesa sample for comparisons with other regions.

Compositions of Dogoszhi pottery at sites in and around Chaco Canyon were sampled better and analytical data are more complete and more precise than the Black Mesa data. As a result, compositions characteristic of the Chaco core it-self are statistically better defined and easier to distinguish from compositions characteristic of outlying areas than in the case of Black Mesa. Therefore, for the Chaco reference group, proveniences outside the Chaco core area were admitted to the Chaco reference group and a more lenient probability criterion (1%) was used for membership in the group.

When multivariate probabilities of membership in the Chaco reference group were calculated using all thirty-one reliable elements[2] for the MURR data alone, some reference group members identified for the combined MURR, SC-MRE-NIST, and BNL data appeared marginal and several

previously ungrouped specimens conformed better to the Chaco reference group compositional profile (appendix 4.A). These observations do not warrant reconstitution of the combined data reference group, however, because the combined MURR and SCMRE-NIST data represent a better sampling of Dogoszhi pottery from Chaco Canyon than do the MURR data alone. Nonetheless, the higher probabilities generated using only the MURR data are useful for interpretation, since they identify additional ungrouped specimens that are probably derived from the same source(s) as the Chaco reference group specimens.[3]

The Dogoszhi pottery specimens analyzed at BNL, SCMRE-NIST, and MURR come from numerous sites spread across a wide area of the northern Southwest. Because a number of production centers and several production zones are represented in this sample, the structure of the data is quite complex. In an effort to simplify this complexity, analytical results are presented below in two sections. The next section deals with production and exchange of ceramics within the Chacoan regional system and relies on the MURR data only. The subsequent section utilizes the combined BNL, SCMRE-NIST, and MURR data sets to address questions about the production and exchange of Dogoszhi pottery on a broader geographic scale throughout the northern Southwest.

CHACOAN REGIONAL SYSTEM

With the exception of the Chaco reference group itself, the compositional groups identified in the MURR analyses were too small to permit multivariate evaluation. However, the partitions in the data are clearly illustrated on the first four principal components extracted from the MURR data variance-covariance matrix. These partitions provide evidence for where Dogoszhi-style pottery was being produced in the Chacoan regional system.

Compositional patterning in the Chacoan regional system

A total of six compositional signatures can be recognized in the MURR data. The Chaco reference group is the largest and best defined of the six. The other groups are the Tocito, Chimney Rock, Chimney Rock A, Guadalupe, and Kin Ya'a groups. All six groups are distinct from one another and are assumed to represent distinct production zones. In general, the names given to the groups indicate where the distributional evidence suggests their members were being produced.

Four of the groups defined in the MURR data (Chaco, Tocito, Chimney Rock, and Chimney Rock A) are clearly distinguished by the first two principal components. Element coordinates in this RQ-mode PCA space (Neff 1994) indicate that the Chimney Rock and Chimney Rock A groups diverge from the Chaco reference group because of generally lower levels of many elements, including rare earths. The Chimney Rock A group represents an extreme of this diluted compositional profile. Element coordinates also indicate that the Tocito group diverges from the Chaco group in a different direction and that the basis of this differentiation includes higher calcium, sodium, strontium, manganese, iron, barium, and chromium along with lower cesium and antimony.

An RQ-mode plot of components 1 and 4 of the MURR data illustrates the compositional differentiation of the Guadalupe and Kin Ya'a groups from the Chaco reference group and the separation between the Tocito and Chaco groups (figure 4.2). Element coordinates indicate that lower antimony along with higher hafnium, zirconium, and tantalum help pull the Guadalupe and Kin Ya'a groups away from the Chaco reference group. A bivariate hafnium–antimony plot confirms the contribution of these elements to the group separation, but shows as well that substantial overlap remains, particularly between the Chaco reference group and the Kin Ya'a group. Probabilities of group membership also suggest that Kin Ya'a group members are compositionally closer than Guadalupe group members to the Chaco reference group (appendix 4.A). A number of elements contribute to a clear separation between the Guadalupe and Kin Ya'a groups, including iron.

Although most of the unassigned specimens cannot be assigned to the Chaco reference group based on their multivariate probability of membership using the combined MURR and SCMRE-NIST data (appendix 4.A), they appear to fit best with the Chaco reference group based on their locations in principal component space. Most of these ungrouped specimens are best interpreted as representing slightly divergent resource choices or paste preparation practices within the Chaco production zone.

Dogoszhi production in the Chacoan regional system

The groups defined for sites within the Chacoan regional system reflect production at several production centers or zones. Perhaps the clearest example of localized production is the Chimney Rock A group, which is extremely homogeneous as well as divergent chemically from all other specimens in the data set. These observations coupled with the fact that all group members come from a single site (Chim-

4.2 RQ-mode plot of principal components 1 and 4 extracted from the variance-covariance matrix of the MURR data set, showing the Chaco reference group along with Chimney Rock, Chimney Rock A, Tocito, Kin Ya'a, and Guadalupe groups (selected variable coordinates are connected to the origin in order to provide an idea of the variance-covariance structure in the data)

ney Rock) suggest that the group represents a very localized set of ceramic resources, probably only used by potters at the site of Chimney Rock or in its immediate vicinity. The other Chimney Rock group is a less extreme example of the chemical profile manifested at Chimney Rock A. Chimney Rock and three other sites along the eastern tributaries of the San Juan River (Morris 41, Aztec, and Salmon) are most heavily represented in this group. Thus, this group would appear to represent a general upstream (eastern) San Juan River compositional profile.

The Guadalupe and Tocito groups are both linked closely to specific geographic locations. The Guadalupe group includes all but three specimens from the site of Guadalupe and no specimens from anywhere else. Thus, it appears to represent an eastern production zone lying along the Puerco River. The Tocito group is dominated by twelve specimens from the Tocito site, which is located on the eastern slopes of the Chuska Mountains near their northernmost extension. Thus, this group appears to represent a northeastern Chuskas compositional profile. The fact that several specimens in the Tocito group show moderate probabilities of membership in the Chaco reference group suggests that the Chaco and Tocito resource zones may overlap. This possible overlap has implications for the origins of Chaco reference group members. If specimens in the Tocito group originated in the northeastern Chuskas and if the ceramic resource bases represented by the Chaco reference group and Tocito group overlapped, then

the geographic area represented by the Chaco group may include part of the eastern Chuska Mountains.

The Chaco reference group is dominated by analyses from sites in or near Chaco Canyon, but it also includes a majority of the analyses from sites on the eastern slopes of the Chuska Mountains (Peach Springs and Skunk Springs) and from sites located roughly half-way between Chaco Canyon and the Chuskas (Four Clowns and Indian Creek). Three samples from the other Chuskan site of Tocito, which were not assigned to the Tocito group, are members of the Chaco reference group. Thus, the provenience data alone suggest that the Chaco group represents a broad Dogoszhi production zone lying between the Chuskas and Chaco Canyon.

The suggestion that specimens in the Chaco group originated in an area that includes the eastern Chuskas can also be reconciled with the chemical differences observed between the Tocito and Chaco groups. The elements differentiating the Tocito group from the Chaco reference group (for example, sodium, calcium, iron, and chromium) could be enriched by igneous rock temper. If so, the chemical differentiation of the two groups could be largely a result of paste recipe differences with a Dogoszhi ceramic production zone lying along the eastern slope of the Chuska mountains.[4]

Trachyte (sanidine basalt) temper provides a plausible source of the chemical variation observed to underlie the Chaco-Tocito group partition. As was discussed previously, this temper only occurs naturally in a few localities in the

4.3 RQ-mode plot of principal components 1 and 2 extracted from the correlation matrix of the total BNL, NIST, and MURR data sets, showing Chaco and Black Mesa reference groups along with a third group centered on the site of Tocito

Chuskas (Warren 1967; Windes 1977) and characterizes a large proportion of all Chacoan pottery, including white wares (Neitzel and Bishop 1990; Toll 1985). Given the small likelihood of temper being imported into the canyon, restriction of trachyte sources to the Chuskas would also appear to indicate that there was frequent movement of vessels into Chaco Canyon from the west (Toll 1985).

The Kin Ya'a group is only partially distinct from the Chaco reference group but appears to differ from it in that fewer proveniences to the west of Chaco Canyon are included (only three of eleven). Thus, the archaeological contexts of the analyzed specimens would seem to suggest that whereas the Chaco reference group originates mainly west of the Chaco core zone, the Kin Ya'a specimens may originate in a zone extending south and/or east from Chaco Canyon. An alternative interpretation of the Kin Ya'a group is suggested by comparison of the Chaco data to reference groups of Pueblo III ceramics from the Four Corners region. As reported by Glowacki and colleagues (chapter 5), several members of the Kin Ya'a group fall well within the ranges of variation of the main Four Corners group, which consists mostly of samples from Lowry Ruin and Sand Canyon Pueblo in southwestern Colorado. Based on this evidence, it is possible that the Kin Ya'a group, like the Chaco reference group and the Tocito group, originate north and/or west of Chaco Canyon.

THE NORTHERN SOUTHWEST

In this section, Dogoszhi-style ceramics from sites located outside the Chacoan regional system are added to the analyses to obtain a picture of ceramic production and exchange across the northern Southwest. Compositional patterning for the northern Southwest was analyzed using the combined BNL, SCMRE-NIST, and MURR data sets.[5] Regional source affiliation in the combined data sets are readily illustrated on the first four components of the correlation matrix of the combined data sets (for example, figure 4.3).

Compositional patterning in the northern Southwest

The Chaco and Black Mesa reference groups along with a smaller group centered on the site of Tocito are well separated on the first two principal components of the combined data set (figure 4.3). Separation of the two reference groups is almost entirely along component 1, which, as the locations of points representing variable coordinates illustrate, is due most obviously to higher concentrations in the Chaco specimens of rare earths, especially lanthanum, cesium, samarium, and europium.

Six Black Mesa clays and the ungrouped BNL analyses are plotted together with the reference group 90% confidence ellipses in figure 4.4. Two clay samples (HDCL84 and HDCL88) show reasonably good correspondence with the Black Mesa reference group on PC 1 and 2 (figure 4.4).

4.4 Ungrouped Black Mesa Dogoszhi analyses along with six Black Mesa area clays plotted on principal components 1 and 2 of the correlation matrix of the total BNL, NIST, and MURR data sets. Ellipses representing the 90% confidence level for membership in the Black Mesa, Chaco, and Tocito groups are also shown.

These samples also have the highest probabilities of membership in the group (appendix 4.A). Both of these clay samples are from sites along Moenkopi Wash in the central part of Black Mesa. Since far more than half of the Black Mesa reference group members are from this same general area (sites D:11:348, D:11:275, D:11:290, and D:11:280), the Black Mesa reference group would seem to reflect ceramic production in the central part of Black Mesa.

Although a few of the ungrouped BNL analyses fall within the 90% confidence ellipse of the Chaco reference group components on 1 and 2 (figure 4.4), none of the ungrouped analyses shows above .05% probability of membership in the group, and all but three show below .0005% probability of membership (appendix 4.A). These observations provide very little basis for postulating a Chaco area origin for any of the Black Mesa samples. On the contrary, the fact that ungrouped Black Mesa specimens tend to fall in the same region of the plot as the Black Mesa reference group (figure 4.4) suggests that they are either outliers from that group or represent other, more sparsely sampled groups from the vicinity of Black Mesa.

Apart from the Chaco and Black Mesa reference groups and the Tocito group, one other compositional signature can be recognized in the combined data. This group is dominated by specimens from two sites in the Klethla Valley, located on the western edge of Black Mesa. This group is compositional-ly heterogeneous, but it is clearly distinct from both the Black Mesa and Chaco reference groups, as demonstrated by a PCA plot of components 1 and 3 (figure 4.5).

Figure 4.5 shows NIST Allentown analyses projected onto components 1 and 3 along with the two reference group ellipses, the Black Mesa clays, the unassigned Black Mesa specimens, and the Klethla Valley group. A subset of five Allentown specimens diverges from the Chaco and Black Mesa reference groups toward the high end of component 3, where four of the Black Mesa clays and the Klethla Valley group lie. There are several reasons for inferring that these relatively high values indicate derivation from the general vicinity of Black Mesa, perhaps from clays that are exposed around the mesa's edges. First, four clay specimens with relatively high values on component 3 were collected at the base of Hopi First Mesa, just off the southeast corner of Black Mesa. Second, the Klethla Valley pottery group is centered along the western edge of Black Mesa. Finally, Deutchman (1979) has identified Cow Springs sandstone, which is found along the southeastern and western edges of Black Mesa, as a potential source of kaolinitic clays used for ceramic manufacture.

The remaining five Allentown specimens fall slightly high on component 1, which might link them with ceramic resources in the Chaco area (figure 4.5). On the other hand, all five show highest probabilities of membership in the Black Mesa group, the highest (SWAT06) exceeding 22% (appendix

4.5: Ungrouped Black Mesa, NIST Allentown, and Black Mesa area clays plotted on principal components 1 and 3 of the correlation matrix of the total BNL, NIST, and MURR data sets. Ellipses representing the 90% confidence level for membership in the Black Mesa, Chaco, Tocito, and Klethla Valley groups are also shown.

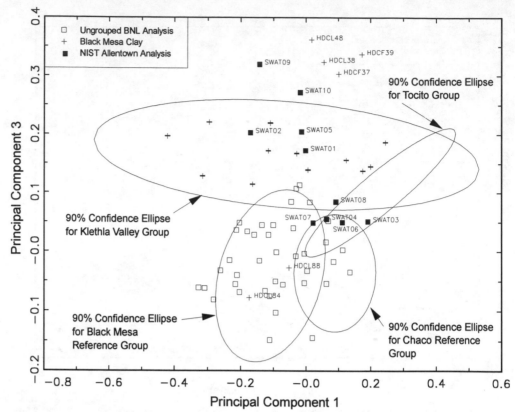

4.A). Thus while none of the Allentown pottery can be linked to a specific source, the compositional evidence clearly suggests that Allentown ceramics were produced at several sources with at least one being located to the northwest of Allentown, around Black Mesa. When ungrouped NIST and MURR analyses are plotted along with the reference group 90% confidence ellipses, a few data points on each plot fall well within the Black Mesa reference group. This might suggest some movement of Black Mesa pottery into the Chaco core. It is worth noting in this connection that several of these ungrouped specimens also have probabilities of membership in the Black Mesa group greater than 1% (appendix 4.A).

Unfortunately, the two specimens with highest probability of membership in the Black Mesa reference group (SWPB17 and SWPB41) also show moderately high probabilities of membership in the Chaco reference group, so their production source remains ambiguous. JNE133, on the other hand, has a compositional profile that clearly fits best with the Black Mesa reference group both in principal component space and in the full 20-dimensional space (appendix 4.A). Several other ungrouped NIST and MURR analyses have unusually high values on component 3, which may indicate derivation from sources around the edge of Black Mesa (see figure 4.5). Thus, the present investigation yields tentative evidence that Dogoszhi pottery produced in the vicinity of

Black Mesa was sometimes consumed in or near Chaco Canyon.

Apart from the Chaco reference group, the other groups defined within the Chacoan regional system are chemically distinct from the Black Mesa reference group. The distinctiveness of the Tocito group is well illustrated in figure 4.5. The Kin Ya'a and Guadalupe groups both show negligible probabilities of membership in the Black Mesa group (appendix 4.A); both would fall within the range of variation of the Chaco group in figures 4.4 and 4.5. Chimney Rock and Chimney Rock A also show negligible probabilities of membership in the Black Mesa reference group. Additionally, they are distinct from both the Black Mesa and Chaco reference groups in the principal components space of the total data set. Chimney Rock A is particularly unusual in composition, due in large part to very low rare earth element concentrations.

Production and exchange in the northern Southwest
The archaeological proveniences listed in table 4.1, along with the source zone inferences just discussed, suggest that there was substantial movement of Dogoszhi pottery across the northern Southwest. The Chaco reference group, thought to have been produced in a zone encompassing the eastern slope of the Chuska mountains, includes specimens from Wallace Ruin, Chimney Rock, and Morris 41, as well as

Salmon, Aztec, and sites within Chaco Canyon. The inference of ceramic movement might be questioned for one or several of these sites (for example, the eastern Chuskas production zone for the Chaco reference group might have extended east as far as Four Clowns, Indian Creek, or even Chaco Canyon). However, it seems extremely unlikely that Dogoszhi pots conforming to the Chaco reference group's compositional profile were produced in all the widespread locations where they are found archaeologically. The Chimney Rock group, inferred to originate along one or more of the tributaries of the San Juan River, also occurs at numerous sites throughout the Chaco regional system (table 4.1). At least some of these occurrences must result from ceramic movement out of the production zone.

Both northern and southern peripheral sites show diminished frequencies of Dogoszhi pottery linked to the eastern Chuskas production zone. The northern peripheral sites of Chimney Rock and Wallace have the lowest representation of Chaco reference group specimens of all MURR sites. Allentown appears to represent a similar peripheral situation to the southwest, since none of the ten analyses from that site showed above .0005% probability of membership in the Chaco reference group (appendix 4.A). The compositional evidence indicates instead that some Dogoszhi pottery at Allentown may have originated at sites around Black Mesa.

Toward the east, there is an especially obvious break in ceramic connections. Guadalupe stands out among all MURR sites because of the complete absence of any Chaco reference group specimens. Equally striking is the observation that two compositional groups linked to production zones east of the Chaco core zone (Chimney Rock A and Guadalupe) are confined to single sites. From the point of view of ceramic movement, then, the dominant connections of Chacoan sites such as Pueblo Bonito, Pueblo Pintado, Aztec, and Salmon seem to have been toward the west and north, with a minimum of contact toward the east.

The Black Mesa reference group is inferred to represent production at one or more sites on Black Mesa, probably located close to Moenkopi Wash. The Klethla Valley group is inferred to represent production along the western edge of Black Mesa, but its compositional heterogeneity indicates that several production centers are probably included in this production zone.

The SCMRE-NIST analyses from Allentown are compositionally heterogeneous and are not inferred to represent a single production center (Neitzel and Bishop 1990). The compositional results presented here indicate that some ves-sels probably originated in the Black Mesa area, while others probably originated in production centers supplying pottery to the Chaco core (presumably the eastern Chuskas and adjacent zones).

Both the probabilities presented in appendix 4.A and graphical display of the data (for example, figures 4.4, 4.5) suggest that there may have been some movement of Dogoszhi-style pottery made on Black Mesa southeast to Allentown and into the Chaco core. This finding is consistent with the inference that Chaco core sites tended to look west in terms of ceramic exchange. On the other hand, there does not appear to have been a corresponding movement of Chaco area pottery west to Black Mesa.

CONCLUSION

INAA offers the most informative technique for pursuing research questions suggested by previous temper-based studies of Chacoan ceramics. The results presented here refine to some extent our understanding of the nature of ceramic production within the three major areas that are known to have exported large quantities of vessels to Chaco Canyon (table 4.1). They also broaden the scope of our understanding of ceramic trade, considering trade throughout the Chacoan region (as well as in other parts of the northern Southwest) instead of focusing just on Chaco Canyon.

Our understanding of the production and exchange of Dogoszhi-style ceramics is still far from complete. We are just beginning to define the broad outlines of a picture that is sure to be filled in and modified by future research. Our broad outlines reveal a complex picture of overlapping production zones made even more complex by the apparent frequency of ceramic movement between sites.

The two major production zones documented in the present study are represented by two regional reference groups centered on Chaco Canyon and Black Mesa. The production zone represented by the Chaco reference group is quite broad, encompassing the eastern Chuska Mountains. The Black Mesa reference group represents a production zone in the central part of the mesa in the vicinity of Moenkopi Wash.

A number of smaller groups defined in the analysis represent other production zones both within and outside the three major production areas defined in previous temper-based analyses (table 4.1). The most ambiguous results come from the southern area, where a possible production center in the vicinity of Kin Ya'a was identified. The western production area of the Chuska Mountains included not only the

broad zone encompassed by the Chaco reference group but also a localized production center at the eastern Chuskan site of Tocito. The northern production area included localized production centers at Chimney Rock and in the vicinity of the eastern San Juan River.

Outside the three major production areas defined by temper-based analyses, another production center was identified at the site of Guadalupe, located at the southeastern edge of the Chacoan regional system. Outside the Chacoan regional system, one additional production center was identified in the Klethla Valley of Black Mesa. The discovery of this latter center indicates that Dogoszhi-style pottery was produced at multiple locations on Black Mesa.

Our results reinforce previous conclusions about large quantities of ceramics being imported into Chaco Canyon from multiple sources (table 4.1). As with the results of earlier temper-based analyses, our neutron activation analyses suggest that the canyon's most important ceramic source was the eastern Chuskas. Although our Chaco reference group includes sites in and near Chaco Canyon, we question whether the samples from these sites were in fact produced there. Instead, based on the results of both our own analyses and earlier temper-based studies, we suggest that a large proportion of these samples was made in the eastern Chuskas and then transported to the canyon. Apart from the eastern Chuskas, our analyses identified two other source areas for canyon ceramics, Chimney Rock, located at the northeastern edge of the Chacoan regional system, and Black Mesa, located outside the Chacoan regional system.

One final contribution of the analyses presented here has been to broaden the focus of ceramic exchange to include areas other than Chaco Canyon. For example, our analyses reveal how Dogoszhi-style ceramics made in the eastern Chuskas ended up not just in Chaco Canyon but also at several northern Chacoan sites, including Wallace Ruin, Chimney Rock, Morris 41, Salmon, and Aztec. Similarly, Dogoszhi-style ceramics made at Black Mesa were exported not only to the canyon but also to Allentown, which is located southeast of the mesa at the southwestern edge of the Chacoan regional system.

As with earlier temper-based analyses and INAA, our work suggests potential directions for future research. Both the ungrouped specimens and the fuzzy boundaries of the production zones identified in this study highlight the need to expand the sample of sites for which neutron activation of Dogoszhi-style ceramics has been done. The ungrouped specimens probably include both outliers from the defined reference and local production groups and representatives of other groups that were sampled only lightly in this study.

The fuzzy boundaries of production zones identified in this study could be delimited more clearly with additional INAA of not only Dogoszhi-style ceramics from more sites but also of raw materials from different sources. Such analyses would narrow the geographic extent of some of the hypothesized Dogoszhi production zones. For example, we think that Aztec and Salmon lie outside the zone where Dogoszhi specimens in the Chaco reference group were produced. This interpretation would be strengthened if it could be shown that domestic wares and/or raw materials of the Aztec/Salmon region are compositionally distinct from the Chaco reference group. Another example is that sites in the southern part of the Chacoan regional system are comparatively underrepresented in the present study. The possible existence of a southern compositional profile (the Kin Ya'a group) suggests further sampling of Dogoszhi-style pottery and clays from south of Chaco Canyon is warranted.

We argued above that the Dogoszhi style was associated with the ceremonial, political, economic, and social power of Chacoan society. Because of that association, we felt that answers to questions about where Dogoszhi-style pottery was produced and how widely it was traded could be important for understanding the organization and extent of Chacoan society as well as the nature of its broader influence. Further research is necessary before such an understanding can be achieved. Based on the results presented here, it should be obvious that an informative strategy for achieving this goal is to apply INAA to both more ceramic samples from more sites as well as to clays from a variety of sources.

Acknowledgments. This research was funded in part by a Richard Carley Hunt postdoctoral fellowship awarded to Jill Neitzel by the Wenner-Gren Foundation for Anthropological Research. The assistance of Curtis Schaafsma of the Museum of New Mexico, Jeannie Mobley-Tanaka of the University of Colorado Museum, Penny Whitten of the San Juan County Museum, Bruce Bradley of Crow Canyon Archaeological Center, Frank Eddy of the University of Colorado, and Tony Lutonsky of the Bureau of Land Management in providing Dogoszhi sherds for analysis is gratefully acknowledged. Completion of the analysis at MURR would have been impossible without assistance from Cynthia Hays-Lewis in all phases of the laboratory work. The National Science Foundation funded the analyses through a grant to the MURR archaeometry laboratory (DBS 9342768).

Notes

1. For example, SCMRE-NIST unassigned specimens SWPA07 and SWPB41 along with SCMRE-NIST Allentown specimen SWAT06 show relatively high probabilities of membership in the Black Mesa reference group, but archaeological proveniences outside Black Mesa preclude using them to define reference group characteristics based on the criteria adopted here. Ungrouped SCMRE-NIST specimens SWPB41 would be an even more problematic group member because it shows a high probability of membership in both the Chaco and Black Mesa reference groups. For purposes of interpretation, these specimens suggest that Dogoszhi pottery may have moved from Black Mesa to Allentown or Chaco Canyon. But we prefer to regard this as an inference requiring further testing and not to use these SCMRE-NIST specimens to estimate the parameters of the Black Mesa reference group.

2. Thirty-three elements are determined at MURR, but two elements were excluded from consideration in pattern recognition and statistical analysis. Ni was below detection in too many cases for it to be used. Co was excluded because a substantial proportion of the samples had to be obtained by drilling sherds with a tungsten-carbide burr, and many of the drilled sherds had elevated Co levels that were suggestive of slight contamination.

3. The fact that a few specimens in the Tocito and Kin Ya'a groups show above 1% probability of membership in the Chaco reference group indicates some general regional similarities.

4. Cursory low-power microscopic examination of the pastes of Tocito and Chaco group specimens suggests that there is, indeed, a temper/texture difference.

5. Because it was originally analyzed as part of the SCMRE-NIST data set, the Chacoan great house of Allentown is considered in this section rather than in the previous one on the Chacoan regional system, which presents the results of the MURR analyses only.

Appendix A

Descriptive information and group membership probabilities for Dogoszhi pottery samples and related clays (Probabilities under "Chaco core" and "Black Mesa" are based on the elements Ba, K, Na, La, Lu, Sm, Yb, Ce, Co, Cr, Cs, Eu, Fe, Hf, Rb, Sb, Sc, Ta, Th, and Zn. Probabilities listed under "Ch. Core (MURR)" are based on Al,, Ba, Ca, Dy, K, Mn, Na, Ti, V, As, La Lu, Nd, Sm, U, Yb, Ce, Cr, Cs, Eu, Fe, Hf, Rb, Sb, Sc, Sr, Ta, Tb, Th, Zn, and Zr.)

					Probabilities		
Chemical Group	Anid	Data	Site	Description	Chaco Core	Black Mesa	Ch. Core (MURR)
Chaco Core	JNE003	MURR	Wallace Ruin	Dogozhi Style	3.794	0.000	0.054
Chaco Core	JNE004	MURR	Wallace Ruin	Dogozhi Style	46.450	0.000	22.300
Chaco Core	JNE007	MURR	Wallace Ruin	Dogozhi Style	3.901	0.000	1.448
Chaco Core	JNE011	MURR	Wallace Ruin	Dogozhi Style	77.373	0.000	56.326
Chaco Core	JNE017	MURR	Chimney Rock	Dogozhi Style	81.810	0.000	99.396
Chaco Core	JNE018	MURR	Chimney Rock	Dogozhi Style	96.792	0.000	96.792
Chaco Core	JNE022	MURR	Chimney Rock	Dogozhi Style	98.446	0.000	99.997
Chaco Core	JNE031	MURR	Morris 41	Dogozhi Style	43.553	0.000	87.622
Chaco Core	JNE036	MURR	Morris 41	Dogozhi Style	2.396	0.000	29.421
Chaco Core	JNE037	MURR	Morris 41	Dogozhi Style	6.026	0.000	2.669
Chaco Core	JNE038	MURR	Morris 41	Dogozhi Style	16.612	0.000	12.916
Chaco Core	JNE041	MURR	Morris 41	Dogozhi Style	3.795	0.000	1.892
Chaco Core	JNE043	MURR	Morris 41	Dogozhi Style	4.549	0.000	7.285
Chaco Core	JNE046	MURR	Salmon Ruin	Dogozhi Style	63.370	0.000	82.232
Chaco Core	JNE048	MURR	Salmon Ruin	Dogozhi Style	66.642	0.000	66.343
Chaco Core	JNE049	MURR	Salmon Ruin	Dogozhi Style	5.612	0.000	0.049
Chaco Core	JNE052	MURR	Salmon Ruin	Dogozhi Style	92.461	0.000	96.454
Chaco Core	JNE055	MURR	Salmon Ruin	Dogozhi Style	3.070	0.000	21.658
Chaco Core	JNE058	MURR	Salmon Ruin	Dogozhi Style	59.625	0.000	46.418
Chaco Core	JNE061	MURR	Four Clowns	Dogozhi Style	13.087	0.000	8.514
Chaco Core	JNE062	MURR	Four Clowns	Dogozhi Style	76.735	0.000	79.286
Chaco Core	JNE063	MURR	Four Clowns	Dogozhi Style	89.610	0.000	60.852
Chaco Core	JNE064	MURR	Four Clowns	Dogozhi Style	97.507	0.000	98.869
Chaco Core	JNE065	MURR	Four Clowns	Dogozhi Style	16.072	0.000	43.620
Chaco Core	JNE068	MURR	Four Clowns	Dogozhi Style	51.335	0.000	67.406
Chaco Core	JNE069	MURR	Four Clowns	Dogozhi Style	23.011	0.000	28.924
Chaco Core	JNE070	MURR	Four Clowns	Dogozhi Style	77.981	0.000	84.307
Chaco Core	JNE072	MURR	Four Clowns	Dogozhi Style	90.875	0.000	99.683
Chaco Core	JNE073	MURR	Four Clowns	Dogozhi Style	37.387	0.000	23.517
Chaco Core	JNE074	MURR	Four Clowns	Dogozhi Style	17.290	0.000	24.768
Chaco Core	JNE092	MURR	Indian Creek	Dogozhi Style	83.938	0.000	92.715

continued

Chemical Group	Anid	Data	Site	Description	Chaco Core	Black Mesa	Ch. Core (MURR)
						Probabilities	
Chaco Core	JNE094	MURR	Indian Creek	Dogozhi Style	95.413	0.000	12.757
Chaco Core	JNE095	MURR	Indian Creek	Dogozhi Style	97.287	0.000	95.098
Chaco Core	JNE096	MURR	Indian Creek	Dogozhi Style	83.707	0.000	39.502
Chaco Core	JNE098	MURR	Indian Creek	Dogozhi Style	99.356	0.000	98.279
Chaco Core	JNE099	MURR	Indian Creek	Dogozhi Style	99.952	0.000	95.316
Chaco Core	JNE100	MURR	Indian Creek	Dogozhi Style	14.148	0.000	2.438
Chaco Core	JNE101	MURR	Indian Creek	Dogozhi Style	3.843	0.002	14.023
Chaco Core	JNE102	MURR	Indian Creek	Dogozhi Style	30.353	0.000	33.377
Chaco Core	JNE103	MURR	Indian Creek	Dogozhi Style	1.656	0.000	4.670
Chaco Core	JNE108	MURR	Aztec West	Dogozhi Style	96.404	0.000	99.810
Chaco Core	JNE109	MURR	Aztec West	Dogozhi Style	22.236	0.126	14.661
Chaco Core	JNE111	MURR	Aztec West	Dogozhi Style	97.230	0.000	99.574
Chaco Core	JNE113	MURR	Aztec West	Dogozhi Style	2.409	0.000	0.134
Chaco Core	JNE114	MURR	Aztec West	Dogozhi Style	26.142	0.003	1.457
Chaco Core	JNE115	MURR	Aztec West	Dogozhi Style	34.370	0.004	5.589
Chaco Core	JNE116	MURR	Aztec West	Dogozhi Style	20.500	0.326	10.928
Chaco Core	JNE120	MURR	Aztec West	Dogozhi Style	39.379	0.000	77.348
Chaco Core	JNE121	MURR	Pueblo Pintado	Dogozhi Style	44.675	0.000	64.469
Chaco Core	JNE123	MURR	Pueblo Pintado	Dogozhi Style	16.123	0.269	13.847
Chaco Core	JNE127	MURR	Pueblo Pintado	Dogozhi Style	87.025	0.000	93.865
Chaco Core	JNE128	MURR	Pueblo Pintado	Dogozhi Style	77.417	0.016	78.446
Chaco Core	JNE131	MURR	Pueblo Pintado	Dogozhi Style	88.546	0.000	23.451
Chaco Core	JNE132	MURR	Pueblo Pintado	Dogozhi Style	93.156	0.000	94.797
Chaco Core	JNE136	MURR	Kin Ya'a	Dogozhi Style	30.942	0.004	4.306
Chaco Core	JNE139	MURR	Kin Ya'a	Dogozhi Style	32.062	0.000	22.040
Chaco Core	JNE142	MURR	Kin Ya'a	Dogozhi Style	14.862	0.034	38.387
Chaco Core	JNE144	MURR	Skunk Springs	Dogozhi Style	72.891	0.000	95.141
Chaco Core	JNE146	MURR	Skunk Springs	Dogozhi Style	98.512	0.000	97.102
Chaco Core	JNE147	MURR	Skunk Springs	Dogozhi Style	27.926	0.000	3.252
Chaco Core	JNE148	MURR	Skunk Springs	Dogozhi Style	99.344	0.000	99.761
Chaco Core	JNE149	MURR	Skunk Springs	Dogozhi Style	99.390	0.000	97.638
Chaco Core	JNE150	MURR	Skunk Springs	Dogozhi Style	47.485	0.000	58.083
Chaco Core	JNE151	MURR	Skunk Springs	Dogozhi Style	21.647	0.000	7.366
Chaco Core	JNE152	MURR	Skunk Springs	Dogozhi Style	82.237	0.000	96.579
Chaco Core	JNE154	MURR	Skunk Springs	Dogozhi Style	64.096	0.000	44.345
Chaco Core	JNE155	MURR	Skunk Springs	Dogozhi Style	38.870	0.000	64.525
Chaco Core	JNE156	MURR	Skunk Springs	Dogozhi Style	5.309	0.000	26.102
Chaco Core	JNE157	MURR	Skunk Springs	Dogozhi Style	72.716	0.000	79.985
Chaco Core	JNE158	MURR	Skunk Springs	Dogozhi Style	95.488	0.000	99.213
Chaco Core	JNE160	MURR	Tocito	Dogozhi Style	97.453	0.000	96.903
Chaco Core	JNE162	MURR	Tocito	Dogozhi Style	95.718	0.000	66.398
Chaco Core	JNE173	MURR	Tocito	Dogozhi Style	31.371	0.000	41.447
Chaco Core	JNE174	MURR	Peach Springs	Dogozhi Style	37.287	0.000	29.682
Chaco Core	JNE176	MURR	Peach Springs	Dogozhi Style	88.190	0.000	68.088
Chaco Core	JNE177	MURR	Peach Springs	Dogozhi Style	8.688	0.000	8.953
Chaco Core	JNE178	MURR	Peach Springs	Dogozhi Style	2.862	0.000	2.245
Chaco Core	JNE181	MURR	Peach Springs	Dogozhi Style	55.780	0.000	77.759
Chaco Core	JNE183	MURR	Peach Springs	Dogozhi Style	17.261	0.362	16.717
Chaco Core	JNE184	MURR	Peach Springs	Dogozhi Style	11.795	0.001	31.556
Chaco Core	JNE187	MURR	Peach Springs	Dogozhi Style	3.118	0.209	32.007
Chaco Core	JNE188	MURR	Peach Springs	Dogozhi Style	8.230	0.000	22.364

continued

Chemical Gr.	Anid	Data	Site	Descrip.	Probabilities Chaco Core	Black Mesa	Ch. Core (MURR)
Chaco Core	SWPA01	NIST->MURR	Pueblo del Arroyo	Cylinder	90.204	2.068	-
Chaco Core	SWPA03	NIST->MURR	Pueblo del Arroyo	Bowl	84.068	6.236	-
Chaco Core	SWPA05	NIST->MURR	Pueblo del Arroyo	Bowl	39.225	0.000	-
Chaco Core	SWPA06	NIST->MURR	Pueblo del Arroyo	Bowl	98.650	28.707	-
Chaco Core	SWPB05	NIST->MURR	Pueblo Bonito	Cylinder	62.144	0.325	-
Chaco Core	SWPB06	NIST->MURR	Pueblo Bonito	Cylinder	46.446	0.000	-
Chaco Core	SWPB07	NIST->MURR	Pueblo Bonito	Cylinder	27.036	5.690	-
Chaco Core	SWPB08	NIST->MURR	Pueblo Bonito	Cylinder	5.731	0.000	-
Chaco Core	SWPB10	NIST->MURR	Pueblo Bonito	Cylinder	63.100	0.001	-
Chaco Core	SWPB11	NIST->MURR	Pueblo Bonito	Cylinder	40.939	0.004	-
Chaco Core	SWPB13	NIST->MURR	Pueblo Bonito	Dogozhi Style	38.957	1.034	-
Chaco Core	SWPB14	NIST->MURR	Pueblo Bonito	Bowl	16.609	8.808	-
Chaco Core	SWPB19	NIST->MURR	Pueblo Bonito	Bowl	19.298	0.757	-
Chaco Core	SWPB20	NIST->MURR	Pueblo Bonito	Bowl	2.925	0.226	-
Chaco Core	SWPB21	NIST->MURR	Pueblo Bonito	Bowl	96.716	0.438	-
Chaco Core	SWPB22	NIST->MURR	Pueblo Bonito	Bowl	87.515	12.006	-
Chaco Core	SWPB23	NIST->MURR	Pueblo Bonito	Bowl	47.214	0.028	-
Chaco Core	SWPB25	NIST->MURR	Pueblo Bonito	Bowl	35.542	0.003	-
Chaco Core	SWPB26	NIST->MURR	Pueblo Bonito	Bowl	96.737	9.845	-
Chaco Core	SWPB28	NIST->MURR	Pueblo Bonito	Bowl	6.792	0.004	-
Chaco Core	SWPB29	NIST->MURR	Pueblo Bonito	Bowl	27.850	1.826	-
Chaco Core	SWPB33	NIST->MURR	Pueblo Bonito	Bowl	89.912	1.022	-
Chaco Core	SWPB34	NIST->MURR	Pueblo Bonito	Bowl	68.802	0.001	-
Chaco Core	SWPB35	NIST->MURR	Pueblo Bonito	Bowl	45.563	0.187	-
Chaco Core	SWPB36	NIST->MURR	Pueblo Bonito	Bowl	2.447	1.195	-
Chaco Core	SWPB37	NIST->MURR	Pueblo Bonito	Bowl	76.397	0.173	-
Chaco Core	SWPB39	NIST->MURR	Pueblo Bonito	Bowl	62.914	0.449	-
Chaco Core	SWPB40	NIST->MURR	Pueblo Bonito	Bowl	74.646	35.922	-
Chaco Core	SWPB43	NIST->MURR	Pueblo Bonito	Bowl	20.302	0.000	-
Black Mesa	HD2416	BNL OXIDE->NIST->MURR	AZ C:8:23, AZ NA 11024	Dogozhi Bowl	0.000	45.566	-
Black Mesa	HD2418	BNL OXIDE->NIST->MURR	AZ C:8:23, NA 11024	Dogozhi Jar	0.000	28.028	-
Black Mesa	HD2511	BNL OXIDE->NIST->MURR	NA11,125	Dogozhi Jar	0.000	13.148	-
Black Mesa	HD2514	BNL OXIDE->NIST->MURR	NA11,125	Dogozhi Bowl	0.000	29.121	-
Black Mesa	HD2517	BNL OXIDE->NIST->MURR	NA11,125	Dogozhi Bowl	0.000	91.182	-
Black Mesa	HD5706	BNL OXIDE->NIST->MURR	AZ D:9:7, AZ NA 11057	Dogozhi Jar	0.000	56.435	-
Black Mesa	HD5711	BNL OXIDE->NIST->MURR	5708	Dogozhi Jar	0.001	76.590	-
Black Mesa	HDB113	BNL OXIDE->NIST->MURR	D:11:348	Dogozhi Jar	0.000	30.471	-
Black Mesa	HDB120	BNL OXIDE->NIST->MURR	D:11:348	Dogozhi Jar	0.000	13.690	-
Black Mesa	HDBM06	BNL OXIDE->NIST->MURR	D:7:19	Dogozhi Jar	0.002	47.659	-
Black Mesa	HDBM19	BNL OXIDE->NIST->MURR	D:7:19	Dogozhi Jar	0.000	67.874	-
Black Mesa	HDBM28	BNL OXIDE->NIST->MURR	D:7:19	Dogozhi Jar	0.000	67.075	-
Black Mesa	HDBM31	BNL OXIDE->NIST->MURR	D:11:275	Dogozhi Jar	0.000	18.870	-
Black Mesa	HDBM32	BNL OXIDE->NIST->MURR	D:11:275	Dogozhi Jar	0.000	14.852	-
Black Mesa	HDBM34	BNL OXIDE->NIST->MURR	D:11:275	Dogozhi Jar	0.000	37.264	-
Black Mesa	HDBM35	BNL OXIDE->NIST->MURR	D:11:275	Dogozhi Jar	0.000	35.478	-
Black Mesa	HDBM52	BNL OXIDE->NIST->MURR	D:11:275	Dogozhi Jar	0.000	58.229	-
Black Mesa	HDBM53	BNL OXIDE->NIST->MURR	D:11:275	Dogozhi Jar	0.000	56.669	-
Black Mesa	HDBM54	BNL OXIDE->NIST->MURR	D:11:275	Dogozhi Bowl	0.045	56.595	-
Black Mesa	HDBM55	BNL OXIDE->NIST->MURR	D:11:275	Dogozhi Jar	0.000	46.991	-
Black Mesa	HDBM56	BNL OXIDE->NIST->MURR	D:11:275	Dogozhi Bowl	0.000	90.046	-
Black Mesa	HDBM60	BNL OXIDE->NIST->MURR	D:11:275	Dogozhi Jar	0.000	26.165	-
Black Mesa	HDBM62	BNL OXIDE->NIST->MURR	D:11:290	Dogozhi Jar	0.000	41.403	-
Black Mesa	HDBM64	BNL OXIDE->NIST->MURR	D:11:290	Dogozhi Jar	0.000	87.104	-
Black Mesa	HDBM65	BNL OXIDE->NIST->MURR	D:11:290	Dogozhi Bowl	0.000	83.756	-
Black Mesa	HDBM68	BNL OXIDE->NIST->MURR	D:11:290	Dogozhi Jar	0.000	47.363	-
Black Mesa	HDBM70	BNL OXIDE->NIST->MURR	D:11:290	Dogozhi Bowl	0.000	95.594	-
Black Mesa	HDBM82	BNL OXIDE->NIST->MURR	D:11:290	Dogozhi Jar	0.000	76.320	-
Black Mesa	HDBM83	BNL OXIDE->NIST->MURR	D:11:290	Dogozhi Jar	0.000	72.630	-
Black Mesa	HDBM84	BNL OXIDE->NIST->MURR	D:11:290	Dogozhi Jar	0.000	49.659	-
Black Mesa	HDBM86	BNL OXIDE->NIST->MURR	D:11:290	Dogozhi Jar	0.000	47.868	-

continued

Chemical Gr.	Anid	Data	Site	Descrip.	Probabilities Chaco Core	Black Mesa	Ch. Core (MURR)
Black Mesa	HDBM87	BNL OXIDE->NIST->MURR	D:11:290	Dogozhi Jar	0.000	27.358	-
Black Mesa	HDBM89	BNL OXIDE->NIST->MURR	D:11:290	Dogozhi Bowl	0.000	52.169	-
Black Mesa	HDBM90	BNL OXIDE->NIST->MURR	D:11:290	Dogozhi Jar	0.000	21.928	-
Black Mesa	HDBM94	BNL OXIDE->NIST->MURR	AZ D:11:280	Dogozhi Jar	0.000	62.053	-
Black Mesa	HDBM95	BNL OXIDE->NIST->MURR	AZ D:11:280	Dogozhi Jar	0.000	31.884	-
Black Mesa	HDBM99	BNL OXIDE->NIST->MURR	AZ D:11:280	Dogozhi Jar	0.000	66.046	-
Black Mesa	HDCS19	BNL OXIDE->NIST->MURR	AZ D:10:5, AZ NA 8163	Dogozhi Bowl	0.000	48.673	-
Black Mesa	HDCS21	BNL OXIDE->NIST->MURR	AZ D:10:5, AZ NA 8163	Dogozhi Jar	0.000	14.392	-
Tocito	JNE026	MURR	Chimney Rock	Dogozhi Style	0.000	0.000	0.001
Tocito	JNE059	MURR	Salmon Ruin	Dogozhi Style	0.001	0.000	0.000
Tocito	JNE060	MURR	Salmon Ruin	Dogozhi Style	1.220	0.000	0.183
Tocito	JNE067	MURR	Four Clowns	Dogozhi Style	0.000	0.000	0.000
Tocito	JNE159	MURR	Tocito	Dogozhi Style	0.007	0.000	0.002
Tocito	JNE161	MURR	Tocito	Dogozhi Style	0.001	0.000	0.123
Tocito	JNE163	MURR	Tocito	Dogozhi Style	0.000	0.000	0.000
Tocito	JNE164	MURR	Tocito	Dogozhi Style	0.132	0.000	0.718
Tocito	JNE165	MURR	Tocito	Dogozhi Style	0.000	0.000	0.015
Tocito	JNE166	MURR	Tocito	Dogozhi Style	0.159	0.000	0.548
Tocito	JNE167	MURR	Tocito	Dogozhi Style	0.013	0.000	0.021
Tocito	JNE168	MURR	Tocito	Dogozhi Style	0.458	0.000	1.151
Tocito	JNE169	MURR	Tocito	Dogozhi Style	0.000	0.000	0.000
Tocito	JNE170	MURR	Tocito	Dogozhi Style	0.000	0.000	0.000
Tocito	JNE171	MURR	Tocito	Dogozhi Style	0.393	0.000	6.526
Tocito	JNE172	MURR	Tocito	Dogozhi Style	0.000	0.000	0.000
Chimney Rock	JNE008	MURR	Wallace Ruin	Dogozhi Style	0.000	0.000	0.010
Chimney Rock	JNE016	MURR	Chimney Rock	Dogozhi Style	0.000	0.000	0.000
Chimney Rock	JNE019	MURR	Chimney Rock	Dogozhi Style	0.000	0.001	0.000
Chimney Rock	JNE027	MURR	Chimney Rock	Dogozhi Style	0.000	0.000	0.000
Chimney Rock	JNE028	MURR	Chimney Rock	Dogozhi Style	0.000	0.000	0.000
Chimney Rock	JNE030	MURR	Chimney Rock	Dogozhi Style	0.000	0.000	0.000
Chimney Rock	JNE033	MURR	Morris 41	Dogozhi Style	0.000	0.000	0.000
Chimney Rock	JNE039	MURR	Morris 41	Dogozhi Style	0.000	0.000	0.149
Chimney Rock	JNE050	MURR	Salmon Ruin	Dogozhi Style	0.000	0.005	0.001
Chimney Rock	JNE051	MURR	Salmon Ruin	Dogozhi Style	0.000	0.032	0.000
Chimney Rock	JNE053	MURR	Salmon Ruin	Dogozhi Style	0.000	0.001	0.000
Chimney Rock	JNE075	MURR	Four Clowns	Dogozhi Style	0.000	0.000	0.000
Chimney Rock	JNE106	MURR	Aztec West	Dogozhi Style	0.227	0.053	0.002
Chimney Rock	JNE110	MURR	Aztec West	Dogozhi Style	0.000	0.000	0.000
Chimney Rock	JNE122	MURR	Pueblo Pintado	Dogozhi Style	0.000	0.190	0.003
Chimney Rock	JNE124	MURR	Pueblo Pintado	Dogozhi Style	0.001	0.498	0.263
Chimney Rock	JNE145	MURR	Skunk Springs	Dogozhi Style	0.002	0.000	0.004
Chimney Rock	JNE175	MURR	Peach Springs	Dogozhi Style	0.000	0.000	0.000
Chimney Rock	JNE185	MURR	Peach Springs	Dogozhi Style	0.000	0.000	0.000
Chimney Rock	JNE186	MURR	Peach Springs	Dogozhi Style	0.002	0.008	0.005
Chimney Rock A	JNE020	MURR	Chimney Rock	Dogozhi Style	0.000	0.000	0.000
Chimney Rock A	JNE021	MURR	Chimney Rock	Dogozhi Style	0.000	0.000	0.000
Chimney Rock A	JNE023	MURR	Chimney Rock	Dogozhi Style	0.000	0.000	0.000
Chimney Rock A	JNE024	MURR	Chimney Rock	Dogozhi Style	0.000	0.000	0.000
Chimney Rock A	JNE025	MURR	Chimney Rock	Dogozhi Style	0.000	0.000	0.000
Chimney Rock A	JNE029	MURR	Chimney Rock	Dogozhi Style	0.000	0.000	0.000
Guadalupe	JNE076	MURR	Guadalupe	Dogozhi Style	0.000	0.000	0.000
Guadalupe	JNE077	MURR	Guadalupe	Dogozhi Style	0.040	0.046	0.006
Guadalupe	JNE078	MURR	Guadalupe	Dogozhi Style	0.000	0.000	0.001
Guadalupe	JNE079	MURR	Guadalupe	Dogozhi Style	0.000	0.000	0.000
Guadalupe	JNE082	MURR	Guadalupe	Dogozhi Style	0.000	0.001	0.000
Guadalupe	JNE083	MURR	Guadalupe	Dogozhi Style	0.005	0.000	0.016

continued

Chemical Gr.	Anid	Data	Site	Descrip.	Chaco Core	Black Mesa	Ch. Core (MURR)
						Probabilities	
Guadalupe	JNE084	MURR	Guadalupe	Dogozhi Style	0.000	0.000	0.001
Guadalupe	JNE085	MURR	Guadalupe	Dogozhi Style	0.000	0.004	0.000
Guadalupe	JNE087	MURR	Guadalupe	Dogozhi Style	0.000	0.000	0.000
Guadalupe	JNE088	MURR	Guadalupe	Dogozhi Style	0.000	0.000	0.000
Guadalupe	JNE089	MURR	Guadalupe	Dogozhi Style	0.000	0.000	0.000
Guadalupe	JNE090	MURR	Guadalupe	Dogozhi Style	0.010	0.000	0.001
							-
Kin Ya'a	JNE066	MURR	Four Clowns	Dogozhi Style	0.008	0.000	0.122
Kin Ya'a	JNE093	MURR	Indian Creek	Dogozhi Style	0.642	0.000	0.698
Kin Ya'a	JNE097	MURR	Indian Creek	Dogozhi Style	0.001	0.000	0.141
Kin Ya'a	JNE125	MURR	Pueblo Pintado	Dogozhi Style	2.875	0.000	0.594
Kin Ya'a	JNE129	MURR	Pueblo Pintado	Dogozhi Style	0.111	0.000	5.907
Kin Ya'a	JNE130	MURR	Pueblo Pintado	Dogozhi Style	0.559	0.000	0.839
Kin Ya'a	JNE134	MURR	Pueblo Pintado	Dogozhi Style	0.000	0.000	0.000
Kin Ya'a	JNE137	MURR	Kin Ya'a	Dogozhi Style	0.009	0.000	0.000
Kin Ya'a	JNE138	MURR	Kin Ya'a	Dogozhi Style	0.001	0.000	0.001
Kin Ya'a	JNE140	MURR	Kin Ya'a	Dogozhi Style	0.011	0.023	0.051
Kin Ya'a	JNE141	MURR	Kin Ya'a	Dogozhi Style	0.440	0.000	0.009
Kin Ya'a	JNE143	MURR	Kin Ya'a	Dogozhi Style	0.000	0.024	0.000
							-
Allentown Misc.	SWAT01	NIST->MURR	Allentown	Dogozhi Bowl	0.000	0.112	-
Allentown Misc.	SWAT02	NIST->MURR	Allentown	Dogozhi Bowl	0.000	0.008	-
Allentown Misc.	SWAT03	NIST->MURR	Allentown	Dogozhi Bowl	0.000	0.000	-
Allentown Misc	SWAT04	NIST->MURR	Allentown	Dogozhi Bowl	0.000	1.554	-
Allentown Misc	SWAT05	NIST->MURR	Allentown	Dogozhi Bowl	0.000	0.005	-
Allentown Misc	SWAT06	NIST->MURR	Allentown	Dogozhi Bowl	0.000	22.072	-
Allentown Misc	SWAT07	NIST->MURR	Allentown	Dogozhi Bowl	0.000	0.000	-
Allentown Misc	SWAT08	NIST->MURR	Allentown	Dogozhi Bowl	0.000	0.016	-
Allentown Misc	SWAT09	NIST->MURR	Allentown	Dogozhi Bowl	0.000	0.000	-
Allentown Misc	SWAT10	NIST->MURR	Allentown	Dogozhi Bowl	0.000	0.001	-
							-
Klethla Valley (BNL)	HD2411	BNL OXIDE->NIST->MURR	AZ C:8:23, AZ NA 11024	Dogozhi Jar	0.000	0.745	-
Klethla Valley (BNL)	HD2503	BNL OXIDE->NIST->MURR	NA11,125	Dogozhi Jar	0.000	0.000	-
Klethla Valley (BNL)	HD2504	BNL OXIDE->NIST->MURR	NA11,125	Dogozhi Jar	0.000	0.000	-
Klethla Valley (BNL)	HD2506	BNL OXIDE->NIST->MURR	NA11,125	Dogozhi Bowl	0.000	1.504	-
Klethla Valley (BNL)	HD2507	BNL OXIDE->NIST->MURR	NA11,125	Dogozhi Jar	0.000	0.000	-
Klethla Valley (BNL)	HD2508	BNL OXIDE->NIST->MURR	NA11,125	Dogozhi Bowl	0.000	0.001	-
Klethla Valley (BNL)	HD2510	BNL OXIDE->NIST->MURR	NA11,125	Dogozhi Jar	0.000	0.000	-
Klethla Valley (BNL)	HD2512	BNL OXIDE->NIST->MURR	NA11,125	Dogozhi Bowl	0.000	0.001	-
Klethla Valley (BNL)	HD5710	BNL OXIDE->NIST->MURR	5708	Dogozhi Jar	0.000	0.001	-
Klethla Valley (BNL)	HD5712	BNL OXIDE->NIST->MURR	5708	Dogozhi Jar	0.000	0.040	-
Klethla Valley (BNL)	HD5713	BNL OXIDE->NIST->MURR	5708	Dogozhi Bowl	0.000	8.807	-
Klethla Valley (BNL)	HD5714	BNL OXIDE->NIST->MURR	5708	Dogozhi Jar	0.000	0.000	-
							-
Black Mesa Clays	HDCF37	BNL OXIDE->NIST->MURR	First Mesa, Below	Fired Briquette	0.000	0.011	-
Black Mesa Clays	HDCF39	BNL OXIDE->NIST->MURR	First Mesa, Below	Fired Briquette	0.000	0.019	-
Black Mesa Clays	HDCL38	BNL OXIDE->NIST->MURR	First Mesa, Below	Levigated Briq.	0.000	0.024	-
Black Mesa Clays	HDCL48	BNL OXIDE->NIST->MURR	First Mesa, Below	Levigated Briq.	0.000	0.015	-
Black Mesa Clays	HDCL84	BNL OXIDE->NIST->MURR	AZ D:11:11	Levigated Clay	0.000	0.368	-
Black Mesa Clays	HDCL88	BNL OXIDE->NIST->MURR	AZ D:11:275	Levigated	0.000	0.153	-
							-
MURR Ungrouped	JNE001	MURR	Wallace Ruin	Dolgozhi Style	0.003	0.000	0.010
MURR Ungrouped	JNE002	MURR	Wallace Ruin	Dolgozhi Style	0.000	0.000	0.002
MURR Ungrouped	JNE005	MURR	Wallace Ruin	Dolgozhi Style	0.000	0.000	0.000
MURR Ungrouped	JNE006	MURR	Wallace Ruin	Dolgozhi Style	0.002	0.000	0.014
MURR Ungrouped	JNE009	MURR	Wallace Ruin	Dolgozhi Style	0.008	0.000	0.045
MURR Ungrouped	JNE010	MURR	Wallace Ruin	Dolgozhi Style	0.453	0.000	4.776
MURR Ungrouped	JNE012	MURR	Wallace Ruin	Dolgozhi Style	0.000	0.000	0.000
MURR Ungrouped	JNE013	MURR	Wallace Ruin	Dolgozhi Style	0.000	0.000	0.000
MURR Ungrouped	JNE014	MURR	Wallace Ruin	Dolgozhi Style	0.000	0.000	0.000
MURR Ungrouped	JNE015	MURR	Wallace Ruin	Dolgozhi Style	0.010	0.000	0.754

continued

Chemical Gr.	Anid	Data	Site	Descrip.	Probabilities Chaco Core	Black Mesa	Ch. Core (MURR)
MURR Ungrouped	JNE032	MURR	Morris 41	Dolgozhi Style	0.037	0.000	0.007
MURR Ungrouped	JNE034	MURR	Morris 41	Dolgozhi Style	0.080	0.000	10.607
MURR Ungrouped	JNE035	MURR	Morris 41	Dolgozhi Style	0.000	0.000	0.000
MURR Ungrouped	JNE040	MURR	Morris 41	Dolgozhi Style	0.000	0.000	0.004
MURR Ungrouped	JNE042	MURR	Morris 41	Dolgozhi Style	0.971	0.000	4.443
MURR Ungrouped	JNE044	MURR	Morris 41	Dolgozhi Style	0.274	0.000	12.552
MURR Ungrouped	JNE045	MURR	Morris 41	Dolgozhi Style	0.094	0.000	0.013
MURR Ungrouped	JNE047	MURR	Salmon Ruin	Dolgozhi Style	0.023	0.000	0.566
MURR Ungrouped	JNE054	MURR	Salmon Ruin	Dolgozhi Style	0.059	0.000	1.081
MURR Ungrouped	JNE056	MURR	Salmon Ruin	Dolgozhi Style	0.001	0.000	0.001
MURR Ungrouped	JNE057	MURR	Salmon Ruin	Dolgozhi Style	0.142	0.000	13.122
MURR Ungrouped	JNE071	MURR	Four Clowns	Dolgozhi Style	0.886	0.000	19.026
MURR Ungrouped	JNE080	MURR	Guadalupe	Dolgozhi Style	0.000	0.131	0.000
MURR Ungrouped	JNE081	MURR	Guadalupe	Dolgozhi Style	0.000	0.747	0.000
MURR Ungrouped	JNE086	MURR	Guadalupe	Dolgozhi Style	0.006	0.000	0.337
MURR Ungrouped	JNE091	MURR	Indian Creek	Dolgozhi Style	0.010	0.055	0.241
MURR Ungrouped	JNE104	MURR	Indian Creek	Dolgozhi Style	0.000	0.009	0.012
MURR Ungrouped	JNE105	MURR	Indian Creek	Dolgozhi Style	0.000	0.000	0.000
MURR Ungrouped	JNE107	MURR	Aztec West	Dolgozhi Style	0.000	0.000	0.000
MURR Ungrouped	JNE112	MURR	Aztec West	Dolgozhi Style	0.003	0.000	0.087
MURR Ungrouped	JNE117	MURR	Aztec West	Dolgozhi Style	0.002	0.104	0.059
MURR Ungrouped	JNE118	MURR	Aztec West	Dolgozhi Style	0.019	1.308	0.097
MURR Ungrouped	JNE119	MURR	Aztec West	Dolgozhi Style	0.000	0.000	0.000
MURR Ungrouped	JNE126	MURR	Pueblo Pintado	Dolgozhi Style	0.011	0.015	0.004
MURR Ungrouped	JNE133	MURR	Aztec West	Dolgozhi Style	0.000	6.552	0.238
MURR Ungrouped	JNE135	MURR	Aztec West	Dolgozhi Style	0.000	0.000	0.000
MURR Ungrouped	JNE153	MURR	Skunk Springs	Dolgozhi Style	0.085	0.000	1.527
MURR Ungrouped	JNE179	MURR	Peach Springs	Dolgozhi Style	0.000	0.000	0.000
MURR Ungrouped	JNE180	MURR	Peach Springs	Dolgozhi Style	0.005	0.001	0.000
MURR Ungrouped	JNE182	MURR	Peach Springs	Dolgozhi Style	0.000	0.000	0.054
							-
NIST Ungrouped	SWPA02	NIST->MURR	Pueblo del Arroyo	Dogozhi Bowl	0.460	6.133	-
NIST Ungrouped	SWPA04	NIST->MURR	Pueblo del Arroyo	Dogozhi Bowl	0.158	0.072	-
NIST Ungrouped	SWPA07	NIST->MURR	Pueblo del Arroyo	Dogozhi Bowl	0.119	10.504	-
NIST Ungrouped	SWPB01	NIST->MURR	Pueblo Bonito	Dogozhi Cylinder	0.803	0.000	-
NIST Ungrouped	SWPB02	NIST->MURR	Pueblo Bonito	Dogozhi Cylinder	0.000	0.000	-
NIST Ungrouped	SWPB03	NIST->MURR	Pueblo Bonito	Dogozhi Cylinder	0.000	0.000	-
NIST Ungrouped	SWPB04	NIST->MURR	Pueblo Bonito	Dogozhi Cylinder	0.000	0.042	-
NIST Ungrouped	SWPB09	NIST->MURR	Pueblo Bonito	Dogozhi Cylinder	0.000	0.001	-
NIST Ungrouped	SWPB12	NIST->MURR	Pueblo Bonito	Dogozhi Bowl	0.000	0.000	-
NIST Ungrouped	SWPB15	NIST->MURR	Pueblo Bonito	Dogozhi Bowl	0.051	0.143	-
NIST Ungrouped	SWPB16	NIST->MURR	Pueblo Bonito	Dogozhi Bowl	0.000	0.000	-
NIST Ungrouped	SWPB17	NIST->MURR	Pueblo Bonito	Dogozhi Bowl	0.000	0.000	-
NIST Ungrouped	SWPB18	NIST->MURR	Pueblo Bonito	Dogozhi Bowl	3.456	48.220	-
NIST Ungrouped	SWPB24	NIST->MURR	Pueblo Bonito	Dogozhi Bowl	0.920	0.007	-
NIST Ungrouped	SWPB27	NIST->MURR	Pueblo Bonito	Dogozhi Bowl	0.000	0.001	-
NIST Ungrouped	SWPB30	NIST->MURR	Pueblo Bonito	Dogozhi Bowl	0.000	0.001	-
NIST Ungrouped	SWPB31	NIST->MURR	Pueblo Bonito	Dogozhi Bowl	0.000	9.713	-
NIST Ungrouped	SWPB38	NIST->MURR	Pueblo Bonito	Dogozhi Bowl	0.000	0.029	-
NIST Ungrouped	SWPB41	NISI->MURR	Pueblo Bonito	Dogozhi Bowl	61.256	80.139	-
NIST Ungrouped	SWPB42	NIST->MURR	Pueblo Bonito	Dogozhi Bowl	0.000	0.000	-
							-
BNL Ungrouped	HD2404	BNL OXIDE->NIST->MURR	AZ C:8:23, AZ NA 11024	Dogozhi Jar	0.000	0.000	-
BNL Ungrouped	HD2410	BNL OXIDE->NIST->MURR	AZ C:8:23, AZ NA 11024	Dogozhi Jar	0.000	0.000	-
BNL Ungrouped	HD2419	BNL OXIDE->NIST->MURR	AZ C:8:23, NA 11024	Dogozhi Bowl	0.000	0.001	-
BNL Ungrouped	HD2505	BNL OXIDE->NIST->MURR	NA11,125	Dogozhi Bowl	0.000	0.235	-
BNL Ungrouped	HD2513	BNL OXIDE->NIST->MURR	NA11,125	Dogozhi Bowl	0.000	0.094	-
BNL Ungrouped	HD2515	BNL OXIDE->NIST->MURR	NA11,125	Dogozhi Jar	0.000	0.000	-
BNL Ungrouped	HD5703	BNL OXIDE->NIST->MURR	AZ D:9:7, AZ NA 11057	Dogozhi Jar	0.009	0.000	-
BNL Ungrouped	HD5705	BNL OXIDE->NIST->MURR	AZ D:9:7, AZ NA 11057	Dogozhi Jar	0.000	0.000	-

continued

Chemical Gr.	Anid	Data	Site	Descrip.	Probabilities Chaco Core	Black Mesa	Ch. Core (MURR)
BNL Ungrouped	HD5707	BNL OXIDE->NIST->MURR	AZ D:9:7, AZ NA 11057	Dogozhi Jar	0.000	0.001	-
BNL Ungrouped	HD5708	BNL OXIDE->NIST->MURR	AZ D:9:7, AZ NA 11057	Dogozhi Bowl	0.000	1.679	-
BNL Ungrouped	HD5709	BNL OXIDE->NIST->MURR	5708	Dogozhi Jar	0.000	0.002	-
BNL Ungrouped	HDB116	BNL OXIDE->NIST->MURR	D:11:348	Dogozhi Bowl	0.024	0.178	-
BNL Ungrouped	HDBM17	BNL OXIDE->NIST->MURR	D:7:19	Dogozhi Jar	0.000	0.001	-
BNL Ungrouped	HDBM18	BNL OXIDE->NIST->MURR	D:7:19	Dogozhi Jar	0.000	2.711	-
BNL Ungrouped	HDBM20	BNL OXIDE->NIST->MURR	D:7:19	Dogozhi Jar	0.000	0.001	-
BNL Ungrouped	HDBM21	BNL OXIDE->NIST->MURR	D:7:19	Dogozhi Jar	0.000	1.172	-
BNL Ungrouped	HDBM30	BNL OXIDE->NIST->MURR	D:7:19	Dogozhi Jar	0.000	0.629	-
BNL Ungrouped	HDBM33	BNL OXIDE->NIST->MURR	D:11:275	Dogozhi Jar	0.000	0.092	-
BNL Ungrouped	HDBM58	BNL OXIDE->NIST->MURR	D:11:290	Dogozhi Bowl	0.000	1.028	-
BNL Ungrouped	HDBM59	BNL OXIDE->NIST->MURR	D:11:275	Dogozhi Jar	0.000	0.112	-
BNL Ungrouped	HDBM61	BNL OXIDE->NIST->MURR	D:11:290	Dogozhi Jar	0.000	0.268	-
BNL Ungrouped	HDBM63	BNL OXIDE->NIST->MURR	D:11:290	Dogozhi Bowl	0.000	7.104	-
BNL Ungrouped	HDBM66	BNL OXIDE->NIST->MURR	D:11:290	Dogozhi Jar	0.000	0.010	-
BNL Ungrouped	HDBM67	BNL OXIDE->NIST->MURR	D:11:290	Dogozhi Jar	0.000	0.000	-
BNL Ungrouped	HDBM69	BNL OXIDE->NIST->MURR	D:11:290	Dogozhi Bowl	0.000	8.745	-
BNL Ungrouped	HDBM85	BNL OXIDE->NIST->MURR	D:11:290	Dogozhi Jar	0.000	7.895	-
BNL Ungrouped	HDBM88	BNL OXIDE->NIST->MURR	D:11:290	Dogozhi Bowl	0.000	0.004	-
BNL Ungrouped	HDCS03	BNL OXIDE->NIST->MURR	AZ D:10:5, AZ NA 8163	Dogozhi Jar	0.000	0.001	-
BNL Ungrouped	HDCS08	BNL OXIDE->NIST->MURR	AZ D:10:5, AZ NA 8163	Dogozhi Jar	0.000	0.006	-
BNL Ungrouped	HDCS09	BNL OXIDE->NIST->MURR	AZ D:10:5, AZ NA 8163	Dogozhi Jar	0.000	0.001	-
BNL Ungrouped	HDCS10	BNL OXIDE->NIST->MURR	AZ D:10:5, AZ NA 8163	Dogozhi Jar	0.000	0.041	-
BNL Ungrouped	HDCS11	BNL OXIDE->NIST->MURR	AZ D:10:5, AZ NA 8163	Dogozhi Jar	0.000	3.850	-
BNL Ungrouped	HDCS14	BNL OXIDE->NIST->MURR	AZ D:10:5, AZ NA 8163	Dogozhi Jar	0.000	0.068	-
BNL Ungrouped	HDCS15	BNL OXIDE->NIST->MURR	AZ D:10:5, AZ NA 8163	Dogozhi Jar	0.000	0.245	-
BNL Ungrouped	HDCS17	BNL OXIDE->NIST->MURR	AZ D:10:5, AZ NA 8163	Dogozhi Jar	0.000	0.000	-
BNL Ungrouped	HDCS18	BNL OXIDE->NIST->MURR	AZ D:10:5, AZ NA 8163	Dogozhi Jar	0.000	1.729	-
BNL Ungrouped	HDCS20	BNL OXIDE->NIST->MURR	AZ D:10:5, AZ NA 8163	Dogozhi Jar	0.000	0.711	-
BNL Ungrouped	HDCS22	BNL OXIDE->NIST->MURR	AZ D:10:5, AZ NA 8163	Dogozhi Bowl	0.000	0.000	-

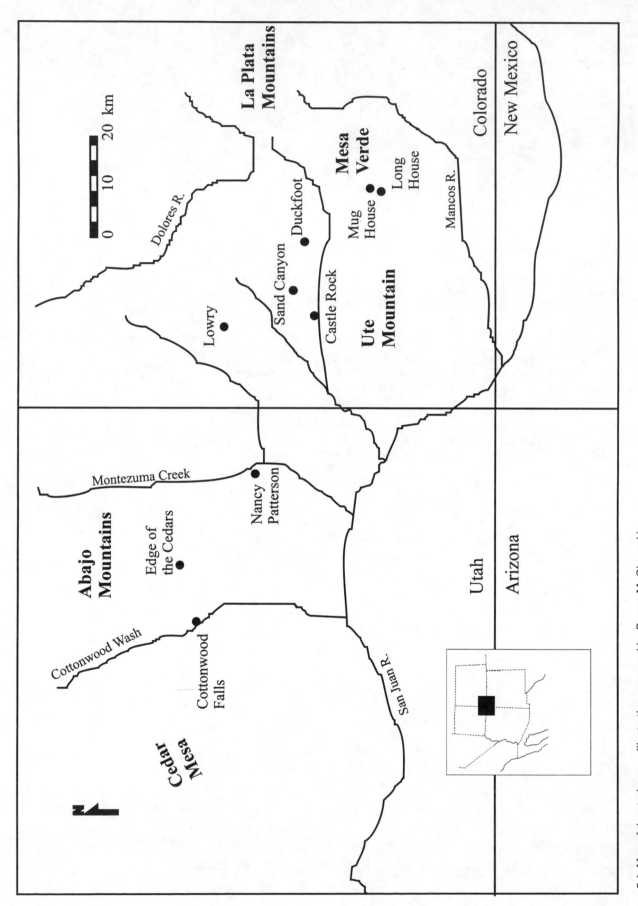

5.1 Map of the study area. *Illustration prepared by Donna M. Glowacki*

Resource Use, Red-Ware Production, and Vessel Distribution in the Northern San Juan Region

Donna M. Glowacki, Hector Neff, Michelle Hegmon, James W. Kendrick, and W. James Judge

ONE OF THE ADVANTAGES of instrumental neutron activation analysis (INAA) data is that multiple databases can be combined relatively easily because of the standard-comparator method employed in generating these data (Glascock 1992; chapter 1). Some of the benefits gained by this method are illustrated here through the synthesis of several INAA-based sourcing projects conducted in the northern San Juan region since 1990 (Glowacki 1995; Glowacki, Neff, and Glascock 1998; Hegmon et al. 1997; Neff and Glascock 1996). The synthesis of data from these projects—originally conducted independently—facilitates comparisons across vessel categories, over time and space. This synthesis includes compositional data on white, red, and corrugated gray wares from the Pueblo I period (AD 700 to 900) through the Pueblo III period (AD 1150 to 1300) and encompasses a geographic area from Comb Ridge in southeast Utah to Mesa Verde National Park in southwestern Colorado (figure 5.1). The broader comparative framework provided by this synthesis makes it possible to refine interpretations of likely source clays, to examine resource use over a broader area, and to explore evidence regarding the distribution of vessels.

Individually, the various projects provided insights about different aspects of pottery production and distribution in the northern San Juan region. However, the pottery and clay sample-size limitations of each of these projects left some issues unresolved. In the earliest of these projects, Hegmon and her colleagues (Hegmon et al. 1997; see also Hegmon 1993; Hegmon, Hurst, and Allison 1995) analyzed white and red wares from the Pueblo I period. They were interested in comparing the production and distribution of two different pottery wares, and concluded that much of the red ware (specifically San Juan Red Ware) was produced in southeast Utah and distributed widely, whereas the white wares (White Mesa Black-on-white in southeast Utah and Piedra Black-on-white in southwestern Colorado) were produced and distributed at more localized scales. Of specific relevance to this synthesis are their conclusions that two of the three red-ware groups, which included pottery found in both southeast Utah and southwestern Colorado, were made from Morrison Formation clays, probably from Montezuma Canyon in southeast Utah. The third group, comprised solely of specimens from the Duckfoot site in southwestern Colorado, was made from a different and not clearly identified source.[1]

The second project involved Pueblo III period black-on-white and corrugated pottery from Mug House and Long House on Mesa Verde as well as Sand Canyon and Castle Rock pueblos in southwestern Colorado (Glowacki 1995, Glowacki, Neff, and Glascock 1995; 1998). Glowacki identified four compositional groups: a Sand Canyon group, a Mesa Verde group, a Castle Rock group, and a corrugated group. Each of these groups was associated with different areas and/or source materials and was interpreted as a distinct production zone. In addition, Glowacki found evidence for vessel circulation between Sand Canyon and Castle Rock pueblos (which are approximately 7 km apart located at the upper and lower ends of Sand Canyon respectively). The results also suggested that vessels were transported between the Sand Canyon locality and Mesa Verde, a distance of about 25 to 30 km. The Sand Canyon and Mesa Verde compositional groups in this study are subgroups of the MVI compositional group, even though these two subgroups source to materials from two different geologic formations (Dakota and Menefee, respectively). Glowacki suggested an increased sample size

might improve establishing Sand Canyon and Mesa Verde as statistically separable groups. The results of this synthesis clarify this issue.

In the most recent project, Judge and Kendrick analyzed two pottery types (Mancos Black-on-white [AD 900 to 1150] and Mesa Verde Black-on-white [AD 1180 to 1300]) from the Lowry community in southwestern Colorado (Neff and Glascock 1996). Their main goal was to examine the effects of increasing settlement aggregation on the types of clay sources used by the Lowry community potters over time. A majority of the samples from Lowry comprised a single compositional group, and none of the clays analyzed as a part of this project were clay sources for the pottery in this group. Therefore, to understand the compositional patterning in the Lowry data set, a comparison of the Lowry data with data from the other northern San Juan region projects was necessary.

The combined data set (*n*=315 pottery samples) used for this synthesis facilitates refinement of the compositional patterning originally found in the earlier projects from this region. The number of raw material samples in the combined data set (*n*=66) enables the identification of additional sources for the previously established compositional groups. This synthesis of the INAA data currently available in the northern San Juan region informs on: (1) patterns in resource use within the region, (2) possible red-ware production in southwestern Colorado, and (3) vessel distribution within the region and beyond.

GEOLOGICAL SETTING OF THE NORTHERN SAN JUAN

Understanding the geology of the northern San Juan region is critical for making well-informed interpretations based on INAA data. Much of this region is part of the Four Corners Platform, a subdivision of the San Juan Basin. It is bounded by Barker Dome on the east, the Sleeping Ute Mountain Uplift on the west, and the Dolores Plateau on the north (Wanek 1959:667). The geological setting of the northern San Juan consists primarily of six formations. In stratigraphic order from the youngest to the oldest, the formations are: Cliff House Sandstone, Menefee, Point Lookout Sandstone, Mancos, Dakota, and Morrison. Cliff House Sandstone, Menefee, and Point Lookout Sandstone comprise the Mesaverde Group. The mesa tops in Mesa Verde proper have the remnants of Tertiary gravels. The major water drainages are the Mancos River, McElmo Creek, and the Dolores River. Igneous rock sources are found predominantly in plugs, dikes, and

the Ute Mountain, which is an extrusive igneous formation. Igneous rock cobbles are also carried by the major water drainages (for example, the Mancos River).

Cliff House Sandstone

This is the upper formation of the Mesaverde group and the top of Mesa Verde. It was originally deposited during the Upper Cretaceous period in the marine, near-shore environment of a transgressive sea. As a result, Cliff House Sandstone is highly variable. In general, Cliff House Sandstone conformably overlies the Menefee Formation, although there is some intertonguing with the Menefee Formation and local unconformities. It is primarily composed of a massive, cliff-forming bed of sandstone, varying from 45 to 100 m thick with smaller lenses of shale interspersed throughout the formation (Griffitts 1990; Wanek 1959:694–697). The scarcity of shale lenses makes Cliff House Sandstone an unlikely clay source.

Menefee Formation

Menefee, an Upper Cretaceous period formation and middle member of the Mesaverde Group, lies directly below the Cliff House Sandstone Formation. The alcoves that house the cliff dwellings of Mesa Verde are found at the juncture of the Cliff House Sandstone and Menefee Formations. The Menefee Formation was produced in a continental depositional environment consisting mostly of streams, river flood plains, and coastal swamps. As a result, this stratum is often very carbonaceous with many plant remains in addition to siltstone, clay shale, carbonaceous shale, coal, sandstone, and bentonite deposits (Griffitts 1990; Wanek 1959:688–694). It conformably overlies Point Lookout Sandstone and ranges in thickness from 100 to 245 m. Possible clay sources are present within the Menefee Formation. X-ray diffraction data indicate this formation is characterized by a higher K-feldspar and plagioclase content than Mancos, Morrison, and Dakota (Glowacki 1995). Chemically, Menefee Formation clays are on average higher in arsenic, cesium, rubidium, antimony, barium, potassium, and sodium than the other formations (Glowacki 1995), which is consistent with higher K-feldspar and plagioclase content.

Point Lookout Sandstone

Point Lookout Sandstone is an Upper Cretaceous deposit that forms the basal layer of the Mesaverde group and lies below the Menefee Formation (Wanek 1959:685–688). Point Lookout Sandstone is found along the top of the north es-

Table 5.1 Original pottery compositional groups re-evaluated in this synthesis

Compositional group	Number	Pottery types	Possible clay sources
San Juan	17	San Juan Red Ware	Morrison? Alluvial?
Nancy Patterson	33	San Juan Red Ware	Morrison? Alluvial?
Duckfoot	5	San Juan Red Ware	Alluvial - McElmo
White Mesa	9	White Mesa Black-on-white	Morrison? Dakota?
Sand Canyon	35	Mesa Verde Black-on-white	Dakota
Mesa Verde	43	Mesa Verde Black-on-white	Menefee
Castle Rock	18	Mesa Verde Black-on-white	Alluvial - McElmo
Corrugated	43	Mesa Verde Corrugated	Mancos?
Lowry	112	Mancos, Mesa Verde Black-on-white	Dakota

carpment of Mesa Verde. This formation was deposited in the marine environment of a regressive sea and is from 25 to 40 m thick. It rises stratigraphically northward and conformably overlies the Mancos Formation, which comprises the base of the north escarpment at Mesa Verde. Point Lookout Sandstone includes both an upper massive cliff-forming sandstone member and a lower transitional layer of interbedded sandstone and shale. There is no clay associated with this formation.

Mancos Formation

The Mancos Formation was deposited during the Upper Cretaceous period in a marine environment that was mostly transgressive and offshore. It is between 300 and 600 m thick forming the massive slopes at the base of the north escarpment of Mesa Verde. This formation is predominantly composed of dark shales that include thin bentonitic lenses, limestone, and thin sandstone layers, as well as many fossilized marine animals (Griffitts 1990; Wanek 1959:680–684). The weathering shales provide ample possible clay sources. The Mancos clays analyzed have higher average concentrations of transition metals, including cobalt, chromium, iron, scandium, zinc, titanium, vanadium, manganese, and calcium than the Menefee, Dakota, and Morrison Formations (Glowacki 1995).

Dakota Formation

The Dakota formation underlies the Mancos Formation. It was formed in the marine, near-shore environment of a transgressive sea, and is the basal formation of the Upper Cretaceous deposits (Griffitts 1990; Wanek 1959:677–680). The Dakota Formation is one of the most widespread geologic units in the West covering much of the northern San Juan region. This formation lies unconformably over Morrison formation ranging from a few meters to several hundred meters thick. The Dakota Formation contains sandstone, carbonaceous shale, coal, siltstone, and conglomerate. The weathered shales in this formation provide possible clay

sources. Kaolinite phase in the Dakota is higher than in the Menefee, Mancos, and Morrison Formations and seems to be a characteristic difference (Glowacki 1995). The Dakota Formation clays analyzed contain higher average concentrations of uranium, hafnium, tantalum, thorium, zirconium, and aluminum, than the Menefee, Mancos, and Morrison Formations (Glowacki 1995). The aluminum content may reflect the higher Kaolinite phase.

Morrison Formation

The Morrison Formation, deposited during the late Jurassic period, is overlain by the Dakota Formation. It was deposited in continental environments such as swamps, broad streams, and lakes. The formation is between 150 and 200 m thick (Griffitts 1990; Ekren and Houser 1965:13–18). The Morrison formation outcrops in the western portion of the northern San Juan region and forms much of the McElmo drainage. It is primarily composed of shales, sandstones, mudstones, and conglomerates. Clays in this formation are basically montmorillonites and make good plasticizers for clay bodies. The Morrison Formation is higher in the Illite/Smectite fraction than Mancos, Menefee, and Dakota (Glowacki 1995). On the average, the Morrison clays analyzed are enriched in rare earth elements such as lanthanum, samarium, cesium, and dysprosium (Glowacki 1995).

RESULTS

The northern San Juan synthesis is based on a database comprised of a total of 315 pottery samples and sixty-six clay samples. The original, separate analyses defined eight pottery compositional groups: San Juan ($n=17$), Nancy Patterson ($n=33$), Duckfoot ($n=5$), White Mesa ($n=9$), Sand Canyon ($n=35$), Mesa Verde ($n=43$), Castle Rock ($n=18$), and Corrugated ($n=43$) (table 5.1). The analysis of the combined data sets involved a directed pattern-recognition approach in which the new data from Lowry was compared to the compositional groups established by the earlier studies. The di-

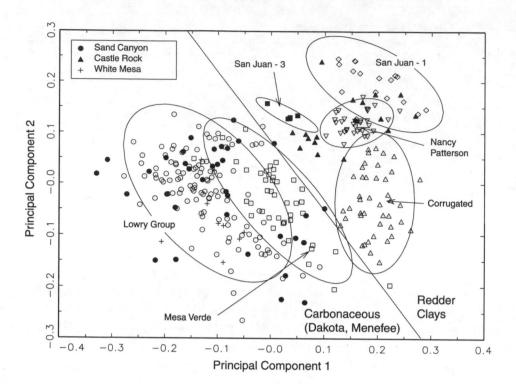

5.2 Compositional group distribution in principal component space showing the distinction between the carbonaceous and redder clays. Note that the Sand Canyon, Castle Rock, and White Mesa groups are denoted by symbols only; no confidence ellipses are drawn around these cases. The diagonal line through the middle of the figure marks the division between the pottery manufactured with redder and carbonaceous clays. *Illustration prepared by Hector Neff*

rected pattern-recognition approach involved displaying the new data with the preexisting reference groups on different axes, including both elemental concentrations and principal components (see chapter 2).

The majority of the newly analyzed ceramics from Lowry belonged to a single compositional group (*n*=112), containing both Mancos and Mesa Verde Black-on-white pottery. The chemical similarity of both of these pottery types suggests resource use and pottery production did not change dramatically through time. Sherds assigned to the Lowry group all have p-values for group membership that exceed the 1% level.

Multivariate analysis of all the data reveals that the Lowry compositional group overlaps with Sand Canyon group and also slightly with the Mesa Verde group (figure 5.2). These three groups of white wares, in addition to the White Mesa compositional group, are distinct from the five other groups that include white, red, and corrugated wares. This distinction is related to a difference in clay sources between carbonaceous and redder clays. These results suggest that the chemical composition of ceramics comprising the Lowry group are similar to the Sand Canyon and Mesa Verde groups and most likely derive from carbonaceous clays.

Multivariate comparisons establish that the range of compositional variation within the Lowry and Sand Canyon groups is present only in the chemical signature of the Dakota formation. The only clay source matching the Lowry group is Dakota clay sampled from the middle of Sand Can-

yon Pueblo. The most likely explanation for determining a clay source for the Lowry compositional group is that a Dakota clay closer to the Lowry area was exploited by the Lowry potters. It seems unlikely that all of the Lowry pottery or all the Lowry clay came from Sand Canyon, a distance of about 25 km.

The analysis of the pottery from the Lowry Community also provides tentative evidence that vessels were being imported from other areas, specifically areas with access to Menefee Formation clays, such as on Mesa Verde. The chemical signature of three pots from the Lowry community exceed a 1% p-value for membership in the Mesa Verde group (Neff and Glascock 1996: Table 2) indicating these pots were chemically similar to pottery found at Long House and Mug House on Mesa Verde proper. If Menefee clays were used to produce these three vessels, then either the pots or the clays must have been transported from Mesa Verde to the Lowry area. The distance between the Lowry area and Mesa Verde proper is about 45 km, suggesting that it is more likely that the vessels were transported than raw clay.

Additionally, this synthesis helped resolve a potentially problematic, tentative conclusion reached by Glowacki (1995). Originally, the white-ware groups labeled Sand Canyon and Mesa Verde were subgroups of a larger reference group (MV1), even though they were spatially distinct and were associated with different source clays (Dakota and Menefee respectively). Glowacki (1995) felt that if the sample

size were increased, then these two subgroups might form two distinct compositional groups at the first-hierarchical level of the data structure. Comparison of the Lowry group to the Mesa Verde group reveals that not a single member of the Mesa Verde group shows even a 0.005% probability of membership in the Lowry group (Neff and Glascock 1996: Table 3). Therefore, this analysis of the combined databases indicates that these groups should be considered statistically distinct.

PATTERNS OF VARIATION IN RESOURCE USE

Archaeologists have long assumed that red and white wares were made from different clays. Compositional analyses, including this synthesis, generally confirm this assumption. Pottery in some of the compositional groups in the northern San Juan database was built using predominately carbonaceous clays such as Dakota and Menefee. Other vessels were constructed using redder clays that include Morrison, Mancos, and alluvial clays (figure 5.2). Mineralogically, the most striking difference between these clays is that the carbonaceous clays tend to have a higher kaolinite phase than the redder clays. Chemically, the carbonaceous clays are enriched in thorium, uranium, hafnium, and tantalum, while the redder clays are enriched in iron, manganese, and other transition metals. Three of the compositional groups that contain Black-on-whibe pottery (Lowry, Sand Canyon, and Mesa Verde) source to the carbonaceous clays. The remaining five groups, which include white, red, and corrugated wares, appear to derive from the redder clays. The compositional distinctiveness of these two clay groups reflects major geologic differences between formations. Based on the results of this synthesis, red wares were not made from cretaceous clays, but some white wares could be produced using the redder clays. A possible explanation for the preferential selection of different clays for each pottery type might be related to differing firing regimes black-on-white, corrugated, and red-ware pottery.

Variability in each geologic formation is considerably greater than variability within each pottery chemical compositional group. Dakota Formation clays are the most variable exhibiting far more variation than the pottery in the compositional groups linked to Dakota Formation clays (for example, Lowry and Sand Canyon). The relative homogeneity of pottery clays obtained from the heterogeneous Dakota Formation suggests that potters may have specifically selected certain kinds of clays within the formation. Preferential selection of specific qualities in raw materials has also been noted

by Hegmon (1995b) in the consistent selection of specific tempers by Pueblo I potters.

Compositional data also demonstrate the long-term use of Dakota Formation clays by potters producing white-ware pottery in the northern San Juan region. The Lowry group contains predominantly Mancos Black-on-white (AD 900 to 1150) and Mesa Verde Black-on-white (AD 1150 to 1300) ceramics that source to the Dakota Formation. Both ceramic types were produced using Dakota clays suggesting that resource use in the Lowry area does not change over time. Earlier use of the Dakota Formation is also suggested. At least two of Hegmon's White Mesa Black-on-white bowls, dating to the late Pueblo I period (AD 750 to 900), are also analytically linked to the Dakota formation (Neff and Glascock 1996). Additionally, these clays were also used to produce Mesa Verde Black-on-white bowls in the Sand Canyon group (Glowacki, Neff, and Glascock 1998). Therefore, Dakota Formation clays were used to produce pottery throughout the occupation of the northern San Juan region.

ADDITIONAL INSIGHTS INTO RED-WARE PRODUCTION

Recent research by Hegmon and her colleagues (1997) has focused primarily on understanding the organization of red-ware production. They originally concluded that two groups of San Juan Red Ware (San Juan and Nancy Patterson) most likely sourced to Morrison Formation clays. Based on the results of this synthesis, a Morrison clay is still the most likely source for these groups since the red-ware groups fall in the redder clay category (figure 5.2). However, none of the analyzed Morrison clays statistically falls within the range of variation exhibited by the red-ware groups. Therefore, the use of Menefee, Mancos, and alluvial clay sources in red-ware production has not been ruled out through this analysis.

Hegmon's original study did not identify a likely source for the small Duckfoot group (see figure 5.2). Although the sample size is small (*n*=5), the results from this synthesis suggest a tentative link between the Duckfoot group and the McElmo Creek alluvial clays in southwestern Colorado that were used to produce pottery at Castle Rock Pueblo. The McElmo drainage is only about 3 km away from the Duckfoot site in southwestern Colorado (see figure 5.1).

The constituents of the alluvial clay from McElmo Creek are primarily secondary material from the Mancos Formation, but may also include small amounts of Morrison and Dakota clays. The tentative link between the Duckfoot group and McElmo Creek alluvial clays suggests the source for

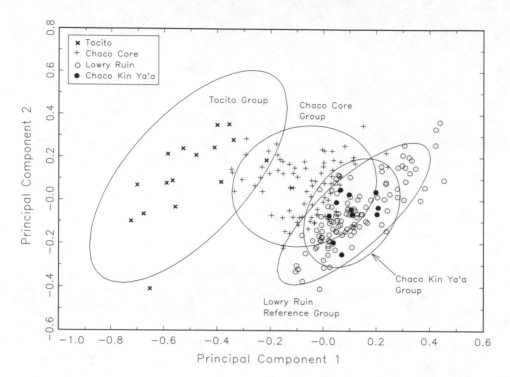

5.3 Similarities between Chaco Kin Ya'a and Lowry in principal component space. *Illustration prepared by Hector Neff*

these red-ware vessels could be a cultural or natural mixture of clays from the Mancos, Morrison, and possibly Dakota Formations. Natural mixtures can also be found in alluvial clays from the Montezuma Canyon drainage indicating that more analysis of alluvial clays is necessary. Therefore, San Juan Red Ware potters may have been preferentially exploiting alluvial clays from drainages throughout the northern San Juan region.

In sum, the results of this synthesis contribute to Hegmon and her colleagues' initial interpretations by providing additional information on the potential sources of red-ware clays. Although white ware was sometimes made from redder clays, the production of red-ware apparently never involved the use of carbonaceous clays from the Dakota and Menefee Formations. This is possibly related to the iron content and firing regime requirements necessary for producing red wares.

San Juan Red Ware is most abundant in southeastern Utah, where it is thought to have been primarily produced (Hegmon et al. 1997; Hegmon, Hurst, and Nelson 1995). However, this synthesis suggests that at least some San Juan Red Ware was produced in southwestern Colorado as well. If this is the case, it suggests a complex pattern of red-ware production and distribution involving at least some production peripheral to the core production zone in southeastern Utah.

SUPRAREGIONAL INTERACTION

INAA data from the Chaco area analyzed by Neitzel and her colleagues (chapter 4) was compared with the synthesized data set from the northern San Juan region. Six vessels from a small compositional group of Dogoszhi-style pottery (Kin Ya'a group) from four sites near Chaco Canyon statistically belong in the Lowry white-ware group (figure 5.3). This similarity implies that the six vessels from the Chaco area were also made from Dakota Formation clay. A majority of specimens from the Chaco core area are in a completely different group (*n*=81) further indicating that these six pots were indeed produced elsewhere. Therefore, this evidence suggests that these pots from the northern San Juan region were circulated south to the Chaco area (see chapter 4 for details about the compositional groups). However, because there is no chemical compositional analysis of clays from the Chaco area, it is impossible to rule out the possibility these Dogoszhi-style vessels were produced using locally available clays similar in chemical composition to the clays found in the northern San Juan region.

CONCLUSIONS

This synthesis of INAA data from three separate projects in the northern San Juan region has provided insights into several aspects of pottery production. Various resources (carbonaceous and redder clays) were used in different areas and for different wares. At the same time, there is clear evidence of the continuity of resource use, specifically Dakota Formation clays; prehistoric potters clearly selected specific clays within

this highly variable formation, and their selection criteria apparently changed little over time. The larger sample size created through this synthesis made it possible to more confidently, statistically separate two white ware groups—Sand Canyon and Mesa Verde—that could not be completely distinguished in earlier analyses. The data from the Lowry and Mesa Verde groups also provided evidence for pottery circulation between these areas. Finally, although most red ware was produced in southeastern Utah, the results from this synthesis suggested a possible southwestern Colorado source for red-ware production.

One of the strengths of this synthesis is demonstrating the importance of giving adequate attention to sampling raw materials for INAA projects. This is exemplified by the initial results of the Lowry project, in that none of the eight clays submitted with this project were chemically similar to the compositional group. The existing raw materials database for this region made it possible to link the Lowry compositional group unequivocally to the Dakota Formation, even if source clays in the vicinity of Lowry have not been located.

At least two directions for future research in the northern San Juan region are suggested by the results of this synthesis. First, because of the variation within the Dakota Formation, raw clay samples from this formation need to be systematically collected from a broader area. This sampling is important because a better understanding of the variability within this formation will enable informed interpretations of how this resource was used by potters in the past. The fact that the Dakota Formation is so extensive, covering much of the northern San Juan region, further substantiates the need for additional sampling. Second, the tentative link between McElmo alluvial clay and Duckfoot red-ware group warrants further investigation. Systematic sampling of alluvial clays needs to be emphasized and is especially important for understanding red-ware production. Determining to what extent San Juan Red Ware was produced outside of southeastern Utah is an essential component of defining the zone of red-ware production and exploring implications regarding the organization of red-ware production and exchange.

Acknowledgments. These three projects were initially funded by NSF grant DBS-9102016, the Karen S. Greiner Foundation (Colorado State University), Smithsonian postdoctoral fellowship (for Hegmon), the Wenner-Gren Foundation for Anthropological Research, Crow Canyon Archaeological Center, and the 67th Pecos Conference Kiln Auction proceeds. These analyses were carried out at both the Smithsonian Institution's Conservation Analytical Laboratories (Hegmon) and the University of Missouri Research Reactor. Institutional support for these projects was provided by: Anasazi Heritage Center (Bureau of Land Management); Mesa Verde National Park; Museum of Peoples and Cultures (Brigham Young University), Center for Archaeological Investigations (Southern Illinois University), Crow Canyon Archaeological Center, and the Edge of the Cedars State Park. Individual assistance and suggestions on these projects was provided by: James Allison, Ronald Bishop, James Blackman, Jack Ellingson, Michael Glascock, Mary Griffitts, Winston Hurst, Joel Janetski, Kristin Kuckelman, Ricky Lightfoot, R. Lee Lyman, William Melson, Scott Ortman, Chris Pierce, Clint Swink, Charmaine Thompson, Mark Varien, and W. Raymond Wood. We would like to thank Marilyn Beaudry-Corbett and two anonymous reviewers for their suggestions. Jill Neitzel allowed us to use her data from the Chaco area for comparison.

Notes

1. A source for the third group (from Duckfoot site) was not identified in Hegmon's original research. However, the most recent and comprehensive publication of that research (Hegmon et al. 1997) was finalized after this synthesis project had begun, and that publication (Hegmon et al. 1997:459) briefly mentions the results of this synthesis regarding a possible source for the third group.

Artifact Design, Composition, and Context

Updating the Analysis of Ceramic Circulation at Point of Pines, Arizona

M. Nieves Zedeño

ETWEEN BLACK AND WHITE there are numerous shades of gray, says the popular aphorism, reminding us that observable reality seldom conforms to conceptual dichotomies. "Migration versus diffusion," "local versus traded," and "style versus function" are classic examples of conceptual dichotomies around which archaeological interpretation of ceramic variability has revolved, ever since prehistorians became concerned with intercultural or intersocietal relationships. Despite substantive changes in ceramic theory and heady levels of technical and methodological sophistication reached over the last sixty years, we remain reluctant to part with dichotomous thinking. Conceptual dichotomies are attractive because they impose order and elegance on the ceramic record by reducing noisy variation to a few mutually exclusive and readily interpretable categories. While order is an essential component of analysis and inference, ordering concepts are not eternal; these must be continuously assessed and revised if our knowledge of the multiplicity and complexity of behaviors behind ceramic variability is to be advanced. Here, I am specifically concerned with advancing our conceptual understanding of variability related to ceramic circulation mechanisms and refining analytical criteria to isolate their material correlates.

Elsewhere, I argue that the distribution of prehistoric nonlocal ceramics in the northern Southwest resulted from multiple circulation mechanisms, including various forms of exchange, seasonal mobility, and migration, and that each of these has the potential to inform us about how individuals and groups interacted with each other and with available natural and manufactured resources (Zedeño 1991; 1992; 1994; 1995; 1998; Zedeño and Triadan 2000). This volume presents an ideal opportunity for reassessing previous work in light of

current data and perspectives on ceramic circulation in late prehistoric Southwestern communities. Few archaeological records equal the wealth of ceramics found in aggregated pueblos, where vast inventories of painted and unpainted pots attest to the behavioral complexity of ceramic manufacture and circulation, thus challenging our ability to investigate the effects of social interaction on material culture (Reid and Whittlesey 1999). Unfortunately, an overly strong focus on the study of exchange has delayed our understanding of how and why alternative circulation mechanisms influenced the generation of ceramic variation, and how we can better reconstruct these processes from the archaeological record. In particular, the impact of migration and coresidence of ethnically or politically distinct groups on ceramic production is poorly understood, even though migration episodes doubtless occurred throughout the development of Southwest communities (Wilson 1988) and were partially responsible for the formation of aggregated pueblos in the late prehistoric and early historic periods (for example, E.C. Adams 1991; papers in Cameron, ed. 1995; Nelson 2000; Reid and Whittlesey 1997).

Here evidence of ceramic circulation associated with the migration of Kayenta-Anasazi people to the Point of Pines region (Haury 1958) is revisited and ensuing changes in ceramic manufacture in the highlands of east-central Arizona are discussed. The study builds on recent ceramic research conducted in the neighboring Grasshopper region (Crown 1981; Montgomery 1992; Reid et al. 1992; Triadan 1997; Zedeño 1994; Zedeño and Triadan 2000), updating conceptual and analytical criteria to reconstruct circulation mechanisms and to further our knowledge of the role of people-people and people-artifact interaction(s) in the gener-

ation of highly varied ceramic assemblages. First, an outline for refining frameworks used to isolate and interpret relevant ceramic variability along three dimensions—technological, compositional, and contextual—is presented. This outline is then illustrated with data on a ceramic sample from Point of Pines and other contemporaneous sites in east-central and northern Arizona. Last, implications are developed for designing further ceramic research.

ARTIFACT DESIGN, COMPOSITION, AND CONTEXT

Archaeologists generally acknowledge that building inferences on ceramic manufacture and circulation requires a multidimensional perspective (for example, D.E. Arnold 1981; Simon and Redman 1990; see Zedeño 1994). This perspective, however, has evolved in response to the need for more parsimonious criteria to interpret data on ceramic technology and composition recovered in the last few years. Changes entail the incorporation of recently revised conceptual and analytical approaches to the identification of behaviors encoded in ceramic variability (for example, Schiffer and Skibo 1997).

Artifact design

The first improvement to the multidimensional perspective entails the replacement of a "style versus technology" dichotomy for conceptualizing formal variability with an "artifact design" approach, which captures the artisan's effort to create products embodying causal factors that defy conventional theoretical or analytical boundaries (Schiffer and Skibo 1997:27). *Artifact design* denotes the process of conceptualization and practical construction of an object: A potter designs an object for a particular purpose(s) and, usually, builds it under the constraints of prior knowledge of manufacturing technology. An all-encompassing technological analysis targets the identification of variability generated in the process of designing and manufacturing artifacts with specific formal properties and performance characteristics. Formal properties, such as shape, size, or decoration, play differential roles in the actual performance of an artifact in a specific context; size and shape determine a vessel's performance in cooking and storage (Schiffer and Skibo 1997), whereas shape and decorative motifs may be essential to a vessel's social and ritual performance (see Hegmon 1995a). Formal properties and performance characteristics may in turn define contexts and modes of circulation. For example, Crown (1994) suggests

that the circulation and local reproduction of Salado polychromes across the fourteenth-century Southwest responded to a panregional cult in which decorative motifs (for example, Pinedale Style) played a critical role in cueing people who shared those beliefs. Decoration of Salado Polychrome bowls, therefore, was a primary performance characteristic (Schiffer and Skibo 1997:31) that determined the context and mode of manufacture, circulation, and, perhaps, use of these vessels.

An artifact design approach also forces the analyst to confront variation arising from multiple sources of knowledge that both constrain the execution of a concept and allow the potter to manufacture a vessel successfully. There are at least four sources of such technical knowledge: (1) the teaching frameworks, through which socially sanctioned and technically sound artifact designs are successfully passed on intergenerationally (Schiffer and Skibo 1995:232–233)—these designs are standard combinations of formal properties that characterize manufacturing traditions; (2) the ability of a potter to experiment with, and successfully employ, new materials and techniques, thereby enriching a tradition with periodic or sporadic innovations; (3) interaction between a potter and a foreign artifact, which may result in the borrowing or emulation of visually discernible formal properties (Lindauer 1995); and (4) interaction among two or more potters who have been trained under different teaching frameworks, which may lead to the merging of distinct artifact designs.

These sources of knowledge are not mutually exclusive, but can simultaneously define and constrain the conceptual design and practical execution of an artifact. For example, a potter may implement an innovation to a traditional design by adopting a formal property, such as color scheme, that has been visually discerned from a foreign vessel. This innovation may entail experimentation with pigments and firing conditions, but may not alter the basic paste recipe, vessel forming technique, or painting sequence of the original design. On the other hand, an innovation resulting from face-to-face interaction with foreign potters may profoundly alter a manufacturing tradition and could lead to "hybridization," or the appearance of new artifact designs that combine formal properties of two or more manufacturing traditions. The recognition of circulation-related patterning in the ceramic record largely depends on the investigator's ability to isolate variation stemming from different sources of technical knowledge guiding ceramic manufacture.

Composition

The complementary analyses of petrographic and chemical components of ceramic pastes basically serve to distinguish local from nonlocal artifacts; the interpretation of data on paste composition is founded upon assumptions of relative abundance and distribution of ceramic artifacts and of compositional distinctiveness of raw material sources used in ceramic manufacture (see Bishop, Rands, and Holley 1982; Glascock 1992). Increasingly, archaeologists have incorporated a problem-oriented, broad regional analysis of raw materials and ceramic artifacts that contributes background knowledge on compositional variability of potential clay and temper sources and also increases the probability of finding provenance points for nonlocal artifacts from the assemblages under study. Furthermore, assemblage-specific research has taken compositional analysis beyond the basic "local versus nonlocal" dichotomy and into a consideration of the role of raw material variability and availability in the development of paste recipes for specific artifact designs (for example, Habicht-Mauche 1993; Triadan 1997; Zedeño 1994).

An integrated analysis of site assemblage and comparative regional raw material and artifact composition allows a detailed characterization of paste recipes present in one or more artifact designs not only within a manufacturing tradition, but also between widely or even subtly different traditions. By enhancing our ability to differentiate among variations related to performance, knowledge, and provenance, integrated compositional analysis provides baseline information for developing material correlates of different circulation mechanisms.

Context

In principle, the contextual dimension furnishes criteria for building inferences about the behaviors that produced differential distributions of technologically and compositionally varied artifacts in the archaeological record. In the years when archaeologists were only beginning to incorporate compositional analysis into reconstructions of trade networks, attention was placed on modeling patterns of spatial distribution of nonlocal artifacts over relatively broad areas (for example, Douglass 1991; Findlow and Bolognese 1982; F. Plog 1977; Upham 1982). The critical assumption was that nonlocal artifacts were manufactured in a few loci and traded widely. For a long time, mathematical models used to predict forms of exchange were the only methodological link between the archaeological record and theoretical explanations (Earle 1982:7). Abstract, simple models were eventually

dropped because they could not handle problems of equifinality (Hodder 1982:202; see Zedeño 1998).

Although predictive modeling has fallen into disuse, at least in the Southwest (S. Plog 1993), we remain attached to the last vestiges of distributional studies: We tend to focus on a single "nonlocal" artifact category (for example, Cibola White Ware, Dogozhi Style, Tanque Verde Red-on-brown, Salado Polychromes) and search for provenance information across broad areas. As Blinman and Wilson (1993:67) point out, however, nonlocal artifact distributions only suggest that artifacts traveled from point of origin to point of recovery, but do not tell us just how they traveled or whether circulation mechanisms changed from one region to another or over time. Although the need to study circulation mechanisms from a regional perspective may seem inherently obvious, in practice, behavioral inferences that go beyond the mere identification of nonlocal artifact distributions must include observations made on specific archaeological contexts under strict temporal and spatial control. At a minimum, these observations must include (1) assemblage structure, or the co-occurrence of one or more local and nonlocal artifact categories; (2) variation in artifact design of local and nonlocal ceramic traditions represented in an assemblage; and (3) contexts of production, use, and discard of local and nonlocal artifacts. Taken as a whole, these observations should yield the data necessary for isolating circulation mechanisms and building inferences about the impact of circulation-related interactions on local ceramic manufacture.

POINT OF PINES REVISITED

Forty years have passed since Emil Haury published his *Evidence at Point of Pines for a Prehistoric Migration from Northern Arizona* (1958), yet this classic work remains uncontested as *the* case for migration and ethnic coresidence in the prehistoric Southwest. Its endurance rests largely on the multiple lines of evidence that Haury had at hand for building the argument: human remains, architecture, foodstuffs, a host of artifacts, and information about the timing of abandonment and southward population movement from northern Arizona. Even though archaeologists are convinced that this is not the only instance of migration during the late thirteenth and fourteenth centuries, few if any other sites have produced data comparable to Point of Pines. It is precisely for this reason the ceramic evidence associated with the Kayenta migration to Point of Pines is reconsidered here; the goal was to apply modern methods and techniques of ceramic analysis to this assemblage to refine criteria for identifying ceramic cor-

relates for migration and ethnic coresidence, and develop further criteria for distinguishing ceramics circulated through migration from those circulated through alternative mechanisms

The site and its history

Point of Pines is located in the San Carlos Apache Reservation, approximately 96 km (60 air miles) due east of Globe, Arizona, and immediately south of the great bend of the Black River (Robinson 1958:1) (figure 6.1). The center of the Point of Pines region is Circle Prairie, a grass-covered plateau at 1800 m (6,000 ft) in elevation, bounded on the south and southwest by the uplift fault known as Nantack Ridge (Gifford 1957:13). Point of Pines falls within the mountain transition zone between the Sonoran Desert and the Colorado Plateau in an area of high biotic diversity (Neely 1974; Woodbury 1961).

The local geology is characterized by a complex series of volcanic and sedimentary rocks of probable Tertiary and Quaternary age that were faulted and tilted to form the Nantack Ridge-Circle Prairie area. Massive older volcanic flows of porphyritic andesite and thin-bedded basalt are partially covered by moderately consolidated conglomerates and sandstones. The low ridges on which sites such as Point of Pines lie consist of a yellow-brown conglomerate composed of a silty-clay matrix containing pebbles and small cobbles of tuff and basalt (Thompson 1993:510; Woodbury 1961:10–11). Residual clays are nearly absent on surface deposits; surface clays are of secondary deposition and contain varying amounts of tuff particles, muscovite, and fine sand. The geology and sedimentology of the region contrasts sharply with the environment of the surrounding mountain, plateau, and desert regions.

Point of Pines is located near the center of a triangle formed by three major prehistoric culture areas: Mimbres, Hohokam, and Mogollon. Ready accessibility to a rich natural environment, complete with extensive agricultural soils of volcanic origin and nearby streams, attracted diverse groups of people at different times. In fact, the analysis of architecture, community layout, burial practices, human remains, and artifact assemblages at the main ruin and nearby sites has revealed great heterogeneity (J.L. Adams 1994; Haury 1958; Johnson 1965; Lowell 1991; Morris 1957; Neely 1974; Robinson 1958; Wasley 1952). Additionally, the strategic location of Point of Pines—accessible from multiple directions and through natural passes—likely stimulated the circulation of goods to and from the settlement. Large aggregated pueblos

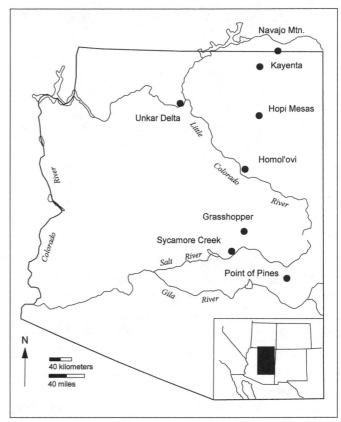

6.1 Location of the Point of Pines region and areas represented in the ceramic sample. *Illustration prepared by Daniela Triadan*

such as Turkey Creek and Point of Pines developed in east-central Arizona in the early to mid-thirteenth century, at least twenty-five to fifty years earlier than in other regions along the Mogollon Rim (Reid 1989). By the fourteenth century, Point of Pines had become the most populous village in the Mogollon highlands, comparable in size, complexity, and demographic heterogeneity to contemporaneous Western Pueblos, such as Hawikku (Hodge 1937), Homolovi I (E.C. Adams 1991), and Awatovi (Hawley-Ellis 1967). It is estimated, on the basis of ceramic cross-dating, that Point of Pines was abandoned by the mid-fifteenth century.

Emil Haury's interpretation of the developmental history of Point of Pines was deeply rooted in the notion that this settlement was inhabited by ethnically and culturally diverse groups (Haury 1989). Haury saw in Point of Pines a clear example of the cultural unification of Anasazi and Mogollon; in addition, he and his colleagues found evidence of Hohokam presence in the region since at least AD 1000 (Neely 1974). His notion of cultural and ethnic diversity was cemented with evidence of a large immigration from northeastern Arizona. The documentation of a Kayenta Anasazi immigration into Point of Pines during the Great Drought (AD 1276 to

1299) is still considered a model of elegance and persuasion. The material evidence Haury presented in support of his interpretations included a well-defined room block associated with food remains, ritual facilities, human remains, ceramic containers, and wooden artifacts that were identical to those known to have occurred in northeastern Arizona. Additionally, a cluster of Western Anasazi pit houses dating to the immigration episode and containing foreign ceramics was found beneath a late fourteenth-century outlying room block of the main pueblo. These pit houses have been interpreted by Alexander Lindsay, Jr., as the temporary abode of immigrant families before they moved into their masonry quarters (Haury 1989:58).

Haury's original ceramic analysis focused on examining the effect that interaction between immigrant and local potters had on ceramic manufacture. He identified the production of Maverick Mountain Polychrome, a painted ware whose technology resembles the northern Tsegi Orange Ware and that apparently developed out of a local adaptation of foreign potters thrust into a new environment. Subsequent typological analysis by Lindsay (1987, 1992) contributed additional information about formal similarities between Kayenta and Point of Pines ceramics. Until now, however, a systematic compositional analysis of the Kayenta-Maverick Mountain materials has not been undertaken. Similarly, many other decorated and plain wares at the site, which potentially could provide information about additional migration episodes and other circulation mechanisms, exchange in particular, have not been submitted to modern analytical techniques.[1] This is unfortunate, because the Point of Pines assemblage is perhaps the most varied in the Mogollon highlands and one of the most varied in the late prehistoric Southwest. Thus, the potential for finding evidence of multiple circulation mechanisms acting simultaneously and/or sequentially to form such an assemblage is great.

The ceramic assemblage

The ceramic assemblage from Point of Pines includes a large number of decorated and undecorated wares made in the Southwest during the late Pueblo III (AD 1250 to 1300) and Pueblo IV (AD 1300 to 1450) periods. Furthermore, the stratigraphic sequence shows visible changes in the typological structure of assemblages, particularly between AD 1250 to 1400. The local ceramic tradition consists of classic mountain Mogollon ceramics: finely indented corrugated, red slipped, smudged, painted, and plain brown wares (Breternitz, Gifford, and Olson 1957; Wasley 1952). Nonlocal traditions include

Cibola and Tusayan White wares; White Mountain Red Ware; Tsegi Orange Ware; Hohokam Red-on-brown; small amounts of Hopi Yellow Ware, Casas Grandes polychromes, and other decorated wares. In addition, between the 1280s and the late 1300s, a number of decorated types emerged in this and neighboring regions: Kinishba Polychrome, Salado Polychromes (Roosevelt Red Ware), Maverick Mountain Polychromes, Point of Pines Polychrome, and San Carlos Red-on-brown. The appearance of these wares has been interpreted as indicating reorganization of interaction networks that resulted from extensive population relocation during the Pueblo IV period (Carlson 1982; Crown 1994; Lindsay 1987, 1992; Reid and Whittlesey 1997; Triadan 1997; Wendorf 1950). This assemblage, therefore, is appropriate for conducting an integrated technological, compositional, and contextual analysis needed to derive correlates for ceramic circulation.

SAMPLING RATIONALE

Two kinds of samples were selected for analysis. The first, or core sample ($n=314$), was drawn mostly from floor assemblages dated by tree rings or cross-dated between AD 1250 and 1350; these assemblages are from Point of Pines, Turkey Creek, and eight nearby sites. Eight ceramic wares were selected to increase the probability of identifying multiple sources of variation. The time span covered by the core sample, roughly one hundred years, was considered sufficiently long to allow the definition of assemblage structure before and after migration, and the identification of changes in artifact designs ensuing from different forms of interaction. The core sample included thirteen clays collected in the vicinity of Point of Pines and Turkey Creek and three unfired sherds recovered from room floors at the main ruin.

The second, or comparative sample ($n=68$), was selected to obtain data on broad regional variation in sources of ceramics thought to be associated with the Kayenta migration episode. This small sample included Tsegi Orange Ware sherds from several late Pueblo III sites in northern, central, and southeastern Arizona, including Betatakin, Kiet Siel, two sites near Navajo Mountain, one site in the Grand Canyon area, Homolovi IV in the middle Little Colorado River valley, an ancestral Hopi site on Third Mesa, and Tsegi-like sherds from Sycamore Creek in the eastern Tonto Basin and Goat Hill in the Safford Valley (figure 6.1). In addition, five clays from sources located in the Navajo Mountain-Rainbow Bridge area were added to the sample for comparative purposes. Finally, compositional and technological information of contemporaneous decorated and plain ceramics, in the form of

large data sets from the Grasshopper (Triadan 1997; Zedeño 1994) and Silver Creek regions in east-central Arizona (chapter 7), and from Pottery Knoll in southeastern Utah (Neff, Larson, and Glascock 1997), were instrumental in expanding the reach of this analysis.

COMPOSITIONAL GROUPS

To identify source variability, 361 samples of ceramics,[2] eighteen clays, and three unfired sherds were submitted to instrumental neutron activation analysis (INAA); ninety-six of these sherds and four sand samples were analyzed petrographically. Formal properties (paste color and texture, wall thickness and vessel shape, surface finish, decoration techniques and motifs, and firing conditions) were recorded to document variation in artifact designs present in the sample. In addition, three hundred decorated and undecorated sherds were examined macroscopically and under a low-power microscope to refine and expand observations made on the sample analyzed compositionally.

Through the statistical processing of chemical data seven compositional groups were identified (figures 6.2 and 6.3):

Group 1 (*n*=117) and Group 2 (*n*=35) represent locally manufactured ceramics. Due to the volcanic environment in which local clays were formed, the chemical fingerprint of local materials contrasts sharply with those of ceramics made outside the region. A comparison between local clays and ceramic samples (Mahalanobis jackknife probabilities for posterior classification range between 60 and 90%) shows that the Point of Pines potters utilized both residual and alluvial clay sources; however, they used them differently. The petrography indicates that alluvial clay sources represented in Group 1 were likely obtained from the nearby creek and also from sediments collected at the bottom of large reservoirs. These dark brown, naturally tempered clays were used for the manufacture of a wide variety of painted and unpainted wares throughout the occupation of the area, including patterned corrugated and painted corrugated ceramics, Salado Polychromes, Maverick Mountain Polychromes, and Point of Pines Polychrome (local White Mountain Red Ware).

The light gray residual clays included in Group 2 are found underlying extrusive volcanic sediments. These were used to manufacture a narrow range of painted pottery: Maverick Mountain Polychrome, Gila Polychrome, Tonto Polychrome, and local vessels. A larger sample may reveal more variation in pottery made of residual clays, but thus far the compositional pattern does not suggest their widespread use in the manufacture of corrugated vessels. The overall scarcity of surface deposits of residual clays may have prevented potters from exploiting these sources intensively. Differences in temper technology between Groups 1 and 2 suggest that the use of residual clays did not conform with the traditional brown ware paste recipes: Alluvial clays are naturally tempered with volcanic particles whereas residual clays were tempered by adding sand, ground sherds, or both. Contextually there may be differences as well: The ceramic types represented in Group 2 have a narrow temporal range, indicating manufacture in the post-immigration period (AD 1285 to ca. 1350).

Group 3 (*n*=50) and Group 4 (*n*=26) include nonlocal ceramics associated with the Kayenta Anasazi migration episode. Group 3 includes (1) Tsegi Orange Ware polychromes from the northeastern Arizona sites, (2) Pinto Black on Red and Pinto Polychrome from Point of Pines, and (3) Tusayan/Pinedale B/W from Point of Pines. Group 3 exhibits a relative degree of chemical affinity with Tsegi Orange Ware samples from southeastern Utah that were analyzed by Neff, Larson, and Glascock (1997). Their analysis suggests that these materials were manufactured with orange-firing clays from the Chinle Formation. Because Chinle clays are widespread in northern Arizona, interpretation of compositional similarities between Group 3 and the Utah materials remains tentative until a systematic study of chemical variability of Chinle clay outcrops is undertaken.

Group 4 includes (1) Tusayan/Pinedale B/W samples, (2) Kiet Siel Corrugated, and (3) Tsegi Orange Ware, all from Point of Pines. Additional comparisons among Group 4 and samples from southeastern Utah likewise show a relatively high degree of chemical affinity (the Mahalanobis jackknife probability range is 10 to 80%) between the samples and a Chinle-derived reference subgroup that Neff, Larson, and Glascock (1997) argue is local to Pottery Knoll. The fact that both polychrome and white ware samples from Point of Pines are chemically similar to materials from northeastern Arizona and southeastern Utah strengthens the preliminary interpretation that the Point of Pines samples, as well as those from the Hopi, Homolovi, and Grand Canyon sites, originated somewhere near the Utah-Arizona border.

Group 5 (*n*=20) represents nonlocal pre-migration ceramics. Group 5 is entirely composed of Cibola White Ware of the Reserve-Tularosa tradition, including samples from Turkey Creek and Point of Pines. The analysis shows that the sources of Cibola White Ware are far more heterogeneous than indicated by the group assignment; twenty-two of twenty-eight unassigned samples are of this ware, and each sample

6.2 Multi-ware groups.
*Illustration prepared by
M. Nieves Zedeño*

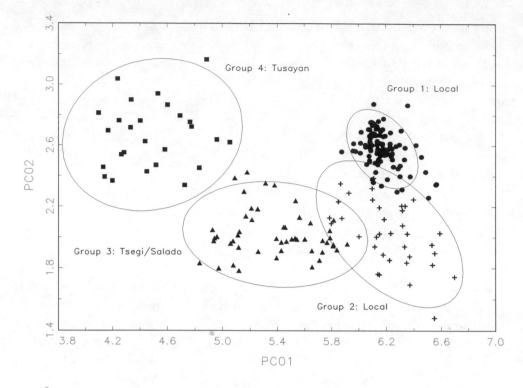

6.3 Single-ware groups.
*Illustration prepared by
M. Nieves Zedeño*

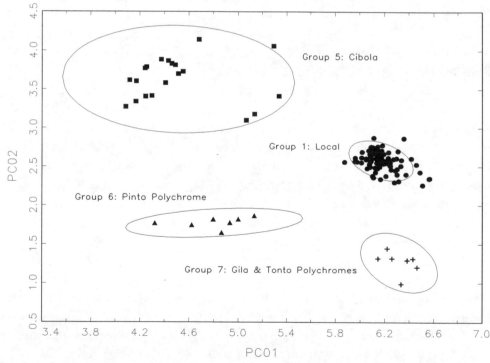

could indicate a potential source. Chemical affinity between Cibola White Ware samples and a tempered clay recovered from Bailey Ruin (Triadan, Mills, and Duff, chapter 7) points to Silver Creek as one of the sources of Cibola White Ware that circulated into the Grasshopper and Point of Pines regions during the thirteenth and perhaps the early fourteenth centuries.

Group 6 (*n*=9) and Group 7 (*n*=8) represent nonlocal mi-

gration and postmigration ceramics. Groups 6 and 7 contain Pinto Polychrome and Gila and Tonto Polychromes, respectively. Comparisons of chemical composition among these groups and samples from the Grasshopper, Silver Creek, and Zuni regions failed to reveal probable production loci for either group.

Finally, the analysis of White Mountain Red Ware (not included in the scatter plots) shows that Fourmile Polychrome

vessels were introduced into Point of Pines sometime in the early fourteenth century (Triadan 1997; Triadan, Mills, and Duff, chapter 7). Subsequently, Fourmile Polychrome vessels were reproduced at Point of Pines; the local copies are called Point of Pines Polychromes and are frequently associated with the occupation of outlying room blocks built in the mid- to late 1300s (Wendorf 1950).

COMPOSITIONAL, FORMAL, AND CONTEXTUAL TRENDS

Interpreting the intricate grouping described above requires the use of multiple perspectives. By integrating information on composition, artifact design, and context for each of the seven groups, one may begin to outline patterns of variation associated with different circulation mechanisms and forms of interaction. Here, compositional groups are first examined against assemblage structure. Then, the timing of appearance and recurrence of nonlocal wares in the recovery contexts is discussed. Last, variation in artifact design is addressed as it relates to interaction.

Assemblage structure and compositional groups

At the broadest level, one may distinguish two classes of compositional groups: multiware and single-ware. There are two sets of multiware groups in this sample: The first set, including Groups 1 and 2, represents the range of wares manufactured in the Point of Pines area. The second set, including Groups 3 and 4, is nonlocal and contains ceramics traditionally associated with the Kayenta migration episode. Both sets show the range of ware variability that one would expect to find in an average household (for example, painted and unpainted bowls and jars). Logically, migrating groups would have brought different kinds of artifacts and pots needed to continue with their daily activities while traveling and when first settling in the new home. These, of course, could have included nonlocal artifacts that the immigrants had made or obtained before or during their journey, thus introducing yet another element of variability into the record.

In contrast to multiware compositional groups or group sets, single-ware nonlocal groups might represent alternative circulation mechanisms. Single-ware nonlocal groups are most likely the result of exchange; the circulation of a single ware across communities/settlements suggests preferential consumption of particular kinds of pottery. The Point of Pines sample may be too small to be helpful in identifying and interpreting true single-ware nonlocal groups. Nevertheless, the relationship between these and multiware groups can

be evaluated with reference to other data sets, such that one from Chodistaas Pueblo in the Grasshopper region, where a very large whole vessel assemblage from floor and roof contexts was analyzed formally and compositionally (Crown 1981; Montgomery 1992; Zedeño 1994).

Timing and recurrence of ware groups

There is a key difference between local and nonlocal multiware group sets: The local groups include a broad temporal range, spanning at least a century. This temporal span is characteristic of a ceramic tradition that changed and was enriched both by experimentation and by different kinds of interactions. In contrast, the nonlocal multiware groups are strictly contemporaneous, dating to the late thirteenth century. The wares included in Groups 3 and 4 have neither antecedents in the earlier occupation at Turkey Creek Pueblo nor do they appear in the fourteenth century component at Point of Pines. Groups 3 and 4 probably represent household assemblages that were transported together for a long distance. Pottery broken along the migration route might have been replaced with vessels manufactured with immediately available clays or with pots obtained from other groups; this replacement would explain some of the compositional heterogeneity present in Tsegi Orange Ware, early Salado Polychromes, and Tusayan White Ware at Point of Pines. Ceramics introduced by the immigrants seemingly entered discard contexts within the first few years of arrival at the site; thereafter, they were replaced with pottery made with locally available clays. Indeed, most nonlocal pieces were recovered from trash deposits in or near the immigrant quarters, whereas very few remained on their room floors (Haury 1958:4). Replacement behaviors associated with the manufacture of Tsegi Orange and Tusayan White Wares are particularly distinctive, because their production loci were abandoned during the Great Drought. Abandonment of the homeland negated any possibility of obtaining Tsegi and Tusayan pots through exchange. Both wares ceased to be manufactured sometime around the turn of the fourteenth century.

Single-ware nonlocal groups have their own characteristics and associations in the ceramic record, which may not be at all visible unless information about recovery context as well as provenance is available. First, single-ware nonlocal groups tend to be ubiquitous in an assemblage, covering a broad temporal range. They may not, however, include the entire range of paste recipes, vessel shapes, sizes, and decorative motifs found at their production loci. Second, because of their ready availability from nonlocal sources, ceramics in sin-

gle-ware groups are seldom replaced or reproduced locally, unless they cease to be available. Third, a ware may be obtained from single or multiple sources, resulting in compositional heterogeneity within assemblages as well as shifts in source signatures through time. Fourth, when a ware becomes unavailable, it might be emulated by the local potters or even replaced with another ware. Cibola White Ware is undoubtedly the best example of circulation through exchange in east-central Arizona, exhibiting all the characteristics discussed above (Montgomery and Reid 1990; Van Keuren 1999; Zedeño 1995; Zedeño et al. 1993).

Variation in artifact design

The convergence of local and nonlocal potting groups is represented by hybrid artifact designs, which are interpreted here as indicating the establishment of long-term, face-to-face interaction between potters trained under different teaching frameworks. There are three types of behaviors involved in the development of a hybrid artifact design: first is replacement, or the manufacture of "nonlocal" pottery with locally available clays; these pots, made with foreign technologies, tend to be formally indistinguishable from nonlocal ones. Second is emulation, or the reproduction of foreign ceramics by the local potters, and vice versa. Reproductions generally show a wide range of variability, but maintain the standard technological characteristics of the potter's tradition. And third is the manufacture of true hybrids, or pots that incorporate elements of both traditions.

True hybrids, as opposed to replacements or emulation, represent a third artifact design that did not exist prior to the arrival of a foreign potting group. While emulation may occur by visual and tactile interaction between a potter and a foreign artifact and replacement simply indicates the presence of a foreign potting group, true hybridization generally implies face-to-face interaction between foreign and local potters. Hybrid ceramic technologies, too, have unique characteristics and associations in the ceramic record, which must be evaluated against those of emulation alone or independent innovation:

First, sufficiently large assemblages usually include a foreign ware along with replacements and local reproductions. The Point of Pines assemblage includes imported Tsegi Orange Ware, Tsegi Orange Ware made with local clays and foreign techniques, and Maverick Mountain polychromes. Maverick Mountain polychromes combine, to various degrees, formal properties of Tsegi Orange and other local and nonlocal wares. For example, bowls display Tsegi and Tusay-

an-like designs on interior surfaces, St. Johns Polychrome (White Mountain Red Ware) banded designs on exterior surfaces, thick-walled bowl shapes, and ground sherds often added to the local clays. Furthermore, there is a broader range of variation in Maverick Mountain vessel shapes than in Tsegi Orange Ware, for the latter are limited almost exclusively to bowls.

Second, the full spectrum of formal variation found in a foreign ware exhibits a hybrid ceramic design. At Point of Pines practically every color scheme and decorative motif of late Pueblo III Tsegi Orange Ware types is also reproduced in Maverick Mountain Polychromes. A similar process of hybridization may be found in White Mountain and Grasshopper Red Ware assemblages from the Grasshopper region (Triadan 1997).

Third, hybrid ceramic designs are not limited to the local manufacture of only one foreign ware. Whereas emulation generally is selective and limited to pottery not readily available through exchange, the hybridization process extends to all or most of the wares brought in the immigrants' assemblages, as needed in their daily activities. For example, aside from Tsegi Orange Ware, Kayenta perforated plates and corrugated jars were reproduced at Point of Pines (Lindsay 1987; Haury 1958:4). Pinto Black on Red and Pinto Polychrome bowls were also reproduced with northern and hybrid ceramic designs. Tusayan White Ware, on the other hand, may not have been replaced in significant numbers. This is not surprising, however, because the production of white wares had ceased across the Western Anasazi and Mogollon regions by the early fourteenth century.

It must be taken into account that hybridization may take different forms and intensities, affecting each assemblage differentially. Face-to-face interaction among ethnically diverse potters may not necessarily lead to changes in the artifact designs of either tradition. The processes by which interaction leads to the development of new artifact designs may depend on a potter or potting group's ability or willingness to access—or to provide access to—information and resources needed to that effect. These processes, too, are subject to historical contingency. In the case of Point of Pines, hybridization introduced the new, short-lived Maverick Mountain Polychromes (ca. AD 1285 to 1300). This ware reflects, to a large extent, the immigrant group's ability to incorporate aspects of local artifact designs. According to Haury's (1958:5–6) dendrochronological reconstruction, immigrants were burned in their quarters within less than twenty-five years of their arrival. Thereafter, the Point of Pines dwellers built an

exterior wall around the pueblo. The northern ceramic tradition outlived the people perhaps a few more years at Point of Pines and other immigrant sites located in the Safford Valley (Woodson 1994) before it was replaced by other polychrome wares. Elements of the immigrants' tradition, however, lingered on in Salado and Tucson Polychromes (Crown 1994; Lindsay 1992).

Thus, from Point of Pines one may learn that ethnic coresidence can visibly change assemblage structure within a generation or less, given access to information and resources. Reproduction and persistence of these changes, on the other hand, may depend on the duration of the interaction and the degree to which all interacting potting groups were involved in the process of innovating their own artifact designs. It is only through detailed contextual analysis of compositionally and technologically varied assemblages that one may begin to develop correlates for these processes. New data on a possible episode of immigration of Kayenta Anasazi people into Homolovi I includes ceramic assemblages exhibiting most of the characteristics discussed here (Lyons 1999). A future comparative analysis may reveal in greater detail the nature of technological, compositional, and contextual variation associated with the presence of immigrant potters at a settlement.

A word of caution is in order. Depending on contextual and historical contingencies, circulation patterns of a single ware can vary from region to region or even from site to site. Within a site, a ceramic ware may indicate local production, migration, coresidence, and exchange (Zedeño 1998). This is the case of the Salado Polychromes at Point of Pines. The Point of Pines sample includes at least two multi-ware and two single-ware sources of Salado Polychromes. Some of the earliest Salado Polychromes were likely introduced by immigrant groups, thus lending support to Crown's (1994:213) hypothesis on the correlation between the Kayenta migration and the spread of the early Salado pottery across the Southwest. Point of Pines is the only known site in the Southwest where the earliest Salado types are found in direct association with Kayenta Anasazi ceramics (Haury 1976). However, the intricate compositional, temporal, and formal variation of Salado ceramics throughout the occupation of Point of Pines and other contemporaneous sites, such as Grasshopper (Reid et al. 1992), suggests that emulation, replacement, and hybridization of this ware occurred in tandem with exchange. This hybrid technology persisted for at least one century and was reproduced at and beyond Point of Pines, thus representing a far more complex range of people-people and people-artifact interactions than that marked by Maverick Mountain Polychromes.

The modes and contexts of manufacture and circulation of the early Salado Polychromes remain as mysterious as ever. Specific formal properties of Pinto Black on Red and Pinto Polychrome vessels associated with the Kayenta Anasazi ceramics, such as wall thickness, surface finish, slip and paint color and texture, and execution of Tularosa and Pinedale decorative motifs, suggest that the northern immigrants became acquainted with Salado Polychromes shortly before or during their journey. The immigrant potters' long-standing ceramic tradition contained the necessary technical knowledge for manufacturing Salado ceramics, including the application of organic black paints over red and white slips. What these potters lacked were the motor habits and structural rules for executing the classic motifs of the Tularosa-Pinedale stylistic tradition that characterizes some of the earliest Pinto pottery (Crown 1981; 1994). Instead, they used Dogoszhi- and Tusayan-style grammar to emulate them. The implications of the association of Salado Polychromes and the Kayenta Anasazi are yet to be fully understood. Ongoing research along the Middle Little Colorado Valley and regional comparisons suggest that the Salado Polychrome "concept" may be traced to at least two parent traditions (Lyons 1999).

CONCLUSIONS

The complex compositional patterning discussed here is to be expected when nonlocal ceramics enter an assemblage through different mechanisms of circulation. Distinguishing each of these mechanisms requires that the behaviors involved in the generation of variability in artifact design be examined without the distorting lens of dichotomous thinking. Here I have discussed how different types of interactions may introduce signature changes in a ceramic tradition and how we can use these signatures for identifying circulation mechanisms.

Migration and ethnic coresidence have a distinctive effect on ceramic manufacture and circulation; most notably, they can trigger the development of hybrid ceramic technologies. The ceramic record of migration and coresidence must be analyzed from compositional, contextual, and formal perspectives. A single perspective, alone, does not provide the information needed to distinguish migration-related variability from other sources of ceramic variation. A similar multidimensional approach should be helpful for isolating variation due to exchange. Unfortunately, compositional studies commonly emphasize production and distribution of single wares. Such a narrow focus confines the interpretation of ceramic

variability to distributional patterns that may not reveal the full range of behaviors that produce complex and varied ceramic assemblages.

Single-ware distributional analysis is particularly pernicious in regions where prehistoric potters selected different clay sources to manufacture different wares, as is the case of numerous ceramic manufacturing loci in the Colorado Plateau (Zedeño et al. 1993). In such cases, one cannot argue convincingly that the nonlocal distribution of a ware was the product of mobility, migration, or exchange without analyzing other wares that were part of the same manufacturing tradition. Ideally, distributional and assemblage analyses should be complementary, providing both interregional and in-depth contextual perspectives on ceramic variability. This is the approach that a number of volume contributors have taken and that should lead to more parsimonious interpretations of ceramic variability in the Southwest.

Acknowledgments. The research presented in this paper was funded by the National Science Foundation (NSF) (SBR-9507599). Instrumental neutron activation analysis was conducted at the University of Missouri-Columbia research reactor facility (NSF Grant DBS-9102016). R. Thompson authorized the use of Point of Pines ceramics housed in the Arizona State Museum (ASM); L. Lindsay helped me select the samples from the ASM collection; E. Hughes and J. Bell facilitated the loan of these materials. Permission to collect clays was granted by the San Carlos Apache Tribe. Comparative samples were furnished by E. C. Adams (ASM), K. Hayes-Gilpin (Northern Arizona University), M. Elson (Desert Archaeology, Inc.), K. Woodson (Gila River Indian Community), A. Sullivan (University of Cincinnati), the Navajo Nation Historic Preservation Department, and the National Park Service. A. Duff, D. Larson, H. Neff, B. Mills, and D. Triadan allowed me to use their INAA data for comparison. I owe special thanks to all the colleagues for their comments, especially P. Crown, D. Glowacki, B. Mills, H. Neff, A. Nielsen, JJ Reid, M. Schiffer, M. Smith, D. Triadan, B. Walker, two anonymous reviewers, and the students from the Laboratory of Traditional Technology.

Notes

1. The Pinto Polychrome samples from Point of Pines submitted to INAA by Crown (1994) and to ICP by White and Burton (1992) are an exception.
2. Of these, sixty-three samples including specimens of Kinishba red, Kinishba Polychrome, White Mountain Red Ware, and Point of Pines Polychrome were analyzed by Daniela Triadan (see chapter 7).

From Compositional to Anthropological

Fourteenth-Century Red-Ware Circulation and Its Implications for Pueblo Reorganization

Daniela Triadan, Barbara J. Mills, and Andrew I. Duff

MIGRATION AND SUBSEQUENT SOCIAL and political reorganization have again become a focus of archaeologists studying the late prehistoric period in the Greater Southwest (see, for example, Adler 1996; Cameron 1995; Duff 1998; Mills 1998; Spielmann 1998). In contrast with earlier diffusionist models that concentrated on site intrusions (for example, Di Peso 1958; Haury 1958; Rouse 1958), researchers today acknowledge that migration is a complex process. They focus on questions such as how and why people moved, the distances moved, and the social scale of migration (Anthony 1990; Duff 1998). Ceramic distributions, long used to delineate culture areas (such as Anasazi, Mogollon, and Hohokam) and their subregions (such as Western and Eastern Anasazi), and to trace migrations are consequently also re-evaluated along these lines of questioning.

Clearly, the spatial distribution of ceramics is the result of a complex array of prehistoric behavior. The patterns observed in the archaeological record may be the result of trade or other forms of exchange, information transfer, residence patterns, migration, or combinations of these factors. However, we think that mobility played an integral part in the distribution of fourteenth-century painted wares in east-central Arizona (Triadan 1997, 1998) and the spread of similar design styles.

During the thirteenth and fourteenth centuries, the northern Southwest was characterized by substantial population movements. Around AD 1280, large areas on the northern part of the Colorado Plateau and in the Four Corners region were abandoned as locations of permanent habitation. At the same time, settlement aggregation accelerated in areas on the southern Colorado Plateau, in the mountainous regions south of the Mogollon Rim, and in the Zuni and Hopi areas. These population shifts coincided with the production of new types of polychrome ceramics and the widespread use of stylistically similarly painted ceramic wares. For instance, the Pinedale decorative style developed during the late AD 1200s and was applied to several different wares, such as Roosevelt Red, White Mountain Red, Zuni Glaze, and Cibola White (see Carlson 1970; Crown 1994). Also, between AD 1300 and 1320, a dramatic shift of design concepts occurred in the northern Southwest, as designs on painted pottery changed from largely geometric concentric patterns to boldly asymmetrical layouts. Examples are the Fourmile style of White Mountain Red Ware (Carlson 1970:94), and the Sikyatki style of Jeddito Yellow Ware (Hays 1991).

The integration of ceramic compositional analyses and other archaeological data (for example, Bishop et al. 1988; Crown 1994; Triadan 1997; Zedeño 1994; chapter 6) has the potential to reconstruct some of the processes involved in the social and demographic changes that occurred in the northern Southwest in late prehistory. However, to assess demographic developments that took place over a large geographic area using ceramics, we must apply compositional analyses at a scale comparable to the processes we seek to understand. Given the cost and time involved in chemical and mineralogical characterization, a collaborative approach in addressing these problems is essential.

Each of the authors conducted compositional research on late thirteenth- and fourteenth-century painted ceramics from neighboring areas in east-central Arizona, which provided the opportunity to pool our compositional databases. The research presented here focuses predominantly on the production and distribution of late thirteenth- and four-

Fourmile Polychrome
circa AD 1320–1380

Cedar Creek Polychrome
circa AD 1300–1320

Pinedale Polychrome
circa AD 1260–1320

St. Johns Polychrome
circa AD 1175–1260

St. Johns Black-on-red
circa AD 1175–1260

7.1 Thirteenth- and fourteenth-century White Mountain Red Ware types. *Illustration prepared by Daniela Triadan*

teenth-century White Mountain Red Ware and its social and demographic implications, but includes contemporaneous painted ceramic wares and types that overlap with its distribution, such as Cibola White Ware.

White Mountain Red Ware was produced from approximately AD 1100 to 1400 and can be divided into several chronologically distinct types (figure 7.1). Following Carlson's (1970) classification, the White Mountain Red Ware series diverged at the end of the 1200s into a western and eastern series of types. For this study, the eastern types are referred to as early Zuni Glaze Ware; White Mountain Red Ware is reserved for the western series.

White Mountain Red Ware is generally characterized by a light paste, tempered with sherd and quartz, and a distinctive orange-red slip that covers the entire vessel. Designs are painted in black or, in the case of the polychrome types, black-and-white mineral paint (Carlson 1970). The following White Mountain Red Ware types are of relevance to this study: Pinedale Black-on-red, Pinedale Polychrome, Cedar Creek Polychrome, and Fourmile Polychrome (see figure 7.1).

Cibola White Ware is stylistically related to White Mountain Red Ware and has similar paste characteristics. In fact, Carlson (1970:1) states that the main difference between the two wares is the color of the slip. One difference between White Mountain Red Ware and Cibola White Ware is the firing technology used in the production of some Cibola vessels. Cibola White Ware pots were decorated either with iron-based or manganese-based paints (Zedeño 1994). In contrast to White Mountain Red Ware, the Cibola White Ware vessels that were decorated with iron-based paint were probably fired in a mostly reducing atmosphere, at least at the end of the firing cycle. The Cibola White Ware type of Pinedale Black-on-white dates to about AD 1260 to 1350; after AD 1280 it occurs mostly as jars.

White Mountain Red Ware is one of the polychrome wares that were widely distributed in east-central Arizona during the late thirteenth and fourteenth centuries (Carlson 1970: Figs. 24, 28, 32, 38; Graves 1982:319; Haury 1934:129, Fig. 23). Because of this wide distribution and relative stylistic and technological uniformity, White Mountain Red Ware has long been at the center of models of trade (for example, Carlson 1970; Graves 1982) and socio-political organization (Cordell and Plog 1979; Lightfoot and Jewett 1984; Upham 1982; Upham, Lightfoot, and Feinman 1981). Indeed, it has played a pivotal role in the reconstruction of late prehistoric Pueblo organization in east-central Arizona, exchange being

the underlying explanatory framework for its circulation in all these models. More recently, however, Triadan (1997:94, 106) has argued that migration was likely an important factor in the distribution of these ceramics.

LATE PREHISTORIC SETTLEMENT DEVELOPMENT AND PAINTED CERAMIC DISTRIBUTIONS

This study focused on the core areas of late White Mountain Red Ware distribution: the Silver Creek and Upper Little Colorado drainages, as well as areas to the north and south of the Mogollon Rim (figure 7.2), where these ceramics became very common or even the predominant painted ware during the late thirteenth and fourteenth centuries. What follows is an overview of the settlement trends and ceramic assemblages in these areas.

Throughout its history of occupation, the Silver Creek area was generally characterized by low population densities (Mills 1998; Newcomb 1997, 1999). Ceramic assemblages of sites dating to the early to mid-1200s in the upper Silver Creek drainage are dominated by Cibola White Ware and Show Low Red Ware, whereas assemblages of contemporaneous sites farther to the northeast, for instance in the Hay Hollow Valley, contain Cibola White Ware, White Mountain Red Ware, and Roosevelt Red Ware. At approximately AD 1275, the population in the Silver Creek area aggregated into fewer, larger villages that were established around this time (figure 7.3). Immigration into the area was probably a contributing factor to the aggregation. White Mountain Red Ware, Cibola White Ware, and Pinto Polychrome, a Roosevelt Red Ware type, are present in the assemblages of these larger sites. Sometime between AD 1320 to 1330, another period of settlement reorganization occurred and some of these sites were abandoned (figure 7.4). The region was totally abandoned for residential purposes by approximately AD 1400 (Mills 1998).

Settlement aggregation in the Upper Little Colorado region began at about the beginning of the thirteenth century, and is characterized by two different architectural patterns. In the area near Springerville, sites occur along tributaries of the Upper Little Colorado River and resemble Tularosa Phase settlements of the Pine Lawn Valley (for example, Martin et al. 1956, Martin, Rinaldo, and Barter 1957). Characterized by agglomerative growth, these sites range from twenty to sixty rooms and most of them have square great kivas. Farther down-river, toward St. Johns, aggregated settlements consisted of multiple room blocks clustered around post-Chacoan

great houses with circular kivas in a pattern characteristic of Cibolan aggregation (Kintigh 1994; Kintigh, Howell, and Duff 1996). Despite this difference in settlement plan, the painted ceramic assemblages from these sites are similar. They are characterized by Cibola White, White Mountain Red, and early Zuni Glaze wares. All these villages appear to have been abandoned around AD 1280, when a shift to larger settlements, located immediately adjacent to the Upper Little Colorado River, occurred (Kintigh 1996; figure 7.3), some of which were abandoned by circa AD 1325. Several additional large pueblos were constructed along the river at about AD 1330 and occupied until the region was abandoned after AD 1380 (figure 7.4). Ware frequencies differ among these late thirteenth and fourteenth-century sites, but all have Cibola White, White Mountain Red, Zuni Glaze, Roosevelt Red, and Jeddito Yellow. Sites near St. Johns have greater proportions of Jeddito Yellow and Roosevelt Red Wares, while those to the south contain more Zuni Glaze, White Mountain Red and Cibola White Wares (Duff 1999).

Prior to the fourteenth century, settlement density in the Grasshopper region was very low (Reid 1989; Reid et al. 1996; Tuggle 1970). Only a few small settlements that date to circa AD 1260 to 1290 (figure 7.3) existed in the area, and these may represent seasonal occupations. Cibola White Ware was the predominant painted ceramic ware, with some Roosevelt Red Ware also present (Montgomery and Reid 1990; Zedeño 1994). Major settlement aggregation in the region started around the beginning of the fourteenth century, and numerous large pueblos were established and continued to expand during the next thirty years (Reid et al. 1996; Reid, Tuggle, and Klie 1982; Tuggle 1982; figure 7.4). Painted ceramic assemblages at these sites consist predominantly of White Mountain Red Ware (mostly Fourmile Polychrome), Grasshopper Polychrome, a local copy of Fourmile Polychrome, and the Roosevelt Red Ware types of Pinto-Gila, Gila, and Tonto Polychrome. After AD 1325 to 1330, some settlement dispersion seemed to have occurred and smaller settlements were established in highly defensive locations in cliffs and on top of high buttes in the area between the Grasshopper Plateau and the Sierra Ancha (Ciolek-Torrello and Lange 1990; Reid, Tuggle, and Klie 1982; Reid et al. 1996; Tuggle 1982; Tuggle et al. 1982). The area was completely abandoned around AD 1400.

In the Kinishba region settlement aggregation started somewhat earlier, during the late thirteenth century. Some fairly large settlements containing mostly Cibola White Ware were established (figure 7.3, see also Reid et al. 1996; Spier

7.2 Location of sites
from which
ceramics were
sampled and
analyzed by INAA.
*Illustration
prepared by
Daniela Triadan*

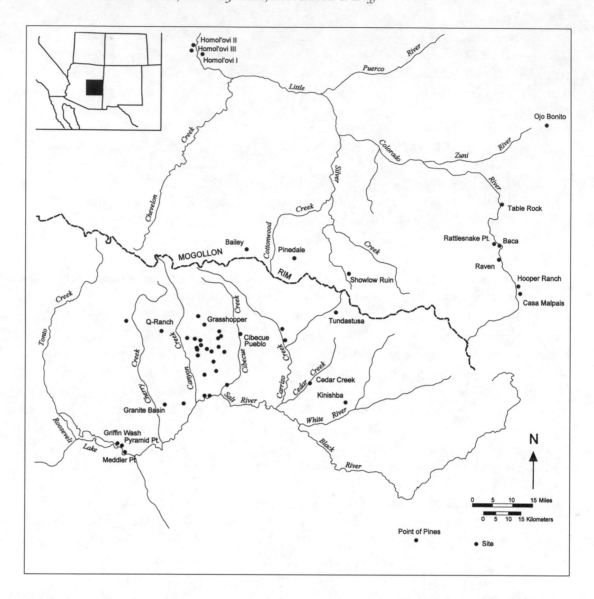

1918). During the fourteenth century, aggregation culminated in several large villages (figure 7.4; Spier 1918). The ceramic assemblages of these sites are characterized by large quantities of White Mountain Red Ware (mostly Fourmile Poly-chrome) Roosevelt Red Ware, and a red-slipped, unpainted type, Kinishba Red.

In the Point of Pines region aggregation also started in the 1200s. At least one large settlement, Turkey Creek Pueblo, with more than three hundred rooms was established around AD 1240 (Lowell 1991:15); Point of Pines Pueblo was founded around AD 1275 (figure 7.3). By about AD 1280, Turkey Creek was abandoned and it appears that its inhabitants moved to nearby Point of Pines Pueblo (Haury 1989:117). The most common painted ceramics in these early sites were Cibola White Ware, McDonald Painted, McDonald Painted Corrugated, and Tularosa White-on-red. In the fourteenth century,

aggregation culminated in the very large settlement of Point of Pines, which at the peak of its occupation had over eight hundred rooms, and a few smaller sites in its vicinity (figure 7.4; Haury 1989:117–118). Point of Pines is one of the late prehistoric sites where the immigration of people, in this case from the Kayenta area, has been conclusively demonstrated (Haury 1958) and is clearly reflected in the ceramic assemblage (Lindsay 1987; Zedeño, chapter 6). During the fourteenth century, White Mountain Red Ware became the predominant painted ware in the Point of Pines region (see chapter 6).

During the Roosevelt Phase, circa AD 1250 to 1325, pueblo-style room blocks and Black-on-white and White Mountain Red Ware pottery occurred in the eastern Tonto Basin. Assemblages of painted pottery at sites with masonry room blocks (figure 7.3) are very similar to assemblages of contem-

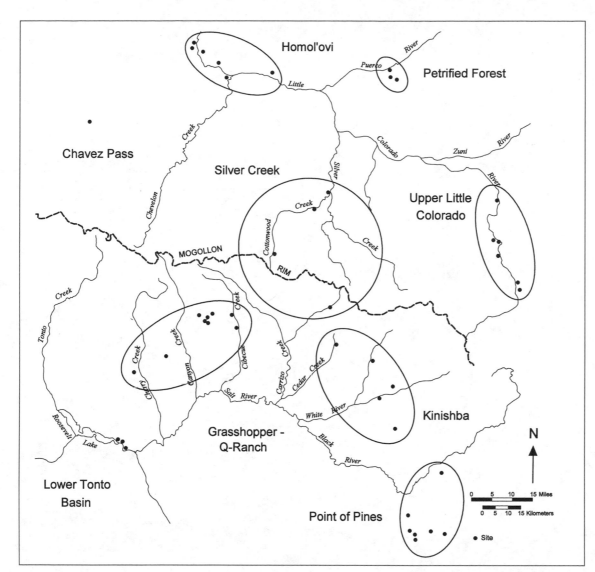

7.3 Large late thirteenth- to early fourteenth-century settlements (circa AD 1260 to 1330). *Illustration prepared by Daniela Triadan*

porary sites in the nearby Mogollon highlands. On the basis of these findings M.T. Stark, Elson, and Clark (1995), and Clark (1995) argue for the immigration of Puebloan groups from the mountain areas to the north and northeast, starting around AD 1275. The resident population continued to live in dispersed settlements made up of individual compounds. After circa AD 1325, at the beginning of the Gila Phase, some people abandoned the area whereas the rest of the population aggregated in a few large settlements (figure 7.4). At that time, compounds ceased to exist and the villages that were still occupied consisted of blocks of contiguous rooms. Painted ceramics are predominantly Roosevelt Red Ware, particularly Gila and Tonto Polychrome. The eastern Tonto Basin was abandoned by the end of the Gila Phase around AD 1400.

There is no archaeological evidence for a resident population between AD 1225 and 1260 (E.C. Adams 1996; 1998) in

the Middle Little Colorado River area. Thus, the late thirteenth- and fourteenth-century villages were all established by newcomers to the region. According to E.C. Adams (1998), Homol'ovi IV was built around AD 1260 and occupied until circa 1280, probably by people with ties to the Hopi mesas. Decorated ceramics found at Homol'ovi IV are predominantly Winslow Orange Ware, followed in frequency by Jeddito Orange Ware. Homolovi IV was abandoned around AD 1280 and replaced by five settlements (figure 7.3) that were established by people who may have come from the Silver Creek drainage. Painted ceramics at these sites are White Mountain Red Ware and local Winslow Orange Wares decorated predominantly in Pinedale style that generally copy White Mountain Red Ware types (E.C. Adams 1996, 1998). One of these settlements, Homol'ovi III was abandoned around 1300, but periodically reused; the others were aban-

7.4 Large mid-fourteenth-
to late fourteenth-
century settlements
(circa AD 1330 to 1400).
*Illustration prepared by
Daniela Triadan*

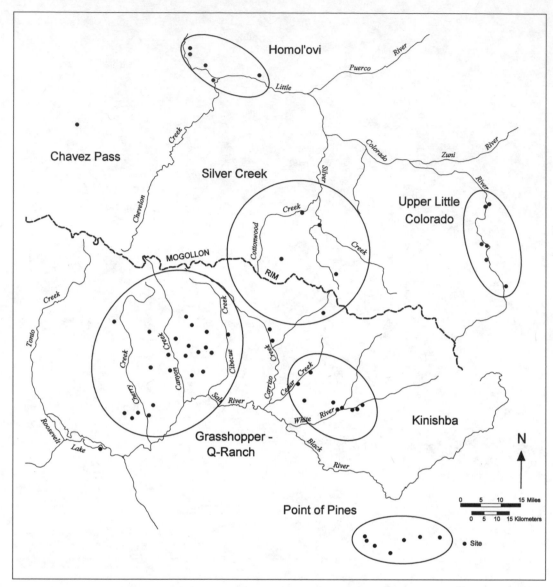

doned between about 1375 and 1400 (figure 7.4). Homol'ovi II, the largest settlement in the Middle Little Colorado drainage, was occupied from circa 1330 until some time after 1400 (E.C. Adams 1998). It had close ties to the villages on the Hopi Mesas (E.C. Adams and Hays 1991). The majority of the decorated ceramics at this site were Jeddito Yellow Ware that were probably produced on the Hopi mesas (Bishop et al. 1988). The Middle Little Colorado River area was completely abandoned shortly after AD 1400.

To summarize, during the late 1200s White Mountain Red Ware occurred in high proportions in ceramic assemblages of sites in the Silver Creek area (Mills 1998, 1999), as well as sites in the Upper Little Colorado drainage. After AD 1300 the ware became the *predominant painted pottery* in areas south of the Mogollon Rim, such as the Grasshopper, Kinishba, and Point of Pines regions, where settlements became

highly aggregated during this time (Haury 1989; Lowell 1991; Reid 1989; Reid et al. 1996) and where it had been scarce before. It replaced Cibola White Ware in these areas (Montgomery and Reid 1990). Also, around AD 1275 White Mountain Red Ware started to occur in considerable quantities in some newly established settlements in the eastern Tonto Basin around today's Roosevelt Lake (Christenson 1995; Heidke 1995a; Heidke and Stark 1995: App. D) and in settlements in the Homol'ovi area (E.C. Adams 1996, 1998). At the same time, settlements in the former core distribution areas were abandoned. Thus, the distribution of late prehistoric White Mountain Red Ware seems to be intricately linked to demographic developments in east-central Arizona.

Previous compositional research on White Mountain Red Ware from the Grasshopper region and sites in adjacent areas south of the Mogollon Rim by Triadan (1997) has demon-

strated that this pottery was imported into these areas during the early 1300s and could be differentiated into at least two distinct compositional groups. These nonlocal ceramics were made from light-firing clays and were tempered with sherds and quartz (Triadan 1997: Plates 3, 4). Later in the occupation of Grasshopper Pueblo, diabase-tempered, brown-paste copies of White Mountain Red Ware were produced that are classified predominantly as Grasshopper Polychrome. These vessels are compositionally distinct from the imports and match archaeological and source clays from the pueblo (Triadan 1997:29–55, Plates 5, 6). Similar to the Grasshopper region, White Mountain Red Ware was not part of the indigenous ceramic traditions prior to settlement aggregation in other areas outside the Silver Creek and Upper Little Colorado drainages, such as the Kinishba, Point of Pines, and Homol'ovi regions and the Tonto Basin. It is thus reasonable to assume that light-paste, sherd-tempered White Mountain Red Ware was imported into these areas as well. In addition, these regions are geologically distinct from the Silver Creek and Upper Little Colorado drainages and from each other, and raw materials used for local pottery production should reflect mineralogical and chemical signatures that are characteristic for each of these areas. Hence, compositional analyses should provide data that allow us to investigate whether geographical shifts of White Mountain Red Ware production loci occurred and to assess patterns of its circulation.

REGIONAL GEOLOGY

Geological diversity defines the ability of archaeologists to identify the provenance of ceramics. The chemical and mineralogical compositions of clays are determined by the geological formations from which they weather. Depending on the presence or absence of particular geological strata, clays may differ from region to region, and certain types of clay may be characteristic for specific areas. Thus, clays not only reflect their geologic origin, but may reflect their geographic provenance as well. In addition, crushed igneous rocks were often used as tempering agents, and igneous formations can be highly localized and unique to a specific area.

The Silver Creek, Upper Little Colorado and Homol'ovi areas all lie north of the Mogollon Rim on the southern part of the Colorado Plateau. The southern boundary of the Silver Creek drainage is the Mogollon Rim, which also marks the southern edge of the plateau. At the higher elevations along the rim are extensive deposits of undifferentiated Cretaceous sandstones and shales, capped by Tertiary "rim gravels." The Cretaceous rocks are marine and nonmarine

nearshore deposits that contain fine- to coarse-grained feldspathic sandstones (Nations 1989; Stinson 1996:44). Pockets of Tertiary Bidahochi Formation sandstones and claystones are found further north, within 16 to 24 km of the rim. A zone of Middle Permian Kaibab Limestone is located in the middle reaches of the drainage, but closer to its confluence with the Little Colorado, Silver Creek cuts through Middle and Lower Triassic Period Moenkopi Formation deposits (figure 7.5; Reynolds 1988; see also Garrett 1982; Mills et al. 1999; Stinson 1996).

Quaternary cinder cones and basalt flows cover much of the southern portion of the Upper Little Colorado drainage (figure 7.5; Wilson, Moore, and O'Haire 1960). Immediately beneath these basalt deposits are numerous Quaternary terrace gravels. The flood plains are generally characterized by deposits of Quaternary alluvium. Small outcrops of Cretaceous deposits are restricted to this southern part of the region (see figure 7.5; Sirrine 1958: 51, 55, Plate 6). The Petrified Forest Member of the sedimentary Late Triassic Chinle Formation is exposed from the Richville Valley north to the slopes that surround the St. Johns Valley. In the St. Johns Valley there are also outcrops of both Triassic Moenkopi Formation and Shinarump Conglomerate deposits (figure 7.5; Akers 1964; Duff 1999; Wilson, Moore, and O'Haire 1960).

The Middle Little Colorado River drainage, where the Homol'ovi group of late thirteenth- and fourteenth-century sites is situated, consists of an extensive alluvial floodplain. North of the river are predominantly sedimentary deposits of the Shinarump Conglomerate of the lower member of the Late Triassic Chinle Formation, with occasional outcrops of the Tertiary Bidahochi Formation which form isolated mesas. These rocks overlie the Early Triassic sedimentary Moenkopi Formation which is exposed extensively to the south of the river (figure 7.5).

The Kinishba and Grasshopper regions and the Tonto Basin are located south of the Mogollon Rim in a mountainous transition zone between the Colorado Plateau Zone and the Basin-and-Range Zone to the south (Moore 1968:4–6). The area around Kinishba is characterized by Quaternary alluvial deposits (on which the pueblo is located), and basaltic flows in the North Fork and lower drainage of the White River. These Quaternary deposits overlie sedimentary deposits of the Pennsylvanian-Permian Supai Formation, and the older Naco Formation that outcrops farther to the west. To the east, the area is dominated by extensive Quaternary extrusive andesitic to basaltic flows, tuffs, and agglomerate that form

the peaks of the White Mountains (figure 7.5; Moore 1968:58–59, 79–80, Plate 2; Reynolds 1988).

Point of Pines is located about 60 km southeast of Kinishba on the Natanes Plateau, which forms an escarpment overlooking Bonita Creek and the Gila Mountains to the south. The area consists almost exclusively of Tertiary extrusive volcanic rocks, predominantly tuffs, and some Tertiary to Quaternary alluvium (figure 7.5; see chapter 6, for a more detailed description).

The Grasshopper Plateau is part of a physiographic sub-province called the Carrizo Slope (Moore 1968:6–8) and extends from the Canyon Creek/Oak Creek drainage in the west to Cibecue Creek in the east. The northern and southern boundaries are the Mogollon Rim and Salt River Canyon, respectively. The area is characterized predominantly by Paleozoic sediments that overlie Younger Precambrian rocks. Marine sediments of the Pennsylvanian Naco and the Pennsylvanian–Permian Supai formations form a large part of the area. To the north along the Mogollon Rim, Upper Paleozoic formations, such as the Permian Coconino Sandstone and the younger Kaibab Formation, are overlain by undifferentiated Cretaceous sandstones and shales and Tertiary "rim gravels" consisting of consolidated gravel and conglomerate. To the south the "rim gravels" cap the sediments of the Naco and the lower member of the Supai formations on mountains and ridges (figure 7.5; Moore 1968:57–61, Plate 2). The area to the west of the Grasshopper Plateau consists predominantly of Older Precambrian granitic and related intrusive igneous rocks and a greenstone metadiorite complex. Overlying these igneous rocks are Younger Precambrian sedimentary rocks and extensive outcroppings of intrusive diabase.

The Tonto Basin immediately to the south and west of this area is characterized by extensive Tertiary to Quaternary alluvial deposits along Tonto Creek. The eastern part of the basin is bounded predominantly by granitoid rocks of Precambrian age with some outcroppings of diabase and Younger Precambrian sedimentary deposits (figure 7.5; Reynolds 1988).

The above described regions are clearly highly distinctive in their geology. Thus, raw materials used in local pottery production should reflect mineralogical and chemical signatures that are unique for each region, and indeed do, as we will discuss below.

COMPOSITIONAL ANALYSES

To assess the production and circulation of thirteenth- and fourteenth-century painted ceramics from a supraregional perspective, we merged our compositional data. Our samples consisted predominantly of fourteenth-century White Mountain Red Ware, mostly Fourmile Polychrome (figure 7.1). However, as we were investigating processes that took place over time, we also analyzed a number of additional types and wares to help assess changes in production and to establish regional reference groups (for example, Schneider, Hoffmann, and Wirz 1979).

All ceramics were analyzed by instrumental neutron activation analysis (INAA) either at the University of Missouri Research Reactor Center (MURR) or at the Smithsonian Center for Materials Research and Education (SCMRE, formerly the Conservation Analytical Laboratory) in collaboration with the reactor at the National Institute of Standards and Technology (NIST). We followed sampling and analytical procedures described by Blackman (1986) and by Glascock (1992; see also chapter 2). Interlaboratory comparability was achieved by using the same standard reference materials and check standard at both facilities. Data could thus be directly compared without calibration.

By pooling our respective compositional data sets, a regional database of 817 analyzed ceramics and source materials was created. The database includes Triadan's (1997) data from the Grasshopper region and adjacent mountain areas. Sites that were substantially sampled are: Grasshopper, Kinishba,

OPPOSITE: 7.5 Geological map of areas north and south of the Mogollon Rim in east-central Arizona. Qy, Q, Qo =alluvial deposits (Holocene to latest Pliocene); Tsy =sedimentary parts of the Bidahochi Formation (Pliocene to middle Miocene); QTb, Tby, Tb=basaltic rocks (Holocene to middle Miocene); Tvy=rhyolithic to andesitic rocks associated with units Tby and Tb (Pliocene to middle Miocene); Tv=silicic to mafic flows and pyroclastic rocks (middle Miocene to Oligocene); Tsm, Tso=sedimentary rocks, predominantly "rim gravels" and associated finer grained rocks (Tso) in the area along and south of the Mogollon Rim to the Salt River (middle Miocene to Eocene); Ks=sedimentary rocks, Dakota Sandstone and Mancos Shale and related rocks (Cretaceous); TRC=Chinle Formation (Late Triassic); TRM=Moenkopi Formation (Middle [?] and Early Triassic); P=Kaibab Limestone and Coconino Sandstone (Permian); PP=sedimentary rocks, Supai Group (Permian/Pennsylvanian) and Naco Group (Pennsylvanian); MC=sedimentary rocks, Redwall Limestone (Mississipian) and Martin Formation (Devonian); Ys=sedimentary rocks Troy Quartzite, Mescal Limestone and Apache Group (middle Proterozoic); Yd=diabase (middle Proterozoic); TKg, Yg, Xg=granoid rocks (middle Proterozoic to early Proterozoic); Xq=Quartzite (early Proterozoic); and Xm, Xms, Xmv=metamorphic, metasedimentary, and metavolcanic rocks (early Proterozoic) *After Reynolds 1988. Illustration prepared by Daniela Triadan*

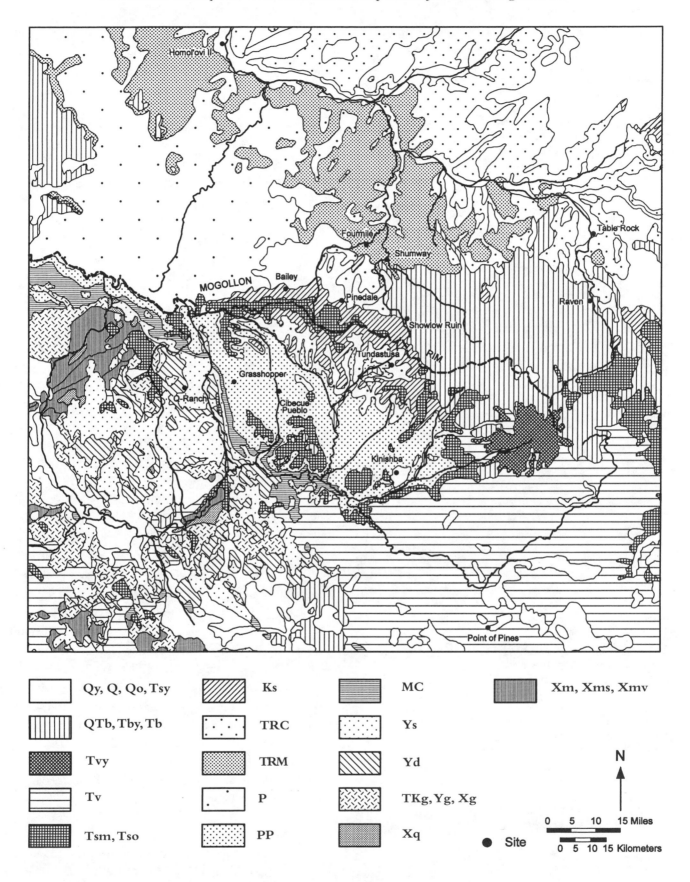

Daniela Triadan, Barbara J. Mills, and Andrew I. Duff

Table 7.1 Proveniences of ceramic samples analyzed by INAA

Site	Name	# of samples
AZ P:13:2	Young Pueblo	3
AZ P:14:1	Grasshopper Pueblo	122
AZ P:14:12	Hilltop Pueblo	8
AZ P:14:13	Brush Mtn. Pueblo	9
AZ P:14:14	Red Rock House	6
AZ P:14:15	Oak Creek Pueblo	4
AZ P:14:25	Red Canyon Tank Pueblo	5
AZ P:14:71		5
AZ P:14:281		7
AZ V:2:1	Canyon Creek Cliff Dwelling	7
AZ V:2:3	Spotted Mtn. Pueblo	7
AZ V:2:5	Hole Canyon Cliff Dwelling	3
AZ V:2:7	Ruin's Tank Pueblo	9
AZ V:2:13	Blue House Mtn. Pueblo	6
AZ V:2:23		4
AZ V:2:49	Canyon Butte Pueblo	6
AZ V:2:62		6
AZ V:2:79	Double Springs Cliff Dwelling	2
AZ V:2:83		6
AZ V:2:87		7
GFS 81-79		5
GFS 82-1	Spring Creek Pueblo	7
GFS 85-3 (Spier 251)	Cedar Creek Pueblo	31
GFS 86-3	Black Mtn. Pueblo	8
AZ P:15:4 (Spier 263)	Carrizo Creek Pueblo	5
AZ P:15:12 (Spier 264)	Blue Spring Pueblo	5
GFS89-6	Sanrace Cliff Dwelling	1
AZ V:4:1	Kinishba Pueblo	143
AZ P:16:3	Tundastusa	5
AZ P:15:13	Cibecue Pueblo	5
AZ V:1:26	Granite Basin Ruin	3
AZ P:12:2	Pinedale Ruin	9
AZ P:12:3	Showlow Ruin	5
AZ P:13:13	Q-Ranch	6
AZ P:11:1	Bailey Ruin	62
AZ W:10:50	Point of Pines	63
AZ V:5:1	Pyramid Point	17
AZ V:5:4	Meddler Point	6
AZ V:5:90	Griffin Wash	51
AZ J:14:3	Homol'ovi I	18
AZ J:14:14	Homol'ovi III	11
AZ J:14:15	Homol'ovi II	6
AZ Q:7:5	Table Rock Pueblo	11
AZ Q:11:118	Rattlesnake Point	15
AZ Q:11:74	Baca Pueblo	14
AZ Q:11:48	Raven Ruin	8
AZ Q:15:3	Casa Malpais	3
AZ Q:15:6	Hooper Ranch	15
LA 11433	Ojo Bonito	2
TOTAL		772

Note: AZ are Arizona State Museum survey numbers, GFS are Grasshopper Field School numbers, and LA is a Laboratory of Anthropology (New Mexico) number.

Cedar Creek, Point of Pines, three sites in the Tonto Basin, three sites in the Homol'ovi area, Bailey Ruin, and four sites in the Upper Little Colorado River drainage (table 7.1; figure 7.2). Numerous other sites were represented with smaller samples. Analyzed ceramics from Bailey Ruin included White Mountain Red Ware, Cibola White Ware and Roosevelt Red Ware, and those from Kinishba and Cedar Creek Pueblo included some Kinishba Red Plain. We also analyzed a variety of source and archaeological clays and potential tempering materials (n=45).

Moreover, Triadan had submitted fifty-one samples of imported and local White Mountain Red Ware to petrographic analysis (Triadan 1997). For this project an additional forty-five sherds were analyzed to determine their mineralogy.

RESULTS

Based on the analysis of our combined data sets, light-paste, sherd-tempered White Mountain Red Ware can now be differentiated into four compositional groups (one of Triadan's original large groups, Group 1 [Triadan 1997], could be divided when additional samples were analyzed), WMR Group 1, WMR Group 2, WMR Group 3 and Bailey (figures 7.6 and 7.7).

As we mentioned before, these ceramics are *nonlocal* to all sampled regions except probably areas along or north of the Mogollon Rim, especially the Silver Creek area. Except for the Upper Little Colorado drainage and the Homol'ovi area, light-paste White Mountain Red Ware from the sampled sites located outside the Silver Creek area fall into WMR Group 1, 2, and 3, and all of these sites have ceramics that belong to each of the three groups. Analyzed ceramics from the Upper Little Colorado and Homol'ovi sites could be assigned to WMR Group 1 and 3 but not to WMR Group 2. The fourth group contained only White Mountain Red Ware from Bailey Ruin. Interestingly, Cibola White Ware from Bailey has the same chemical composition as the White Mountain Red Ware from that site (figures 7.6 and 7.7). Moreover, a sherd-tempered clay recovered from a vessel on a room floor at Bailey matches both the White Mountain Red Ware and Cibola White Ware compositionally. Clearly, both Cibola White Ware and White Mountain Red Ware were made at Bailey Ruin (see also Mills et al. 1999).

To determine the production loci for the other three White Mountain Red Ware compositional groups is more difficult, primarily because to date we have analyzed only a small number of samples from other Silver Creek settlements that were still occupied during the fourteenth century. How-

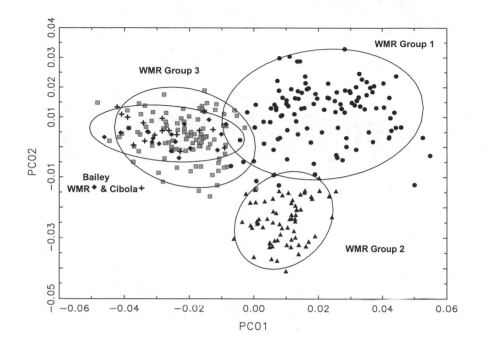

7.6 Bivariate plot of principal components scores, showing principal components 1 and 2 of the four light-paste White Mountain Red Ware groups. The principal components were calculated on the basis of twenty-six elements and the samples assigned to the four groups. The ellipses represent a confidence level of 90% for membership in the respective compositional groups. *Illustration prepared by Daniela Triadan*

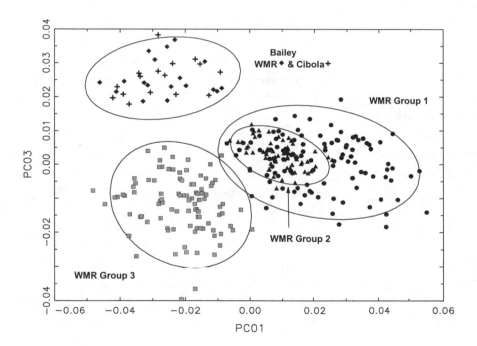

7.7 Bivariate plot of principal components scores, showing principal components 1 and 3 of the four light-paste groups of White Mountain Red Ware. The principal components were calculated on the basis of twenty-six elements and the samples assigned to the four groups. The ellipses represent a confidence level of 90% for membership in the respective compositional groups. *Illustration prepared by Daniela Triadan*

ever, given the abundance of White Mountain Red Ware in Silver Creek sites in the late thirteenth and early fourteenth centuries, the ceramics assigned to WMR Groups 1, 2 and 3 were probably also made in the Silver Creek area. The most likely source(s) are light-firing, kaolinitic clays that weather from the extensive Cretaceous deposits along the Mogollon Rim (see Moore 1968:72–73; figure 7.5). It is important to reiterate that from about AD 1260 to AD 1320/1330 only seven pueblos and after AD 1320/1330 only four large pueblos

(Showlow, Fourmile, Shumway, and Pinedale) were still occupied in the Silver Creek drainage (Mills 1998: Table 4.1). Pinedale and Showlow Ruins are close to the Mogollon Rim and the Cretaceous formations and Fourmile is located near a small outcrop of Cretaceous deposits (figure 7.5). These sites are likely manufacturing loci for Group 1, Group 2 and Group 3 ceramics.

In addition to the four light-paste White Mountain Red Ware groups, we can also define compositional groups for

7.8 Bivariate plot of principal components scores, showing principal components 1 and 2 of the three large, light-paste White Mountain Red Ware groups and groups local to Grasshopper, Kinishba, and Point of Pines. The principal components were calculated on the basis of twenty-six elements and the whole data set except analyzed source clays. The ellipses represent a confidence level of 90% for membership in the respective compositional groups. *Illustration prepared by Daniela Triadan*

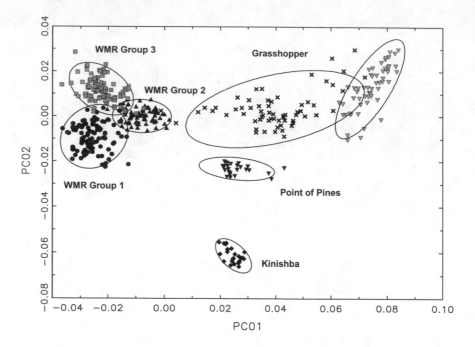

Point of Pines and Kinishba that reflect *local* production at or around these pueblos (figure 7.8). Both of these groups are compositionally quite distinct from the two local Grasshopper groups and any of the other compositional groups. The group that represents Point of Pines consists of brown corrugated ceramics; red-slipped plain ware (Kinishba Red); local White Mountain Red Ware that is not distinguishable by its surface from imported light-paste White Mountain Red Ware; Point of Pines Polychrome, which are technically inferior copies and two samples of unfired brown utilitarian pottery. These pots were tempered with volcanic tuff. The unfired pottery as well as the mineralogy provide strong evidence that some White Mountain Red Ware was produced at Point of Pines, which complements Zedeño's (chapter 6) findings. At Point of Pines and at Grasshopper, local copies are later than the imported light-paste White Mountain Red Ware (Carlson 1970:77–82; Triadan 1997:56–78; Wendorf 1950:49), and may have replaced the imported vessels (Triadan 1997).

The compositional group that represents Kinishba is not so easily interpreted. The group consists predominantly of ceramics of an unpainted, red-slipped type, Kinishba Red, from Kinishba and Cedar Creek Pueblo (GFS 85-3), located about 15 km to the west of Kinishba (figure 7.5). However, two samples from Kinishba included in this group are White Mountain Red Ware. We argue that this group represents ceramics local to the general area around Kinishba because ceramics of the same type from both sites could be assigned to

this compositionally fairly homogeneous group and they are quite distinct from the ceramics produced at Grasshopper and Point of Pines and from the light-paste, imported White Mountain Red Ware. Petrographic analysis supports this interpretation. All analyzed sherds were tempered with andesitic or basaltic rock fragments that are often porphyritic. A basalt flow along the course of the White River and the North Fork of the White River as well as some other andesitic to basaltic outcrops are located about 4 km to the south, east, and west of Kinishba Pueblo (see figure 7.5; Moore 1968: Plate 2).

CONCLUSIONS

The results of the compositional analyses demonstrate that between AD 1275 and 1330, light-paste, sherd-tempered White Mountain Red Ware and Cibola White Ware ceramics were produced at one of the early aggregated settlements in the Silver Creek area, the Bailey Ruin (Mills 1998; Mills et al. 1999). The production of both of these wares at Bailey may indicate the integration of earlier populations that resided in the northeastern part of the Silver Creek area, such as the Hay Hollow Valley, with populations in the upper Silver Creek drainage. As mentioned above, the ceramic assemblages of earlier sites in the upper Silver Creek drainage consist predominantly of Cibola White and Show Low Red Wares, whereas assemblages of sites farther to the northeast contain both early Cibola White Ware and White Mountain Red Ware types.

Although the exact production loci for the White Mountain Red Ware found in the large aggregated fourteenth-century sites outside the Silver Creek drainage could not be identified, the Silver Creek area is the likely production zone of these ceramics for the following reasons: First, White Mountain Red Ware was definitely produced at one of the Silver Creek sites. Second, White Mountain Red Ware was very rare in painted ceramic assemblages in the sampled regions outside the Silver Creek area (with exception of the Upper Little Colorado drainage) until the establishment of large aggregated settlements. And third, a few samples from Bailey, Pinedale, and Showlow Ruins could be assigned to WMR Groups 1 and 3. We would like to emphasize again that only very few White Mountain Red Ware ceramics from Silver Creek sites other than Bailey have been analyzed and that this hypothesis needs to be evaluated further with additional data from these sites.

Settlement data for the Mogollon Mountain areas (Reid et al. 1996), the Tonto Basin (Clark 1995; M. T. Stark, Elson, and Clark 1995), and the Middle Little Colorado River (E.C. Adams 1996; 1998) strongly suggest the immigration of people during the late 1200s and 1300s. Parallel with aggregation in these areas, light-paste White Mountain Red Ware becomes a substantial component of the painted ceramic assemblages in sites south of the Mogollon Rim, areas that were sparsely populated during the thirteenth century. The evidence that at some of the sites White Mountain Red Ware was produced with local materials, but with a decorating scheme that was nonlocal to these areas, supports the inference that people who knew how to make this pottery were at these pueblos. They probably moved to these areas from places where White Mountain Red Ware had been traditionally made and eventually produced local copies (Triadan 1997:93–94).

One of the more intriguing results of the analysis is that light-paste White Mountain Red Ware from almost all sites located outside the Silver Creek area can be attributed to all the White Mountain Red Ware compositional groups, except the group that represents Bailey production. There is no geographical differentiation that corresponds with these three compositional groups. Kinishba, Point of Pines and the sites in the Tonto Basin all contained White Mountain Red Ware that could be assigned to each of the three groups. Light-paste White Mountain Red Ware from the Upper Little Colorado pueblos and the sites at Homol'ovi could be assigned to two of the groups. If these three compositional groups represent production in the Silver Creek region, then this suggests that people from this area contributed some of the population that moved into all of these settlements. If the three compositional groups represent production at different villages or procurement zones within the Silver Creek region, then it would also indicate that people moved in household units rather than whole village groups (see also Duff 1998).

This study demonstrates that the integration of compositional analyses with archaeological information can provide strong data to address anthropological questions. However, complex issues like the large-scale population shifts that occurred during the thirteenth and fourteenth centuries can only begin to be explained through collaborative efforts that provide supraregional compositional information.

Acknowledgments. All analyses were carried out either at the Research Reactor Facility at the University of Missouri, Columbia (MURR) or at the Smithsonian Center for Materials Research and Education (SCMRE, formerly the Conservation Analytical Laboratory) in collaboration with the reactor facilities at the National Institute for Standards and Technology (NIST). Both Duff and Triadan spent time at MURR as predoctoral interns of the archaeometry program, funded by NSF grants (DBS 9102016, and SBR-9503035). Triadan carried out additional analyses as the Material Analysis Postdoctoral Fellow at SCMRE-NIST. We are especially grateful for the guidance and advice of Hector Neff, Michael Glascock, Ronald Bishop, and James Blackman at these institutions. Mills's research was conducted as part of the Silver Creek Archaeological Project, funded by NSF grant SBR-9507660 and the Apache-Sitgreaves National Forests. James Woodman graciously provided access to his data from the Silver Creek area, previously analyzed at SCMRE-NIST. We would like to thank Michael Jacobs at the Arizona State Museum, Charles Adams of the Homolovi Research Project, the Field Museum of Natural History in Chicago, and Desert Archaeology, Inc., who supported this research wholeheartedly and generously allowed us to sample the ceramics in their collections. Throughout the preparation of this paper, Charles Adams provided helpful comments and Nieves Zedeño shared insights into the analyses.

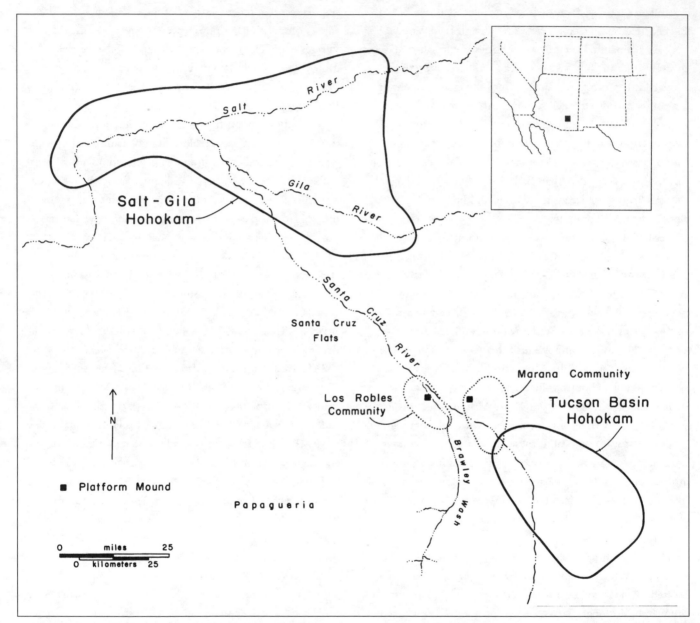

8.1 Location of the Marana and Los Robles communities

Ceramic Production and Distribution in Two Classic Period Hohokam Communities

Karen G. Harry, Paul R. Fish, and Suzanne K. Fish

THIS STUDY INVESTIGATES the organization of ceramic production and distribution in two Hohokam settlement clusters, the Marana and Los Robles communities. These communities, located in southern Arizona, date to the early Classic period (ca. AD 1100 to 1300) of the Hohokam sequence. Like many other site clusters in the Southwest, each community is characterized by a settlement hierarchy consisting of a large site surrounded by smaller sites and a differential distribution between sites of nonlocal and labor-intensive goods. The goal here is to understand how the production and distribution of one such differentially distributed commodity—Tanque Verde Red-on-brown ceramics—was organized within these two communities. To investigate this issue, 558 sherds from the Marana and Los Robles communities were chemically analyzed using instrumental neutron activation analysis (INAA). These include 224 sherds analyzed by P.R. Fish, S.K. Fish, Whittlesey et al. (1992) and 334 sherds analyzed by Harry (1997). In addition, the aplastic inclusions of 413 of these sherds were also mineralogically analyzed.

RESEARCH SETTING

Information about the Marana and Los Robles communities derives from numerous field projects that have been conducted in the region. The existence of the two communities was discovered in the 1980s, through an intensive pedestrian survey (termed the Northern Tucson Basin Survey Project) directed by Paul Fish, Suzanne Fish, and John Madsen (see Downum 1993; S.K. Fish, P.R. Fish, and Madsen 1992; Madsen, Fish, and Fish 1993). The intensity of the survey coverage resulted in the identification of the two Classic period communities. Specifically, the survey resulted in the recognition

of a settlement hierarchy, documentation of the community boundaries, and evidence of internal differentiation and integration within the communities (S.K. Fish, P.R. Fish, and Madsen 1992). Additional information about the communities is available from large- and small-scale excavation projects conducted at specific sites (see Harry 1997:24-27 for a summary of these projects). Of the two communities, Marana is the better understood archaeologically. The reasons are twofold: (1) sites in the Los Robles community tend to be more deeply buried than sites in the Marana community, and (2) more research has been conducted in the latter area.

The Marana and Los Robles communities are located between two major cultural zones of the Hohokam, the Salt-Gila "core" area, and the Tucson Basin "periphery" (figure 8.1). Traditionally, the area adjacent to the Salt and Gila rivers has been considered the heartland of the Hohokam. Inhabitants along these rivers constructed large irrigation canals and had an elaborate material culture. Hohokam living along lesser watercourses, in contrast, were thought to have been culturally peripheral to the Salt-Gila Hohokam, and their material cultures were interpreted as local variants of the heartland culture. The Tucson Basin Hohokam are traditionally viewed as one such variant. Until recently, areas between the core and peripheries, such as that occupied by the Marana and Los Robles communities, were believed to have been sparsely populated and culturally impoverished relative to these other areas. The documentation of hundreds of sites by the Northern Tucson Basin Project, however, has altered this viewpoint. As a result of that survey, we now know that large populations, complex settlement patterns, and monumental architecture existed in an area previously thought to have been largely unoccupied.

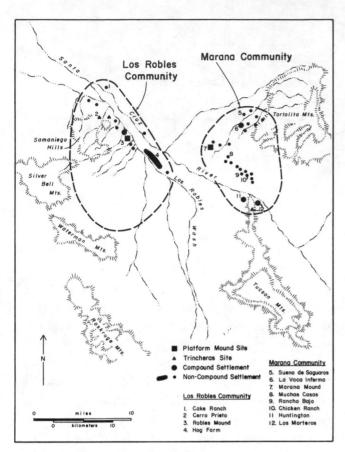

8.2 Location of early Classic period habitation sites in the Marana and Los Robles communities

The Marana and Los Robles communities exhibit similar occupational histories and general settlement structure. Several lines of evidence suggest that by the early Classic period, each cluster functioned as an internally integrated community (see S.K. Fish, P.R. Fish, and Madsen 1992; Downum 1993). Within each area, a settlement pattern has been identified of contiguous sites organized around a primary village having monumental architecture (figure 8.2). Outside these clusters of sites are buffer zones, or areas lacking habitation sites, that separate the sites of each community from those of other clusters. Evidence of settlement hierarchies within each cluster lends further support to the interpretation that they functioned as integrated settlement systems. Additional evidence of integration comes from the recent identification of a Classic period canal linking the Marana platform mound site with sites located at the northern end of the Tucson Mountains (S.K. Fish, P.R. Fish, and Madsen 1992:21).

In the Marana community, a settlement hierarchy has been identified based on site size, visible architectural remains, and ceramic assemblages (S.K. Fish, P.R. Fish, and Madsen 1989, 1992). The largest habitation site (and the pre-

sumed pinnacle of the hierarchy) contains the platform mound; this site also contains higher proportions of nonlocal goods than other sites studied in the community (Bayman 1992, 1994). At the Marana Mound site, about 19% of the ceramic assemblage is Tanque Verde Red-on-brown (table 8.1). Similar proportions characterize the sites of Los Morteros and Huntington Ruin, other sites identified by S.K. Fish, P.R. Fish, and Madsen (1989, 1992) as belonging to the top of the settlement tier. A third site in the community, Chicken Ranch, contains about 8% Tanque Verde Red-on-brown ceramics, and the remaining habitation sites all have less than 5% of this ware. Although comparable data are not available for the Los Robles community, settlement differences are apparent there as well. Like the Marana Mound community, this community also contains a platform mound village surrounded by other habitation sites. Decorated ceramics appear to be less common in the Los Robles than in the Marana community, although alluviation and the paucity of excavation in this community make these data unavailable for most sites.

The intrasite structure of the Marana Platform Mound village is known from intensive mapping (P.R. Fish, S.K. Fish, Brennan et al. 1992) and excavation (Bayman 1994; P. Fish et al. 1992a) projects that have been conducted at the site. The site spans a 1.5 km by 0.5 km area and contains the remains of between twenty-two and twenty-five residential compounds (P.R. Fish, S.K. Fish, Brennan et al. 1992). One such compound encloses the platform mound, which is located near the central portion of the site. Within the mound's compound wall are several rooms that were used as domestic residences; this function is indicated by the nature of the midden refuse (see Bayman 1994:19; Bubemyre 1993). These residences are believed to have functioned as the homes of the economic, political, or social leaders of the community.

RESEARCH ORIENTATION

Hierarchical site clusters constitute a common spatial organization of prehistoric settlements in the greater Southwest. Like the Marana and Los Robles communities, such clusters typically exhibit a settlement hierarchy of three or more tiers, in which a large site with public architecture is surrounded by smaller sites lacking these structures. In addition, the large sites typically contain higher proportions of nonlocal and labor-intensive goods (Jewett 1989). These characteristics invite the obvious interpretation that the largest sites functioned as some sort of social, political, or economic centers. However, substantial disagreement exists concerning the nature of this

centralization. Some archaeologists have proposed that the primary villages were occupied by elite leaders who controlled the production and distribution of commodities (McGuire 1985; Neitzel 1991; Upham 1982; Wilcox 1991b). Centralized production could have occurred either through a system of *attached specialization*, in which the specialists were employed by the elite (Brumfiel and Earle 1987) or through a system of *embedded specialization*, in which the elite themselves were the craft specialists (Ames 1995). Similarly, centralized distribution could take either of two forms. Most Southwestern archaeologists who have invoked redistribution models propose that exchange was controlled by the elite. According to this viewpoint, the elite leaders controlled the distribution of high-status (Lightfoot 1984; McGuire 1985; Neitzel 1991; Upham 1982) and/or utilitarian (Teague 1984; Upham 1982) goods in order to maintain and increase their power. A second viewpoint holds that centralized distribution occurred without elite intervention. Such spatially centralized distribution could result either from ritual exchanges or from marketlike exchanges occurring at trading fairs (S.K. Fish and P.R. Fish 1990:180; S. Plog 1989a, 1989b). Still other archaeologists have rejected all models of centralized production and distribution (Downum 1993; Reid 1985; Reid and Whittlesey 1989). These archaeologists hold that prehistoric Southwestern villages were economically autonomous. According to this view, ceramics were produced in almost every household, and the exchange that did occur took place through the practice of gifting and informal trade between individuals.

The large number of ceramics that have been compositionally analyzed from the Marana and Los Robles communities makes this an ideal setting for evaluating these research issues.

METHODS

The present study draws on two previous analyses of Tanque Verde Red-on-brown sherds. In an initial study conducted by P.R. Fish, S.K. Fish, Whittlesey et al. (1992), 360 sherds were chemically analyzed using instrumental neutron activation analysis. This sample included 215 sherds recovered from the Marana community and nine sherds from the Los Robles community. This initial study resulted in the identification of several compositional groups in the Marana and Los Robles collections and demonstrated the feasibility of compositional analysis in the area. Subsequent to this study, the senior author submitted an additional 361 sherds for INAA (Harry 1997). These sherds were submitted to increase the sample size available from these areas, so that specific research questions concerning intra- and intercommunity economic organization could be addressed. Combined, the sherds from these two projects total 721, of which 558 are from the Marana and Los Robles communities (table 8.2). In addition to these 558 sherds that were chemically analyzed, the present study incorporates the results of a mineralogical analysis conducted on 413 of these sherds (Harry 1997; Heidke and Wiley 1997; see table 8.1).

The instrumental neutron activation analyses were conducted at the Missouri University Research Reactor Facility using the techniques outlined in Glascock (1992). Because the general (Glascock 1992; chapters 1, 2) and specific (P.R. Fish, S.K. Fish, Whittlesey et al. 1992; Harry 1997) data reduction methods have been described elsewhere, they will be only summarized here. Data reduction was based on the concentration data from 32 elements. To derive compositional groups, chemical data for all 721 analyzed Tanque Verde Red-on-brown sherds were used. These procedures resulted in the identification of eight compositional groups, of which six are represented in the sherd collection submitted from the Marana and Los Robles communities. The raw data for these sherds, and the probability that a particular sherd belongs to any given compositional group, can be found in Harry (1997).

To supplement the information obtained from the chemical analyses, a mineralogical study was undertaken on 413 sherds from the two communities. This sample represents all the sherds that were not consumed completely during the chemical analysis. The mineralogical study focused on the aplastic inclusions in the sherds and built upon more than a decade of petrographic research in the region. Because the Hohokam used wash sands to temper their ceramics, petrography has proved to be an especially successful sourcing technique in southern Arizona. The mineralogical analysis consisted of the binocular examination of all analyzed sherds and the petrographic (thin-section) study of twenty-five sherd thin sections. During binocular examination, the sand temper in each sherd was identified as to tectonic origin (that is, whether they were volcanic, igneous, metamorphic, sedimentary, or some mixture of these) and, when possible, to a specific petrofacies, or area containing mineralogically distinct sands. The mineralogical study was conducted by researchers from the Center for Desert Archaeology and is more fully reported in Harry (1997), Heidke and Wiley (1997), and Heidke et al. (1997).

The above approach made it possible to address relatively fine-grained questions concerning the economic organiza-

Table 8.1 Database used in the present study

| Community/site | % Tanque Verde Red-on-brown sherds | | N analyzed sherds | |
	%	Source	NAA	Mineralogical
Marana Community				
Marana Mound	18.7	Bayman 1994:Table A-8	210	115
Los Morteros	20.8	Heidke 1995:Table 5.66	35	31
Huntington	High	Personal observation*	29	28
Chicken Ranch	8.5	Harry 1994	32	30
Muchas Casas	<5	Bayman 1994:64	31	29
Upland Compound**	<4	Sanchez de Carpenter 1995	38	30
Misc. habitation	<5	S. Fish et al. 1992	25	10
Misc. non-habitation	N/A	N/A	10	3
Misc. unknown	N/A	N/A	6	3
TOTAL	N/A	N/A	416	279
Los Robles Community				
Robles Mound	Unknown	N/A	27	22
Cerro Prieto	Unknown	N/A	24	24
Cake Ranch	1.4	Kisselburg and Lancaster 1990	30	30
Hog Farm	N/A	N/A	30	30
Misc. habitation	N/A	N/A	25	22
Misc. non-habitation	N/A	N/A	2	2
Misc. unknown	N/A	N/A	4	4
TOTAL	N/A	N/A	142	134

* Field observations by the author suggest that the Huntington ceramic assemblage contains a similar proportion of Tanque Verde Red-on-Brown ceramics as that of Los Morteros. Because these data are unquantified, however, the exact proportion remains unknown.

** The Upland Compound, as designated here, includes the sites of La Vaca Enferma and Sueño de Saguaro. These sites are combined here because they are located less than 0.5 km apart.

Table 8.2 Number of sherds, by site, assigned to each chemical compositional group

Provenience	A	BC	E	F	G	South Tucson	Phoenix	Papagueria	Unassigned	TOTAL
Marana Community										
Marana Mound	49	58	6	-	2	1	-	-	94	210
Los Morteros	10	12	1	1	-	-	-	-	11	35
Huntington	8	7	1	-	-	-	-	-	13	29
Chicken Ranch	8	11	2	-	-	1	-	-	10	32
Upland Compound	1	-	2	-	17	-	-	-	18	38
Muchas Casas	1	-	1	17	-	-	-	-	12	31
Other Habitation	3	4	1	-	1	-	-	-	16	25
Other Nonhabitation	3	1	1	-	1	-	-	-	4	10
Unknown	-	-	3	-	1	-	-	-	2	6
Los Robles Community										
Robles Mound	1	2	-	1	6	-	-	-	17	27
Cerro Prieto	5	1	-	-	4	-	-	-	14	24
Hog Farm	5	1	5	1	1	-	-	-	17	30
Cake Ranch	2	1	7	-	-	-	-	-	20	30
Other Habitation	2	-	1	-	4	-	-	-	18	25
Other Nonhabitation	-	-	-	-	-	-	-	-	2	2
Unknown	-	-	-	-	-	-	-	-	4	4
Other Areas	9	27	-	-	2	21	11	26	67	163
TOTAL	107	125	31	20	39	23	11	26	339	721

tion of the two communities. The use of both chemical and mineralogical data provided two lines of data by which the topics could be addressed. Because of the nature of the database and the relatively small area (approximately 900 square km) being examined, neither of these databases was sufficient by themselves to address the proposed research issues. Together, however, the data obtained from these two types of studies made it possible to evaluate the three components (production, distribution, and consumption) of the economic system. This information, in turn, was made possible only by the substantial geological diversity that characterizes the research area. Before the results of the compositional analyses are presented, then, a brief description of the geological setting is warranted.

GEOLOGICAL SETTING

The Marana and Los Robles communities encompass a diversity of elevational settings, spanning from riverine to mountain slope areas. Two major rivers cross the communities: the Santa Cruz and the Los Robles (or Brawley Wash) rivers (see figures 8.1 and 8.2). The Santa Cruz River divides the study area into two broad zones that are easily distinguished geologically (Lipman 1993; Madsen 1993; Reynolds 1988). West of the river, the Tucson and Silverbell mountains comprise supracrustal rocks exposed during Late Miocene faulting. These mountains contain primarily volcanic rocks such as basalt, andesite, and rhyolite, and sedimentary rocks. A different geological environment occurs east of the river, where the bedrock is mostly basement (deep crustal) rocks. These rocks consist of granitic rocks and of highly metamorphosed sedimentary rocks exposed during Tertiary period faulting. Within these two zones, localized variations on the general patterns described above can be found.

Sands suitable for use as temper are ubiquitous in this region. Clays, however, are less widespread. Within the Marana and Los Robles communities, clays are confined primarily to the floodplain of the Santa Cruz and Los Robles rivers. These clays tend to be of a high quality and contain relatively few aplastic inclusions. Although alluvial clays are nearly ubiquitous along the riverbanks and floodplain areas, clays are scarce in other areas. One nonriverine source of clay that would have been available prehistorically is Pan Quemado, a prehistoric reservoir located to the southeast of the Cerro Prieto site in the Los Robles community. Another possible clay source may have been the canal that was located in the Marana community. A third source of clay, common in the Tucson Basin but lacking in the Marana and Los Robles communi-

ties, is the mountains. In this area, several argillic clay deposits are known from various mountain exposures. Despite a search for argillic clays in the Marana and Los Robles communities, however, no similar deposits have been identified in this area.

The geological setting has a number of implications for the use and interpretation of compositional data. First, the geological diversity in the area has made it possible to distinguish sands collected from different locations. In particular, sands from either side of the Santa Cruz River are easily distinguished. Within each of these two broad zones more specific distinctions can be made. The recognition of distinct sand zones results from the many petrographic studies conducted in the area since the 1980s. These projects have resulted in the availability of a large sand database and have made it possible to identify numerous petrofacies in the area (for a summary of this work see Heidke and Wiley 1997 and chapter 12). Each petrofacies contains sands that can be distinguished mineralogically from the sands of other petrofacies. In most cases, these sands can be distinguished using the binocular microscope, although occasionally examination under the polarizing microscope is necessary. (The locations of the known petrofacies in and by the Marana and Los Robles communities are shown in Figure 12.5 of this volume.) A few of the petrofacies, in particular the Santa Cruz River and the Brawley Wash petrofacies, contain sands of mixed origin and are therefore more difficult to distinguish using lower level analyses, such as binocular microscopy.

In contrast to sands, clays would not have been easily accessible to all residents of the two communities. In the Los Robles area, most habitation sites are located in the floodplain near clay resources. In the Marana community, however, habitation sites are found in several zones, including riverine, lower bajada, and upper bajada areas. Residents of sites away from the riverine areas may have been required to travel to the floodplain to obtain clay.

The origin of the clays contributes to the distinctiveness of their chemical signature. Because argillic clays derive from a single parent material, they tend to be relatively distinct from other clays. Alluvial clays, in contrast, result from sediments that have been washed downstream and are mixed from several parent sources. Thus, these clays might be expected to be less distinct chemically. In fact, chemical analyses of several clays collected from the study region and adjacent areas demonstrate that these expected patterns do occur (Harry 1997).

RESULTS

Instrumental neutron activation analysis

Using the procedures outlined above, a total of eight compositional groups was identified in the 721-sherd sample. Six of these groups were present in the collections from the Marana and Los Robles communities (table 8.2).[1] Figure 8.3 plots the eight compositional groups relative to the first and second principal components. This figure demonstrates that the Phoenix, Papagueria, and F groups are the most distinct chemically, whereas the remaining groups all exhibit substantial overlap on these two axes. Greater separation, however, is displayed on other axes. Groups A through G, the primary groups associated with the Marana and Los Robles communities, are plotted relative to discriminant functions 2 and 3 in figure 8.4. This graph demonstrates the clear separation of some groups (such as groups A and BC) that exhibit substantial overlap in figure 8.3.

These two-dimensional graphs illustrate the importance of using statistical techniques to evaluate group identification. In the present study, several groups exhibit substantial chemical similarity. This is not surprising: distributional data of groups A though G and the South Tucson group suggest that they were all produced in the same general region (that is, the Tucson Basin or adjacent region; see P.R. Fish, S.K. Fish, Whittlesey et al. 1992 and Harry 1997), and the potential for chemical similarity of alluvial clays in this region has already been noted. This general similarity results in the overlap of these groups on two-dimensional plots. When multiple dimensions are considered, however, the groups show clear and unambiguous separation (see Harry 1997 for the statistical data). The distinctiveness is demonstrated by Mahalanobis distance-derived probabilities. For groups having sufficient sample sizes (that is, groups A, BC, and G), these probabilities were based on all thirty-two elements. For all other groups except the Phoenix group, the probabilities were based on the first thirteen principal components. Because of the small sample size of the latter group, it was not evaluated using Mahalanobis distance-derived probabilities; however, its distinctiveness from the other groups is clearly visible on numerous projections of the data (P.R. Fish, S.K. Fish, Whittlesey et al. 1992; Neff et al. 1996).

A conservative approach was taken in defining the compositional groups. Only those hypothetical groups that could be shown to be internally coherent were retained as compositional groups. For example, Mahalanobis distance-derived probabilities demonstrate that all sherds assigned to group A show less than 0.0001 % probability of belonging to group

BC, and only six sherds assigned to group BC exhibit probabilities of greater than 0.0001 of belonging to group A. Even for the latter six sherds, the probabilities of overlap with group A are extremely low, with all p-values being less than or equal to 0.002. Groups E, F and G are less well defined due to their smaller sample sizes, but also show clear separation from one another. For all groups, compositional boundaries are characterized by an abrupt decrease in Mahalanobis probabilities, so that unassigned sherds show little probability of belonging to any group. These patterns indicate that the unassigned sherds are distinct from the compositional groups, and that the compositional groups are clearly bounded and distinct from one another.

The conservative approach adopted here resulted in a relatively high proportion (47%) of the analyzed sherds remaining unassigned to any compositional group. These unassigned sherds may indicate either (1) representatives of other groups; (2) outliers of the existing groups, or (3) anomalously prepared pastes whose compositional affinity with the existing groups has been obscured. Given the unusually high proportion of the sherds that remain unassigned, the first possibility (that is, that they are representatives of unidentified groups) likely accounts for many or most of the unassigned sherds. As discussed above, a primary source of clays in the study region is the riverine zone. These alluvial clays consist of sediments that have washed downstream and are mixed in origin, resulting in clays that overlap chemically. Many of the unassigned sherds, therefore, may reflect vessels constructed of chemically similar alluvial clays.

Mineralogical analysis

As discussed above, the present study builds upon more than a decade of petrographic research conducted in the Tucson Basin and adjacent regions. Most previous studies, however, have been of pre-Classic sherds. These studies indicate that sands used to temper pre-Classic sherds generally derive from bajada washes. Parent materials of sands in those sherds are usually unmixed and the petrofacies easily identified. Based on these findings, it was expected that similar patterns would be reflected in the present Tanque Verde Red-on-brown collection. Instead, however, none of the sherds in the present collection could be securely assigned to a specific petrofacies, and only five sherds could be even tentatively given petrofacies assignments (table 8.3; Harry 1997; Heidke and Wiley 1997). The five sherds given tentative assignments include one sherd provisionally assigned to the Samaniego (C) petrofacies (the petrofacies that encompasses the Robles Mound

site), and three sherds provisionally assigned to petrofacies J and J1, two petrofacies located south of the study region (see figure 12.5 of this volume). No sherds were identified as containing sands from the Tortolita petrofacies, the petrofacies within which the Marana Mound site is located.

Geologically, the sherds fall into two major groups: one containing mostly felsitic minerals and another containing a mixture of felsitic and granitic grains. The sherds in the first group were almost certainly produced somewhere west of the Santa Cruz River where volcanic outcrops are common. The production area(s) of sherds in the latter group is more difficult to pinpoint. They contain sands that could derive either from an area containing a mixture of bedrock outcroppings or from a major trunk stream, such as the Santa Cruz or Brawley River. Regardless, the sands clearly do not derive from either of the two petrofacies (that is, the Samaniego or Tortolita) surrounding the two platform mound sites. These two petrofacies are quite easily identified using the binocular microscope and have available a substantial body of thin-section data. Thus, it appears that none of the 446 analyzed sherds contain Tortolita sands, and at best only one contains Samaniego sands. Instead, the sands appear to come either from a major trunk stream (such as the Santa Cruz River or Brawley Wash) or from an unsampled bajada wash draining mixed bedrock sources.

PRODUCTION AND DISTRIBUTION OF TANQUE VERDE RED-ON-BROWN CERAMICS

The compositional data presented above make it possible to evaluate the economic organization of the Marana and Los Robles communities as it pertains to the circulation of Tanque Verde Red-on-brown ceramics. The *production* organization of Tanque Verde Red-on-brown ceramics is interpreted primarily from the mineralogic data. Although clays from the region have been analyzed chemically, correlation between the clays and the ceramic compositional groups were negligible (P.R. Fish, S.K. Fish, Whittlesey et al. 1992; Harry 1997). The organization of *distribution* for these vessels is best evaluated from the chemical data.

The mineralogic data suggest that few, if any, Tanque Verde Red-on-brown vessels were produced at the platform mound sites. As discussed above, few or none of the sherds that were mineralogically analyzed contain sands from the Tortolita or Samaniego petrofacies, the two petrofacies that encompass the Marana and Los Robles mound sites, respectively. This would indicate that, unless potters were using nonlocal sands to construct their vessels, Tanque Verde Red-

on-brown ceramics were produced at best only rarely in these petrofacies. Several lines of evidence argue against the use of nonlocal sands. First, it is considered unlikely on theoretical grounds that the potters used nonlocal sands. Because sands are ubiquitous in the study region, residents of virtually every site in the Marana and Los Robles communities would have had access to a nearby sand source. Additionally, ethnographic data show that most potters who use sand as a tempering agent travel less than 1 km to obtain the material (Miksa and Heidke 1995). This generalization is supported archaeologically. Studies of Hohokam pottery production have demonstrated that, in those areas studied, prehistoric potters tempered their vessels with the nearest available sands (D.R. Abbott 1994:142, Abbott, Schaller, and Birnie 1991:5; Harry 2000; Heidke 1993b, 1995b). Second, there is no indication that the Tortolita or Samaniego sands were intentionally avoided. These sands occur frequently in other wares, including high-value (see D.R. Abbott 1985) red wares. Furthermore, the sands found in the Tanque Verde Red-on-brown sherds seem inferior tempering agents when compared with the Tortolita and Samaniego sands because they contain numerous calcium carbonate inclusions that can cause the vessel wall to spall. These inclusions are rare in the Tortolita and Samaniego sands.

The mineralogic study, then, indicates that few Tanque Verde Red-on-brown vessels were made within the platform mound villages. This, in turn, demonstrates that the production of these vessels was neither conducted nor controlled by the leaders of the community living at the mound villages. Rather, ceramic production was likely carried out by independent artisans residing at nonmound villages. Contrary to the expectations of some models (see Reid 1985; Reid and Whittlesey 1989), however, ceramics were not produced in every village. Instead, many households were dependent on other producers for the acquisition of these wares. The large volume of ceramics obtained from other villages suggests that some form of specialized production was present. For example, nearly 20% of the sherds from the Marana Mound village were Tanque Verde Red-on-brown; virtually all these sherds represent vessels made somewhere other than that site.

The mechanisms by which these vessels were distributed can be evaluated through a consideration of intra- and intersite ceramic compositional patterning. Others (Alden 1982; Graves 1991; Longacre and Stark 1992; Pires-Ferreira 1976; Teague 1984) have proposed that if distribution was centralized (either through elite-controlled redistribution or through non-elite controlled mechanisms such as trade fairs

8.3 Eight compositional reference groups plotted relative to principal components 1 and 2 of the 721 sherd data set

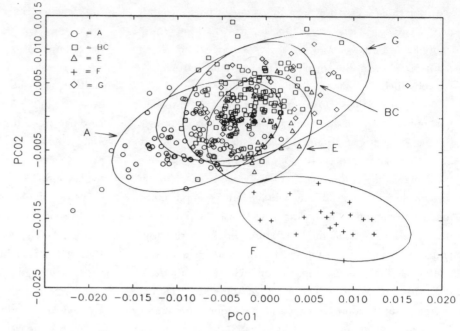

8.4 Plot of canonical discriminant functions 2 and 3 derived from discriminant analysis of the five study area reference groups

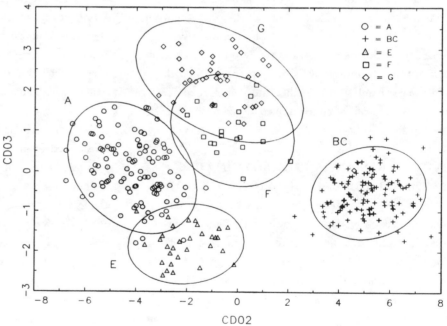

or marketplaces), this will be reflected in ceramic diversity. Specifically, in the present case, if non-mound villages were dependent on the mound villages for the acquisition of Tanque Verde Red-on-brown wares, then the number of compositional groups represented at each platform mound village should equal or exceed that represented in the remainder of the community. Additionally, all compositional groups found at non-mound sites should also be present at the mound site.

Figure 8.5 (adapted from table 8.2) graphically illustrates the distribution patterns of the ceramic compositional groups. The expectations of community-wide centralized distribution are not met. In the Marana community, two compositional groups (groups F and G, present at the sites of Muchas Casas and the Upland Compound, respectively) occur that are not found in the sample from the Marana Mound site. These patterns indicate that the residents of Muchas Casas and the Upland Compound site maintained exchange ties independent of the mound site. In the Los Robles community, similar patterns occur. Group E is found at the sites of Cake Ranch and Hog Farm, but is missing from the ceramic collection of the Robles Mound site.

Despite the dissimilarity of these ceramic collections, other sites exhibit more similar assemblages. In the Marana Mound community, the mound site, Los Morteros, Huntington and Chicken Ranch all have compositionally similar ceramic collections. Not only are the same compositional groups present at these sites, but the proportion of sherds assigned to each group is similar at each site. These patterns suggest that these residents likely participated in some form of centralized exchange network. To evaluate whether this network was controlled by the residents living in the mound compound, intrasite data are required. To address this issue, the ceramics analyzed from the Marana Mound site were divided into three groups: those collected from within 50 m of the platform mound, those collected from proveniences located between 50 and 300 m of the mound, and those obtained from more than 300 m from the mound. The ceramics collected from within 50 m of the mound were recovered from midden and structure proveniences and are believed to represent household refuse deposited by residents of the mound compound.

Table 8.4 shows that compositional group frequency varies with distance from the mound. Group A, frequent in the collections from the Los Morteros, Huntington, and Chicken Ranch sites, comprises more than one-fourth of the ceramics from the nonmound proveniences but is absent from the ceramics collected from the mound vicinity. Similarly, group E is present in the collections from Los Morteros, Huntington, Chicken Ranch, and the nonmound proveniences of the Marana Mound site, but is absent from the mound proveniences. This information indicates that the residents living nearest the mound maintained more restricted exchange ties than residents living in other areas. Why they should have obtained their vessels from fewer sources is unknown, although this may reflect restricted allegiances maintained by the mound residents for social or political reasons. Furthermore, the data indicate that the people living at the base of the platform mound did not control the distribution of Tanque Verde Red-on-brown ceramics to the residents of Los Morteros, Huntington, Chicken Ranch, and other areas of the mound village.

Significantly, the four sites (the Marana Mound site, Los Morteros, Huntington, and Chicken Ranch) exhibiting similar compositional diversity are those sites in the Marana community having the highest proportion of Tanque Verde Red-on-brown ceramics. This suggests that sites near the top of the settlement hierarchy participated in centralized exchange networks from which the smaller sites were excluded.

Table 8.3 Results of mineralogical study

Petrographic group*	Qty	%
Felsite-rich		
1	33	7.4
1 (C?)	1	0.2
1 (J?)	2	0.4
1 (J1?)	1	0.2
Mixed 2	160	35.9
Indeterminate -	249	55.8

* Assigned by Harry

Table 8.4 Number and proportion of sherds, by chemical group and distance from platform mound, recovered from different areas of the Marana platform mound site

		< 50 m	50-300 m	>300 m	TOTAL
A	n	-	23	26	49
	column %	-	27.7	30.2	23.3
BC	n	18	21	19	58
	column %	43.9	25.3	22.1	27.6
E	n	-	3	3	6
	column %	-	3.6	3.5	2.9
G	n	1	1	-	2
	column %	2.4	1.2	-	1.0
S. Tucson					
	n	-	1	-	1
	column %	-	1.2	-	0.5
Unassigned					
	n	22	34	38	94
	column %	53.7	41.0	44.2	44.8
TOTAL					
	n	41	83	86	210
	column %	100	100	100	100

To obtain Tanque Verde Red-on-brown vessels, residents of the latter sites cultivated and maintained independent exchange ties. Both reciprocal and centralized exchange mechanisms, then, appear to have been responsible for the movement of Tanque Verde Red-on-brown ceramics in the Marana community. This information suggests that distribution mechanisms within the Marana community do not fall neatly into any one category. Sites near the top of the hierarchy participated in centralized exchange, but other sites were excluded from these networks and instead maintained independent trade ties.

CONCLUSIONS

This study indicates that the differential distribution of Tanque Verde Red-on-brown ceramics reflects neither the centralized control of production nor the centralized control of distribution from the mound sites. Consumption of these wares, however, clearly was associated with social and economic status. Although these ceramics were available to all

8.5 Proportions of sherds assigned to the various chemical reference groups, for sites in the Marana and Los Robles communities.

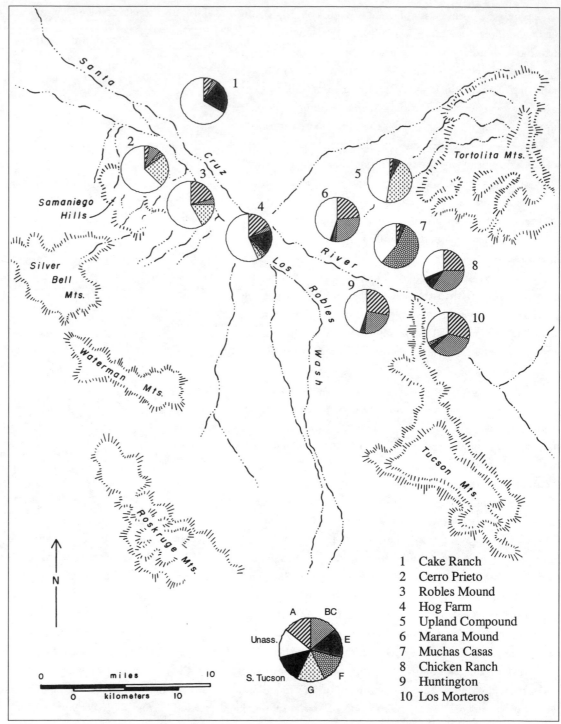

1 Cake Ranch
2 Cerro Prieto
3 Robles Mound
4 Hog Farm
5 Upland Compound
6 Marana Mound
7 Muchas Casas
8 Chicken Ranch
9 Huntington
10 Los Morteros

members of the Marana and Los Robles communities, they were consumed in higher proportions at some villages. Compared with other sites in the communities, sites having high proportions of Tanque Verde Red-on-brown ceramics also have greater quantities of nonlocal and other luxury goods (Bayman 1994; S.K. Fish, P.R. Fish, and Madsen 1992). The association of Tanque Verde Red-on-brown ceramics with oth-

er status indicators suggests that they functioned as wealth items and that their differential consumption reflects social and economic differences. Using Brumfiel and Earle's (1987) terminology, such items are referred to as *generalized wealth*. Access to these wares was not restricted in the sense that they could be consumed only by the elite, but they were consumed more frequently by persons of elevated status. In the

Marana community, these economically advantaged people resided at the sites of the Marana Mound, Los Morteros, Huntington, and Chicken Ranch. These individuals did not control access to Tanque Verde Red-on-brown vessels, but they did exclude economically less advantaged persons from participating in their distribution system. Perhaps in response, the residents of these other sites maintained other, separate exchange ties.

The findings discussed above show that the economic organization of settlement communities does not fall neatly into either of the two schools of thought that have dominated the study of Southwestern site clusters. These schools, prominent in the 1980s, were characterized by opposing viewpoints that have been intensely and often passionately debated. According to one school of thought, the presence of settlement hierarchies indicates the existence of a highly complex society, characterized by elite leaders who controlled the production and exchange of commodities from the largest villages (Lightfoot 1984; McGuire 1985; Upham 1982; Wilcox 1991b). The alternative view holds that the prehistoric communities were characterized by an egalitarian society, in which each village was largely self-sufficient and economically independent of the large villages (Downum 1993; Reid 1985; Reid and Whittlesey 1989). According to this viewpoint, ceramics were produced in almost every household and the exchange that did occur took place through the practice of giving gifts and informal trade between individuals.

As discussed above, neither of these models adequately describes the production, distribution, or consumption of Tanque Verde Red-on-brown ceramics. Contrary to the expectations of the egalitarian models proposed by Reid (1985; Reid and Whittlesey 1989), ceramics were not produced in every village. Instead, many households were dependent on other producers for the acquisition of these wares. Also, in contrast to the expectations of the egalitarian models, some centralized distribution mechanisms were present and some individuals could afford to acquire more of these vessels. The data do not however completely meet the expectations of the elite-control models. Neither production nor distribution was regulated by the leaders living near platform mounds.

Rather, the economic organization indicated for the Marana and Los Robles communities appears to have been somewhere between that suggested by either of these models.

The present study demonstrates that compositional analysis can be an effective means by which to study prehistoric economic organization. Numerous studies have attempted to model economic organization in the prehistoric Southwest. Most of these studies have relied on indirect evidence, such as settlement pattern and artifact distributions. The findings discussed above, however, demonstrate the importance of using direct data; many of the conclusions here are at odds with previous interpretations based on indirect evidence. In particular, it cannot be assumed that small sites having few luxury goods were dependent on the larger settlements for the acquisition of these commodities. Additionally, the study illustrates the advantages that can be gained by applying both mineralogical and chemical analysis to the same data set. Finally, this study shows that compositional analysis can provide useful information for studying not only regional issues, but intraregional ones as well.

Acknowledgments. This study was made possible by funding from the National Science Foundation to the Missouri Research Reactor (BNS-8801707) and to the senior author (Dissertation Improvement Grant #SBR-9400239). Additional funds were provided by the Wenner-Gren Foundation for Anthropological Research (Predoctoral Grant #5722), the Missouri University Research Reactor, the Agnese Lindley Foundation, the University of Arizona Graduate College, Arizona Archaeological and Historical Society, and the Gilbert Ray Altschul Scholarship Fund of Statistical Research, Inc. Special thanks are due to Hector Neff and Michael Glascock for their help with the neutron activation analysis, and to Elizabeth Miksa, James Heidke, Michael Wiley, and Diana Kamilli of the Center for Desert Archaeology for conducting the mineralogical analysis.

Notes

1. Groups A and BC correspond to the reference groups termed Marana-A and Marana-BC by P.R. Fish, S.K. Fish, Whittlesey et al. (1992). The South Tucson, Phoenix, and Papagueria groups correspond to P.R. Fish, S.K. Fish, Whittlesey et al.'s (1992) group of the same name.

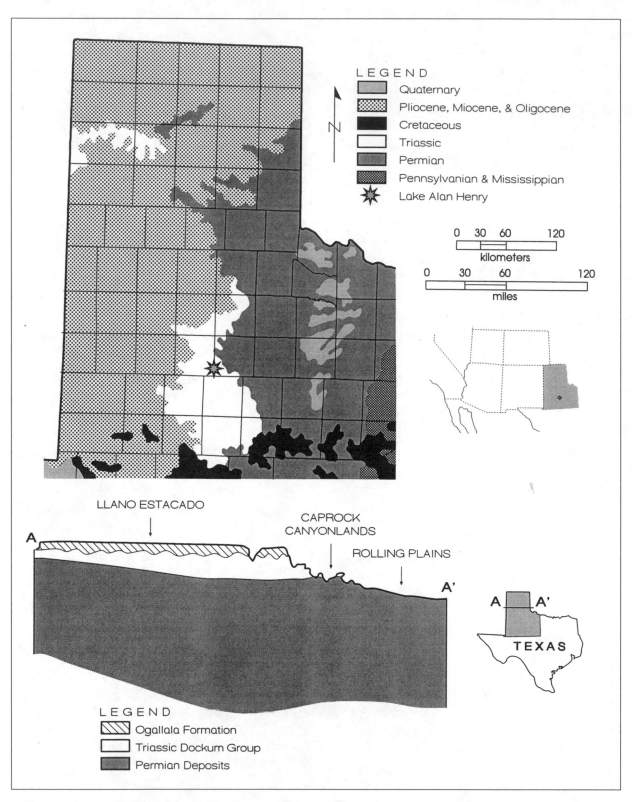

LEGEND
Quaternary
Pliocene, Miocene, & Oligocene
Cretaceous
Triassic
Permian
Pennsylvanian & Mississippian
Lake Alan Henry

kilometers
0 30 60 120

miles
0 30 60 120

LLANO ESTACADO

CAPROCK
CANYONLANDS

ROLLING PLAINS

A A'

A A'

TEXAS

LEGEND
Ogallala Formation
Triassic Dockum Group
Permian Deposits

9.1 Location of the Lake Alan Henry relative to the surface geology and generalized regional cross section of the Texas Panhandle-Plains. *Illustration prepared by Sandy Hannum*

9

Protohistoric Ceramics from the Texas Southern Plains
Documenting Plains-Pueblo Interactions

Douglas K. Boyd, Kathryn Reese-Taylor, Hector Neff, and Michael D. Glascock

THIS CHAPTER EXAMINES current archaeological models concerning Plains-Pueblo interaction during the protohistoric period (AD 1500 to 1750) using the results of instrumental neutron activation analyses (INAA) of selected ceramic samples from two sites in the Texas southern plains. Specifically, the following questions related to production and distribution of protohistoric pottery vessels are addressed: Were all the vessels recovered from settlements dating to the Protohistoric period imported onto the southern Plains from the pueblos or were some locally manufactured by Plains groups based on Puebloan prototypes?

The nature and extent of the interaction between southern plains bison-hunting nomads and sedentary agricultural Puebloan people has long been a popular topic of archaeological discussion and debate (for example, Baugh 1986; Creel 1991; Speth 1991; Spielmann 1983; Spielmann, ed. 1991; Wilcox and Masse 1981). This interaction was apparently a symbiotic relationship involving the exchange of bison-related products, such as meat and hides, for agricultural products, such as corn, tobacco, and cotton. Trade between these groups began in prehistoric times, but intensified after European contact, in large part because of Spanish involvement. Many different groups on the southern plains, including peoples identified as Apaches, Jumanos, Teyas, and Comanches, established economic relationships with the easternmost frontier pueblo villages such as Taos, Pecos, and various villages in the Galisteo Basin and the Salinas district. The interaction between these groups is mentioned throughout the ethnographic literature (see Boyd et al. 1993: Table 35), but few details are known and the complex exchange systems are poorly understood.

While the Plains-Pueblo exchange certainly involved many items of varying importance, archaeological evidence is generally limited to the nonperishable artifacts that may have been only a minor component in the trade. In the southern Plains, obsidian, turquoise, and *Olivella* shell beads are somewhat rare, but are consistently found in protohistoric Indian sites and provide direct evidence of exchange with people living in villages in what is now New Mexico.

In addition, archaeologists have long recognized that southern plains peoples obtained large numbers of pottery vessels from Puebloan peoples (for example, Krieger 1946). These vessels were certainly desirable and useful to the nomadic groups, but the contents of the vessels, most likely perishable agricultural products, were probably what was being sought (Habicht-Mauche 1991; Speth 1991; Spielmann 1983; Spielmann, ed. 1991). The ceramics found in protohistoric archaeological sites are the most tangible and abundant form of archaeological evidence of this exchange.

GEOLOGIC HISTORY OF THE TEXAS PANHANDLE-PLAINS

The unique landscape of the Panhandle-Plains is owing to regional bedrock geology and geomorphic history (figure 9.1). Climatic conditions certainly played a role, but the geology was the major factor controlling the region's long and complex geomorphic history. The presence of erosion-resistant layers of indurated caliche and sandstones, interspersed with softer shales, mudstones, siltstones, and clays, determined the patterns of erosion that shaped the Rolling Plains and Caprock Canyonlands, and left the Llano Estacado as an isolated mesa.

The Panhandle-Plains consists of layered geologic deposits that are being exposed by the headward erosion of the several

major river valleys. The entire sequence, best represented in Palo Duro Canyon (Matthews 1969), has three major depositional units. The bottom layer is comprised of Permian shales, clays, mudstones, and sandstones that represent marine deposits laid down on an ancient sea floor (Gustavson, Finley, and McGillis 1980). Because these layers are typically red in color, the name "Permian redbeds" is often used to identify the Rolling Plains. At the top of these deposits is an unconformity, representing fifty million years or so, that is immediately overlain by late Triassic-age deposits assigned to the Dockum Group. These alternating layers of sandstones, mudstones, and shales were deposited along the shoreline of an ancient sea. The multicolored Triassic layers exposed in Palo Duro Canyon are descriptively called "Spanish Skirts." Jurassic and Cretaceous deposits are missing over most of the Texas Panhandle-Plains and represent an unconformity of more than one hundred million years. Tertiary-age Ogallala Formation sediments, which rest directly on top of the Triassic deposits, are a series of layered sands, gravels, and clays that can be roughly divided into upper and lower units (Holliday and Welty 1981). The lower unit is primarily fluvial and lacustrine sediments deposited by meandering streams coming off the Rocky Mountains. The upper unit is a capping layer of well-developed caliche that formed during an extended period of landscape stability and eolian deposition (Gustavson 1986). The Ogallala Formation forms the bluff edge of the Caprock Escarpment of the Llano Estacado and is best known as the primary ground water aquifer underlying much of the Great Plains (Baker 1915; Gustavson and Holliday 1985). The only significant divergence from this Permian-Triassic-Tertiary sequence is that Cretaceous limestones are present in the southern end of the Llano Estacado (Brand 1953).

The regional geology is rather simple in that headward stream erosion throughout the Quaternary has continued to expose the layered formations and resulted in the dissected modern landscapes of the Canadian River valley, the Caprock Escarpment, and the Rolling Plains. With respect to identification of ceramic sources based on chemical or mineralogical identifications of clay and/or temper additives, two geologic factors are important. First, the Panhandle-Plains is nearly devoid of any significant sources of igneous or metamorphic rocks. Small, isolated pieces of igneous or metamorphic rocks (particularly metaquartzites) may be found as stream-rolled cobbles in the Ogallala gravels, but they represent a very minor source. Although some such materials could be and were used as ceramic temper, most types of volcanically derived or altered rocks simply are not present anywhere in the region.

The second important factor is that the sedimentary materials that make up the parent bedrock, and hence the alluvial clays, are homogeneous across a vast region. The Tertiary Ogallala formation, Triassic Dockum Group formations, and various Permian formations that comprise the surface geology of the Panhandle-Plains region are basically the same as sedimentary deposits found across much of western New Mexico, eastern Oklahoma, eastern Colorado, and western Kansas (although formation names are often different across state lines). For example, many of the Permian and Triassic formations exposed in the Pecos Valley of New Mexico (and in the vicinity of Pecos Pueblo), are essentially lateral equivalents to the Permian and Triassic exposures in the Caprock Canyonlands and Rolling Plains.

LONGHORN AND HEADSTREAM SITES

The Longhorn and Headstream sites (41KT53 and 41KT51, respectively) are two protohistoric sites in Garza County, Texas, that were investigated in 1991 as part of the Lake Alan Henry project. The investigations are reported in detail by Boyd et al. (1993) and summarized by Boyd (1997). These sites are located on opposite sides of a small tributary to the Double Mountain Fork of the Brazos River, within a small and secluded canyon. They are interpreted as having been temporary encampments where bison-hunting peoples lived repeatedly, probably on a seasonal basis. Hide processing was an important activity, but killing and butchering do not seem to have occurred at these sites. Occupations at these sites may have taken place during intervals between bison hunts, as many other activities unrelated to bison (such as baking of plant foods and hunting of small/medium-sized game animals) are also evident. The occupations are attributed to the Garza complex and are well dated with twenty-two radiocarbon dates and numerous time-diagnostic artifacts. Although the occupations may have begun as early as circa AD 1400 or 1500 (in prehistoric times) and lasted as late as AD 1800, they were most intensive during the seventeenth century. Thus, these sites were occupied by people whose culture was changing rapidly during the period of European contact. European artifacts recovered include cow and horse bones, possible native-made gun flints, a lead ball, Spanish majolica sherds, and glass beads.

Archaeological evidence also indicates the occupants of these sites were heavily involved in the Plains-Pueblo exchange system. Obsidian flakes from the Jemez Mountains, an *Olivella* shell bead, and a turquoise bead provide direct evidence of contact with the Puebloan peoples of New Mexico.

The most provocative evidence, however, is the ceramic assemblages from the two sites, which include 3,482 sherds representing a minimum of twenty-eight different vessels. Of the identified ceramic types, the majority are distinctive decorated and undecorated wares of Puebloan manufacture, including Tewa Polychrome, several varieties of late Rio Grande glaze wares, Pecos-style pipes, red wares, and micaceous utility wares. One vessel (represented by seventeen sherds) is of an unidentified engraved ware that is possibly from a Caddoan source. In addition, a significant portion of the assemblage (57% of the sherds and 18% of the identified vessels) is comprised of plain utility wares whose origins are in question.

PROTOHISTORIC CERAMICS

Ceramics found in these protohistoric sites constitute an extremely important body of evidence for several reasons: (1) they are often relatively abundant in campsites occupied for any length of time; (2) they are widespread throughout the southern plains, but there are distinctive patterns to the distribution of various types; (3) they include distinctive varieties of decorated wares that can be linked to specific Puebloan manufacturing localities (that is, a single village); (4) they frequently include ceramics from other sources (for example, Caddoan-like pottery) that provide evidence of exchange in different directions; and (5) they include many varieties of undecorated plain wares that served as utilitarian vessels. This last group is particularly important because of an ongoing debate, largely based upon interpretations of petrographic data, in the archaeological literature.

Based on the results of her petrographic study, Habicht-Mauche (1987, 1988, 1991) proposed that indigenous Southern Plains groups, specifically identifiable archaeologically as the Tierra Blanca complex of the Texas Panhandle, adopted Puebloan pottery-making techniques and manufactured a substantial amount of their own plain-ware pottery. The ceramic type name *Tierra Blanca Plain* was proposed to represent these indigenous striated plain wares that resemble Puebloan utilitarian wares such as the Faint Striated type from Pecos Pueblo. Habicht-Mauche (1987:186) suggests that people of the Garza complex of the southern Texas Panhandle-Plains either made their own Tierra Blanca Plain or obtained it in trade with Tierra Blanca peoples.

Based on the Lake Alan Henry petrographic study and a review of the Tierra Blanca petrographic data, Boyd and Reese-Taylor (1993) proposed the opposite point of view. They suggested that the evidence does not support the idea that indigenous protohistoric Plains groups had a widespread ceramic industry. The petrographic data seem to indicate that there may be some locally made plain wares in protohistoric assemblages from the Texas Panhandle-Plains, but that the vast majority of plain wares are virtually indistinguishable from Puebloan-made glaze wares and red wares found at the same sites. Thus, an important but unresolved research question is whether Tierra Blanca Plain is a valid type or whether most of the striated plain wares found at protohistoric sites in the southern Plains are, in fact, Puebloan-made. Visual analyses of ceramic materials are not sufficient to address this problem. The evidence that will help resolve this controversy is detailed and quantifiable data obtained through mineralogical and elemental analyses. The petrographic data of the Tierra Blanca and Lake Alan Henry studies are important first steps toward resolving some of the problems of ceramic sourcing.

Following the petrographic analysis on the Lake Alan Henry ceramics, the same samples were subjected to INAA. The petrographic and INAA studies provide mineralogical and elemental data that allow a comprehensive look at Lake Alan Henry assemblages with an eye toward identification of ceramic sourcing. The results of these studies (table 9.1) have many implications for defining ceramic production and exchange during the protohistoric period.

PETROGRAPHIC ANALYSIS

The composition of forty-five ceramic sherds from the Longhorn and Headstream sites and eight clay samples from the surrounding area have been characterized using petrographic analysis. The results from the petrographic analysis, reported by Boyd and Reese-Taylor (1993), indicate that the ceramic assemblages from the Longhorn and Headstream sites are highly variable. Of the forty-five analyzed ceramic specimens, twenty-five are interpreted as being of definite Puebloan origin, one specimen is of a non-Puebloan source, and nineteen are of unknown origin. Interpretations of potential manufacturing or resource procurement locales for the different specimens (table 9.2) are based upon previous petrographic studies identifying regional or Pueblo-specific tempers (Habicht-Mauche 1987, 1988, 1991; Shepard 1942, 1965; Warren 1981a, 1981b) in conjunction with visual type identifications of decorated sherds by various Puebloan ceramic experts. Specifically, the petrographic study did not reveal any clear difference in mineralogical composition between sherds typologically identified as Puebloan glaze wares and those plain-ware sherds that could be classified based on visual examination as either Tierra Blanca Plain (Habicht-Mauche

Table 9.1 Comparison of instrumental neutron activation analysis and petrographic analysis results (by INAA groups) for the Lake Alan Henry sample

INAA#	Ceramic type	Site	INAA gp.	Petr. gp.
LAH002	Glaze ware	Longhorn	Main 1	II-G
LAH008	Red ware	Longhorn	Main 1	I-E
LAH009	Red ware	Longhorn	Main 1	I-B
LAH010	Red ware	Longhorn	Main 1	none
LAH019	Micaceous	Longhorn	Main 1	I-D
LAH021	Micaceous	Longhorn	Main 1	I-E
LAH024	Plain ware	Longhorn	Main 1	II-G
LAH026	Plain ware	Longhorn	Main 1	II-G
LAH027	Plain ware	Longhorn	Main 1	none
LAH029	Plain ware	Longhorn	Main 1	none
LAH039	Red ware	Headstream	Main 1	II-G
LAH048	Plain ware	Longhorn	Main 1	none
LAH050	Plain ware	Longhorn	Main 1	none
LAH054	Red ware	Longhorn	Main 1	II-C
LAH057	Plain ware	Headstream	Main 1	none
LAH058	Plain ware	Headstream	Main 1	none
LAH001	Glaze ware	Longhorn	Main 2	I-E
LAH003	Glaze ware	Longhorn	Main 2	I-E
LAH004	Glaze ware	Longhorn	Main 2	II-D
LAH006	Glaze ware	Longhorn	Main 2	II-G
LAH007	Glaze ware	Longhorn	Main 2	I-E
LAH011	Red ware	Longhorn	Main 2	none
LAH028	Plain ware	Longhorn	Main 2	none
LAH030	Glaze ware	Longhorn	Main 2	I-E
LAH031	Glaze ware	Longhorn	Main 2	I-E
LAH034	Plain ware	Headstream	Main 2	none
LAH035	Plain ware	Headstream	Main 2	none
LAH036	Plain ware	Headstream	Main 2	none
LAH037	Plain ware	Headstream	Main 2	none
LAH038	Plain ware	Headstream	Main 2	II-G
LAH041	Red ware	Headstream	Main 2	none
LAH044	Glaze ware	Headstream	Main 2	II-G
LAH049	Plain ware	Longhorn	Main 2	II-G
LAH052	Red ware	Longhorn	Main 2	I-B
LAH053	Red ware	Longhorn	Main 2	none
LAH056	Glaze ware	Longhorn	Main 2	none
LAH059	Plain ware	Headstream	Main 2	none
LAH061	Local clay, alluvial	Longhorn	Clay	none
LAH062	Local clay, alluvial	Longhorn	Clay	none
LAH063	Local clay, green Triassic	nonsite	Clay	none
LAH064	Local clay, red Triassic	nonsite	Clay	none
LAH065	Local clay, alluvial	nonsite	Clay	none
LAH066	Local clay, micaceous	nonsite	Clay	none
LAH016	Micaceous	Longhorn	Main Micaceous	I-C
LAH017	Micaceous	Longhorn	Main Micaceous	I-C
LAH018	Micaceous	Longhorn	Main Micaceous	II-F
LAH051	Micaceous	Longhorn	Main Micaceous	I-C
LAH013	Pipe	Longhorn	Pipe/Engraved	none
LAH014	Pipe	Longhorn	Pipe/Engraved	II-A
LAH015	Engraved	Longhorn	Pipe/Engraved	none
LAH022	Plain ware	Longhorn	Plain 1	II-G
LAH045	Plain ware	Longhorn	Plain 1	II-G
LAH046	Plain ware	Longhorn	Plain 1	II-G
LAH025	Plain ware	Longhorn	Plain 2	II-G
LAH032	Plain ware	Longhorn	Plain 2	none
LAH033	Plain ware	Longhorn	Plain 2	none
LAH047	Plain ware	Longhorn	Plain 2	II-G
LAH005	Glaze ware	Longhorn	Unassigned	II-E
LAH012	Matte Paint	Longhorn	Unassigned	I-A
LAH020	Micaceous	Longhorn	Unassigned	II-G
LAH023	Plain ware	Longhorn	Unassigned	II-F
LAH040	Red ware	Headstream	Unassigned	none
LAH042	Red ware	Headstream	Unassigned	I-A
LAH043	Red ware	Headstream	Unassigned	I-A
LAH055	Glaze ware	Longhorn	Unassigned	II-G
LAH060	Plain ware	Headstream	Unassigned	II-D
LAH061	Alluvial Clay	Longhorn	Clay	none
LAH062	Alluvial Clay	Longhorn	Clay	none
LAH063	Green Triassic Clay	non-site	Clay	none
LAH064	Red Triassic Clay	non-site	Clay	none
LAH065	Alluvial Clay	non-site	Clay	none
LAH066	Micaceous Clay	non-site	Clay	none

1987, 1988, 1991) or Puebloan utility ware. Instead, the petrographic analysis indicated similar production locales for both decorated wares (visually identified as Puebloan-made) and the majority of plain wares.

Many of the striated plain-ware sherds from the Lake Alan Henry collection could easily be typed as Tierra Blanca Plain. A detailed visual (10–40x) examination and comparison of the Lake Alan Henry plain wares and the Tierra Blanca type specimens (the actual thin-sectioned sherds from Texas sites used in the Tierra Blanca petrographic study) revealed no significant differences. In fact, the similarities are striking, and some specimens are, for all practical purposes, visually identical in composition and finish. Based on the petrographic data, however, it appears that most of the Lake Alan Henry plain wares represent Puebloan culinary wares rather than Plains-made wares. Two main Puebloan sources may be represented in the Lake Alan Henry striated plain wares: Pecos Pueblo (Paste Groups IID, IIE, IIF, and IIG) and the Salinas area (Paste Group IE). This interpretation is supported by visual identifications (by David Snow and Curtis Schaafsma) of Pecos and Salinas glaze wares and red wares in the Lake Alan Henry assemblages. In addition, the fact that Pecos Pueblo and certain Salinas pueblos became major Plains trade centers during the seventeenth century suggests that these sources should be considered as likely candidates for striated plain wares found in the Southern Plains.

The Lake Alan Henry petrographic analysis suggests that there is no strong evidence to support the conclusion that Tierra Blanca Plain is a distinctive, indigenous Plains ceramic type. It appears that most of the Tierra Blanca Plain ceramics identified at Texas sites in Habicht-Mauche's (1988) petrographic study fall within the range of variability for Pecos Pueblo, while others could easily be Corona series plain wares made at various pueblos in the Salinas district.

INSTRUMENTAL NEUTRON ACTIVATION ANALYSIS

INAA provides further data for addressing the research problems related to manufacturing sources of protohistoric ceramics. The INAA data augment the results of the Lake Alan Henry petrographic study outlined above (Boyd and Reese-Taylor 1993). Samples selected for the analysis consisted of sixty ceramic fragments cut from large sherds and six local clay samples (five from the immediate vicinity of the Longhorn and Headstream sites and one from a locality in nearby Borden County). The selected samples represent a wide variety of decorated and undecorated wares and have been matched with the petrographic data to provide a cross check between both data sets (see table 9.1). INAA samples were taken from the same sherds that were analyzed petrographically in many cases, or from sherds known to be from the same vessel or same paste group as a petrographically analyzed sherd.

Based on the instrumental neutron activation analysis data, the archaeological samples from the Lake Alan Henry project are sorted into five meaningful groups based upon a total of thirty-three elements. Approximately 90% of the variability within this data set is subsumed in the first ten principal components. The first several principal components afford a reasonable basis for defining intergroup relationships, and plotting the samples by the first two principal components illustrates the group clusters (figure 9.2). Other statistical analyses and plottings of the compositional data (using principal components and trace elements) indicate that these groupings are valid (Neff and Glascock 1995b).

The sixty ceramic samples are divided into one of seven groups (table 9.3). The largest number of specimens (N=37) fall into a large cluster designated as the Main group. This group is further divided into two subsets, Main 1 and Main 2. Main 1 consists of one glaze-ware sherd (6.25%), five red-ware sherds (31.25%), two micaceous-ware sherds (12.5%), and eight plain-ware sherds (50%). These are from two different vessels and four sherd groups from the Longhorn and

Table 9.2 Summary of source area interpretations for ceramic paste groups in the Lake Alan Henry assemblages (Longhorn and Headstream sites) based on petrographic analysis and visual identifications*

Group**	Types	Interpretations
IA	1 red-ware sherd 2 matte paint sherds	Tewa wares from northern Rio Grande Pueblo area, specific pueblo unknown. Distinctive volcanic glass temper.
IB	2 red-ware sherds	Puebloan source, possibly represents the Salinas area.
IC	1 micaceous utility sherd	Possibly represents Puebloan or Jicarilla Apache ceramics from the Taos/Picuris region of northern New Mexico.
ID	1 micaceous utility sherd	Unknown source.
IE	1 plain-ware sherd 1 micaceous utility sherd 1 red-ware sherd 3 glaze-ware sherds	Puebloan source, possibly represents the Salinas area.
IIA	1 Pecos-style pipe sherd	Probably represents Pecos Pueblo.
IIB	1 engraved sherd	Unknown source, probably non-Puebloan.
IIC	2 plain-ware sherds 1 red-ware sherd	Unknown source, but the Salinas area and Pecos Pueblo cannot be ruled out.
IID	1 plain-ware sherd 2 glaze-ware sherds	Possibly represents Pecos pueblo, but other sources cannot be ruled out.
IIE	1 red-ware sherd 3 glaze-ware sherds	Probably represents Pecos Pueblo, but other sources cannot be ruled out.
IIF	2 plain-ware sherds 1 micaceous utility sherd 1 red-ware sherd	Probably represents Pecos Pueblo, but other sources cannot be ruled out.
IIG	8 plain-ware sherds 1 micaceous utility sherd 3 red-ware sherds 4 glaze-ware sherds	Possibly represents Pecos Pueblo, but other sources, especially non-Puebloan, cannot be ruled out.

* Lake Alan Henry assemblages subjected to petrographic analysis include 45 sherds from the Longhorn and Headstream sites. Ceramic paste groups and source area interpretations are defined and discussed in Boyd and Reese-Taylor (1993).

** Ceramic Paste Groups I and II are differentiated by the ratio of clastic sedimentary to igneous resources in the nonplastic component of the ceramic paste (that is, the temper). Group I is dominated by common igneous resources (principally feldspars), while Group II is dominated by common clastic sedimentary resources (principally quartz). Identification of subgroups is based on relative frequencies of other minerals.

Table 9.3 Results of instrumental neutron activation analysis of local clays and protohistoric ceramic sherds from Lake Alan Henry sites (Longhorn and Headstream) in Kent County, Texas

Visual type ID	Main 1	Main 2	Plain 1	Plain 2	Micaceous main	Pipe/engraved	Unassigned	TOTAL
Glaze ware	1	9	0	0	0	0	2	12
Red ware	5	4	0	0	0	0	3	12
Matte Paint ware	0	0	0	0	0	0	1	1
Plain ware	8	8	3	4	0	0	2	25
Mica. Plain ware	2	0	0	0	4	0	1	7
Engraved ware	0	0	0	0	0	1	0	1
Pecos-style Pipe	0	0	0	0	0	2	0	2
Local clays*	0	0	0	0	0	0	6	6
TOTAL	16	21	3	4	4	3	15	66

* Holocene alluvial clay and Triassic mudstone clay samples collected from near the Longhorn and Headstream sites in Kent County ($n=5$) and in Borden County ($n=1$).

Headstream sites. Main 2 consists of nine glaze-ware sherds (42.9%), four red-ware sherds (19%), and eight plain-ware sherds (38.1%). These are from four different sherd groups from the Longhorn and Headsteam sites.

What differentiates Main 1 from Main 2 is a tendency toward lower frequency of rare earth elements. Dilution of rare earth elements may indicate a difference in the texture of the pastes rather than a difference in clay source. Rare earth elements tend to be enriched in clay, and this dilution effect may correspond with finer texture (that is, a higher clay component) of ceramic fabrics in Main 2 compared to Main 1 (Neff and Glascock 1995b:5). The fact that glaze-painted ceramics are more common in Main 2 than Main 1 could indicate that it is not a chemical difference between the clays that distinguishes these groups, but a technological difference in the processing of the clays. The paste of the glaze-ware sherds in the Lake Alan Henry sample is generally much finer in texture than the paste observed in nonpainted and plain-ware sherds. This may simply mean that potters gave more attention to the selection and processing of clays used to make vessels that were painted.

Besides the sherds in the two main groups, which represent 62% of the sixty sherds in the INAA sample, the remaining sherds ($n=29$) are either assigned to one of four minor groups or fall into an unassigned group (see table 9.3). One minor group consists of two pipe fragments and one engraved sherd. This group is distinguished by high levels of aluminum, cesium, and rare earth elements. The pipe sherds are from two different Pecos-style pipes from the Longhorn site and are visually identified as pipes made at Pecos Pueblo. The engraved sherd from the Longhorn site is thought to represent a Caddoan-style ware, but all of the engraved sherds are so small that this interpretation is questionable.

A second minor group is designated Plain 1. It is comprised of three plain-ware sherds from the Longhorn site.

This group is distinguished by high levels of mercury and zirconium, as well as low levels of antimony, manganese, cobalt, and other metals. Notably, all three sherds in this group are from the same portion of a partially reconstructed plain-ware jar that has an unfinished exterior (as opposed to striated). These three specimens were intentionally put into the sample as a test case to see how tightly the INAA data for sherds from a single vessel would cluster. The INAA data for these sherds do indeed cluster tightly and indicate that the clay in this vessel is very different in composition from all the other vessels. The other minor group of plain wares, Plain 2, consists of four sherds distinguished by high levels of antimony, arsenic, calcium, and metals combined with low levels of rare earth elements. These sherds are from two different vessels and one sherd group from the Longhorn site.

Finally, the fourth minor group, Main Micaceous, consists of four micaceous sherds distinguished by high levels of cobalt and other metals, but low levels of other elements. That these specimens cluster together is not surprising since they all exhibit a large proportion of micaceous temper. Three of the four sherds are from the same vessel from the Longhorn site, which was visually identified as something akin to the heavily micaceous plain wares from Taos or Picuris Pueblos or the similar wares made by their Jicarilla Apache neighbors. The fourth micaceous sherd is from a different vessel at the Longhorn site.

If the protohistoric Plains peoples made their own plain-ware pots, one would expect the INAA data to isolate groups of locally made plain wares that are distinctive in composition from the Puebloan-made glaze wares and red wares. This may be the case for the seven plain-ware sherds that fall into the Plain 1 and Plain 2 groups since no Puebloan-made sherds are included in these groups. These sherds, then, are possible candidates for representing locally made Plains ceramics, but they represent only a small percentage of the total

assemblage of plain wares from both sites. If the majority of plain-ware sherds in the Lake Alan Henry INAA sample were in fact locally made, most of the plain-ware sherds should be found in discrete INAA groupings that are compositionally distinct from the Puebloan wares. This is clearly not the case since sixteen of the plain-ware sherds in groups in Main 1 and Main 2 are similar in composition to ten glaze-ware and nine red-ware sherds of definite Puebloan manufacture. The INAA data suggest that these sixteen sherds represent Puebloan-made utility vessels rather than locally made pots.

Table 9.4 compares the INAA groupings with the ceramic identification groupings to give an idea of the size of the plain-ware assemblage represented by the INAA sample sherds. Notably, the sixteen plain-ware sherds in the Main 1 and Main 2 groups represent 605 of the 707 plain utility sherds from the Longhorn and Headstream sites. Consequently, if the visual groupings are correct, approximately 86% of the total plain-ware assemblage is similar in composition to and cannot be separated from the Puebloan-made glaze wares and red wares based on the INAA data. In contrast, only 12% of the plain-ware assemblage, (that is, those sherds represented by the Plain 1 and Plain 2 groups), are sufficiently different from the Puebloan-made wares to suggest that they may be locally made or made elsewhere on the Plains.

The INAA data show that five of the six local clay samples overlap considerably with the Main 1 and Main 2 groups but not with the Plain 1 or Plain 2 groups. These five clay samples (that is, all but LAH064) plot within the 90% confidence ellipse of the Main group for principal components 1 and 2 (see figure 9.2). The implications of this are not altogether clear, except to note that the local clays are as similar in composition to the Puebloan-made glaze wares and red wares of the Main 1 and Main 2 groups as they are to any of the plain wares in these groups. The clay samples include two bedrock clays from Triassic Dockum group mudstones, a micaceous clay derived from weathering of a Triassic Dockum group sandstone, and three Holocene alluvial clays ultimately derived from parent materials in the Triassic Dockum group and Ogallala Formation. Geologically, these clays are likely to be quite similar to Triassic clays and Triassic-derived alluvial clays found in the Pecos valley and to the west (New Mexico Geological Society 1982).

DISCUSSION

The Lake Alan Henry petrographic and INAA studies pro-

Table 9.4 Summary of twenty-five plain-ware sherds by INAA groups and ceramic identification groups*

INAA	Ceramic ID	Sherds**	%***
Main 1 (n=8)	2 vessels; 4 sherd groups	366	51.8
Main 2 (n=8)	4 sherd groups	239	33.8
Plain 1 (n=3)	1 vessel	19	2.7
Plain 2 (n=4)	2 vessels; 1 sherd groups	66	9.3
Unassigned (n=2)	1 vessel; 1 sherd group	17	2.4
TOTAL		707	100.0

*Ceramic groupings identified in the Longhorn and Headstream sites ceramic assemblages by Boyd et al. (1993:Tables 7 and 17).
** Total sherds represented in the ceramic identification groups
*** of plainware assemblage.

vide some interesting data useful for speculating on the sources of ceramics found in protohistoric sites in the Texas Panhandle-Plains. Neither study, however, includes a sufficiently large sample of either Plains or Puebloan ceramics to support strong conclusions regarding specific production localities. Three serious flaws limit the interpretability of the data in both studies: (1) the small samples sizes; (2) the lack of local clay samples from the eastern Puebloan area; and (3) the lack of comparative ceramics from various of the eastern Puebloan manufacturing centers. Given the insufficiencies in the data sets, much more work is obviously needed, but a few observations may be offered.

The independent results of the INAA and the petrographic analyses of protohistoric ceramics from Lake Alan Henry both show that the majority of plain wares found at the Longhorn and Headstream sites are from pots that are similar in composition to the glaze wares and red wares. If the glaze wares and red wares found in the southern plains are in fact Puebloan-made, as is widely assumed to be the case, this data suggests that most of the plain-ware sherds in the Lake Alan Henry sample probably represent Puebloan-made pots. The glaze wares and red wares that are most similar to the plain wares are visually identified by Southwestern ceramic experts as being Glaze E and F (or V and VI) period ceramics manufactured at several different locations, including (but not necessarily limited to) Pecos Pueblo, various pueblos in the Salinas area, and possibly in the Galisteo Basin (Boyd et al. 1993:207). These ceramic styles date from circa AD 1515 to 1700 according to Snow (1982:258–259). Based on these interpretations, we must reexamine the previously proposed hypothesis that a large portion of the plain wares found at protohistoric sites in the Texas southern plains are locally made but patterned after Puebloan prototypes.

The Main 1 and Main 2 groups both include sherds for which petrographic analysis identified the temper as being of

Table 9.5 Comparison of INAA and petrographic data for protohistoric ceramic sherds from Lake Alan Henry sites (Longhorn and Headstream) in Kent County, Texas*

Petro. group	Main 1	Main 2	Plain 1	Plain 2	Micaceous main	Pipe/ engraved	Unassigned	TOTAL
IA							2R, mp	3
IB	R	R						2
IC					3M			3
ID	M							1
IE	R, P	5G						7
IIA						pp		1
IIB								0
IIC	R							1
IID		G					P	2
IIE							G	1
IIF					M		P	2
IIG	G, 2P, R	2G, 2P	3P	2P			G, M	15
Unassigned	R, 6P	G, 6P, 3R		2P		pp, E	R	22
TOTAL	16	21	3	4	4	3	9	60

* Petrographic paste groups are defined and discussed by Boyd and Reese-Taylor (1993).

Key: E = engraved ware; G = glazeware; M = micaceous ware; P = plain utility ware (or plainware); R = redware; mp = matte paint; pp = Pecos-style pipe.

igneous and sedimentary origin (that is, ceramic paste groups I and II in Boyd and Reese-Taylor 1993). This simply means that the chemical similarities of the clay components for many specimens crosscut the petrographic groupings that may be indicative of different source areas (table 9.5). These data support the notion that the problem is very complex and more rigorous sampling of clays and ceramics is needed. However, the interpretive groupings do show that there is considerable overlap between plain wares of unknown origin and the glaze wares and red wares presumed to be of Puebloan origin.

Regarding the validity of Tierra Blanca Plain as an indigenous southern plains ceramic type, three contrasting hypotheses that relate to plain-ware production locales during the protohistoric period are considered. First, we must acknowledge the possibility that the plain utility wares, the red wares, and the glaze wares in the Lake Alan Henry sample are similar in composition because they were all produced on the Texas southern plains. If this is the case, Tierra Blanca Plain is a valid type and the protohistoric inhabitants of the Texas plains (for example, peoples of the Tierra Blanca and Garza complexes) had a well developed ceramic industry and produced a wide range of decorated and undecorated wares. This model is extremely unlikely because no archaeological or ethnographic evidence supports the idea that glaze-painted or red-ware ceramics were actually made anywhere on the plains. On the contrary, the evidence is strong that glaze-ware vessels were produced only by Puebloan peoples at specific pueblos. The evidence is equally strong for the Plains-Pueblo

interaction being the mechanism by which large amounts of Puebloan painted pottery were transported to various localities throughout the southern Plains during the protohistoric period. The idea that the glaze wares and red wares found in protohistoric sites in the Texas Panhandle-Plains were actually manufactured on the plains also contradicts the visual identifications of much of the Texas material by many Southwestern ceramic experts. It can only be concluded that this is an unlikely scenario, at best.

Second, it is possible that Tierra Blanca Plain does constitute a meaningful ceramic type representing utilitarian pots produced locally by plains peoples, and we are unable to distinguish the plain wares from Puebloan-made ceramics because of broad similarities in both the clay and temper resources of the eastern Puebloan areas and the southern plains. At this time, the evidence is inconclusive to support this hypothesis. To substantiate this model, additional mineralogical and compositional studies of ceramics from numerous pueblos and plains sites would be required to define the distinctions between the tempers and the clays of various decorated and plain-ware types to determine their source with confidence.

Finally, it is possible that all the red wares and glaze wares and most of the plain wares found in Texas Panhandle-Plains protohistoric sites were in fact produced in Puebloan villages and imported onto the plains. It is certainly possible, perhaps even likely, that plain-ware pots occasionally were made on the plains, but this scenario suggests that the protohistoric bison-hunting nomads obtained the vast majority of their pot-

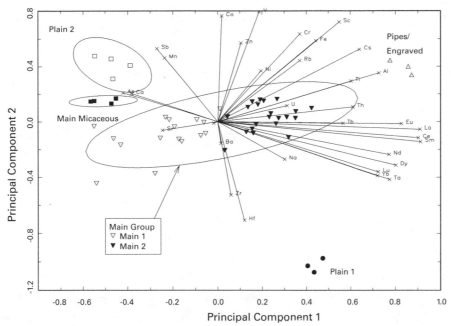

9.2 Biplot graph of INAA data showing compositional groupings based on principal components 1 and 2. Ellipses represent the 90% confidence level for membership in the group. *Illustration prepared by Hector Neff*

tery through the pueblo trade. We propose that this is the most plausible explanation for the similarities in temper and clay seen among the ceramic sherds recovered from the Lake Alan Henry project. This model is consistent with the visual identification of Puebloan ceramics and the extensive ethnographic evidence for protohistoric Plains-Pueblo exchange.

The Lake Alan Henry INAA data does not rule out the possibility that some or many of the sherds in the Main group (including Main 1 and Main 2) represent local plains-made wares because the local alluvial clay samples fall within the range of variability for the Main group. However, it must be reiterated that the broad compositional range of the Main group could easily include ceramics made from clays derived over a much wider area. It is virtually impossible to define what is "local" and what is not in such a small sample. An alternative interpretation is that the local Panhandle-Plains clay samples are similar in composition to some of the Puebloan-made glaze wares and red wares because of broad regional similarities in geology. Although formation names may be different, very similar geological conditions are found across a vast region encompassing much of east-central New Mexico, eastern Oklahoma, eastern Colorado, western Kansas and the Panhandle-Plains region of Texas. In fact, many of the Permian and Triassic formations exposed across east-central New Mexico and into the Pecos River valley (and in the vicinity of Pecos Pueblo) are essentially lateral equivalents of the Permian and Triassic exposures in the Caprock Canyonlands and Rolling Plains (see figure 9.1). Given the geologic homogeneity of these regions, then, the similarities between the local

clays and the clays used to produce some of the Puebloan pottery are not unexpected, and the INAA evidence does not necessarily point to local production of any of the materials in the Main group. The sample of local clays is too small and too geographically limited to understand the regional variability.

In conclusion, the results of both the petrographic and instrumental neutron activation analyses demonstrate that there are no significant compositional or chemical differences among many of the glaze wares, red wares, and the majority of plain utility wares recovered from the Longhorn and Headstream sites. This is especially true of the glaze wares, red wares, and plain wares in the Main INAA group, and it is quite likely that these wares originate from the same source(s). Unless one seriously entertains the notion that glaze wares and red wares were made on the plains, a proposition that is rather unlikely, the most satisfying alternative interpretation is that Pueblo people probably made these plain wares. The extensive documentation for long-term interaction between Plains nomads and sedentary Puebloan peoples suggests that intercultural exchange is still the most likely mechanism to explain how and why large amounts of Puebloan pottery, plain and decorated, ended up scattered across the southern plains of Texas.

These studies also make it clear that the problem of identifying ceramic production localities is far too complex to be resolved by limited analyses such as these, and that much larger and more widespread samples of clays and ceramics are needed. Defining the geologic similarities and differences be-

Douglas K. Boyd, Kathryn Reese-Taylor, Hector Neff, and Michael D. Glascock

tween the Pecos River valley of New Mexico and the Texas southern plains, for example, will require considerable effort. Furthermore, the full range of compositional variability of Puebloan plain and striated utility ceramics must be understood before Plains-made ceramics can be confidently identified through mineralogical or elemental analyses. Archaeological researchers in the southern plains should be aware of the interpretive problems inherent in the use of Tierra Blanca Plain as representing a widespread indigenous plains ceramic tradition. By using this type name, researchers are assuming that the wares were manufactured on the plains, but this assumption is far from proven. Until it can be demonstrated more convincingly that the striated plain utility wares found at protohistoric sites in the southern plains are actually plains-made rather than Puebloan-made, the use of Tierra Blanca Plain as a ceramic type will only cause further confusion. The proposition that the majority of plain utility wares found in protohistoric Garza and Tierra Blanca complex sites were produced in Puebloan villages and imported onto the southern plains still stands as the most viable explanation of the current data.

Acknowledgments. The 1991 archeological field work done at the Longhorn and Headstream sites, along with the subsequent artifact and data analyses and reporting, were funded by the City of Lubbock, Texas, in conjunction with construction of Lake Alan Henry. The petrographic analysis of the ceramic assemblages was conducted as part of this project and was published in 1993, but it was not until 1994 that the samples were submitted for INAA study. The authors thank the people at Prewitt and Associates, Inc. of Austin, Texas, for supporting the continuation of this research long after the federally-mandated project expired. The Research Reactor Center, University of Missouri-Columbia, completed the INAA study of our sample in 1995, and they were most helpful during the process of interpreting the complex analytical data. Finally, special thanks go to the editors—Donna Glowacki and Hector Neff—for their untiring efforts to see that the vast amounts of INAA data accumulated from many diverse projects were brought together into a single volume to further our understanding of ceramic production in the Southwest.

Patayan Ceramic Variability

Using Trace Elements and Petrographic Analysis to Study Brown and Buff Wares in Southern California

John A. Hildebrand, G. Timothy Gross, Jerry Schaefer, and Hector Neff

ON THE LOWER COLORADO RIVER and adjacent desert and upland regions of southern California and western Arizona, the late prehistoric Patayan produced predominantly undecorated ceramics using a paddle and anvil technique (Colton 1945; Rogers 1945a; Waters 1982). Patayan ceramic vessels were important to both mixed horticultural economies along the Colorado and adjacent river systems, and to largely hunting and gathering economies in the adjacent uplands. Patayan ceramic production began at about AD 700 (Schroeder 1961), and continued into recent times among the Yuman speakers of this region, descendants of the Patayan (Rogers 1936). Broadly speaking, in the lower Colorado River area, Patayan peoples produced light-colored buff-ware ceramics. In northwestern Arizona, and the Peninsular Ranges of southern California and Baja California, Patayan peoples produced darker colored brown-ware ceramics. In the Salton Trough desert region both buff- ware and brown-ware ceramics were produced, with brown wares dominant in the west and buff wares dominant in the east.

A major problem for archaeologists working with Patayan ceramics has been the lack of a reliable taxonomy to classify these largely undecorated pottery wares into temporally and spatially meaningful types (Lyneis 1988). The subdivision of Patayan ceramics into two named wares—Tizon Brown Ware and Lower Colorado Buff Ware—is based primarily on differences in the materials used in manufacture, the choice of which is more likely based on material availability, rather than on cultural selection. In the Peninsular Range, batholithic materials are present which weather into residual clays with a high iron content, hence a reddish-brown color results from firing in an oxidizing atmosphere. These residual clays con-tain a large fraction of granitic inclusions, and when present in prehistoric pottery, the inclusions may not represent added temper but the remnants of incompletely weathered parent rock (Shepard 1964). In the lower Colorado River and Salton Trough regions, alluvial clays are available with a low iron content, hence their buff color, and which contain little or no intrinsic inclusions. In this case, tempering materials may be purposefully added to the alluvial clays. For the historic Kumeyaay/Kamia, a Yuman-speaking group known to have occupied both mountain and desert regions west of the low-er Colorado River (Hicks 1963), the same potters may have produced both brown-ware and buff-ware ceramics while occupying these two environments during seasonal migra-tions. The same may be said of the Pai groups and their an-cestors to the east of the Colorado River. The point here is that material availability is an important component of ce-ramic manufacture.

In the classical typologic sense of southwestern ceramics (Wheat, Gifford, and Wasley 1958), Patayan ceramics have been divided into two wares—Tizon Brown Ware and Lower Colorado Buff Ware—based on their material and technical characteristics, but further subdivision into pottery types is difficult. The initial definition of Tizon Brown Ware (Dobyns and Euler 1958) was spatially restricted to northwestern Ari-zona and explicitly associated with the ethnohistoric groups of this region. Seven Tizon Brown Ware types were defined, distinguished primarily by the coarse or fine character of their inclusions and by surface treatment, such as painting or wiping. Tizon Brown Ware is described as a pottery tradition of shaping vessels by paddle-and-anvil from residual granitic-derived clays, and firing in an uncontrolled oxidizing atmo-sphere. Euler (1959) subsequently expanded the scope of

Tizon Brown Ware to include southern California ceramics, because of their technical similarity to northwestern Arizona ceramics, but he advised against applying Arizona type names to the southern California ceramics. Subdivision of southern California brown wares into types has been attempted, based primarily on color, surface treatment, and inclusions (May 1978; Rogers 1945b). The difficulty is that there are significant local variations in the materials used in brown-ware manufacture, and, in addition, there is a lack of recognized stylistic variation to aid in type definition. Despite years of effort directed at developing a brown-ware typology, Malcolm Rogers expressed his frustration in a letter to E. W. Gifford dated June 27, 1945:

> Plain wares of residual clay derived from granitic magmas exhibit a bewildering amount of apparently identical sherds regardless of cultural origin. As a result I have a mass (or better yet a mess) of reddish browns extending in a great arc out of Lower California through the mountains of Southern California and across the Mohave Desert into northwestern Arizona. Even after years of study, if one should hand me a bag of unidentified sherds representing that area, I could identify few as to their geographical origin. (Rogers 1945c:2)

Despite these difficulties, it is possible to improve typological systems for these brown wares on the basis of their technical attributes. For example, results presented here suggest that southern California brown wares include a ceramic ware produced along the western margin of the Salton Trough that cannot be classified as Tizon Brown Ware because it was not produced from residual clay. We call this class of ceramics Salton Brown Ware, after the ceramic type Salton Brown defined by Rogers (1945b). The key characteristics of this ware are the use of reddish-brown firing alluvial clays and sand temper or inclusions. Other recent ceramic studies along the eastern margin of the Peninsular Range have described these ceramics, but did not recognize them as being a separate ware from Tizon Brown Ware (Cook 1986).

For Lower Colorado Buff Ware, a system of types has been presented by Waters (1982), based on Rogers (1945b). In defining these types, the primary ceramic traits were variations in surface treatment, jar rim form, and vessel form. Temper and/or inclusion were of secondary importance in type definition, but these traits are important to subsequent classification of sherd collections, since on most sherds, rim and vessel form are indeterminate. Based on recent excavations, the Waters/Rogers typological system has been modified for type geographical and temporal distribution (Schaefer 1994a).

We present preliminary results from an on-going project to identify the sources of raw materials used in the production of Patayan ceramics from the southern California coast, Peninsular Range mountains, and Salton Trough desert. A total of seventy-five archaeological sherds and twenty-five clay samples were analyzed using petrographic thin section and instrumental neutron activation analysis (INAA). The petrographic thin sections allow observation of mineral and other inclusions in the clay, whereas the INAA allows quantitative estimation of elemental abundance.

Archaeological sherds selected for analysis were obtained from six sites that lie along an east-west transect crossing the coastal plain, the Peninsular Range mountains, and the Salton Trough desert (figure 10.1). Detailed petrographic and trace element studies of regional clay sources and of Patayan ceramic wares allows constraints on the variability of Patayan ceramic production, and thereby provides insight into Patayan population mobility, trade, cultural change, and other domestic activities. Our results suggest that long-range east-to-west transport of pottery occurred, with vessels produced in the Salton Trough appearing in the Peninsular Range and on the Pacific coast. Little comparable transport of ceramics from west-to-east is observed.

GEOLOGIC BACKGROUND

The extreme southern portion of California can be divided into several northeast-southwest trending geologic zones: the San Diego coastal plains, the Peninsula Range mountains, and the Salton Trough desert. The origin of these zones is related to the adjacent boundary between the oceanic and continental tectonic plates. During Mesozoic times (about 150 Ma), a lithospheric subduction zone was active off the west coast of North America, between the Farallon plate (oceanic) and the North American plate (continental). The subduction zone accreted oceanic volcanic rocks (of island arc origin) to the southwestern edge of the continent (Santiago Peak Volcanics), and emplaced volcanic rocks entirely within the continental crust (Salinia volcanics) as plutonic intrusions (Gastil 1975). Accretion of oceanic crust and plutonic intrusion created the Peninsular Range at about 100 Ma. These processes gave the Peninsular Range a strong geochemical gradient, with oceanic crustal affinities (basic-gabbroic rocks) grading into continental crustal affinities (acidic-granitic rocks) in a west-to-east direction.

After plutonic emplacement had ended, an era of Peninsular Range erosion began in Tertiary times. A low coastal plain with substantial river systems running from east-to-west stretched from the Peninsular Range to the sea. A forearc ba-

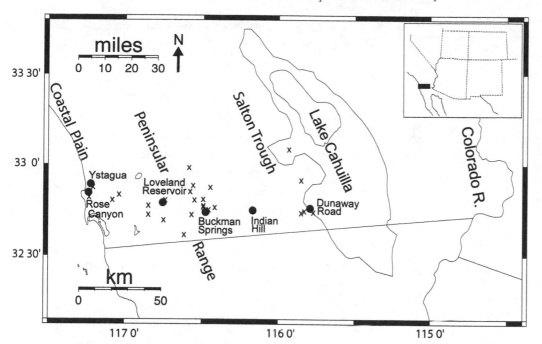

10.1 The study area encompasses an east-west transect in southern California stretching from the San Diego coastal plain, to the Peninsular Range mountains, to the Salton Trough desert region. Archaeological sites providing ceramics for this study are designated (solid circles), along with clay source areas (x's). The shoreline of Holocene Lake Cahuilla is shown on the eastern margin of the study area, as well as the contemporary Salton Sea. Inset shows the location of the study area with respect to the greater southwest. *Illustration prepared by the authors*

sin captured argillaceous marine sediments in deep water, and sandy sediments in lagoonal and littoral settings. River-borne materials created cobbles/boulder conglomerates, which were laid down in a thick sequence primarily in the Eocene epoch (P.L. Abbott 1985).

As the North American plate approached the Pacific-Farallon spreading center, subduction ceased along the continental margin and was replaced with a transform fault boundary. This transform fault system, which developed into the San Andreas Fault system of today, began opening the Gulf of California during the Miocene Epoch. Crustal rifting associated with transform faulting formed the Salton Trough as a rift valley, and uplifted the Peninsular Ranges along the western rift valley shoulder. As rifting lowered the Salton Trough elevation, the waters of the Gulf of California extended into it, depositing marine sediments.

The Colorado River flowed into the Miocene-Pliocene Salton Trough, and as the river carved the Grand Canyon in northern Arizona, deltic sediments were deposited in the Salton Trough, eventually blocking access of the Gulf waters. During this period predominantly lacustrine sediments were deposited in the Salton Trough. However, the large load of silt carried by the Colorado River made for a rapidly fluctuating location for the river flow. During some periods the river would flow directly into the Gulf of California, bypassing the Salton Trough. During other times, buildup of the delta periodically diverted the river's flow into the Salton Trough. When directed into the Salton Trough, the river flow

formed a large inland lake, known as Lake Cahuilla, the prehistoric equivalent of the modern Salton Sea. During late Holocene times, the Salton Trough filled to approximately 12 m elevation when the Colorado River was directed into it, and the lake evaporated when the river reverted to its original course (Wilke 1978). Geomorphological evidence, historical observations, and radiocarbon dating suggest that there were at least six fillings of the Salton Trough in the last two thousand years, with five intervening periods of at least partial desiccation (Laylander 1997; Schaefer 1994a; Waters 1983).

Clay sources in southern California

The Peninsular Range mountains, the coastal plain, and the Salton Trough desert contain clay deposits that were exploited for prehistoric as well as modern ceramic manufacture (Morton 1977; Weber 1963). These clays are divided into residual sources, those that are derived from weathering of the parent rock in situ and alluvial sources, those that are transported and redeposited in the process of weathering. The Peninsular Range mountains contain residual clays from weathering of gabbroic-granitic materials, whereas the coast and desert regions contain alluvial clays from marine and lacustrine sedimentary rocks.

Peninsular Range batholith. Many separate plutonic intrusions make up the Peninsular Range batholith in southern California (Todd, Erskine, and Morton 1988), with each pluton representing a distinct magmatic event. As the plutons form, their chemical components differentiate into distinct

Table 10.1: Location and geologic setting of clay sources

Sample#	Source	Lat./°N	Long./ °W	Geology
SIC001	Dunaway Rd.	32.76	115.79	Holocene Lake Cahuilla
SIC002	Superstition Mnt.	32.92	115.85	Brawley Fmt.
SIC040	Rose Canyon	32.83	117.23	Ardath Shale
SIC041	Cottonwood Ck.	32.81	116.49	Gabbro
SIC042	Buckman Spg.-1	32.78	116.49	Gabbro
SIC043	Buckman Spg.-3	32.77	116.49	Granodiorite
SIC044	Laguna Mnt.	32.88	116.45	Granodiorite
SIC051	Dehesa Rd.	32.78	116.85	Gabbro
SIC052	Lyons Pk.	32.70	116.75	Gabbro
SIC053	McGinty Mnt.	32.73	116.85	Gabbro
SIC054	Japatul Rd.	32.80	116.75	Gabbro
SIC055	Guatay Mnt.	32.86	116.58	Gabbro
SIC056	Oakzanita Pk.	32.89	116.56	Gabbro
SIC057	Cuyamaca Mid. Pk.	32.99	116.59	Gabbro
SIC058	Long Valley	32.81	116.55	Gabbro
SIC059	Big Potrero Pk.	32.62	116.62	Gabbro
SIC060	Los Pinos Mnt.	32.73	116.57	Gabbro
SIC061	Sheephead Mnt. Rd.	32.76	116.47	Julian Schist
SIC062	Yuha Buttes-1	32.75	115.83	Palm Springs Fmt.
SIC084	Ystagua	32.89	117.22	Ardath Shale
SIC085	Adm. Baker	32.81	117.08	Santiago Peak Meta.
SIC086	Manzanita	32.77	116.42	Granodiorite
SIC087	San Sebastian	33.09	115.93	Palm Springs Fmt.
SIC088	Mission Gorge	32.84	117.04	Friars Fmt.
SIC089	Yuha Buttes-10	32.74	115.85	Imperial Fmt.

mineral assemblages. The presence of silica minerals produced from the melt can be classified within a continuum from granite, which is quartz rich, to gabbro, which is plagioclase rich. Rocks of the Peninsular Range batholith have compositions between gabbro and granodiorite, with more gabbroic rocks in the west and more granitic rocks in the east. This is consistent with derivation of western batholith rocks from crust with oceanic affinities and eastern batholith rocks from crust with continental affinities. The batholith provides the parent rocks for some of the coastal plain and the western Salton Trough sediments, giving them similar chemical constituents.

In the Peninsular Range, clays are produced most readily by the weathering of high-alumina (Al_2O_3) minerals, primarily plagioclase feldspar and biotite mica. Plagioclase feldspar is the most abundant mineral (50%) in the western gabbroic plutons, whereas, in the eastern granitic pluton more abundant minerals are quartz (30%), which cannot form clay, and orthoclase (K-feldspar, 25%), which is resistant to weathering. As a secondary constituent, however, biotite mica—which does weather to clay—occurs most abundantly (15%) in the

eastern granitic plutons. Other secondary constituents that are present, yet that are unlikely to produce clays include amphibole (15%) and pyroxene (15%) and these occur primarily in the western gabbroic plutons. The above suggests that the western gabbroic plutons are more likely to produce clay from weathering, since they contain abundant plagioclase feldspars, and that these clays may have residual constituents of amphibole and pyroxene. The eastern granitic plutons will less readily produce clays, but these clays will be rich in biotite mica and quartz.

Sixteen clay samples from the Peninsular Range batholith (figure 10.2b) were submitted for chemical and petrographic analysis (table 10.1). Most of these samples (twelve) were from gabbroic plutons, as these locations consistently produced workable clays. Selected locations within granodiorite plutons were also found to produce workable clays, primarily near springs (for example, Buckman Springs) which provide ample chemical weathering. An ethnographic clay sample from Owas Hilmawa of the Manzanita Reservation, collected by Malcolm Rogers (1936), is also from weathered granodiorite in the Peninsular Range. One sample of micaceous Julian schist metasedimentary rock from the Peninsular Range was also submitted, but its chemical signature suggests that it was not used for ceramic production, as discussed below.

Two clay samples from the foothills of the Peninsular Range were submitted for analysis: one from the Friars Formation (SIC088), which is rock weathered from the western edge of the batholith, and one from the Santiago Peak Metavolcanic (SIC085), which is island-arc volcanic rock accreted to the continent just west of the Peninsular Range batholith (table 10.1). Chemical composition results, discussed below, suggest that the Friars Formation was used for prehistoric ceramic production, whereas, the Santiago Peak Metavolcanics were not.

Coastal sediments. The southern California coastal plain has Eocene through Pleistocene Epoch sedimentary facies derived from large scale weathering of the adjacent mountains (P.L. Abbott 1985). The highest rate of sedimentation occurred during the Eocene Epoch, when two sequences of marine transgression and recession left a pattern of sediments including four types of shoreline associated environments: fluvial on land, littoral near the shoreline, shallow water, and deep water. As the shoreline moved with changes in sea level, so did these depositional environments.

For the purpose of this study of clay sources, it was noted that fine clay materials are most likely deposited in the deep

water sequences, the littoral and shallow water facies being dominated by sand and silt. On the Eocene southern California coast, Ardath Shale is the most prominent deep-water facies. It produces an olive-gray clay that fires reddish brown in an oxidizing atmosphere, and was mined on a large scale for brick production during the recent past (Weber 1963). There is also a fictionalized, albeit seemingly credible, reference to use of the Ardath Shale by the coastal Kumeyaay for pottery production (Lee 1945:29). Two samples of the Ardath Shale (SIC040, SIC084), collected near two coastal occupation sites, were submitted for trace-element and petrographic analysis (table 10.1). The Ardath Shale chemical signature, however, suggests that it was not used for prehistoric ceramic production, as discussed below.

Salton Trough sediments. Beginning in the late-Miocene/early Pliocene, the Salton Trough was connected to the Gulf of California, resulting in deposition of marine sediments (Morton 1977). Called the Imperial Formation, these sediments attained a thickness of up to 1000 m and are predominantly a sequence of yellow-gray clay, interbedded with sandstone. Oyster beds in the upper portion of this unit indicate a shallow deltic marine environment during the later part of their deposition. The Imperial Formation is extensively exposed in the western Salton Trough, from the Coyote Mountains north to the Vallecito Mountains and in the Yuha Buttes region.

Following the growth of the Colorado River delta, marine access to the Salton Trough was blocked, leading to deposition of the Palm Springs Formation, a lacustrine reddish clay, interbedded with arkosic sandstone. These sediments were more than 2000 m thick and date from the Pliocene and Pleistocene. They are extensively exposed in the Vallecito-Fish Creek Basin, in the Tierra Blanca Mountains, and in the Yuha Basin of the western Salton Trough.

During the Pleistocene and Holocene, freshwater Lake Cahuilla periodically filled the Salton Trough. There are three recognizable intervals of sedimentation associated with the lake. The first is the Borrego Formation, a gray clay interbedded with sandstone of lacustrine origin. Extensive deposits of these sediments can be found west of the modern Salton Sea. The second interval of lacustrine deposition is called the Brawley Formation. It was formed during the late Pleistocene and contains light gray clays, sandstone, and pebble gravels of lacustrine origin. Brawley Formation deposits can be found in the Superstition Hills and Superstition Mountain region, southwest of the Salton Sea. The third interval of deposition is from Holocene Lake Cahuilla, which produced

tan and gray fossiliferous clay, silt, sand, and gravel. The central part of the Salton Trough, below 12 m elevation, is underlain by clay and silt deposits of Holocene Lake Cahuilla. Shoreline deposits of unconsolidated sand and fine gravel grade basinward into silt and clay. During modern times, mining operations near El Centro used this clay to produce brick and drain tile (Morton 1977).

Five clay samples (figure 10.1, table 10.1) from the Salton Trough were submitted for chemical and petrographic analysis. Samples were collected from the marine Imperial Formation (SIC089) and from the lacustrine Palm Springs Formation in the Yuha Basin (SIC062) and near Harper's Well (San Sebastian, SIC087). A sample of lacustrine Brawley Formation was collected in the Superstition Mountain region (SIC002). One sample of the Holocene Lake Cahuilla clay was collected from the Dunaway Road site along the southwestern shoreline (SIC001).

CULTURAL BACKGROUND

Late prehistoric cultural sequence (AD 600 to 1769)

The late prehistoric occupants of southern California and western Arizona have been variously designated Yuman (Rogers 1945a), Patayan (Colton 1945), and Hakataya (Schroeder 1957, 1979). Recognizing objections to the terms Yuman and Hakataya (Colton 1945; Harner 1958; Waters 1982:276–281), the designation Patayan is used here. Broadly, the Patayan occupied the Colorado River margins and adjacent areas. Ceramic evidence for their occupation consists of paddle-and-anvil constructed, predominantly undecorated wares. The Patayan cultural sequence is divided into three phases on the basis of changes in material culture and settlement pattern (Rogers 1945a; Waters 1982:281). Patayan I (AD 600 to 1000) is characterized by the beginning of ceramic production near the Colorado River, the use of small projectile points, cremation of the dead, and the beginning of maize agriculture. The principal area of Patayan I settlement was within the lower Colorado and Gila River valleys. Additional settlement was within the eastern portion of the Salton Trough.

During Patayan II times (AD 1000 to 1500), use of ceramics spread to the Peninsular Ranges of southern California and to northwestern Arizona, and new ceramic forms were developed within the Colorado and Gila River valleys and within the Salton Trough, possibly reflecting changes in diet and cooking practices related to expansion of maize agriculture in the Colorado River Valley. The water level of Lake Cahuilla was at its maximum height during much of this

time, and settlement data show occupation of the lakeshore was intensified (Rogers 1945a; Wilke 1978).

During Patayan III times (AD 1500 to 1769), ceramics were used along the Colorado River, in the Peninsular Ranges of southern California, in northwestern Arizona, and in the Salton Trough (Waters 1982:292). Some Patayan II ceramic types continued into this period, and new ceramic types were introduced. Agricultural practices were adopted by the inhabitants of the New River and Alamo River in the Salton Trough, and have been hypothesized for the inhabitants of the Peninsular Ranges as well (Treganza 1947; Wilke and Lawton 1975). The Patayan III period ended with the arrival of Europeans, whose increasing numbers disrupted aboriginal subsistence and settlement patterns. Documentary evidence for cultural identity between the Patayan III and the historic Yumans (e.g. Quechan, Kamia, and Kumeyaay) is related by Spanish chroniclers and missionaries (Forbes 1965:96). Ceramics continued to be made in all areas until the 1930s, with potters making innovations in both utilitarian and decorative items for the Euro-american market (Griset 1990, 1996; Schaefer 1994b). The Patayan ceramic tradition continues among the Paipai/Kumeyaay of northern Baja California (Wilken 1987).

The present study focuses on the region historically occupied by the Kumeyaay and Kamia, and we draw primarily from ethnohistoric sources concerned with ceramic usage by these peoples (Rogers 1936). The Kumeyaay occupied a territory that ranged from the Pacific coast near San Diego to the Imperial Valley, whereas the Kamia occupied the Imperial Valley including the New River and Alamo River, where they practiced mixed horticulture using seasonal floodwaters (Luomala 1978: Figure 1; Hedges 1975). These territories encompass varied environments from the coastal plain, through the mountains, to the low desert. Both groups had a settlement system including both permanent villages and resource gathering localities. For the Kumeyaay there was a seasonal movement from lowland to highland villages (Luomala 1978:599).

Pottery was used in a number of activities including food and water storage, cooking and serving, water transport, ceremony, personal adornment, gaming, manufacture, and as containers for cremations (E.H. Davis 1967; DuBois 1907). A key role for ceramics was for seasonal storage of gathered staples, such as the acorn and mesquite pods, for the Kumeyaay, and agricultural products, such as corn and squash, for the Kamia. Ceramics were used at village and other sites, attested by the presence of sherds at most Patayan II and III sites. Ceramics are also found as isolated ollas cached in rockshelters and as broken pots dropped along trails.

Yuman ceramic manufacture has been described in detail by Rogers (1936). Ollas and bowls were made by a paddle-and-anvil method, with the base of the pot being started on a basket or olla. Coils of clay were added to this base. The coils were smoothed and thinned by placing an anvil (either a smooth stone or a ceramic anvil) inside the vessel and striking the outer surface with a wooden paddle. The vessels were fired in a pit using oak or agave, and later cow manure, as fuel. Pottery making was generally practiced during the summer to facilitate drying during the vessel forming process (Rogers 1936).

Several ethnographic accounts describe clay procurement. Rogers (1936:4) describes two clay sources for his primary informant, Owas Hilmawa, of the Manzanita Reservation in the eastern Peninsular Range: one in Mason Valley and one in the Manzanita area. The Mason Valley source is described as a micaceous clay, noted as being widely sought for ceramic manufacture of cooking pots, with potters traveling long distances to obtain it. The Manzanita clay source is derived from weathered granitic rocks in that region, quarried from the banks of drainages where it was exposed by erosion. Rogers also notes that clay deposits were considered public property and were not privately owned. Heizer and Treganza (1944:333–334) mention Rogers's clay sources and also list an alluvial source in the Colorado Desert of Imperial Valley (probably Lake Cahuilla sediments), as well as sources in the Borrego Valley, Dos Cabezas Springs in the desert foothills, and Spring Valley in the coastal foothills. In discussing the Dos Cabezas Springs clays, Heizer and Treganza (1944:334) include the following statement:

The Diegueño women secured potters clay from near these springs. Each woman of this tribe had her own clay deposit which "worked well for her and liked her." For her, other clays would form pottery which would crack (H. Sharp, personal observation). This supports the idea that potters may have habitually exploited the same clay sources, but did not necessarily control them through ownership.

In discussing clays used by the Kumeyaay of northern Baja California, Hoenthal (1950:12–13) says that the potters recognized two different types of clay: one that needed no temper and one which could not be worked successfully without the addition of temper. Hoenthal's informant told him that clays were quarried from veins in the Sierra de Juarez foothills. The added temper was weathered granitic rocks that had been processed by mortar and pestle.

ARCHAEOLOGICAL CERAMIC DATA

Archaeological sherds selected for analysis were obtained from six sites that lie along on an east-west transect crossing the San Diego coastal plain, the Peninsular Range mountains, and the Salton Trough desert (figure 10.1). From east-to-west these are: Dunaway Road (IMP-5204), Indian Hill Rockshelter (SDi-2537), Buckman Springs (SDi-4787), Loveland Reservoir (SDi-14,283), Rose Canyon (SDi-12,557), and *Ystagua* (SDi-4609). At all but one site, sherds were obtained from controlled excavations; at Indian Hill Rockshelter sherds were obtained from surface collection.

Dunaway Road (IMP-5204)

The Dunaway Road site is located in the West Mesa region of the Salton Trough, immediately north of Yuha Wash in Imperial County. It is situated at sea level on a 1 m high sandy berm associated with a recessional shoreline of Lake Cahuilla. Radiocarbon samples from midden concentrations, and its location at a low elevation on a recessional beach line, suggests a late seventeenth-century (Patayan III) date for the Dunaway Road site (Schaefer 1986, 1994b). The site was completely excavated, revealing four spatially discrete activity areas. The largest was associated with two midden concentrations and a stone-lined hearth. Large quantities of fish bone, and a paucity of mammal bones, suggest fishing was the major economic pursuit. Pollen analysis suggests an early spring-summer mesquite exploitation, with emphasis on gathering blossoms.

A total of 407 ceramic sherds were recovered that were classified as 59% buff ware (predominantly Tumco Buff) and 41% brown ware (predominantly Salton Brown Ware). A study of rim forms on buff ware and brown ware sherds suggests that the same group of potters were manufacturing both wares. Six buff ware and nine brown ware sherds were selected for INAA and petrographic analysis. A clay sample submitted for analysis (SIC001) was collected from the Holocene Lake Cahuilla surface just under the sandy beach berm. Additional clay samples were collected in the adjacent Yuha Buttes region (SIC062 and SIC089).

Indian Hill Rockshelter (SDi-2537)

Indian Hill Rockshelter is located at the eastern base of the Peninsular Ranges in the foothills of the Jacumba Mountains, at an elevation of 660 m. The rockshelter is formed by a granodiorite monolith roof covering a floor area of 72 m². Middens of 1.0 to 1.6 m depth accumulated inside and across the rockshelter opening, leaving a ceiling height of 1 to 1.5 m in-side, and midden extends in front of the rockshelter. Also associated with the site are milling loci of mortars and slicks, cupule areas, pictograph panels, and yoni petroglyphs. Immediately available water derives from several bedrock tanks; additional water is found at springs located 5 km south and a palm oasis 2 to 3 km northwest. The rockshelter is in a transitional zone between the scrub vegetation community of the lower desert and the woodlands of higher elevations.

The Indian Hill Rockshelter has undergone several test and data-recovery excavations (McDonald 1992; W.J. Wallace 1962; W.J. Wallace and Taylor 1960; Wilke, McDonald, and Payen 1986), and the entire interior of the rockshelter has been excavated. The site is exceptional for the Colorado Desert, being the only investigated culturally stratified site that extends from the Late Archaic period (2,000 to 4,000 B.C. through to the Late Prehistoric and ethnohistoric periods (AD 1000 to 1850). McDonald (1992) concluded that the site was variously used as a residential base and temporary camp during its long history of occupation. Among the most notable features are a complex of stone-lined cache pits and three inhumations, all dating to the Archaic period. The substantial Patayan period levels comprise the uppermost 25% of the midden and produced a total of 3,445 ceramic sherds. The bulk of that collection derives from the excavations of Wilke, McDonald, and Payen (1986) and McDonald (1992), analyzed by Griset (1986, 1996) and McDonald (1992). They found a 2:1 ratio of brown-ware to buff-ware sherds, but they did not specifically distinguish Salton Brown Ware among what was otherwise defined as Tizon Brown Ware. McDonald (1992:247) does describe, without percentages, an "intermediate" type that conforms to Salton Brown Ware with buff-to-brown exterior color and uniformly size-sorted, water-worn grains of quartz, feldspar with muscovite and biotite inclusions. She concluded this must be from residual clays that washed down to the vicinity of Indian Hill. Tumco Buff was the most common buff-ware type. For the purposes of this study, seven sherds were surface collected from within the rockshelter and adjacent midden area; four buff-ware and three brown-ware sherds were submitted for analysis.

Buckman Springs (SDi-4787)

The Buckman Springs site (Kumeyaay name *Wikalokal*, singing rocks), is located in the Peninsular Range of southeastern San Diego County at an elevation of 975 m. This site is located in a densely clustered complex of at least six sites, separated by a few kilometers along the edge of the Cottonwood Valley. They are located near the boundary between oak

groves within the Cottonwood Valley, and chaparral on the surrounding hillsides. The acorn is abundant, outcropping bedrocks provide milling features, and a nearby permanent spring and intermittent stream provide water sources. These sites may have been inhabited primarily during the late summer and autumn months when a series of seeds and nuts became available. The relatively low elevation of the Cottonwood Valley, yet its position close to the higher elevations of the Laguna Mountains, may have made it an attractive winter occupation site as well.

Impacted by an interstate freeway, the Buckman Springs site was excavated in 1971 by San Diego State University. The excavation yielded 85,841 ceramic sherds, of which 99% were classified in the field as brown ware and 1% as buff ware (Hagstrum and Hildebrand 1990). The occupation of the Buckman Springs site spans Archaic to Historic time periods, from about 400 B.C. to AD 1890, based on radiocarbon dating (Hildebrand and Hagstrum 1995). Buckman Springs ceramics are presumed to be from Patayan II, III, and Historic Yuman occupations (AD 1000 to 1890), consistent with the initial date for ceramics at the adjacent Cottonwood Creek site (SDI-777; May 1976). No attempt was made to differentiate Tizon Brown Ware and Salton Brown Ware ceramics in this collection. For purpose of analysis, a stratified random sample was selected from four contiguous 2 x 2 m units, excavated in 10-cm levels, from the central portion of the site. Analysis of rim and body sherd curvature suggests that these sherds were from open-mouthed vessels used in food preparation (Hagstrum and Hildebrand 1990). Twenty-three brown-ware and two buff-ware sherds were selected for analysis, ranging from the surface to 90 cm depth. Clay samples were obtained from near the Buckman Springs (SIC042, SIC043), and from the adjacent Cottonwood Creek site (SIC041).

Loveland Reservoir (SDi-14,283)

The Loveland Reservoir site is located on the banks of the Sweetwater River in the western portion of the Peninsular Range mountains, at an elevation of 425 m. The site is situated on a finger of granitic rock that juts out into the river. Bedrock exposed on the surface has been heavily used for milling; Banks (1972:51) noted 229 bedrock mortars at the site. Dark, anthropic soils containing numerous artifacts are present. Early excavations at the site are reported by Banks (1972), and sherds for the present study were recovered from a 1 x 1 m test unit excavated for a site evaluation project (Robbins-Wade, Gross, and Shultz 1996). No radiocarbon dates were obtained, but the artifact assemblage includes ceramics, along with Cottonwood Triangular and Desert Side-Notched points, mano and metate fragments, and a shell bead. This site was most likely occupied primarily during the Patayan III period. Six brown-ware sherds were selected for analysis, making no attempt to differentiate Tizon Brown Ware and Salton Brown Ware. A clay sample was obtained near the site from Japatul Road (SIC054).

Rose Canyon (SDi-12,557)

The Rose Canyon site is located on the west bank of Rose Creek, approximately 5 km north of Mission Bay in the City of San Diego (Bissel 1997). It appears to have been a food processing camp with up to 110 cm of midden deposits. Early occupation is suggested by an uncalibrated radiocarbon date of 2290 ± 70 b.p. (Beta #89585) for materials recovered from the lower levels of the site (Bissel 1997). Surface and subsurface remains are dispersed over a substantial area, with several areas of concentration (Bissel 1997:74). Sherds for this analysis were selected from units excavated as a data recovery program associated with the City of San Diego's Rose Canyon Trunk Sewer project. The report on that project (Bissel 1997) suggests a Late Prehistoric (Patayan II and III) occupation by the artifact assemblage, including the presence of ceramics. One buff-ware and ten brown-ware sherds were submitted for analysis. A clay sample was obtained from the Ardath Shale that forms the eastern wall of Rose Canyon above the site area (SIC040).

Ystagua (SDi-4609)

A complex of archaeological sites in Sorrento Valley, near the Pacific coast, is believed to be the historically recorded village of Ystagua (Gallegos, Kyle, and Carrico 1989). The site is situated on both sides of a permanent stream, and contains multiple occupation components, including a substantial Late Prehistoric (Patayan) component (Gallegos, Kyle, and Carrico 1989). Based on mission records, this site is presumed to be one of the major Late Prehistoric population centers along the San Diego coastal zone. The sherds submitted for analysis were selected from excavations at a portion of the site designated SDi-4609, part of a cultural resource management project which excavated ten 2 x 2 m units in 10 cm arbitrary levels (Hector 1985). Ceramics were recovered from the upper levels of the site (Wade 1985:71). Radiocarbon dates obtained from these units span AD 710 to 1410, and combined with the presence of Late Prehistoric projectile points (Hector 1985:57), suggest a Late Prehistoric site occupation. Nine brown-ware sherds from this site were submitted for analysis.

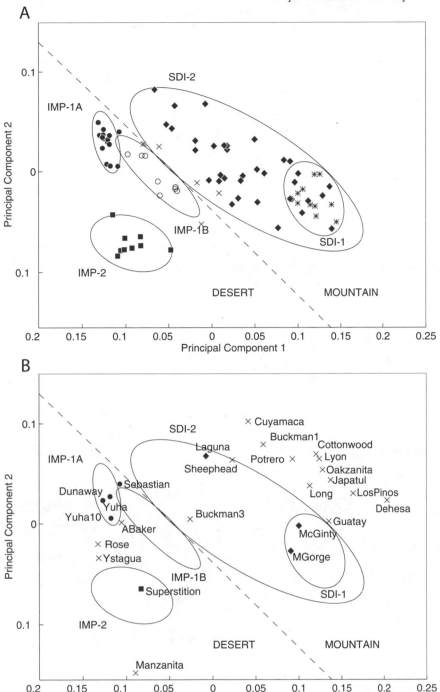

10.2 The first and second principal components from NAA are plotted for (a) archaeological ceramics and (b) clay sources. The following compositional groups are designated by unique symbols and enclosed in 95 percent confidence ellipses: IMP-1A (solid circle), IMP-1B (open circle), IMP-2 (solid square), SDI-1 (star), and SDI-2 (solid diamond). Compositional groups with a desert affiliation (IMP = Imperial County) are shown to the left of the solid line, and groups with a mountain affiliation (SDI = San Diego County) are to the right. Samples designated by an X could not be assigned to a compositional group. *Illustration prepared by the authors*

A clay sample of Ardath Shale was obtained from the bank of the stream within the site area (SIC084).

ANALYTIC PROCEDURES

For each sherd or clay sample, a petrographic thin section was produced and INAA was conducted at the University of Missouri Research Reactor (MURR). The petrographic thin sections allow observation of mineral and other inclusions in the clay, whereas INAA allows quantitative estimation of elemental abundance. To prepare the thin sections, a portion of the sherd was cast in epoxy resin, polished, cemented to a glass-slide, cut, polished to a thickness of 30μm, and sealed with a glass-coverslip. Mineral inclusions were quantified by a point-count method with a minimum count of one hundred. For the clay samples, a test square 5 cm x 5 cm was produced, with hand sorting to remove any large residual rock or or-

ganic fragments from the clay. Test squares were fired to 600°C for 3 hours; both thin section and INAA were conducted on these clay sample test squares to approximate native ceramic processing. For the INAA, the archaeological sherds were prepared using standard MURR procedures (Glascock 1992; Neff 1992; chapter 1). Elemental concentrations were derived from two irradiations and three gamma spectra counts to assay a total of thirty-three elements. For the southern California sherds, nickel was below detection in a large number of specimens and therefore was dropped from the data analysis. Concentration data from the thirty-two remaining elements were analyzed using principal components analysis (PCA) to reveal source-related subgroupings of sherds and clays (chapter 2). PCA provides a series of linear combinations of the concentration data, arranged in decreasing order of variance subsumed (table 10.2). Hypothetical groupings can be evaluated with multivariate statistics based on Mahalanobis distance (Bieber et al. 1976; Bishop and Neff 1989; Harbottle 1976), converted into probabilities of group membership for individual specimens. Each specimen is removed from its presumed group before calculating its own probability of membership (Baxter 1994b; Leese and Main 1994). Table 10.3 sorts the southern California ceramic samples into four compositional groups and gives their probabilities of group membership, based on scores from the first six principal components of the data.

RESULTS

A primary division of southern California ceramics is between those that appear to originate in the eastern, desert portion of the study area and those that appear to originate in the western, mountain region. Characterization as buff-ware or brown-ware ceramics is one expression of this difference. A buff-ware–brown-ware spatial gradient has been documented with buff wares dominant in eastern (Salton Trough) sites, and brown wares dominant in western (Peninsular Range and coastal) sites (Schaefer 1994a). Buff wares are thought to originate in the desert region and are derived from sedimentary clays. A desert origin for buff wares is confirmed by both thin section and INAA, (as discussed in the following sections) and is consistent with their naming as Lower Colorado Buff Ware (Waters 1982).

Within the brown wares, there is a desert component and a mountain component, but to recognize this division requires examination of ceramic pastes and tempers. In brief, the brown wares can be divided into those produced in the desert from sedimentary clays and sand temper (Salton

Brown Ware), and those produced in the mountains from residual clays and, when temper is added, granitic temper (Tizon Brown Ware). The compositional division between desert and mountain ceramics is most apparent in a plot of INAA principal component 1 and 2 (PC1 and PC2), the largest axes of variation in the data. Figure 10.2a shows PC1 and PC2 for sherd samples, and figure 10.2b plots them for clay samples. Sherd compositions cluster into five groups: Three groups are from the desert region, and are designated IMP (Imperial County), and two groups are from the mountain region, designated SDI (San Diego County). The groups IMP-1A and IMP-1B, which can be considered as a larger group (IMP-1), contain samples hypothesized to originate in the desert region. Another presumed desert group, IMP-2, diverges from IMP-1 on PC2 (figure 10.2). Groups hypothesized to originate farther west, in the Peninsular Range mountains of San Diego County, are designated SDI-1 and SDI-2 and have higher values of PC1. An approximate dividing line between desert and mountain samples is drawn on the PC1 and PC2 plot (figure 10.2). As the biplot mapping elemental contributions to PC1 and PC2 illustrates (figure 10.3), the mountain groups tend to be higher in transition metals, whereas the desert groups tend to be higher in light rare earth elements (REEs) along with cesium, uranium, thorium, rubidium, potassium, and barium. A plot of scandium (a transition metal) and lanthanum (a light REE) separates the desert and mountain compositions even more effectively than the first two principal components, and eliminates ambiguity regarding the compositional affiliations of some of the clays and the unassigned specimens (figure 10.4). The scandium-lanthanum plot also effects a nearly perfect discrimination of the three desert groups from one another.

Lower Colorado Buff Ware

A total of twelve Lower Colorado Buff Ware sherds were submitted for analysis, originating from four of the study sites. Thin-section analysis revealed that ten of these buff-ware sherds were tempered with clay fragments (5 to 25% of total sherd volume), either fired clay from coarsely ground potsherds or hardened fragments of the original clay deposit. These sherds were typed as Tumco Buff in the Waters (1982) typology. In addition, two buff-ware sherds from Indian Hill Rockshelter had no clay fragment inclusions, but instead were tempered with many angular, poorly sorted quartz fragments. These sherds were typed as Topoc Buff (Waters 1982).

Both Tumco and Topoc types of Lower Colorado Buff Ware were assigned to compositional group IMP-1A (table

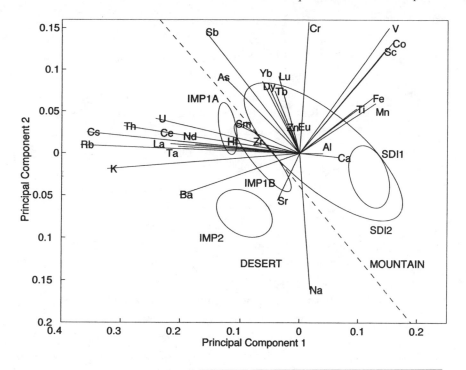

10.3 The contributions of individual elements to the first and second principal components are shown superimposed on the archaeological ceramic compositional groups of figure 10.2a. *Illustration prepared by the authors*

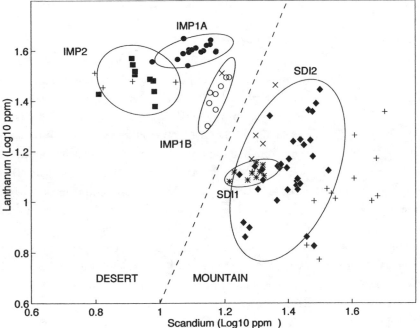

10.4 The log-base10 concentrations of lanthanum and scandium are plotted for the compositional groups (symbols as in Figure 2). These two elements provide an excellent separation between desert (IMP) and mountain (SDI) compositional groups and also resolve the affiliation ambiguity for the unassigned specimens; of the five unassigned archaeological ceramics (X symbols) four have mountain affiliations and one has desert affiliation. *Illustration prepared by the authors*

10.3), forming a tight cluster on the PC1 and PC2 plot (figure 10.2a). Also included in group IMP-1A are sampled desert clays from Holocene Lake Cahuilla at the Dunaway Road site (SIC001), and from the Palm Springs Formation at Yuha Buttes (SIC062) and San Sebastian (SIC087). That both Tumco Buff and Topoc Buff fall in the same compositional group suggests that they were made from the same clay source, and that their differing tempers (clay or quartz) do

not affect their observed chemical compositions.

Salton Brown Ware

Among the brown ware sherds submitted for analysis, a total of eighteen Salton Brown Ware sherds were discriminated, primarily from the three eastern-most sites (Dunaway Road, Indian Hill, and Buckman Springs). A single Salton Brown Ware sherd was identified from Loveland Reservoir, and an-

Table 10.2 Principal components analysis of variance-covariance matrix for Southern California data set (*N*=100)

Component	Eigenvalue	Var. (%)	Cum. Var. (%)
1	0.9175	56.56	56.56
2	0.1874	11.55	68.12
3	0.0921	5.67	73.79
4	0.0659	4.06	77.85
5	0.0556	3.42	81.28
6	0.0449	2.77	84.04
7	0.0399	2.46	86.50
8	0.0362	2.23	88.73
9	0.0281	1.73	90.47
10	0.0262	1.61	92.08
11	0.0179	1.10	93.18
12	0.0159	0.98	94.16
13	0.0141	0.87	95.03
14	0.0133	0.82	95.85
15	0.0107	0.66	96.51
16	0.0104	0.64	97.15
17	0.0079	0.49	97.64
18	0.0075	0.46	98.10
19	0.0060	0.37	98.47
20	0.0053	0.32	98.80
21	0.0043	0.27	99.06
22	0.0034	0.21	99.27
23	0.0026	0.16	99.43
24	0.0023	0.14	99.57
25	0.0018	0.11	99.69
26	0.0013	0.08	99.76
27	0.0012	0.08	99.84
28	0.0008	0.05	99.89
29	0.0006	0.04	99.93
30	0.0005	0.03	99.96
31	0.0004	0.03	99.98
32	0.0003	0.02	100.00

other was identified from Ystagua. No attempt was made to differentiate entire brown-ware sherd assemblages into Salton Brown Ware and Tizon Brown Ware at the hand specimen level, prior to obtaining the INAA and thin section results. After compositional grouping by INAA, however, it was clear that each compositional grouping had distinctive mineral inclusions, as observed by thin section analysis (table 10.4). Since our original choices for brown-ware specimens did not select for Salton Brown Ware or Tizon Brown Ware, the observed ratio of these wares in the analyzed sample should reflect the overall occurrence patterns for brown wares at these sites.

Salton Brown Ware sherds were assigned to INAA compositional groups IMP-1B and IMP-2 (table 10.3). Seven Salton Brown Ware sherds were assigned to group IMP-1B, and nine were assigned to IMP-2. All but one of the Salton Brown Ware sherds assigned to IMP-1B were from the easternmost site, Dunaway Road; a single sherd from the west-

ernmost coastal site, Ystagua, was also assigned to this group. The sherds in compositional group IMP-2 were almost equally divided between the three easternmost sites: Dunaway Road, Indian Hill, and Buckman Springs. One brownware sherd from Loveland Reservoir (SIC046) had high probabilities for membership in both IMP-1 and SDI-2 and was therefore unassigned, although its compositional and mineral inclusion affinities appear to be more desert than mountain in character.

Thin-section study revealed that the Salton Brown Ware sherds in compositional groups IMP-1B and IMP-2 had sand inclusions (70% of total sherd volume) with the following average composition: 60% quartz, 10% plagioclase, 10 to 20% biotite, 5% muscovite, and 5% amphibole. Evaporite inclusions, which occur at trace levels, include calcite and chlorite. Table 10.4 presents a summary of brown ware mineral inclusions observed by thin-section analysis.

Clay sampled from the Brawley formation in the Superstition Mountains (SIC002) was assigned to group IMP-2 with an 80% probability, based on its scores from the first six principal components. No clay samples were included in group IMP-1B. In table 10.3, IMP-1A and IMP-1B are presented as a single group for the probability calculations, since the number of samples in group IMP-1B is too small to allow calculation of probabilities, and since the two groups are chemically similar enough to be considered a compositional continuum. Group IMP-1B tends to have lower REE concentrations and slightly higher transition metal concentrations than IMP-1A (figure 10.3) suggesting that IMP-1B specimens carry some influence from mountain-derived raw materials, perhaps via natural or artificial admixture of mountain-derived sands, silts, or clays. Inclusion of the Superstition Mountain clay in IMP-2, and the chemical similarity of IMP-1B to the Dunaway Road, Yuha Buttes, and San Sebastian clays included in group IMP-1A, leaves little doubt that Salton Brown Ware sherds are derived from sedimentary clays of desert origin.

Differences between compositional groups IMP-1B and IMP-2 for Salton Brown Ware also may be further discerned by thin-section analysis (table 10.4). Mineral inclusions for the two groups are similar, except for their mica content. IMP-1B has a lower overall level of mica (15%) and contains biotite and muscovite micas in similar proportions (9% biotite, 6% muscovite). IMP-2, in contrast, has a higher overall mica content (25%), with biotite (20%) significantly more abundant than muscovite (5%). Likewise, IMP-1B has mineral inclusions that are angular and poorly sorted, whereas

Table 10.3 Compositional affiliation and group membership probabilities

Chem. gr.	Sample ID	Site	Material	Type	IMP-1	IMP-2	SDI-1	SDI-2
	SIC001	Dunaway Rd.	Clay	—	92.8	1.2	0.4	0.0
	SIC009	Rose Canyon	Ceramic	Tumco	83.7	0.8	0.4	0.0
	SIC024	Dunaway Rd.	Ceramic	Tumco	77.6	0.8	0.3	0.0
	SIC025	Dunaway Rd.	Ceramic	Tumco	94.0	0.8	0.4	0.0
	SIC026	Dunaway Rd.	Ceramic	Tumco	84.8	0.9	0.3	0.0
	SIC027	Dunaway Rd.	Ceramic	Tumco	99.7	1.1	0.4	0.0
	SIC028	Dunaway Rd.	Ceramic	Tumco	88.0	1.0	0.3	0.0
IMP-1A	SIC062	Yuha Buttes	Clay	—	89.5	1.2	0.4	0.0
	SIC073	Buckman Sp.	Ceramic	Tumco	41.8	1.2	0.4	0.0
	SIC076	Buckman Sp.	Ceramic	Tumco	41.6	0.6	0.2	0.0
	SIC077	Indian Hill	Ceramic	Tumco	5.9	2.0	0.3	0.0
	SIC078	Indian Hill	Ceramic	Tumco	88.3	1.3	0.4	0.0
	SIC080	Indian Hill	Ceramic	Topoc	36.0	3.6	0.6	0.0
	SIC081	Indian Hill	Ceramic	Topoc	2.7	2.6	0.3	0.4
	SIC087	San Sebastian	Clay	—	7.8	1.9	0.2	0.0
	SIC089	Yuha Butte10	Clay	—	17.4	2.9	0.4	0.0
	SIC015	Dunaway Rd.	Ceramic	Salton	41.3	9.6	0.9	0.0
	SIC018	Dunaway Rd.	Ceramic	Salton	45.9	3.0	1.0	0.0
	SIC020	Dunaway Rd.	Ceramic	Salton	28.1	10.2	0.6	1.1
IMP-1B	SIC021	Dunaway Rd.	Ceramic	Salton	39.8	13.1	1.3	0.0
	SIC022	Dunaway Rd.	Ceramic	Salton	29.8	11.1	1.5	0.0
	SIC023	Dunaway Rd.	Ceramic	Salton	41.3	8.0	0.6	0.1
	SIC066	Buckman Sp.	Ceramic	Salton	2.1	34.4	0.9	0.1
	SIC100	Ystagua	Ceramic	Salton	33.3	4.3	0.8	0.0
	SIC002	Superst. Mnt.	Clay	—	0.2	10.8	0.5	0.0
	SIC014	Dunaway Rd.	Ceramic	Salton	0.0	82.2	0.2	0.0
	SIC016	Dunaway Rd.	Ceramic	Salton	0.0	99.0	0.2	0.0
	SIC029	Buckman Sp.	Ceramic	Salton	0.0	18.3	0.3	0.0
IMP-2	SIC071	Buckman Sp.	Ceramic	Salton	0.0	43.1	0.1	0.0
	SIC072	Buckman Sp.	Ceramic	Salton	0.0	10.9	0.2	0.0
	SIC079	Indian Hill	Ceramic	Salton	0.0	93.2	0.1	0.0
	SIC082	Indian Hill	Ceramic	Salton	0.0	29.5	0.6	0.0
	SIC083	Indian Hill	Ceramic	Salton	0.0	3.7	0.1	0.0
	SIC030	Buckman Sp.	Ceramic	Tizon	0.0	0.5	2.6	3.7
	SIC031	Buckman Sp.	Ceramic	Tizon	0.0	1.5	66.7	3.2
	SIC033	Buckman Sp.	Ceramic	Tizon	0.0	1.1	11.1	0.1
	SIC035	Buckman Sp.	Ceramic	Tizon	0.0	1.2	88.8	0.6
SDI-1	SIC036	Buckman Sp.	Ceramic	Tizon	0.0	1.3	96.3	1.7
	SIC038	Buckman Sp.	Ceramic	Tizon	0.0	1.0	74.0	1.5
	SIC064	Buckman Sp.	Ceramic	Tizon	0.0	1.1	29.7	9.3
	SIC065	Buckman Sp.	Ceramic	Tizon	0.0	1.2	63.8	8.9
	SIC068	Buckman Sp.	Ceramic	Tizon	0.0	1.4	31.2	5.2
	SIC069	Buckman Sp.	Ceramic	Tizon	0.0	0.9	30.8	12.3
	SIC003	Rose Canyon	Ceramic	Tizon	0.0	0.3	0.1	26.4
	SIC005	Rose Canyon	Ceramic	Tizon	0.0	1.0	3.4	6.0
	SIC007	Rose Canyon	Ceramic	Tizon	0.0	0.6	0.5	37.0
	SIC008	Rose Canyon	Ceramic	Tizon	0.0	0.5	0.1	56.7
	SIC010	Rose Canyon	Ceramic	Tizon	0.0	1.4	0.1	47.4
	SIC011	Rose Canyon	Ceramic	Tizon	0.0	0.6	0.1	64.7
SDI-2	SIC012	Rose Canyon	Ceramic	Tizon	0.1	0.2	0.3	37.1
	SIC013	Rose Canyon	Ceramic	Tizon	0.0	0.4	0.1	42.0
	SIC032	Buckman Sp.	Ceramic	Tizon	0.0	4.2	0.3	18.8
	SIC034	Buckman Sp.	Ceramic	Tizon	0.0	0.8	0.2	90.8
	SIC037	Buckman Sp.	Ceramic	Tizon	0.0	4.1	0.8	12.8
	SIC039	Buckman Sp.	Ceramic	Tizon	0.1	0.7	0.7	55.2
	SIC044	Laguna Mnt.	Clay	—	0.0	1.7	0.4	35.3

continued

Table 10.3 Compositional affiliation and group membership probabilities. *continued*

Chem. gr.	Sample ID	Site	Material	Type	IMP-1	IMP-2	SDI-1	SDI-2
	SIC045	Loveland Res.	Ceramic	Tizon	0.0	0.2	0.1	49.2
	SIC047	Loveland Res.	Ceramic	Tizon	0.4	0.3	0.1	62.1
SDI-2	SIC048	Loveland Res.	Ceramic	Tizon	0.0	0.2	0.1	19.3
	SIC049	Loveland Res.	Ceramic	Tizon	0.0	0.7	0.1	27.4
	SIC050	Loveland Res.	Ceramic	Tizon	0.0	0.2	1.0	12.8
	SIC053	McGinty Mnt.	Clay	—	0.0	0.7	0.3	69.1
	SIC063	Buckman Sp.	Ceramic	Tizon	0.0	1.9	1.1	8.5
	SIC067	Buckman Sp.	Ceramic	Tizon	0.0	0.8	1.5	20.0
	SIC070	Buckman Sp.	Ceramic	Tizon	0.0	1.9	0.8	92.8
	SIC074	Buckman Sp.	Ceramic	Tizon	0.0	1.1	0.6	76.3
	SIC075	Buckman Sp.	Ceramic	Tizon	0.0	2.3	0.3	38.7
	SIC088	Miss. Gorge1	Clay	—	0.0	0.2	0.2	36.1
	SIC090	Miss. Flume	Ceramic	Historic	0.1	2.0	0.3	94.9
	SIC091	Ystagua	Ceramic	Tizon	0.0	0.5	0.8	9.5
	SIC092	Ystagua	Ceramic	Tizon	0.0	0.3	0.2	33.5
	SIC093	Ystagua	Ceramic	Tizon	0.0	0.7	0.1	68.0
	SIC094	Ystagua	Ceramic	Tizon	0.2	0.3	0.1	84.8
	SIC095	Ystagua	Ceramic	Tizon	0.1	0.7	0.1	79.6
	SIC096	Ystagua	Ceramic	Tizon	0.0	0.4	0.4	84.7
	SIC097	Ystagua	Ceramic	Tizon	0.8	0.7	0.2	85.3
	SIC098	Ystagua	Ceramic	Tizon	0.0	1.3	0.3	51.6
	SIC099	Ystagua	Ceramic	Tizon	0.1	0.6	0.1	59.4
	SIC004	Rose Canyon	Ceramic	Tizon	0.0	0.5	0.2	0.8
Unassigned	SIC006	Rose Canyon	Ceramic	Tizon	0.0	2.4	0.7	7.8
Ceramic	SIC017	Dunaway Rd.	Ceramic	Tizon	0.0	3.4	2.9	0.2
	SIC019	Dunaway Rd.	Ceramic	Tizon	7.2	5.3	1.4	1.4
	SIC046	Loveland Res.	Ceramic	Salton	0.1	8.3	0.7	7.3
	SIC040	Rose Canyon	Clay	—	0.0	17.7	0.2	0.0
	SIC041	Cottonwd Ck.	Clay	—	0.0	0.2	0.0	0.0
	SIC042	Buckman Sp1	Clay	—	0.0	0.9	0.1	0.2
	SIC043	Buckman Sp3	Clay	—	0.0	1.3	0.0	0.0
	SIC051	Dehesa Rd.	Clay	—	0.0	0.1	0.0	0.0
	SIC052	Lyons Pk.	Clay	—	0.0	0.2	0.1	0.0
Unassigned	SIC054	Japatul Rd.	Clay	—	0.0	0.2	0.1	0.0
Clay	SIC055	Guatay Mnt.	Clay	—	0.0	0.2	0.4	3.1
	SIC056	Oakzanita Pk.	Clay	—	0.0	0.2	0.3	0.0
	SIC057	Cuyamaca Pk.	Clay	—	0.0	0.7	2.9	0.1
	SIC058	Long Valley	Clay	—	0.0	0.2	0.1	0.8
	SIC059	BigPotreroPk.	Clay	—	0.0	0.5	0.2	0.0
	SIC060	Los Pinos .	Clay	—	0.0	0.3	0.4	0.1
	SIC061	Sheephead .	Clay	—	0.0	0.4	0.3	0.0
	SIC084	Ystagua	Clay	—	0.0	16.3	0.2	0.0
	SIC085	Adm. Baker	Clay	—	0.0	15.7	0.1	0.0
	SIC086	Manzanita	Clay	—	0.0	8.6	0.1	0.0

IMP-2 has mineral inclusions that are sub-angular and moderate-to-well sorted. It is tempting to suggest that the mineral inclusions of IMP-1B are purposefully added crushed sands, whereas those of IMP-2 are the natural inclusions of the Brawley formation. A key chemical difference between IMP-1B and IMP-2 is in the levels of barium, strontium, and sodium; IMP-2 has much higher levels of these elements than IMP-1B. All these elements are contained in soluble minerals, suggesting that IMP-2 may have some component of evaporites derived from saline lake sediments. A single misassignment between IMP-1B and IMP-2 indicated by the probabilities in table 10.3 (SIC066, an IMP-1B specimen

shows higher probability of membership in IMP-2) may be attributable to the small size of these groups. Note that this misassignment does not cross the basic mountains-desert dichotomy, and is between the two compositional groups of Salton Brown Ware.

Tizon Brown Ware

Among the analyzed brown ware sherds, a total of forty-five Tizon Brown Ware sherds were discriminated, primarily from the four westernmost sites (Ystagua, Rose Canyon, Loveland Reservoir, and Buckman Springs). Tizon Brown Ware sherds were assigned to INAA compositional groups SDI-1 and SDI-2 (table 10.3). Ten Tizon Brown Ware sherds were assigned to group SDI-1, and 31 were assigned to SDI-2. All sherds assigned to groups SDI-1 and SDI-2 were from the westernmost sites; no brown-ware sherds from the easternmost sites (Dunaway Road and Indian Hill Rockshelter) were assigned to compositional groups SDI-1 and SDI-2 (table 10.3). The two SDI compositional groups may be considered a single continuum, as indicated by the high probabilities for membership in SDI-2 shown by many of the SDI-1 specimens (table 10.3). Group SDI-1 forms a well-defined cluster in the PC1 and PC2 plot (figure 10.2a), and is composed entirely of sherds from the Buckman Springs site. Group SDI-2 has a more diffuse compositional distribution, and includes sherds from both the Peninsular Range sites (Buckman Springs and Loveland Reservoir) and the coastal sites (Rose Canyon and Ystagua). A single sample from the ceramic tile lining of an historic flume near the San Diego Mission, which was constructed in the early 1800s using native labor, is also included in SDI-2.

Four Tizon Brown Ware sherds from the Rose Canyon and Dunaway Road sites (SIC004, SIC006, SIC017, and SIC019) were not assigned to any compositional group. On the PC1 and PC2 plot (figure 10.2a) these sherds fall between the desert (IMP) and mountain (SDI) compositional groups. Based on the scandium-lanthanum plot (figure 10.4), these four specimens can be tentatively linked to the mountain (SDI) compositional groups.

Thin sections revealed that Tizon Brown Ware sherds were tempered with residual inclusions from the parent rock (65% of total sherd volume) with the following average composition (table 10.4): 50% quartz, 20% plagioclase, 20% amphibole, 4% biotite, and 1% muscovite. Tourmaline and pyroxene inclusions occur at trace levels. Relative to Salton Brown Ware, Tizon Brown Ware inclusions are comprised of more plagioclase and amphibole, and less quartz and mica.

Three clay sources are included in the SDI-2 compositional group. These clays were collected at widely separated locations, spanning the summit (Mount Laguna: SIC044), to the western slope (McGinty Mountain: SIC053), to the foothills (Mission Gorge: SIC088) of the Peninsular Range mountains (figure 10.1). They link the SDI-2 group to a broad region of the Peninsular Range mountains. The geologic setting for each of these clays is also varied: the Mount Laguna clay is derived from a granodiorite source, the McGinty Mountain from a gabbro, and the Mission Gorge from an eroded gabbro (Friars Formation). The SDI-1 compositional group can also be linked to the mountains, since all of its members come from the Buckman Springs site, and since clays collected at Buckman Springs (SIC041) and at the nearby Guatay Mountain (SIC055) show marginal probabilities of membership in the SDI-1 group ($5.0\% > p > 1.0\%$; table 10.3).

Fourteen of the Peninsular Range clays samples were not assigned to any compositional group but consistently plot closer to the mountain ceramic groups (SDI-1 and 2) than to the desert groups (IMP-1A, 1B and 2). These unassigned mountain clays tend to be higher in transition metals than the mountain-derived pottery (figures 10.2b and 10.3). Likewise, the unassigned clays have more amphibole mineral inclusions, and fewer quartz, plagioclase, and mica mineral inclusions, than the SDI group sherds (table 10.4). Dilution of the unassigned clays by the addition of granitic temper would help to bring them in better agreement with the compositional and mineral content of the SDI groups. Likewise, additional weathering could put these clays into better agreement with the SDI group compositions.

SDI-1 and SDI-2 are compositionally similar, and SDI-1 is subsumed within SDI-2 on most projections of the chemical data. Chromium and scandium elemental data yield one of the clearest separations of these two groups with the SDI-1 group enriched in chromium and depleted in scandium relative to the SDI-2 group. Principal components 4 and 5 also separate these groups and suggest a tendency toward enrichment of potassium, rubidium, cesium and sodium in SDI-2 (figure 10.5). Variation in these latter elements may be interpreted in light of the geochemical gradient present in the Peninsular Range batholith. Basic rocks, with more calcic plagioclase, are found in the western portion of the batholith, imparting a more calcium rich, potassium-depleted fingerprint to clays derived from them. A higher orthoclase component in the eastern batholith would impart a comparatively potassium-rich, calcium-depleted composition.

Table 10.4 Average mineral inclusions for Brownware compositional groups

Chem. group	Ceram. type	Sorting	Total incl.	Qtz* (%)	Pl* (%)	Bt* (%)	Ms* (%)	Am. (%)	Rock (%)	Trace incl.
IMP-1B	Salton	Poor	65	62	12	9	6	5	5	Cal, Chl
IMP-2	Salton	Mod.-well	73	60	10	20	5	2	2	Cal, Chl
SDI-1	Tizon	Mod.	67	48	17	3	1	27	1	Cpx, Tur
SDI-2	Tizon	Poor-mod.	61	54	23	5	1	13	1	Cpx, Tur
Unassigned	Gabbro	Poor-mod.	63	42	14	1	0	39	1	Cpx

*Mineral abbreviations: Qtz = quartz, Pl = plagioclase, Bt = biotite, Ms = muscovite, Am = amphibole, Cal = calcite, Chl = chlorite, Cpx = clinopyroxene, Tur = tourmaline.

There is generally an inverse relation between potassium and calcium in the mountain-derived groups, with SDI-1 showing a low-potassium, high-calcium composition suggesting more basic rocks, and SDI-2 showing higher potassium and lower calcium. The clay data (table 10.3, figure 10.2b) are in general accord with this hypothesis. Dehesa, Lyons, and Japatul are western batholith clay sources that have compositions similar to SDI-1, with enhanced calcium and reduced potassium. Laguna, Buckman-1, Buckman-3, Long Valley, Los Pinos and Oakzanita are more eastern clay sources that have a more potassium rich, calcium poor composition similar to SDI-2. A notable exception to this pattern is McGinty Mountain, a western clay sources but with low calcium concentration. The above pattern requires testing along with more detailed study of the geologic context of each clay sample, for example, to determine position within the internal structure of a gabbroic pluton (for example, Nishimori 1976). For the time being, it is plausible to suggest that SDI-1 may subsume compositional profiles characteristic of the western batholith, while SDI-2 subsumes compositions more consistent with the mountains farther east. Note that this pattern suggests that the cluster of SDI-1 sherds found at Buckman Springs is not of local origin, but from sources located further west. None of the sampled clays have a calcium-to-potassium ratio as low as some of the SDI-2 sherds, probably owing to a lack of clay samples from the eastern portion of the batholith (figure 10.1).

Petrographic analysis supports the suggestion that the SDI-1 compositional group is associated with the western batholith. SDI-1 sherd mineral inclusions are enriched in amphibole and diminished in quartz relative to SDI-2 sherds (table 10.4). Amphibole would contribute to a calcium- and aluminum-rich, and potassium-poor signature to the composition. In addition, amphibole is rich in the transition metals iron and titanium.

A single metasedimentary (Julian Schist) derived clay from the Peninsular Range was submitted for INAA (table 10.3, SIC061). This clay has an unusual compositional profile that is low in chromium but still enriched in other transition metals, such as scandium. Since none of the sherds has such a transition metal profile, it appears that prehistoric ceramics were not made from schist-derived clays.

Ethnographic clay samples were collected by Malcolm Rogers (1936) from Owas Hilmawa of the Manzanita Reservation, a practicing Kumeyaay potter in the early 1900s. We obtained a sample of this clay from the San Diego Museum of Man (labeled E-1 primary clay) and submitted it for analysis. Curiously, this sample does not match any of the sherd compositional groups, nor the other clay sources submitted (figure 10.2b). Rogers (1936) notes the unpromising appearance of this clay. A possible explanation for its use is that occupancy of the reservation, and diminished residential mobility, had restricted Owas Hilmawa's access to traditional clay sources.

An apparent anomaly in the clay-ceramic relationship is that the Ardath Shale samples (SIC040 and SIC084) from the coast, and the Santiago Peak Metavolcanic sample (SIC085) from the coastal foothills, fall near the desert compositional groups in some projections of the data (figure 10.2b). This appears to contradict the basic desert-mountain dichotomy evident in the pottery and other clay samples. However, we anticipate that with a larger sample for IMP-2, and therefore a better basis for estimating its compositional parameters, the apparent resemblance of the Ardath Shale coastal clay and the desert compositional groups would disappear.

DISCUSSION

The above compositional patterns document similarities between clay sources and prehistoric sherds, allowing inferences to be drawn about the production and transport of ceramic materials. At the Dunaway Road site on the shoreline of Lake Cahuilla, sherds were observed from all three desert compositional groups (IMP-1A = 5, IMP-1B = 6, IMP-2 = 2) in addition to two unassigned sherds whose composition is intermediate between desert and mountain groups. Since IMP-1A clays are present at this site (SIC001) and at the nearby Yuha Butte Palm Springs Formation (SIC062) and Imperial Formation (SIC089), local ceramic production of

Lower Colorado Buff Ware ceramics may have occurred at the Dunaway Road site. The large percentage of Salton Brown Ware sherds present is also suggestive of local production, although the exact clay source for the IMP-1B "type" of Salton Brown Ware is still undetermined. Sherds collected at the Indian Hill Rockshelter on the eastern edge of the Salton Trough, were from two desert compositional groups (IMP-1A = 4, IMP-2 = 3). Neither of the known clay sources associated with these desert groups (Lake Cahuilla and Palm Springs Formation for IMP-1A; Brawley Formation for IMP-2) are present at the Indian Hill site. However, Palm Springs Formation clay is available a few miles north of the site (near Sweeney Pass) and another clay source of unknown composition is reported near Dos Cabeza Springs a few miles to the southeast (Heizer and Treganza 1944), leaving open the possibility that Lower Colorado Buff Ware (Tumco Buff and Topoc Buff), as well as Salton Brown Ware, were locally produced.

The pattern emerging for the two desert sites (Dunaway Road and Indian Hill) is that the majority of their ceramics are Lower Colorado Buff Ware and Salton Brown Ware, which were probably locally produced from desert clays. There is less evidence for transport of nonlocal ceramics, such as Tizon Brown Ware, into the Salton Trough region than has been previously assumed. Only two sherds (out of fifteen total sampled) were possibly of nondesert origin at the Dunaway Road site (SIC017 and SIC019), yet neither of these sherds unambiguously fit a mountain compositional group (SDI-1 or 2). No nondesert sherds were observed among the seven sampled at Indian Hill Rockshelter. Only a small percentage of the brown ware at desert sites appears to be derived from the mountains. The majority of desert brown ware sherds appear to be made from desert clays of the Brawley Formation (and perhaps other, as yet unidentified source clays). A substantial proportion of brown-ware sherds at desert sites probably have been misidentified as Tizon Brown Ware, leading to an inaccurate assessment of the amount of transport of mountain ceramics to the desert. Indeed, it can be difficult to distinguish the two types based on only superficial observation of color and mica content. Petrographic analysis suggests that attention must be paid to the percentages of mineral inclusions to distinguish Salton Brown Ware from Tizon Brown Ware (table 10.4), and this is supported by the compositional results from INAA.

At the Buckman Springs site in the Peninsular Range mountains, sherds from all compositional groups, both desert and mountain, were observed. Mountain compositions are represented by ten Tizon Brown Ware sherds in SDI-1, and nine Tizon Brown Ware sherds in SDI-2. Since SDI-1 sherds have a relatively narrow range of compositions, and since they occur only at the Buckman Springs site, these ceramics may have been locally produced. However, SDI-1 clays are rich in calcium and transition metals, associated with higher levels of amphibole mineral inclusions (figure 10.2a, table 10.4), consistent with the geochemical character of the batholith west of Buckman Springs. Also, no appropriate clay source local to Buckman Springs has been identified, although clays near the site were extensively sampled (SIC042 Buckman Springs-1, SIC043 Buckman Springs-3, SCI-041 Cottonwood, SIC061 Sheephead Mountain Rd.). None of the sampled local clays is a good match to the SDI-1 compositional group.

Tizon Brown Ware sherds from Buckman Springs assigned to SDI-2 show a broader range of compositions, and their generally lowered calcium content relative to SDI-1 suggests that their source clays are from the central or eastern Peninsular Range batholith. Clay sources to the east of Buckman Springs should be sampled to test this proposition. Desert ceramics at the Buckman Springs site are represented by two Tumco Buff sherds in IMP-1A, one Salton Brown Ware sherd in IMP-1B, and three Salton Brown Ware sherds in IMP-2. These ceramics probably originated in the Salton Trough and were transported to Buckman Springs, most likely during seasonal migration rather than by trade (F. Shipek, personal communication 1997).

Tizon Brown Ware ceramics found at the Loveland Reservoir site were assigned to mountain compositional group SDI-2. These samples fall in the calcium-rich portion of SDI-2, consistent with their source materials originating in the western portion of the Peninsular Range batholith. A single Salton Brown Ware sample (SIC046) is unassigned, with a composition that is intermediate between desert and mountain groups; indeed it has significant probabilities for inclusion in both IMP-1B and SDI-2 (table 10.3). This sample may represent a western Salton Trough or eastern Peninsular Range composition, suggesting transport from the east, to the Loveland Reservoir site.

The sites at Rose Canyon and Ystagua, near the Pacific coast, contain sherds with both desert and mountain compositions. Eight Tizon Brown Ware sherds from Rose Canyon and nine from Ystagua were assigned to SDI-2. Generally these sherds are at the calcium-rich end of SDI-2 compositions, suggesting a western batholith source. A Tumco Buff sherd (SIC009) from the Rose Canyon site fits into IMP-1A.

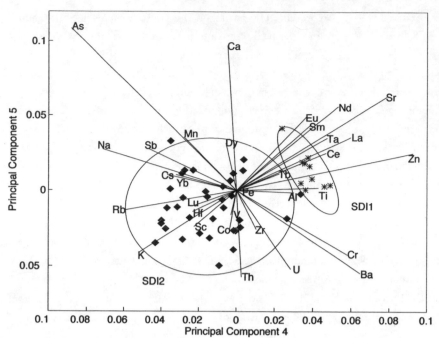

10.5 The fourth and fifth principal components are shown to separate the two mountain compositional groups, SDI-1 and SDI-2. The contribution of individual elements to these principal components is superimposed. *Illustration prepared by the authors*

The tight clustering of this sample with other group members leaves little doubt that it was produced from desert clays. More than 100 km separates the IMP-1A desert source clays and the coastal Rose Canyon site. Likewise, a Salton Brown Ware sherd (SIC100) from the Ystagua site was included in desert group IMP-1B, again suggesting ceramic production in the Salton Trough or eastern Peninsular Range and subsequent transport to the coast. Two unassigned samples from the Rose Canyon site (SIC004 and SIC006) have compositions that are intermediate between desert and mountain groups, although they are most likely mountain clays (figure 10.4, table 10.3). No sherds from the Rose Canyon or Ystagua sites are a compositional match to the local Ardath Shale clays (SIC040 and SIC084).

The pattern emerging for the mountain sites (Buckman Springs and Loveland Reservoir) and the coastal sites (Rose Canyon and Ystagua) is that their ceramics are primarily Tizon Brown Ware produced from mountain clays, yet Lower Colorado Buff Ware and Salton Brown Ware sherds produced from desert clays are also present in significant numbers. This is evidence for westward transport of nonlocal ceramics, Lower Colorado Buff Ware and Salton Brown Ware, into the Peninsular Range and Pacific coast regions. There is little or no evidence for ceramic transport in the opposite direction (eastward), either from the Peninsular Range mountains to the Salton Trough, or from the Pacific coast to the Peninsular Range mountains. There is yet no evidence for production of ceramics with the coastal Ardath Shale clay (SIC040 and

SIC084); sampling and analysis of other potential clay sources is being undertaken to test if this pattern holds for other coastal clay sources.

What factors would create a pattern of ceramic production in the mountains and desert and not on the coast? One consideration is the time of year appropriate for pottery production. Ethnographic accounts for the Kumeyaay suggest that the summer months were conducive to pottery production, since during these periods clay will dry rapidly to allow vessel formation, and both the ground and the fuel used in firing are dry (Rogers 1936:4–5). Patterns of seasonal migration suggest that during summer months coastal Kumeyaay may have been resident in the mountains. A mountain location for pottery production is also consistent with a stated choice of oak as the fuel for firing, since oaks are primarily found in the mountains. For Yuman groups in the Salton Trough desert, potters may have been less constrained by weather patterns. In this region rainfall is scarce, but comes predominantly during the summer months as thunderstorms, and rarely as fall hurricanes. The fuel for desert firing is said to be dried yucca leaves or the dead roots of salt bush (Rogers 1936), available essentially any season. Pottery production, therefore, may not be seasonally constrained in the Salton Trough desert. Perhaps little or no ceramic production was undertaken on the coast because it was primarily occupied during winter months when the weather was not conducive, and because of a lack of appropriate fuel for firing.

CONCLUSIONS

We have applied two analytic techniques—petrographic thin-section analysis of mineral inclusions, and INAA of chemical composition—to characterize brown-ware and buff-ware ceramics produced by Patayan peoples in southern California. These predominantly undecorated ceramics are difficult to place within a temporal and spatial typology reminiscent of Southwestern painted ceramics. For plain wares, temper and chemical composition are viable alternative criteria to classify ceramics, and this approach may deserve wider application to Southwestern plain-ware ceramics.

Three distinct ceramic wares are observed in association with distinct geological settings: Lower Colorado Buff Ware, Salton Brown Ware, and Tizon Brown Ware. In the Salton Trough desert, lacustrine clays are available with a low iron content, yielding a buff ceramic. These clays contain little or no intrinsic inclusions and hardened clay or crushed quartz tempering materials were purposefully added for the production of Lower Colorado Buff Ware ceramics. Sedimentary clays also are used for Salton Brown Ware, especially those near the western margin of the Salton Trough, derived from weathering of the Peninsular Range batholith, giving a reddish-brown color when fired in an oxidizing atmosphere; abundant sand is included in these clays. In the Peninsular Range mountains, a variety of batholithic rocks are present—from gabbros to granodiorites—which weather into residual clays. In the western portion of the batholith, gabbroic compositions are found with plagioclase as the primary clay-producing mineral, and amphibole as a characteristic secondary mineral. In the eastern batholith, granodioritic compositions dominate with biotite as the primary clay-producing mineral.

Long-range east-to-west transport of Lower Colorado Buff Ware and Salton Brown Ware ceramics is observed with vessels produced in the Salton Trough appearing in the Peninsular Range and on the Pacific coast. Little comparable transport of Tizon Brown Ware ceramics from west-to-east is observed.

These results should aid in the development of ceramic typology and in the interpretation of ceramic assemblages found in late prehistoric Patayan sites. This preliminary study has illustrated the potential for characterizing brown-ware and buff-ware ceramic sherds and source materials from the Salton Trough and Peninsular Range of southern California. We expect that refinements to the patterns presented here will be made as a larger sample of sherds and clays are examined from a broader geographical base.

Acknowledgments. This research was supported by a grant to MURR from the National Science Foundation (SBR-9503035) and by a grant from the UCSD Academic Senate. We thank Sergio Herrera for assistance with sample preparation for INAA and various analytic tasks. We thank Sue Wade and Andrew Pigniolo for use of ceramic data and for helpful discussions on southern California ceramics, and Alison Shaw, Pat Castillo, Jim Hawkins and Jeff Gee for assistance with petrographic analysis. Ken Hedges of the San Diego Museum of Man provided clay samples collected by Malcolm Rogers and other ceramic data, and Rae Schwaderer of the Anza Borrego State Park provided sherds from Indian Hill Rockshelter. Earlier versions of this paper were presented in 1997 at the Society for American Archaeology Annual Meeting in Nashville, and in 1998 at the Society for California Archaeology Annual Meeting in San Diego.

Typologies and Classification of Great Basin Pottery

A New Look at Death Valley Brown Wares

Jelmer W. Eerkens, Hector Neff, and Michael D. Glascock

MOST CERAMIC RESEARCH in the Greater Southwest has been concerned with the pottery of sedentary and agricultural groups. Little is known about the ceramic technology of the hunting and gathering populations in the western and southwestern extents of the Southwest and beyond. Around six hundred to one thousand years ago, and in many areas, these mobile Numic speakers seem to have replaced Anasazi cultures (Baldwin 1950; Larson 1990; Lyneis 1992). Although the Paiute and Shoshone that lived (and still live) in these areas did not leave behind as many pots and sherds as their Southwestern neighbors or Anasazi predecessors, ceramics are still common in residential sites dating to this period. Ceramics in the Southwest proper play an essential role in the reconstruction of prehistoric lifeways. Unfortunately, they are often ignored in hunter–gatherer settings (for exceptions, see Baldwin 1950; Griset, ed. 1986; A. Hunt 1960; Lyneis 1988; and J.M. Mack, ed. 1990).

The reasons for this bias are many, and include historical factors, in which archaeologists have stressed stone tools and earlier prepottery phases of prehistory, but also probably stems from the fact that the brown wares in this area are extremely variable with respect to such elements as rim form, size, shape, color, surface finish, and firing properties, and are usually undecorated. Ceramic studies in other areas, such as the Southwest core, often emphasize decoration as means for addressing topics such as interaction, exchange, and worldview, and for creating finer chronologies. Hence, many of the theories and methods successfully applied elsewhere do not readily lend themselves to brown wares. As a result, studies of hunter–gatherer pottery in the Great Basin are rarely more than descriptive accounts of the number, and occasionally variety, of sherds recovered. Analytically and interpretatively,

these studies rarely contribute more than a rough temporal designation of the site as "late prehistoric."

Here, late prehistoric hunter-gatherer pottery from one small region in the Great Basin, Death Valley (see figure 11.1) is revisited. From the large numbers of sherds collected by previous archaeologists and housed at the Death Valley National Park Museum Archives, a small sample was selected for instrumental neutron activation analysis (INAA) in an

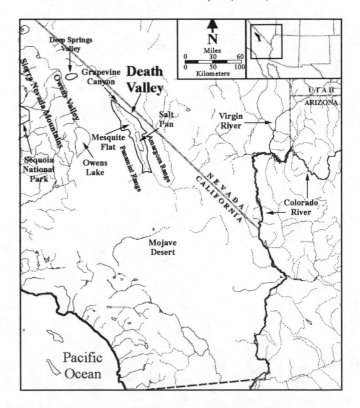

11.1 Map of study area showing location of Death Valley and places mentioned in text. *Illustration prepared by Jelmer Eerkens*

140

attempt to extract more interpretive value from this class of artifacts and to learn about the ceramic technology of prehistoric hunter-gatherers in the area.

DEATH VALLEY BROWN WARE

Although outside the Southwest proper, Death Valley is at the crossroads of several traditionally defined North American culture areas, including the Southwest to the east, the Great Basin to the north and northeast, California to the west, and the Mojave Desert to the south. The Timbisha Shoshone, who currently occupy the region and were present at European contact, speak a Numic language and are part of the Great Basin culture area. The presence of modest numbers of turquoise artifacts and black-on-white or black-on-gray Anasazi ceramics in Death Valley, attest to the fact that earlier Death Valley inhabitants (AD 500 to 1200) had regular contact with Southwestern pueblo peoples to the east. Many of these artifacts probably derive from the Virgin River area (80 km east) or the Colorado River (130 km southeast). Similarly, the Timbisha Shoshone share many cultural characteristics with their Southwestern Southern Paiute neighbors to the east. By focusing on the Death Valley case in particular, much can be learned by extension and analogy about late prehistoric hunter-gatherer ceramic technology in the desert west in general.

Pottery was clearly an important part of prehistoric living in Death Valley. Late prehistoric inhabitants used and left behind significant numbers of broken pots. For example, in a survey of the Mesquite Flat area pot sherds were the most numerous find (W.J. Wallace 1986). Similarly, well over 50% of all prehistoric sites that have been recorded in the valley contain pottery (Barton 1983; Deal and D'Ascenzo 1987; A. Hunt 1960; Tagg 1984; W.J. Wallace 1957, 1958, 1968, 1988; W.J. Wallace and Taylor 1955, 1956). Pottery is not, however, ubiquitously distributed across the region (Eerkens 2001). In some places, such as along the margins of salt pans and within dunal areas, almost every site contains at least some, and often hundreds, of sherds (A. Hunt 1960; W.J. Wallace 1986). Yet, in other areas, such as higher elevation localities and more remote side valleys, few ceramics have been found (W.J. Wallace 1957; W.J. Wallace and Taylor 1955, 1956).

Little is known about ceramics from Death Valley, despite more than sixty years of archaeological research. One of the main problems thwarting advance is a lack of an agreed upon and reproducible typology that can be used to subdivide sherds into meaningful spatial, temporal, and/or functional categories. Early typological work by Alice Hunt (1960) has

not been adopted by others, probably because it is complex and she did not provide adequate detail on the criteria used to define her types. Most archaeologists continue to classify all brown ware found in Death Valley as Owens Valley Brown Ware, despite convincing evidence that most sherds do not display temper and clay characteristics consistent with the geology of that area (C. Hunt 1960). Furthermore, no systematic comparison has been carried out to demonstrate that sherds from the two areas are similar. Although just a name, the Owens Valley Brown Ware misnomer actually misleads archaeologists and other interested parties about the origins of Death Valley pottery, serves to gloss over possible differences between the two areas, and masks the potential for discovering movement of pots between the valleys (though see Colton [1953] for a discussion of using geographic place names). Moreover, a lack of chronological control (that is, radiocarbon dates) in excavated sites has not allowed researchers to investigate change in ceramics through time. Little is known about when brown wares make their first appearance, other than it occurs sometime after AD 1000. Nor do archaeologists know if brown wares undergo any visible changes during the ceramic period. Because they are assumed to be of a single type, brown wares, and by default sites containing brown ware, are lumped into a single temporal phase, Death Valley IV, or approximately AD 1000 to historic times. In short, grouping pottery from Death Valley into a single all-inclusive and highly variable category called Owens Valley Brown Ware has weakened the value of ceramic analysis (Bettinger 1986; Pippin 1986; see also Lyneis 1988 for similar sentiments regarding Mojave Desert pottery). Being all the same type and time period, there is little to compare or contrast between assemblages, other than the number or density of sherds.

This study reports results of INAA of forty-one different brown-ware vessels collected in Death Valley, including one ethnographic pot and forty archaeological sherds. Like Charles Hunt (1960) almost forty years ago, we hope to show that brown wares are not all alike and pattern in meaningful ways. Four main issues are explored: (1) where Death Valley pottery was made, (2) how chemical characterization compares with formal variability in Death Valley pottery, (3) how chemical characterization compares with previous classifications, and (4) how dividing Death Valley pottery into distinct groups can deepen our understanding of prehistoric behavior. Also briefly considered here is how ethnographic pottery compares compositionally with archaeologically collected pottery.

ENVIRONMENT AND PREHISTORY

Death Valley is a 250-km trough on the southern margin of the Basin and Range geographic province, just east of the Colorado River and north of the Mojave Desert, in eastern California. Active block-faulting, caused by a slow spreading of the Basin and Range, continues to deepen the valley, despite continuous input of sediment from surrounding mountains. A stretched and thinned upper crust also gives rise to volcanic activity. Several basalt flows and rhyolite domes are visible on the valley floor, and the surrounding hills are made up of numerous ash flows, exposed in strata.

Elevations within the valley bottom range from minus 86 m at Badwater, the lowest point in North America, to approximately 900 m above sea level in the northern end. The valley is bordered by the Panamint Range (2500 to 3300 m) on the west and the Amargosa Range (2000 to 2700 m) on the east, creating extreme topographic relief. For example, within 25 km, one can travel from sea level to over 10,000 feet. The area is also witness to extremes in temperature and precipitation. Historically, precipitation within the valley bottom has averaged less than 5 cm per year, with some years registering no measurable rainfall. Precipitation rises with elevation, and rainfall reaches over 30 cm per year in the higher mountain ranges. While winters are generally mild, summer temperatures in the valley bottom may reach 50°C or more. At the same time, snow can be found in the surrounding mountains for much of the year, and summer temperatures in montane environments rarely reach 25°C.

High topographic relief coupled with differential rainfall and temperature by elevation gives rise to a diverse ecology within the Death Valley area. Many plant and animal communities can be found within short distances of one another, varying from Desert Scrub and Salt Flat communities in the valley bottom, to piñon/juniper woodland in mid-elevations, to subalpine and bristlecone-pine forest in higher elevations. The inverse correlation between temperature and altitude causes plants to bloom first in the warmer and lower regions, and gradually, over the course of several weeks, at higher elevations.

Despite these extremes, people did quite well in prehistoric Death Valley. Although probably never boasting a large or dense population, occupants made the most of the biodiversity within the region (Steward 1938). Major plant food resources of the late prehistoric inhabitants included mesquite, piñon, seeds from several species of grass, and cactus. In addition, various roots, tubers, berries, and greens were exploited. Animal products, although probably of less dietary impor-

tance than vegetable items, included rabbits, mountain sheep, deer, and small rodents, as well as the collection of lizards, tortoise, and some insect species. Seasonal transhumance between ecological zones to take advantage of locally abundant resources was probably the rule rather than the exception in Death Valley (that is, in opposition to the transport of food resources to a central base), and may have included travel to and between different Great Basin valley systems.

POTTERY IN DEATH VALLEY

Pottery became an important part of the cultural adaptation to Death Valley only during the later part of prehistory. The earliest dated ceramics recovered from the area include sherds decorated in Southwest Anasazi styles. Whether these items were locally made or imported is not known, although the latter it is often assumed, and was not investigated as part of the current research. However, the presence of these items suggests at least a latent knowledge of the usefulness of pottery for desert living, and may have paved the way for the later development of Owens Valley Brown Ware ceramic technology, the more common and well-known Death Valley type.

Few absolute dates exist from the Death Valley area to help date the introduction of brown ware to the region. Reports commonly suggest a date around AD 1000 to 1200, but these figures are based more on conventional wisdom or analogies to nearby areas than direct evidence. An emphasis on survey rather than excavation and an ethic of preservation and protection over exploration within the National Park have contributed to this situation, and it is unlikely we will learn more about when brown-ware pottery was first used in Death Valley in the near future. In nearby Owens Valley where radiocarbon dates do exist, pottery seems to make its appearance around AD 1400. In short, pottery seems to have been introduced to Death Valley *sometime* during the late prehistoric period or Death Valley IV (between AD 1000 to 1750). Even less is known about possible changes in ceramic technology, if any, during the ensuing years in which pottery was made.

As is the case for other parts of the Great Basin and Southwest (Pippin 1986), there is disagreement over what these pot sherds should be called, whether Owens Valley Brown, Death Valley Brown, Intermountain Brown, Shoshone Brown, or some other term, though the first term is most often used. Because they are typed under a single all-inclusive term, there is an implicit assumption that all sherds are alike. Using petrographic analysis of pottery thin sections,

Charles Hunt (1960) long ago showed this not to be the case. He found pottery tempers grouped into several distinct types, indicative of the original location of pot manufacture. However, the typology he developed with Alice Hunt, as well as this technique of analysis, has not been adopted by subsequent researchers, and recent investigations tend to lump pottery into a single spacio-temporal and functional group.

There also seems to be disagreement over the location of production of Death Valley brown wares. Based on thin section studies and stylistic characteristics, some have suggested that nearly all pottery was imported to the Death Valley region (A. Hunt 1960; C. Hunt 1960), while others, based on ethnographic data and the widespread availability of clay, believe brown wares to be locally produced (Deal and D'Ascenzo 1987: 19; Tagg 1984: 24; W.J. Wallace 1986).

Clay would have been available in both upland locations, as residual or decomposing parent bedrock (such as granite or basalt), and lowland locations, as both decomposing alluvium and sedimentary clay in playa lake beds. Charles Hunt (1960) felt the latter would not have been suitable for ceramic production due to the presence of calcium carbonates, salts, and other evaporite minerals. His convictions were substantiated by the near-absence of salt minerals in more than seventy-five thin sections from Death Valley. The possibility of removing such minerals through leaching, washing, or souring clay, was not considered, and, as a result, the issue of local versus nonlocal pottery production has not been resolved.

INAA SAMPLING
OF DEATH VALLEY BROWN WARE

In order to help resolve these questions, a sample of Death Valley sherds and clay sources was submitted for INAA. Analysis was undertaken on forty-one distinct sherds collected within the valley. Included was one ethnographic pot and forty archaeological sherds collected during surface survey. To investigate variability within individual ceramic vessels and to verify replicability of the analyses, two additional samples were taken from different locations on sherds already included among the forty archaeological samples, giving a total of forty-three samples analyzed. Compositional data were compared to analogous data collected from brown-ware assemblages from other parts of California (see Eerkens, Neff, and Glascock1998; chapter 10). In addition, five clay samples from Death Valley were analyzed for comparative purposes, representing lowland (four) and upland (one) locations. These clays were collected from central Death Valley near the findspots of most ceramics included in the study.

The INAA pottery sample represents sherds collected from two main areas (figure 11.1), Mesquite Flat (twenty samples), and the margins of the Death Valley Salt Pan (sixteen samples). Two additional samples come from Strozzi Ranch in the Grapevine mountains, while the final two samples represent unknown localities within Death Valley. In an effort to maximize the number of individual vessels sampled, only one sherd was analyzed per site, except in cases where sherds from the same site were obviously from distinct pots. Moreover, to investigate how chemical data relates to vessel shape and size, only rim sherds were sampled. In this manner, chemical composition could be compared to attributes such as vessel thickness (measured 1 cm below the lip), estimated mouth diameter, wall shape (straight versus bowled or rounded), lip shape (rounded, squared or flat, or pointy), lip lateralization (sloped to the exterior, interior, or symmetrical), rim form (direct versus recurved or outflaring), mode of surface finish (whether wiped with a tool such as a small stone [encoded "tooled"], wiped with the fingers or brushed with a narrow item such as a bundle of twigs [encoded "brushed"], or not wiped and left smooth [encoded "smooth"]), and the presence or absence of decoration, which is often limited to the vessel rim and/or neck. The method of welding or blending coils together was also recorded. As seen in wall profiles, some sherds seemed to have coils which overlapped on the interior, where clay from the upper coil was pushed or extended down onto the lower coil on the interior side of the pot only. Other pots seemed to have coils that overlapped on the exterior, and some pots displayed coils that were not overlapped and were neatly stacked vertically on top of one another. These three-coil welding styles were encoded as interior, exterior, and even, respectively.

A fresh break on each sherd was also observed under low-power magnification (30x) to determine firing properties as seen in the core (whether an oxidizing or reducing atmosphere) and to examine the types, density, and average size of temper particles within each sample. The latter two attributes are largely subjective in nature and were based on visual examination, hence only temper large enough to be seen through low-powered magnification was included. Sherds which appeared to contain less than 33% temper by total sherd volume were classified as low density, 33% to 66% temper was termed medium density, and greater than 66% temper by volume was classified high density. Apparent average temper particle size below 0.25 mm in diameter was considered fine, between 0.25 and 0.5 mm was classified medium, and larger than 0.5 mm was termed coarse.

INAA RESULTS

As in most compositional studies, the INAA results were used to divide sherds into groups or clusters. Parts per million concentrations of thirty-two elements were used to define boundaries around certain sets of samples, where variability within sets was greater than variability between sets (chapter 1), and samples within the groups tend to covary among different elements. Nickel was the only element of the thirty-three typically produced at MURR that had to be dropped from the analysis due to levels below detection limits for most samples. The statistical methods employed to create the groups have been described elsewhere by Glascock (1992) and Neff (chapter 2).

Results from the chemical analysis show Death Valley pottery to be variable and complex. No single cohesive group or chemical signature defines the sample of sherds submitted for INAA, and variability within the data set for individual elements (such as calcium, rubidium) was often equal to or more variable than analogous data from pottery from Owens Valley, Sequoia National Park, Deep Springs Valley (Eerkens, Neff, and Glascock 1998), and extreme Southern California (see chapter 10). This variability, however, was not uniformly distributed across the data set, and samples tended to cluster into distinct compositional groups, where chemical differences between groups were greater than differences within groups. Approximately half (eighteen) of the Death Valley specimens display characteristics unlike other pottery from California analyzed to date, and were combined here into a single loosely defined group. For reasons discussed below, this group was defined as Death Valley 1 (DV1). In particular, these sherds exhibit elevated concentrations of strontium and, to a lesser degree, barium, chromium, and arsenic, in concert with lower levels of zinc, uranium, and thorium. Figure 11.2 shows bivariate plots for raw parts per million (ppm) concentration values of cerium and strontium and shows separation between brown-ware sherds collected in Death Valley and 140 others from various regions in Eastern California (Eerkens, Neff, and Glascock 1998). A similar effect can be achieved using principal component analysis, where Death Valley sherds stand off from other eastern Californian sherds. Note that sherds in figure 11.2 (that is, data points) are labeled only by where they were collected and not their chemical reference group. The DV1 sherds discussed above were given solid circles in Figure 11.2.

Two sherds (fig 11.2) from Northern Owens Valley and one from Deep Springs Valley have similar chemical signatures for these elements and may belong to the Death Valley

chemical group (but have slightly higher cerium values). Several Death Valley sherds display signatures at odds with the majority of other samples from the region and do not seem to be part of the DV1 group. These samples were given open circles with crosses in the middle in figure 11.2.

Within the DV1 group, three subgroups were further provisionally defined, DV1A, DV1B, and DV1C, composed of five, three, and four sherds respectively. Although sample sizes are small, these specimens again appear to form discrete clusters within the larger DV1 group. In addition to the larger DV1 group, two other sets of five and four artifacts appear to separate as distinct chemical groups. Similar in some respects to DV1 (with elevated strontium, chromium and lower zinc, uranium, thorium), they are distinct on several other elements, including iron, hafnium, potassium, cobalt, and vanadium. These groups were termed Death Valley 2 (DV2) and Death Valley 3 (DV3). DV2, in particular, shows ties to DV1, while DV3 departs further from this pattern. Figure 11.3 presents bivariate plots of unlogged values (raw data in ppm) for iron, tantalum, and vanasium. Principal component analysis further supports these findings, suggesting that better separation is achieved in higher dimensional spaces. Additional chemical analyses should be undertaken to determine the uniqueness and viability of these subgroups.

The higher levels of strontium seen in the majority of Death Valley sherds may be related to the presence of various calcium carbonates in the local geology. Strontium readily substitutes for calcium in the molecular structure of some calcium carbonates, especially aragonite. Moreover, Death Valley is a source of strontianite, a member of the aragonite mineral family that is commonly found with calcite and contains high levels of strontium. The mobility of strontium in clay and its tendency to bond with carbonates combined with the presence of significant quantities of strontainite in Death Valley may explain the high levels of strontium seen in the Death Valley sherds and clays. The senior author is currently investigating this possibility at the University of Calgary using an electron microprobe and petrographic analysis of thin sections of Death Valley pottery.

Only one sherd was defined as a "trade ware," having strong similarities to pottery collected from the western fringes of Owens Lake in Southern Owens Valley, approximately 160 walking km to the west. While no sherds displayed characteristics suggesting membership in the Sequoia, Northern Owens Valley, or Southern California (see chapter 10) chemical groups, several unassigned Death Valley pieces showed affinities to other sherds collected in Deep Springs

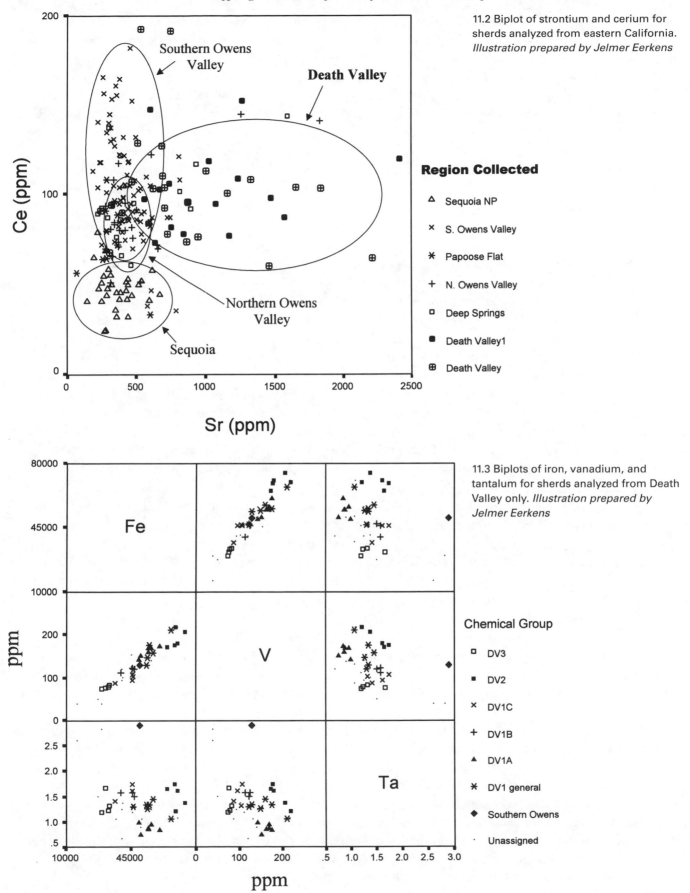

11.2 Biplot of strontium and cerium for sherds analyzed from eastern California. *Illustration prepared by Jelmer Eerkens*

11.3 Biplots of iron, vanadium, and tantalum for sherds analyzed from Death Valley only. *Illustration prepared by Jelmer Eerkens*

Valley, Papoose Flat, and Northern Owens Valley. Yet, variability among these pieces was too great to warrant definition of a unique group. It is possible that these items derive from a distinct, but highly variable, clay source located somewhere between these areas (to the northwest of Death Valley), but this issue will have to await further research. Finally, the single ethnographic sherd examined proved to be the greatest outlier within the larger California pottery data set, having unusually high or low concentrations of almost every element analyzed.

Thus, of the forty archaeological sherds subjected to INAA, twenty-seven (67.5%) were assigned to clusters unique to Death Valley, and one to a cluster from Southern Owens Valley. The final twelve (30%), as well as the ethnographic sample, represent outliers that, based on current evidence, could not be assigned to discrete groups, even when compared to previously defined chemically based pottery groups from Owens Valley, Sequoia National Park, Deep Springs Valley, and extreme Southern California. Given the present information indicating they are not from the west or north, past inferences suggesting most Death Valley sherds are from areas to the east (C. Hunt 1960), and the presence of other painted ceramics in Death Valley known to be from the Southwest, it seems likely that at least some of these unassigned specimens are from regions of the Southwest to the east or southeast. Indeed, subsequent INAA analyses suggests that at least three of the unknown specimens are derived from clays collected to the northeast, in the Nevada Test Site (Eerkens 2001).

The two samples representing duplicates of the same pots, that is, specimens used to check the consistency of the INAA method, proved to be very similar to their appropriate counterparts. This suggests that chemical variability within a single pot is far less than variability between pots.

The five clay samples submitted for INAA proved, quantitatively, to be distinct from most of the Death Valley pottery samples. At the same time, the clays displayed certain properties making them distinct from other clay samples collected from California and Western Nevada, suggesting that clays in the area do contain a distinct chemical signature. In particular, and like the DV1 pottery group, the Death Valley clays contained unusually high concentrations of strontium, combined with lower levels of zinc and uranium, when compared to these other clay samples. When compared to the pottery specimens, however, these trends were sometimes greatly exaggerated. For example, while the DV1 pottery group (n=18) contained average strontium values of 1045 ppm and DV2 av-

eraged 1017 ppm (compared to, for example, thirty-six Southern Owens Valley sherds at 389 ppm), Death Valley clays (n=5) displayed average strontium values of 2836 ppm (compared to 483 ppm for twenty-one other clays collected to the north and west of Death Valley). Indeed, two clay samples collected in the Mesquite Flat region were provisionally assigned to the DV1 chemical reference group based on these similarities. In short, the sampled Death Valley clays do not exactly match the Death Valley pottery samples on a quantitative bases, but qualitatively are very similar, particularly to the DV1 pottery group. Clearly, the effects of temper added to the pottery sherds may be playing a role here, and future analysis will address this issue.

DISCUSSION

Having defined and discussed the chemical data and groups, four main questions present themselves. First, given the INAA pottery and clay data, what is the likely geographic origin of the clays used to make the pots ultimately discarded in Death Valley, in other words, were Death Valley pots made locally or carried in? Second, do the chemical groups correspond to any physical attributes on the sherds so that we can apply this new typology to other Death Valley pottery without having to subject each piece to INAA? Third, how do previous typologies of Death Valley pottery compare to INAA data? Finally, what do the clusters tell us about the prehistoric behavior of Death Valley inhabitants?

Origin of Death Valley pottery

Death Valley pottery (minus one Southern Owens Valley trade ware and twelve unassigned specimens) has little similarity to either clay or pottery collected in Owens Valley, hence the term Owens Valley Brown Ware is misleading and inappropriate for the majority of ceramics from Death Valley. Furthermore, these sherds show little affinity for clays collected to the north. In light of the qualitative similarities to the sampled Death Valley clays, particularly by the high values of strontium, the DV1 pottery group is interpreted as being local in origin. It is possible that these sherds derive from a chemically similar clay source to the south or east, as clay from these areas was not sampled, but the widespread availability of clay within Death Valley and the large number of sherds displaying these tendencies suggests a more local origin, probably within the valley proper. The case for DV2 and DV3, while certainly not from the west or north, is less clear. These sherds show certain affinities to Death Valley clay, but depart in some respects as well, particularly the DV3 group.

These items may have been made from clay found in a more distant or geologically different part of the valley, or from a nearby valley located to the east or south. In any event, the source of this clay was chemically similar but slightly different from clays from the center of Death Valley where the sherds were found.

The reasons why the Death Valley clays do not exactly match the pottery probably include the senior author's failure to sample the exact same clay beds and sources used by prehistoric inhabitants, but may also stem from the alteration of clay prior to firing through souring, leaching, addition of temper, and/or mixing of clays by Shoshone potters. Such alteration is likely to change quantitative chemical values, but ratios between different elements and qualitative differences should, for the most part, hold.

That much of Death Valley pottery is local in origin is in opposition to the conclusions reached by Charles Hunt (1960). He rejected valley bottom clays as suitable raw material for making pottery, stating that they contained too many salts and/or calcium carbonate minerals. In part, this led him to believe that all pottery was brought in from outside the valley, primarily from the east. However, he may not have adequately considered the potential for leaching clays of these minerals and/or alternative sources of clay, such as mid-elevation locations relatively free of salts. Moreover, experimental firing of small tiles made from valley bottom clays by the senior author suggests that some are of pottery quality (that is, they do not explode during firing or flake or fall apart following firing) and may have served prehistoric potters well. Finally, examination of fresh breaks on sherds under a black light suggests that some do contain calcium carbonate minerals such as calcite, which fluoresce when exposed to ultraviolet light, without any detrimental effects to the stability of the pot.

In sum, DV1 is interpreted as being made within Death Valley from local clay. Until further clay samples from regions to the south and east are collected and analyzed, DV2 and DV3 are tentatively interpreted as local to or from just east of Death Valley as well. Further sampling of clay from within Death Valley may also help to tie these groups to more specific localities within the valley.

Comparing chemical data and physical attributes

Table 11.1 presents values for several physical attributes of the sherds measured within each group, including thickness just below the rim, estimated mouth diameter, wall profile, neck or rim profile, lip shape, presence or absence of decoration,

surface finish, the density and average size of temper constituents, and surface color. Even with such small sample sizes, the range of characteristics for most attributes tends to overlap between groups. This suggests that it is not possible, with certainty, to assign a sherd to a particular chemical group based on physical characteristics alone.

At the same time, there are trends towards certain sizes, shapes, or attribute types within different groups. The small sample sizes prohibit rigorous statistical comparison and suggest caution in drawing absolute conclusions, but several differences can be observed. For example, DV3 sherds appear to depart from many of the norms seen in other groups in that they are about 20% thicker and display surface colors more in the grays than browns or reds. Temper within these sherds also tends to be on the large, coarse side, with fewer ferruginous (likely magnetite) and more clear quartz grains. These data are congruous with the INAA results, which suggest that DV3 is different from DV1 and DV2. Similarly, DV2 sherds have more micaceous and dark ferruginous temper constituents (and as a result higher iron levels) than either DV1 or DV3, are often smooth on the surface, and are more often recurved and decorated than DV1 pots. Within the sample analyzed for INAA, these sherds were also exclusively found on Mesquite Flat. Sherds in the DV1A group tend to be fired in an oxidizing atmosphere and often contain transparent green to yellow temper particles (likely epidote or olivine). Future thin-section work (currently in progress) will help in the identification of mineral temper constituents.

In some respects, the DV2, DV3, and unassigned sherds seem to share certain characteristics when contrasted to DV1. For example, these sherds are more often recurved (41% versus 6%), decorated (32% versus 11%), and smooth on their surface (40% versus 19%), than their DV1 counterparts. These differences suggest that DV2, DV3, and many of the unassigned specimens may represent distinct ceramic traditions, emphasizing different styles of manufacture and finish, vessel shapes, and/or qualities and sources of clay.

On the whole, DV1, DV2, and DV3 sherds, when considered separately, are more standardized than unassigned sherds. For example, lip lateralization (that is, whether the lip slopes towards the interior, exterior, or is symmetrical) is either symmetrical or exterior lateralized among DV1 rim sherds (thirteen symmetrical, five exterior), and entirely symmetrical among DV2 and DV3, but is more diverse among unassigned specimens, where all three forms occur (eight symmetrical, three interior, two exterior). Similarly, DV1 (for eight of nine sherds measurable for this attribute), DV2 (three of three),

Table 11.1: Physical Attributes of Sherds by Chemical Group

Attribute	DV 1 (n=18)	DV 1A (n=5)	DV 1B (n=3)	DV 1C (n=4)	DV 2 (n=5)	DV 3 (n=4)	Unassigned and Trade (n=13)
Locations found	8 Mesquite 8 Salt Pan 1 Grapevine 1 Unknown	2 Mesquite 2 Salt Pan 1 Unknown	1 Mesquite 1 Salt Pan 1 1 Grapevine	4 Salt Pan	5 Mesquite	2 Mesquite 2 Salt Pan	5 Mesquite 6 Salt Pan 1 Grapevine 1 Unknown
Avg. thickness	5.3	5.1	5.5	5.0	5.0	6.5	5.1
Avg. ddiameter	25.1	23.2	29.2	23.4	25	25	21.4
Wall profile	9 Bowled 5 Straight	3 Bowled 1 Straight	2 Bowled 1 Straight	1 Bowled 1 Straight	4 Bowled	4 Bowled	3 Bowled 5 Straight
Rim form	17 Direct 1 Recurve	4 Direct 1 Recurve	3 Direct	4 Direct	2 Direct 3 Recurve	2 Direct 2 Recurve	9 Direct 4 Recurve
Lip shape	14 Rounded 4 Squared	5 Rounded	3 Rounded	2 Rounded 2 Squared	4 Rounded 1 Squared	3 Rounded 1 Squared	6 Rounded 3 Squared 4 Pointy
Lip lateralization	13 Sym.* 5 Exterior	2 Sym. 3 Exterior	1 Sym. 2 Exterior	4 Sym.	5 Sym.	4 Sym.	8 Sym. 2 Exterior 3 Interior
Finish	6 Tooled 7 Brushed 3 Smooth	2 Tooled 2 Brushed	1 Tooled 2 Brushed	1 Tooled 2 Brushed	2 Tooled 2 Smooth	3 Tooled 1 Brushed	1 Tooled 4 Brushed 6 Smooth
Coil welding	8 Interior 1 Even	1 Interior		2 Interior 1 Even	3 Interior	2 Interior 1 Even	2 Interior 2 Even 3 Exterior
% Decorated	11% (n=2)	0% (n=0)	0% (n=0)	0% (n=0)	40% (n=2)	25% (n=1)	31% (n=4)
firing atmosphere	9 Oxidized 9 Reduced	4 Oxidized 1 Reduced	1 Oxidized 2 Reduced	1 Oxidized 3 Reduced	3 Oxidized 2 Reduced	1 Oxidized 3 Reduced	4 Oxidized 9 Reduced
Temper size	6 Fine 9 Medium 3 Coarse	2 Fine 3 Medium	2 Fine 1 Medium	3 Medium 1 Coarse	1 Fine 4 Medium	2 Medium 2 Coarse	3 Fine 7 Medium 3 Coarse
Temper density	8 Low 7 Medium 3 High	1 Low 4 Medium	3 Low	2 Low 1 Medium 1 High	1 Low 2 Medium 2 High	4 Medium	4 Low 7 Medium 2 High
Range in surface color	Red, Grey to Dark & Red Brown	Red; Grey-Brown	Grey to Red Brown	Red; Grey-Brown	Grey & Red Brown; Black	Yellow to Brown Grey	Red to Dark Brown; Grey; Red

* symmetrical

and DV3 (two of three) pots were constructed mainly by overlapping coils on the interior of the pot, while unassigned sherds display coils overlapping on the exterior (three of seven), interior (two of seven), as well as nonoverlapping or even coils (two of seven), where coils were stacked on top of one another. These findings support the INAA results, suggesting DV1, DV2, and DV3 represents distinct and coherent groups made by a restricted range of individuals with a common method of manufacture, while unassigned sherds represent multiple people and more diverse manufacturing techniques.

In short, while groups tended to have restricted variation, the range of characteristics between groups overlapped sufficiently to make assignment of unanalyzed sherds to groups, based solely on physical characteristics, impossible. With additional studies, however, it may be possible to give probabili-

ties of membership based on observable traits, particularly if multiple attributes are used in combination. For example, decorated sherds with recurved rims are unlikely to belong to DV1 (n=0 of 18) but are more likely to belong to DV2 (n=2 of 5) or DV3 (n=1 of 4), based on the current sample of sherds analyzed. For the time being then, INAA or some other method of compositional analysis will have to be used to replicate the typology defined here.

Comparison of chemical data and previous typologies
Unfortunately, this study was unable to compare the typology developed by Alice Hunt (1960) in categorizing Death Valley pottery to the typology developed from INAA data. This was largely because we were unable to replicate her typology, despite the fact that nine of the same sherds Hunt used to de-

velop her typology were included in the INAA study. The main typological division in the Hunt system concerns the mode of thinning and finish, that is, whether the pot was thinned using paddle and anvil technology or was wiped using fingers or some other object (such as a stone or pot sherd). Hunt had found that approximately 25% of the one thousand sherds she collected from around the Death Valley Salt Pan were thinned using paddle and anvil. Of the sherds included in this study, however, only two, both DV3, displayed any obvious dimpling characteristic of the paddle and anvil technique (A. Hunt 1960). Moreover, one of these sherds contained wiping marks on the opposite (that is, the supposed paddled) surface, making for confusion as to the source of the dimples (whether by paddle and anvil or simply depressing fingers into the wet clay to help shape the pot). Similarly, in a sample of over four thousand sherds collected from Mesquite Flat, only 25 km north of the Salt Pan, W.J. Wallace (1986) did not find a single sherd finished by paddle and anvil. It seems remarkable, particularly given their geographic proximity and the overlap in raw materials between the two areas, that one collection would contain so much paddle and anvil finished pottery while the other lacked it completely.

Further replication of Hunt's typology could not be performed because much of it was based on the analysis of petrographic thin sections, a method not used here. However, there is likely to be some correlation between the two typologies developed, and some of the previously mentioned differences between chemical groups. For example, the presence of transparent green and yellow temper may correspond to types defined by Hunt. Based on the descriptions offered by A. Hunt, there seems to be some correspondence between what she defined as "Shoshone Ware" and the DV1 group. Moreover, our DV1A fits the description offered for Hunt's II B1 (her "Death Valley Brown"), and our DV1B roughly matches Hunt's II A3, both specific varieties of Hunt's "Shoshone Ware." In fact, one of the DV1A sherds included in this study may have been thin sectioned by Hunt and used to define her Death Valley Brown type. Similarly, our DV3 may be related to Hunt's Southern Paiute Utility Ware, specifically her type II A1. Our DV2 does not seem to match any of the types defined by Hunt, but in this study its range was confined to Mesquite Flat, an area she did not study.

At the same time, some of the definitions provided by Alice Hunt seem too restrictive for the chemical groups defined here. For example, a third variety of Shoshone Ware contains specimens with only smooth exteriors. Yet, smooth surfaces were relatively rare in the DV1 group, and never occurred exclusively in any of our chemical groups. Similarly, DV3 seems to include greater variation than Alice Hunt defined specifically for Southern Paiute Utility Ware (II A1). It seems then, there is some degree of overlap between Hunt's typologies and our own. Unfortunately, the present study did not generate the necessary data to reliably duplicate Hunt's typology, namely a mineralogical study of temper constituents through petrographic thin sections. Thus, without her original sherd classification or petrographic study, the exact degree of overlap is not known. The degree of correlation between our chemical groups and the types defined by Hunt will have to await verification by a more thorough analysis of thin sections of samples included in the INAA study.

Inferences about prehistoric behavior

Other than the attempts of the Hunts (A. Hunt 1960; C. Hunt 1960) to separate Death Valley pottery into distinct types, Death Valley archaeologists have generally lumped pottery into a single category. Yet, INAA has shown that ceramics from this area are quite diverse. Even within the small sample of forty sherds, there are no fewer than five distinct groups with three or more members. In addition, twelve sherds remain unassigned which, with a larger sample and additional studies, would undoubtedly find membership in further groups. We believe that dividing Death Valley pottery into meaningful groups goes a long way toward furthering our understanding of prehistoric behavior.

First, as discussed above, the chemical groups display different modal and average shapes, sizes, and styles of production. Many of these differences, such as preferences for a certain type of coil welding or lip lateralization, appear to be unrelated to pottery function. This suggests manufacture by disparate peoples with different pottery-making traditions. Differences in other traits, such as preferences for a certain thickness or rim form, may be more directly related to the function of pots, and may indicate different roles for ceramics within these traditions. Whether the differences are a function of chronological change in how and where pottery was made, represent simultaneous use of Death Valley by different peoples, exchange of vessels across space, or preferences for certain clays for certain pot functions is unknown, but should be the subject of future research. However, outlining some of the differences through INAA and acknowledging that different traditions emphasize different features and do not necessarily incorporate the full range of variation seen in all brown-ware pottery is an important first step in deepening

our understanding of brown-ware pottery, and how and why it varies within the region.

Second, just as sourcing obsidian and tracking movement of shell artifacts has deepened our understanding of long distance exchange and mobility patterns in the area (see, for example, Basgall 1989; Hughes and Bennyhoff 1986), sourcing pottery and developing a typology of different source groups can also contribute to this arena. At least 45 to 65% of the sherds were determined to be of local origin. The current research also shows that long-distance trade of pottery with areas to the north, south, and west was not an important aspect of making a living in Death Valley. Only one of the forty archaeological sherds analyzed was confidently placed within an existing group that has origins 100 or more kilometers away, an item derived from Southern Owens Valley (160 km west). This piece is decorated and has a recurved rim, traits that are rare to the Owens Valley area (Griset 1988; Riddell 1951), but more typical of Death Valley pots (Eerkens 2000). No Death Valley sherds matched the chemical signatures of groups and clays native to Sequoia National Park, Northern Owens Valley, or extreme Southern California. If trade or exchange was important to prehistoric Death Valley inhabitants, it was over shorter distances, or was carried out with people living to the east (for which no database of ceramics analyzed by INAA currently exists). It seems likely that a significant fraction of the 30% unassigned sherds are from areas in this direction, indicating the ties Death Valley people had with the western Southwest. Again, developing a typology and dividing ceramics into different categories, in this case local versus extralocal, is crucial to recovering such information.

Finally, the development of a typology, if tied to chronological dates, can help document change in ceramic technology through time. The single ethnographic specimen analyzed was without exact information regarding when it was made or by whom, but was labeled as being from the twentieth century and made by a Timbisha (Death Valley) Shoshone, probably near Furnace Creek. It proved to be unlike any other sherd analyzed from Death Valley, or anywhere else in California for that matter, and did not match any of the sampled clays either. Moreover, the vessel is shaped like a deep circular pan, atypical of prehistoric Death Valley or Great Basin ceramic forms (Griset 1988; Pippin 1986; Riddell 1951; Steward 1928; Touhy 1986, 1990; W.J. Wallace 1986). Although only a single sample, together these items suggest a change in the style of manufacture and the source of clays from prehistoric to historic times. Others have noted that pottery was one of the first crafts abandoned by Native Cali-

fornian peoples following contact with Europeans in the early nineteenth century, replaced quickly by metal cooking containers (Griset 1988). It may be this replacement, combined with a loss of knowledge about how to make pottery, which led to such a departure in traditional ceramic manufacture. Timbisha Shoshone in the twentieth century may have tried to rekindle the pottery craft, but resorted to using imported, perhaps commercially sold, clays to make pots similar in appearance to pans, a common shape of metal cooking vessels. Indeed, ethnohistoric photographs of Western Great Basin people often show metal pans in domestic shelters (Milliken, Gilreth, and Delacorte 1995). It is possible that such a pan served as a mold for the ethnographic vessel.

CONCLUSIONS

Previous research in Death Valley has tended to lump all brown ware into a single category, and, as a result, has compromised the utility of ceramic analysis. This study has shown that brown wares from Death Valley are not all alike. Sherds tend to fall into chemically distinct, but technologically, physically, and visually overlapping categories. Although there are trends towards certain shapes, sizes, styles, and construction techniques, it is not possible with absolute certainty to assign sherds to chemical categories based on these visible characteristics alone.

INAA of sherds and clays and the development of a preliminary typology for Death Valley brown wares have helped to resolve the debate on where this pottery was manufactured, in addition to providing new information on mobility and exchange patterns of late prehistoric inhabitants. Slightly less than half of the samples analyzed were attributed to three distinct local clays from central Death Valley. An additional nine samples were probably produced from clays found elsewhere in the valley, such as in more remote locations or just outside the valley (to the east or south). A single specimen was attributed to clays from Southern Owens Valley, while twelve were unlike other sherds thus far analyzed from the desert west. These twelve may be imported from areas to the east, such as the Virgin River area or the Colorado River area to the southeast. A high degree of chemical diversity among the sampled sherds may be consonant with high residential mobility for late prehistoric people in the region. However, additional clay sourcing analysis is needed to verify this conclusion.

Future INAA studies should seek to expand the database of sherds and clay samples. For example, we are currently in the process of analyzing specimens from the Mojave Desert

to the south and the Nevada Test Site to the northeast. Doing so will increase the power of statistical comparisons between chemical groups, will better document the range of variation within groups, will give a broader overview of ceramic variability within Death Valley, will better document the extent and frequency of long distance exchange and/or mobility, and will bring greater precision in assigning chemical groups to specific geographic locations.

Acknowledgments. The INAA portion of this study was funded by a dissertation improvement grant from the Wenner-Gren Foundation for Anthropological Research (#6529). Special thanks to MURR and Sergio Herrera for help with the analysis, to Death Valley National Park, especially Caven Clark, Tim Canaday, and Blair Davenport, for making archaeological collections available for study, and to William Lucius for reading an earlier copy of this report.

A Petrographic Approach to
Sand-Tempered Pottery Provenance Studies
Examples from Two Hohokam Local Systems

James M. Heidke, Elizabeth J. Miksa, and Henry D. Wallace

UNTIL QUITE RECENTLY, many archaeologists believed that pottery production by each and every household was the typical pattern followed in virtually every geographic area of the North American Southwest throughout prehistory (S. Plog 1995b:269). However, that "autonomous village" model (S. Plog 1980, 1995b) is no longer accepted by many (Mills and Crown 1995). Instead, it is recognized that exchange relationships develop because of various demographic, social, economic, religious, and political factors (S. Plog 1995b:270). Precise determination of the nature of production and the intensity of exchange relationships becomes mandatory when archaeologists seek to explain the ways that prehistoric Southwestern societies were organized and evolved (S. Plog 1995b:271). Here evidence gathered over the last fifteen years regarding the nature of production and intensity of exchange relationships in two portions of the Sonoran Desert—the Tucson and Tonto basins—is reviewed.

In the Sonoran Desert area, Wilcox (1980:237) proposed that the Gladwins' (Gladwin and Gladwin 1933) Hohokam culture area model be redefined as a dynamic regional system of interacting populations. According to Wilcox (Wilcox, McGuire, and Sternberg 1981:200; Wilcox and Sternberg 1983:194), the Hohokam regional system consisted of a number of local systems—such as the Phoenix Basin, lower Verde River, Tonto Basin, and Tucson Basin systems—each comprising many interacting communities variably adapted to life in the desert environment of southern Arizona. Wilcox's concept directs research toward the structure of each local system and how it changed over time. Delineation of exchange systems within the Hohokam regional system is one research topic suggested by Wilcox (1980:240–241), and one that can

be addressed with ceramic data. Ceramic production and distribution studies are, by definition, investigations into the system's horizontal complexity, and their results complement settlement studies focused on its vertical complexity (Gregory 1991:160–163; Wilcox 1991b:255–258, 261–262). The approach to provenance determination taken here, and, ultimately, political economy, is based on source identification of temper sands. Sand samples have been collected from both the Tucson and Tonto basins. Their compositions have been characterized using quantitative petrographic techniques to establish models, termed *actualistic petrofacies models*, of the geographic distribution of sand compositions available in each basin. A sherd's sand-temper provenance is inferred by comparing its composition with that of the known petrofacies.

A SHORT HISTORY OF PETROGRAPHIC RESEARCH IN THE HOHOKAM AREA

Petrographic analysis of Hohokam pottery has a long and interesting history and has often led the discipline in methodological and theoretical developments. Hohokam petrographic studies were initiated by Nora Gladwin during her analysis of pottery recovered from the 1934 to 1935 excavations at Snaketown (Gladwin 1975). Gladwin was trained in petrographic analysis at Bryn Mawr College and joined the staff of the Gila Pueblo Archaeological Foundation of Globe, Arizona, in the mid-1930s (Haury 1988:31), at about the same time that the usefulness of the petrographic approach was demonstrated in Shepard's (1936) technological analysis of pottery from Pecos Pueblo. Undoubtedly, Nora Gladwin's interest in ceramic technology was fostered by the close relationship between Harold Gladwin, Nora's stepfather and

founder of the Gila Pueblo Archaeological Foundation, and Alfred Kidder, director of the Pecos Pueblo research (Haury 1988:2–3). Gladwin examined one hundred thin sections of pottery recovered from Snaketown and an unspecified number of Mogollon sites located in southwestern New Mexico. She identified temporal- and ware-related compositional variability in the Snaketown sherds (Gladwin 1975:231). She also found the temper composition of Hohokam and Mogollon wares to be dissimilar (Gladwin 1975:231–232).

Much of the prehistoric pottery manufactured in the Sonoran Desert region is sand tempered. Shepard (1936:411, 563, 578) suggested collecting sand samples for comparative purposes, but her famous study of Pecos pottery did not make use of that type of collection, nor did Nora Gladwin's Snaketown study. Although Shepard's suggestion is not acknowledged, R.M. Wallace's (1957) petrographic analysis of late Classic period ceramics from the University Indian Ruin, located in the northeastern Tucson Basin, utilized this novel approach. He collected sand samples from washes located close to the site and compared their compositions with that of sand-tempered pottery recovered from the site. He found that the compositions of the sands and sand tempers were similar (R.M. Wallace 1957:219). R.M. Wallace also compared the temper composition of pottery from University Indian Ruin with that seen in the pottery from two contemporary sites located in the Papaguería, west of Tucson. He found that the pottery from each site had a "distinctly different" composition (R.M. Wallace 1957:219).

Many petrographic investigations of Hohokam pottery temper were conducted in the 1970s and 1980s (Antieau and Pepoy 1981; Dulaney 1988; Fournier 1988a, 1988b, 1989a, 1989b; Fournier and Doyel 1985; Garrett 1991; Hepburn 1984; Loomis 1980; Rose 1979; Rose and Fournier 1981; Severa and Severson 1978; P. Stein 1979; Weisman 1987). Most of these studies, however, examined small numbers of sherds and resulted in descriptive reports that did not address provenance issues. None of the researchers made use of R. Wallace's innovative approach. It was not until Lombard's work in the mid- to late-1980s that Hohokam petrographic studies again moved forward. Like R.M. Wallace, Lombard collected wash sands, but, unlike Wallace, he collected samples from the entire Tucson Basin. Furthermore, he introduced the Gazzi-Dickinson (Dickinson 1970; Gazzi 1966) point-counting technique to Hohokam petrographic studies (Lombard 1986), and the petrofacies approach (Mansfield 1971) to evaluating compositional data (Lombard 1987b).

A MAP IS NOT THE TERRITORY

This principle, made famous by Korzybski (1958:750), asserts that there is a relationship between a report and the thing reported. That relationship tends to be of a classificatory nature (Bateson 1979:30). The classification depicted in every map is, however, research and scale dependant. Thus, we use Korzybski's principle to remind us that the classification of "map units" reported in a "geologic map" rarely portrays the full extent of compositional variability present in a region's wash sands. The process of actualistic petrofacies modeling, on the other hand, strives to identify all major sand compositions present in a region and the provenance of all sand tempers commonly observed.

The chemical characterization provenance studies described in the other studies in this volume focus on explaining patterns of ceramic economy from a scalar perspective that is relatively large. That is, ceramics manufactured in areas that are on the order of drainage basins are distinguished from one another, thus allowing interactions such as exchange or migration between groups in different regions to be hypothesized. The focus of the optically based petrographic studies described here is much narrower. Under favorable circumstances, temper characterization can be used to explain patterns of ceramic economy *within* drainage basins, thus allowing interactions among settlements within a region to be hypothesized, as well as those between regions.

In chapter 1, Neff and Glowacki enumerate the problems that ceramic pastes pose for analysis. The clays that make up the bulk of ceramic pastes are widely distributed and thus are difficult to sample and map, while natural and cultural modifications, such as the addition of temper, may greatly alter the chemistry of a paste from its parent material. Neff and Glowacki (figure 1.2) sketch out two common approaches to provenance research. The first is used for "easily identified" localized sources, and has as its basis the characterization of geological source materials prior to the characterization of archaeological materials. The second is used for widespread indistinct sources, and has as its basis the characterization of groups of similar archaeological materials, with empirical or inferential provenance determination coming at a later stage in the analysis.

The chemical characterization studies described in this book follow the latter path because of the difficulty of matching ceramic pastes to their parent materials. However, we characterize temper in archaeological ceramics based on comparison to known geologic materials, an approach that is more like Neff and Glowacki's first path. While it is true that

this method requires training and experience in petrographic techniques, it also affords a "direct guide for locations of centers of production" (Shepard 1995:xi) and provides the means to analyze thousands of sherds, sufficient by any standard for the statistical analysis of data. Unfortunately, this temper characterization method cannot be used everywhere, and, even in favorable areas, may not be applicable at all times.

SOURCES OF VARIATION IN CERAMIC COMPOSITIONS

As noted in chapter 1, ceramic compositions are the result of a complex series of natural and cultural processes. In order to demonstrate the utility and appropriateness of the petrofacies method, it will help to develop a general model describing sources of variation in geologic materials and in ceramics. One cannot always measure the effects of geologic or behavioral variation; in some cases, the final interpretation allows one only to hypothesize what they might have been. An explicit acknowledgement of the sources of variation in ceramic compositions should help prevent errors in interpretation later.

For the purpose of this discussion, five sources of variation in ceramic compositions are considered:

1. Distribution of the geologic resource.
2. Variability of the geologic resource.
3. Economy of a ceramic production and distribution system, especially insofar as this may affect procurement.
4. Technological alteration of the materials used in making a ceramic paste.
5. Use history of a ceramic artifact and/or its postdepositional alteration.

They are presented in an order that reflects the process of transforming raw materials into objects, using and discarding the objects, and retrieving their remains from archaeological deposits. However, one should keep in mind that some aspects of the process can be known a priori (points 1 and 2), some are revealed during analysis (points 4 and 5), while others are inferred a posteriori, after consideration of all lines of evidence preserved in the archaeological record (point 3).

Geological resource distribution

Geologic resources can be distributed in a variety of ways that affect the strategies that people might use to procure them. The size and shape of a resource on the landscape has physical, spatial, and temporal attributes that limit the means by which people can extract the commodities they seek. For instance, some geologic materials form widely distributed, more-or-less continuous sources. Examples of continuous resources include alluvial fans, bajadas, large exposed bedrock outcrops, and large river terraces. Other resources are more restricted. Resources carried in or arrayed along rivers may have a ribbon-shaped distribution, while some resources are so restricted that they are, in effect, points on the landscape.

Resources that are continuously distributed are relatively easy to access, and their access could be difficult to control. Broadly distributed resources may require less planning to procure, and/or may be procured in conjunction with other activities. They are also much less likely to be depleted through time than resources that are more restricted. In contrast, point sources may be very difficult to access. Advance planning or deliberate trips may be required to procure resources, and they may be relatively easy to control in a political or social sense. Point sources may also be subject to depletion on human time scales. Ribbon-shaped resources—those that are intermediate in distribution between continuous and point sources—may have qualities similar to either continuous or point sources, depending on their extent and location relative to procurement activities.

Geologic resource variability

Once the distribution of a resource has been determined, it is necessary to examine the compositional variability within that distribution; in other words, How heterogeneous is the deposit? Understanding the geographic availability of a type of resource (sand or clay) does little to organize our knowledge of its composition. Obviously, a broadly distributed resource that is extremely homogeneous limits our ability to assign provenance in a way that is not true for heterogeneous deposits. For instance, an alluvial plain might offer a continuous source of temper sand, yet the sand might vary in composition if the contributing bedrock changes from one end of the plain to the other (figure 12.1a). Likewise, a series of point sources in a large region may be very similar to one another, some may group together compositionally, or each may have its own petrographic or chemical signature. For instance, a series of alluvial clays derived from different bedrock units under similar conditions might each be viable point sources of potting clay and have unique chemical signatures (figure 12.1b). Thus, each type of resource needs to be considered in terms of its distribution *and* its variability relative to the scale of investigation.

The degree to which a geologic resource can be differen-

12.1 Block diagrams illustrating the interplay between resource distribution and variability. A, Relatively continuous source of sand is heterogenous because it comes from a variety of bedrock sources. B, Arrows indicate point sources of clay that are heterogenous because they originated in source rocks that have different compositions

intraregional economic patterns, but may serve to separate the products of one region from another. Obviously, the type of analysis conducted plays a role in the differentiation of sources. Visual identification of rocks in hand sample is not as precise as a petrographic or chemical characterization of their composition. The challenge for any compositional analysis is to choose the right combination of geological sample density, analytical method, and archaeological sample population required to answer the questions being posed. The degree to which the challenge can be met depends to a large extent on the resources available to the investigator, ranging from availability of suitable maps to the accessibility of primary geological samples and money to carry out a research program.

Ceramic economy

The organization of production and the nature of preindustrial economic systems have been a focus of archaeological and ethnographic studies for approximately the last thirty years (Bey and Pool 1992; Costin 1991; Mills and Crown 1995; B.L. Stark 1985; M.T. Stark 1993; van der Leeuw 1984). One of the most comprehensive models addressing the organization of production is presented by Costin (1991). We can apply Costin's (1991) typology to the issue of raw-material procurement in order to evaluate how economic, social, and geologic factors interact. This complex interaction among factors has the potential to confound one's ability to identify and interpret provenance.

As noted above, the distribution of a resource will affect the degree to which it can be controlled. Point sources, being limited in distribution, could be much more subject to human control (either by an individual or by representatives of a state) than ribbon or continuous resources. Furthermore, one can envision a situation in which a resource confined to a point source was used by many producers in a dispersed production system (sensu Costin 1991), whereas it could have been controlled by one (or a small number) of producers in a nucleated production system (sensu Costin 1991). Also noted above, evidence of procurement at point sources is much more likely to be preserved than that at continuous or ribbon sources. However, potters employed in factory-level production are more likely to leave procurement evidence on the landscape, even on continuous or ribbon resources. Such a large-scale production system might require more than one source to maintain production, so the composition of products might have synchronic and/or diachronic variation. Conversely, potters producing a small number of pots each year are less likely to deplete a resource; thus their products

tiated into discrete source areas is highly dependent on the scale of analysis, in terms of the number of samples collected and the intended type of compositional analysis. The provenance postulate (chapter 1; Weigand, Harbottle, and Sayre 1977:24) explicitly states that recognizable variation between sources must exist in order to conduct a provenance study. However, the scale at which a resource needs to be differentiated depends on the scale of the research questions being posed. If it were sampled intensively, a heterogenous, continuous source, such as a large deposit of marine clay, might be suitable for the investigation of intraregional ceramic production and consumption patterns. A series of homogeneous point sources might prove impossible to use for determining

may be more homogeneous through time.

Finally, access to geologic resources might be restricted by ownership, warfare, weather, or taboos, not just by the straight-line distance. Choices about which resource to use may be affected by cultural notions about what constitutes the "best" source of material, not just by "objective" material properties (Aronson, Skibo, and Stark 1994; Rice 1987:117; Rye 1981:17). Thus, the procurement of geologic resources represents a web of interacting variables. How far people are willing, allowed, or required to go; how much effort they expend to procure a raw material; and how important it is to use one source over another all affect the composition of the final product.

Technological alteration of materials

The formation of a ceramic paste can range from simple to complex. Obviously, the mixing of clays, addition of temper to clay, addition of water (or other fluids) to make a paste, or the removal of coarse material from a clay affect the petrographic and chemical compositions of a ceramic body. Insofar as is possible, it is necessary to ascertain the technology of ceramic production so that the potential influences on composition can be deduced and accounted for.

Use history/postdepositional alteration

Chemical and mineral composition can change according to what was placed in a vessel, whether it was used for cooking or storage, and by the postdepositional geologic or pedogenic environment. Processes such as the filling of pore spaces with salts (Wiley 1994) or the postdepositional leaching of cations from a paste are examples of such changes. Depending on the nature of the provenance study, these effects can be accounted for by measures as simple as observing or quantifying visible changes, or as complex as measuring the water and soil chemistry in and around an archaeological site versus the chemistry of potential source locations.

THE PETROFACIES METHOD: CHARACTERIZING SAND TEMPER PROVENANCE

Sand-tempered Hohokam pottery is nearly unique in the context of the sources of variability in ceramic pastes discussed above. The diverse geology of the mountain ranges in central and southern Arizona has resulted in spectacular heterogeneity in sand compositions within many well-defined drainage basins. Because of the long history of mining in this area, geologic maps are often readily available and quite detailed. Furthermore, the problems associated with constructing modern housing on ancient alluvial features has led to the mapping of surficial geology in many areas of interest to Hohokam archaeologists. Finally, research money has been available due to the need to mitigate the effects of ongoing development to archaeologic resources in and near the Phoenix and Tucson metropolitan areas.

Raw materials first!

Given the heterogeneous nature of sand compositions available as temper to prehistoric potters in the various Hohokam local systems, the ready availability of the resource, and the development of a quantitative petrographic method, it is highly appropriate to focus on sand-temper composition in order to characterize pottery-production provenance. To do this, naturally occurring sands must be the unit of study. Figure 12.2 is a schematic diagram of the steps necessary to carry out sand-temper provenance characterization.

Here the petrofacies method is used to map out and characterize the sands available as temper. When sands in a well-defined region can be broken into subsets on the basis of composition and spatial contiguity, petrofacies (*petrographic facies*) can be defined. The petrofacies concept is used for the study of rock units according to their petrologic characteristics as opposed to their form, boundaries, or relationship to other rock units (Bates and Jackson 1984:379). In this context, each petrofacies represents a distinct sand composition zone. For the purposes of archaeology, we can think of petrofacies as temper resource-procurement zones whose sand compositions are distinct from one another at a relevant scale of investigation. Thus, in using petrofacies models, it is no longer necessary to postulate that variation between sources is greater than that within sources: The requisite variation is demonstrated to exist.

To create a petrofacies model, available map information (geological, geomorphological, pedological, and so on) is used to develop a preliminary petrofacies map, or model of likely sand compositions in the area under study, generally a well-defined basin or region (figure 12.2, steps A to C). The preliminary petrofacies map is tested by collecting sand samples from each of the hypothesized petrofacies. Sand samples are washed in the laboratory to remove material that is less than sand-sized and to dissolve caliche coatings; then the samples are mounted in epoxy blocks and thin sectioned. At each stage of collection and processing, steps are taken to ensure that each sand sample is random and that it represents the larger sand unit from which it comes (Miksa and Heidke 2001). Once sands are fully processed, a

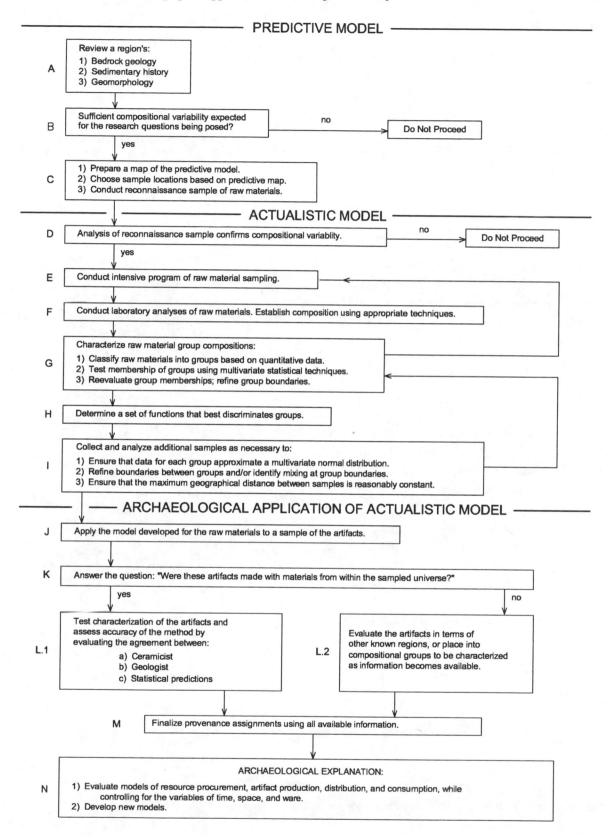

12.2 Flow chart showing the analytical procedures used to implement a quantitative, actualistic petrofacies model as a means to characterize temper provenance

cleaned "hand sample" as well as a thin section are available for each sample location.

Once thin sections are prepared, the preliminary petrofacies model can be evaluated using petrographic modal analysis, or point counting, a quantitative method that provides data on the quantity and composition of grain types present (figure 12.2, steps D to F). To conduct the point count, a grid is imposed over the sample to be counted, and the composition of the grain under each grid point is recorded using a petrographic microscope. We use the Gazzi-Dickinson point-counting method, independently developed by Gazzi (1966) and Dickinson (1970), to explore the provenance of sub-quartzose sandstones, including the graywackes, or dirty sandstones, which comprise sand in a clay paste.

The Gazzi-Dickinson point-counting method quantifies the sand-sized mineral and rock constituents in a sedimentary rock according to grain size; any mineral that is sand-sized or larger is counted as a single mineral, even if it is contained in a rock fragment. Thus, fine-grained rock fragments are counted as rocks that can be further subdivided into types according to their source and texture (sedimentary-siltstone, sedimentary-chert, volcanic-felsitic, and so forth). Coarse-grained rocks and minerals are counted as the mineral phase to which they belong (quartz, hornblende, and so forth), because any coarse-grained rock might break down into its mineral constituents with transport. Table 12.1 lists the common grain parameters used to point count rock and mineral types encountered in central and southern Arizona sands, while figure 12.3 illustrates the relationship between the point-count grain parameters, some common igneous rock types in which they occur, and their general chemical compositions.

By using this method, sand-maturity effects are minimized and sands within a large system can be compared to one another and to their source materials. It is this property of the Gazzi-Dickinson point-counting method that makes it suitable for the comparison of sand-tempered pottery ("sand in a clay paste") with geological sources of sand. Dickinson (1971a, 1971b) immediately recognized the utility of this point-counting method for archaeological problems and applied it to pottery in the South Pacific islands. Dickinson's student, James Lombard, applied this method to Tucson Basin sands and pottery in the 1980s, thus initiating the case studies described here.

Once point counting is completed, statistical analyses are conducted with the sand point-count data to refine petrofacies boundaries, assign sand samples to petrofacies, demonstrate that

Table 12.1 Common point count parameters used in the analysis of sand and sherd thin sections

Parameter	Description
Monomineralic grains	
QTZ	All quartz types
KSPAR	Alkali feldspars
MICR	Microcline
PLAG	Plagioclase feldspar stained pink, less than 10% altered
PLAGAL	Same as plagioclase but 10 to 90% altered to sericite, clay minerals, or epidote
PLAGGN	Same as plagioclase but >90% altered to sericite, clay minerals, or epidote
PYR	Undifferentiated members of the pyroxene and amphibole groups
MUSC	Muscovite
BIOT	Biotite
CHLR	Undifferentiated chlorite group minerals
OPAQ	Undifferentiated opaque minerals such as iron oxides and titanium oxides
EPID	Undifferentiated members of the epidote family
CACO	Undifferentiated sand-sized carbonate minerals
Volcanic lithic fragments	
LVF	Felsic to intermediate volcanic rock such as rhyolite and dacite
LVFb	Biotite-bearing felsic to intermediate volcanic rock such as biotite-rhyolite
LVM	Intermediate to basic volcanic such as basalt and andesite
LVV	Glassy volcanics
LVH	Hypabyssal volcanics such as microgranite
Sedimentary lithic fragments	
LSS	Siltstones
LSA	Shale, slate, mudstone, and the matrix of graywacke
LSCH	Chert
LSCA	Carbonates such as limestone and aragonite
GROG	Sherd temper (counted only in sherd samples)
Metamorphic lithic fragments	
LMM	Quartzite, not foliated
LMF	Quartzite, foliated
LMA	Metamorphic aggregate, not foliated, such as metasediments or metavolcanics.
LMT	Quartz-feldspar-mica aggregate, foliated, such as fine-grained schists or gneisses.
LMTP	Phyllite
Unknown and indeterminate grains	
UNKN	Grains that cannot be identified, grains that are indeterminate, and grains such as sphene and zircon that occur in extremely low percentages.

	Light————————————————Rock Color————————————————Dark		
	Albite————————————————Plagioclase Type———————————— Andesine		
	←←←Increasing SiO$_2$←←←←←←←←←←←←←←←←←←←←←←←←←←←←←←		
	←←←←Increasing Na$_2$O, K$_2$O←←←←←←←←←←←←←←←←←←←←←←←←←←←		
	→→→→→→→→→→→→→→→Increasing CaO→→→→→→→→→→→→→→→→→→→		
	→→→→→→→→→→→→→→→→→→→Increasing MgO, FeO, Fe$_2$O$_3$→→→→		
	Rock Chemistry		
Rock Texture	Acid	Intermediate	Basic
Fine-grained extrusive rocks, such as tuff	Rhyolite LVF, LVV	Dacite, Latite LVF, LVM, LVV	Basalt, Andesite LVM
Medium-grained hypabyssal rocks or dikes	Microgranite QTZ, P*, KSPAR, MICR, LVH	Microgranodiorite P*, PYR, QTZ, LVH	Diabase P*, PYR, OO
Coarse-grained intrusive rocks found in plutons or batholiths	Granite QTZ, P*, KSPAR, MICR, BIOT, MUSC, minor PYR	Granodiorite Monzodiorite P*, PYR, QTZ	Diorite, Gabbro P*, PYR, OO

***P indicates any of the plagioclase parameters: PLAG, PLAGAL, PLAGGN**

12.3 Point count parameters used in the petrographic analysis of common igneous rock types

the compositions of the petrofacies are statistically distinguishable, and to determine a set of functions that best discriminates between the petrofacies (figure 12.2, steps G to I). The methods employed are described in more detail in the section on statistics below (see also Heidke and Miksa 2000b).

An important facet of petrofacies modeling is the iterative nature of the process. A preliminary petrofacies map is developed, sand samples are collected and point counted, the quantitative data are evaluated statistically, and the petrofacies boundaries are modified and refined. Generally, it is necessary to return to the study area and collect more sand samples to further refine problem areas in the model and to verify the location of petrofacies boundaries (figure 12.2, steps E to I). Two or more iterations are necessary to develop an actualistic petrofacies model before it can be applied to pottery.

After the petrofacies model has been developed, it can be applied to characterize temper composition in pottery. It is neither desirable nor generally feasible to thin section all sherds that require temper identification. As a result, we have developed a means of using the petrographic thin-section data and the discriminant analysis results to identify compositions in loose sands and sand-tempered sherds. To do this, sands from each petrofacies are examined under a binocular stereomicroscope; the grain types found in each sample are

identified and described; and the relative abundance of each grain type is identified. The goal is to facilitate identification of sand tempers as they appear in hand sample to a ceramicist. Written descriptions of sand samples keyed to actual sand grains glued into small, labeled matchboxes are among the tools used to train ourselves in the identification of sands from each petrofacies (Miksa 1995). A flow chart is developed to help assign samples to petrofacies (Heidke and Miksa 2000a:Fig. 3.4). The flow chart is a decision-making tool that allows us to compare the grain types and relative abundances in an unknown sample with the known sands, thus leading to a petrofacies characterization. The written petrofacies descriptions and grain boxes, used in conjunction with the flow chart and loose sand samples, comprise a key for identifying compositions (figure 12.2, steps J to K). This key forms the bridge between the high-power microscopy, used to analyze thin sections, and the low-power microscopy, used to routinely identify sand temper in sherds.

Once the sand identification keys are prepared, characterization of sand tempers can begin (figure 12.2, step L). Three variables are used to characterize temper composition. Temper type is used to characterize what type of material was used as temper (sand, crushed rock, and so forth). Temper type characterizations are not dependent on geographic loca-

tion. In Shepard's (1995:xi) terms, the temper type attribute defines the general classes of tempering material.

Generic temper composition is used to characterize the geographic and tectonic origin of the temper. A given sherd is attributed to a generic temper composition based on binocular microscopic observation of the rock fragments and monomineralic grains known to define particular geographic and tectonic settings. Generic temper compositions are defined for each geographic area. For instance, in the Tonto Basin, all the granitic petrofacies are grouped together under a single "generic" attribute code, whereas the granitic petrofacies in the Tucson Basin have a different "generic" code. Tempers are designated as extrabasinal if they cannot be attributed to any of the generic temper sources available in a basin. Extrapolating from Shepard (1995:xi), the generic temper composition attribute defines a general production center. That is, we can indicate whether or not a vessel was produced in a basin and limit the parts of the basin where it could have been made.

A petrofacies attribute is used to characterize the specific provenance for the observed temper grains. A given sherd is attributed to a petrofacies based on binocular microscopic observation of the distinctive suite of rock fragments and monomineralic grains in the abundances known to define a particular petrofacies. In Shepard's terms (1995:xi), the petrofacies attribute restricts the production location of a sherd to a very limited area. Under optimal conditions (that is, very limited geologic material, and/or existence of production evidence at a site), one can identify the community where a vessel was produced.

The advantage of this system lies in the finer level of spatial resolution implied by the petrofacies. In practice, the information represented by the generic temper composition attribute is redundant with the information represented by the petrofacies attribute when the sand temper observed in a given sherd permits its assignment to a petrofacies. However, the temper grains that can be observed in small or badly burned sherds are often insufficient to categorize the petrofacies of the sand. Important compositional and limited provenance information would be lost in those cases, because their petrofacies assignments have to be recorded as "indeterminate." The tripartite system advocated here allows tempers to be assigned to petrofacies, or groups of petrofacies, without thin sectioning each sherd and without sacrificing accuracy or precision unnecessarily.

The binocular microscopic temper characterization is tested by classifying petrofacies membership of approximately 5% of the sand-tempered sherds using the discriminant functions derived from the sand samples (figure 12.2, step L.1). A stratified sample of characterized sherds is selected for point counting. The stratification process can never be truly random, since only sherds large enough to be thin sectioned (that is, ≥ 27 x 46 mm) can be included in the sample. Sand-sized material in sherds is counted using the same methods and grain types as for the sands, but a sherd-temper parameter is included as well. Once all the sherds are point counted, the data are classified as unweighted samples using the sand discriminant functions. The resulting classification quantitatively assesses the validity of temper assignments made using the binocular stereomicroscope. It also provides the means by which large numbers of sherds can be characterized in terms of temper provenance, since all sherds submitted for temper characterization need not be point counted. This aspect of petrographic analysis, emphasized by Shepard throughout her career (1936:407, 1938:205, 1939a:252, 1939b:251–252, 1942:140–141, 230, 1964:519), seems to have been lost since the introduction of chemical approaches to source determination, where samples are restricted to those characterized by the chemical technique.

As of early 2001, we have completed petrofacies models for much of central and southern Arizona (figure 12.4). More than one thousand sand samples have been collected, and more than nine hundred of them have been point counted. Thousands of sherds have been characterized to petrofacies using the binocular stereomicroscope, and hundreds have been thin sectioned and point counted to verify their petrofacies characterizations.

STATISTICAL APPROACHES: UNDERSTANDING IS A THREE-EDGED SWORD

A "key grain" approach (Dickinson and Shutler 1979:1674), one in which the provenance assignment of a sherd is based on one or more geographically restricted, easily distinguishable rock or mineral types, is a more effective approach than one based on statistical probabilities (Heidke, Miksa, and Wiley 1998). Unfortunately, the landscape is rarely divided into discrete areas that are easily identified by key grains. Thus, probabilities rooted in quantifiable compositional attributes must be used. Straczynski's (1996) epigram, "Understanding is a three-edged sword. Your side, their side, and the truth," reminds us that a petrologist's and ceramicist's approach to provenance characterization differ, although the goal of both analysts is the same: to ascertain a sherd's temper provenance truthfully. Multivariate statistical analyses of com-

12.4 Currently defined petrofacies in the Gila River watershed

positional data provide a consistent, objective perspective on provenance determination, and, thus, a means to reconcile those differences and arrive at a consensus regarding a sherd's composition and provenance.

Four types of statistical analyses have been conducted with the sand and sherd point-count data. First, correspondence analysis has been used as a method of data reduction and exploration. As a statistical tool, correspondence analysis facilitates the refinement of petrofacies boundaries and the assignment of particular sand samples to particular petrofacies (figure 12.2, step G). Second, discriminant analysis has been

used to demonstrate that petrofacies' compositions are statistically distinguishable from one another and to determine sets of functions that best discriminate between petrofacies (figure 12.2, step H). Third, functions derived from discriminant analyses of sand data have been used to predict the petrofacies membership of point-counted, sand-tempered sherds (figure 12.2, step L.1). Finally, multiple linear regression mixture modeling has been employed to assess the composition of a sherd's sand temper when there is reason to believe that it represents a mixture of sands from multiple petrofacies.

Correspondence analysis

Correspondence analysis is a technique for the display of rows and columns of a two-way contingency table as points in a low-dimensional vector space (Carr 1990). The geometry of the rows, which represent individual sand samples, is related to the geometry of the columns, which represent the point-count parameters, resulting in a "correspondence" between the rows and columns (Greenacre 1984). The technique employed by correspondence analysis is purely deterministic (Ringrose 1992); it provides little indication of the strength of any apparent relationships. Many authors (Baxter 1991, Escoufier and Junca 1986) emphasize the exploratory, as opposed to confirmatory (Lewis 1986), nature of its results for that reason. Melguen (1974) first recognized the usefulness of correspondence analysis as a tool for recognizing and characterizing sedimentary facies. We have used it for these tasks since the late 1980s (Heidke 1989; Heidke, Kamilli, and Miksa 1996; Heidke and Miksa 2000b; M.T. Stark and Heidke 1992).

There are two primary reasons for the use of correspondence analysis as a method of data reduction and exploration: The technique assumes that all values in the matrix are positive (zeros are acceptable), and it assumes that all row and column totals are greater than zero (Hill 1979:10; Weller and Romney 1990:72). These are important assumptions when a data set contains point-counted compositional data gathered from sands that are derived from an extremely heterogeneous set of source rocks. Many of the grain types recorded in our petrographic studies are not present in sands collected from all parts of a basin. This type of fundamental between-sample compositional variability, necessary to actualistic petrofacies model building, represents one of the greatest differences separating the analytical requirements of petrologic data from those of chemical characterization studies. In chemical studies, there is an expectation that all elements recorded are present in all samples; usually only the relative concentrations of elements and compounds exhibit variation between samples.

Discriminant analysis

Discriminant analysis is a statistical technique designed to study differences between two or more groups of objects with respect to several variables (Klecka 1980). The compositional data are grouped by petrofacies. Individual sand and sherd samples are the objects, and point-count parameters are the variables. Discriminant analysis provides a means to define actualistic petrofacies (Ingersoll 1990:733). It also provides a means to evaluate the degree of intrapetrofacies

compositional variability present in a basin, a concern expressed by Lindauer (1992:278). In addition, functions derived from discriminant analyses of sand point-count data can be used to *predict* the petrofacies membership of point-counted, sand-tempered sherds. This use of discriminant analysis provides a rigorous test statistic to evaluate a sherd's assignment to a given petrofacies, a concern expressed by Cable (1989:8). The point-count data for the sherds are included as "ungrouped" or "unclassified" samples during the discriminant analysis. By doing so, the sand discriminant functions provide a means to assign (classify) each sherd's temper composition to the group (petrofacies) it most closely resembles. This procedure represents a major departure from the way that discriminant analysis has been used in studies of paste chemistry (Arnold, Neff, and Bishop 1991; Rands and Bishop 1980; Stoltman, Burton, and Haas 1992). In those studies, discriminant analysis is used to define compositional groups on the basis of the ceramics included in the study, not the source materials.

We apply a log-ratio transformation to the sand and sand temper point-count data prior to entering it in a discriminant analysis. This transformation is recommended by Richard and Clark (1989), Ingersoll (1990), and Weltje et al. (1996) because it removes constant-sum and nonnegativity constraints from the proportional (point-count) data. Log ratios are unconstrained variables of the form $\ln(x/y)$, where x and y represent two components of the same composition (Weltje et al. 1996:126). Following Aitchison's (1986:268–269) recommendation, all zero values for x are replaced with positive values smaller than the smallest recordable value; 0.5 is generally used to replace all zero values prior to calculating logratios. Discriminant analysis of log-ratio transformed data has been used to demonstrate that petrofacies compositions are statistically distinguishable and to predict petrofacies membership of point-counted sherds (Heidke, Kamilli, and Miksa 1996; Heidke and Miksa 2000b; M.T. Stark and Heidke 1992).

Mixture modeling

Multiple linear regression mixture modeling is a technique for decomposing the effects of a mixture of independent variables on a dependent variable. It differs from ordinary regression models because the independent variables sum to a constant value (Wilkinson 1990:178). Barceló, Pawlowsky, and Grunsky (1995:137) provide a succinct description of this technique:

Finite mixture models can be used when the observations available can be viewed as arising from a superpopulation G which is a mixture of a finite number c of subpopulations $G_1,...,G_c$ in some proportions $\pi_1,...,\pi_c$ which satisfy the conditions $\pi_1 > 0$ and $\pi_1 + ... + \pi_c = 1$.

We have used this technique only once (Heidke, Miksa, and Wiley 1998). In that case, "key grain" compositional evidence indicated that a discriminant model's predicted petrofacies membership for a sherd was in error. We suspected that sands from two or more petrofacies contributed to the sand temper in the sherd. However, we were unable to include sands from the most likely source for the temper—the West Branch of the Santa Cruz River—in the discriminant analysis for two reasons. First, recent construction activity and other urban impacts made sampling nearly impossible. Second, the West Branch of the Santa Cruz River is a higher order landscape element than the small drainages we generally sample.

Fortunately, mixture modeling is an appropriate method to use in such a situation when the scale of the landscape elements is considered. Ingersoll, Kretchmer, and Valles (1993) present a method for arranging petrofacies into a three-order hierarchy, where lower order elements (talus piles, alluvial fans, and local drainages) feed into higher order elements (streams and rivers). Sands from first-order landscape elements, those that come from single rock types or that locally mix rock types, are used to construct petrofacies models. Unfortunately, the West Branch of the Santa Cruz River is a minor trunk stream that combines sands from these first-order landscape elements, so it should not be included with the lower order samples in an analysis. The multiple linear regression mixture modeling technique apportioned the sherd point-count data into petrofacies that contribute to the West Branch of the Santa Cruz River, and the solution confirmed our hypothesis that the temper sand was collected from that trunk stream.

RESEARCH ORIENTATION:
TIME, SPACE, AND THE POTTER'S CRAFT

All research described here has resulted from cultural resource management projects carried out by Desert Archaeology, Inc. (DAI), formerly the Institute for American Research, Arizona Division. Attention has been focused on diagnostic sherds, that is, all decorated pottery and undecorated rim sherds and reconstructible vessels recovered from well-dated contexts. DAI's ceramic analyses are structured in terms of the operational tasks involved in the production sequence of handmade pottery (Rye 1981). Material correlates of multiple production tasks are recorded, including raw material procurement attributes; forming, finishing, and decorative attributes; and firing and postfiring attributes. This attribute data can be used to develop technological profiles (Costin and Hagstrum 1995) and compare relative labor costs (Feinman, Upham, and Lightfoot 1981) of different kinds of pottery. The production-sequence approach also yields data essential for evaluating the technological style of prehistoric artisans (Gosselain 1992; Lechtman 1977; Lemonnier 1993). Therefore, unlike the other studies included in this volume, provenance characterization is not the "basic purpose" (chapter 1) of the petrographic studies reported here. Rather, the potter's choice to temper, the type of tempering material chosen (sand, rock, sherd, and so forth), and the provenance of sand tempers (petrofacies) are attributes recorded in order to characterize *some* aspects of a pot's production sequence and the potter's technological style. While these three attributes characterize provenance, they also reflect cultural influences on the craft's evolution.

Raw material procurement attributes

The manufacture of pottery begins with the collection of raw materials, primarily water, clay, temper (if added), and fuel (Crown and Wills 1995:247; Rye 1981:29). Material procurement attributes recorded in DAI's ceramic studies have been limited to aspects of the temper, which provide evidence regarding production technology (temper type) and resource provenance (generic temper composition and petrofacies). The three temper attributes are recorded after a sherd is examined at 10 to 15x magnification, using a Unitron ZSM binocular microscope fitted with a Stocker and Yale Lite Mite Series 9 circular fluorescent illuminator. The modal size of nonplastic grains is recorded after comparing the sand grains in a vessel's body against reference samples mounted on a W.F. McCollough "sand-gauge."

Intrabasinal production is inferred when sherds tempered with compositions available in a basin are recovered from sites located in the basin. Local production is inferred when a sherd's sand-temper composition is the same as that of the petrofacies in which the sherd was recovered. This simple definition of a "local" resource is derived from ethnographic cases. Building on Arnold's (1985) survey of the ethnographic literature on distance to temper resources, the relationship between a type of tempering material (sand) and the distance traditional potters travel to collect it (table 12.2) was examined. Seventy-three percent of the pottery-making groups for

Table 12.2 Distance to sand-temper resource measurements summarized from ethnographic sources.

Community/Group	Location	Distance (km)[a]	Primary source	Type[b]
Acatlán	Mexico	<1.00	Foster 1960: 208[c]	T
Aguacatenango	Mexico	.04	Deal 1998: 39	T
San Isidro	Mexico	1.50	Arnold 1991: Table 5	T
El Porvenir	Honduras	<1.00	Mouat and Arnold 1988: 248	T
Aco	Peru	2.50	Hagstrum 1989: 195	T
Dodowa	Ghana	<1.00	Quarcoo and Johnson 1968: 50, 56	TM
Taourirt	Morocco	.01	Beckett 1958: 187	ET
Dangwara	India	.01	Miller 1985: 212	ET
Dïr	Pakistan	1.50	Rye and Evans 1976: 20	T
Swat	Pakistan	2.00	Rye and Evans 1976: 28[c]	T
Dusun	Borneo	<1.00	Alman 1959: 567	T
Mammala	Indonesia	<1.00	Spriggs and Miller 1979: Tab. 1, Fig. 10	TM
Morella	Indonesia	<1.00	Spriggs and Miller 1979: Tab. 1, Fig. 10	TM
Canramos	Philippines	.01	Maye 1967: 200	T
San Nicolas	Philippines	<1.00	Longacre et al. 2000: 274	T

[a] Distance of the sand-temper resource from a pottery-making community. Statements that indicate a source of temper in or very near the potter's home (e.g., in the courtyard or behind the house) were assigned a value that is less than 1 km. If a distance was not mentioned in a primary source but a description included a place name for the source and a map indicating its location, the distance from the community was measured using a straight-line (or geodesic) distance. If a settlement is nucleated, the distance was measured from its center.

[b] This column refers to the type of information source that the distance measurement was obtained from. "T" is a distance mentioned in a text, "M" represents a distance measured from a map, and "E" represents a distance estimated from information provided in a text.

[c] Included in Arnold's (1985: Table 2.2) study.

which there is data travel no more than 1 km to collect temper sands, and the furthest distance recorded is 2.5 km. Thus, any sand-tempered pottery with a composition similar to that available in washes located within 2.5 km of the archaeological site from which the sherd was recovered should, in a behavioral sense, be considered the product of "local" manufacture because some potters travel that far to collect temper sands. However, the ethnographic evidence also suggests that compatibility between a sherd's sand-temper composition and that of wash sands located within 1 km of its recovery site may be a better measure of "local" production. Sand-tempered pottery displaying compositions that are not available within 2.5 km of a site are best considered nonlocal items.

Forming, finishing, and decorative attributes

Rye (1981:62) distinguishes three main stages of vessel forming: primary forming, secondary forming, and surface modification. During primary forming the prepared clay body is manipulated into a form that resembles the finished vessel (Rye 1981:62). A vessel-shape attribute is used to characterize each diagnostic sherd's primary form (bowl, jar, scoop, and so on). During secondary forming, the shape of a vessel is further refined and the final, relative proportions of the pot are established (Rye 1981:62). In DAI studies, a vessel-form attribute is used to characterize a diagnostic sherd's final pro-

portions, while vessel wall thickness, orifice diameter, and aperture diameter measurements provide quantitative data on those proportions. The final shape of a vessel's lip is characterized by a rim-shape attribute. Surface modifications considered part of the forming sequence include polishing, scraping, smoothing, incising, impressing, and carving (Rye 1981:62). Interior and exterior surface treatment attributes are used to qualitatively characterize those aspects of vessel forming and decoration. The orientation of polishing facets and the color, depth, and location of red slips are attributes used to characterize variability in red wares. Design layout and motif attributes are used to characterize variability in painted wares.

Firing attributes

The purpose of firing is to subject the formed vessel to sufficient heat for a sufficient time that the complete destruction of the clay mineral crystals is assured and that the vessel exhibits the required hardness, porosity, and thermal shock resistance characteristics required of it (Rye 1981:96). Core color and fire clouding are recorded in DAI studies; they are qualitative measures of the firing atmosphere and temperature (Rice 1987:343–345, 476; Rye 1981:114–118).

Technological style

A potter's technological style is reflected in the attribute data.

Technological styles are, in Lechtman's words, "renderings of appropriate technological behavior communicated through performance" (1977:14). They reflect "different ways of doing the same thing" (Lemonnier 1983:17, quoted in Gosselain 1992:560). With regard to pottery manufacture, technological style refers to the *actual* choices a potter made during vessel fabrication, even when other choices were possible. As Gosselain (1992:580) states, "although there are many viable options, the artisan is only familiar with a small number, and this situation governs each step of decision making." The technological style of a prehistoric potter's culture affected her choice of tempering material and primary and secondary forming techniques. Those choices are reflected in the ceramic ware, temper composition, and vessel shape, form and size attributes.

Dating issues

In our role as archaeologists, we are interested in ideas regarding the social and cultural context of ceramic containers. However, we must first determine when the pottery was made. We do that by identifying ceramic collections from trash deposits and intact floor assemblages that lack evidence of temporal or behavioral mixing. All diagnostic sherds recovered from a feature are laid out at one time in the order of the feature's excavated strata and levels, along with any subfeatures present, such as hearths, postholes, and storage pits. In addition, all diagnostic sherds from a site are laid out at the same time whenever possible.

By laying out all the diagnostic sherds from a feature at one time, we are able to assess quickly whether or not the collection is temporally mixed, and see whether pieces of a pot have been recovered from more than one vertical or horizontal excavation unit. This procedure yields reasonably accurate estimates of the minimum number of (diagnostic) vessels present in a deposit. It also allows us to judge whether a deposit may have filled slowly, with just one diagnostic sherd from each pot represented and a relatively smaller average sherd size, or rapidly, with many pieces of just a few pots represented and a relatively larger average sherd size. Furthermore, by laying out all the diagnostic pottery from a site at one time, we are able to see whether pieces of a pot were recovered from more than one deposit. This allows us to assess which features, and more specifically which strata and levels of features, may have been collecting trash at the same time.

CERAMIC PRODUCTION AND DISTRIBUTION IN THE TUCSON BASIN

At this point we turn our attention to pottery production and exchange in the Tucson Basin local system during the Sedentary (circa AD 950–1150) and Classic periods (circa AD 1150–1450). Data summarized here comes from fifty-one sites located throughout the Tucson Basin and its western neighbor, the Avra Valley, both of which are included in the greater Tucson Basin petrofacies model (figure 12.5). Physiographic descriptions of both basins are presented below, but the petrofacies model and its corresponding Hohokam local system will be referred to as the "Tucson Basin."

The physiographic situations of the Tucson Basin and Avra Valley are ideal for the petrographic study of sand temper. Located in the Basin and Range province of the Southern Arizona Desert (Chronic 1983), these two basins are downfaulted sediment-filled troughs. The Tucson Basin is bounded by the Tortolita-Santa Catalina-Rincon mountain complex to the northwest, north, and east; the Tucson Mountains to the west; the Sierrita Mountains to the southwest; and the Santa Rita Mountains to the southeast. The Avra Valley is bounded by the Tucson Mountains on the east, the Sierrita Mountains on the south, and the Roskruge, Waterman, and Silverbell mountains on the west.

The rocks comprising the Tortolita, Santa Catalina, and Rincon mountains are dominated by granites and gneisses, although isolated volcanic rocks occur at the extreme northwestern edge of the Tortolita Mountains, and schist and sedimentary rocks occur on the eastern flanks of the Santa Catalina and Rincon mountains (Bykerk-Kaufman 1990; Dickinson 1992). The Tucson Mountains comprise a volcanic rock complex, with limited exposures of granitic rocks and a cover of sedimentary rocks on the western side (Lipman 1993). The Sierrita Mountains are extremely complex (Cooper 1960, 1971); however, the north flank of the Sierrita Mountains is predominantly granitic with limited volcanic and sedimentary rocks. Quartz and feldspars from the granitic rocks are the primary grain types carried into both the Tucson Basin and the Avra Valley from the Sierrita Mountains. The Santa Rita Mountains also comprise a complex mixture of rock types (Drewes 1972); they contribute granitic, volcanic, and sedimentary rocks to the Tucson Basin. The Roskruge, Waterman, and Silverbell Mountains are volcanic and sedimentary complexes with minor plutonic outcrops, much like the Tucson Mountains in a general sense (Bikerman 1967; Keith 1976; McClymonds 1957; Peterson 1990); however, each range comprises distinctive volcanic rock types that

12.5 Current Tucson
Basin petrofacies
map

A	Rincon	J1	Beehive
B	Catalina	J2	Twin Hills
C	Samaniego	J3	Wasson
D	Avra	K	Black Mountain
E	Tortolita	L	Golden Gate
F	Durham	M	Rillito
G	Santa Rita	MW	Rillito West
H	University	N	Owl Head
I	Empire	O	Sierrita
		P	Hughes
		Q	Amole
		R	Batamote
		S	Sutherland
		T	Recortado
		U	Cocoraque
		V	Dos Titos
		W	Waterman
		Y	Roskruge
		Z	Sahuarita

KEY

Miles
0 5 10

Kilometers
0 5 10 15 20

Unsampled

Petrofacies boundary and designation

Provisional petrofacies boundary

are readily distinguished from one another, even as sand or sand temper. Sands originating from all of the mountain ranges surrounding the Tucson Basin and Avra Valley are very distinct; thus, the sands derived from the granite and gneiss of the Tortolita–Santa Catalina–Rincon mountain complex are easily distinguished from those originating from the many types of volcanic rocks of the Tucson, Roskruge, Waterman, and Silverbell mountains, the mixed rocks of the Santa Rita Mountains, or the microcline-rich granitic rocks of the Sierrita Mountains.

Currently, thirty-six petrofacies are defined for the greater Tucson Basin, based on the analysis of 291 point-counted

sand samples (table 12.3). Although the Tucson Basin is the area where temper resource compositions were first modeled (Lombard 1987b), areas such as the Tonto Basin and lower Verde River area are now better understood (Heidke and Miksa 2000a; Heidke, Kamilli, and Miksa 1996). Discriminant analyses have been conducted on an ad hoc basis in order to answer specific research questions, but no basin-wide discriminant analysis model has been developed for the Tucson area.

Sedentary and Classic Period Ceramic Production in the Beehive Petrofacies

The Tucson Basin petrofacies model permits questions re-

garding ceramic production and distribution to be addressed. Foremost among those is the changing nature of ceramic production in the Beehive Petrofacies over time. Pottery tempered with Beehive Petrofacies sand has been documented in virtually every ceramic collection from the Tucson Basin so far examined. It is identified in pottery by the presence of distinctive sand-sized, multicolored, irregular, subangular felsite fragments with attached biotite derived from the Tuff of Beehive Peak (Lipman 1993). Pottery production began in the Beehive Petrofacies by the Agua Caliente phase, circa AD 150 to 550 (Heidke, Miksa, and Wiley 1998). Thus, a tradition of ceramic manufacture at settlements located in the southern Tucson Mountains started by the time that a domestic, utilitarian ceramic container technology was adopted by the basin's residents. Other ceramic studies have shown that pottery continued to be produced in the Beehive Petrofacies from the Tortolita phase, circa AD 550 to 650/700, through the protohistoric period, circa AD 1450 to 1700 (Heidke 1990, 1993a, 1996c; Thiel and Faught 1995).

Settlement in the Beehive Petrofacies was clearly established by the Colonial period (circa AD 750–950), with occupation centered on the Dakota Wash site (Craig 1989). In the Sedentary period, circa AD 950 to 1150, the main occupation moved slightly northward to the West Branch site (Huntington 1986). However, during the Classic period (circa AD 1150–1450), occupation again centered on the Dakota Wash site (Craig 1988), as well as the nearby site known as Salida del Sol (Douglas 1991). One type of quantitative information regarding the nature of ceramic production that occurred at those sites prehistorically is the percentage of pottery made at them that has been recovered from other sites in the basin. Currently, this type of quantitative information is available only for the Sedentary and Classic periods, because distributional data for the Pioneer period is inadequate (too few sites in our database) and Colonial period pottery was frequently tempered with crushed schist and/or gneiss rather than sand. Figure 12.6 summarizes temporal and ware-related variability in the relative frequency of pottery produced in the Beehive Petrofacies and recovered from Early Rincon (circa AD 950–1000), Middle Rincon (circa AD 1000–1100), Late Rincon (circa AD 1100–1150), Tanque Verde (circa AD 1150–1350), and Tucson (circa AD 1350–1450) phase sites located throughout the basin.

Provenance data from eighty-nine discrete data sets are summarized in figure 12.6. The median sample size of the plain-ware, red-on-brown, and red-ware data sets is thirty-three sherds (range 11–1,073, n=71 data sets), while the medi-

Table 12.3 Map symbol, generic composition, petrofacies name, and number of point counted samples included in the current Tucson Basin model

Symbol	Petrofacies	Samples
Granitic sand sources		
3	Cañada del Oro	7
E	Tortolita	35
O	Sierrita	16
Q	Amole	5
S	Sutherland	12
Granitic and mixed lithic (volcanic, metamorphic, and sedimentary) sand sources		
1	Santa Cruz River	13
2	Brawley Wash	25
6	McClellan Wash	2
F	Durham	4
G	Santa Rita	7
H	University	11
K	Black Mountain	5
P	Hughes	5
Z	Sahuarita	4
Metamorphic core complex sand sources		
4	Rillito Creek	3
5	Pantano Wash	4
8	Tanque Verde Creek	5
A	Rincon	6
B	Catalina	10
N	Owl Head	5
Mixed volcanic and granitic sand sources		
7	West Branch of the Santa Cruz River	1
C	Samaniego	5
M	Rillito	14
MW	Rillito West	4
U	Cocoraque	3
Volcanic sand sources		
D	Avra	6
I	Empire	8
J1	Beehive	8
J2	Twin Hills	9
J3	Wasson	5
L	Golden Gate	15
R	Batamote	5
T	Recortado	9
W	Waterman	7
Y	Roskruge	3
Other metamorphic sand source		
V	Dos Titos	5

an sample size of each polychrome data set is three sherds (range 1–50, n=18 data sets). Altogether, temper characterization data recorded from 5,535 sherds are represented in the figure; 264 of those sherds have been point-counted. Additional information regarding the data sets included in figure 12.6 is reported elsewhere.[1] Temper characterization data recorded from 390 Middle Rincon Red-on-brown sherds re-

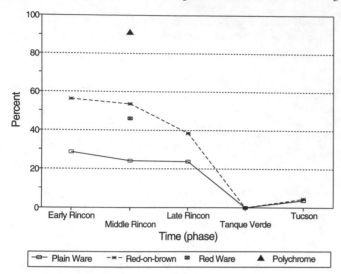

12.6 Median percent Beehive Petrofacies pottery recovered from Sedentary period (Early, Middle, and Late Rincon phase) and Classic period (Tanque Verde and Tucson phase) sites located outside of the petrofacies

12.7 Distance-decay functions of Middle Rincon Red-on-Brown pottery produced at the West Branch site and St. Mary's Hospital Ruin. All distance measurements between sites located to the east of the Tucson Mountains are geodesic, or straight line; distance measurements between sites located on both sides of the Tucson Mountains used gaps and passes to cross the mountains but are otherwise geodesic. The percentage produced at the West Branch site is indicated by an asterisk; the percentage produced at the St. Mary's Hospital Ruin is indicated by a solid diamond

covered from the West Branch site are not included in figure 12.6 (since that figure summarizes data from sites outside of the Beehive Petrofacies), though their provenance data will be drawn upon later in this chapter (figure 12.7).

The strongest trend expressed in figure 12.6 is the decrease over time in the amount of plain ware and red-on-brown pottery produced at sites located in the Beehive Petrofacies and recovered from sites located outside of it. In each of the three Sedentary period Rincon phases, a greater percentage of the red-on-brown pottery was produced in the West Branch community relative to the plain-ware pottery. In the Middle Rincon phase almost half of the red ware and more than 90% of the polychrome ceramics were produced in the West Branch community. The ceramic production and distribution evidence indicate that West Branch potters were specialists in the production of red-on-brown, red-ware, and polychrome vessels. Following Costin's (1991:8) typology for the organization of specialist production, the evidence suggests "community specialization." That is, "autonomous individual or household-based production units, aggregated within a single community, producing for unrestricted regional consumption" (Costin 1991:8).

Estimating annual ceramic production rates for West Branch community courtyard groups

The 1984 excavation at the West Branch site produced abundant evidence for ceramic production there. Huntington (1986:369–371) demonstrated that at least one house in each courtyard group contained pottery manufacturing tools, and many also contained raw materials necessary for ceramic production. Heidke (1996c) proposed a method for estimating the number of vessels produced annually in each of the West Branch community's courtyard groups. Estimates were calculated using the three components necessary for the reconstruction of any economic system: production, distribution, and consumption (Costin 1991:1). The calculation required an estimate of the number of contemporaneous houses in the basin, an estimate of the quantity of each ware that each house received from West Branch, an estimate of the replacement rate of those wares at those sites, and an estimate of the number of contemporaneous courtyard groups in the West Branch community. Equations 1 to 4 show how the model was developed mathematically:

[Equation 1] Number of contemporary houses in the Tucson Basin = ((Population estimate for Tucson Basin ÷ Average number of occupants per courtyard

group) x Average number of houses per courtyard group)

[Equation 2] Average number of pots produced in the West Branch community replaced annually by the inhabitants of a house at another site = (Number of plain ware p-ts replaced per house per year x Median West Branch plain ware %) + (Number of red-on-brown pots replaced per house per year x Median West Branch red-on-brown %) + (Number of red-ware pots replaced per house per year x Median West Branch red ware %) + (Number of polychrome pots replaced per house per year x Median West Branch polychrome %)

[Equation 3] Number of contemporary courtyard groups at West Branch = (Mapped area of site x Correction factor for inhabited portion of mapped areas) ÷ Average area of a West Branch courtyard group

[Equation 4] Number of pots produced in each West Branch courtyard group per year = (Equation 1 x Equation 2) ÷ Equation 3

Estimates focused on the Middle Rincon phase because ceramic replacement rate data have been calculated for a Middle Rincon occupation (H.D. Wallace and Heidke 1986) and rigorously evaluated using three alternative methods (H.D. Wallace et al. 1991), and because population estimates were available for that span of time (Doelle 1995). Since the procedures used to implement each equation are described in detail elsewhere (Heidke 1996c), they are not duplicated here. It is sufficient to note that estimating the number of vessels produced in each courtyard group followed a process of mathematical exploration that yielded imprecise results intentionally. The goal was to calculate a range of plausible values, not a single number. Minimum and maximum values were calculated using different starting assumptions regarding the average number of people inhabiting a courtyard group, the average number of houses in a courtyard group, and the number of vessels replaced by the inhabitants of each house annually (table 12.4). Because the method makes each step in the overall estimate explicit, any given value can be replaced easily and the estimate recalculated. Here the "inputs" have been refined using data that were not available previously. The revised estimate is comparable to the earlier one. The current estimate is that 26 to 165 pots were produced in each West Branch courtyard group annually during the Middle Rincon phase; this range is similar to the 30 to 182 vessel range reported previously (Heidke 1996c).

Is the estimated range of 26 to 165 pots manufactured per West Branch courtyard group per year realistic? A preliminary review of the ethnographic and ethnoarchaeological literature suggests that it is. Ethnographic data from five communities of traditional potters that hand build pottery for their own use and trade are available for comparative purposes (Allen 1984:422; Graves 1991:Table 6.5 and 6.9; Lauer 1974:158; Specht 1972:128, 135; M.T. Stark 1993).[2] The annual production rate of those potters ranges from 0.2 to 377 pots per year, with a median rate of forty and a mean rate of approximately seventy vessels annually. Clearly, the West Branch estimate of 26 to 165 pots falls nicely within the 0.2- to 377-pot range documented in the ethnographic studies.

The annual production rate figures drawn from ethnological sources also provide an interesting perspective with which to examine Rincon Polychrome production. Rincon Polychrome was produced in the Tucson area from approximately AD 1040 to 1100. The polychrome vessels were created by applying black-and-white painted designs onto polished, red-slipped bowls and jars (Greenleaf 1975). The painted designs reveal a close relationship between Rincon Polychrome and the contemporary red-on-brown type, Middle Rincon Red-on-brown. Design elements and most layouts are similar or identical in the two types (H.D. Wallace 1986). Based on the technological characteristics reviewed above, H.D. Wallace and Heidke (1986:240) hypothesized that Rincon Polychrome was produced by a limited set of interacting potters. Certainly more than one or two potters were involved, but, they reasoned, the overall number probably was not large (H.D. Wallace and Heidke 1986:268). Using data reported in table 12.4, we estimate that 54 to 234 Rincon Polychrome vessels were produced in the West Branch community each year. That amount could have been produced by a limited set of potters working part-time.

Spatial and temporal variability in the ceramic-distribution system

Another type of quantitative information that helps us to understand the nature of ceramic production and distribution in Middle Rincon times is the distance between manufacturing and consuming sites. As noted by Costin (1991:41), when large regions are considered in a study of production, it is often possible to determine whether different parts of the region were served by different production and distribution systems. This approach involves identification of regional variants of a good, defined through compositional analysis. Figure 12.7 compares the regional distribution of a single

Table 12.4. Procedure and data used to estimate the number of vessels produced annually in each of the West Branch community's courtyard groups

	Minimum Estimate	Maximum Estimate
Equation 1		
a. Population estimate for the Tucson Basin	3,500	3,500
b. Average number of occupants per courtyard group	8	5
c. Number of contemporary courtyard groups (a ÷ b)	437.5	700.0
d. Average number of houses per courtyard group	1.5	2.0
e. Number of contemporary houses in the Tucson Basin (c x d)	656	1,400
Equation 2		
f. Number of plain ware pots replaced per house per year	3.7	10.9
g. Median proportion West Branch plain ware	0.242	0.242
h. Average number of West Branch plain ware pots replaced per house per year	0.895	2.638
i. Number of red-on-brown pots replaced per house per year	2.5	7.6
j. Median proportion West Branch red-on-brown	0.534	0.534
k. Average number of West Branch red-on-brown pots replaced per house per year	1.335	4.058
l. Number of red ware pots replaced per house per year	0.4	0.9
m. Median proportion West Branch red ware	0.460	0.460
n. Average number of West Branch red ware pots replaced per house per year	0.184	0.414
o. Number of polychrome pots replaced per house per year	0.1	0.2
p. Median proportion West Branch polychrome	0.913	0.913
q. Average number of West Branch polychrome pots replaced per house per year	0.091	0.183
r. Average number of pots produced in the West Branch community annually replaced by the inhabitants of a house at another site (h + k + n + q)	2.505	7.293
Equation 3		
s. Mapped area of West Branch site, in m²	286,200	286,200
t. Correction factor for inhabited portion of mapped area	0.2725	0.2725
u. Corrected area of West Branch site, in m² (s x t)	77,989.5	77,989.5
v. Average area of West Branch courtyard group, in m²	1,258.5	1,258.5
w. Number of contemporary courtyard groups at West Branch (u ÷ v)	62	62
Equation 4		
Number of pots produced in each West Branch courtyard group annually ((e x r) ÷ w)	26.504	164.681

type–Middle Rincon Red-on-brown–produced at two locations: the West Branch community, located in the Beehive Petrofacies, and the St. Mary's Hospital Ruin, located in the Twin Hills Petrofacies. The St. Mary's Hospital Ruin provenance is identified in pottery by the presence of distinctive sand-sized, buff-colored, rounded volcanic rock fragments with tiny, black mineral crystals derived from Twin Hills Dacite (Lipman 1993).

It is clear that the two patterns are quite different. The amount of Middle Rincon Red-on-brown pottery produced in the West Branch community that has been recovered from most sites is similar, regardless of their distance from West Branch. In contrast to the West Branch pattern, the amount of Middle Rincon Red-on-brown produced at the St. Mary's Hospital Ruin decreases rapidly the farther away from that settlement the recovery site is located. Furthermore, based on Hodder and Orton's (1976) simulations, the type of "smooth" falloff curve exhibited by the St. Mary's Hospital Ruin data is characteristic of reciprocal-exchange relationships (Hodder

and Orton 1976:146), whereas the West Branch curve's "plateau" and "secondary peak" (at the Hodges Ruin, a point addressed further below) are characteristic of redistributive-exchange relationships (Hodder and Orton 1976:146–153).

Reciprocal exchange involves the transfer of goods between individuals or groups of the same status, and can frequently be regarded as an expression of the social obligations between the parties (Champion 1980:107). Relatively small numbers of goods are produced or acquired, and economic relationships are closely tied up with kinship, neighborhood, religious, and political contacts (Hodder and Orton 1976:66). Redistributive exchange, in contrast, presupposes the existence of a central authority and marked differences in social ranking (Champion 1980:107–108). But, as Wilcox (1991b:269) has observed, if there were significant differences in status among pre-Classic Hohokam individuals, they have yet to be documented in the archaeological record.

How then are we to explain the differences in the types of

exchange relationships suggested by the shapes of the two falloff curves? An aspect of ceremonial exchange may provide the answer: ceramic exchange facilitated by the establishment of Hohokam ballcourts (Wilcox 1991c). Hohokam ballcourts are elliptical mounds where a version of the Mesoamerican ball game is believed to have been played (Gladwin et al. 1975; Wilcox and Sternberg 1983). They co-occur with a complex of traits, including a unique mortuary ritual and a distinctive iconography present on ceramic, stone, and shell artifacts. These traits are perceived as the markers of a new ideology or religion (Doyel 1991; H.D. Wallace 1995b; H.D. Wallace, Heidke, and Doelle 1995; Wilcox 1991a). The ball-game itself may have been a social mechanism to adjudicate the new realities of exchange flows in southern Arizona following the success of irrigation agriculture and resulting population increases (Wilcox 1991c:123). Hohokam peoples living in individual settlements were not wholly autonomous (Wilcox 1987:160); they depended on people in other settlements for spouses, goods, and information (Wilcox 1991b:263). A ceremonial exchange system would have provided a way to transport large quantities of goods in a short period of time and supplemented exchanges contingent on kinship connections (that is, reciprocal exchange).

Formalization of the ballgame and the construction of large, conspicuous ballcourts at fixed locations apparently helped to bring such a system of ceremonial exchange into existence by the early Colonial period (Wilcox 1991c:123–124). Furthermore, data on ballcourt distributions and orientations indicate a horizontal and vertical complexity of functions among settlements in a local system (Wilcox 1991b:261), and craft specialization, such as that documented in the work of the West Branch community's potters (Heidke 1996b, 1999), implies a specific kind of horizontal social complexity that is often apparent during and after the emergence of more vertically complex societies (Wilcox 1991b:258). The calendrical aspect of the ballcourt system suggested by Wilcox (1987, 1991c) may have fostered the development of ceramic specialization since ceremonies associated with ballcourts would have drawn people to specific settlements at specific times and, thus, provided known and reliable locations for exchange.

The secondary peak in the percentage of Middle Rincon Red-on-brown pottery produced at West Branch and recovered from the Hodges Ruin suggests that the Hodges Ruin was a center for the redistribution of pottery made at West Branch. The importance of the Hodges Ruin in the Tucson Basin's local system is attested to by the fact that its ballcourt

shares the same orientation as Ballcourt 1 at Snaketown, an orientation shared with only two other sites in the Hohokam regional system (see Wilcox 1991c:120–121). Its position near the confluence of the Santa Cruz River and Rillito Creek would have facilitated the redistribution of pottery (produced at the West Branch site) into the eastern basin, following the natural corridor formed by Rillito Creek.

Settlements in the eastern basin likely supplied West Branch potters with gneiss and/or schist. Those micaceous rocks are not found in Beehive Petrofacies sands or in the nearby bedrock. The closest sources for those rocks lie in the Santa Catalina and Rincon mountains, some 22 to 31 km north and east of the West Branch community. Gneiss and/or schist were materials favored by Colonial and Sedentary period potters as a tempering agent, and were used alone or mixed with sand. For example, Huntington (1986:361–362) describes a deposit of gneiss found in association with potter's tools on the floor of a Middle Rincon pithouse at the Wyoming Street Locus of the West Branch site.

By AD 1100, the regional ballcourt network had disintegrated (Wilcox 1991b:272) and, by AD 1150, vast changes had occurred in regional systems throughout the North American Southwest and northern Mexico (Wilcox 1986:143). In the Tucson Basin, ballcourts were probably no longer built or used after Middle Rincon times, circa AD 1100 (Doelle and H. Wallace 1991:321). A marked reduction in the technological decision to use crushed gneiss/schist temper occurred sometime between AD 1040 and 1100 (Heidke 1996a: Table 3.9). Perhaps access to gneiss/schist became more difficult for potters in the West Branch community after the demise of the ballcourt system and/or the "meaning" associated with these micaceous tempers was abandoned along with the ballcourt system (Deaver 1984:398; Heidke 1989:113).

Reduction in the basin-wide distribution of pottery produced at sites located in the Beehive Petrofacies over time is, therefore, presumed to be a local expression of the ballcourt system's abandonment as well as the panregional restructuring of exchange systems that occurred at about the same time. By the Classic period the amount of pottery produced at sites in the Beehive Petrofacies and distributed widely throughout the basin had dropped precipitously, but it appears that the residents of nearby sites still received a large percentage of their ceramics from potters residing in that area. For example, the San Xavier Bridge site is located approximately 5.8 km south of the Dakota Wash site, and 56% of the point-counted Tanque Verde Red-on-brown sherds recovered from that site were tempered with Beehive Petrofa-

cies sands (Lombard 1987a: Table 20.3). At the same time, the northern Tucson Basin sites discussed by Harry et al. (chapter 8) received virtually no Tanque Verde Red-on-brown produced in the Beehive Petrofacies.

CERAMIC PRODUCTION AND DISTRIBUTION IN THE TONTO BASIN

The Tonto Basin is a narrow structural valley located in the mountainous "Transition Zone" of central Arizona, an 80 km wide band along the base of the Mogollon Rim and Colorado Plateau that separates the plateau to the north from the Basin and Range province of the southern deserts (Chronic 1983). It is bounded by the Mazatzal Mountains on the west, the Sierra Ancha Mountains on the east, and Two Bar Ridge and the Salt River Mountains on the south. A variety of plutonic, hypabyssal, volcanic, metamorphic, and sedimentary source rocks are exposed in the basin's mountains and foothills. They supply a wide range of distinct sand compositions, all of which were available to prehistoric potters.

The Tonto Basin's actualistic petrofacies model, used here to infer intrabasinal and extrabasinal raw material provenance, has an overall accuracy of 81% (N=178 point-counted sand samples).[3] That model demonstrates that seventeen distinct sand-temper compositions were available to prehistoric potters residing in the Tonto Basin (figure 12.8, table 12.5), and provides a means to infer sand-temper resource provenance.[4]

Based on our research in the area, two sand compositions are common in pottery recovered from sites located throughout the basin: a diabasic sand, available on the eastern side of the basin in the Armer and Cline petrofacies, and a nearly pure granitic sand, available in the Ash Petrofacies on the western side of the basin.

Excavation data collected from three widely spaced archaeological project areas in the Tonto Basin are summarized here. Roosevelt Community Development Study (RCDS) sites are located along the northern bank of the Salt River ("Salt River arm") in the Lower Tonto Basin (Elson, Stark, and Gregory 1995b). This area is also referred to as the eastern Tonto Basin. Tonto Creek Archaeological Project (TCAP) sites are located along the western bank of Tonto Creek ("Tonto Creek arm") in the Lower Tonto Basin (Clark and Vint 2000). Rye Creek Mitigation Project (RCM) sites are located in the Upper Tonto Basin (Elson and Craig 1992).

The temper composition of all plain ware, red-ware, brown corrugated, Salado Red Corrugated, and Salado White-on-red rim sherds and reconstructible vessels recovered from well-dated trash deposits and intact floor assemblages at sites in the three project areas was characterized. Altogether, 3,474 sherds were examined (Heidke and Miksa 2000a). A sample of the characterized sherds stratified by temper composition, period, site, and ceramic ware (Heidke and Miksa 2000a; Miksa and Heidke 1995; M.T. Stark and Heidke 1992) was point-counted in order to test the binocular microscopic characterization of temper provenance. Altogether, 268 sherds were point-counted. The functions derived from the discriminant analyses of the sand data were used to predict the petrofacies membership of the point-counted sample of sand-tempered sherds from Tonto Basin petrofacies. The discriminant analysis showed that the accuracy of both the RCDS and TCAP temper characterization data sets is 94%. Sherds recovered from the RCM project area were characterized before the Tonto Basin's actualistic petrofacies model was completed. Therefore, approximate petrofacies frequencies were interpolated for them, based on the discriminant analysis of point-counted sherds from RCM sites. The following discussion is an abbreviated presentation of material reported in Heidke (2001).

Temporal trends in utilitarian ceramic provenance

Occupation of the Tonto Basin began by at least the Late Archaic period (1200 BC–AD 100). To date, excavations in the basin have not provided evidence for plain-ware production earlier than circa AD 100. The Early Ceramic phase (AD 100–600) temper provenance data recorded from one site—Eagle Ridge Locus B—provide an important, though limited, starting point for tracing the craft's development in the basin. The most important facet of the Eagle Ridge provenance data is the spatially restricted nature of ceramic production and distribution at this early time. More than 75% of the pottery recovered from Eagle Ridge's Early Ceramic phase locus contains a temper composition available within little more than 2 km of the site. Another 13% of the Eagle Ridge pottery is tempered with sands from the Tonto Basin's Ash Petrofacies, located approximately 23 km northwest of the site, while 11% of the plain ware contains extrabasinal tempers. The temper provenance data from Eagle Ridge, therefore, indicate that most vessels were produced in the eastern Tonto Basin, although pottery produced elsewhere in the basin and outside of the basin was also documented.

Current data suggest that interaction between the Tonto Basin's indigenous residents and Hohokam groups from the Phoenix Basin began by the Snaketown phase (AD 675–750). Hohokam migrants first settled in the eastern Tonto Basin during the late Snaketown or early Gila Butte phase (circa AD

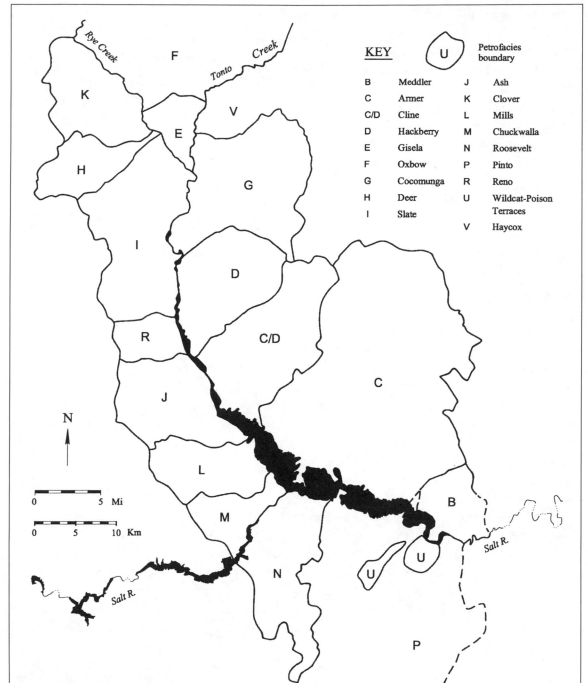

12.8 Current Tonto Basin petrofacies map

KEY Petrofacies boundary

B	Meddler	J	Ash
C	Armer	K	Clover
C/D	Cline	L	Mills
D	Hackberry	M	Chuckwalla
E	Gisela	N	Roosevelt
F	Oxbow	P	Pinto
G	Cocomunga	R	Reno
H	Deer	U	Wildcat-Poison Terraces
I	Slate	V	Haycox

750) and they brought coarse muscovite schist-tempered pottery with them (M. T. Stark, Vint, and Heidke 1995). The timing of the Hohokam appearance in the eastern Tonto Basin is interesting, since it occurred when the Phoenix Basin population was growing and after the best locations for canal irrigation in the Phoenix Basin were settled (Gregory 1995:161). Factors other than irrigation potential most likely determined settlement locations of indigenous Tonto Basin groups, so areas optimal for canal irrigation may have been relatively unexploited environmental niches (Clark 1995:372). By the

late Colonial period (AD 850–950), the eastern basin's occupation still exhibited clear ties to the Phoenix Basin, but given the reduced amount of coarse muscovite schist-tempered pottery recovered from settlements there, the strength of those ties appears to have decreased.

Locally produced plain-ware pottery makes up a very small part of the ceramic collections from Colonial period sites in the Tonto Basin. Only Deer Creek Village, located in the upper basin, appears to have been relatively self-sufficient. Nearly 65% of the plain ware recovered from Deer Creek

Village was tempered with locally available sands. The next highest percentage of locally produced plain ware is much lower (14% at AZ U:3:224 [ASM] located in the TCAP area). By the Colonial period, settlements located in the Ash Petrofacies appear to have developed a reputation for pottery production. Granitic sand-tempered pottery produced there was recovered from all Colonial period sites investigated.

By the following Sedentary period (AD 950–1150), groups descended from the original Colonial period Hohokam immigrants were firmly established. Settlements in the eastern basin became increasingly focused on other Tonto Basin communities and away from the Phoenix Basin (Elson, Gregory, and Stark 1995:450–451). There is evidence of local plain-ware production at all sites, but locally produced pottery makes up a very small part of Sedentary period collections. Plain wares manufactured in the Ash Petrofacies and Armer/Cline Petrofacies were recovered from sites in all three project areas. Together, those two sources account for 59 to 82% of the plain-ware pottery recovered from each Sedentary period site. Very small amounts of Sedentary period red ware were recovered from some of the RCDS and RCM sites included in this study, but, on average, 75% of it was produced outside of the basin.

Plagioclase alteration data, recorded from pots tempered with Armer/Cline Petrofacies diabasic sand, suggest that a shift in the location of pottery-producing settlements occurred after AD 1150, at the beginning of the Classic period (Heidke and Miksa 2000a). The shift in the location of pottery-producing settlements is related to the migration of puebloan people into the Tonto Basin at this time. Immigration is documented archaeologically by the relatively rapid introduction of a distinctive architectural tradition (room blocks constructed out of coursed cobble masonry), which involved an organization of domestic space not found in the indigenous tradition of masonry compounds and pithouse architecture (Clark 1995). Room blocks also exhibit higher frequencies of "high elevation" construction wood species (Miksicek 1995:83), corn pollen (Elson, Gregory, and Stark 1995:453), *Conus* shell tinklers (Vokes 1995), White Mountain Red Ware (M.T. Stark 1995:Table 10.5), brown- and red-slipped corrugated pottery (M.T. Stark and Heidke 1995), and the only macaw remains recovered from the eastern Tonto Basin (James 1995:112–114).

The appearance of immigrants had economic consequences that affected agricultural and craft production in the Tonto Basin. Early Classic period (circa AD 1150–1350) room block sites, such as Griffin Wash, Meddler Point Locus B,

Table 12.5 Map symbol, generic composition, petrofacies name, and number of point counted samples included in the current Tonto Basin model

Symbol	Petrofacies	Samples
Mineral-rich petrofacies		
B	Meddler	15
C	Armer	20
C/D	Cline	
	(4 = Armer composition,	
	3 = Hackberry composition)	7
D	Hackberry	12
F	Oxbow	13
J	Ash	13
L	Mills	7
P	Pinto	12
U	Wildcat-Poison Terraces	7
Rock-fragment–rich petrofacies		
E	Gisela	9
G	Cocomunga	8
H	Deer	4
I	Slate	25
K	Clover	11
M	Chuckwalla	4
R	Reno	8
V	Haycox	3
Low order stream samples (not included in final correspondence and discriminant models)		
N	Roosevelt Petrofacies	7
Trunk streams (not included in final correspondence and discriminant models)		
A	Salt River	3
S	Rye Creek	5
T	Tonto Creek	10

Saguaro Muerto, and AZ U:8:454/14c (ASM) on Schoolhouse Point Mesa, were located on the peripheries of settlements dominated by compound architecture. Early Classic period immigrants apparently lacked access to a sufficient amount of irrigable land to meet their subsistence needs and focused on part-time craft production as a means to supplement their food resources. Locus B at the Griffin Wash site appears to be a particularly strong candidate for an area where immigrants actually made utilitarian pottery. Little care was taken in that room-block's wall construction, floor preparation, and architectural planning (Swartz and Randolph 1994:410). Furthermore, only one hearth was identified in the fourteen excavated rooms (Elson and Lindeman 1994:Table 9.6), whereas twenty-nine hearths were identified in the eighteen rooms excavated in the nearby room block designated Locus A (Swartz and Randolph 1994:Table 9.3). The ground stone assemblages recovered from the two loci also show functional differentiation. Polishing stones make up 52% of the ground stone assemblage from Locus B, but only 21% of the assemblage from Locus A (J.L. Adams 1995:99). In

addition, 62% of the polishing stones recovered from Locus B display use alteration consistent with pottery polishing (J.L. Adams 1995:99).

Pool (1992:284) notes that, within a region, potters sometimes restrict their manufacture to specific classes of pottery, creating a system of complementary specialization. Evidence of complementary specialization in the production of specific wares and vessel shapes, forms, and sizes first becomes detectable in the early Classic period ceramic collections. Although low levels of local utilitarian ceramic production continued to occur throughout the basin, most plain wares and red wares were manufactured in the Ash Petrofacies, whereas most brown corrugated, Salado Red Corrugated, and Salado White-on-red ceramics were made in the Armer/Cline Petrofacies. Significantly, the highest percentage of locally produced plain ware and red ware was recovered from the Middle-of-the-Road site (located in the Ash Petrofacies), while the highest percentages of locally manufactured brown-corrugated, Salado Red Corrugated, and Salado White-on-red ceramics were recovered from the Griffin Wash site (located in the Armer Petrofacies).

In deposits recovered from settlements outside of the two dominant early Classic period ceramic producing petrofacies, consumers received a disproportionately large percentage of bowls manufactured in the Armer/Cline Petrofacies and jars manufactured in the Ash Petrofacies. With regard to specific bowl vessel forms, the Armer/Cline Petrofacies is represented by a disproportionately large percentage of subhemispherical outcurved bowls, whereas the Ash Petrofacies is represented by a disproportionately large percentage of hemispherical bowls. In addition to the more common bowl forms, potters in the Armer/Cline Petrofacies produced two vessel forms usually associated with groups who lived to the north and east of the Tonto Basin: the Salado Red Corrugated "double bowl" and "jar-in-a-bowl" forms. Both of those vessel forms occur in the Reserve Indented Corrugated ceramic series at sites that predate or are contemporaneous with the early Classic period (Barter 1957; Breternitz 1960; Rinaldo and Bluhm 1956). No relationship between temper source and jar vessel form was identified. However, jars produced in the Ash Petrofacies are generally much larger than those produced in the Armer/Cline Petrofacies.

Organization of utilitarian ceramic production and distribution

Numerous typologies have been proposed to characterize modes of craft production (Clark and Parry 1990; Costin

1991; Costin and Hagstrum 1995; Peacock 1982; Pool 1992; van der Leeuw 1984). Each has its own strengths and weaknesses. For example, Clark and Parry's (1990) and Costin's (1991; Costin and Hagstrum 1995) typologies focus on specialist production, but do not address domestic, nonspecialized craft production. As noted by Pool (1992:283–284), nonspecialized, domestic production and consumption provide a baseline against which other more complex systems may be measured. Overall, Costin's (1991; Costin and Hagstrum 1995) multidimensional typology seems the most useful way to examine the Tonto Basin evidence, once a mode for nonspecialized, domestic production is added to the typology (Heidke 2001:Table 3.16). Costin (1991:8) identified four parameters in earlier studies of craft production that describe its organization: the context of production (the nature of control over production and distribution); the constitution (or scale) of the production units; the relative regional concentration of production facilities; and the intensity of production (the degree to which it is a part-time, as opposed to a full-time, activity).

Ceramic production units were organized by household throughout Tonto Basin's prehistory. Evidence of food and craft production indicates that potters worked at the craft on a part-time basis. The labor investment of Tonto Basin potters is inferred to have been low, given their focus on utilitarian wares. Locally produced plain wares were recovered from virtually all sites included in this study, although the percentage of locally made plain ware was usually quite low. From this we infer that dispersed household production of plain ware was widespread throughout the basin's prehistoric occupation. The same can be said for the production of early Classic period red-ware and brown corrugated ware.

Nonspecialized domestic production is only one of the organizational modes responsible for those wares' manufacture. Over time an increasingly large percentage of the plain ware was manufactured in the Ash Petrofacies, and an even larger percentage of the early Classic period red ware was manufactured there (figure 12.9). From this we hypothesize that the mode of ceramic production in the Ash Petrofacies may have changed from dispersed individual specialization, in the Sedentary period, to nucleated community specialization, in the early Classic period. Nucleated community specialization appears to be the production mode responsible for the manufacture of most corrugated wares, especially Salado Red Corrugated and Salado White-on-red.

Quantitative measures of productive intensity, based on ethnoarchaeological studies of handmade pottery manufac-

ture (M.T. Stark 1993), were used to evaluate variation in part-time ceramic production (Heidke 2001; Heidke and Miksa 2000a). Based on the ethnographic data, a productive intensity representing a combination of occasional potters and part-time specialists should result in the manufacture of approximately eighty pots per household annually. At that rate, one to ten households in the Ash Petrofacies could have manufactured all Colonial period vessels attributed to that source, while four to twenty-six households could have made all of the Sedentary period vessels. Similarly, no more than three households in the Armer/Cline Petrofacies could have supplied all Colonial period vessels attributed to that source, while three to twenty households could have produced all Sedentary period vessels.

Based on the ethnographic data, a productive intensity representing that of the most active part-time specialists should result in the annual manufacture of approximately 350 pots per household. At that rate, four to fourteen households in the Armer/Cline Petrofacies could have manufactured all early Classic period vessels attributed to that source. H.D. Wallace (1995a: Table 4.1) estimates that there were somewhere between three and thirteen contemporaneous households present at the Griffin Wash site, while Gregory (1995:176) estimates that the total was no more than seven. Those two estimates are nearly identical to the estimate of four to fourteen households of potters in the Armer/Cline Petrofacies during the early Classic period, and suggest that potters residing at the Griffin Wash site *could* have produced all pottery assigned to that petrofacies. Estimates of distribution effort suggest that the productive intensity of potters living in the Ash Petrofacies during the early Classic period was lower than the intensity of potters residing in the Armer/Cline Petrofacies, and/or that the method they used to distribute their pots involved greater consumer participation. On the basis of these considerations, it appears that seven to thirty-four households in the Ash Petrofacies could have produced all of the early Classic period vessels attributed to that source.

ARCHAEOLOGICAL AND GEOLOGICAL CONCLUSIONS

Seven archaeological conclusions can be drawn from the analyses reported in this chapter. We view them as hypotheses that can be tested with new data from either the Tucson or Tonto basins. Furthermore, they can be evaluated with provenance data from other Hohokam local systems (D.R. Abbott 1994b; D.R. Abbott and Walsh-Anduze 1995; Whittlesey 1997). In this way, ceramic provenance data can help Ho-

12.9 Median percent Ash and Armer/Cline petrofacies pottery recovered from Colonial, Sedentary, and Classic period sites in the Tonto Basin

hokam archaeologists: (1) focus their research on the structure of the *regional* system and how it changed over time; (2) look for differential or parallel timing of changes; and (3) document the occurrence and distribution of particular organizational forms (Wilcox 1980:240).

First, the ceramic provenance analyses confirm the existence of distinct Hohokam local systems. Most ceramics recovered from settlements in a local system were produced somewhere in that local system. There are, of course, rare exceptions to this finding. For example, schist-tempered buff and plain-ware pottery produced in the middle Gila River valley dominate Colonial period ceramic collections from the eastern Tonto Basin (M.T. Stark, Vint, and Heidke 1995). Analysis of that material suggests that exchange was not the primary mechanism responsible for bringing those pots into the basin. Instead, seasonal migrants (or short-term residents) brought the coarse muscovite schist-tempered pottery with them. Second, although temporal- and ware-related variability has been documented, at least two ceramic production modes (sensu Costin 1991) were common: specialist production and nonspecialist production. Third, the number of ceramic-producing specialist households in each local system probably was not large. Perhaps 5 to 15% of all households specialized in ceramic production at any one time. Fourth, the evidence suggests that specific communities often specialized in ceramic production (the West Branch site, in the Tucson Basin, and the Griffin Wash site, in the Tonto Basin); decorated (West Branch) and undecorated (Griffin Wash) wares were produced in those communities. Fifth, one concomitant of community-based specialization in small-scale

societies is the operation of multicentric economies (*sensu* Bohannan 1967) involving the circulation of different classes of goods in a combination of trade and exchange transactions. These classes of goods are often distinguished in terms of their relative values. They circulate in two or more exchange spheres that are basically exclusive, but institutionalized means generally exist to convert goods from one exchange sphere into the other (Bohannan 1967:124–125). The exchange spheres in multicentric economies may involve different spatial ranges too, such as local, regional, and long-distance networks (M.T. Stark 1993:290). It is unlikely that ceramic exchange occurred in isolation from other exchange relationships, but, rather, as an integral part of a local system's multicentric economy. The circulation of pottery made in the West Branch community, located centrally in the Tucson Basin, and gneiss/schist rock tempers, procured in the northern and eastern basin, is one example of two goods that circulated in a Hohokam local system. M.T. Stark and Heidke (1995) explore additional aspects of multicentric economies with respect to early Classic period data from the Tonto Basin. Ceremonies at pre-Classic ballcourts and Classic period platform mounds may have facilitated transactions within each local system's multicentric economy. Sixth, changes in regional and macroregional systems are reflected in the ceramic production and distribution data, especially the Sedentary-to-Classic period transition. Seventh, the "criterion of abundance" *is not* a reliable indicator of ceramic production centers *unless* it is used in the context of a very large, regional study. Evidence from the Tucson and Tonto basins demonstrates that, when pottery was manufactured by specialists, very high frequencies of ceramics produced in one petrofacies can be recovered from sites located in another petrofacies. Finally, an eighth finding, not addressed directly in this paper, is that most ceramics recovered from a local system that were produced outside it are decorated types, rather than the "utilitarian" plain, red, and corrugated wares.

In closing, we offer several observations about the use of petrographic methods that include binocular microscopic *and* thin section analysis to characterize pottery provenance. First, petrographic methods allow general classes of tempering materials to be identified in the course of a ceramic attribute analysis. Second, the actualistic petrofacies method outlined here allows provenance of all diagnostic sherds in a collection to be characterized, although it is likely that the provenance of some sherds will be characterized as indeterminate. Shepard (1942:142), for example, suggested that 5 to 10% of the analyzed sherds might be unclassifiable to a trained petrographer using a binocular microscope. Our percentage of indeterminate provenance assignments is similar. In the Tucson Basin data set discussed here, 9.4% of the 6,246 sherds were unclassifiable to the trained ceramicist using a binocular stereomicroscope. Similarly, 13.3% of the 3,474 Tonto Basin sherds had their temper provenance characterized as indeterminate. While both of these figures are slightly higher than those suggested by Shepard, we must remember that the spatial scale of investigation is much finer than the one used by Shepard (see, for example, Miksa and Heidke 1995:Fig. 9.23). Third, production sources can be identified, often to an area of tens of square kilometers or less, because temper provenance is characterized with reference to known sand compositions (petrofacies). Finally, once an actualistic petrofacies model is developed, it can be used to characterize pottery from any collection recovered from the modeled area, including those excavated decades ago and those that will be collected in the future.

We have been successful in applying the petrofacies method to sand-tempered sherds in central and southern Arizona. However, the geologic diversity in many other parts of the greater Southwest make it possible to extend the methods summarized here far beyond their current bounds. Excellent results should be obtained if the petrofacies method were used throughout the Basin and Range province of Arizona and Sonora and the mountainous central core of Sonora. Shepard's (1936) ground-breaking contributions to ceramic petrography were possible because the Rio Grande Valley of New Mexico can provide good provenance characterizations based on petrofacies (Ingersoll 1990; Ingersoll, Kretchmer, and Valles 1993). Unfortunately, some parts of this region are homogenous over distances of tens of kilometers, thus reducing the potential sensitivity of the method. Finally, the mountainous areas of western Arizona, east-central Arizona, southwestern New Mexico, northwestern Chihuahua and extreme western Texas have sufficient geologic diversity to provide moderate results using the petrofacies method. The challenge now is to identify the times and places that can provide the archaeological conditions under which the method can be applied. For those willing to make the intellectual and financial investment, the clear benefit of petrofacies models for the explanation of past human behavior far outweighs the initial cost of their development. In the arbitrage between imagination and historical reality, we know of no better way of collecting "the outward and visible signs of whatever may be truth" (Bateson 1979:30) when studying a compositionally heterogeneous set of sand-tempered ceramics.

James M. Heidke, Elizabeth J. Miksa, and Henry D. Wallace

Notes

1. Sedentary period temper provenance data collected before 1994 are summarized in Heidke (1996b:Table A.1), while most Sedentary and Classic period temper provenance data sets collected after 1993 are summarized in Heidke (1998, 1999, 2000) and Heidke and Wiley (1997). For reasons discussed in Heidke (1996c), a re-examination of the Los Morteros material (collected in the late 1980s but reported in Heidke 1996b) is required before those temper data are useable. Thus, the Los Morteros data are not included in this study.

2. The data from Graves must underrepresent annual ceramic production rates because the intraregional distribution figures (1991:Table 6.5) cover the years 1976 to 1980, whereas the interregional distribution figures cover the years 1976 to 1977 and 1979 to 1980 (1991:Table 6.9). A correction factor based on Graves' (1991:142) estimate of the number of vessels exchanged annually out of Dangtalan (350 vessels), mean use-life and frequency of vessel classes (Longacre 1985:Tables 13.1, 13.2), and the total number of households residing in the community compared to the number for which there are data (fifty-five versus forty-nine households; Longacre 1985, 1991:97) suggests that the average annual ceramic production of Dangtalan's potting households may be nearly twice as high as the figures used here. However, increasing the annual production rate figures for Dangtalan's potting households does not affect the interpretation presented here; rather, it makes it more believable.

3. A total of 203 sand samples have been point counted for the Tonto Basin petrofacies model; however, the final discriminant analysis excluded sand samples collected from the Roosevelt Petrofacies, the Salt River, Tonto Creek, Rye Creek, and three placer deposits because they are not comparable to the other Tonto Basin samples. The Roosevelt Petrofacies and placer deposit samples represent highly localized, low-order sources, while the three trunk streams represent mixed compositions from high-order sources. Including sands from different stream orders in the discriminant analysis would be inappropriate (Ingersoll, Kretchmer, and Valles 1993). Furthermore, except for a few sherds tempered with placer deposit sands, textural and compositional evidence indicates that these low-order and high-order sources were not used to temper pottery. Miksa and Heidke (1995) present the full argument and data used to reach this decision.

4. The Cline Petrofacies represents the area where the interfingering of the respective northward spatial end members of the Armer Petrofacies' composition and the southward spatial end members of the Hackberry Petrofacies' composition occurs. In this area, streams that begin in the mountains display a diabasic composition, while those that begin on the alluvial fans and terraces exhibit a mixed granitic and diabasic composition. To resolve this spatial and compositional problem, sands in the Cline Petrofacies that have a diabasic composition were combined with the Armer Petrofacies sands into a group called the Armer/Cline Petrofacies. Sands in the Cline Petrofacies that have a mixed granitic and diabasic composition were combined with the Hackberry Petrofacies sands into a group called the Cline/Hackberry Petrofacies. Thus, there are eighteen *petrofacies* shown on the map, but there are only seventeen *distinct compositions*.

13

Using INAA in the Greater Southwest

Donna M. Glowacki and Hector Neff

THE INCREASING USE of instrumental neutron activation analysis (INAA) in the study of Southwestern ceramics has had a number of consequences. Perhaps most important, as pointed out in the introduction, INAA and other provenance techniques have conclusively demonstrated the inadequacy of the view that most villages throughout the region were self-sufficient and that there was very little interaction between them (see also Gumerman and Dean 1989:100; S. Plog 1994:148). By providing a tool for documenting ceramic circulation, INAA and other approaches to ceramic provenance encourage more interactive and regional research designs. As INAA databases have grown, broader regional studies based on syntheses of multiple databases have become feasible, as demonstrated in the present volume by the papers of Creel et al. (chapter 3), Glowacki et al. (chapter 5), and Triadan et al. (chapter 7). INAA studies have also provided a foundation from which we can now begin to ask and answer broader questions about the social, economic, and political implications of the organization of production and circulation of vessels (for example, Duff 1999; Harry 1997; chapter 8; Triadan 1997; Zedeño 1994, chapter 6).

Our goal in this concluding chapter is to complement the research presented with a discussion of the application of INAA in the Greater Southwest and its contributions toward increasing our understanding of ceramic production and distribution. We begin with some general remarks on INAA-based ceramic provenance studies in the Southwest, under which heading we discuss typologies, technological practices that influence compositional patterning, and population movements. The chapter is concluded with a discussion of issues relevant for future studies using INAA data.

TOPICS HIGHLIGHTED BY VOLUME CONTRIBUTIONS

The basic goal in a ceramic provenance project based on INAA is to identify ceramic production areas. The methods by which this goal can be realized are discussed in chapter 1. The information gained from these efforts also informs on aspects of ceramic studies, such as the circulation of ceramic vessels and the interactions inferred from these patterns of circulation. Virtually all INAA studies, thus, address the issue of local and nonlocal production, at least implicitly.

Many of the INAA studies presented here reinforce or disprove previous notions about pottery production and distribution in various parts of the Southwest. For example, in the Mimbres area, it had long been assumed that Playas Red Ware and Tularosa Smudged Corrugated were imported to the Mimbres Valley. However, Creel and his colleagues (chapter 3) demonstrate these wares are, in fact, locally produced. Thus, Playas Red, once thought to be primarily from northern Chihuahua (Paquime), and Tularosa Smudged Corrugated were probably produced widely throughout the southern Southwest.

Typologies

In addition to determining chemical signatures for local and nonlocal ceramics, compositional analysis is one means of testing the plausibility of ceramic typologies on the basis of other attributes. As Neff (1993) points out, typologies in many cases represent hypotheses about how ceramics are related by common descent. Compositional analysis provides a partial test of these hypotheses: If compositional analysis shows that ceramics of a single "type" were made from distinct raw materials, then the hypothesis of common descent

diminishes in plausibility.

The study by Boyd et al. (chapter 9) is an application of compositional analysis to test hypotheses about relationships that are embedded in southern Plains ceramic typologies. The origins of the region's plain pottery, a much-debated topic, has been addressed previously using petrographic analysis (Boyd and Reese-Taylor 1993; Habicht-Mauche 1987, 1988, 1991). Boyd and his colleagues (chapter 9) use INAA as a complement to petrographic analyses to evaluate whether Tierra Blanca is a valid, Plains-derived type, or a Puebloan-produced plain ware. The results of their analysis are inconclusive primarily because of sample-size limitations and the lack of a comparative data set of eastern Rio Grande clays. Additional INAA analysis would more securely anchor these data, allowing for more conclusive interpretations of the source of Tierra Blanca production.

Pottery traditions in southern and eastern California are poorly understood because the pottery of these regions consists of indistinguishable, undecorated brown wares, which, as a result, are subsumed within a single typological category. For instance, Patayan ceramics are predominantly undecorated, making it difficult to assign a temporal and spatial typology. INAA and petrographic analyses in the study by Hildebrand and his colleagues (chapter 10) are important tools for evaluating and refining Patayan ceramic classifications. For example, they were able to identify a new ceramic ware, produced along the western margin of the Salton Trough, that they now call Salton Brown Ware. Eerkens and his colleagues (chapter 11) use INAA to determine whether brown-ware production was local or nonlocal to Death Valley and to ascertain whether a useful typology for the Death Valley brown wares could be developed using physical attributes correlated with chemical composition groups. Unfortunately, the overlap between compositional groups and physical traits does not allow typological assignment with total certainty.

These studies demonstrate that INAA can contribute toward better understanding of ceramic relationships and can help refine ceramic classifications, the latter being especially important for nondecorated wares. Although a majority of INAA studies have focused on decorated wares, attention to undecorated wares is increasing, in part, because INAA is a productive means for identifying the source of production, particularly when the surface of the ceramics are nondistinguishable and the tempers used are homogeneous. As provenance investigation based on INAA and other analytical techniques becomes even more routine in archaeological research, we may anticipate that the resulting information on source zones and compositional relationships will appear in type descriptions more often.

Resource-selection criteria and compositional variability

One area to which INAA has contributed, but which has not been extensively addressed in the literature, is understanding the importance of the resource selection-criteria used by potters in the past for the production of ceramic vessels. Potters have varying techniques for selecting and processing clays, and they often mix clays together to obtain a more desirable clay consistency and to increase plasticity. Ethnographically, the complexity of this step has been noted (for example, D.E. Arnold 1985; Cushing 1920). These activities affect the clay body and, as a result, ceramic composition and patterning in provenance data. Therefore, as Heidke and his colleagues (chapter 12) point out, it is important to understand the sources of variability that these processes add to ceramic composition in order to interpret results from compositional analyses more accurately.

Most INAA studies to date really go only partway toward understanding the causes of compositional variability. Analysis stops with a series of compositional groups, which, one hypothesizes, actually represent sources or source zones. One may also have hypotheses about where those zones might be located, but the work has only begun and further testing remains to be done. The compositional groups may have been created by clay source differences, variation in paste recipes, diagenetic changes, or some combination of all three effects. Although Heidke and his colleagues (chapter 12) are correct when they state, "explicit acknowledgment of the sources of variation in ceramic composition should help us avoid errors in interpretation later," acknowledgment by itself is not enough. We need to carry out explicit tests of the multiple hypotheses about sources of compositional variation. The effect of temper on compositional groups is perhaps easiest to address, and it has been given the most explicit consideration (for example, D.E. Arnold, Neff, and Bishop 1991; Neff, Bishop, and Sayre 1988, 1989). The compositional effects of clay refinement have also been studied (Blackman 1992; Kilikoglou, Maniatis, and Grimanis 1988).

One example of how prehistoric clay selection practices affect compositional groups is the selection of clay from only a specific portion of a particular geologic formation to be used for pottery production. Although the geologic formation itself may be highly variable, potentially providing an ideal situation for discriminating distinct resource use within

the formation, the actual source chemical signature is more homogeneous. This type of behavior has been identified in the northern San Juan region in southwestern Colorado where potters seem to have consistently used a specific portion of the Dakota formation for white-ware production (chapter 5). Unfortunately, if the preferred clays are distributed widely and discontinuously in a formation, the sources for chemically similar pottery may also be widely distributed. These observations point to the necessity of comprehensive sampling of geological formations.

Potters often not only have criteria for viable potting clays in general, but also select specific clays depending on the vessel type being produced (for example, Cushing 1920). This behavior appears to have been the case for ceramic manufacturing loci on the Colorado Plateau (Zedeño et al. 1993). Additionally, the selection of specific clays for a particular vessel type has begun to be identified in some of the recent INAA studies in the Southwest (Glowacki et al. 1998; Zedeño 1994, chapter 6). As more studies involving multiple wares are undertaken, this type of clay selection may be identified on a widespread basis throughout the Southwest.

The point of this discussion is that resource procurement for ceramic production was often quite involved, requiring specialized knowledge and time investment. The specifics of resource procurement bear directly on compositional group formation and may facilitate or impede linking these groups to source clays. A thorough understanding of available clay sources and possible changes during paste preparation are thus critical parts of understanding production and interpreting INAA data.

Influence of the movement of people on pottery distribution

The movement of people into and out of villages introduces variability in both pottery production and distribution. Therefore, the mobility of people, and thus pots, potentially underlies some of the patterns of assemblage compositional diversity (that is, the presence of both local and nonlocal pots) in INAA data (for example, Triadan 1997; chapter 7; Zedeño 1994). People move around for various reasons, including migrations, seasonal mobility, and intermarriage. In the present volume, mobility is invoked in several of the studies to explain observed patterns of compositional diversity.

Settlement mobility and seasonality are important aspects of many cultures, and it is reasonable to assume that such activities helped to structure pottery production and distribution in the past. For example, Hildebrand et al. (chapter 10)

and Eerkens et al. (chapter 11) suggest that seasonal movements between different environmental zones contribute to the compositional diversity of ceramic assemblages in southern and eastern California. Often, nonlocal ceramics are assumed to have been exchanged or brought in by people moving into an already established village. As the California studies suggest, however, in some contexts it is equally plausible that nonlocal vessels represent pottery produced by the occupants of a village on their seasonal rounds using a different ceramic resource catchment. Admittedly, people moving around probably would not carry many ceramic vessels; however, at least some of the vessels present in these assemblages could result from seasonal movement. Therefore, seasonal movement should be considered as a possible mechanism that contributes to compositional diversity.

Migration is another type of population movement used to explain patterning in compositional data. For example, Triadan and her colleagues (chapter 7) suggest that the compositional diversity identified in their analysis of White Mountain Red Wares results primarily from the movement of people out of the Silver Creek area in Arizona to other areas, such as Tonto Basin, Homolovi, and the Upper Little Colorado. Similarly, Zedeño (chapter 6) suggests that two of the compositional groups defined in the Point of Pines data represent ceramics transported when households, possibly from southeastern Utah, moved into the pueblo.

Although migration is a plausible mechanism to explain compositional diversity, how much diversity would result solely from migration? What archaeological data are needed to differentiate the various plausible sources of compositional diversity? Even when the context of a particular region and time indicate that migration is a critical mechanism for the circulation of pots, it should not be assumed that migration precludes other mechanisms, such as trade or other types of exchange, intermarriage, emulation, and seasonal movements. The presence of nonlocal ceramics in an assemblage, more often than not, is due to multiple processes. The Pueblo reorganization of the fourteenth century clearly demands some attention to the processes of migration. Not surprisingly, both studies invoking migration as an explanation for compositional diversity concern this period (see chapters 6 and 7).

Triadan and her colleagues point out that migration and population movement are important factors in ceramic distribution. Although they acknowledge that multiple mechanisms contribute to ceramic circulation, their interpretation of the White Mountain Red are data heavily emphasizes migration over other potential mechanisms of ceramic circula-

tion. The argument that population movement can significantly contribute to the distribution of ceramics is certainly well taken. However, trade, gift giving, and other types of exchange also may have contributed to the distribution of White Mountain Red Ware (an argument with which Triadan and her colleagues probably agree). In fact, the latter kind of interaction may have established the ties that later facilitated migration.

The interrelatedness of the various mechanisms for circulation make interpretations about the meaning of compositional diversity difficult. Therefore, it is important that research also focus on discriminating between the various mechanisms for ceramic circulation. Toward this end, Zedeño attempts to deal with the equifinality of circulation mechanisms in interpreting compositional diversity by developing criteria for differentiating between various potential sources of compositional diversity. Relying on composition, artifact design, and context, Zedeño concludes that local production, migration, preferential consumption (exchange), emulation, and hybridization all contributed to the formation of the ceramic assemblage from Point of Pines.

Hypotheses about migration, seasonal mobility, exchange, intermarriage, or other mechanisms require testing with multiple lines of evidence; compositional diversity by itself is compatible with all such mechanisms of ceramic circulation. In some cases, it may even be empirically impossible to identify the sources of diversity. However, there seems little doubt that an approach emphasizing multiple lines of evidence offers more potential for identifying specific circulation mechanisms than an approach emphasizing only one category of evidence.

Importance of provenance studies on the Southwest periphery

Social interaction and ceramic circulation did not end abruptly at the boundaries drawn around the culture areas of the Southwest. For example, interaction and trade between the Pueblos and the southern Plains has long been documented in the archaeological record (for example, Kidder 1932; Kreiger 1946:10; Wedel 1950; Spielmann 1991). Likewise, interaction and exchange also linked southern California desert people with Southwestern groups (chapter 11). Ultimately, a comprehensive understanding of interaction in the Southwest will require us to describe how interaction patterns varied across the various frontiers.

Another rationale for incorporating ceramic compositional studies from the Southwestern periphery is that doing so

provides a comparative perspective from which to view the range of variation in Southwestern ceramic circulation patterns. The studies from the southern Plains, Death Valley, and southeastern California provide comparative evidence from several areas peripheral to the Southwest. However, these studies are not monolithic comparative cases, rather they are examples of the kinds of activities and behaviors occurring in the peripheral areas of the Southwest.

DIRECTIONS FOR FURTHER RESEARCH

As with all research, there is room for improvement in studies employing INAA for ceramic compositional research. INAA has become more routine in the past ten years, primarily because the financial feasibility of analysis has increased. Many of the INAA studies initially undertaken in any geographic area are pilot studies designed to get a sense of the effectiveness of INAA in that particular region. Because of the exploratory nature of initial applications of INAA, these studies are often basic descriptions of compositional groups and speculations on their interpretation. In the Southwest, the exploratory studies have convincingly demonstrated that extensive ceramic circulation was prominent in many regions and many time periods. With the larger INAA databases now available, however, we might ask ourselves whether we could do a better job of applying our results to further our understanding of the history of human occupation of the region.

INAA provides us with a powerful tool that basically answers one specific question about pottery: Where did it come from? This, by itself, is just one instrument for describing something about the past (Neff 1998). In addition to the fundamental question of how much INAA studies are contributing to scientific understanding of Southwestern prehistory, there are a number of specific things we can do to improve our answers to the question of where it come from.

Geological sampling

As pointed out previously, compositional groups may be created by source or source-zone differences, paste recipe differences, diagenetic changes, or some combination of these effects. Raw material samples are important for evaluating these competing hypotheses and, if the source-zone hypothesis is not falsified, the raw materials then provide a basis for linking compositional groups to locations on the ground.

Comparison of the Heidke et al. study (chapter 12), which is based on characterization of nonplastic inclusions in ceramic pastes, with the INAA studies in this volume indicates that raw material sampling has not been given sufficient at-

tention by researchers using INAA. Conclusions have to be qualified in many cases (for example, chapters 9, 4, and 7) because the raw material sample is insufficient to make explicit links between compositional groups and locations on the ground. The compositional groups identified in these studies are assumed to represent sources, but, because those sources remain unidentified, inferences about ceramic production and distribution must remain speculative. Clearly, much more emphasis on clay and temper sampling is required.

The study by Heidke and his colleagues illustrates a number of ways in which raw material sampling in INAA studies could be improved. First, sampling needs to be carried out more extensively to account satisfactorily for variability both within and between formations. Admittedly, expenditure of scarce resources to analyze soil and sand samples may often seem less productive than building up a database of analyzed pottery. Leaving compositional groups floating in space, however, will not contribute very much. Fortunately, the use of standard-comparator INAA (Glascock 1992) ensures that the accumulating raw materials data will be useable in the future, even if data have to be combined from several different laboratories. In the long run, therefore, if users of INAA continue to pay at least a little attention to raw material sampling, eventually there should come a time when the accumulation of raw material samples from many regions renders the issue of raw material sampling less pressing.

A second issue concerns the approach to raw-material survey: Which clays or sands should be sampled and analyzed? Raw-materials sampling for INAA studies should provide a representative sample of the resources available to provide a strong comparative base. One method for obtaining a representative sample involves the systematic sampling of geologic formations to account for the compositional variation. This is basically the approach adopted by Heidke and his colleagues (chapter 12), and it is the approach to raw-material sampling used productively by Neff and Bove (1999) in Pacific coastal Guatemala. Additionally, it is also useful to make sure that the clays sampled are viable potting clays, by consulting experienced contemporary potters and replicators (Bishop et al 1988; Glowacki et al. 1997). A combination of these two approaches is probably best: Systematic sampling ensures that a formation has been adequately sampled, and selecting viable potting clays guarantees that it was at least possible that the source could have been used to make pots.

In sum, raw-material sample sizes should to be increased in INAA studies and more thought should be given to raw-material sampling strategies. Collecting a few clays as an af-

terthought is not good enough. For example, because Hildebrand and his colleagues (chapter 10) devoted such great attention to raw-material sampling, their inferences about source zones are comparatively convincing.

Analysis of undecorated wares

Currently, most INAA research often involves the analysis and comparison of decorated pottery. INAA also can be a powerful tool for determining where plain, corrugated, and other not-so-fancy ceramics were produced, as illustrated by Hildebrand and his colleagues (chapter 10) and Eerkens and his colleagues (chapter 11). Although the circulation of undecorated wares remains poorly understood, some provenance studies suggest that corrugated wares and plain wares were circulated as frequently as decorated wares (for example, D.R. Abbott 2000; Duff 1999; Neff, Larson, and Glascock 1997; Zedeño 1994). It must be borne in mind that the kinds of interactions that resulted in the movement of undecorated wares may not have been the same as those that moved decorated wares (D.R. Abbott 2000; Duff 1999; Zedeño 1994). Thus, we may need to develop different frameworks to understand the production and distribution of the undecorated ware.

Issues related to quantitative analysis

Chemical data can be statistically analyzed using a variety of techniques. Most of the projects reported here use a statistical approach derived from the work of Sayre (1975) and outlined by Neff (chapter 2). In some cases, an effort is made to use techniques, such as k-means cluster analysis (for example, chapter 3), that have not been commonly applied in INAA compositional studies. There is nothing inherently wrong with any approach to group definition. The mistake is to accept the raw output of a clustering algorithm without further critical evaluation of the validity of the suggested groups. In part, the extent to which groups can be evaluated statistically depends on the size of the sample. A small total sample size means that group sizes will be relatively small. Three or four specimens may appear to form a group on a number of dimensions, but three or four is an insufficient basis for estimating group parameters. Larger samples will generally be associated with larger groups, and larger groups will be associated with better group parameter estimates; better parameter estimates, in turn, afford more confidence in comparing raw materials to the groups and making inferences about source zones.

Sample size also limits our interpretations. We have to be

careful not to infer too much based on compositional groups containing very few samples. Too often, we are eager to state some broad-reaching interpretation on the basis of a small sample, without at least acknowledging that a larger sample size may drastically change the picture. Our intention in mentioning this issue is not to question the interpretations of any of the compositional groups defined in this volume, but to encourage larger sample sizes and explicit acknowledgment of sample size limitations.

Communicating the results of a provenance study in a clear and direct manner can be somewhat difficult given that subgroup structure in the data may sometimes be complex and hierarchical. PCA plots are a useful means for the analyst to understand the data structure, but they may not be the best way to present data at meetings or in publications. This is not to say that PCA plots should be avoided altogether, but there are alternative ways the data can be presented that may communicate the results more effectively. For example, schematic representations of the structure of the data set (for example, Glowacki, Neff, and Glascock 1998:222, Figure 2) conveys the same information as a PCA plot with regard to number of compositional groups and how many samples are contained within each group. It is worth thinking more about how we present data so that illustrations are clear and convey the information in the most direct and meaningful manner.

It would be an ideal world if every sample fell neatly within an established compositional group. Unfortunately, some proportion of the sample in virtually all provenance studies will remain unassigned for one reason or another. Statistical approaches always create outliers. Also, the boundaries between sources on the ground are not well marked (that is, clays for making ceramics can come from almost anywhere), so the boundaries between compositional groups also are not always clear-cut, and some specimens may appear to be members of more than one group. Because of the vagaries of sampling, some groups are likely to be represented by only a couple of samples, and the group, therefore, will not be recognizable. Generalizing from the studies in this volume, the percentage of unassigned specimens in Southwestern ceramic compositional data sets seems to hover around 30%.

Although unassigned specimens are unavoidable, their presence cannot be ignored. In some cases, provisional assignments may be suggested even though statistical assignment to reference groups is impossible. Presenting the data on the unassigned specimens can also be problematic because it makes figures difficult to interpret. To present these data clearly, plots of principal components or elemental concentrations may in-

clude the outliers along with reference group ellipses in order to illustrate the relationship of the outliers to the compositional groups. Data points for individual reference group members may be omitted in order to simplify these plots, and labels can be attached to the unassigned data points in order facilitate discussion of possible compositional affiliations. Another tactic is to include a list of the unassigned specimens with provisional group assignments indicated.

CONCLUSIONS

The studies in this volume reiterate that vessel movement occurred at a number of geographic scales. Intraregional interaction, perhaps not surprisingly, appears to be the most prevalent level of vessel circulation. This level of interaction is documented for virtually all regions examined here, from the Northern San Juan region to southern California. On a slightly larger geographic scale, inter-regional interaction occurred between adjacent regions. This is exemplified by the results from Chaco Canyon, where the ceramics were imported from the Chuskas and other areas to the north. Inter-regional interaction is also demonstrated between the Silver Creek area and sites below the Mogollon Rim as well as between the Tucson Basin and Papagueria. The third level of vessel circulation occurs on the supraregional level, that is, beyond regions lying immediately adjacent to one another. On this level, there is evidence that vessels were moved between the orthern San Juan region (Mesa Verde) and Chaco Canyon; between southern Utah and the Point of Pines area; between the Pueblos and Plains, and, perhaps, between the Mimbres area and Paquime. The idea that vessel circulation at these different geographic scales was driven by different mechanisms must be kept in mind in designing provenance projects and when using the resulting data to elucidate the nature of prehistoric interaction.

While assemblage diversity clearly documents movement of vessels in many of the studies presented here, the topology of interaction remains fuzzy in many cases because of the failure to tie compositional groups to specific locations. Examples of this problem include Boyd et al. (chapter 9), Neitzel et al. (chapter 4), and Triadan et al. (chapter 7). This problem may dissipate as future compositional investigations accumulate more raw materials data from various regions and as compositional group sizes increase, permitting better group parameter estimates. As source attributions become more secure, the importance of vessel movement at different geographic scales will become clearer, and this may also make it easier to specify and test hypotheses about the mecha-

nisms of vessel movement.

The most concrete contribution made by all the studies reported here consists of the analytical data themselves. Specific models, interpretations, inferences, and theoretical frameworks may be challenged in the future, but the value of provenance determination and, by implication, the analytical data on which the determinations are based, is not likely to be called into question by future methodological or theoretical advances in archaeology. Provenance determination provides a reliable means for monitoring the movement of materials, and movement of materials is a primary process responsible for the creation of an archaeological record. This observation highlights several issues of concern for the future. First, we need to maintain the growing databases created by INAA and other reliable analytical techniques. Second, we need to continue to develop tools for expressing analytical data relative to common standards, so that the accumulated data continue to be useful in the future. Finally, we need to pay more attention to raw material sampling, so that the cumulative database of knowns becomes increasingly useful for tying ceramic compositional groups to locations on the ground. If we do these things, it may be possible in the not-too-distant future for a provenance researcher to carry out a study based on hundreds or thousands of samples from his or her area with only a minimal investment in new analyses. It is exciting to contemplate such a future, in which ceramic provenance determination becomes a routine part of even small CRM projects in the Southwest.

Glossary

Michael D. Glascock

This glossary includes terms associated with the compositional analysis and provenance determination of archaeological ceramics.

accuracy Accuracy is the degree to which an experimental measurement approximates the true value.

activation Activation of a target nucleus occurs when neutrons, protons or other nuclear particles or radiation induce a transformation in the target nucleus that results in the subsequent emission of other nuclear particles or radiation. Measurement of the subsequent emission(s) may be used to identify the species of the target nucleus.

activity The activity of a radioisotope is defined as its rate of decay, and is given by the fundamental law of radioactive decay

$$\frac{dN}{dt} = -\lambda N$$

where N is the number of radioactive nuclei and λ is defined as the decay constant. The decay constant for a radioisotope is related its half-life by the equation

$$\lambda = \frac{\ln 2}{\text{half-life}}$$

archaeometry The term archaeometry was coined in the 1950s by Christopher Hawkes of Oxford University to describe the use of different physical and chemical methods to date, quantify, and analyze archaeological materials.

argillaceous rock Argillaceous rocks are usually derived from mudstone or shale that has undergone a higher degree of consolidation by pressure, cementation or heat than either mudstone or shale. Argillites are transitional rocks between shale and slate in terms of their permeability and hardness.

atom An atom is the smallest particle of an element that exhibits the properties of the element. A single atom consists of a nucleus with Z protons and N neutrons surrounded by Z electrons. Atoms can exist alone or in combination with other atoms as molecules.

atomic number The atomic number, Z, of an atom represents the number of protons present in the nucleus and identifies the elemental species.

atomic weight The atomic weight (or atomic mass of an element) is defined as the weighted average of the masses of all naturally-occurring isotopes in a sample of the element.

atomic absorption spectroscopy (AAS) Atomic absorption spectroscopy is a chemical analysis technique based on the measurement of radiation absorbed by the atoms of the constituent elements in a specimen. Different elements are identified by the characteristic wavelength of radiation absorbed and the intensity of the absorbed radiation is proportional to the amount of the element present. The method requires the sample to be dissolved in water, which makes sample preparation a bit more complicated, and it can be used to measure only one element at a time.

biplot A biplot is a special type of graph following from principal components analysis on which both the samples and elements (shown as vectors of the coefficients) are displayed simultaneously. Examination of biplots from the PCA of ceramic specimens often leads to rapid identification of the analyzed elements responsible for differentiating groups of specimens from one another.

bivariate plot (scatter plot) A two-dimensional graph where the x-axis and y-axis symbolize a pair of measured or calculated variables (for example, elements, principal components, and so on) The points on a bivariate plot represent the positions of individual samples. Bivariate plots are used to recognize possible structure in a data set.

calcareous A specimen that is calcareous contains a relatively high proportion of the mineral calcium carbonate ($CaCO_3$).

ceramic paste A ceramic paste constitutes the mixture of clay(s) and other ingredients used to produce a ceramic object. The original clay(s) may have been levigated or mixed with one another and tempering materials added to produce the final ceramic paste.

chemical analysis The resolution of materials into their chemical components to obtain information about their nature. The analysis is said to be qualitative when the identity of the components is determined. The analysis is said to be quantitative when the relative weight proportions are determined. Chemical analyses are com-

monly quoted in units of weight percent or parts per million (that is, micrograms per gram).

chi-square (χ^2)distribution If the Z scores or standardized values of Z are squared and summed, they form the statistic $\sum Z^2$ where

$$\sum Z^2 = \sum_{i=1}^{N}\left(\frac{X_i - \mu_0}{\sigma}\right)^2$$

When the $\sum Z^2$ statistics for all possible samples of size N from a normal population are plotted, they form a chi-square (χ^2) distribution. Unlike a normal distribution, the χ^2 distribution is not centered around zero, but is entirely positive.

clay Clays are loose, extremely fine-grained natural sediments (typically with a diameter of 4 microns or less) created by the weathering of rocks. Most clays form a plastic moldable mass when finely ground and mixed with water. They retain their shape on drying, and become a permanently hardened ceramic after heating or firing. Geochemically, clays are part of the large family of aluminosilicate minerals forming a majority of rocks on the Earth's surface. Most naturally-occurring clays consist of greater than 50% clay-size particles and lesser amounts of finely divided quartz, feldspar, carbonates, and other impurities. Clay minerals are commonly classified according to their use, origin, composition, mineral constitutents and color. Some of the most common clay minerals are kaolinite, halloisite, montmorillonite, illite, chlorite, attapulgite, paligorskite and sepiolite.

cluster analysis Cluster analysis is a procedure for arranging a number of analyzed samples into homogeneous and distinct subgroups based on their mutual similarities and hierarchical relationships. The cluster analysis method most often applied to chemical composition data is the so-called sequential, agglomerative, hierarchical, non-overlapping method. First, a distance (or difference) matrix is calculated and the data are used to link up or cluster the two closest samples. Then add to this initial cluster either another sample or form a separate cluster from two other samples, according to the clustering criterion being employed. The method proceeds to add either additional samples or clusters at ever decreasing levels of similarity, until all of the samples are swept up into a single large cluster.

correlation Correlation expresses the magnitude of interdependence between two or more measured variables (for example, element concentrations).

correlation coefficient The correlation coefficient, r_{jk}, between two elements j and k is defined by the ratio

$$r_{jk} = \frac{\mathrm{cov}_{jk}}{\sigma_j \sigma_k}$$

where σ_j and σ_k represent the respective sample standard deviations and cov_{jk} is the sample covariance between the elements. Correlation coefficients range in value from +1 to –1. A correlation of +1

indicates a perfect 1:1 relationship between two elements; a correlation coefficient of –1 indicates the two elements are inversely related.

correlation matrix The correlation matrix is a matrix tabulating the correlation coefficients between all pairs of variables measured in a study. See correlation coefficient.

covariance The covariance between two elements is a measure of the joint variation of the elements about their common mean. The covariance for a distribution of N samples is the product of the deviation from the concentration means for both elements and can be calculated from the expression

$$\mathrm{cov}_{jk} = \frac{\sum_{i=1}^{N}(C_{ij} - A_j)\,(C_{ik} - A_k)}{N-1} = \frac{N\sum_{i=1}^{N} C_{ij}\,C_{ik} - \sum_{i=1}^{N} C_{ij}\,\sum_{i=1}^{N} C_{ik}}{N(N-1)}$$

where C_{ij} and C_{ik} denote the respective concentrations of the jth and kth elements for sample i.

The mean elemental concentrations are given by A_j and A_k, respectively. When all of the individual covariances of a data set are determined, they represent the variance-covariance matrix.

covariance matrix See variance-covariance matrix.

criterion of abundance If a large group of the specimens in a ceramic assemblage is represented by a single, homogeneous, compositional fingerprint and the actual source of clay is unknown, then the criterion of abundance suggests that there is a high probability the group was produced locally or very near the site where it is most heavily represented.

cross-validation (jackknifing or leave-one-out) Cross-validation is an approach to assessing the success of sample classification or allocation of a group of N samples in which individual samples are compared to all of the other samples (N-1) in the group by successively omitting the individual sample during the comparison.

decay See radioactive decay.

degrees of freedom The number of 'free' or available remaining observations from a sample of size N minus the number of estimated parameters.

dendrogram A treelike, two-dimensional correlation diagram depicting the mutual relationships between and within samples and groups of samples sharing a common set of measured attributes (for example, element concentrations). Adjacent samples have the greatest similarity and distantly placed samples are the most different from one another.

detection limit The detection limit of an element is the concentration level below which one is unlikely to be able to measure the quantity of this element in the specimen. Detection limits in individual specimens are affected by the experimental parameters and may also be affected by the presence of interfering elements in the measured sample.

diagenesis Diagenesis includes all of the physical and chemical changes that a ceramic material undergoes after firing, including usage, breakage, weathering, leaching and deposition.

dilution Dilution occurs when the concentrations of most trace and major elements are reduced due to the addition of second sample material (for example, temper) with significantly lower concentrations for the diluted elements. For example, the addition of a quartz or sand temper to a clay paste mixture would reduce the concentrations of almost all elements except Si.

discriminant analysis Discriminant analysis is a technique for classifying samples into predefined groups on the basis of multiple variables. It starts with the presumption that all samples in an initially unknown set must be members of two or more known groups. From the distributions of these groups, it is possible to calculate one or more linear functions of the measured variables that achieve the greatest possible discrimination between the groups. The discriminant functions are of the form

$$F_i = a_i C_1 + b_i C_2 + c_i C_3 + \ldots p_i C_p$$

where $C_1, C_2, \ldots C_p$ are the discriminating variables (that is, concentrations of major elements or trace elements), $a_i, b_i, \ldots p_i$ are the discriminating function coefficients and F_i is the discriminant score. The magnitudes of the discriminating function coefficients associated with the variables rank the relative importance of the elements in separating the groups along the discriminant function.

dispersion Dispersion is the tendency for a group of observations to deviate from a mean value.

distribution When a number of measurements or observations are classified according to a single attribute, a distribution is created. For example, when the concentrations of the element iron are measured in a collection of N specimens, the measurements represent the distribution of iron concentrations for the collection.

electromagnetic radiation Electromagnetic radiation is a form of energy originating from the interaction of electric and magnetic fields. X-rays, gamma rays, ultraviolet, and infrared are different wavelengths of electromagnetic radiation with decreasing energy. The frequency of electromagnetic radiation is given by the equation

$$\nu = \frac{c}{\lambda}$$

where c is the velocity of light (3.0×10^{10} cm/sec) and λ is the wavelength in centimeters.

electron The electron is a light-weight, negatively-charged particle surrounding the nucleus.

enrichment Enrichment refers to the higher abundance of certain elements in a sample relative to other similar samples.

enrichment-depletion diagram Enrichment-depletion diagrams are a convenient way of presenting relative enrichment and depletion of the concentrations of trace and major elements in altered samples. The x-axis of the graph shows the elements arranged according to atomic number and the y-axis shows the concentration of the element in the sample(s) of interest relative to concentrations in an unaltered sample. Enrichment-depletion diagrams are useful for displaying element mobility.

error The error is the deviation of a measured value from its correct or true value, or the difference between an observed value and the true value.

Euclidean distance The Euclidean distance between two sample points in concentration hyperspace is calculated in an analogous manner to the way one calculates the length of the diagonal for a triangle in two dimensions (that is, the square root of the sum of squares of each side). For N dimensions, the Euclidean distance between samples i and j is given by

$$d_{ij} = \left[\sum_{k=1}^{N} (C_{ik} - C_{jk})^2 \right]^{1/2}$$

where C_{ik} and C_{jk} are the respective concentrations on element k.

factor analysis Factor analysis is concerned with determining whether the covariances or correlations between a set of observed variables p can be explained in terms of a minimum number of unobserved, latent variables ($f_1, f_2, \ldots f_k$), where $k < p$.

gamma ray Gamma rays are a form of electromagnetic radiation with very short wavelength and high energy emitted from a nucleus undergoing radioactive decay (nuclear transformation). Because gamma rays are unique and have discrete energies, they are useful for the identification of radioisotopes.

gamma-ray spectroscopy Gamma-ray spectroscopy involves the measurement, identification and interpretation of gamma-ray peaks in the spectrum obtained by counting a radioactive specimen, usually following neutron irradiation.

germanium detector Germanium detectors are high-resolution gamma-ray detectors commonly used in instrumental neutron activation analysis (INAA) laboratories. The detector consists of a large crystal of high-purity germanium which convert the energy deposited by a gamma ray into an electical pulse proportional in height to the energy of the gamma ray. Germanium detectors must be kept cooled to liquid nitrogen temperatures (77 ° K) to maintain their excellent energy resolution.

half-life The half-life is the time required for the number of radioactive atoms present in a sample to reduce to half of its original value. Each radioactive isotope has a characteristic half-life.

Hotelling's T^2 statistic Hotelling's T^2 statistic is the multivariate generalization of the univariate Student's t-statistic commonly used to test the significance of between-group differences. If D^2 is the Mahalanobis distance between two group centroids with n_1 and n_2 samples each, then T^2 is defined as

$$T^2 = [\, n_1 n_2 / (n_1 + n_2) \,] D^2$$

The probabilities of membership for individual specimens can be calculated after transformation of the T^2 statistic into the related, F-value by the expression

$$F = \frac{(n_1 + n_2 - p - 1)}{(n_1 + n_2 - 2)p} T^2$$

where p is the number of elements.

hyperspherical structure A hyperspherical structure is a spherical shape of the data distribution in multi-dimensional space. Any projection of the hyperspherical structure into two or three dimen-

sions will appear as circular or spherical, respectively.

igneous Igneous rocks are those formed by the solidification of magma.

inductively coupled plasma-atomic emission spectroscopy (ICP-AES) This analytical method is essentially the same as atomic absorption spectroscopy (AAS) except that a plasma torch is used at much higher temperatures (8,000 to 10,000 degrees C) used to insure that some of the highly refractory elements are dissociated. A liquid sample is injected into the flame as a solution mixed with argon, the characteristic lines of the different elements in the sample are emitted. Using a computer-controlled detector system, it is possible to perform a scan of the emission spectrum and analyze several elements simultaneously.

inductively coupled plasma-mass spectroscopy (ICP-MS) This analytical method operates similarly to the ICP-AES spectrometer except that a mass spectrometer replaces the detector. With this mode, the individual atoms are separated according to their mass and charge such that they can be individually counted. It allows the analyst to determine the concentrations of individual isotopes of a particular element and measure ratios of specific isotopes. Its sensitivity is greater than ICP-AES and INAA for many elements, and precision is comparable. Up to 70 elements can be determined simultaneously.

instrumental neutron activation analysis (INAA) Instrumental neutron activation analysis is a method of chemical analysis involving the exposure of unknown samples and standards to a neutron flux from a nuclear reactor without the use of chemical separations. The exposure to neutrons produces several short- and long-lived radioactive isotopes that emit characteristic gamma rays. The energies of the emitted gamma rays provide information to identify the constituent elements, while the intensity of the emitted radiation is proportional to the amount of the element present in the sample. Gamma-ray spectroscopy is performed at different times after irradiation to measure isotopes with different half lives. The method is particularly sensitive to a large number of trace, minor, and major elements, including the rare-earth elements, transition metals, and so on.

isotope When an element exists in the form of two or more species with the same number of protons but different numbers of neutrons the different species are called isotopes. Different isotopes of an element exhibit different physical properties that are unique to each isotope.

k-means clustering K-means clustering is one of the most widely used clustering techniques by which clusters are formed by minimizing the variation within groups of specimens in the data set. Following an initial partitioning of the data set, specimens located nearest the cluster centroids are reallocated and the centroids are recalculated. Specimens are iteratively moved from cluster to cluster to find the best possible allocation until there are no additional changes in the cluster membership.

linear regression The best-fit straight line to data points on a scatter plot is called a linear regression.

log-normal distribution A distribution whose logarithm follows a normal distribution.

Mahalanobis distance The Mahalanobis distance, D^2, is the squared Euclidean distance between the centroid of group cluster and a specimen k divided by the group variance-covariance in that direction. Mathematically, the Mahalanobis distance is calculated from the expression

$$D_{k,A}^2 = \sum_{i=1}^{N} \sum_{j=1}^{N} (C_{ik} - A_i) \, I_{ij} \, (C_{jk} - A_j)$$

where A_i and A_j are the mean concentrations of elements i and j in the cluster and I_{ij} is the ijth element of the inverse variance-covariance matrix. The Mahalanobis distance statistic incorporates information about the correlations between the different pairs of elements as derived by the off-diagonal terms of the variance-covariance matrix, which the simple Euclidean distance measure does not. Thus, it permits calculation of the probability that a particular specimen belongs to a group based not only on its proximity to the group centroid in Euclidean terms but also on the rate at which the density of data points decreases from the group centroid to the specimen. For a random sample, drawn from a multivariate normal population, Mahalanobis distances are distributed as Hotelling's T^2.

major elements The major elements are those which predominate in any compositional analysis of a geochemical specimen. The most common major elements are Na, Mg, Al, Si, P, K, Ca, Ti, and Fe and their concentrations are usually expressed in weight percent. Geochemists often report the concentrations of these elements as oxides, with iron having two forms (that is, FeO and Fe_2O_3).

metamorphic Solid rocks that have been formed by physical and chemical processes other than weathering and cementation are metamorphic.

microanalysis The analysis of mineral grains in a specimen on a microscopic scale with an electron microprobe is known as microanalysis.

mineral A mineral is a naturally-occurring inorganic element or compound with an orderly crystalline structure and characteristic composition.

multivariate data analysis Multivariate data analysis is a analytical approach where many characteristics about several samples are measured in order to determine the interaction(s) between many variables simultaneously.

neutron Neutrons are uncharged particles with a mass nearly equal to that of a proton and are present in all known atomic nuclei except the hydrogen nucleus. Although an unbound neutron has a half life of approximately 11 minutes, the vast majority of neutrons will activate (or be captured by) atomic nuclei before radioactive decay of the neutron can occur. See *instrumental neutron activation analysis.*

normal distribution A Gaussian- or bell-shaped distribution curve that is symmetrical about the arithmetic mean.

outlier Specimens that lie far away from the bell-shaped distribu-

tion are called outliers. Outliers have a large effect on the mean value of a distribution but no effect on the median.

parts per million (ppm) The term parts per million is used to expressed the concentration by weight of a highly dilute element or compound in a specimen. A concentration of one part per million is equivalent to 1 microgram of the element present in a sample weighing 1 gram.

petrography Petrography is that branch of geology dealing with the description and systematic classification of rocks, especially igneous and metamorphic rocks and especially by means of microscopic examination of thin sections.

precision Precison (or reliability) refers to the reproducibility of a measurement or series of measurements of a value. The standard deviation is a measure of the precision relative to the mean. For a normal distribution around the mean, 68% of the measurements are within one-sigma, 95% of the measurements are within two-sigma, and 99% of the measurements are within three-sigma.

primary clay (residual clay) A primary clay is formed in place by the weathering of rocks from either the chemical decay of feldspar and other rock minerals or from the removal of nonclay mineral constitutents from clay-bearing rock (for example, argillaceous limestone).

principal components analysis (PCA) Principal components analysis is an exploratory technique for reducing the dimensionality of multivariate data similar to factor analysis. In PCA, a set of linear tranformations based on eigenvector methods is performed to determine the direction and magnitude of maximum variance of the compositional data set in hyperspace. The first principal component (PC) is a linear transformation of the original variables (element concentrations) and is oriented in the direction of maximum variance. The second PC is calculated to lie in the direction of maximum remaining variance, with the additional constraint that it must be perpendicular to the first PC. The third PC lies in the direction of maximum variance after the variance attributed to the second PC is removed and is orthogonal to the first two PCs. The procedure continues until the number of PCs is equal to the number of original variables. If a few PCs account for a high proportion of the variance, then the remainder may be discarded and this reduces the number of variables (PCs) that have to be considered to observe structure in the data set. In addition, biplots showing both sample scores and vectors of the element coefficients are frequently used to interpret which elements contribute to differentiation between sample groups. In PCA, the linear transformations of the p variables (element concentrations) are of the form

$$P_i = a_{i1}C_1 + a_{i2}C_2 + ... + a_{ip}C_p$$

for $i = 1,..., p$. Additional requirements that

$$a_{i1}^2 + a_{i2}^2 + ... + a_{ip}^2 = 1$$

and

$$a_{j1}a_{i1} + a_{j2}a_{i2} + ... + a_{jp}a_{ip} = 0$$

ensure that the calculated principal components are uncorrelated. In general, PCA is computed after standardization or transformation of the original compositional data set to logarithms to reduce the weighting of high concentration elements relative to trace elements in the data set.

proton The proton is a positively-charged nuclear particle identical to the nucleus of a hydrogen atom.

provenance Provenance refers to the place(s) of geographic origin for the constitutent material(s) used to produce archaeological ceramics.

provenance postulate The provenience postulate states that chemical analysis can successfully trace artifacts to their sources if the differences in chemical composition between different natural sources that exceed, in some recognizable way, the differences observed within a given source.

provenience Provenience refers to the location where an artifact or sherd was discovered.

qualitative analysis Qualitative analysis is a study of the identity of the components in a substance. The analysis usually involves two stages: sampling and identification of the components present.

quantitative analysis Quantitative analysis involves the determination of the amounts of each component in a substance. The analysis usually entails the following steps: sampling and determination of the amount of each component present in the sample in absolute terms. A semi-quantitative analysis occurs when the amounts of all other components are quoted relative to a single component.

radiation See electromagnetic radiation.

radioactive decay The disintegration of nuclei of radioactive atoms into other atoms is known as radioactive decay. The decrease in the number of radioactive atoms of a particular species with time is related to the half life of the particular radioisotope. See half life.

rare-earth elements (REE) The rare-earth elements (REE) are a series of fifteen metallic elements with atomic numbers from 57 through 71 (that is, La, Ce, Pr, Nd, Pm, Sm, Eu, Gd, Tb, Dy, Ho, Er, Tm, Yb and Lu). The concentrations of the rare earths are usually at the parts per million level and their behavior is similar due to a common state of oxidation. The rare earths are significant constitutents of certain minerals, especially monazite, bastnaesite, and xenotime.

reference group A reference group is a homogeneous collection of specimens with a single provenance against which unknown specimens can be compared for possible membership.

regression analysis Regression analysis is a statistical technique applied to paired data to determine the degree or intensity of mutual association of a dependent variable with one or more independent variables.

reliability The extent to which a series of repeated measurements will produce the same result.

scanning electron microscope (SEM) A scanning electron microscope builds an image of a specimen being examined by moving a finely focused beam of electrons across the surface of the sample. The electron beam moves from point to point, repeatedly, and the

reflected and emitted electron intensities are measured to sequentially build an image.

secondary clay A secondary clay is one that has been transported from its place of formation and redeposited.

sensitivity A measure of the ability to detect an element or isotope by the analytical method being employed. The lower limit of detection for an element or isotope is a measure of its sensitivity.

standard comparator technique A standard comparator technique is an analytical technique where the concentrations of unknowns are determined relative to standards whose concentrations have been certified by a variety of analytical methods.

standard deviation The standard deviation is a measure of the spread of a distribution's values about the mean. The standard deviation is calculated from the square root of the variance as follows

$$\sigma = \frac{\left(\sum_{i=1}^{N} (C_i - A)^2 \right)^{1/2}}{N - 1}$$

For a normally distributed set of numbers, 68% of them are less than one standard deviation different from the mean, 95% are less than two standard deviations different from the mean, and 99% are less than three standard deviations from the mean.

standard reference material A standard reference material (SRM) is a material which has been well-characterized by a number of replicate analytical procedures such that the concentrations of elements in the standard are well known. Federal agencies such as the National Institute of Standards and Technology (NIST) and United States Geological Survey (USGS) have been responsible for producing a number of SRMs used as reference standards during analysis of archaeological, environmental, and geological unknowns.

temper Temper is a modifier such as bone, shell, sand, or pottery which when mixed with clay and water, kneaded into a uniform texture and fired, produces a finished ceramic that is stronger and more resilient.

transition metals The transition metals are elements with atomic numbers ranging from 21 to 30 that generally exhibit a similar geochemical behavior. The specific elements included are Sc, Ti, V, Cr, Mn, Fe, Co, Ni, Cu and Zn. With the exception of Mn and Fe, the transition metals usually have abundances at the parts per million level.

trace element A trace element is defined as an element which is present at concentrations of less than less than 1000 parts per million (that is, 0.1 weight percent). Trace elements will sometimes form mineral species of their own but more commonly they are substitutes for major elements in different rock-forming minerals.

t test The *t* test or Student's *t* is a test of membership significance based on the *t* distribution, which is similar to the normal distribution, but depends upon the number of samples in the distribution. If the number of samples in the distribution is infinite, then the *t* and normal distributions are identical. The *t* test can be used to establish the likelihood that an individual sample could be a member of a hypothetical population with specific characteristics or to test the equivalency of two pools of samples. For a single sample compared

to a certain population of samples, the *t* statistic is calculated from

$$t = \frac{\overline{X} - \mu_0}{\sigma \sqrt{1 / N}}$$

where \overline{X} is the mean of the sample, μ_0 is the hypothetical mean of the population, N is the number of observations and σ is the standard deviation.

On the other hand, the two-sample *t* test evaluates the difference in means between two sample populations in light of the pooled standard deviations of both samples. The pooled estimate of the standard deviation for the two sample populations is given by the expression

$$s_p = \sqrt{\frac{(N_1 - 1)s_1^2 + (N_2 - 1)s_2^2}{N_1 + N_2 - 2}}$$

where s_p is the pooled standard deviations for the two samples, N_1 and N_2 are the number of samples in each sample population, and s_1 and s_2 are the sample standard deviations. The pooled standard error (SE_p) is given by

$$SE_p = s_p \sqrt{\frac{1}{N_1} + \frac{1}{N_2}}$$

From the pooled standard error, it is possible to calculate the number of pooled standard errors of difference between sample means from

$$t = \frac{\overline{X_1} - \overline{X_2}}{SE_p}$$

variance The variance is a parameter that quantifies the deviation of individual sample values about a mean. Mathematically, the variance may be regarded as the average squared deviation of all possible observations from the sample mean, and is defined by the equation

$$\sigma^2 = \frac{\sum_{i=1}^{N} (C_i - A)^2}{N} = \frac{N \sum_{i=1}^{N} C_i^2 - (\sum_{i=1}^{N} C_i)^2}{N(N-1)}$$

where C_i and A represent the individual sample values and the mean value for the distribution, respectively. The variance will be zero if and only if each and every case in the distribution shows exactly the same score (that is, the mean). The more that cases tend to differ from each other and the mean, the larger the variance will be. The measured variance, σ_m^2, represents the sum of the 'natural' variance, σ_n^2, and the variance due to sampling and other analytical errors, σ_a^2 as defined by the equation

$$\sigma_m^2 = \sigma_n^2 + \sigma_a^2$$

which is equal to the square of the standard deviation, σ_m, of the measured mean.

variance-covariance matrix The variance-covariance matrix is the matrix of covariances between all pairs of measured variables in a study. See covariance.

weak-acid extraction technique A sample preparation technique on ceramic sherds suggested by Burton and Simon (1993) for analysis by ICP-AES. Sherds are crushed and allowed to stand in a weak acid solution for several weeks, after which the acid extract is analyzed.

X-ray diffraction X-ray diffraction (XRD) is a technique by

which a beam of X-rays is diffracted by a crystalline substance. The geometry of the diffraction pattern is a function of the lattice dimensions of the periodic array of atoms in the crystal. The intensities of the diffracted X-rays provide information to determine the atomic arrangement and unit-cell dimensions.

X-ray fluorescence analysis X-ray fluorescence (XRF) is an analytical technique used to measure the composition of materials by using X-rays of short wavelength to induce emission of X-rays of longer wavelength (or lower energy).

Z-number See atomic number.

Z scores (standard scores) *Z* scores or standard scores are calculated by subtracting the mean from every number in a group of numbers and then dividing by the standard deviation as follows. Individual *Z* scores are then calculated according to the equation

$$Z = \frac{X - \mu_0}{\sigma}$$

where X is the observed value, μ_0 and σ are the population mean and standard deviation, respectively. As a result, Z scores tell how many standard deviations from the mean an observation differs.

Bibliography

Abascal, M.R., G. Harbottle, and E.V. Sayre

1974 Correlation between terra cotta figurines and pottery from the Valley of Mexico and source clays by neutron activation analysis. In *Archaeological chemistry*, edited by C.W. Beck, 81-91. Washington, DC: American Chemical Society.

Abbott, D.R.

1985 Spheres of intra-cultural exchange and the ceramics of the Salt-Gila aqueduct project. In *Proceedings of the 1983 Hohokam symposium*, Part II, edited by A.E. Dittert, Jr. and D.E. Dove, 419-438. Occasional paper no. 2. Phoenix: Arizona Archaeological Society.

1994a Hohokam social structure and irrigation management: the ceramic evidence from the central Phoenix basin. Ph.D. dissertation, Department of Anthropology, Arizona State University. Tempe.

1994b *The Pueblo Grande Project, Vol. 3: Ceramics and the production and exchange of pottery in the central Phoenix Basin*. Soil Systems Publications in Archaeology No. 20. Phoenix: Soil Systems, Inc.(editor).

2000 *Ceramics and community organization among the Hohokam*. Tucson: University of Arizona Press.

Abbott, D.R., D.M. Schaller, and R.I. Birnie

1991 Compositional analysis of Hohokam pottery from the Salt River valley, Arizona. Paper presented at the 62nd Annual Meeting of the Southwestern Anthropological Association, Tucson.

Abbott, D.R., and M. E. Walsh-Anduze

1995 Temporal patterns without temporal variation: The paradox of Hohokam red ware ceramics. In *Ceramic production in the American Southwest*, edited by B.J. Mills and P.L. Crown, 88-114. Tucson: University of Arizona Press.

Abbott, P.L.

1985 *On the manner of deposition of the Eocene strata in northern San Diego County*. San Diego: San Diego Association of Geologists.

Adams, E.C.

1991 *The origin and development of the Pueblo Katsina cult*. Tucson: University of Arizona Press.

1996 The Pueblo III-Pueblo IV transition in the Hopi area, Arizona. In *The prehistoric Pueblo world A.D. 1150-1350*, edited by

M.A. Adler, 48-58. Tucson: University of Arizona Press.

1998 Late prehistory in the middle Little Colorado River area, a regional perspective. In *migration and reorganization: The Pueblo IV period in the American southwest*, edited by K.A. Spielmann, 53-64. Arizona State University Anthropological Papers, No. 53. Arizona State University: Tempe.

Adams E.C., and K.A. Hays, eds.

1991 *Homol'ovi II: archaeology of an ancestral Hopi village, Arizona*. Anthropological Paper 55. Tucson: University of Arizona.

Adams, J.L.

1994 The development of grinding stone technology in the Point of Pines region, east-central Arizona. Ph.D. Department of Anthropology, University of Arizona, Tucson.

1995 The ground stone assemblage: The development of a grinding technology in the eastern Tonto Basin. In *The Roosevelt Community Development Study*. Vol. 1: *Stone and shell artifacts*, edited by M.D. Elson and J.J. Clark, 43-114. Anthropological Papers No. 14. Tucson: Center for Desert Archaeology.

Adler, M.A., ed.

1996 *The prehistoric Pueblo world, A.D. 1150-1350*. Tucson: University of Arizona Press.

Ahrens, L.H.

1965 *The distribution of elements in our planet*. New York: McGraw-Hill.

Aitchison, J.A.

1986 *The statistical analysis of compositional data*. London: Chapman and Hall.

Akers, J.P.

1964 *Geology and ground water in the central part of Apache County, Arizona*. Geological Survey Water-Supply Paper 1771. Washington, D.C., U.S. Government Printing Office.

Alden, J.R.

1982 Marketplace exchange as indirect distribution: an Iranian example. In *Contexts for prehistoric exchange*, edited by J.E. Ericson and T.K. Earle, 83-101. London: Academic Press.

Aldenderfer, M.S. and R.K. Blashfield

1984 *Cluster analysis*. Quantitative applications in the social sciences, No. 44. Beverly Hills, CA: Sage Publications.

Allen, J.
1984 Pots and poor princes: A multidimensional approach to the role of pottery trading in coastal Papua. In *The many dimensions of pottery: Ceramics in archaeology and anthropology*, edited by S.E. van der Leeuw and A.C. Pritchard, 408-463. Amsterdam: Albert Egges van Giffen Instituut voor Prae-en Protohistorie, Universiteit van Amsterdam.

Ames, K.M.
1995 Chiefly power and household production on the northwest coast. In *Foundations of social inequality*, edited by T.D. Price and G.M. Feinman, 155-187. New York: Plenum Press.

Anderberg, M.R.
1973 *Cluster analysis for applications*. New York: Academic Press.

Anthony, D.W.
1990 Migration in archaeology: The baby and the bathwater. *American Anthropologist* 92(4):895-914.

Antieau, J.M., and R.C. Pepoy
1981 Ceramic analysis. In *The Palo Verde Archaeological Investigations: Hohokam settlement at the confluence: Excavations along the Palo Verde Pipeline*, by J.M. Antieau, 21-36. Research Paper 20. Flagstaff: Museum of Northern Arizona.

Aptech Systems, Inc.
1994 Gauss system and graphics manual. Maple Valley, WA: Aptech Systems, Inc.

Arnold, D.E.
1975 Ecological variables and ceramic production: towards a general model. In *Primitive art and technology*, edited by J.S. Raymond, B. Levoseth, C. Arnold, and G. Reardon, 92-108. Calgary: University of Calgary.
1981 A model for the identification of nonlocal ceramic distribution: View from the present. In Production and distribution: A ceramic viewpoint, edited by H. Howard and E.L. Morris, 31-44. *BAR International Series* 120. Oxford: British Archaeological Reports.
1985 *Ceramic theory and culture process*. New York: Cambridge University Press.

Arnold, D.E., H. Neff, and R.L. Bishop
1991 Compositional analysis and "sources" of pottery: An ethnoarchaeological approach. *American Anthropologist* 93:70-90.

Aronson, M., J. Skibo, and M.T. Stark
1994 Production and use technologies in Kalinga pottery. In *Kalinga ethnoarchaeology: Expanding archaeological method and theory*, edited by W.A. Longacre and J. M. Skibo, 83-111. Washington, D.C.: Smithsonian Institution Press.

Baker, C.L.
1915 *Geology and ground-water resources of the Northern High Plains of Texas, progress report No. 1*. Texas Board of Water Engineers Bulletin No. 6109. Austin: Texas Board of Water Engineers.

Baldwin, G.C.
1950 Pottery of the Southern Paiute. *America Antiquity* 16:50-56.

Banks, T.J.
1972 A late mountain Dieguen̄o site. *Pacific Coast Archaeological Society Quarterly* 8:47-59.

Barceló, C., V. Pawlowsky, and E. Grunsky
1995 Classification problems of samples of finite mixtures of compositions. *Mathematical Geology* 27(1):129-148.

Barter, E.R.
1957 Pottery of the Reserve area. *Fieldiana* 49(1): 89-125.

Barton, C.M.
1983 *Archaeological survey in Northeastern Death Valley National Monument*. Western Archaeological and Conservation Center Publications in Anthropology 23. Tucson: National Park Service.

Basgall, M.E.
1989 Obsidian acquisition and use in prehistoric central eastern California: A preliminary assessment. In *Current directions in California obsidian studies*, edited by R.E. Hughes, 111-126. Contributions of the University of California Archaeological Research Facility 48, Berkeley: Department of Anthropology, University of California.

Bates, R.L., and J.A. Jackson, eds.
1984 *Dictionary of geological terms*. 3d ed. Garden City, NY: Anchor Press.

Bateson, G.
1979 *Mind and nature: A necessary unity*. New York: E. P. Dutton.

Baugh, T.G.
1986 Culture history and protohistoric societies in the Southern Plains. In Current trends in Southern Plains archeology, edited by T.G. Baugh, 167–187. *Plains Anthropologist* 31(114, Pt. 2) Memoir 21.

Baxter, M.J.
1989 The multivariate analysis of compositional data in archaeology: A methodological note. *Archaeometry* 31:45-53.
1991 An empirical study of principal component and correspondence analysis of glass compositions. *Archaeometry* 33:29-41.
1992a Archaeological uses of the biplot–a neglected technique? In *Computer applications and quantitative methods in archaeology, 1991*, edited by G. Lock and J. Moffett, 141-148. BAR International Series S577. Oxford: Tempvs Reparatvm, Archaeological and Historical Associates.
1992b Statistical analysis of chemical compositional data and the comparison of analyses. *Archaeometry* 34:267-277.
1993 Comment on D. Tangri and R.V.S. Wright, "Multivariate analysis of compositional data ..." *Archaeometry* 35(1):112-115.
1994a *Exploratory multivariate analysis in archaeology*. Edinburgh: Edinburgh University Press.
1994b Stepwise discriminant analysis in archaeometry: A critique. *Journal of Archaeological Science* 21:659-666.

Baxter, M.J. and M.P. Heyworth
1991 Comparing correlation matrices: With applications in the study of artefacts and their chemical compositions. In *Archaeometry '90*, edited by E. Pernicka and G.A. Wagner, 355-364. Basel: Birkhauser Verlag.

Bayman, J.M.
1992 The circulation of exotics in a Tucson basin platform mound community. In *Proceedings of the Second Salado Conference, Globe, AZ 1992*, edited by R.C. Lange and S. Germick, 31-37. Phoenix: Arizona Archaeological Society.
1994 Craft production and political economy at the Marana platform mound community. Ph.D. dissertation, Department of Anthropology, Arizona State University, Tempe.

Beckett, T.H.
1958 Two pottery techniques in Morocco. *Man* 251:185-188.

Beier, T. and Mommsen, H.

1994 Modified Mahalanobis filters for grouping pottery by chemical composition. *Archaeometry* 36:287-306.

Bellido Bernedo, A.V.

1989 Neutron activation analysis of ancient Egyptian pottery. Ph.D. dissertation, Department of Chemistry, University of Manchester.

Benfer, R.A. and A.N. Benfer

1981 Automatic classification of inspectional categories: multivariate theories of archaeological data. *American Antiquity* 46:381-396.

Bettinger, R.L.

1986 Intersite comparison of Great Basin brown ware assemblages. In *Pottery of the Great Basin and adjacent areas*, edited by S. Griset, 97-105. Anthropological Papers, No. 111. Salt Lake City: University of Utah.

Bey, G.J. III, and C.A. Pool

1992 *Ceramic production and distribution: an integrated approach.* Boulder, CO: Westview Press.

Bezdek, J.C.

1981 *Pattern recognition with fuzzy objective function algorithms.* New York: Plenum Press.

Bieber, A.M. Jr., D.W. Brooks, G. Harbottle, and E.V. Sayre

1976 Application of multivariate techniques to analytical data on Aegean ceramics. *Archaeometry* 18:59-74.

Bikerman, M.

1967 Isotopic studies in the Roskruge Mountains, Pima County, Arizona. *Geological society of America Bulletin* 78:1029-1036.

Bishop, R.L.

1975 Western Lowland Maya ceramic trade: An archaeological application. Ph.D. dissertation, Department of Anthropology, Southern Illinois University, Carbondale.

1980 Aspects of ceramic compositional modeling. In *Models and methods in regional exchange*, edited by R.E. Fry, 47-66. SAA Papers No. 1. Washington, D.C.: Society for American Archaeology.

1987 Appendix E: Ceramic paste compositional chemistry: Initial observations of variation in the Tucson Basin. In *The archaeology of the San Xavier Bridge site (AZ BB:13:14) Tucson Basin, southern Arizona,* part 3, edited by J.C. Ravesloot. Archaeological Series 171, 395-408, Cultural Resource Management Division, Arizona State Museum, Tucson: University of Arizona.

Bishop, R.L., V. Canouts, S.P. DeAtley, A. Qoyawayma, and C.W. Aikins

1988 The formation of ceramic analytical groups: Hopi pottery production and exchange, AC 1300-1600. *Journal of Field Archaeology* 15:317-337.

Bishop, R.L. and P.L. Crown

1994 Experimental procedures and parameters used in the instrumental neutron activation analysis of the Gila Polychrome ceramics. In *Ceramics and ideology: Salado Polychrome ceramics*, by P. L. Crown, 227-232. Albuquerque: University of New Mexico Press.

Bishop, R.L., G. Harbottle, and E.V. Sayre

1982a Chemical and mathematical procedures employed in the Maya Fine Paste ceramics project. In *Analysis of fine paste ceramics*, edited by J.A. Sabloff, 272-282. Memoirs of the Peabody Museum of Archaeology and Ethnology, Vol. 15, No. 2.

Cambridge. MA: Peabody Museum.

Bishop, R.L. and H. Neff

1989 Multivariate analysis of compositional data in archaeology. *Archaeological chemistry IV*, edited by R.O. Allen, 576-586. Advances in Chemistry Series 220, Washington, D.C.: American Chemical Society.

Bishop, R.L. and R.L. Rands

1982 Maya fine paste ceramics: A compositional perspective In *Analysis of fine paste ceramics*, edited by J.A. Sabloff, 283-314. Memoirs of the Peabody Museum of Archaeology and Ethnology, Vol. 15, No. 2. Cambridge, MA: Peabody Museum.

Bishop, R.L., R.L. Rands, and G.R. Holley

1982b Ceramic compositional analysis in archaeological perspective. In *Advances in archaeological method and theory, vol. 5*, edited by M.B. Schiffer, 275-330. New York: Academic Press.

Bissel, R.M.

1997 Cultural resources research for the Rose Canyon Trunk sewer project. City of San Diego, San Diego County, California.

Blackman, M.J.

1986 Precision in routine INAA over a two-year period as NBSR. In *NBSR reactor summary of activities July 1985 through June 1986*, edited by F. Shorten, 122-126. NBS Technical Note 1231. Washington, D.C.: U.S. Department of Commerce/National Bureau of Standards and Technology.

1992 The effects of natural and human sized sorting on the minerology and chemistry of ceramic clays. In *Chemical characterization of ceramic pastes in archaeology*, edited by H. Neff, 113-124. Madison, WI: Prehistory Press.

Blinman, E. and C.D. Wilson

1992 Ceramic production and exchange during the Basketmaker III and Pueblo I periods in the Northern San Juan region. In *Ceramic production and distribution: an integrated approach*, edited by G.J. Bey III and C.A. Pool, 155 - 173. Boulder, CO: Westview Press.

1993 Ceramic perspectives on northern Anasazi exchange. In *The American Southwest and Mesoamerica*, edited by J.E. Ericson and T.G. Baugh, 65-94. New York: Plenum Press..

Bohannan, P.

1967 The impact of money on an African subsistence economy. In *Tribal and peasant economies: readings in economic anthropology*, edited by G. Dalton, 123-136. Garden City, NY: The Natural History Press.

Boyd, D.K.

1997 *Caprock canyonlands archeology: A synthesis of the late prehistory and history of Lake Alan Henry and the Texas Panhandle-Plains.* Reports of Investigations No. 110. Austin: Prewitt and Associates, Inc.

Boyd, D.K., J. Peck, S.A. Tomka, and K.W. Kibler

1993 *Data recovery at Justiceburg reservoir (Lake Alan Henry), Garza and Kent counties, Texas: Phase III, season 2.* Reports of Investigations No. 88. Austin: Prewitt and Associates, Inc.

Boyd, D.K., and K. Reese-Taylor

1993 Appendix D: Petrographic analysis of ceramic sherds and clay samples. In *Data recovery at Justiceburg Reservoir (Lake Alan Henry), Garza and Kent counties, Texas: Phase III, season 2*, by D.K. Boyd, J. Peck, S.A. Tomka, and K.W. Kibler, 339-378. Reports of Investigation No. 88. Austin: Prewitt and Associates, Inc.

Brand, J.P.
1953 *Cretaceous of the Llano Estacado of Texas.* Report of Investigations No. 20. Austin: Bureau of Economic Geology, University of Texas.

Branstetter-Hardesty, B.
1978 Ceramics of Cerro Portezuelo, Mexico: An industry in transition. Ph.D. dissertation, University of California, Los Angeles.

Breternitz, D.A.
1960 *Excavations at three sites in the Verde Valley.* Flagstaff: Museum of Northern Arizona Bulletin 34.

Breternitz, D.A., J.C. Gifford, and A.P. Olson
1957 Point of Pines phase sequence and utility pottery type revisions. *American Antiquity* 22(4):412-416.

Brewington, R., H. Shafer, and D. James
1997 Continuing neutron activation analysis of Mimbres ceramics: A progress report. In *Proceedings of the ninth Jornada-Mogollon conference*, edited by R. Mauldin, J. Leach, and S. Ruth, 127-130. Publications in Archaeology No. 12. El Paso, TX: Centro de Investigaciones Arqueologicas.

Brooks, D.W., A.M. Bieber, Jr., G. Harbottle, and E.V. Sayre
1974 Biblical studies through activation analysis of ancient pottery. In *Archaeological Chemistry*, edited by C.W. Beck, 48-80. Washington, D.C.: American Chemical Society.

Brumfiel, E. and T.K. Earle
1987 Specialization, exchange, and complex societies: an introduction. In *Specialization, exchange, and complex societies*, edited by E. Brumfiel and T. Earle, 102-118. Cambridge: Cambridge University Press.

Bryan, N.D., L.J. Holmes, and S.M.A. Hoffman
1996 Updating ancient ceramic elemental concentration databases: Bring in the new technique, but without throwing out the old data. Poster presented at the 1996 International Symposium on Archaeometry hosted by the Program of Ancient Technologies on campus of University of Illinois, May 20-24, Urbana, IL.

Bubemyre, T.D.
1993 Implications of ceramic variability at a Hohokam platform mound village. M.A. thesis, Department of Anthropology, University of Arizona, Tucson.

Bubemyre, T. and B.J. Mills
1993 Clay oxidation analysis. In *Across the Colorado Plateau: anthropological studies for the transwestern pipeline expansion project*. Volume 16: *Interpretation of ceramic artifacts*, by B.J. Mills, C.E. Goetze, and M.N. Zedeno, 235-277. Albuquerque: Office of Contract Archaeology and Maxwell Museum.

Burton, J.H. and A.W. Simon
1993 Acid extraction as a simple and inexpensive method for compositional characterization of archaeological ceramics. *American Antiquity* 58:45-59.

1996 A pot is not a rock: A reply to Neff, Glascock, Bishop, and Blackman. *American Antiquity* 61:405-413.

Bykerk-Kauffman, A.
1990 Structural evolution of the northeastern Santa Catalina mountains, Arizona: A glimpse of the pre-extension history of the Catalina complex. Ph.D. dissertation=, Department of Geosciences, University of Arizona, Tucson.

Cable, J.S.
1989 Review of recent research on Tucson Basin prehistory: Proceedings of the second Tucson Basin conference, edited by W.H. Doelle and P.R. Fish. *Arizona Archaeological Council Newsletter* 13(3):7-9.

Cameron, C.M.
1995 Migration and the movement of southwestern peoples. *Journal of Anthropological Archaeology* 14(2):104-124.

Carlson, R.L.
1970 *White Mountain Redware: A pottery tradition of east-central Arizona and western New Mexico.* Anthropological Papers No. 19. Tucson: University of Arizona.

1982 The polychrome complexes. In Southwestern ceramics: a comparative review, edited by A.H. Schroeder. *The Arizona Archaeologist* 15: 210-234. Phoenix: Arizona Archaeological Society.

Carlson, S.B., and W.D. James
1995 An instrumental neutron activation analysis of 18th century lead-glazed earthenwares from four Spanish missions in Texas. *Journal of Radioanalytical and Nuclear Chemistry*, 196(2):207-213.

Carr, J.R.
1990 CORSPOND: A portable FORTRAN-77 program for correspondence analysis. *Computers & Geosciences* 16(3):289-307.

Champion, S.
1980 *Dictionary of terms and techniques in archaeology.* New York: Everest House.

Christenson, A.L.
1995 Non-buffware decorated ceramics and mean ceramic dating. In *The Roosevelt community development study: ceramic chronology, technology, and economics*, Vol. 2, edited by J.M. Heidke and M.T. Stark, 85-132. Anthropological Papers 14. Tucson: Center for Desert Archaeology.

Chronic, H.
1983 *Roadside geology of Arizona.* Missoula, MT: Mountain Press Publishing.

Ciolek-Torrello, R.S., and R.C. Lange
1990 The Gila Pueblo survey of the southeastern Sierra Ancha. *Kiva* 55:127-154.

Clark, J.E., and W.J. Parry
1990 Craft specialization and cultural complexity. *Research in Economic Anthropology* 12:289-346.

Clark, J.J.
1995 The role of migration in social change. In *The Roosevelt development study: New perspectives on Tonto Basin prehistory*, edited by M.D. Elson, M.T. Stark, and D.A. Gregory, 369-384. Anthropological Papers 15. Tucson: Center for Desert Archaeology.

Clark, J.J., and J.M. Vint, eds.
2000 Tonto Creek Archaeological Project: Archaeological investigations along Tonto Creek. Anthropological Papers No. 22. Tucson: Center for Desert Archaeology.

Clemons, R., P. Christiansen, and H.L. James
1980 *Scenic trips to the geologic past no. 10, revised: Southwestern New Mexico.* New Mexico Bureau of Mines and Mineral Resources, Socorro.

Cogswell, J.W., H. Neff, and M.D. Glascock
1996 The effect of firing temperature on the elemental character-

ization of pottery. *Journal of Archaeological Science* 23:283-287.

1998 Analysis of shell-tempered pottery replicates: Implications for provenance studies. *American Antiquity* 63:63-72.

Cogswell, J.W., L.M. Ross, Jr., M.J. O'Brien, H. Neff, and M.D. Glascock

1996 Postmanufacture effects on the chemical characterization of prehistoric pottery: Evidence from the central Mississippi River Valley. 1996 International Symposium on Archaeometry hosted by Program of Ancient Technologies on campus of University of Illinois, May 20-24, Urbana, IL.

Colton, H.S.

1945 The Patayan problem in the Colorado River valley. *Southwestern Journal of Anthropology* 1:114-121.

1953 *Potsherds: An introduction to the study of prehistoric southwestern ceramics and their use in historic reconstruction.* Flagstaff: Museum of Northern Arizona Bulletin 25.

Cook, J.R.

1986 If Tizon could talk. *Casual Papers Cultural Resource Management* 2:85-97.

Cooley, M.E., J.W. Harshbarger, J.P. Akers, and W.F. Hardt

1969 Regional hydrogeology of the Navajo and Hopi reservations, Arizona, New Mexico, and Utah. *Geological survey professional paper 521-A.* Washington, D.C.: U.S. Government Printing Office.

Cooley, W.W. and T. R. Lohnes

1971 *Multivariate data analysis.* New York: John Wiley and Sons.

Cooper, J.R.

1960 *Some geologic features of the Pima mining district, Pima County, Arizona.* Bulletin 1112-C, Washington, D.C.: U.S. Geological Survey.

1971 *Mesozoic stratigraphy of the Sierrita mountains, Pima County, Arizona.* Professional Paper 658-D. Washington, D.C.: U.S. Geological Survey.

Cordell, L.S.

1991 Anna O. Shepard and southwestern archaeology: Ignoring a cautious heretic. In *Ceramic analysis and social inference in American Archaeology: the ceramic legacy of Anna O. Shepard,* edited by R.L. Bishop and F.W. Lange, 132-153. Niwot, CO: University Press of Colorado.

Cordell, L.S., and F. Plog

1979 Escaping the confines of normative thought: A reevaluation of Pueblo prehistory. *American Antiquity* 44(3):405-429.

Corsten, L.C.A. and Gabriel, K.R.

1976 Graphical exploration in comparing variance matrices. *Biometrics* 32:851-863.

Costin, C.L.

1991 Craft specialization: issues in defining, documenting, and explaining the organization of production. In *Archaeological method and theory,* edited by M.B. Schiffer, 1-56. Tucson: University of Arizona Press.

Costin, C.L., and M.B. Hagstrum

1995 Standardization, labor investment, skill and the organization of ceramic production in late prehispanic highland Peru. *American Antiquity* 60(4):619-639.

Craig, D.B.

1988 *Archaeological testing at the Dakota Wash site, AZ AA:16:49 (ASM).* Technical Report No. 88-5. Tucson: Center for Desert Archaeology.

1989 *Archaeological investigations at AA:16:49 (ASM), the Dakota Wash mitigation.* Anthropology Series, Archaeological Report No. 14. Ms. on file, Pima Community College, Tucson.

Creel, D.G.

1991 Bison hides in late prehistoric exchange in the Southern Plains. *American Antiquity* 56(1):40-49.

Crown, P.L.

1981 Variability in ceramic manufacture at the Chodistaas site, east-central Arizona. Ph.D. dissertation, Department of Anthropology, University of Arizona, Tucson.

1994 *Ceramics and ideology: Salado Polychrome pottery.* Albuquerque: University of New Mexico Press.

Crown, P.L. and R.L. Bishop

1991 Manufacture of Gila polychrome in the greater American Southwest: an instrumental neutron activation analysis. In *Homol'ovi II: archaeology of an ancestral Hopi village, Arizona,* edited by E.C. Adams and K.A. Hays, 49-55. Anthropological Papers of the University of Arizona, No. 55, Tucson: University of Arizona.

Crown, P.L., and W.H. Wills

1995 Economic intensification and the origins of ceramic containers in the American Southwest. In *The emergence of pottery: Technology and innovation in ancient societies,* edited by W.K. Barnett and J.W. Hoopes, 241-254. Washington, D.C.: Smithsonian Institution Press.

Culbert, T.P. and L.A. Schwalbe

1987 X-ray fluorescence survey of Tikal ceramics. *Journal of Archaeological Science* 14:635-657.

Cushing, F.H.

1920 *Zuni breadstuff.* Indian Notes and Monographs, vol. 8. (Reprinted in 1974). Museum of the American Indian, New York: Heye Foundation.

Dane, C.H. and G.O. Bachman

1965 *Geologic map of New Mexico.* Washington, D.C.: U.S. Geological Survey.

Davis, E.H.

1967 Diegueno basketry and pottery. *Pacific coast archaeological society quarterly* 3:59-64.

Davis, J.C.

1986 *Statistics and data analysis in geology,* 2nd edition. New York: John Wiley and Sons.

Deal, K. and L. D'Ascenzo

1987 *Archaeological survey of Lower Vine Ranch, Death Valley National Monument.* Western Archaeological and Conservation Center Publications in Anthropology 46. Tucson: National Park Service.

Deaver, W.L.

1984 Pottery. In *Hohokam habitation sites in the northern Santa Rita Mountains,* by A. Ferg, K. C. Rozen, W.L. Deaver, M.D. Tagg, D.A. Phillips Jr., and D.A. Gregory, 237-419. Archaeological Series No. 147. Tucson: Arizona State Museum, University of Arizona.

Deutchman, H.L.

1979 Intraregional interaction on Black Mesa and among the Kayenta Anasazi: the chemical evidence for ceramic exchange. Ph.D. dissertation. Department of Anthropology, Southern Illinois University.

1980 Chemical evidence of ceramic exchange on Black Mesa. In *Models and methods in regional exchange*, edited by R.E. Fry, 119-131. SAA Papers No. 1. Washington, D.C.: Society for American Archaeology.

Dickinson, W.R.

1970 Interpreting detrital modes of graywacke and arkose. *Journal of Sedimentary Petrology* 40:695-707.

1971a Temper sands in Lapita-style potsherds on Malo. *Journal of the Polynesian Society* 80:244-246.

1971b Petrography of some sand tempers in prehistoric pottery from Viti Levu, Fiji. *Fiji Museum Records* 1:107-121.

1992 *Geologic map of the Catalina Core Complex and San Pedro Trough.* Contributed Map CM-92-C, Tucson: Arizona Geological Survey.

Dickinson, W.R., and R. Shutler Jr.

1979 Petrography of sand tempers in Pacific Islands potsherds. *Geological Society of America, Bulletin* No. 90. Part I (summary), 993-995; Part II (microfiche), No. 11, Card 1, 1644-1701.

Di Peso, C.C.

1958 *The Reeve Ruin of southeastern Arizona: a study of a prehistoric western Pueblo migration into the middle San Pedro Valley.* Dragoon, AZ: Amerind Foundation Paper No. 8.

Dobyns H. and R. Euler

1958 Tizon brownware, a descriptive revision. In *Pottery types of the Southwest, No. 3D.* edited by H.S. Colton, 1-13. Flagstaff: Northern Arizona Society of Science and Art.

Doelle, W.H.

1995 Tonto Basin demography in a regional perspective. In *The Roosevelt community development study: new perspectives on Tonto Basin prehistory*, edited by M.D. Elson, M.T. Stark, and D.A. Gregory, 201-226. Anthropological Papers No. 15. Tucson: Center for Desert Archaeology.

Doelle, W.H., and H.D. Wallace

1991 The changing role of the Tucson Basin in the Hohokam regional system. In *Exploring the Hohokam: prehistoric desert peoples of the American Southwest*, edited by G.J. Gumerman, 279-345. Albuquerque: University of New Mexico Press.

Doran, J.E. and F.R. Hodson

1975 *Mathematics and computers in archaeology.* Edinburgh University Press, Edinburgh.

Douglas, J.E.

1991 *Excavations at the Salida del Sol site (AZ AA:16:44 [ASM]), a Classic period Hohokam village in the southern Tucson Basin*, by J.E. Douglas. Anthropology Series, Archaeological Field Report No. 15. Tucson: Center for Archaeological Field Training, Pima Community College.

Douglass, A.

1991 *Prehistoric exchange and sociopolitical development in the Plateau Southwest.* New York: Garland Publishing Inc.

Downum, C.E.

1993 *Between desert and river: Hohokam settlement and land use in the Los Robles community.* Anthropological papers no. 57. Tucson: The University of Arizona Press.

Doyel, D.E.

1991 Hohokam cultural evolution in the Phoenix Basin. In *Exploring the Hohokam: prehistoric desert peoples of the American Southwest*, edited by G.J. Gumerman, 231-278. Albuquerque:

University of New Mexico Press.

Drewes, H.

1972 *Structural geology of the Santa Rita Mountains, southeast of Tucson, Arizona.* Professional Paper 748, Washington, D.C.: U.S. Geological Survey.

DuBois, C.G.

1907 Diegueno mortuary ollas. *American Anthropologist* 9:484-486.

Duff, A.I.

1998 The process of migration in the prehistoric southwest. In *Migration and reorganization: The Pueblo IV period in the American southwest*, edited by K.A. Spielmann, 31-53. Anthropological Research Papers 51. Arizona State University, Tempe.

1999 Regional interaction and the transformation of western Pueblo identities, AD 1275-1400. Ph.D. dissertation, Department of Anthropology, Arizona State University, Tempe.

Dulaney, A.R.

1988 Petrographic analysis of selected ceramics from the Tucson aqueduct project, Pinal County, Arizona. In *Hohokam settlement along the slopes of the Picacho Mountains*, edited by M.M. Callahan, 323-358. Research Paper No. 35, Vol. 4. Flagstaff: Museum of Northern Arizona.

Dunnell, R.C.

1982 Science, social science, and common sense: the agonizing dilemma of modern archaeology. *Journal of Anthropological Research* 38:1-25.

Earle, T.K.

1982 Prehistoric economics and the archaeology of exchange. In *Contexts for Prehistoric Exchange*, edited by J.E. Ericson and K.T. Earle, 1-12. New York: Academic Press.

Eerkens, J.W.

2001 The origins of pottery among late prehistoric hunter-gatherers in California and the Western Great Basin. Ph.D. dissertation. Department of Anthropology, University of California, Santa Barbara.

Eerkens, J.W., H. Neff, and M.D. Glascock

1998 A new look at intermountain brownwares: chemical sourcing of western Great Basin ceramics using Neutron Activation Analysis. Paper Presented at the Great Basin Anthropological Conference, October 8-10, Bend, Oregon.

Ekren, E.B. and F.N. Houser

1965 *Geology and petrology of the Ute Mountains Area, Colorado.* Geological survey professional Paper No. 481. Prepared on behalf of the US Atomic Energy Comission. Washington D.C.: U.S. Government Printing Office.

Elson, M.D., and D.B. Craig, eds.

1992 *The Rye Creek Project: Archaeology in the upper Tonto Basin.* Anthropological Papers No. 11. Tucson: Center for Desert Archaeology.

Elson, M.D., D.A. Gregory, and M.T. Stark

1995a New perspectives on Tonto Basin prehistory. In *The Roosevelt community development study: New perspectives on Tonto Basin prehistory*, edited by M.D. Elson, M.T. Stark, and D.A. Gregory, 441-479. Anthropological Papers No. 15. Tucson: Center for Desert Archaeology.

Elson, M.D., and M. Lindeman

1994 Locus B. In *The Roosevelt community development study: Vol. 2. Meddler Point, Pyramid Point, and Griffin Wash sites*, by M.D. El-

son, D.L. Swartz, D.B. Craig, and J.J. Clark, 374-395. Anthropological Papers No. 13. Tucson: Center for Desert Archaeology.

Elson, M.D., M.T. Stark, and D.A. Gregory, eds.

1995b *The Roosevelt community development study: new perspectives on Tonto Basin prehistory.* Anthropological Papers No. 15. Tucson: Center for Desert Archaeology.

Elston, W.

1957 *Geology and mineral resources of Dwyer quadrangle, Grant, Luna, and Sierra counties, New Mexico.* Bulletin 38, Socorro: State Bureau of Mines and Mineral Resources, New Mexico Institute of Mining and Technology.

Ennes, M.

1996 Report on petrographic analysis of Chupadero Black-on-white ceramics from the Palomas site and Old Town, South-central and Southwestern New Mexico. Unpublished manuscript on file in the Old Town Project files at the Texas Archaeological Research Laboratories, Austin.

Escoufier, Y., and S. Junca

1986 Review of some useful extensions of the usual correspondence analysis approach and the usual log-linear models approach in the analysis of contingency tables, by L.A. Goodman. *International Statistical Review* 54(3):243-309.

Euler, R.

1959 Comparative comments on California pottery. In *University of California, Los Angeles, archaeological survey annual report 1958-1959*, edited by C.W. Meighan, 41-42. Berkeley: University of California Archaeology Survey, Department of Anthropology, University of California.

Everitt, B.S.

1979 Unresolved problems in cluster analysis. *Biometrics* 35: 169-181.

1993 *Cluster analysis*, third edition. London: Edward Arnold.

Feinman, G., S. Upham, and K. Lightfoot

1981 The production step measure: an ordinal index of labor input in ceramic manufacture. *American Antiquity* 46(4):871-874.

Findlow, F.J. and M. Bolognese

1982 Regional modeling of obsidian procurement in the American Southwest. In *Contexts for prehistoric exchange*, edited by E. Ericson and T.K. Earle, 53-82. New York: Academic Press.

Fish, S.K. and P.R. Fish

1990 An archaeologial assesment of ecosystems in the Tucson basin of southern Arizona. In *The ecosystem approach in anthropology: From concept to practice*, edited by E. Moran, 159-190. Ann Arbor: University of Michigan Press.

Fish, P.R., S.K. Fish, C. Brennan, D. Gann, and J. Bayman

1992a Marana: Configuration of an early Classic period Hohokam platform mound site. In *Proceedings of the Second Salado Conference, Globe, AZ, 1992*, edited by R.C. Lange and S. Germick, 62-68. Phoenix: Arizona Archaeological Society.

Fish, S.K., P.R. Fish, and J. Madsen

1989 Differentiation and integration in a Tucson basin Classic period Hohokam community. In *The Sociopolitical structure of prehistoric southwestern societies*, edited by S. Upham, K. Lightfoot, and R. Jewett, 237-267. Boulder, CO: Westview Press.

1992 Evolution and structure of the classic period Marana community. In *The Marana community in the Hohokam world*, edited by

S.K. Fish, P.R. Fish, and J.H. Madsen, 20-40. Anthropological papers no. 56. Tucson: University of Arizona Press.

Fish, P.R., S.K. Fish, S. Whittlesey, H. Neff, M.D. Glascock, and J.M. Elam

1992b An evaluation of the production and exchange of Tanque verde red-on-brown ceramics in southern Arizona. In *Chemical characterization of ceramic pastes in archaeology*, edited by H. Neff, 233-254. Monographs in World Archaeology No. 7. Madison: Prehistory Press.

Forbes, J.D.

1965 *Warriors of the Colorado: The Yumas of the Quechan nation and their neighbors.* Norman: University of Oklahoma Press.

Fournier, D.M.

1988a Ceramic petrographic analysis. In *Excavations at Casa Buena: Changing Hohokam land use along the Squaw Peak Parkway*, edited by J.B. Howard, 1041-1054. Soil Systems Publications in Archaeology No. 11. Phoenix: Soil Systems, Inc.

1988b Ceramic petrographic analysis. In *Excavations at La Lomita Pequeña: A Santa Cruz/Sacaton phase hamlet in the Salt River Valley*, edited by D.R. Mitchell, B.1-B.11. Soil Systems Publications in Archaeology No. 10. Phoenix: Soil Systems, Inc.

1989a Petrographic analysis of Wingfield Plain sherds. In *Settlement, subsistence, and specialization in the northern periphery: The Waddell project*, Vol. 1, edited by M. Green, 583-589. Cultural Resources Report No. 65. Tempe: Archaeological Consulting Services, Inc.

1989b The results of the petrographic analysis of 86 prehistoric sherds from sites AZ T:12:14 (ASU) and AZ T:12:16 (ASU). In *Archaeological investigations at the Grand Canal Ruins: A Classic period site in Phoenix, Arizona*, edited by D.R. Mitchell, 965-975. Soil Systems Publications in Archaeology No. 12. Phoenix: Soil Systems, Inc.

Fournier, D.M., and D.E. Doyel

1985 Petrographic analysis of New River ceramics. In *Hohokam settlement and economic systems in the central New River drainage, Arizona*, edited by D.E. Doyel and M.D. Elson, 769-777. Soil Systems Publications in Archaeology No. 4. Phoenix: Soil Systems, Inc.

Gabriel, K.R.

1971 The biplot–graphic display of matrices with application to principal component analysis. *Biometrika* 58: 453-467.

Gallegos, D., C. Kyle, and R. Carrico

1989 Village of Ystagua (Rimbach SDi-4513) testing, significance, and management. San Diego: ERCE Environmental and Energy Services.

García-Heras, M.

1993 Deposiciones invisibles: micro-procesos de calcitización post-deposicional en cerámicas celtibéricas. *Procesos postdeposicionales, arqueología espacial* 16-17:391-406.

García-Heras, M., R. Fernandez-Ruiz, and J.D. Tornero

1997 Analysis of archaeological ceramics by TXRF and contrasted with INAA. *Journal of Archaeological Science* 24:1003-1014.

Garrett, E.M.

1982 A petrographic analysis of ceramics from Apache-Sitgreaves National Forests, Arizona: Onsite or specialized manufacture? Ph.D. dissertation, Department of Science Education, Kalamazoo: Western Michigan University.

1991 Petrographic analysis of selected sherds from the Water Users

site and four Salt River-Verde River confluence region sites. In *The riverine Hohokam of the Salt and Verde River confluence region: The water users project, Mesa Ranger District, Tonto National Forest, Maricopa County, Arizona: Vol. 2. Descriptive report*, compiled by R.B. Neily and J.E. Kisselburg, 8-1–8-14. Cultural Resources Report No. 47. Tempe: Archaeological Consulting Services, Ltd.

Garrett, E.M., and H.H. Franklin
1983 Petrographic and oxidation analyses of NMAP ceramics. In *Economy and interaction along the Lower Chaco river*, edited by P. Hogan and J.C. Winter, 311-320. Albuquerque: Office of Contract Archaeology and Maxwell Museum.

Gastil, R.G.
1975 Plutonic zones in the Peninsular Ranges of southern California and northern Baja California. *Geology* 3:361-363.

Gazzi, P.
1966 Le arenarie del flysch sopracretaceo dell'Alppeninno modenese: correlazioni con il flysch di Monghidoro. *Mineralogica et petrographica acta* 12:69-97.

Gifford, J.
1957 Archaeological explorations in caves of the Point of Pines Region. Ph.D. dissertation. Department of Anthropology, University of Arizona, Tucson.

Gilman, P.A., V. Canouts, and R.A. Bishop
1994 The production and distribution of classic Mimbres black-on-white pottery. *American Antiquity* 39:695-709.

Gilmore, G.R.
1991 Sources of uncertainty in the neutron activation analysis of pottery. In *Neutron activation and plasma emission spectrometric analysis in archaeology: Techniques and applications*, edited by M.J. Hughes, M.R. Cowell, and D.R. Hook, 1-28. British Museum Occasional Papers No. 82. London: British Museum.

Gladwin, N.
1975 Petrography of Snaketown pottery. In *Excavations at Snaketown: material culture*, by H.S. Gladwin, E.W. Haury, E.B. Sayles, and N. Gladwin, pp 230-232. Reprinted. Tucson: University of Arizona Press. Originally published 1938, Medallion Papers No. 25. Globe, AZ: Gila Pueblo.

Gladwin, W., and H.S. Gladwin
1933 *Some southwestern pottery types, series III*. Medallion Papers 13. Globe, AZ: Gila Pueblo.

Gladwin, H.S., E.W. Haury, E.B. Sayles, and N. Gladwin
1975 *Excavations at Snaketown: Material culture*. Reprinted. Tucson: University of Arizona Press. (Originally published 1938, Medallion Papers No. 25, Globe, AZ: Gila Pueblo.)

Glascock, M.D.
1992 Characterization of archaeological ceramics at MURR by neutron activation analysis and multivariate statistics. In *Chemical characterization of ceramic pastes in archaeology*, edited by H. Neff, 11-26. Monographs in World Archaeology, No. 7. Madison, WI: Prehistory Press.
1994 Nuclear reaction chemical analysis: Prompt and delayed measurements. In *Chemical analysis by nuclear methods*, edited by Z.B. Alfassi, 75-99. New York: John Wiley and Sons.

Glowacki, D.M.
1995 Patterns of ceramic production and vessel movement in the Mesa Verde region. M.A. thesis, Department of Anthropology, University of Missouri, Columbia.

Glowacki, D.M., H. Neff, and M.D. Glascock
1995 Characterization of Mesa Verde black-on-white ceramics from southwestern Colorado using INAA. *Journal of Radioanalytical and Nuclear Chemistry*, 196(2):215-222.
1998 An initial assessment of the production and movement of thirteenth century ceramic vessels in the Mesa Verde Region. *Kiva* 63:217-240.

Glowacki, D.M., H. Neff, M. Hegmon, J. Kendrick, and W.J. Judge
1997 Chemical variation, resource use, and vessel movement in the Northern San Juan. Presented at the 62nd Annual Meetings for the Society for American Archaeology, April 2-7, Nashville, TN.

Gomez, B., M. Rautman, H. Neff, and M.D. Glascock
1995 Clays related to the production of white slip ware. *Report of the Department of Antiquities, Cyprus* 1995:113-128.
1996 Clays used in the manufacture of Cypriot red slip pottery and related ceramics. *Report of the Department of Antiquities, Cyprus*, 69-82. Nicosa, Cyprus: Department of Antiquities

Gosselain, O.P.
1992 Technology and style: Potters and pottery among Bafia of Cameroon. *Man* (N.S.) 27:559-586.

Gould, R.R.
1982 Mustoe Site: The application of neutron activation analysis in the interpretation of a multicomponent archaeological site. Ph.D. dissertation, University of Texas, Austin.

Gower, J.C.
1966 Some distance properties of latent root and vector methods used in multivariate analysis. *Biometrika* 53: 453-67.
1984 Multivariate analysis: Ordination, multidimensional scaling and allied topics. In *Handbook of applicable mathematics VIB–statistics*, edited by E. Lloyd, 727-781. Chichester, UK: John Wiley and Sons.

Graves, M.W.
1982 Breaking down ceramic variation: Testing models of White Mountain redware design style development. *Journal of Anthropological Archaeology* 1(4):305-354.
1991 Pottery production and distribution among the Kalinga: A study of household and regional organization and differentiation. In *Ceramic ethnoarchaeology*, edited by W.A. Longacre, 112-143. Tucson: The University of Arizona Press.

Greenacre, M.J.
1984 *Theory and applications of correspondence analysis*. New York: Academic Press.

Greenleaf, J.C.
1975 *Excavations at Punta de Agua in the Santa Cruz River basin, southeastern Arizona*. Anthropological Papers No. 26. Tucson: University of Arizona.

Gregory, D.A.
1991 Form and variation in Hohokam settlement patterns. In *Chaco and Hohokam: Prehistoric regional systems in the American Southwest*, edited by P.L. Crown and W.J. Judge, 159-193. Santa Fe: School of American Research Press.
1995 Prehistoric settlement patterns in the eastern Tonto Basin. In *The Roosevelt community development study: New perspectives on Tonto Basin prehistory*, edited by M.D. Elson, M.T. Stark, and D.A. Gregory, 127-184. Anthropological Papers No. 15. Tucson: Center for Desert Archaeology.

Griffitts, M.O.
1990 *Guide to the geology of Mesa Verde National Park.* Mesa Verde National Park, CO: Mesa Verde Museum Association.

Griset, S., ed.
1986a *Pottery of the Great Basin and adjacent areas.* Anthropological Papers, no. 111. Salt Lake City: University of Utah.
1986b Ceramic artifacts. In *Excavations at Indian Hill rockshelter, Anza-Borrego Desert State Park, California, 1984-1985*, edited by P.J.Wilke, L.A. Payen, and M. McDonald, 80-100. Report on file at the Resource Protection Division, Sacramento: California Park Service.
1988 Ceramics. In *The archaeology of CA-Iny-30: Prehistoric culture change in the Southern Owens Valley, California*, by M.E. Basgall and K.R. McGuire, 250-278. Report submitted to California Department of Transportation, Bishop.
1990 Historic transformation of Tizon brown ware in Southern California. *Nevada State Museum Anthropological Papers* 23:180-200.
1996 Southern California brownware. Ph.D. dissertation, University of California, Davis.

Gumerman, George J. and Jeffrey S. Dean
1989 Prehistoric Cooperation and Competition in the Western Anasazi Area. In *Dynamics of Southwestern Prehistory*, edited by L. Cordell and G. Gumerman, 99-148. Washington: Smithsonian Institution Press.

Gunneweg, J., I. Perlman, and J. Yellin
1983 The provenience, typology, and chronology of Eastern Sigillata A. *QEDEM 17.* Jerusalem: Institute of Archaeology, Hebrew University.

Gustavson, T.C., ed.
1986 *Geomorphology and Quaternary stratigraphy of the Rolling Plains, Texas Panhandle.* Guidebook 22. Austin: Bureau of Economic Geology, University of Texas.

Gustavson, T.C., R.J. Finley, and K.A. McGillis
1980 *Regional dissolution of Permian salt in the Anadarko, Dalhart, and Palo Duro basins of the Texas Panhandle.* Reports of Investigations No. 106. Bureau of Economic Geology, Austin: University of Texas.

Gustavson T.C., and V.T. Holliday
1985 Depositional architecture of the Quaternary Blackwater Draw and Tertiary Ogallala formations, Texas Panhandle and Eastern New Mexico. Open File Report OF-WTWI-1985-23, 1–29. Bureau of Economic Geology, Austin: University of Texas.

Habicht-Mauche, J.
1987 Southwestern-style culinary ceramics on the Southern Plains: A case study of technological innovation and cross-cultural interaction. *Plains Anthropologist* 32(116):175-189.
1988 An analysis of Southwestern style ceramics from the Southern Plains in the context of Plains-Pueblo interaction. Ph.D. dissertation, Department of Anthropology, Harvard University, Cambridge, Massachusetts.
1991 Evidence for the manufacture of Southwestern-style culinary ceramics on the Southern Plains. In *Farmers, Hunters, and Colonists: Interaction Between the Southwest and the Southern Plains*, edited by K.A. Spielmann, 51-70. Tucson: University of Arizona Press.
1993 *The pottery from Arroyo Hondo Pueblo, New Mexico.* Arroyo Hondo Archaeological Series Vol. 8. Santa Fe: School of American Research Press.

Hagstrum, M.B. and J.A. Hildebrand
1990 The two-curvature method for reconstructing vessel morphology. *American Antiquity* 55:388-403.

Hantman, J., S. Upham, K.Lightfoot, F. Plog, S. Plog, and B. Donaldson
1982 Cibola white wares: a regional perspective. In *Regional analysis of prehistoric ceramic variation: Contemporary studies of Cibola white wares*, edited by A.P. Sullivan and J.L. Hantman, 17-35. Arizona State University Anthropological Research Papers No. 31. Tempe: Arizona State University.

Harbottle, G.
1976 Activation analysis in archaeology. In *Radiochemistry*, Vol. 3, edited by G.W.A. Newton, 33-72. London: The Chemical Society.
1982 Provenience studies using neutron activation analysis: The role of standardization. In *Archaeological Ceramics*, edited by J.S. Olin and A.D. Franklin, 67-77. Washington, D.C.: Smithsonian Institution Press.

Harbottle, G. and R.L. Bishop
1992 Commentary on techniques. In *Chemical Characterization of Ceramic Pastes in Archaeology*, edited by H. Neff, 27-30. Monographs in World Archaeology, No. 7. Madison, WI: Prehistory Press.

Harner, M.J.
1958 Lowland Patayan phases in the Lower Colorado River valley and Colorado desert. *University of California Archaeological Survey Annual Report* 42:93-97, Berkeley: University of California.

Harry, K.G.
1997 Ceramic production, distribution, and consumption in two Classic period Hohokam communities. Ph.D. dissertation, Department of Anthropology, University of Arizona, Tucson.
2000 Community-based craft specialization: The West Branch site. In *The Hohokam Village Revisited*, edited by D.E. Doyel, P.R. Fish, and S.K. Fish, 197-220. Fort Collins, CO: Southwestern and Rocky Mountain Division of the American Association for the Advancement of Science.

Hart, F.A., J.M.V. Storey, S.J. Adams, R.P. Symonds, and J.N. Walsh
1987 An analytical study, using inductively coupled plasma (ICP) spectrometry, of Samian and colour-coated wares from the Roman town at Colchester together with related continental Samian wares. *Journal of Archaeological Science* 14:577-598.

Haury, E.W.
1934 *The Canyon Creek Ruin and the cliff dwellings of the Sierra Ancha.* Medallion Papers 14. Globe, AZ: Gila Pueblo.
1958 Evidence at Point of Pines for prehistoric migration from northern Arizona. In *Migrations in New World culture history*, edited by R.H. Thompson, 1-8. Tucson: University of Arizona Bulletin 29, Social Science Bulletin 27.
1976 Salado: The view from Point of Pines. *Kiva* 42(1):81-84.
1988 Gila Pueblo Archaeological Foundation: A history and some personal notes. *Kiva* 54(1):1-77.
1989 *Point of Pines, Arizona: A history of the University of Arizona archaeological field school.* Anthropological Papers 50. Tucson: University of Arizona Press.

Hawley-Ellis, F.
1967 Where did the Pueblo people come from? *El Palacio* 74(3):35-43.

Hays, K.A.

1991 Ceramics. In *Homol'ovi II: Archaeology of an ancestral Hopi village, Arizona*, edited by E.C. Adams and K.A. Hays, 23-48. Anthropological Paper 55. Tucson: University of Arizona.

Hector, S.M.

1985 Excavations at SDi-4609, a portion of the village of Ystagua, Sorrento Valley, California. Recon, San Diego. Unpublished manuscript on file at the South Coast Information Center at San Diego State University, San Diego, California.

Hedges, K.

1975 Notes on the Kumeyaay: A problem of identification. *Journal of California Anthropology* 2:71-83.

Hegmon, M.

1993 Analyses of production and stylistic information. In, *The Duckfoot Site*, Vol. 1: *Descriptive Archaeology*, edited by R.R. Lightfoot and M.C. Etzkorn, 152-156. Cortez, CO: Crow Canyon Archaeological Center.

1995a *The social dynamics of pottery style in the early puebloan Southwest.* Cortez, CO: Crow Canyon Archaeological Center Occasional Paper No. 5.

1995b Pueblo I ceramic production in Southwest Colorado: Analyses of igneous rock temper. *Kiva* 60(3):371-390.

Hegmon, M. J. R. Allison, H. Neff, and M.D. Glascock

1997 Community specialization, regional exchange, and the formation of early villages: San Juan Red wares in the northern Southwest. *American Antiquity* 62:449-463.

Hegmon, M., W. Hurst, and J.R. Allison

1995 Production for local consumption and exchange: comparisons of early red and white ware ceramics in the San Juan region. In *Ceramic production in the American Southwest*, edited by B.J. Mills and P.L. Crown, 30-62. Tucson: The University of Arizona Press.

Hegmon, M., M. Nelson, and M. Ennes

2000 Corrugated pottery, technological style, and population movement in the Mimbres region of the American southwest. *Journal of Anthropological Research* 56:217-240.

Heidke, J.M.

1989 Ceramic analysis. In *Archaeological investigations at the Redtail site, AA:12:149 (ASM), in the northern Tucson Basin*, by M. Bernard-Shaw, 59-121. Technical Report No. 89-8. Tucson: Center for Desert Archaeology.

1990 Ceramic analysis. In *Archaeological investigations at the Lonetree site, AZ AA:12:120 (ASM), in the northern Tucson Basin*, by M. Bernard-Shaw, 53-118. Technical Report No. 90-1. Tucson: Center for Desert Archaeology.

1993a Early ceramic period pottery from Locus 2. In *Archaeological testing of the Pima Community College Desert Vista campus property: The Valencia North Project*, by B.B. Huckell, 101-111. Technical Report No. 92-13. Tucson: Center for Desert Archaeology.

1993b Applied quantitative ceramic petrology, an example from southeastern Arizona. Paper presented at the Arizona Archaeological Council Meeting and Symposium: Recent Advances in Southwestern Ceramic Analysis, May 7-8, Flagstaff.

1995a Overview of the ceramic collection. In *The Roosevelt community development study: Ceramic chronology, technology, and economics*, Vol.2, edited by J.M. Heidke and M.T. Stark, 6-18. Anthropological Papers 14. Tucson: Center for Desert Ar-

chaeology.

1995b Ceramic analysis. In *Archaeological investigations at Los Morteros, a prehistoric settlement in the northern Tucson basin*, by H. D. Wallace, 263-442. Anthropological papers no. 17. Tucson: Center for Desert Archaeology.

1996a Ceramic artifacts from the Cook Avenue locus. In *Archaeological data recovery project at the Cook Avenue Locus of the West Branch site, AZ AA:16:3 (ASM)*, edited by A. Dart and D. Swartz, 53-76. Technical Report No. 96-8. Tucson: Center for Desert Archaeology.

1996b Ceramic data. In *A Rincon phase occupation at Julian Wash, AZ BB:13:17 (ASM)*, edited by J. Mabry, 109-111. Technical Report No. 96-7. Tucson: Center for Desert Archaeology.

1996c Production and distribution of Rincon phase pottery: evidence from the Julian Wash site. In *A Rincon phase occupation at Julian Wash, AZ BB:13:17 (ASM)*, edited by J. Mabry, 47-71. Technical Report No. 96-7. Tucson: Center for Desert Archaeology.

1998 Early Cienega phase incipient plain ware and Tucson phase ceramics from the Wetlands site. In *Archaeological investigations at the Wetlands site, AZ AA:12:90 (ASM)*, by A.K.L. Freeman, 187-203. Technical Report No. 97-5. Tucson: Center for Desert Archaeology.

1999 Ceramic consumption at AZ BB:13:535 (ASM). In *Archaeological investigations at two sites in the middle Santa Cruz Valley, AZ BB:13:534 (ASM) and AZ BB:13:535 (ASM)*, by J.B. Mabry, M.W. Lindeman, and H. Wöcherl, 46-60. Technical Report No. 98-10. Tucson: Desert Archaeology, Inc.

2000 Ceramic Data. In *Excavations at Sunset Mesa Ruin*, by M.W. Lindeman, 249-260. Technical Report No. 2000-02. Tucson: Desert Archaeology, Inc.

2001 Utilitarian ceramic production and distribution in the prehistoric Tonto Basin. In *Tonto Creek Archaeological Project: 2000 years of settlement in the Tonto Basin*, edited by J.J. Clark and J.M. Vint. Anthropological Paper No. 25. Tucson: Center for Desert Archaeology, in press.

Heidke, J.M., D.C. Kamilli, and E. Miksa

1996 *Petrographic and qualitative analyses of sands and sherds from the lower Verde River area.* Technical Report No. 95-1. Tucson: Center for Desert Archaeology.

Heidke, J.M., and E.J. Miksa

2000a Ceramic temper provenance studies. In *Tonto Creek Archaeological Project: artifact and environmental analyses: Vol. 1, A Tonto Basin perspective on ceramic economy.* Edited by J.M. Vint and J.M. Heidke. 95-146. Anthropological Papers No. 23. Tucson: Center for Desert Archaeology.

2000b Correspondence and discriminant analyses of sand and sand temper compositions, Tonto Basin, Arizona. *Archaeometry* 42(2): 273-299.

Heidke, J.M., E.J. Miksa, D.C. Kamilli, and M.K. Wiley

1997 Appendix five: Desert archaeology letter report. In Ceramic production, distribution, and consumption in two Classic period Hohokam communities, by K.G. Harry, 363-372. Ph.D. dissertation, University of Arizona, Tucson. University Microfilms International, Ann Arbor, Michigan.

Heidke, J.M., E.J. Miksa, and M.K. Wiley

1998 Ceramic artifacts. In *Archaeological investigations of early village sites in the middle Santa Cruz Valley: analyses and synthesis*, edited by J.B. Mabry, 471-544. Anthropological Papers No. 19. Tuc-

son: Center for Desert Archaeology.

Heidke, J.M. and M.T. Stark, eds.
1995 *The Roosevelt community development study: ceramic chronology, technology, and economics*, Vol. 2. Anthropological Papers 14. Tucson: Center for Desert Archaeology.

Heidke, J.M. and M. Wiley
1997 Petrographic and qualitative analysis of Tanque Verde Red-on-brown sherds from the Northern Tucson Basin and Avra Valley. In Ceramic production, distribution, and consumption in two Classic period Hohokam communities, by K.G. Harry, 302-362. Ph.D. dissertation, University of Arizona, Tucson. University Microfilms International, Ann Arbor, Michigan.

Heizer, R.F. and A.E. Treganza
1944 Mines and quarries of the Indians of California. *State of California Division of Mines*, Vol. 40. No. 3. Sacramento: State of California Division of Mines.

Henderson, J.
1989 The scientific analysis of ancient glass and its archaeological interpretation. In *Scientific Analysis in Archaeology*, edited by J. Henderson, 30-62. Monograph 19, London: Oxford University Committee for Archaeology and Los Angeles: UCLA Institute of Archaeology, Archaeological Research Tools No. 5.

Hepburn, J.R.
1984 Ceramic petrographic analysis. In *Hohokam Archaeology Along the Salt-Gila Aqueduct Central Arizona Project*, Vol. 8: *Material culture*, edited by L.S. Teague and P.L. Crown, 341-352. Archaeological Series No. 150. Tucson: Arizona State Museum, University of Arizona.

Hicks F.N.
1963 Ecological sects of aboriginal culture in the Western Yuman area. Ph.D. dissertation, University of California, Los Angeles.

Hildebrand, J.A. and M.B. Hagstrum
1995 Observing subsistence change in native Southern California: the late prehistoric Kumeyaay. *Research in economic anthropology* 16:85-127.

Hill, M.O.
1979 *DECORANA: a FORTRAN program for detrended correspondence analysis and reciprocal averaging*. Ecology and Systematics, Ithaca, NY: Cornell University.

Hodder, I.
1982 Toward a contextual approach to prehistoric exchange. In *Contexts for Prehistoric Exchange*, edited by J.E. Ericson and T.K. Earle, 199-211. New York: Academic Press.

Hodder, I. and C. Orton
1976 *Spatial Analysis in Archaeology*. Cambridge: Cambridge University Press.

Hodge, F.W.
1937 *The history of Hawikku, New Mexico, one of the (so-called) cities of Cibola*. Los Angeles: Southwest Museum.

Hoenthal, W.D.
1950 Southern Diegueno use and knowledge of lithic materials. *Kroeber Anthropological Society Papers* 2:9-16.

Holliday, V.T., and C.M. Welty
1981 Lithic tool resources of the Eastern Llano Estacado. *Bulletin of the Texas Archeological Society* 52:201–214.

Hughes, R.E., and J.A. Bennyhoff
1986 Early trade. In *Handbook of North American Indians*, Vol. 11:

Great Basin, edited by. W.L. D'Azevedo, 238-255. Washington, D.C.: Smithsonian Institution.

Hughes, M.J., M.R. Cowell, and D.R. Hook
1991 INAA procedure at the BM research laboratory. In *Neutron activation and plasma emission spectrometric analysis in archaeology: Techniques and applications*, edited by M.J. Hughes, M.R. Cowell, and D.R. Hook, 29-46. British Museum Occasional Papers No. 82. London: British Museum.

Hunt, A.
1960 *Archaeology of the Death Valley Salt Pan, California*. Anthropological Papers, No. 47. Salt Lake City: University of Utah.

Hunt, C.
1960 Petrography of the pottery. In *Archaeology of the Death Valley Salt Pan, California*, by A. Hunt, 195-201. Anthropological Papers of the University of Utah, No. 47. Salt Lake City: University of Utah.

Huntington, F.W.
1986 *Archaeological investigations at the West Branch site: early and middle Rincon occupation in the southern Tucson Basin*, by F.W. Huntington. Anthropological Papers No. 6. Tucson: Institute for American Research.

Ingersoll, R.V.
1990 Actualistic sandstone petrofacies: Discriminating modern and ancient source rocks. *Geology* 18:733-736.

Ingersoll, R.V., A.G. Kretchmer, and P.K. Valles
1993 The effect of sampling scale on actualistic sandstone petrofacies. *Sedimentology* 40:937-953.

James, S.R.
1995 Hunting and fishing patterns at prehistoric sites along the Salt River: the archaeofaunal analysis. In *The Roosevelt community development study:* Vol. 3. *Paleobotanical and osteological analyses*, edited by M.D. Elson and J.J. Clark, 85-168. Anthropological Papers No. 14. Tucson: Center for Desert Archaeology.

James, W.D., R.L. Brewington, and H.J. Shafer
1995 Compositional analysis of American southwestern ceramics by neutron activation analysis. *Journal of Radioanalytical and Nuclear Chemistry, Articles* 192(1):109-116.

Jewett, R.A.
1989 Distance, interaction, and complexity: the spatial organization of pan-regional settlement clusters in the American southwest. In *The Sociopolitical structure of prehistoric southwestern societies*, edited by S. Upham, K.G. Lightfoot, and R.A. Jewett, 363-380. Boulder: Westview Press.

Johnson, A.E.
1965 The development of western Pueblo culture. Ph.D. dissertation, Department of Anthropology, University of Arizona, Tucson.

Jolliffe, I.T.
1986 *Principal component analysis*. New York: Springer-Verlag.

Joreskog, K.G., Klovan, J.E., and Reyment, R.A.
1976 *Geological factor analysis, methods in geomathematics, 1*. New York: Elsevier Scientific Publishing Co.

Kaplan, M.F.
1980 *The origin and distribution of Tell el Yahudiyeh ware* (SIMA 62). Goteborg.

Kaplan, M.F., G. Harbottle, and E.V. Sayre
1982 Multi-disciplinary analysis of Tell el Yahudiyeh ware. *Archaeometry* 24:127-142.

Kaufman, L. and Rousseeuw, P.J.

1990 *Finding groups in data: An introduction to cluster analysis.* New York: Wiley Interscience.

Keith, W.J.

1976 *Reconnaissance geologic map of the San Vicente and Cocoraque Butte 15' quadrangles, Arizona.* Miscellaneous Field Studies Map MF–769, Boulder: U.S. Geological Survey.

Kennett, D.J., H. Neff, M.D. Glascock, and A.Z. Mason

2001 A geochemical revolution: inductively coupled plasma mass spectrometry. *The SAA Archaeological Record* 1(1):22-26.

Kidder. A.V.

1932 *The artifacts of Pecos.* Phillips Academy Papers of the Southwestern Expedition 7, Andover. New Haven, CT. Yale University Press.

Kilikoglou, V., Y. Maniatis, and A.P. Grimanis

1988 The effect of purification and firing of clays on trace element provenance studies. *Archaeometry* 30:37-46.

Kintigh, K.W.

1994 Chaco, communal architecture, and Cibolan aggregation. In *The ancient southwestern community: Models and methods for the study of prehistoric social organization,* edited by W.H. Wills and R.D. Leonard, 131-143. Albuquerque: University of New Mexico Press.

1996 The Cibola region in the post-Chacoan era. In *The prehistoric Pueblo world, AD. 1150-1350,* edited by M.A. Adler, 131-144. Tucson: University of Arizona Press.

Kintigh, K.W., T.L. Howell, and A.I. Duff

1996 Post-Chacoan organizational developments as evidenced at the Hinkson Site, New Mexico. *Kiva* 61(3):257-274.

Klecka, W.R.

1980 Discriminant analysis. *Quantitative applications in the social sciences, No. 19.* Beverly Hills, CA: Sage Publications.

Kohler, T.A. and E. Blinman

1987 Solving mixture problems in archaeology: analysis of ceramic materials for dating and demographic reconstruction. *Journal of Anthropological Archaeology* 6:1-28.

Kojo, Y.

1996 Production of prehistoric southwestern ceramic: a low-technology approach. *American Antiquity* 61:325-339.

Korzybski, A.

1958 *Science and sanity: An introduction to non-Aristotelian systems and general semantics.* Reprinted. Lakeville, CT: The International Non-Aristotelian Library Publishing Company. (Originally published 1933)

Kreiger, A.D.

1946 *Culture complexes and chronology in northern Texas with extension of Puebloan dating to the Mississippi Valley.* Publication No. 4640. Austin: University of Texas.

Lance, G. and W. Williams

1967 A general theory of classificatory sorting strategies. *Computer Journal* 9:373-380.

Landsberger, S.

1994 Delayed instrumental neutron activation analysis. In *Chemical analysis by nuclear methods,* edited by Z.B. Alfassi, 121-142. New York: John Wiley and Sons.

Larson, D.O.

1990 Impacts of climatic variability and population growth on Virgin Branch Anasazi cultural developments. *American Antiquity* 55: 227-249.

Larson, D.O., H. Neff, D.A. Graybill, J. Michaelson, and E. Ambose

1996 Risk, climatic variability, and the study of southwestern prehistory: An evolutionary perspective. *American Antiquity* 61:217-241.

Lauer, P.K.

1974 *Pottery traditions in the D'Entrecasteaux Islands of Papua.* Occasional Papers in Anthropology. Brisbane: Anthropology Museum, Queensland University.

Laylander D.

1997 The last days of Lake Cahuilla: the Elmore Site. *Pacific Coast Archaeological Society Quarterly* 33:1-138.

LeBlanc, S.

1983 *The Mimbres people: Ancient Pueblo painters of the American Southwest.* London: Thames and Hudson.

Lechtman, H.

1977 Style in technology: some early thoughts. In *Material Culture: Styles, Organization, and Dynamics of Technology,* edited by H. Lechtman and R. Merrill, 3-20. New York: West Publishing.

Lee, M.H.

1945 *Salt water boy.* Caldwell, ID: Caxton Printers.

Leese, M.N.

1992 Evaluating lead isotope data: Comments II (on Sayre et al.). *Archaeometry* 34:318-322.

Leese, M.N. and P.L. Main

1994 The efficient computation of unbiased Mahalanobis distances and their interpretation in archaeometry. *Archaeometry* 36:307-316.

Leese, M.N., M.J. Hughes, and J. Stopford

1989 The chemical composition of tiles from Bordesley: a case study in data treatment. In *Computer applications and quantitative methods in archaeology,* edited by S.P.Q. Rahtz and J. Richards, 241-249. BAR International Series 548. Oxford: British Archaeological Reports.

Lekson, S.H.

1991 Settlement patterns and the Chaco region. In *Chaco and Hohokam: Prehistoric regional systems in the American Southwest,* edited by P.L. Crown and W.J. Judge, 31-55. Santa Fe: School of American Research Press.

Lemoine, C. and M. Picon

1982 La fixation du phosphore par les céramiques lors de leur enfouissement e ses incidences analytiques. *Revue d'archéométrie* 6:101-112.

Lemonnier, P.

1983 L'étude des systèmes techniques, une urgence en technologie culturelle. *Techniques et culture* 1:11-26.

1993 Introduction. In *Technological choices: Transformation in material cultures since the Neolithic,* edited by P. Lemonnier, 1-35. London: Routledge.

Leonard, R.D.

1989 Resource specialization, population growth, and agricultural production in the American Southwest. *American Antiquity* 54:491-503.

Leonard, R.D. and H.E. Reed

1993 Population aggregation in the prehistoric American Southwest: A selectionist model. *American Antiquity* 58:648-661.

Lewis, R.B.

1986 The analysis of contingency tables. In *Advances in archaeological method and theory,* vol. 9, edited by M. B. Schiffer, 277-310. New York: Academic Press.

Lightfoot, K.G.

1984 *Prehistoric political dynamics: a case study from the American southwest.* Dekalb: Northern Illinois University Press.

Lightfoot, K.G., and R.A. Jewett

1984 Late prehistoric ceramic distributions in east-Central Arizona: An examination of Cibola Whiteware, White Mountain Redware and Salado Redware. In *Regional analysis of prehistoric ceramic variation: Contemporary studies of the Cibola Whitewares,* edited by A.P. Sullivan III and J.L. Hantman, 36-73. Anthropological Research Papers 31. Tempe: Arizona State University.

Lindauer, O.

1992 Review of Recent research on Tucson Basin prehistory: Proceedings of the second Tucson Basin conference, edited by W.H. Doelle and P.R. Fish. *Kiva* 57(3):276-279.

1995 Explaining white wares in the Tonto Basin: broad scale exchange, emulation, or both? *Kiva* 61:45-55.

Lindsay, A.J. Jr.

1987 Anasazi population movements to southeastern Arizona. *American Archaeology* 6(3):190-198.

1992 Tucson Polychrome: History, dating, distribution, and design. In *Proceedings of the Second Salado Conference, Globe, AZ 1992,* edited by R. Lange and S. Germick, 230-237. Phoenix: Arizona Archaeological Society Occasional Papers.

Lipman, P.W.

1993 *Geologic map of the Tucson Mountains Caldera, southern Arizona.* Miscellaneous Investigations Series, Map I-2205, U.S. Geological Survey. Washington, D.C.: U.S. Department of the Interior.

Lombard, J.P.

1986 Petrographic results of point counts on 40 ceramic sherds from AZ BB:13:68. In *Archaeological investigations at the Tanque Verde Wash site: A middle Rincon settlement in the eastern Tucson Basin,* by M.D. Elson, 473-484. Anthropological Papers No. 7. Tucson: Institute for American Research.

1987a Ceramic petrography. In *The archaeology of the San Xavier Bridge site (AZ BB:13:14), Tucson Basin, southern Arizona,* edited by J.C. Ravesloot, 335-368. Archaeological Series No. 171. Cultural Resource Management Division, Tucson: Arizona State Museum, University of Arizona.

1987b Provenance of sand temper in Hohokam ceramics, Arizona. *Geoarchaeology* 2(2):91-119.

Longacre, W.A.

1985 Pottery use-life among the Kalinga, northern Luzon, the Philippines. In *Decoding prehistoric ceramics,* edited by B.A. Nelson, 334-346. Carbondale and Edwardsville: Southern Illinois University Press.

1991 Sources of ceramic variability among the Kalinga of northern Luzon. In *Ceramic ethnoarchaeology,* edited by W.A. Longacre, 95-111. Tucson: University of Arizona Press.

Longacre, W.A., and M.T. Stark

1992 Ceramics, kinship, and space: a Kalinga example. *Journal of Anthropological Archaeology* 11(2):125-136.

Loomis, T.P.

1980 Petrographic analysis of prehistoric ceramics from Gu Achi. In *Excavations at Gu Achi: A reappraisal of Hohokam settlement and subsistence in the Arizona Papagueria,* by W. Bruce Masse, 399-432. Publications in Anthropology No. 12. Tucson: Western Archaeological and Conservation Center, National Park Service.

Lowell, J.C.

1991 *Prehistoric households at Turkey Creek Pueblo, Arizona.* Anthropological Papers No. 54. Tucson: University of Arizona.

Luedtke, B.E.

1976 Lithic material distributions and interaction patterns during the Late Woodland period in Michigan. Ph.D. dissertation Department of Anthropology, University of Michigan.

Luomala, K.

1978 Tipai-Ipai. In California, edited by R. F. Heizer, 572-609, *Handbook of North American Indians,* Vol. 8, edited by W.G. Sturtevant, general editor. Washington, D.C.: Smithsonian Institution.

Lyneis, M.M.

1988 Tizon Brown Ware and the problems raised by paddle-and-anvil pottery in the Mojave Desert. *Journal of California and Great Basin Anthropology* 10:146-155.

1992 *The Main Ridge community at Lost City: Virgin Anasazi architecure, ceramics, and burials.* Salt Lake City: University of Utah Press.

Lyons, P.

1999 Tracking prehistoric Hopi migrations: Winslow Orange Ware, the Jeddito style of decoration, and Roosevelt Red Ware. Paper presented to the Hopi Tribe. Manuscript in the author's possession, University of Arizona, Tucson.

Mack, G.

1997 *The geology of Southern New Mexico: A beginner's guide.* Albuquerque: University of New Mexico Press.

Mack, J.M., ed.

1990 *Hunter-gatherer pottery from the Far West.* Anthropological Papers, no. 23. Carson City: Nevada State Museum.

MacRae, F.K.

1971 MIKCA: a FORTRAN IV iterative k-means cluster analysis program. *Behavioural Science* 16: 423-424.

Madsen, J.H.

1993 Geology of the lower Santa Cruz river drainage basin: A pilot study of prehistoric stone procurement. In *The Northern Tucson basin survey: Research directions and background studies,* edited by J.H. Madsen, P.R. Fish, and S.K. Fish, 59-82. Archaeological Series No. 182. Tucson: Cultural Resource Management Division, Arizona State Museum.

Madsen, J.H., P.R. Fish, and S.K. Fish, eds.

1993 *The northern Tucson basin survey: Research direction and background studies.* Arizona State Museum Archaeological Series No. 182. Tucson: The University of Arizona.

Mansfield, C.F.

1971 Stratigraphic variation in sandstone petrology of the Great Valley sequence in the southern Coast Ranges west of Coalinga, California. *Geological Society of America Abstracts with Programs* 3:157.

Marriott, F.H.C.
1971 Practical problems in a method of cluster analysis. *Biometrics* 27:501-514.

Martin, P.S., J.B. Rinaldo, E.R. Barter
1957 Late Mogollon communities: Four sites of the Tularosa Phase, western New Mexico. *Fieldiana*: Anthropology 49(1).

Martin, P.S., J.B. Rinaldo, E.A. Bluhm and H.C. Cutler
1956 Higgins Flat Pueblo, western New Mexico. *Fieldiana*: Anthropology 45.

Matthews, W.H., III
1969 *The geologic story of Palo Duro Canyon*. Guidebook 8. Austin: Bureau of Economic Geology, The University of Texas.

Maxwell, T.D.
1995 The use of comparative and engineering analyses in the study of prehistoric agriculture. In *Evolutionary archaeology: Methodological issues,* edited by P.A. Teltser, 113-128. Tucson: University of Arizona Press.

May, R.V.
1976 An early ceramic date threshold in Southern California. *Masterkey* 50:103-107.

1978 A Southern California indigenous ceramic typology: Contributions to Malcolm J. Rogers research. *ASA Journal* 2:1-54.

McClymonds, N.E.
1957 The stratigraphy and structure of the Waterman Mountains, Pima County, Arizona. M.A. thesis, Department of Geology, University of Arizona, Tucson.

McDonald, M.A.
1992 Indian Hill rockshelter and aboriginal cultural adaptation in Anza-Borrego Desert State Park, Southeastern California Ph.D. dissertation, University of California, Riverside.

McGuire, R.H.
1985 The Role of shell exchange in the explanation of Hohokam prehistory. In *Proceedings of the 1983 Hohokam conference, part II,* edited by A. Dittert and D.E. Dove, 473-479. Occasional Paper 2. Phoenix: Arizona Archaeological Society.

McKenna, P.J. and H.W. Toll
1984 Ceramics. In *The architecture and material culture of 29SJ1360,* by P.J. McKenna, 103-222. Reports of the Chaco Center No. 7. Albuquerque: USDI, National Park Service.

Melguen, M.
1974 Facies analysis by "correspondence analysis": Numerous advantages of this new statistical technique. *Marine Geology* 17:165-182.

Miksa, E.J.
1995 Point count data and petrofacies descriptions. In *The Roosevelt community development study:* Vol. 2. *Ceramic chronology, technology, and economics,* edited by J.M. Hcidke and M.T. Stark, 505-553. Anthropological Papers No. 14. Tucson: Center for Desert Archaeology.

Miksa, E.J., and J.M. Heidke
1995 Drawing a line in the sands: Models of ceramic temper provenance. In *The Roosevelt community development study: Ceramic chronology, technology, and economics,* vol. II, edited by J.M. Heidke and M.T. Stark, 133-206. Anthropological papers no. 14. Tucson: Center for Desert Archaeology.

2001 It all comes out in the wash: Actualistic petrofacies modeling of temper provenance, Tonto Basin, Arizona, USA. *Geoarchaeology* 16(2): 177-222.

Miksicek, C.H.
1995 Temporal trends in the eastern Tonto Basin: an archaeobotanical perspective. In *The Roosevelt community development study:* Vol. 3. *paleobotanical and osteological analyses,* edited by M.D. Elson and J.J. Clark, 43-83. Anthropological Papers No. 14. Tucson: Center for Desert Archaeology.

Milligan, G.W.
1980 An examination of the effect of six types of error perturbation of fifteen clustering algorithms. *Psychometrika* 46:325-342.

Milliken, R., A. Gilreath, and M. Delacorte
1995 Photographic evidence of ethnographic Owens Valley Paiute shelters. Report prepared by Far Western Anthropological Research Group for California Department of Transportation, contract no. 09H259. On file at Far Western Anthropological Research Group, Davis, California.

Mills, B.J.
1998 Migration and Pueblo IV community reorganization in the Silver Creek area, east-central Arizona. In *Migration and reorganization: The Pueblo IV period in the American southwest,* edited by K.A. Spielmann, 65-81. Anthropological Research Papers 51. Tempe: Arizona State University.

1999 Ceramic ware and type systematics. In *Living on the edge of the rim: Excavations and analysis of the Silver Creek Archaeological Research Project, 1993-1998,* edited by B.J. Mills, S.A. Herr and S. Van Keuren, 243-268. Arizona State Museum Archaeological Series 192. Tucson: University of Arizona.

Mills, B.J., A.J. Carpenter, and W. Grimm
1997 Sourcing Chuskan ceramic production: Petrographic and experimental analyses. *Kiva* 62:261-282.

Mills, B.J., and P.L. Crown, eds.
1995 *Ceramic production in the American Southwest.* Tucson: University of Arizona Press.

Mills, B.J., S.A. Herr, S.L. Stinson, and D. Triadan
1999 Ceramic production and distribution in the Silver Creek area. In *Living on the edge of the rim: Excavations and analysis of the Silver Creek archaeological research project, 1993-1998,* edited by B.J. Mills, S.A. Herr, and S. Van Keuren, 295-324. Arizona State Museum Archaeological Series 192. Tucson: University of Arizona.

Molenaar, C.M.
1977 Stratigraphy and depositional history of Upper Cretaceous rocks of the San Juan Basin area, New Mexico and Colorado, with a note on economic resources. In *Guidebook of San Juan Basin III, Northwestern New Mexico,* edited by J.E. Fassett, 159-166. New Mexico Geological Society 28th Field Conference, Socorro, NM. Socorro, NM: New Mexico Geological Society.

Mommsen, H., A. Kreuser, and J. Weber
1988 A method for grouping pottery by chemical composition. *Archaeometry* 30:47-57.

Mommsen, H., T. Beier, U. Diehl, and C. Podzuweit
1992 Provenance determination of Mycenaean sherds found in Tell el Amarna by neutron activation analysis. *Journal of Archaeological Science* 19:295-302.

Mommsen, H., A. Kreuser, E. Lewandowski, and J. Weber
1991 Provenancing of pottery: A status report on neutron activation analysis and classification. In *Neutron activation and plasma*

emission spectrometric analysis in archaeology: Techniques and applications, edited by M.J. Hughes, M.R. Cowell, and D.R. Hook, 57-66. London: British Museum Occasional Paper No. 82.

Montgomery, B.K.
1992 Understanding the formation of the archaeological record: Ceramic variability at Chodistaas Pueblo, Arizona. Ph.D. dissertation. Department of Anthropology, University of Arizona, Tucson.

Montgomery, B.K. and J.J. Reid
1990 An instance of rapid ceramic change in the American southwest. *American Antiquity* 55:88-97.

Moore, R.T.
1968 *Mineral deposits of the Fort Apache Indian Reservation.* Bulletin No. 177. Tucson: Arizona Bureau of Mines.

Morris, E.
1957 Stratigraphic evidence for a cultural continuum at the Point of Pines Ruin. M.A. thesis. Department of Anthropology, University of Arizona, Tucson.

Morton, P.K.
1977 *Geology and mineral resources of Imperial county, California*, California Division of Mines and Geology County Report 7. Sacramento: California Division of Mines an Geology.

Myers, J.E., J.S. Olin, and M.J. Blackman
1992 Archaeological implications of the leaching of calcium compounds from calcareous ceramics at sites in the southeastern United States and Carribean. Poster presented at the 57th Annual Meeting of the Society for American Archaeology, April 8-12, Pittsburgh, PA.

Nations, D.
1989 Cretaceous history of northeastern and east-central Arizona. In *Geological evolution of Arizona*, edited by J. P. Jenney and J. Reynolds, 435-446. Arizona Geological Society Digest 17. Tucson: Arizona Geological Society.

Neely, J.A.
1974 The prehistoric Lund and Stove Canyon sites, Point of Pines, Arizona. Ph.D. dissertation. Department of Anthropology, University of Arizona, Tucson.

Neff, H.
1992a *Chemical characterization of ceramic pastes in archaeology.* Madison, WI: Prehistory Press. (editor)
1992b Introduction. In *Chemical characterization of ceramic pastes in archaeology*, edited by H. Neff, 1-10. Madison, WI: Prehistory Press.
1993 Theory, sampling, and analytical techniques in the archaeological study of prehistoric ceramics. *American Antiquity* 58(1):23-44.
1994 RQ-mode principal components analysis of ceramic compositional data. *Archaeometry* 36:115-130.
1998 Analytical and geographic units in chemistry-based provenance investigations of ceramics. In *Measuring time, space, and material: Unit issues in archaeology*, edited by A.F. Ramenofsky and A. Steffen, 115-127. Salt Lake City: University of Utah Press.

Neff, H., R.L. Bishop, and D.E. Arnold
1988 Reconstructing ceramic production from ceramic compositional data: A Guatemalan example. *Journal of Field Archaeology* 15:339-348.

Neff, H., R.L. Bishop, and R.L. Rands
1988 Similarity/distance measures: Solutions to the mixed level data problem. Manuscript available from the authors.

Neff, H., R.L. Bishop, and E.V. Sayre
1988 Simulation approach to the problem of tempering in compositional studies of archaeological ceramics. *The Journal of Archaeological Science* 15: 159-172.
1989 More observations on the problem of tempering in compositional studies of archaeological ceramics. *The Journal of Archaeological Science* 16:57-69.

Neff, H. and F.J. Bove
1999 Mapping ceramic compositional variation and prehistoric interaction in Pacific coastal Guatemala. Proceedings of the 1996 Urbana International Symposium on Archaeometry. Special Issue, *Journal of Archaeological Science* 26(8):1037-1051.

Neff, H., F.J. Bove, E. Robinson, and B. Arroyo
1994 A ceramic compositional perspective on the Formative to Classic transition in southern Mesoamerica. *Latin American Antiquity* 5:333-358.

Neff, H. and M.D. Glascock
1993 Neutron activation analysis of Dogoszhi style pottery from Chaco sites and other sites in Northern New Mexico and Arizona. M.A. thesis on file, Missouri University Research Reactor, University of Missouri, Columbia.
1995a The current state of nuclear archaeology. *Journal of Radioanalytical and Nuclear Chemistry* 196(2):273-284.
1995b Neutron activation analysis of pottery and clays from the Lake Alan Henry Site. Final Report of the Missouri University Research Reactor, Columbia.
1996 Chemical variation in prehistoric ceramics from Southwestern Colorado: An update with new data from the Lowry ruin excavations with W. James Judge. Report for W. James Judge on file at the Missouri University Research Reactor, Columbia.

Neff, H., M.D. Glascock, R.L. Bishop, and M.J. Blackman
1996 A reassessment of the acid-extraction approach to compositional characterization of archaeological ceramics. *American Antiquity* 61:389-404.

Neff, H. and D.O. Larson
1997 Methodology of comparison in evolutionary archaeology. In *Rediscovering Darwin: Evolutionary theory in archaeological explanation*, edited by C. M. Barton and G. A. Clark, 75-94. Archaeological Publications No. 7. Arlington: American Anthropological Association.

Neff, H., D.O. Larson, and M.D. Glascock
1997 The evolution of Anasazi ceramic production and distribution: Compositional evidence from a Pueblo-III site in south-central Utah. *Journal of Field Archaeology* 24:473-492.

Neher, R., and W. Buchanan
1980 *Soil survey of Luna County, New Mexico.* Washington, D.C.: US Department of Agriculture, Soil Conservation Service.

Neitzel, J.E.
1991 Hohokam material culture and behavior: The dimensions of organizational change. In *Exploring the Hohokam: Prehistoric desert peoples of the American southwest*, edited by G.J. Gumerman, 177-230. Amerind Foundation Publication. Albuquerque: University of New Mexico Press.
1994 Boundary dynamics in the Chacoan regional system. In *The*

ancient Southwestern community: Models and methods for the study of prehistoric social organization, edited by W.H. Wills and R.D. Leonard, 209-240. Albuquerque: University of New Mexico Press.

1995 Elite styles in hierarchically organized societies: the Chacoan regional system. In *Style, society, and person: Archaeological and ethnological perspectives,* edited by C. Carr and J.E. Neitzel, 394-417. New York: Plenum Press.

2000 What is a regional system? Issues of scale and interaction in the prehistoric Southwest. In *The archaeology of regional interaction: Religion, warfare, and exchange across the American Southwest and beyond,* edited by M. Hegmon, 25-40. Boulder: University Press of Colorado.

Neitzel, J.E. and R.L. Bishop
1990 Neutron activation of Dogoszhi style ceramics: Production and exchange in the Chacoan regional system. *Kiva* 56(1):67-85.

Nelson, M.C.
2000 Abandonment: conceptualization, representation, and change. In *Social theory in archaeology,* edited by M.B. Schiffer, 52-62. Salt Lake City: University of Utah Press.

Newcomb, J.M.
1997 Prehistoric population dynamics in the Silver Creek area, east-central Arizona. M.A. thesis, Department of Anthropology, University of Arizona, Tucson.

1999 Silver Creek settlement patterns and paleo-demography. In *Living on the edge of the rim: Excavations and analysis of the Silver Creek Archaeological research project, 1993-1998,* edited by B.J. Mills, S.A. Herr and S. Van Keuren, 31-52. Tucson: Arizona State Museum Archaeological Series 192. University of Arizona.

New Mexico Geological Society
1982 New Mexico highway geologic map. Map Committee: R.E. Clemons, R.W. Kelley, F.E. Kottlowski, and J.M. Robertson. Socorro: New Mexico Geological Society.

Nishimori, R.K.
1976 The petrology and geochemistry of gabbros from the Peninsular Ranges batholith, California, and a model for their origin Ph.D. dissertation, University of California, San Diego.

O'Brien, M.J., R.L. Lyman, and R.D. Leonard
1998 Basic incompatibilities between evolutionary archaeology and behavioral archaeology. *American Antiquity* 63:485-498.

Olin, J.S. and E.V. Sayre
1971 Compositional categories of English and American pottery of the American Colonial period. In *Science and archaeology,* edited by R.H. Brill, 196-209. Cambridge: MIT Press.

Olivier, D.C.
1973 AGCLUS: aggregative hierarchical clustering program. Cambridge, MA: Department of Psychology and Social Relations, Harvard University.

Parham, T., R. Paetzold, and C. Souders
1983 *Soil survey of Grant county, New Mexico, central and southern parts.* Washington, D.C.: US Department of Agriculture, Soil Conservation Service.

Parry, S.J.
1991 *Activation spectrometry in chemical analysis.* New York: John Wiley and Sons.

Peacock, D.P.S., eds.
1982 *Pottery in the Roman world: an ethnoarchaeological approach.* New York: Longman.

Perlman, I. and F. Asaro
1969 Pottery analysis by neutron activation. *Archaeometry* 11:21-52.

Peterson, J.A., ed.
1990 *Preliminary mineral resource assessment of the Tucson and Nogales 1° x 2° quadrangles, Arizona.* (Microform). Open File Report 90-276. Denver: United States Geological Survey.

Picon, M.
1985 Un exemple de pollution aux dimensions kilometriques: la fixation du baryum par les ceramiques. *Revue d'archéometrie* 9:27-29.

1987 La fixation du baryum et du strontium par les ceramiques. *Revue d'archéometrie* 11:41-47.

Pippin, L.C.
1986 Intermountain brown wares: An assessment. In *Pottery of the Great Basin and adjacent areas,* edited by S. Griset, 9-21. Anthropological Papers, No. 111. Salt Lake City: University of Utah.

Pires-Ferreira, J.W.
1976 Obsidian exchange in Formative Mesoamerica. In *The Early Mesoamerican village,* edited by Kent Flannery, 292-306. New York: Academic Press.

Plog, F.
1977 Modeling prehistoric exchange. In *Exchange systems in prehistory,* edited by T.K. Earle and J.E. Ericson, 127-140. New York: Academic Press.

Plog, S.
1980 Village autonomy in the American Southwest: an evalution of the evidence. In *Models and methods in regional exchange,* edited by R.E. Fry, 135-146. SAA Papers No. 1. Washington, D.C.: Society for American Archaeology.

1989a Ritual, exchange, and the development of regional systems. In *The Architecture of social integration in prehistoric pueblos,* edited by W.D. Lipe and M. Hegmon, 143-154. Occasional paper no. 1. Cortez: Crow Canyon Archaeological Center.

1989b The sociopolitics of exchange (and archaeological research) in the northern southwest. In *The Sociopolitical structure of prehistoric southwestern societies,* edited by S. Upham, K.G. Lightfoot, and R.A. Jewett, 129-148. Boulder: Westview Press.

1990 Sociopolitical implications of Southwestern stylistic variation. In *The use of style in archaeology,* edited by M. Conkey and C. Hastorf, 61-72. Cambridge: Cambridge University Press.

1993 Changing perspectives on North and Middle American exchange systems. In *The Southwest and Mesoamerica,* edited by J.E. Ericson and T.G. Baugh, 285-292. New York: Plenum Press.

1994 Introduction: Regions and Boundaries in the Prehistoric Southwest. In *The Ancient Southwestern Community: Methods and Models for the Study of Prehistoric Social Organizations,* edited by W.W. Wills and R. Leonard, 147-148. Albuquerque: University of New Mexico Press.

1995a Approaches to style: complements and contrasts. In *Style, society, and person: Archaeological and ethnological perspectives,* edited by C. Carr and J.E. Neitzel, 369-387. New York: Plenum Press.

1995b Paradigms and pottery: the analysis of production and ex-

change in the American Southwest. In *Ceramic production in the American Southwest*, edited by B.J. Mills and P.L. Crown, 268-280. Tucson: University of Arizona Press.

Pollard, A.M.

1986 Data analysis. In *Greek and Cypriot pottery: A review of scientific studies*, edited by R. E. Jones, 56-83. Fitch Laboratory Occasional Paper, No. 1. Athens: The British School.

Pollard, A.M. and C. Heron

1996 *Archaeological chemistry*. Cambridge: Royal Society of Chemistry Information Services.

Pool, C.A.

1992 Integrating ceramic production and distribution. In *Ceramic production and distribution: an integrated approach*, edited by G.J. Bey III and C.A. Pool, 275-313. Boulder, CO: Westview Press.

Rands, R.L., and R.L. Bishop

1980 Resource procurement zones and patterns of ceramic exchange in the Palenque region, Mexico. In *Models and methods in regional exchange*, edited by R.E. Fry, 19-46. SAA Papers No. 1. Washington, D.C.: Society for American Archaeology.

Rapp, G. Jr.

1985 The provenance of artifactual raw materials. In *Archaeological geology*, edited by G. Rapp, Jr., and J.A. Gifford, 353-375. New Haven, CT: Yale University Press.

Rautman, M., B. Gomez, H. Neff, and M.D. Glascock

1993 Neutron activation analysis of Late Roman ceramics from Kalavasos-Kopetra and the environs of the Vasilikos Valley. *Report of the Department of Antiquities, Cyprus*, 233-264.

Reedy, T.J. and C.L. Reedy

1992 Comments …IV (on Sayre et al.). *Archaeometry* 34:327-329.

Reid, J.J.

1985 Measuring social complexity in the American southwest. In *Status, structure, and stratification: Current archaeological reconstructions*, edited by M. Thompson, M.T. Garcia, and F.J. Kense, 167-174. Calgary: Archaeological Association of the University of Calgary.

1989 A Grasshopper perspective on the Mogollon of the Arizona mountains. In *Dynamics of southwest prehistory*, edited by L.S. Cordell and G.J. Gumerman, 65-97. Washington, D.C.: Smithsonian Institution Press.

Reid, J.J., B.K. Montgomery, M.N. Zedeño, and M.A. Neupert

1992 The origin of Roosevelt Redware. In *Proceedings of the second Salado conference, Globe, AZ 1992*, edited by R. Lang and S. Germick, 212-215. Phoenix: Arizona Archaeological Society.

Reid, J.J., M.B. Schiffer, and W.L. Rathje

1975 Behavioral archaeology: Four strategies. *American Anthropologist* 77:864-869.

Reid, J.J., H.D. Tuggle, and B.J. Klie

1982 The Q Ranch Sites. In *Cholla Project Archaeology*, Vol. 3: *The Q Ranch region*, edited by J. J. Reid, 33-104. Arizona State Museum Archaeological Series No. 161, Tucson: University of Arizona.

Reid, J.J., J.R. Welch, B.K. Montgomery, and M.N. Zedeño

1996 A demographic overview of the late Pueblo III period in the mountains of east-central Arizona. In *The prehistoric Pueblo world, A.D. 1150-1350*, edited by M.A. Adler, 73-85. Tucson: University of Arizona Press.

Reid, J.J. and S. Whittlesey

1989 The complicated and the complex: observations on the archaeological record of large pueblos. In *The Sociopolitical structure of prehistoric Southwestern societies*, edited by S. Upham, K. Lightfoot, and R.A. Jewett, 184-195. Boulder, CO: Westview Press.

1997 *The archaeology of ancient Arizona*. Tucson: University of Arizona Press.

1999 *Grasshopper Pueblo, a story of archaeology and ancient life*. Tucson: University of Arizona Press.

Reynolds, S.J.

1988 Geologic map of Arizona. Map 26, produced in cooperation with the U.S. Geological Survey. Tucson: Arizona Geological Society.

Rice, P.

1987 *Pottery analysis: A sourcebook*. Chicago: University of Chicago Press.

1996 Recent ceramic analysis: 2. Composition, production, and theory. *Journal of Archaeological Research* 4(3):165-202.

Rice, P.M. and M. Saffer

1982 Cluster analysis of mixed-level data: pottery provenience as an example. *Journal of Archaeological Science* 9:395-409.

Richard, L.R., and D.B. Clark

1989 Multivariate statistical models for granites in terrane analysis: Nova Scotia, Morocco, and Iberia. *Geological Society of America Bulletin* 101:1157-1162.

Riddell, H.S.

1951 The archaeology of a Paiute village site in Owens Valley. *University of California Archaeological Survey Reports* 12:14-28.

Rinaldo, J.B., and E.A. Bluhm

1956 Late Mogollon pottery types of the Reserve area. *Fieldiana* 36(7):149-187.

Ringrose, T.J.

1992 Bootstrapping and correspondence analysis in archaeology. *Journal of Archaeological Science* 19:615-629.

Roaf, M. and J. Galbraith

1994 Pottery and p-values: "Seafaring merchants of Ur?" revisited. *Antiquity* 68:770-783.

Robbins-Wade, M., G.T. Gross, and R.D. Shultz

1996 Archaeological survey and testing program for Loveland reservoir fishing access, San Diego County, California. El Cajon, CA.: Affinis.

Robinson, W.J.

1958 Burial costumes at Point of Pines Ruin. M.A. thesis. Department of Anthropology, University of Arizona, Tucson.

Rogers, M.J.

1936 Yuman pottery making. *San Diego Museum Papers No. 2*. San Diego: Museum of Man.

1945a An outline of Yuman prehistory. *Southwestern Journal of Anthropology*, 1:167-198.

1945b Final Yuman pottery types. on file, San Diego Museum of Man. Manuscript on file at the San Diego Museum of Man, San Diego, California.

1945c Letter to E.W. Gifford Dated June 27, 1945 on file, San Diego Museum of Man.

Romesburg, H.C.

1984 *Cluster analysis for researchers*. Belmont, CA: Lifetime Learning.

Rose, J.C.
1979　Ceramic analysis of 18 sherds from AZ Y:8:3. In *The Coronet Real Project: Archaeological investigations on the Luke Range, southwestern Arizona,* by B.B. Huckell, 139-148. Archaeological Series No. 129. Tucson: Arizona State Museum, University of Arizona.

Rose, J.C., and D.M. Fournier
1981　Petrographic analysis of four sherd types from the Gila Bend area of Arizona. In *Test excavations at Painted Rock Reservoir: Sites AZ Z:1:7, AZ Z:1:8, and AZ S:16:36,* by L. S. Teague, 77-87. Archaeological Series No. 143. Tucson: Arizona State Museum, University of Arizona.

Rouse, I.
1958　The inference of migration from anthropological evidence. In *Migrations in New World culture history,* edited by R. H. Thompson, 63-68. University of Arizona Bulletin 29, Social Science Bulletin 27. Tucson: University of Arizona Press.

Rugge, D.
1977　Petrographic analysis of pottery from the Mimbres valley. Unpublished manuscript on file, Mimbres Foundation, Maxwell Museum of Anthropology, University of New Mexico, Albuquerque.

Rye, O.S.
1981　*Pottery technology: Principles and reconstruction.* Manuals on Archaeology No. 4. Washington, D.C.: Taraxacum Press.

Sayre, E.V.
1975　Brookhaven procedures for statistical analysis of multivariate archaeometric data. Unpublished manuscript, Brookhaven National Laboratory, Upton, NY.

Sayre, E.V. and R.W. Dodson
1957　Neutron activation study of Mediterranean potsherds. *American Journal of Archaeology* 61:35-41.

Sayre, E.V., K.A. Yener, and E.C. Joel
1992a　Reply (to Comments on Sayre et al. 1992a). *Archaeometry* 34:330-336.

Sayre, E.V., K.A. Yener, E.C. Joel, and I.L. Barnes
1992b　Statistical evaluation of the presently accumulated lead isotope data from Anatolia and surrounding regions. *Archaeometry* 34:73-105.

Schaefer, J.
1986　Late prehistoric sdaptations during the final recessions of Lake Cahuilla: Fish camps and quarries on West Mesa, Imperial County, California. San Diego: Mooney-LeVine and Associates.
1994a　The challenge of archaeological research in the Colorado desert: New approaches and discoveries. *Journal of California and Great Basin Anthropology* 16(1):60-80.
1994b　The stuff of creation: Recent approaches to ceramics analysis in the Colorado desert. In *Recent research along the Lower Colorado river,* 81-100. Statistical Research Technical Series, No. 51. Tucson: Statistical Research.

Schiffer, M.B.
1995　Social theory and history in behavioral archaeology. In *Expanding archaeology,* edited by J.M. Skibo, W.H. Walker, and A.E. Nielsen, 22-35. Salt Lake City: University of Utah Press.
1996　Some relationships between behavioral and evolutionary archaeologies. *American Antiquity* 61:643-662.

Schiffer, M.B. and J.M. Skibo
1995　[1987] Theory and experiment in the study of technological change. Reprinted from Current Anthropology in *Behavioral archaeology, first principles,* by M.B. Schiffer. Salt Lake City: University of Utah Press.
1997　The explanation of artifact variability. *American Antiquity* 62(1)27-50.

Schneider, G.
1996　Chemical grouping of Roman Terra Sigillata finds from Turkey, Jordan, and Syria. In *Archaeometry 94: The proceedings of the 29th international symposium on archaeometry,* edited by S. Demirci, A.M. Ozer, and G.D. Summers, 189-196. Tubitak, Ankara.

Schneider, G., B. Hoffmann, and E. Wirz
1979　Significance and dependability of reference groups for chemical determinations of provenance of ceramic artifacts. In *Proceedings of the 18th international symposium on archaeometry and archaeological prospection,* 269-285. Archäo-Physika 10. Bonn: Rheinisches Landesmuseum.

Schroeder, A.H.
1957　The Hakataya cultural tradition. *American Antiquity* 23:176-178.
1961　Archaeological excavations at Willow Beach, Arizona. *University of Utah Anthropological Papers, no. 50,* Salt Lake City.
1979　Prehistory: Hakataya. In Southwest, edited by A. Ortiz, 100-107. *Handbook of North American indians, vol. 9,* W. G. Sturtevant, general editor. Washington, D.C.: Smithsonian Institution.

Schubert, P.
1986　Petrographic modal analysis–a necessary complement to chemical analysis of ceramic coarse ware. *Archaeometry* 28:163-178.

Schwalbe, L.A. and T.P. Culbert
1988　Analytical measures of variability and group differences in X-ray fluorescence data. *Journal of Archaeological Science* 15:669-681.

Scott, A.J. and M.J. Symons
1971　Clustering methods based on the likelihood ratio criteria. *Biometrics* 27:387-397.

Scott, G.R., R. B. O'Sullivan, and D. L. Weide
1984　*Geological map of the Chaco culture National Historical Park, Northwestern New Mexico.* U.S. Geological Survey Map I-1571. Washington, D.C.: U.S. Geological Survey.

Severa, J., and M.B. Severson
1978　Petrographic analysis. In *The Quijotoa Valley project,* by E.J. Rosenthal, D.R. Brown, M. Severson, and J.B. Clonts, 281-288. Tucson: Western Archaeological and Conservation Center, National Park Service.

Shafer, H.
1996　The Classic Mimbres phenomenon and some new interpretations. Paper presented at the 9th Mogollon Archaeology Conference organized by Western New Mexico University Museum, Silver City, New Mexico.

Shennan, S.
1997　*Quantifying archaeology,* 2nd edition. Edinburgh: Edinburgh University Press.

Shepard, A.O.

1936 The technology of Pecos pottery. In *The pottery of Pecos,* Vol. 2, by A.V. Kidder and A.O. Shepard, 389-587. New Haven, CT: Yale University Press.

1938 Technological notes on the pottery from Unshagi. In *The Jemez Pueblo of Unshagi, New Mexico,* by P. Reiter, 205-211. University of New Mexico Bulletin Monograph Series 1(5). Albuquerque: University of New Mexico Press.

1939a Technology of La Plata pottery. In *Archaeological studies in the La Plata district, southwestern Colorado and northwestern New Mexico,* by E. Morris, 249-287. Publication 519. Washington, D.C.: Carnegie Institution of Washington.

1939b Technological notes on the pottery of San Jose. In *Excavations at San Jose, British Honduras,* by J. E. Thompson, 251-277. Washington D.C., The Carnegie Institution of Washington.

1942 Rio Grande Glaze paint ware: a study illustrating the place of ceramic technological analysis in archaeological research. *Contributions to American Anthropology and History, no. 39,* Publication 528. Washington, D.C.: Carnegie Institution of Washington.

1964 Temper identification: "technological sherd-splitting" or an unanswered challenge. *American Antiquity* 29(4):518-520.

1965 Rio Grande Glaze-Paint pottery: A test of petrographic analysis. In *Ceramics and man,* edited by F.R. Matson, 62-87. Viking Fund Publications in Anthropology, No. 41. Chicago: Aldire Publishing Company.

1995 *Ceramics for the archaeologist.* Reprinted. Ann Arbor: Braun-Brumfield, Inc. Originally published 1956, Publication 609. Washington, D.C.: Carnegie Institution of Washington.

Simon, A. and C. Redman

1990 An integrated approach to the Roosevelt Lake ceramics. In *A design for Salado research,* edited by G. Rice, 65-77. Roosevelt Monograph Series I. Tempe: Arizona State University.

Sirrine, G.K.

1958 Geology of the Springerville-St. Johns area, Apache County, Arizona. Ph.D. dissertation, The University of Texas. Ann Arbor, MI: University Microfilms.

Skibo, J.M. and M.B. Schiffer

1995 The clay cooking pot: An exploration of women's technology. In *Expanding archaeology,* edited by J.M. Skibo, W.H. Walker, and A.E. Nielsen, 80-91. Salt Lake City: University of Utah Press.

Slane, K.W., J.M. Elam, M.D. Glascock, and H. Neff

1994 Compositional analysis of Eastern Sigillata A and related wares from Tel Anafa (Israel). *Journal of Archaeological Science* 21:51-64.

Sneath, P.H.A.

1977 A method for testing the distinctness of clusters: a test of the disjunction of two clusters in Euclidean space as measured by their overlap. *Mathematical Geology* 9:123-144.

Sneath, P.H.A. and R.R. Sokal

1973 *Numerical taxonomy.* San Francisco: W.H. Freeman.

Snow, D.H.

1982 The Rio Grande Glaze, Matte-Paint, and Plainware tradition. In Southwestern ceramics: a comparative review, edited by Albert H. Schroeder. *The Arizona Archeologist* 15:235-278.

Sokal, R.R. and F.J. Rohlf

1962 The comparison of dendrograms by objective methods. *Taxon* 11:33-40.

Specht, J.

1972 The pottery industry of Buka Island, Territory of Papua, New Guinea. *Anthropology and Physical Anthropology in Oceania* 7:125-144.

Speth, J.D.

1991 Some unexplored aspects of mutualistic Plains-Pueblo food exchange. In *Farmers, hunters, and colonists: Interaction between the Southwest and the Southern Plains,* edited by K.A. Spielmann, 18-35. Tucson: University of Arizona Press.

Spielmann, K.A.

1983 Late Prehistoric exchange between the Southwest and Southern Plains. *Plains anthropologist* 28(102, Pt. 1):257-272.

1991 Farmers, hunters, and colonists: Interaction between the Southwest and the Southern Plains. Tucson: University of Arizona Press. (editor)

1998 *Pueblo IV migration and community reorganization.* Arizona State University Anthropological Research Papers 51. Tempe: Arizona State University. (editor)

Spier, L.

1918 *Ruins in the White Mountains, Arizona.* Anthropological Paper No. 18, Vol. 5, 363-387. Washington, D.C.: Museum of Natural History.

Stark, B.L.

1985 Archaeological identification of pottery production locations: Ethnoarchaeological and archaeological data in Mesoamerica. In *Decoding prehistoric ceramics,* edited by B.A. Nelson, 158-223. Carbondale: Southern Illinois University Press.

Stark, M.T.

1993 *Pottery economics: a Kalinga ethnoarchaeological study.* Ph.D. dissertation, University of Arizona. Ann Arbor, MI: University Microfilms.

1995 Commodities and interaction in the prehistoric Tonto Basin. In *The Roosevelt community development study: New perspectives on Tonto Basin prehistory,* edited by M.D. Elson, M.T. Stark, and D.A. Gregory, 307-342. Anthropological Papers No. 15. Tucson: Center for Desert Archaeology.

Stark, M.T., M.D. Elson, and J.J. Clark

1995a Causes and consequences of migration in the 13th century Tonto Basin. *Journal of Anthropological Archaeology* 14:212-246.

Stark, M.T., and J.M. Heidke

1992 The plainware and redware ceramic assemblages. In *The Rye Creek project: archaeology in the upper Tonto Basin:* Vol. 2. *Artifact and specific analyses,* by M.D. Elson and D.B. Craig, 89-214. Anthropological Papers No. 11. Tucson: Center for Desert Archaeology.

1995 Early Classic period variability in utilitarian ceramic production and distribution. In *The Roosevelt community development study:* Vol. 2. *Ceramic chronology, technology, and economics,* edited by J.M. Heidke and M.T. Stark, 133-204. Anthropological Papers No. 14. Tucson: Center for Desert Archaeology.

Stark, M.T., J.M. Vint, and J.M. Heidke

1995b Compositional variability in utilitarian ceramics at a Colonial period site. In *The Roosevelt community development study:* Vol. 2. *Ceramic chronology, technology, and economics,* edited by J.M. Heidke and M.T. Stark, 273-295. Anthropological Papers No. 14. Tucson: Center for Desert Archaeology.

Stein, J.R. and S.H. Lekson
1992 Anasazi ritual landscapes. *Anasazi regional organization and the Chaco system*, edited by D.E. Doyel, 87–100. Maxwell Museum of Anthropology Anthropological Papers No. 5. Albuquerque: Maxwell Museum of Anthropology.

Stein, P.H.
1979 *Archaeological investigations along the Salt-Gila aqueduct.* Technical Report No. 79-9. Flagstaff: Museum of Northern Arizona.

Steponaitis, V.P. and M.J. Blackman
1981 Chemical characterization of Mississippian pottery. Paper presented at the 38th Annual Meeting of the Southeastern Archaeological Conference. Asheville, North Carolina.

Steponaitis, V.P., M.J. Blackman, and H. Neff
1996 Large-scale patterns in the chemical composition of Mississippian pottery. *American Antiquity* 61:555–572.

Steward, J.H.
1928 Pottery from Deep Springs Valley, Inyo County, California. *American Anthropologist* 30:348.
1938 Basin-Plateau aboriginal sociopolitical groups. Bureau of American Ethnology Bulletin 120. Washington, D.C.: Bureau of American Ethnology.

Stewart, J.D., P. Fralick, R.G.V. Hancock, J.H. Kelley, and E.M. Garrett.
1990 Petrographic analysis and INAA geochemistry of prehistoric ceramics from Robinson Pueblo, New Mexico. *Journal of Archaeological Science* 17:601–625.

Stinson, S.L.
1996 Roosevelt red ware and the organization of ceramic production in the Silver Creek drainage. M.A. thesis, Department of Anthropology, University of Arizona, Tucson.

Stoltman, J.B.
1989 A quantitative approach to the petrographic analysis of ceramic thin sections. *American Antiquity* 54:147–160.
1996 Petrographic observations of selected sherds from Wind Mountain. In *Mimbres-Mogollon archaeology: Charles C. Di Peso's excavations at Wind Mountain*, by A. Woosley and A. McIntyre, 367–371. Dragoon, AZ: Amerind Foundation and Albuquerque: University of New Mexico Press.

Stoltman, J.B., J.H. Burton, and J. Haas
1992 Chemical and petrographic characterizations of ceramic pastes: two perspectives on a single data set. In *Chemical characterization of ceramic pastes in archaeology*, edited by H. Neff, 85–92. Monographs in World Archaeology No. 7. Madison, WI: Prehistory Press.

Straczynski, J.M.
1994 "Into the fire" from *Babylon 5*, Production No. 406. North Hollywood, California: Babylonian Productions, Inc. (Videotape)

Swartz, D.L., and B.G. Randolph
1994 The Griffin Wash site AZ V:5:90/96 (ASM/TNF). In *The Roosevelt community development study: Vol. 2. Meddler Point, Pyramid Point, and Griffin Wash sites*, by M.D. Elson, D.L. Swartz, D.B. Craig, and J.J. Clark, 297–415. Anthropological Papers No. 13. Tucson: Center for Desert Archaeology.

Tagg, M.D.
1984 *The Timba-Sha survey and boundary fencing project.* Western Archaeological and Conservation Center Publications in Anthropology 27. Tucson: National Park Service.

Tangri, D. and R.V.S. Wright
1993 Multivariate analysis of compositional data: Applied comparisons favour standard principal components analysis over Aitchison's loglinear contrast method. *Archaeometry* 35:103–115.

Teague, L.S.
1984 The organization of Hohokam economy. In *Part 2 of Hohokam archaeology along the Salt-Gila aqueduct, central Arizona project: Synthesis and conclusions*, vol. IX, edited by L.S. Teague and P.L. Crown, 187–250. Tucson: Arizona State Museum archaeological series no. 150. University of Arizona.

Thiel, J.H., and M.K. Faught
1995 Historic period artifacts. In *Beneath the streets: Prehistoric, Spanish, and American period archaeology in downtown Tucson*, by J.H. Thiel, M.K. Faught, and J.M. Bayman, 159–212. Technical Report No. 94-11. Tucson: Center for Desert Archaeology.

Thompson, R.H.
1993 Prehistoric channel cutting at Point of Pines, Arizona. In *Actes du XII congres international des sciences prehistoriques et protohistoriques, Bratislava (1991)*, 504–516. Nitra, Slovakia: Institut archeologique de'l Academie Slovaque des Sciences.

Todd, V.R., B.G. Erskine, and D.M. Morton
1988 Metamorphic and tectonic evolution of the northern Peninsular Ranges Batholith, southern California. In *Metamorphism and crustal evolution of the western United States*, edited by W.G. Ernst, 895–937. Englewood Cliffs, NJ: Prentice Hall.

Toll, H.W.
1984 Trends in ceramic import and distribution in Chaco canyon. In *Recent research on Chaco prehistory*, edited by W.J. Judge and J.D. Schelberg, 115–135. Reports of the Chaco Center No. 8. USDI, Albuquerque: National Park Service.
1985 Pottery production, public architecture, and the Chaco Anasazi system. Ph.D. dissertation, Department of Anthropology, University of Colorado, Boulder.
1991 Material distributions and exchange in the Chaco system. In *Chaco and Hohokam: Prehistoric regional systems in the American Southwest*, edited by P.L. Crown and W.J. Judge, 97–107. Santa Fe, NM: School of American Research Press.
1997 Chaco Ceramics. In *Ceramics, lithics, and ornaments of Chaco canyon: analyses of artifacts from the Chaco project, 1971-1978, volume I*, edited by F.J. Mathien, 17–550. Chaco Canyon Studies Publications in Archaeology 18G. Albuquerque: USDI, National Park Service.

Toll, H.W. and P.J. McKenna
1987 The ceramography of Pueblo Alto. In *Investigations at the Pueblo Alto complex*, Vol. 3 (part 1): artifactual and biological analyses, edited by F.J. Mathien and T.C. Windes, 19–230. Chaco Studies Publications in Archaeology 18F. USDI, National Park Service, Albuquerque.
1992 The rhetoric and the ceramics: Discussion of the types, functions, distributions, and sources of the ceramics of 29SJ627. In *Excavations at 29SJ627, Chaco canyon, New Mexico, vol.2*, edited by F.J. Mathien, 37–248. Reports of the Chaco Center No. 11. Albuquerque: USDI, National Park Service.

Toll, H.W., T.C. Windes, and P.J. McKenna
1980 Late ceramic patterns in Chaco Canyon: The pragmatics of modeling ceramic exchange. In *Models and methods in regional*

exchange, edited by R.E. Fry, 95-118. SAA Papers No. 1. Washington, D.C.: Society for American Archaeology.

Touhy, D.R.

1986 Ethnographic specimens of Basin Brownware. In *Pottery of the Great Basin and adjacent areas*, edited by S. Griset, 27-36. Anthropological Papers, No. 111. Salt Lake City: University of Utah.

1990 Second thoughts on Shoshoni pots from Nevada and elsewhere. In *Hunter-gatherer pottery from the Far West*, edited by J. Mack, 83-105. Anthropological Papers, No. 23. Carson City: Nevada State Museum.

Treganza, A.E.

1947 Possibilities of an aboriginal practice of agriculture among the southern Diegueno. *American Antiquity* 12:169-173.

Triadan, D.

1997 *Ceramic commodities and common containers: Production and distribution of White Mountain Red Ware in the Grasshopper region, Arizona*. Tucson: Anthropological Papers of the Univeristy of Arizona, No. 61.

1998 Socio-demographic implications of Pueblo IV ceramic production and circulation: sourcing White Mountain Red Ware from the Grasshopper region. In *Migration and reorganization: the Pueblo IV period in the American southwest*, edited by K.A. Spielmann, 233-253. Anthropological Research Papers 51. Tempe: Arizona State University.

Triadan, D., H. Neff, and M.D. Glascock

1997 An evaluation of the archaeological relevance of weak-acid extraction ICP: White Mountain redware as a case study. *Journal of Archaeological Science* 24:997-1002.

Tuggle, H.D.

1970 Prehistoric community relationships in east-central Arizona. Ph.D. dissertation, Department of Anthropology, University of Arizona.

1982 Settlement patterns in the Q Ranch region. In *Cholla project archaeology*, Vol. 3: *The Q Ranch region*, edited by J.J. Reid, 151-175. Tucson: Arizona State Museum Archaeological Series No. 161, University of Arizona.

Tuggle, H.D., K.W. Kintigh, and J.J. Reid

1982a Trace-element analysis of white wares. In *Cholla project archaeology, volume 5*, edited by J.J. Reid, 22-38. Tucson: Cultural Resource Management Division, Arizona State Museum, Archaeological Series No. 161.

Tuggle, H.D., B.J. Klie, S.M. Whittlesey, and J.J. Reid

1982b Appendix 3: additional information on sites used in interassemblage analysis. In *Cholla project archaeology*, Vol. 3: The Q Ranch region, edited by J.J. Reid, 237-328. Tucson: Arizona State Museum Archaeological Series No. 161, University of Arizona.

Upham, S.

1982 *Polities and power: An economic and political history of the western Pueblo*. New York: Academic Press.

Upham, S., K.G. Lightfoot, and G.M. Feinman

1981 Explaining socially determined ceramic distribution in the prehistoric plateau Southwest. *American Antiquity* 46(4):822-833.

van der Leeuw, S.E.

1984 Dust to dust: a transformational view of the ceramic cycle. In *The many dimensions of pottery: ceramics in archaeology and anthro-*

pology, edited by S. E. van der Leeuw and A. C. Pritchard, 705-778. Amsterdam: Albert Egges van Giffen Instituut voor Praeen Protohistorie, Universiteit van Amsterdam.

Van Keuren, S.

1999 *Ceramic design structure and the organization of Cibola white ware production in the Grasshopper region, Arizona*. Tucson: Arizona State Museum Archaeological Series 191.

Venables, W.N. and B.D. Ripley

1997 *Modern applied statistics with S-plus*, 2nd edition. New York: Springer-Verlag.

Vitali, V. and U.M. Franklin

1986 New approaches to the characterization and classification of ceramics on the basis of their elemental composition. *Journal of Archaeological Science* 13:161-170.

Vitali, V., J.W. Simmons, E.F. Henrickson, L.D. Levine, and R.G.V. Hancock

1987 A hierarchic taxonomic procedure for provenance determination: a case study of Chalcolithic ceramics from the Central Zagros. *Journal of Archaeological Science* 14:423-435.

Vokes, A.W.

1995 The shell assemblage. In *The Roosevelt community development study: Vol. 1. stone and shell artifacts*, edited by M.D. Elson and J.J. Clark, 151-211. Anthropological Papers No. 14. Tucson: Center for Desert Archaeology.

Wade, S.A.

1985 Ceramics. In *Excavations at SDi-4609, a portion of the village of Ystagua, Sorrento valley, California*, edited by S.M. Hector, 70-77. San Diego: Recon.

Wallace, H.D.

1986 *Rincon phase decorated ceramics: a focus on the West Branch site*. Anthropological Papers No. 1. Tucson: Institute for American Research.

1995a Ceramic accumulation rates and prehistoric Tonto Basin households. In *The Roosevelt community development study: New perspectives on Tonto Basin prehistory*, edited by M.D. Elson, M.T. Stark, and D.A. Gregory, 79-126. Anthropological Papers No. 15. Tucson: Center for Desert Archaeology.

1995b Decorated buffware and brownware ceramics. In *The Roosevelt community development study: Vol. 2. ceramic chronology, technology, and economics*, edited by J.M. Heidke and M.T. Stark, 19-84. Anthropological Papers No. 14. Tucson: Center for Desert Archaeology.

Wallace, H.D., and J. Heidke

1986 Ceramic production and distribution. In *Archaeological investigations at the Tanque Verde Wash site, a Middle Rincon settlement in the eastern Tucson Basin*, by M.D. Elson, 233-270. Anthropological Papers No. 7. Tucson: Institute for American Research.

Wallace, H.D., J. Heidke, D.B. Craig, and M.D. Elson.

1991 Ceramic flow rates and the scale of prehistoric ceramic production and distribution in the Tucson Basin. Paper presented at the 62nd Annual Meeting of the Southwestern Anthropological Association, April 12, Tucson.

Wallace, H.D., J.M. Heidke, and W.H. Doelle

1995 Hohokam origins. *Kiva* 60(4):575-618.

Wallace, R.M.

1957 Petrographic analysis of pottery from University Indian Ruin. In *Excavations, 1940, at University Indian Ruin, Tucson, Arizona*,

by J. D. Hayden, 209-219. Technical Series No. 5. Globe, AZ: Southwestern Monuments Association.

Wallace, W.J.

1957 Archaeological investigations in Death Valley National Monument 1952-1957. Manuscript on file at the Western Archaeological and Conservation Center, Tucson.

1958 Archaeological investigations in Death Valley National Monument. *University of California Archaeological Survey Reports* 42: 7-22.

1962 Archaeological excavations in the southern section of the Anza-Borrego Desert State Park. Sacramento: California Department of Parks and Recreation Archaeological Report.

1968 Archaeological explorations in the northern section of Death Valley National Monument. Manuscript on file at the Western Archaeological and Conservation Center, Tucson.

1986 The pottery of Mesquite Flat, Death Valley, California. In *Pottery of the Great Basin and adjacent areas*, edited by S. Griset, 71-74. Anthropological Papers, No. 111. Salt Lake City: University of Utah.

1988 *Old Crump Flat and Ubehebe craters: Two rockshelters in Death Valley National Monument.* Monographs in California and Great Basin Anthropology 2. David, CA: National Park Service.

Wallace, W.J., and E.S. Taylor

1955 Archaeology of Wildrose Canyon, Death Valley National Monument. *American Antiquity* 20: 355-367.

1956 The surface archaeology of Butte Valley, Death Valley National Monument. Contributions to California Archaeology 1. Los Angeles: Archaeological Research Associates.

1960 The Indian Hill Rockshelter, Preliminary Excavations. *The Masterkey* 34(2):66-82.

Walter, V. and Y. Besnus

1989 Un exemple de pollution en phosphore et en manganèse de céramiques anciennes. *Revue d'archéométrie* 13:55-64.

Wanek, A.A.

1959 *Geology and fuel resources of the Mesa Verde area, Montezuma and La Plata counties, Colorado.* Prepared in cooperation with the National Park Service. Washington, D.C.: U.S. Government Printing Office.

Ward, J.H.

1963 Hierarchical grouping to optimize an objective function. *Journal of the American Statistical Association* 58:236-244.

Warren, A.H.

1967 Petrographic analyses of pottery and lithics. In *An archaeological survey of the Chuska valley and Chaco plateau, New Mexico*, by A.H. Harris, J. Schoenwetter, and A.H. Warren, 104-134. Museum of New Mexico Research Records No. 4. Santa Fe: Museum of New Mexico Press.

1981a A petrographic study of the pottery of Gran Quivira. In *Contributions to Gran Quivira archaeology*, edited by A. Hayes, 67-73. Publications in Archaeology 17. Washington, D.C.: National Park Service.

1981b A petrographic study of the ceramics of four historic sites in Galisteo Basin. *Pottery Southwest* 8(2):2, 4.

Wasley, W.W.

1952 The late Pueblo occupation at Point of Pines, east-central Arizona. M.A. thesis. Department of Anthropology, University of Arizona, Tucson.

Waters, M.R.

1982 The lowland Patayan ceramic tradition. In *Hohokam and Patayan: Prehistory of southwestern Arizona*, edited R.H. McGuire and M.B. Schiffer, 275-298. New York: Academic Press.

1983 Late Holocene lacustrine chronology and archaeology of ancient Lake Cahuilla, California. *Quaternary Research* 19:373-387.

Weber, F.H.

1963 *Geology and mineral resources of San Diego County, California.* California Division of Mines and Geology County Report 3. Sacramento: California Division of Mines and Geology.

Wedel, W.R.

1950 Notes on Plains-Southwestern contacts in light of archaeology. In *For the Dean: essays in anthropology in honor of Byron Cummings*, edited by E.K. Reed and D.S. King, 99-116. Tucson: Hohokam Museums Association.

Weigand, P.C., G. Harbottle, and E.V. Sayre

1977 Turquoise sources and source analysis: Mesoamerica and the southwestern U.S.A. In *Exchange systems in prehistory*, edited by T.K. Earle and J.E. Ericson, 15-34. New York: Academic Press.

Weisman, R.

1987 Pioneer to Sedentary ceramic technology at La Ciudad. In *Specialized studies in the economy, environment, and culture of La Ciudad*, edited by J.E. Kisselburg, G.E. Rice, and B L. Shears, 1-40. Tempe: Office of Cultural Resource Management, Arizona State University.

Weller, S.C., and A.K. Romney

1990 *Metric scaling: Correspondence analysis.* Sage University Papers No. 07-075. Newbury Park, CA: Sage Publications.

Weltje, G.J., S.O.K.J. Van Ansenwoude, and P.L. De Boer

1996 High-frequency detrital signals in eocene fan-delta sandstones of mixed parentage (south-central Pyrennes, Spain): a reconstruction of chemical weathering in transit. *Journal of Sedimentary Research* 66(1):119-131.

Wendorf, F.

1950 *A report on the excavation of a small ruin near Point of Pines, east-central Arizona.* University of Arizona Bulletin 21(3), Social Science Bulletin 19. Tucson: University of Arizona Press.

Wheat, J.B., J.C. Gifford, and W.W. Wasley

1958 Ceramic variety, type cluster, and ceramic systems in Southwestern pottery analysis. *American Antiquity* 24:34-47.

White, D. and J. Burton

1992 Pinto Polychrome: A clue to the origin of Salado Polychromes. *In Proceedings of the second Salado conference, Globe, AZ 1992*, edited by R. Lange and S. Germick, 216-222. Phoenix: Arizona Archaeological Society.

Whittlesey, S.

1987 Problems of ceramic production and exchange: an overview. In *The archaeology of the San Xavier Bridge Site (AZ BB:13:14), Tucson Basin, southern Arizona*, edited by J.C. Ravesloot, 99-115. Arizona State Museum Archaeological Series 171. Tucson: The University of Arizona.

1997 Toward a unified theory of ceramic production and distribution: examples from the central Arizona deserts. In *Vanishing river: Landscapes and lives of the lower Verde Valley*, edited by S.M. Whittlesey, R. Ciolek-Torrello, and J.H. Altschul, 417-446. Tucson: SRI Press.

Wilcox, D.R.

1980 The current status of the Hohokam concept. In *Current issues in Hohokam prehistory: proceedings of a symposium*, edited by D. Doyel and F. Plog, 236–242. Anthropological Research Papers No. 23. Tempe: Arizona State University.

1986 The Tepiman connection: a model of Mesoamerican-Southwestern interaction. In *Ripples in the Chichimec Sea: New considerations of Southwestern-Mesoamerican interactions*, edited by F.J. Mathien and R.H. McGuire, 135–154. Carbondale: Southern Illinois University Press.

1987 The evolution of Hohokam ceremonial systems. In *Astronomy and ceremony in the prehistoric Southwest*, edited by J. Carlson and W.J. Judge, 149–168. Papers of the Maxwell Museum of Anthropology 2. Albuquerque: Maxwell Museum of Anthropology.

1991a Hohokam religion: an archaeologist's perspective. In *The Hohokam: Ancient people of the desert*, edited by D.G. Noble, 47–59. Santa Fe, NM: School of American Research Press.

1991b Hohokam social complexity. In *Chaco and Hohokam: prehistoric regional systems in the American Southwest*, edited by P.L. Crown and W.J. Judge, 253–275. Santa Fe: School of American Research Press.

1991c The Mesoamerican ballgame in the American Southwest. In *The Mesoamerican ballgame*, edited by V.L. Scarsborough and D.R. Wilcox, 101–125. Tucson: University of Arizona Press.

1999 A peregrine view of macroregional systems in the North American Southwest, A.D. 750–1250. In *Great towns and regional polities in the Prehistoric American Southwest and Southeast*, edited by J.E. Neitzel, 115–141. Albuquerque: University of New Mexico Press.

Wilcox, D.R., and B. Masse, eds.

1981 *The Protohistoric Period in the North American Southwest.* Anthropological Research Papers No. 24. Tempe: Arizona State University.

Wilcox, D.R., T.R. McGuire, and C. Sternberg

1981 *Snaketown revisited: A partial cultural resource study, analysis of site structure and an ethnohistoric study of the proposed Hohokam-Pima National Monument.* Archaeological Series No. 155. Tucson: Cultural Resource Management Division, Arizona State Museum, University of Arizona.

Wilcox, D.R., and C. Sternberg

1983 *Hohokam ballcourts and their interpretation.* Archaeological Series No. 160. Tucson: Cultural Resource Management Division, Arizona State Museum, University of Arizona.

Wiley, M.K.

1994 *West Branch petrography: Caliche study.* Letter Report No. 94–148, Tucson: Desert Archaeology, Inc.

Wilke, P.J.

1978 Latep Prehistoric human ecology at Lake Cahuilla, Coachella Valley, California. *Contributions of the University of California archaeological research facility No. 38*, Berkeley: Department of Anthropology, University of California.

Wilke, P.J. and H.W. Lawton

1975 Early observations on the cultural geography of the Coachella valley. *Ballena Press anthropological papers, No. 3*, 9–43, L.J. Bean, general editor. Ramona, CA: Ballena Press.

Wilke, P.J., A.M. McDonald, and L.A. Payen

1986 Excavations at Indian Hill rockshelter, Anza-Borrego Desert State Park, California, 1984–1985. Report on file at the Resource Protection Division, Sacramento: California Park Service.

Wilken, M.

1987 Paipai potters of Baja California: A living tradition. *Masterkey* 60:18–26.

Wilkinson, L.

1990 *SYSTAT: the system for statistics.*

Wilks, S.S.

1962 *Mathematical statistics.* New York: John Wiley and Sons.

Williams, C.T. and F. Wall

1991 An INAA scheme for the routine determination of 27 elements in geological and archaeological samples. In *Neutron activation and plasma emission spectrometric analysis in archaeology: Techniques and applications*, edited by M.J. Hughes, M.R. Cowell, and D.R. Hook, 105–120. British Museum Occasional Papers No. 82. London: British Museum.

Wilson, C.D.

1988 An evaluation of individual migration as an explanation for the presence of smudged ceramics in the Dolores Project area. In *Dolores Archaeological Program: Supporting studies: Additive and reductive technologies*, compiled by E. Blinman, C.J. Phagan, and R.H. Wilshusen, 425–433. Denver: Engineering and Research Center, Bureau of Reclamation, Department of the Interior.

Wilson, C.D. and E. Blinman

1995 Changing specialization of white ware manufacture in the northern San Juan region. In *Ceramic production in the American Southwest*, edited by B.J. Mills and P.L. Crown, 63–87. Tucson: University of Arizona Press.

Wilson, E.D., R.T. Moore, and R.T. O'Haire

1960 Geologic map of Navajo and Apache Counties, Arizona. Arizona Bureau of Mines, Tucson: University of Arizona.

Windes, T.C.

1977 Typology and technology of Anasazi ceramics. In *Settlement and subsistence along the Lower Chaco river: The CGP survey*, edited by C.A. Rehrer, 279–360. Albuquerque: University of New Mexico Press.

Wishart, D.

1987 CLUSTAN User Manual. St. Andrews: University of St. Andrews.

Woodbury, R.

1961 *Prehistoric agriculture at Point of Pines, Arizona.* Memoirs of the Society for American Archaeology 17. Salt Lake City: University of Utah Press.

Woodson, K.

1994 The Goat Hill Site: A Kayenta Anasazi pueblo in the Safford Valley of southeastern Arizona. Paper presented at the 67th anniversary of the Pecos Conference. August, Mesa Verde, CO.

Yellin, J., I. Perlman, F. Asaro, H.V. Michel, and D.F. Mosier

1978 Comparison of neutron activation analysis from Lawrence Berkeley Laboratory and the Hebrew University. *Archaeometry* 20:95–100.

Zedeño, M.N.

1991 Refining inferences of ceramic circulation: A stylistic, technological, and compositional analysis of whole vessels from Chodistaas, Arizona. Ph.D. dissertation. Southern Methodist University, Denton, TX.

1992 Roosevelt Black-on-white revisited. In *Proceedings of the second Salado conference, Globe, AZ 1992*, edited by R. Lange and S. Germick, 206-211. Phoenix: Arizona Archaeological Society.

1994 *Sourcing prehistoric ceramics at Chodistaas Pueblo, Arizona: the circulation of people and pots in the Grasshopper region.* Tucson: Anthropological Papers of the University of Arizona, No. 58.

1995 The role of population movement and technology transfer in the manufacture of Southwestern ceramics. In *Organization of ceramic production in the American Southwest*, edited by P. Crown and B. Mills, 115-141. Tucson: University of Arizona Press.

1998 Defining material correlates for ceramic circulation in the prehistoric puebloan Southwest. *Journal of Anthropological Research* 54:461-476.

Zedeño, M.N., J. Busman, J. Burton, and B. Mills
1993 Ceramic compositional analyses. In *Across the Colorado Plateau: Anthropological studies for the Transwestern pipeline expansion project*. Vol. 16: *Interpretation of ceramic artifacts*. Albuquerque: Office of Contract Archaeology and Maxwell Museum of Anthropology, University of New Mexico.

Zedeño, M.N. and D. Triadan
2000 Ceramic evidence for community reorganization and change in east-central Arizona. *Kiva* 65(3):215-233.

Zhou, D., T. Chang, and J.C. Davis
1983 Dual extraction of R-mode and Q-mode factor solutions. *Mathematical Geology* 15:581-606.

Contributors

Ronald L. Bishop
Smithsonian Center for Materials Research and Education, Museum Support Center

Douglas K. Boyd
Prewitt and Associates, Inc.

Darrell Creel
Texas Archaeological Research Laboratory, University of Texas, Austin

Andrew I. Duff
Department of Anthropology, Washington State University

Jelmer W. Eerkens
Far Western Anthropological Research Group, Davis, California

Paul R. Fish
Arizona State Museum, University of Arizona, Tucson, Arizona

Suzanne K. Fish
Arizona State Museum, University of Arizona, Tucson, Arizona

Michael D. Glascock
Research Reactor (MURR), University of Missouri

Donna M. Glowacki
Crow Canyon Archaeological Center,
Department of Anthropology, Arizona State University

G. Timothy Gross
Affinis

Karen G. Harry
Department of Anthropology and Ethnic Studies, University of Nevada, Las Vegas

Michelle Hegmon
Department of Anthropology, Arizona State University

James M. Heidke
Desert Archaeology, Inc.

John A. Hildebrand
Scripps Institution of Oceanography, UC San Diego

W. James Judge
Department of Anthropology, Fort Lewis College

James W. Kendrick
National Park Service, El Malpais National Monument

Elizabeth J. Miksa
Desert Archaeology, Inc.

Barbara J. Mills
Department of Anthropology, University of Arizona

Hector Neff
Missouri University Research Reactor Center

Jill E. Neitzel
Department of Anthropology, University of Delaware

Kathryn Reese-Taylor
Department of Anthropology, University of Wisconsin-La Crosse

Jerry Schaefer
ASM Affiliates

Daniela Triadan
Department of Anthropology, University of Arizona

Henry D. Wallace
Desert Archaeology, Inc.

Matthew Williams
TeraQuest Metrics, Inc.

M. Nieves Zedeño
Bureau of Applied Research in Anthropology, University of Arizona